DEGAS,
IMPRESSIONISM,
AND THE
PARIS
MILLINERY
TRADE

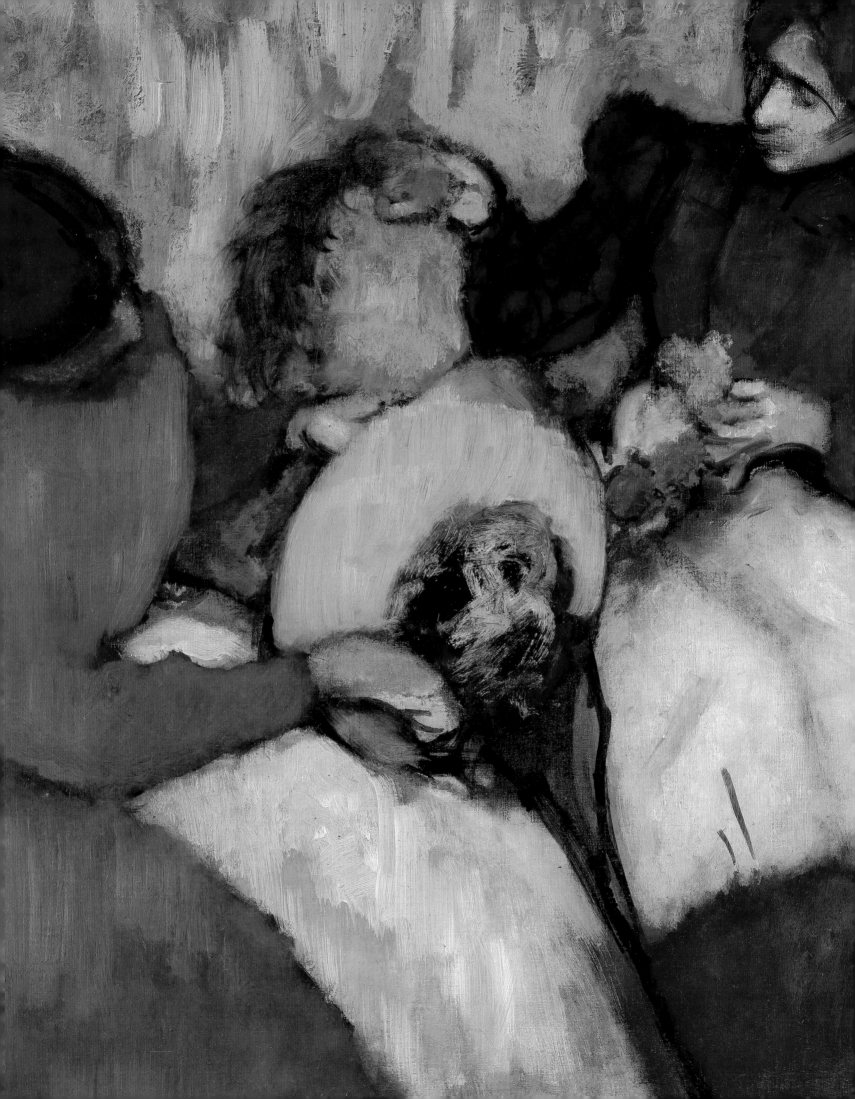

DEGAS, IMPRESSIONISM, AND THE PARIS MILLINERY TRADE

SIMON KELLY AND ESTHER BELL

WITH SUSAN HINER AND FRANÇOISE TÉTART-VITTU

AND MELISSA E. BURON, LAURA L. CAMERLENGO,
KIMBERLY CHRISMAN-CAMPBELL, AND ABIGAIL YODER

FINE ARTS MUSEUMS OF SAN FRANCISCO · LEGION OF HONOR
SAINT LOUIS ART MUSEUM

PUBLISHED BY THE
FINE ARTS MUSEUMS OF SAN FRANCISCO · LEGION OF HONOR
AND
DELMONICO BOOKS · PRESTEL
MUNICH LONDON NEW YORK

CONTENTS

CATALOGUE

ESTHER BELL, MELISSA E. BURON, LAURA L. CAMERLENGO,
KIMBERLY CHRISMAN-CAMPBELL, SIMON KELLY, AND ABIGAIL YODER

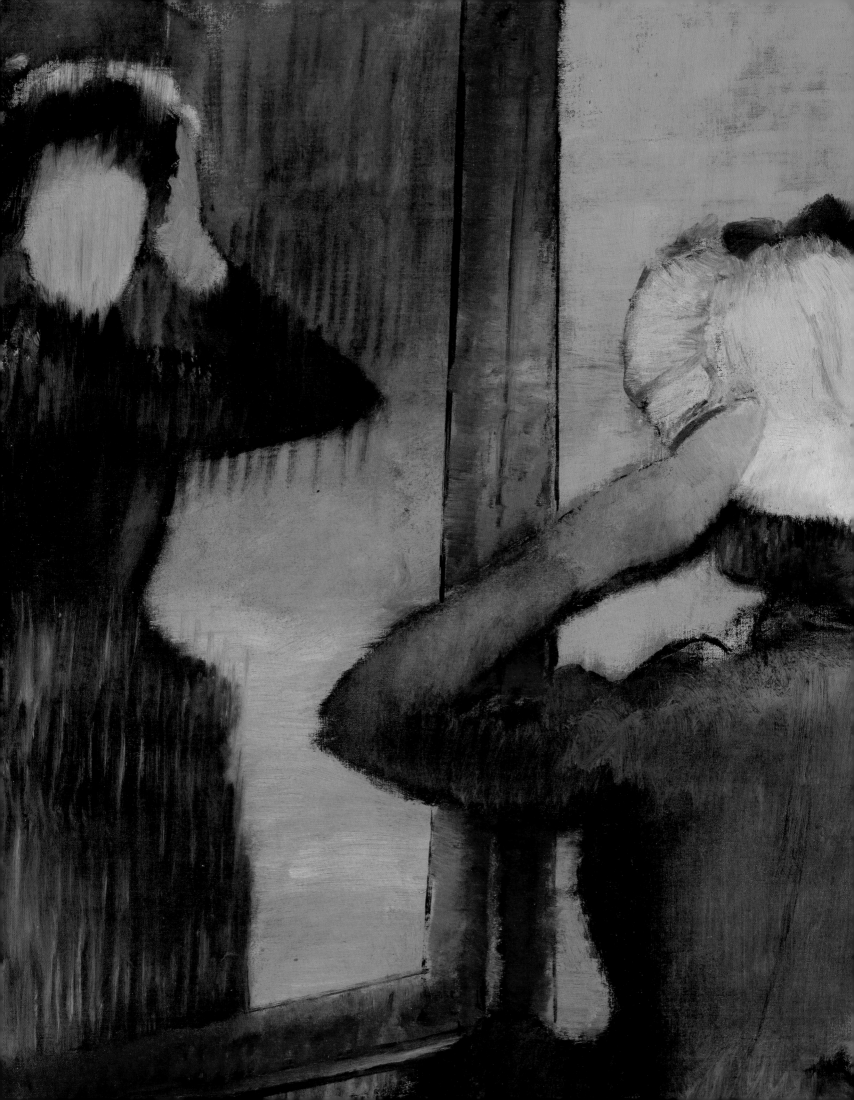

FOREWORD

THE HAT WAS AN ESSENTIAL ACCESSORY of dress for both women and men in late nineteenth- and early twentieth-century Paris, the fashion capital of the world at that time. At its heyday, nearly one thousand milliners populated the city, in the process driving a commerce of artificial flowers, exotic feathers, and other traditional materials such as silk, velvet, and straw. Millinery salons were not only places to purchase stylish commodities, however—they also served as studios for the many women who created these beautiful and intricate works.

The Impressionists, who avidly chronicled contemporary life, explored the hat in its myriad aspects, including its complex creation, its display and sale in salons, and its eventual placement atop the heads of fashionable wearers. The objects are represented most notably in the works of Edgar Degas, whose poignant depictions of the shopping for and donning of hats represent a critical area in his exploration of modern urban life. His portrayal of hatmaking in particular became a focus for his formal artistic experimentation for more than thirty years. Significantly, Degas, along with other Impressionists such as Édouard Manet and Pierre-Auguste Renoir, appreciated milliners not just as aesthetic subjects, but as fellow artists with admirable creative skills of their own.

Degas, Impressionism, and the Paris Millinery Trade is the first exhibition to explore the remarkably rich visual imagery of the hat industry between 1875 and 1914. It is the first partnership between the Saint Louis Art Museum and the Fine Arts Museums of San Francisco. Our collaboration on this presentation is especially meaningful because our collections feature two seminal paintings that treat the subject and anchor the show—Degas's *The Milliners* (ca. 1898; cat. no. 90) from the Saint Louis Art Museum and Manet's *At the Milliner's* (1881; cat. no. 22) from the Fine Arts Museums. The project also benefits from nine examples of the Fine Arts Museums' significant holding of French-made hats and bonnets dating to the pinnacle of French millinery production. This exhibition and its accompanying catalogue were organized by Simon Kelly, curator of modern and contemporary art at the Saint Louis Art Museum, and Esther Bell, curator in charge of European paintings at the Fine Arts Museums.

We are extremely grateful to the many lenders whose generosity in sharing their works affords the unique opportunity to see together key paintings, related preparatory drawings, and pastels by Degas and his contemporaries. Our donors were equally instrumental in making this project possible. The Saint Louis presentation is generously supported by the William T. Kemper Foundation, Commerce Bank, Trustee. Financial assistance has been given by the Missouri Arts Council, a state agency. The exhibition is supported by a grant from the National Endowment for the Arts. For the Fine Arts Museums of San Francisco exhibition, we express our warmest appreciation to Presenting Sponsors John A. and Cynthia Fry Gunn and Diane B. Wilsey, as well as Patron's Circle donor Marion Moore Cope. The catalogue is published with the assistance of the Andrew W. Mellon Foundation Endowment for Publications.

We thank John R. Musgrave, president of the Saint Louis Art Museum Board of Commissioners, and Diane B. Wilsey, president of the Fine Arts Museums of San Francisco Board of Trustees, for their leadership at the board level. Starting with exhibition curators Simon and Esther, we acknowledge the dedication, support, and hard work of the staffs of the Saint Louis Art Museum and Fine Arts Museums' in mounting *Degas, Impressionism, and the Paris Millinery Trade* and ensuring a successful run.

We look forward to welcoming our visitors to this exhibition, which not only provides new insight into the work of a great Impressionist artist and his circle but also evokes a lost golden age of elegant and spectacular fashion.

BRENT R. BENJAMIN
The Barbara B. Taylor Director, Saint Louis Art Museum

MAX HOLLEIN
Director and CEO, Fine Arts Museums of San Francisco

LENDERS TO THE EXHIBITION

———— ◆ ————

Acquavella Galleries

Art Gallery of Ontario, Toronto

The Art Institute of Chicago

Bibliothèque nationale de France, Paris

John E. and Lucy M. Buchanan

Chicago History Museum

The Cleveland Museum of Art

The Courtauld Gallery, London

Denver Art Museum

Dixon Gallery and Gardens, Memphis

Fine Arts Museums of San Francisco

Ann and Gordon Getty

Harvard Art Museums/Fogg Museum

Indianapolis Museum of Art

The J. Paul Getty Museum, Los Angeles

Justin Miller Art, Sydney, Australia

Los Angeles County Museum of Art

Maryland State Archives

The Metropolitan Museum of Art, New York

Mildred Lane Kemper Art Museum, Washington
 University, St. Louis

Minneapolis Institute of Art

Missouri History Museum

The Morgan Library & Museum, New York

The Montreal Museum of Fine Arts

Musée des arts décoratifs, Paris

Musée d'Orsay, Paris

Musée Marmottan Monet, Paris

Museo Thyssen-Bornemisza, Madrid

Museum of Fine Arts, Boston

Nasjonalmuseet for kunst, arkitektur og design, Oslo

National Gallery of Art, Washington

National Gallery of Canada, Ottawa

National Portrait Gallery, Smithsonian Institution

Ny Carlsberg Glyptotek, Copenhagen

Ordrupgaard Museum, Charlottenlund, Denmark

Philadelphia Museum of Art

Saint Louis Art Museum

Sterling and Francine Clark Art Institute,
 Williamstown, Massachusetts

Virginia Museum of Fine Arts, Richmond

Diane B. Wilsey

Private collections

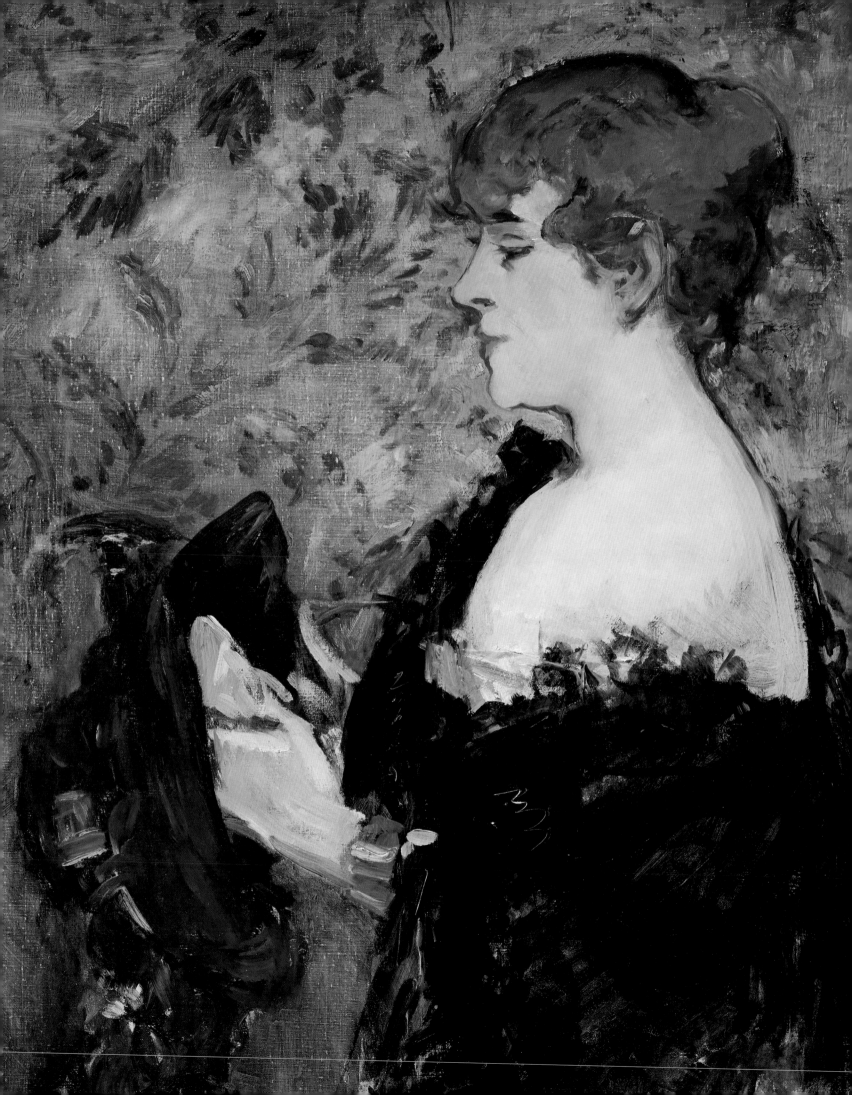

ACKNOWLEDGMENTS

THERE ARE MANY KEY CONTRIBUTORS to this collaboration between the Saint Louis Art Museum and the Fine Arts Museums of San Francisco. We are extremely grateful to those directors, museum colleagues, galleries, auction-house professionals, scholars, and private collectors who generously supported the loans to this effort. Without them, the exhibition would not have been possible. At museums and libraries we thank Stephan Jost and Sasha Suda (Art Gallery of Ontario, Toronto); James Rondeau and Gloria Groom (Art Institute of Chicago); Bruno Racine and Jocelyn Monchamp (Bibliothèque nationale de France, Paris); Gary Johnson and Petra Slinkard (Chicago History Museum); William M. Griswold and William Robinson (Cleveland Museum of Art); Ernst Vegelin van Claerbergen (Courtauld Gallery, London); Christoph Heinrich and Timothy Standring (Denver Art Museum); Kevin Sharp (Dixon Gallery and Gardens, Memphis); Martha Tedeschi, Maureen Donovan, Deborah Martin Kao, and Cassandra Albinson (Harvard Art Museums, Cambridge, Massachusetts); Charles Venable, Martin Krause, and Claire Hoevel (Indianapolis Museum of Art); Timothy Potts, Richard Rand, Davide Gasparotto, and Scott Allan (J. Paul Getty Museum, Los Angeles); Michael Govan, Sharon S. Takeda, Kaye D. Spilker, Clarissa M. Esguerra, Catherine C. McLean, and Leigh Wishner (Los Angeles County Museum of Art); Elaine Rice Bachmann (Maryland State Archives, Annapolis); Thomas P. Campbell, Keith Christiansen, and Susan Stein (Metropolitan Museum of Art, New York); Sabine Eckmann (Mildred Lane Kemper Art Museum, Washington University in Saint Louis); Kaywin Feldman and Patrick Noon (Minneapolis Institute of Art); Shannon Meyer (Missouri History Museum, St. Louis); Colin B. Bailey and Jennifer Tonkovich (Morgan Library and Museum, New York); Nathalie Bondil and Anne Grace (Montreal Museum of Fine Arts); Olivier Gabet, Marie-Sophie Carron de la Carrière, Réjane Barjiel, and Marie-Pierre Ribère (Musée des arts décoratifs, Paris); Guy Cogeval, Xavier Rey, and Claire Bernardi (Musée d'Orsay, Paris); Patrick de Carolis and Marianne Mathieu (Musée Marmottan Monet, Paris); Guillermo Solana, Paloma Alarcó, Clara Marcellán, and Paula Luengo (Museo Thyssen-Bornemisza, Madrid); Matthew Teitelbaum, Lauren Whitley, Helen Burnham, Pamela Parmal, and Claudia P. Iannuccilli (Museum of Fine Arts, Boston); Audun Eckhoff, Nils Ohlsen, and Ellen Johanne Lerberg (Nasjonalmuseet for kunst, arkitektur og design, Oslo); Earl A. Powell III, Mary G. Morton, Kimberly A. Jones, and Margaret Morgan Grasselli (National Gallery of Art, Washington); Marc Mayer and Anabelle Kienle Poňka (National Gallery of Canada, Ottawa); Kim Sajet and Brandon Brame Fortune (National Portrait Gallery, Washington); Flemming Friborg and Line Clausen Pedersen (Ny Carlsberg Glyptotek, Copenhagen); Anne-Birgitte Fonsmark (Ordrupgaard Museum, Copenhagen); Timothy Rub, Dilys E. Blum, Kristina Haugland, Barbara Darlin, Stephanie Feaster, Sara Reiter, Bernice Morris, and Lisa Stockebrand (Philadelphia Museum of Art); Olivier Meslay, Francis Oakley, Kathleen Morris, Jay Clarke, and Lara Yeager-Crasselt (Sterling and Francine Clark Art Institute, Williamstown, Massachusetts); and Alex Nyerges and Mitchell Merling (Virginia Museum of Fine Arts, Richmond).

Our sincere appreciation also goes to private collectors Lucy M. Buchanan; Ann and Gordon Getty, along with their curator, Deborah A. Hatch; Diane B. Wilsey; and others who wish to remain anonymous. We would also like to thank the galleries Acquavella Galleries, New York, and Justin Miller Art, Sydney. Many of these loans were facilitated by our valued colleagues Lisa Cavanaugh (Christie's, Chicago) and Deborah Coy and Sharon Kim (Christie's, New York); Molly Ott Ambler and Thomas Denzler (Sotheby's, New York) and Helena Newman (Sotheby's, London); Lara Daly (Pym's Gallery, London); and Randy Rosen. We additionally acknowledge Stephanie Buck, Michael Conforti, Lloyd DeWitt, Douglas Druick, Jane Glaubinger, Nancy Ireson, Thomas Lentz, and Stephanie Smith for their assistance with loans in their previous directorial and curatorial positions.

None of this would be possible without our funders. The Saint Louis presentation is generously sponsored by the William T. Kemper Foundation, Commerce Bank, Trustee. Financial assistance has been given by the Missouri Arts Council, a state agency. The exhibition is supported by a grant from the National Endowment for the Arts. Presenting Sponsors John A. and Cynthia Fry Gunn and Diane B. Wilsey, as well as Patron's Circle donor Marion Moore Cope, supported the Fine Arts Museums of San Francisco exhibition. The boards of both institutions are champions of such projects and the staff that realizes them, and we thank Diane B. Wilsey, president of the Fine Arts Museums

of San Francisco Board of Trustees, and John R. Musgrave, president of the Saint Louis Art Museum Board of Commissioners, for their leadership. We especially thank Simon Kelly, curator of modern and contemporary art at the Saint Louis Art Museum, and Esther Bell, curator in charge of European paintings at the Fine Arts Museums, for organizing such an outstanding exhibition and catalogue.

At the Fine Arts Museums of San Francisco, heartfelt appreciation goes to Sabri Ozun, former interim chief financial officer, and Ed Prohaska, chief financial officer; Julian Cox, chief curator and founding curator of photography; and Jill D'Alessandro, curator of costume and textile arts, for their contributions. Further thanks are extended to the Museums' exhibitions team, including Krista Brugnara, director of exhibitions; Elise Effmann Clifford, head paintings conservator; Tricia O'Reagan, paintings conservator; Sarah Kleiner, assistant paintings conservator; and Natasa Morovic, frames and gilded surfaces conservator; Sarah Gates, head textiles conservator; Anne Getts, Andrew W. Mellon Assistant Textiles Conservator; and Emily Meyer, senior museum mountmaker, provided invaluable assistance, as did Deanna Griffin, director of registration and collections management, and Kimberley Montgomery, associate registrar; Stuart Hata, director of retail operations, and Tim Niedert, book and media manager; Tomomi Itakura, head of exhibition design, and Emilia Bevilacqua, associate exhibition designer; Dan Meza, chief designer and art director, and his department of talented graphic designers; Lisa Podos, former director of advancement and engagement; Susan Klein, director of marketing and communications; and Sheila Pressley, director of education, and her department for their programming support. Singular thanks are due to Hilary Magowan, senior exhibitions coordinator, who oversaw the development of both the exhibition checklist and installation details, and to Abigail Dansiger, research librarian, who graciously attended to numerous scholarly needs. Members of the Museums' extended staff, including Department of European Paintings Joseph F. McCrindle Interns Grace Roderick and Lexi Paulson, created the solid foundation for all of our efforts.

At the Saint Louis Art Museum, much gratitude goes to Carolyn Schmidt, deputy director and controller, and Carl Hamm, deputy director. We also thank Jeanette Fausz, director of exhibitions and collections; Elizabeth Wyckoff, curator of prints, drawings, and photographs; Diane Mallow, associate registrar; Ella Rothgangel, registrar; Jon Cournoyer, head of design, and David Burnett, installation designer; Amanda Thompson Rundahl, director of learning and engagement, and Ann Murphy Burroughs, head of engagement and interpretation; Hugh Shockey, head of conservation, and Claire Winfield, assistant paintings conservator; Zoe Perkins, textiles conservator; Patricia

Crowe, director of marketing and communications, and Matthew Hathaway, communications manager; Amber Withycombe, director of institutional giving; Marianne Cavanaugh, head librarian, Clare Vasquez, public services librarian, and Bryan Young, serials and interlibrary loan coordinator; Jessica Slawski, manager of digital assets; and Debbie Boyer, director of retail sales. We also thank interns Lacy Murphy, Kirsten Marples, Mia Laufer, and Michele Hopkins.

We are grateful to our catalogue contributors, Kimberly Chrisman-Campbell, Susan Hiner, and Françoise Tétart-Vittu. These esteemed scholars lent their expertise to the project and wrote essays and object entries. Fine Arts Museums of San Francisco assistant curator of costume and textile arts Laura L. Camerlengo was a vital resource for all matters pertaining to fashion history and for decoding the nuances of various hat materials in paintings. Melissa E. Buron, associate curator of European paintings, supported the departmental organization of this exhibition. Grace Woods-Puckett provided invaluable art-historical research. In Saint Louis, research assistant Abigail Yoder tirelessly contributed to the catalogue and logistical development of the show.

This compendium of our research and organization was produced by the Fine Arts Museums of San Francisco publications department, under the guidance of Leslie Dutcher, director of publications. Special mention goes to Jane Hyun, editor, who oversaw this catalogue with her excellent and thoughtful editing. Thanks also go to Diana Murphy, editorial assistant, for her grace in garnering catalogue images. For their fine translation expertise, we thank Alexandra Bonfante-Warren and Rose Vekony.

The catalogue's elegant design is thanks to Joan Sommers of Glue + Paper Workshop. Mary DelMonico and her colleagues at DelMonico Books • Prestel enthusiastically embraced the project. Our sincere appreciation goes to Karen Farquhar for her agility in managing the book's production. The catalogue is published with the assistance of the Andrew W. Mellon Foundation Endowment for Publications, for which we are grateful.

A number of friends and colleagues contributed their expertise during the development of the project. Our gratitude goes to Colin B. Bailey, Alexandra Bosc, Marilyn Brown, April Calahan, Elizabeth Childs, Barbara Divver, Flavie Durand-Ruel, Paul-Louis Durand-Ruel, Gloria Groom, Nancy Mowll Mathews, Jennifer Ouellette, Theodore Reff, George Shackelford, Harriet Stratis, Beth Szuhay, and Richard Thomson.

BRENT R. BENJAMIN
The Barbara B. Taylor Director, Saint Louis Art Museum

MAX HOLLEIN
Director and CEO, Fine Arts Museums of San Francisco

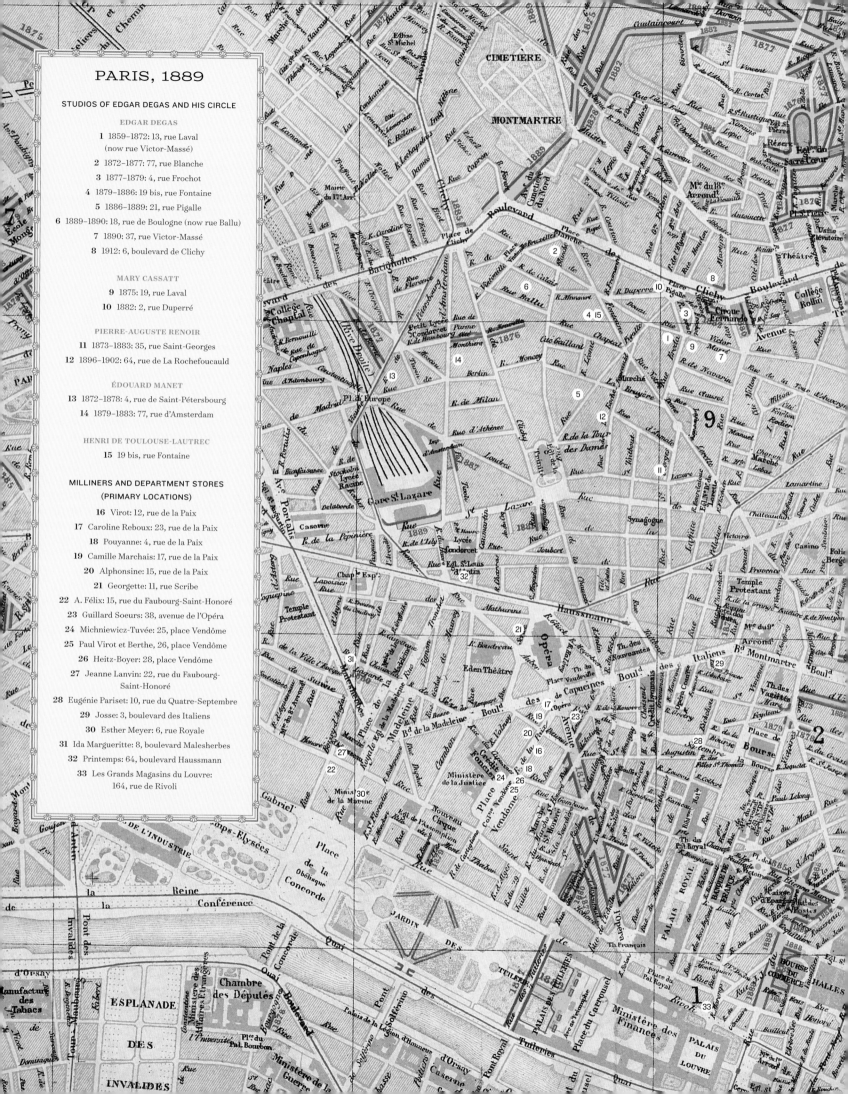

PARIS, 1889

STUDIOS OF EDGAR DEGAS AND HIS CIRCLE

EDGAR DEGAS

1 1859–1872: 13, rue Laval
 (now rue Victor-Massé)
2 1872–1877: 77, rue Blanche
3 1877–1879: 4, rue Frochot
4 1879–1886: 19 bis, rue Fontaine
5 1886–1889: 21, rue Pigalle
6 1889–1890: 18, rue de Boulogne (now rue Ballu)
7 1890: 37, rue Victor-Massé
8 1912: 6, boulevard de Clichy

MARY CASSATT

9 1875: 19, rue Laval
10 1882: 2, rue Duperré

PIERRE-AUGUSTE RENOIR

11 1873–1883: 35, rue Saint-Georges
12 1896–1902: 64, rue de La Rochefoucauld

ÉDOUARD MANET

13 1872–1878: 4, rue de Saint-Pétersbourg
14 1879–1883: 77, rue d'Amsterdam

HENRI DE TOULOUSE-LAUTREC

15 19 bis, rue Fontaine

MILLINERS AND DEPARTMENT STORES
(PRIMARY LOCATIONS)

16 Virot: 12, rue de la Paix
17 Caroline Reboux: 23, rue de la Paix
18 Pouyanne: 4, rue de la Paix
19 Camille Marchais: 17, rue de la Paix
20 Alphonsine: 15, rue de la Paix
21 Georgette: 11, rue Scribe
22 A. Félix: 15, rue du Faubourg-Saint-Honoré
23 Guillard Soeurs: 38, avenue de l'Opéra
24 Michniewicz-Tuvée: 25, place Vendôme
25 Paul Virot et Berthe: 26, place Vendôme
26 Heitz-Boyer: 28, place Vendôme
27 Jeanne Lanvin: 22, rue du Faubourg-
 Saint-Honoré
28 Eugénie Pariset: 10, rue du Quatre-Septembre
29 Josse: 3, boulevard des Italiens
30 Esther Meyer: 6, rue Royale
31 Ida Margueritte: 8, boulevard Malesherbes
32 Printemps: 64, boulevard Haussmann
33 Les Grands Magasins du Louvre:
 164, rue de Rivoli

INTRODUCTION

SIMON KELLY AND ESTHER BELL

THIS CATALOGUE, in conjunction with the exhibition *Degas, Impressionism, and the Paris Millinery Trade*, explores a remarkable period in Paris from around 1870 to 1914. The city was then, as it arguably still is, the center of the fashion industry, and hats designed there set the global standard. Around one thousand milliners created a rich and diverse array of hats, often covered with extravagant trimmings such as silk flowers and ribbons, ostrich plumes, and even whole birds.[1] The industry grew to sustain a massive international trade in exotic feathers as well as a more local but substantial trade in artificial flowers. Hats produced in Paris were also purchased there on a large scale, principally by women, as part of an emerging modern culture of shopping and consumerism, which in turn supported a network of independent millinery shops in close proximity to and competition with the grand department stores.

Degas, Impressionism, and the Paris Millinery Trade focuses on the intersection between this historical context and avant-garde picture making. In particular, we concentrate on the work of Edgar Degas, who explored the theme of millinery—both the producers and consumers of hats as well as the hats themselves—with an exceptional intensity. There have been numerous exhibitions on Degas, but this is the first to focus on his output of millinery-inspired works.[2] Reunited for the first time are all of his millinery paintings, as well as a number of important related pastels.[3] We also wanted to explore the work of those in Degas's circle—notably Mary Cassatt, Édouard Manet,

Pierre-Auguste Renoir, Henri de Toulouse-Lautrec, and Federico Zandomeneghi—who were likewise fascinated by the subject matter.

The exhibition argues that the representation of millinery became a central theme within the broader avant-garde ambition to showcase the diversity of Parisian modern life. We focus not only on such paintings, pastels, drawings, and prints but also on the hats.[4] In the late nineteenth century, milliners were elite workers in the fashion industry and enjoyed the status of creative artists in their own right. Commentators described their products as works of art, and the objects often had price tags to match. The exhibition explores the hats of Caroline Reboux and Madame Virot as well as lesser-known makers such as Monsieur Heitz-Boyer and Cordeau et Laugaudin. Particularly well represented is Madame Georgette, who produced spectacular, large hats in the years before World War I.

In treating the objects mentioned above as part of an integrated visual culture, we have also examined networks of association between painters and milliners. Such connections were heightened by the proximity of artists' studios to the millinery fashion district around the rue de la Paix (see map on opposite page).[5] Over his lifetime Degas's eight studios were all located in the Montmartre area: he regularly visited milliners' shops on the rue de la Paix (although frustratingly their names are unknown to us today).[6] We do know that Manet visited the famed shop of Madame Virot on the same street. Renoir, whose own studios were even

closer to the rue de la Paix than those of Degas, undoubtedly spent time there as well as at the shop of Esther Meyer further to the southwest. Henri de Toulouse-Lautrec often pictured the salon of Renée Vert.

In examining Parisian hatmaking from the start of the Third Republic until the outbreak of World War I, the exhibition explores a broad range of styles. Hat and bonnet designs often responded to dress silhouettes, particularly the bustle, which was a central aspect of contemporary fashion for much of the later nineteenth century. The 1870s and early 1880s saw an eclectic array of headwear in straw, felt, and satin, while the mid-1880s witnessed a vogue for smaller bibis. By the early twentieth century, hats had expanded to enormous proportions. They could be close to two feet in diameter while extensive, and often weighty, trimmings served to highlight the social significance of the owner.

The essays in this volume seek to establish the rich history of the millinery industry and the pointed interest shared by Degas and his contemporaries in producing images of its consumers, workers, and especially wares. Simon Kelly's text provides the broader Impressionist iconography surrounding the production and commerce of hats in the nineteenth century—and more specifically within the body of Degas's oeuvre. Kelly explores how the artist's twenty-seven millinery works—often radical in their experimentation with color and abstracted forms—are central to his portrayal of women, fashion, and Parisian modern life. Fashion historian Françoise Tétart-Vittu examines the largely female profession of millinery from 1870 to 1910. The trade first emerged within the eighteenth-century guild system with its *marchandes de modes*; by the second half of the nineteenth century—the true golden age of hats—milliners, many of whom had reached global renown, were ubiquitous in the capital. As a result, a mythology developed surrounding the Parisian *modiste*, prevalent not only in the visual culture but also in the literature of nineteenth-century France. Susan Hiner's essay elucidates the genealogy of the *modiste* in the French imagination and moreover her greater social importance. Finally, Esther Bell establishes Degas's millinery pictures as emblematic of the artist's larger practice of creating a tension between modernity and the grand tradition. The millinery industry, like his practice, was simultaneously historicizing and modernizing in its ultimate creations.

Our catalogue is divided into six sections. The first investigates the millinery shop as a space of fashionable commodities but also host to complex social relationships among those who inhabited it—from the elite consumers to the various workers, from *premières* (those who designed hats and thus carried the most prestige) to *trottins* (errand girls who delivered the hats to their new owners). The hierarchy between these women, and a clear division of labor, plays a crucial role in the images of these settings. The following section more specifically investigates consumer culture and the spectacle of hat shopping. In examples by Degas, for instance, these precious objects were often emphatically placed in the foreground, where they were transformed into alluring objects of desire.

The next three sections explore various styles of hats. The avid demand for plumed headwear relied on a complex and burgeoning industry for luxury feathers imported from as far as Africa and Central and South America. By the early twentieth century, it was reported that the appetite for Parisian fashion was responsible for more than 300 million bird deaths annually, a hyperbolic figure that nonetheless indicates that the French capital had become a center of this international luxury trade. Men's hats, particularly those in the bowler and top-hat styles, though more subdued in their materials, were an essential part of the urbane *flâneur*'s daily uniform. Moreover, in works by such artists as Toulouse-Lautrec and Degas, these hats often displayed strong undercurrents of masculine privilege and resounding virility. The section devoted to women's flowered and ribboned hats reveals not only the massive artificial-flower industry in Paris, but also the ways in which milliners could transform a basic form into a sculptural armature for elaborate trimmings.

The final section includes Degas's late millinery paintings and pastels, which by the 1890s had become increasingly abstract and colorful. With examples from the J. Paul Getty Museum, Virginia Museum of Fine Arts, Saint Louis Art Museum, and Musée d'Orsay, this exhibition presents the first occasion to view this oeuvre together. In such works, Degas celebrated milliners as fellow artists worthy of veneration; examples by contemporaries such as Zandomeneghi, Louise-Catherine Breslau, Georges Jeanniot, and Eugène Atget show that Degas was not alone in this estimation.

Our project seeks to provide a new perspective on the visual culture of late nineteenth-century Paris, highlighting the hitherto neglected significance of millinery within Impressionist iconography and especially in the work of Edgar Degas. In the pages of this catalogue, Paris emerges as the home to a flourishing trade and a richly creative space for inventive hatmaking. We also hope to foster a fresh appreciation for a talented, little-known group of milliners and their extraordinary creations that inspired the imagery of the most innovative painters of the day.

1 There are, however, relatively few milliners in Paris today. Only forty-one are listed in today's *Pages jaunes*.

2 See notably the major 1988 retrospective *Degas*, organized by Jean Sutherland Boggs for the Galeries Nationales du Grand Palais, Paris; National Gallery of Canada, Ottawa; and the Metropolitan Museum of Art, New York. *Degas: A New Vision* (National Gallery of Victoria, Melbourne, 2016) represents another survey of the artist's multifaceted output. Recently there have been many exhibitions on particular aspects of Degas's work, notably *Degas and the Ballet: Picturing Movement* (Royal Academy of Arts, London, 2011), *Degas and the Nude* (Museum of Fine Arts, Boston, 2011), *Edgar Degas: The Late Work* (Fondation Beyeler, Riehen/Basel, 2012), *Degas' Method* (Ny Carlsberg Glyptotek, Copenhagen, 2013), *Degas/Cassatt* (National Gallery of Art, Washington, DC, 2014), and *Degas: A Strange New Beauty* (Museum of Modern Art, New York, 2016).

3 Several pastels are too fragile to travel; they are reproduced here in the catalogue.

4 The idea of integrating Impressionist paintings and pastels with contemporary fashion was explored recently, and successfully, in the major exhibition *Impressionism, Fashion, and Modernity* (Art Institute of Chicago, 2012). In contrast to that show, however, this exhibition focuses on a specific aspect of contemporary fashion: millinery.

5 The rue de la Paix was created in 1806 by Napoléon I as part of an effort to open up the Right Bank of Paris. Initially called rue Napoléon, it was renamed in 1814 to celebrate the Bourbon Restoration and a newly established peace. The place Vendôme, rue du Quatre-Septembre, and boulevard des Italiens were close by and also filled with milliners' shops. Although the focus of the millinery trade was on the Right Bank, there were also important fashion areas on the Left Bank, notably Paris's first department store, Au Bon Marché.

6 For more on artists' studios, see John Milner, *The Studios of Paris: The Capital of Art in the Late Nineteenth Century* (New Haven, CT: Yale University Press, 1988).

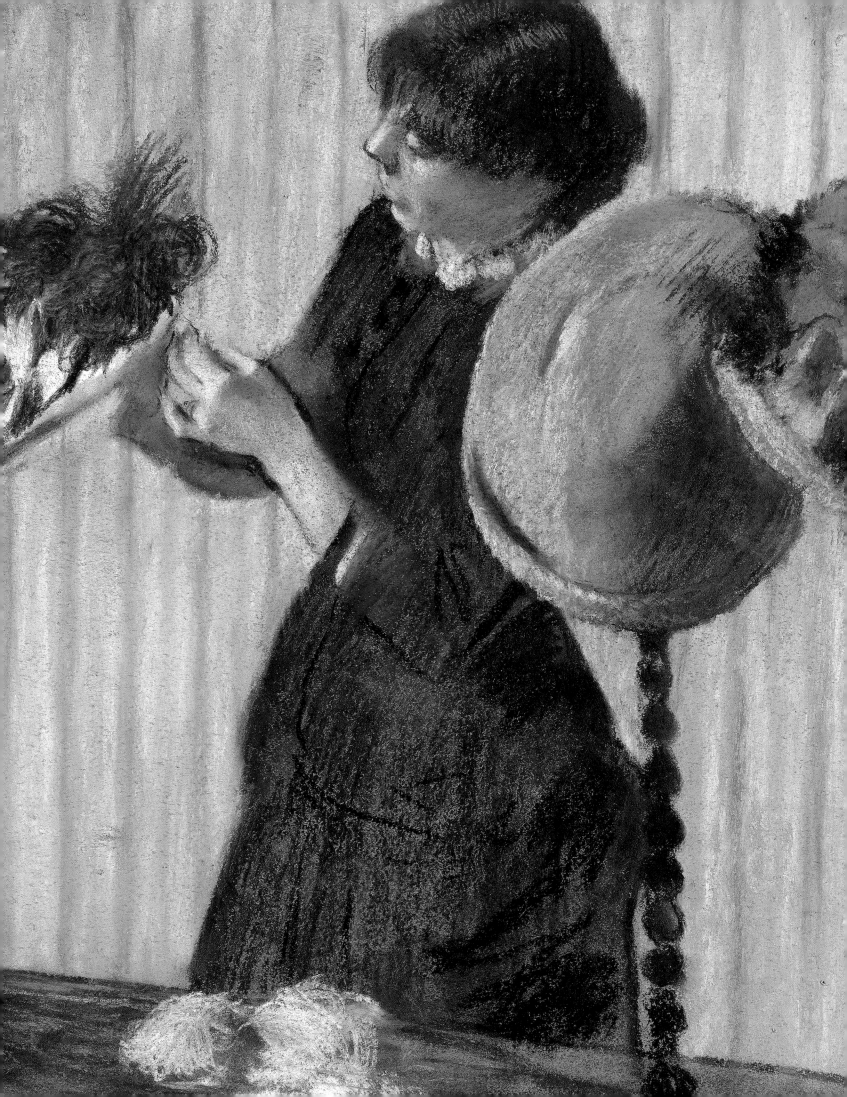

"SILK AND FEATHER, SATIN AND STRAW":
DEGAS, WOMEN,
AND THE
PARIS
MILLINERY TRADE

SIMON KELLY

IN 1903 PAUL GAUGUIN WROTE of Edgar Degas's characteristically restrained love of hat fashion: "brought up in an elegant world, he didn't dare go into ecstasies before the milliners' shops on the rue de la Paix, the pretty laces, those famous tricks of the trade with which our Parisiennes knock you off an extravagant hat."[1] Degas's fascination with the world of glamorous spectacle that emerged in nineteenth-century Paris was recorded by several of his friends. Until the end of his life, he would regularly window-shop along the streets of the capital, even asking his friend Ambroise Vollard to describe to him the contents of these windows when his eyesight failed in his final years.[2]

Within a newly commodified Parisian culture, the millinery trade occupied a central place that is difficult to fully appreciate today. Degas's lifetime saw the golden age of this trade, before conservation laws and fashion changes led to a decline after World War I. In the late nineteenth century there were around a thousand millinery shops in Paris. Major secondary trades also provided the materials for hats, notably *fleuristes*, who created artificial flowers, and *plumassiers*, who prepared bird plumage. Hats were an indispensable accessory for women of every social class. For the art critic and fashion writer Arsène Alexandre, the hat was "the dress's crowning glory, the final touch."[3]

The millinery trade represents an important aspect of Impressionist iconography that has generally been underrecognized. Many artists within Degas's circle treated the millinery industry in their work, including Louise-Catherine Breslau, Eva Gonzalès, Georges Jeanniot, Édouard Manet, Pierre-Auguste Renoir, James Tissot, Henri de Toulouse-Lautrec, and Federico Zandomeneghi. None, however, explored the trade with the same intensity as Degas. None examined the varied elements of both the production and consumption of hats with his insight. Millinery represents a central element of Degas's broader artistic project of the exploration of Parisian modern life. Scholars have identified

twenty-two works in his millinery output.[4] This corpus of works can, however, be expanded to include twenty-seven images, consisting of five paintings, nineteen pastels, two drawings, and an unidentified *Modiste* shown at the 1876 Impressionist exhibition.[5] The paintings were a focus for intermittent revision over the years, and the pastels ranged from densely worked exhibition pieces, often assembled from several conjoined pieces of paper, to far more sketchily rendered studies in charcoal and pastel.[6]

Despite the importance of millinery subjects within Degas's oeuvre, there has been relatively little discussion of them in the voluminous literature on the artist. The millinery images were first discussed as a group in 1919 by Paul Lafond, Degas's lifelong friend and an art historian, who described the "dismay" that they had caused when first revealed to a Parisian public.[7] Thereafter they were often dismissed in somewhat summary fashion as writers focused to a greater extent on Degas's better-known and more prolific images of dancers, nudes, and racecourses.[8] A newly sophisticated reading emerged in the 1980s with the sociohistorical interpretation of Eunice Lipton that situated the millinery works within the context of nineteenth-century women's labor.[9] Hollis Clayson then developed this approach in an important examination of the intersection between millinery and prostitution.[10] Ruth E. Iskin has provided the most sustained and thoughtful discussion of Degas's millinery works, placing them within the context of Parisian consumer culture and arguing that they reflected the artist's interest in "a specifically feminine world of fashion consumption."[11] Exhibition catalogues have also provided valuable analyses of individual milliner works, notably Gloria Groom's exploration of *The Millinery Shop* (1879–1886; cat. no. 1) in *Impressionism, Fashion, and Modernity* (2012).[12]

Within the context of these writings, this essay seeks to highlight the iconographical and formal radicalism of Degas's millinery imagery, building in particular on the work of Iskin. I argue that Degas's millinery works represent a key element in understanding his broader attitudes toward the imaging of women. Three quarters of Degas's output represented women, and the millinery works are a significant group within that wider body: they profoundly complicate traditional notions regarding Degas's supposed misogyny.[13] I argue too that the millinery images are a central element in Degas's analysis of Parisian modern

life, fashion, and especially the world of trade and commerce. The millinery trade was an important focus for a local and global mercantile network, with hats as the end product of a complicated chain of production. Degas was highly innovative in treating such a commercial theme of a kind that had rarely, if ever, been represented in high art. George Moore, the Irish critic whom Degas is known to have respected, argued that the millinery imagery showed "the most astonishing revolution of all" in Degas's output, namely "the introduction of the shop-window into art."[14] The millinery works thus provide an important intersection of two key elements—women and trade—within Degas's avant-garde output.

This essay initially examines the context of the massive transformations in Paris during the second half of the nineteenth century, especially the rise of the department store. It then charts the development of Degas's output of millinery images from the early 1880s, when he most intensely concentrated on the theme. It explores the key protagonists within Degas's millinery images: the milliner (*modiste*) herself, the consumer, and the hats. The essay then looks at the artist's return to the subject for a second intense period in the mid- to late 1890s. In so doing, we see the millinery works as a laboratory for Degas's late experiments with color and the evolution in his oeuvre from linear precision to coloristic abstraction. While many of the earlier images were exhibited and sold for good prices, these later works stayed with Degas until his death and were largely unknown until they appeared in his posthumous studio sale.

PARIS AS SHOPPING CAPITAL

Degas's millinery images need to be placed within the context of the remarkable commercial expansion of Paris in the mid- to late nineteenth century. Perhaps most notably this period saw the rise of the department store, which initiated new, modern modes of retailing.[15] A very wide range of goods was sold in a single location, removing the need to visit multiple specialist stores. Commodities were sold at fixed prices, as opposed to more traditional methods of bargaining that were practiced in smaller shops. Customers were, for the first time, also offered a "return" policy, whereby they could bring back objects with which

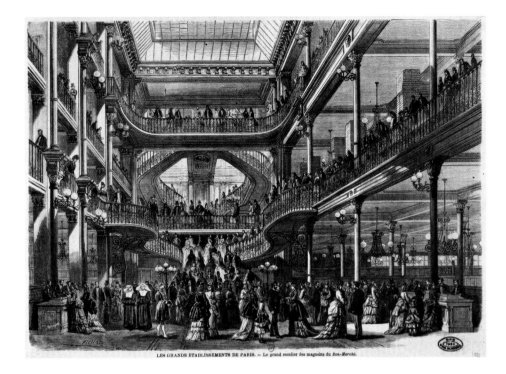

LES GRANDS ETABLISSEMENTS DE PARIS. — Le grand escalier des magasins du *Bon-Marché*.

they were not satisfied. The department store transformed methods of display, encouraging elaborate arrangements that were designed to impress, overwhelm, and seduce the public, especially women, into purchasing.

Commodities were arranged in enormous architectural spaces, such as that of the massive Au Bon Marché. The first department store, it was founded in 1852 and redesigned in the late 1860s–early 1870s with dramatic iron architecture and a spectacular glass ceiling by Louis-Charles Boileau and Gustave Eiffel (the future architect of the Eiffel Tower).[16] An 1872 print (fig. 1) showcases the grand staircase that enticed customers to ascend through the many levels of the store. Au Bon Marché inspired Émile Zola's naturalist novel *Au bonheur des dames* (*The Ladies' Paradise*, 1883), which gave literary form to the new consumer culture created by the department store.[17] In one passage, Zola evoked the dramatic new types of display, describing an enormous floral and feather decoration in the center of the store of the book's title:

> The flowers went up and up: there were great mystical lilies, branches of apple blossom, sheaves of fragrant lilac, and endless blossoming which, on a level with the first floor, was crowned with plumes of ostrich feathers, white feathers which seemed to be the breath floating away from this crowd of flowers. . . . In the foliage and the petals, in the midst of all this muslin, silk, and velvet, in which drops of gum were like drops of dew, there flew birds of paradise for hats, purple tangaras with black tails and septicolours with shimmering breasts, shot with all the colours of the rainbow.[18]

Here Zola described the spectacle of the department store while specifically referencing decorations intended for hat trimmings. The year before, the journalist Pierre Giffard described extravagant vistas of summer straw hats that seemed to glow on department store walls: "All the walls of the establishment are covered with panama hats, manila hats, and other sombreros destined for the coastal resorts or the outskirts of Paris. All you can see from top to bottom on the walls of the great bazaar is brilliant white headwear."[19] Such spectacular displays fetishized commodities, presenting them as quasi-religious objects in these new secular temples of commerce.

Nonetheless, the impact of department stores, although considerable, should not be overemphasized regarding the millinery trade. For all the glamour of these new spaces, this trade remained dominated by smaller independent stores. The *Annuaire-almanach du commerce* for 1882 listed 944 milliners in its pages, of which only three were department stores (Au Bon Marché, Les Grands Magasins du Louvre, and La Samaritaine).[20] A Paris travel

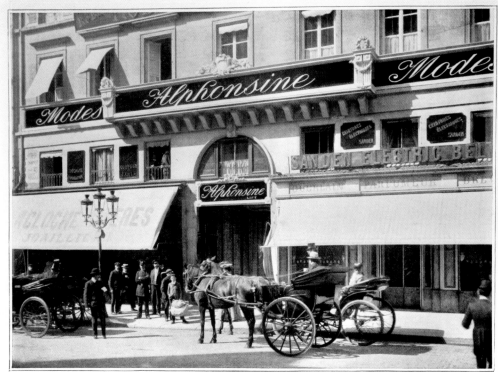

MAISON ALPHONSINE. — LA FAÇADE SUR LA RUE DE LA PAIX

2 Paul Boyer, *Maison Alphonsine—
The façade onto the rue de la Paix*,
in "Une grande modiste au XXe
siecle," *Les Modes*, October 1904, 18.
Photograph. Bibliothèque nationale
de France, Paris, FOL-V-4312

3 Edgar Degas, *The Laundress*, 1869.
Oil on canvas, 36 ¼ x 29 ⅛ in. (92.5 x
74 cm). Neue Pinakothek, Munich,
Inv. Nr. 14310

guide for international visitors published on the occasion
of the 1900 Exposition Universelle offered an introduction
to millinery shopping, noting that "the great fashionable
milliners"—Caroline Reboux, Madame Virot, Camille et
Valentine, Esther Meyer—were to be found in the rue de
la Paix and its neighborhood, while cheaper milliners were
spread across the whole of Paris. The writer noted that
all kinds of millinery could be found in department stores
but "it will . . . be found more satisfactory, as a rule, to go
to special houses."[21] The elite milliners on the rue de la
Paix (and on the immediately adjoining streets like the rue
du Quatre-Septembre or avenue de l'Opéra) represented
the high end of the trade and were invariably those that
established new hat trends. Their privileged status ensured
higher prices and limited the number of customers.[22] In the
1880s Madame Virot attracted special attention, apparently
becoming a millionaire: the chronicler Paul Eudel noted of
her that "in all Paris, no one is as skillful at making the most
of a ribbon or artfully placing a flower or feather."[23] Degas's
close friend Manet visited her salon, and it is probable that
Degas also visited her on one of his many trips along the

rue de la Paix. By 1904 the milliner Alphonsine sought to
emulate Virot's fame with an impressive showroom on the
rue de la Paix, fronted by ornate gilt lettering (see fig. 2).[24]

Unlike other Impressionists, such as Manet or
Toulouse-Lautrec, we do not know for sure which specific
milliners Degas visited, although he certainly frequented
the rue de la Paix.[25] Fashion was in his blood. His father,
Augustin De Gas, was a wealthy Italian-French banker who
cultivated a dapper persona. Degas's American mother,
Célestine Musson, was from a fashionable family that had
owned a mansion in New Orleans and a country house in
the Mississippi Delta.[26] Degas's paternal family members
also signed their name "De Gas" from the 1840s, signifying
aristocratic pretensions. His paternal grandfather, who
had made the family money in Italy, even acquired a one-
hundred-room palazzo in Naples and married off three of
his daughters to members of the Italian aristocracy. Degas
himself chose not to use the particulate after the late 1860s,
perhaps recognizing that the family in fact came from the
grande bourgeoisie.[27] Throughout his life, Degas dressed
smartly whenever he left his Parisian townhouse, always

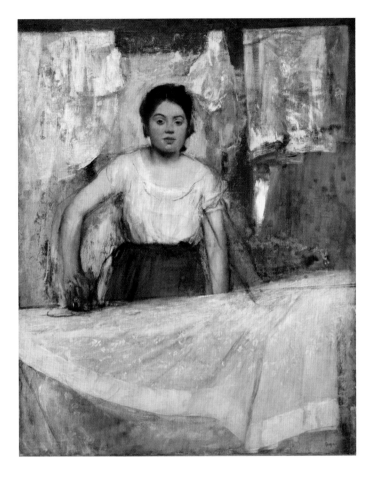

in his renderings of modern commerce.[32] His images of millinery instead focused on more intimate dramas, generally with one or two protagonists, that probably took place in spaces such as those on the rue de la Paix.[33] These subtle scenes of social interaction between different classes—affluent consumer and poorly paid salesgirl, or *première* and impoverished assistant—continue a similar interest seen in other areas of Degas's output, notably the many works that show maids attending their mistresses dating to the late 1870s.[34] Degas's work can therefore be seen as showing empathy for both worker and consumer, although in very different ways.

THE MILLINER: A "VERY *HUMAN* QUALITY"

Degas's interest in millinery represents a key element in his wider project to reflect the complexity of modern urban life. He sought here to treat everyday, urban realist subject matter with a new seriousness: he preferred the term "realist" to "Impressionist" in describing himself, perhaps seeing this word as carrying a greater sense of weightiness. Degas inherited the kinds of subject matter previously treated in prints and caricatures by artists such as Paul Gavarni and Honoré Daumier, now picturing them with the resonances previously ascribed to history painting. In so doing, he was heeding the call of the poet and critic Charles Baudelaire, who had encouraged painters to depict modern life and men in their "cravats and patent leather boots."[35]

Degas's first Salon display in 1865 had been a history painting, *Scene of War in the Middle Ages*, but it was indifferently received. The following year, perhaps as a calculated move to attract attention, he showed his first modern subject: a large-scale steeplechase scene.[36] By the end of the decade he was developing his fascination with representing Parisian working women, starting with his first laundress subject (1869; fig. 3). Thereafter he produced a series of laundress scenes in the early 1870s and, during an 1872 visit to New Orleans, he would even reminisce that "one Paris laundry girl, with bare arms, is worth it all for such a pronounced Parisian as I am."[37] The novelists Edmond and Jules de Goncourt spent a day in the artist's studio on February 12, 1874, and noted that he "has fallen in

wearing a hat: a top hat in his youth and middle age and increasingly a bowler hat in his later years. As late as 1912, he chided his young friend Daniel Halévy for not wearing a hat when out in public.[28] Degas had a particular appreciation for the nuances of hat design: on one occasion, he discussed, although in a somewhat tongue-in-cheek fashion, the merits of a peasant bonnet painted by the wife of his friend Jeanniot.[29] (He also had a passion for another important accessory: canes.[30])

Degas's fascination with fashion and millinery was underpinned by the very geographical circumstances of his lifestyle. The studios in Montmartre that he occupied over the course of his career were always close—about a mile away—from the rue de la Paix and the heart of the fashion district. He was also a very regular attender at the Paris Opéra in the adjoining neighborhood.[31] As has been noted, Degas, like the other Impressionists, chose not to represent—at least overtly—the new department-store spaces

love with modern life": they cited, in particular, his research into the laundress profession—his ability to "speak their language"—and the various gestures and methods employed by laundresses.[38] Degas would explore the work of milliners with the same thoroughness.

Degas's first recorded millinery work is *Modiste*, shown at the second Impressionist exhibition in 1876 as part of a larger display of modern life works, including several images of laundresses. Despite the artist's title, which seems to reference a single figure, a contemporary review by Émile Porcheron described the work as depicting a "workshop" of milliners "too ugly not to be virtuous."[39] The painting has not been firmly identified but it is possible that it was an early iteration of *The Milliners* (ca. 1882–before 1905; cat. no. 88).[40] Degas's interest in millinery may have been encouraged by the very circumstances of his Montmartre studio's location on the rue Laval, where he worked from 1859 to 1872, since it was on the top floor of a building that housed a milliner on its ground floor.[41] In treating the subject of millinery, like laundresses, Degas was representing an iconography that had largely been treated only in prints. Perhaps the most significant precedent for Degas was the work of Gavarni. Degas much admired him, collecting two thousand of his prints, and considered him a "great philosopher" who "knew about women."[42] Gavarni produced a small number of images of milliners, including their predecessors the *marchande de modes* (see fig. 4), and it is possible that Degas knew these works.[43]

During the period that Degas produced millinery subject matter, the French garment trade expanded exponentially. From 1866 to 1906, there was an increase of one million female workers across the country, with a remarkable 80 percent of that expansion going into the garment industry.[44] That nationwide expansion was concentrated in Paris, where by the end of the nineteenth century half of women's jobs were in the garment trade. The largest groups in this Parisian industry were *couturières* (or "dressmakers") and makers of *lingerie* (underwear) but there were also large numbers of milliners, with around eight thousand workers in the trade, according to the fashion writer Octave Uzanne.[45]

The millinery profession was defined by a strict division of labor. The fashion writer and art critic Arsène Alexandre identified four essential occupations involved in the creation of a hat: the *formière* (former), who

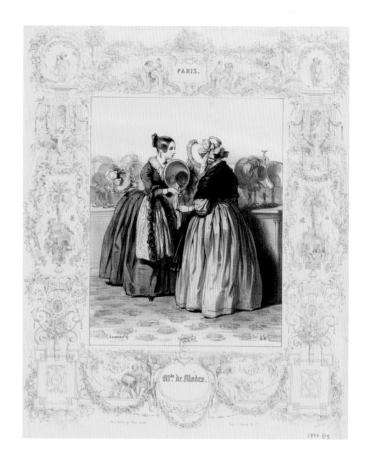

constructed the armature of the object; the *apprêteuse* (preparer), who covered this structure with its basic visible material and color; the *garnisseuse* (trimmer), who was responsible for the decoration of the hat and "for giving it life, in throwing onto it all that is original, distinctive, and precious in trimmings";[46] and, most importantly, the *première*, who invented and designed the new hat models and enjoyed the greatest prestige as the imaginative and conceptual leader of the shop, and after whom the shop was generally named. Within the larger stores, there could be a number of *premières* who oversaw individual workshops and reported to the shop owner.

A photograph of the salon of the prestigious millinery Alphonsine shows the owner to the far left amidst several *premières*, highlighting the scale of her enterprise (fig. 5). All these positions had their place within the internal hierarchy of the millinery shop.[47] The writer Charles Benoist, who carefully studied the working conditions in the garment industry, noted that milliners started as apprentices as early as the age of thirteen before reaching the rank of finisher at sixteen and then the more senior role of trimmer at the age of twenty-two. The position of trimmer had

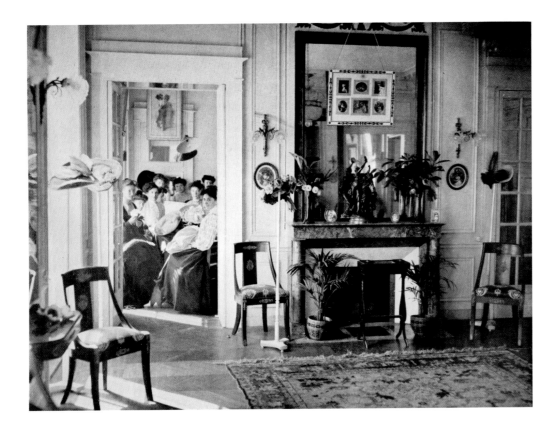

its own hierarchy between the "junior" or *petite* trimmer, "accomplished" or *bonne* trimmer, and the *première*, whose creative designing was often underpinned by a hands-on process of trimming.[48]

Milliners were viewed as the elite workers of the garment trade. Uzanne affirmed that they were "the aristocracy of the working women of Paris, the most elegant and the most distinguished."[49] Milliners were also the highest paid workers in the garment industry. The economist Paul Leroy-Beaulieu drew on extensive government research to affirm that "milliners are the most privileged of all those in the sewing trades in terms of salaries."[50] These wages, however, very much depended on the place of the individual milliner in the hierarchy. Those at the lower rungs—the finishers and the junior trimmers—were still paid relatively little, generally around two to four francs a day, or sixty to one hundred francs a month.[51] *Trottins* (errand girls) were paid even less. Such amounts ensured that these young girls and women often turned to prostitution, as was frequently discussed and caricatured in the press. As milliners rose up the hierarchy, however, their wages increased significantly. As Benoist noted, an accomplished trimmer could earn two

to three hundred francs a month (or up to ten francs a day). The heads of the millinery shops, the *premières*, could earn five hundred francs a month, and sometimes more in the highest-end stores on the rue de la Paix.[52]

Degas's images of milliners take place within the context of this broader discourse regarding the hierarchy of the profession. His works show milliners at different levels in the hierarchy—the lowly, poorly paid junior milliners in his early pastels and the more elevated and prestigious *premières*, often accompanied by an assistant dutifully standing alongside, in his late works. Degas's *Little Milliners* (*Petites modistes*, 1882; fig. 6) is a key example of the artist's early imaging of milliners. Although it has not generally been recognized, his choice of title undoubtedly carried specific meaning in referencing a particular stage within the internal hierarchy of the *modiste*. In the formulation of Benoist, as noted above, the term *petites* signified a stage in the training of "trimmers." "Petites" has traditionally been translated as "little": a term that suggests a certain condescension that Degas probably did not intend: it can also be translated as "junior" in order to signify more precisely the rank of these women. The young woman on the left trims a hat while her

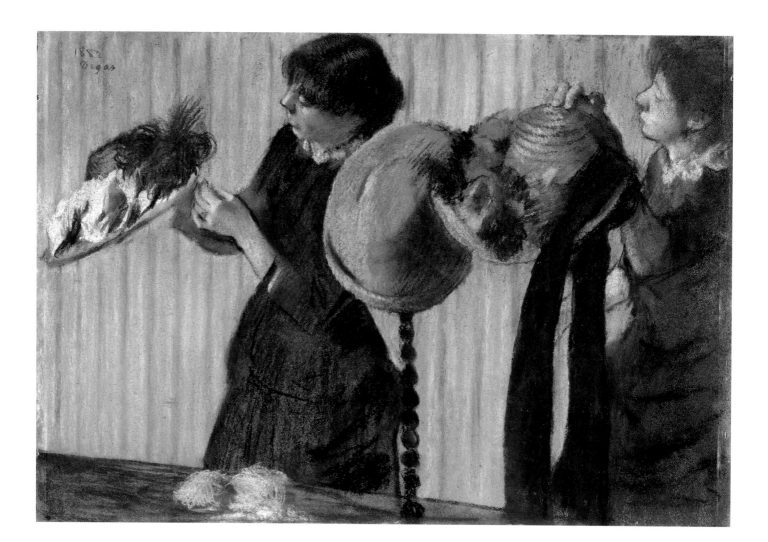

6 Degas, *Little Milliners*, 1882.
Pastel on paper, 19 ¼ x 28 ¼ in. (49 x
71.8 cm). The Nelson-Atkins Museum
of Art, Kansas City, Missouri,
Purchase: acquired through the gener-
osity of an anonymous donor, F79-34

7 Paul Signac, *The Milliners*, 1885–
1886. Oil on canvas, 45 ⅝ x 35 in.
(116 x 89 cm). Foundation E. G. Bührle
Collection, Given by the heirs of Emil
Bührle to the Foundation E. G. Bührle
Collection, Zürich, no. 96 (1960)

8 Degas, *Milliner Trimming a Hat*,
1891–1895. Pastel on paper, 19 x
28 in. (48 x 71 cm). Location unknown
(L1110)

colleague looks on, perhaps having just completed her task.[53]
Degas paid careful attention to the three spring or summer
straw hats on view, representing them in different stages
of operation: before, during, and after trimming. He sensi-
tively rendered the milliners' faces, particularly the woman
to the left absorbed in her work. As Berthe Morisot noted,
Degas "professed the deepest admiration for the very *human*
quality of young shopgirls."[54] His rendering highlighted
the thoughtfulness of the milliners, emphasizing the med-
itated interiority of their work at the lower as well as the
higher ends of the profession. Degas was working at a time
when a discourse had developed around young milliners as
frivolous. Uzanne, for example, described milliners as filled
with "shrieks of laughter," while Alexandre noted that they
were "one of the great jollities of Paris."[55] Degas's pastel
can be seen as a rejoinder to those accusations regarding
their frivolity.

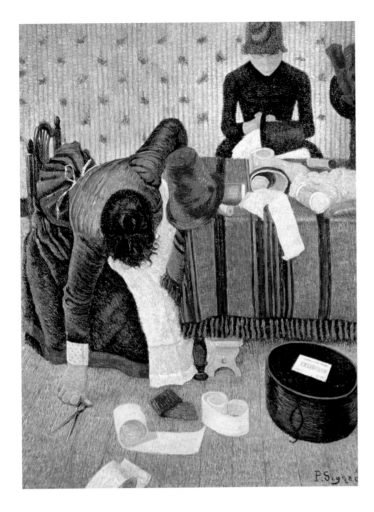

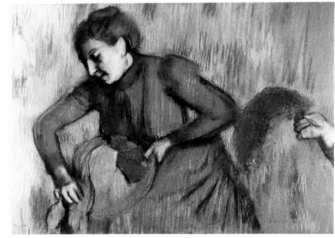

Degas showed *Little Milliners* at the 1886 Impressionist exhibition. It appeared in the company of a comparable view of a millinery atelier by a younger artist, Paul Signac: *The Milliners* (1885–1886; fig. 7).[56] Signac too explored the internal hierarchy of the millinery profession. Here the former is seated in the background, preparing the core structure of a hat, while the trimmer leans over in the foreground. Signac's work also articulated an understanding of the toil of these workers.[57] Critics failed to understand Degas's naturalistic renderings of milliners and used a vocabulary that caricatured and animalized his women, describing them as "squirrel-like" or "monkey-like."[58] Perhaps the most empathetic commentator was Jean Ajalbert, who argued that *Little Milliners* showed the disconnect between the poor wages of these young but talented milliners and the high prices for which their hats sold.[59]

Degas's empathetic treatment of the milliner continued into the 1890s, notably in *Milliner Trimming a Hat* (1891–1895; fig. 8), a little-known pastel in which he evoked the intense study of a middle-aged milliner who was probably a *première*. As Marilyn Brown and Ruth Iskin have argued, it is probable that he saw milliners as fellow artists and empathized with their artistic activity.[60] Degas, in fact, apparently made a gendered comparison between making a hat and making a painting, quipping that Berthe Morisot "made paintings as she would a hat."[61]

By the 1890s the milliner was attracting increasing recognition for the artistic value of her work. Benoist wrote of *premières* as "in effect, queens, who no longer ply a trade but make art. . . . It is no longer their work that one pays for but rather, the term is in vogue, their 'creations,' their 'ideas,' their taste, their skill, what constitutes talent."[62] Alexandre concurred that the *premières* were "true artists"

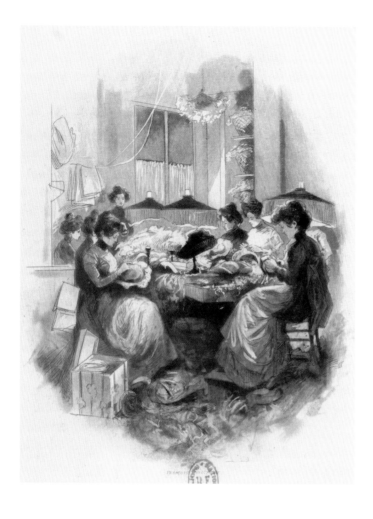

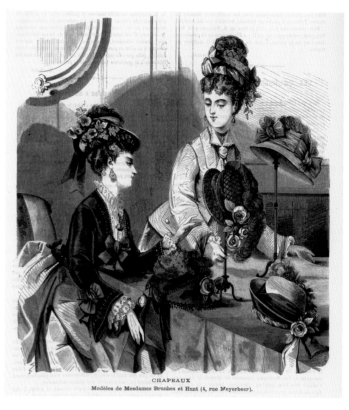

CHAPEAUX
Modèles de Mesdames Brunhes et Hunt (4, rue Meyerbeer).

9 François Courboin, illustration of
a millinery workshop from Arsène
Alexandre, *Les Reines de l'aiguille:
Modistes et couturières* (Paris:
Théophile Belin, 1902)

10 *Hats: Models by Mesdames
Brunhes et Hunt (4, rue Meyerbeer)*,
from *Le Moniteur de la mode*, April
1874, 198. Bibliothèque nationale de
France, Paris, FOL-LC14-85

whose work was informed by a study of the art—and the
hats depicted therein—of the past: "Gainsborough is a
favorite," he noted.[63] Contemporary prints and photographs,
however, foregrounded milliners as working in groups,
often in cramped working conditions.[64] François Courboin's
print of a workshop for Alexandre's *Les Reines de l'aiguille*
(Queens of the needle trade, 1902) shows such an interior
(see fig. 9). Much debate in the 1890s surrounded wom-
en's low pay and the so-called "sweating system," an early
incarnation of the sweatshop. Degas however concentrated
on a close-up evocation, presenting the milliner as an artist
absorbed in creative activity.

THE CONSUMER: "A MOST IMPRESSIVE DRESS"

In the early 1880s Degas produced a major body of work in
which he focused on the female customer in the millinery
shop. In terms of the number of his images, this was the

millinery subject that most preoccupied him at this time, when there was extensive discussion in the press and contemporary literature around the role of the female shopper. From the early 1870s this discourse focused on the figure as flighty and impulsive, subject to her feminine whims when faced with the many desires that the new shopping environment encouraged.[65] For the conservative commentator Giffard, the female shopper was frivolous and overwhelmed by "uncontrollable desires" for "delicious baubles."[66] He noted that certain customers could make fittings a "torment" for saleswomen with endless, seemingly unwarranted, and mercurial requests for new hats.[67]

Other writers attacked women for placing personal shopping satisfaction before family commitments and argued too that the out-of-control shopper could be neurotic and psychologically imbalanced.[68] The novel *Histoire d'un agent de change* by the Catholic writer Mathilde Bourdon was serialized in *Le Journal des demoiselles et petit courrier des dames réunis* in 1880; it presented a spendthrift wife, Georgette, who destroys her family by her addiction to shopping.[69] Zola, Degas's friend during the 1860s and 1870s, also promoted this viewpoint in *Au bonheur des dames*, presenting his character Madame Marty as a woman who shops obsessively, buying goods, including headwear, that she cannot afford: Marty "had spent an hour in the millinery department, installed in a new salon on the first floor, having cupboards emptied for her, taking hats from the rosewood stands with which the two tables there were decked and trying them all on with her daughter—white hats, white bonnets, white toques."[70]

At the same time a more positive mythology developed, as shopping increasingly came to be seen as a means for women to express their independence and individual agency. Shopping, it was argued here, was a modern, "artistic" endeavor carried out by a rational and thoughtful woman whose purchases were the product of meditated thought.[71] Fashion magazines encouraged this view of shopping as a form of art and as a key element within the wider emergence of the construct of the chic Parisienne. Journals such as *Le Moniteur de la mode*, *La Mode illustrée*, and *Le Journal des demoiselles* produced colorful images of independent women, dressed in the latest ensembles.[72] An 1874 issue of *Le Moniteur de la mode* (see fig. 10), for example, shows two affluent women shoppers attentively examining and discussing a range of impressive spring hats at the upscale milliner Brunhes et Hunt on 4, rue Meyerbeer, just to the north of the Palais Garnier. Marie Double, in the fashion magazine *L'Art de la mode*, argued in 1881 for the aesthetic cultivation of the Parisian shopper who was as impassioned by buying a hat as by attending a French Academy play.[73] Buying a hat, or any consumer object, could be seen as a meditated act of self-fashioning.

Degas's work articulated a modern, forward-looking argument for the woman shopper as confident, assured, and thoughtful in her decisions. In a notebook entry from the late 1860s–early 1870s, he already documented his fascination with women's "ornament" and specifically "how they observe, put together, feel about their ensembles."[74] Degas here was also responding to the edicts of his friend Edmond Duranty, to represent the fashions and customs of the modern woman.[75] He was probably also influenced by his friendship with the painter and avid shopper Mary Cassatt, who served as a model for key examples of his millinery works that foreground the thoughtful agency of the woman shopper. In *At the Milliner's* (1882; fig. 61), Degas emphasized his protagonist's pensive, detached pose as she tries on a hat with a subtle gesture, carefully adjusting its angle. As Louisine W. Havemeyer later remembered, "The movement of the hand that places the hat upon her head . . . is very characteristic of her [Cassatt]."[76] Degas may have provided hats as props but it is also possible that this was one of Cassatt's own.[77] Ajalbert also emphasized the readiness of the customer to adapt a hat: "she imagines changes, a ribbon, a hatpin."[78] In *At the Milliner's* (ca. 1882; fig. 11), in contrast, the customer, again modeled on Cassatt, seems far more enthusiastic and excited about her potential purchase. She wears a brown hat with aigrette while a saleswoman offers two alternatives for her review, one of which is rendered with a rich vermilion border of plumes or flowers.

In fact, Cassatt herself showed a deep understanding of hatmaking, recognizing the role of the hat as a marker of her own social standing and identity and also ascribing a prominent role to the rendering of hats in her output. As has been suggested, Cassatt, as an active shopper for hats herself, may have contributed to these works of Degas by suggesting gestures and poses.[79] His close-up focus on gestures can be compared with the far more anecdotal painting of a fitting session by Louis-Robert Carrier-Belleuse (1883; fig. 12), a successful Salon painter. Carrier-Belleuse's evocation of an ornate neo-Rococo setting with excessive

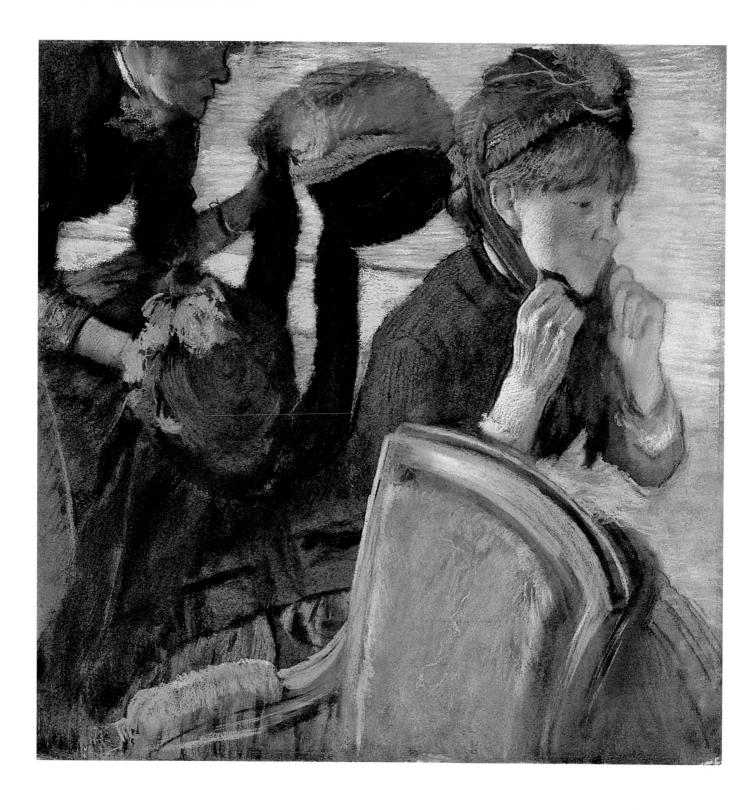

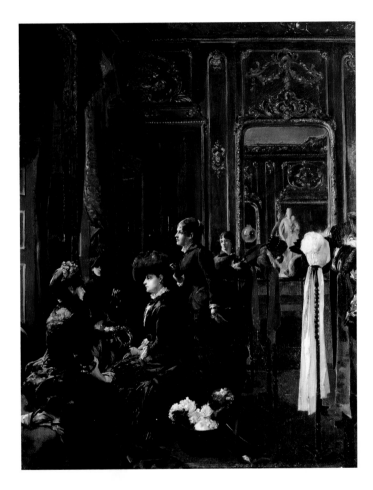

detailing of paraphernalia contrasts markedly with Degas's far more minimal treatments of the fitting-room setting, animated only by bare areas of floors, mirrors, or muslin curtains. The plain environments concentrate attention on the gesture of the sitter as she cocks her hat to one side or allows the suggestion of a smile to play across her face.

In another group of paintings, Degas featured the consumer from behind, trying on a hat in a mirror. His sensitivity to female gesture in these particular works is characteristic of his entire millinery oeuvre. Again he represented the shopper in a sympathetic way, rendering her in a graceful, swanlike pose (cat. no. 16) or a comparably elegant standing position (cat. no. 89). These works can also be seen as incisive rejoinders to the more reactionary, conservative commentary that cast an addiction to shopping as a sign of women's inferiority. Degas's works argue for shopping, and particularly shopping for millinery, as a key element in the emergence of the independent modern woman. According to his English painter friend Walter Sickert, Degas affirmed that "painters too much made of women formal portraits, whereas their hundred and one gestures, their *chatteries*, et cetera, should inspire an infinite variety of design."[80] Degas's empowering images also contrasted with another negative discourse that focused on the loss of women's individual identity within the overwhelming spaces of the new shopping environments. One such example can be seen in Zola's *Au bonheur des dames*. On a sale day in a department store, women became a sea of moving heads: "In the glove and woolens departments, a dense mass of hats and chignons hid the farther reaches of the shop from view. You couldn't even see the crowd's dresses; only the headwear floated above, gaudy with feathers and ribbons."[81] Women here were no longer individually recognizable. Degas's works, in contrast, very much emphasized the uniqueness of each subject, even if only seen from behind.

Degas's ongoing fascination with the millinery trade in the 1880s was encouraged by the network of female friends that he developed around himself and whose fashion choices he carefully studied. His niece Jeanne Fevre later noted that he "liked . . . the company of women very much" and had a wide circle of female friends, an affirmation that complicates the often-repeated assumption of Degas as misogynistic in his rendering of the female form.[82] During the early 1880s, his connection with Cassatt remained strong, aided by their mutual appearance at the Impressionist shows.

Degas also developed an important friendship with Geneviève Straus (*née* Halévy), with whom he shared an interest in fashion and music.[83] Born in 1849, Straus was the cousin of his closest friend, the writer Ludovic Halévy. A charismatic, well-read, and well-traveled woman, Straus would later mentor Marcel Proust and serve as the model for the Duchess of Guermantes in *À la recherche du temps perdu* (*Remembrance of Things Past*; 1913–1927). She

married the composer Georges Bizet; after his premature death in 1875, she moved in with her Halévy cousins before marrying, in 1886, Émile Straus, lawyer to the Rothschild family. Geneviève established a literary and artistic salon in the mid-1880s that attracted a wide range of figures from the arts including writers, artists, and actors.[84] The Italian Count Giuseppe Primoli described the salon as "elegant and intellectual, verging on the bohemian through its intelligence and on the fashionable world through its elegance."[85] Degas became a prominent part of this salon, and Straus described him in a letter of 1885 as "the greatest painter of the century."[86] Their friendship is recorded in a photograph circa 1886–1889, in which he stands alongside her, eyeing a tea table laden with a teapot, cups, and fruit, while she looks directly at the photographer (fig. 13).[87] The photographer (and the woman in whose garden the photograph was taken) was Hortense Howland, another important woman in Degas's circle and one whom he would represent in one of his photographs.[88] Howland's photograph also records Straus's elegant attire—she wears a bonnet with flowers and foliage—and other extant photographs also highlight her flair for wearing a range of elaborate and fashionable headwear.

Degas regularly accompanied Straus to her dress and hat fittings. In one undated letter, he had visited a "fashionable dressmaker's" with her and "attended the fitting of a most impressive dress."[89] Degas's comment reflects the fact that he not only visited milliners but also *couturières*; indeed, he produced the pastel *At the Dressmaker's* (ca. 1882; fig. 14), a work that was probably revised in the 1890s, which records a dress-fitting session.[90] When pressed by Straus as to why he insisted on accompanying her to her fittings, he remarked that he wanted to study "the red hands of the little girl who holds the pins."[91] Degas's ongoing association with Straus continued into the 1890s. Straus's cousin Daniel Halévy recorded dinners that were attended by Degas and Straus in 1890.[92] Their association was, however, ended by the Dreyfus Affair, which precipitated Degas's unfortunate decision to break off links with his Jewish friends.[93]

Degas's friendship with women like Straus and Cassatt undoubtedly heightened his sensitivity to the experience of the female consumer and probably encouraged his positive imagery of her. As Alexandre noted, the customer, especially in high-end stores, could play a considerable role

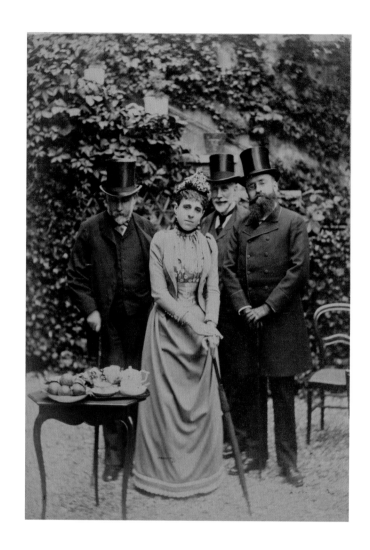

13 Hortense Howland, *A Group of Friends: Edgar Degas, Geneviève Straus, Albert Boulanger-Cavé, and Louis Ganderax*, ca. 1886–1889. Gelatin silver print, album: 10 ¼ x 13 x 1 ⅝ in. (25.9 x 33 x 4.1 cm). The Metropolitan Museum of Art, New York, Gilman Collection, Purchase, Mrs. Walter Annenberg and The Annenberg Foundation, 2005.100.587

14 Degas, *At the Dressmaker's*, ca. 1882. Pastel on board, 20 ⅛ x 30 ¾ in. (51 x 78 cm). Private collection (L684)

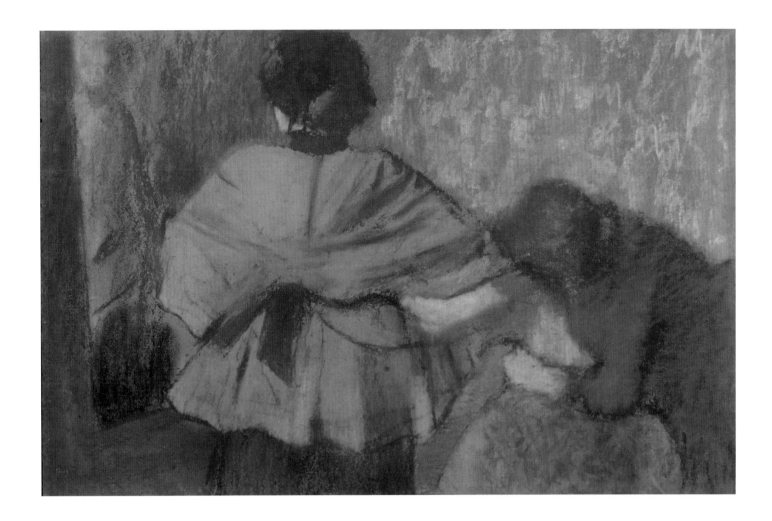

in the creation of the work, working with a *première* to create a hat particularly suited to her;[94] it is quite possible that the creative and sophisticated Cassatt and Straus were such customers. Indeed, Degas's images of fitting sessions may show customers not just trying on existing hats but playing an active role in the creation of custom hats.

HATS: "HATS AND FEATHERS IN A SHOP WINDOW"

This essay has so far examined Degas's imaging of the producers and consumers of hats, but the artist was also fascinated by hats as objects in and of themselves. As Gary Tinterow once noted, Degas focused on hats to a "remarkable degree" in his millinery imaging.[95] Within Paris's newly expanding market, hats were fundamentally commodities, and Degas's representations of them

can be related to his career-long interest in the world of commerce. In the late 1860s, he even compared his studio to a "shop," selling remaindered goods.[96] Later, from 1879, he used the term *articles* to describe his paintings and pastels, a term traditionally used in department stores and *magasins de nouveautés* (dry goods stores) to describe accessories such as hats, umbrellas, and gloves.[97] Hats—generally simple, untrimmed ones in straw and felt—appeared in the department store catalogue of Au Bon Marché as *articles de Paris* alongside purses, photographic albums, and writing paper.[98]

Degas does seem to have drawn a distinction between those works that he produced with the principal intention of sale to the marketplace—his "articles"—and other, more self-consciously experimental work.[99] His commercial interest is also evident in his representations of the Paris Stock Exchange,[100] a site where shares in the commodities

15 Degas, *Cotton Merchants in New Orleans*, 1873. Oil on linen, 23 ⅛ x 28 ¼ in. (58.7 x 71.8 cm). Harvard Art Museums/Fogg Museum, Gift of Herbert N. Straus, 1929.90

16 Degas, *At the Milliner's*, 1882. Pastel on paper, 29 ¾ x 33 ⅝ in. (75.5 x 85.5 cm). Museo Thyssen-Bornemisza, Madrid, Inv. Nr. 516 (1978.10)

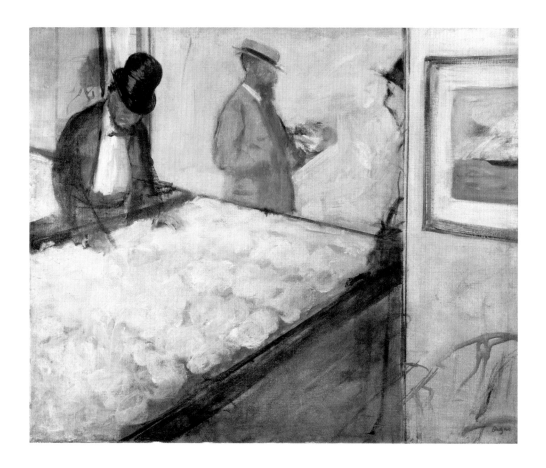

markets—including those for cotton and plumage—rose and fell on a daily basis.[101]

Degas, of course, never saw hats in purely economic terms, and his understanding of their aesthetic qualities has an important precedent in his renderings of the commodity of cotton, a material that was of great importance to his family history. His uncle Michel Musson ran a cotton factoring business in New Orleans that Degas visited regularly during his time in that city in 1872–1873. The artist's younger brother René worked for the business and also set up a cotton import-export company with another brother, Achille.[102] As Brown has explored, the family cotton business was the subject of a key early painting, *A Cotton Office at New Orleans* (1873); he had hoped to sell it to a British textile manufacturer, but it ultimately became the first work of his to be acquired by a French museum.[103]

In this work, as well as the related painting *Cotton Merchants in New Orleans* (1873; fig. 15), Degas displayed a great sensitivity in rendering the fluffy texture of cotton—a material that he would have played through his fingers often—that would provide an important context for his

later renderings of ostrich plumage or the smoothness and sheen of silk flowers.

Degas's imaging of the range of contemporary hat fashion dates to the early 1880s, specifically 1882, when he produced important works such as *At the Milliner's* (fig. 16). Here Degas allowed an array of flowered hats to dominate the pictorial space, placing them in the very foreground of his composition. This pastel needs to be placed within the context of the greatly expanding visual culture of hat imagery at this time. Hats appeared in a wide variety of fashion magazines, most notably *La Modiste universelle*, a publication that had been founded in 1876 by Adolphe Goubaud, also the publisher of the important fashion magazine *Le Moniteur de la mode*. Each monthly issue contained colored lithographs of four *chapeaux-modèles* (model-hats) in the newest fashion.[104] The milliners who contributed to the journal were generally those around the rue de la Paix, such as Madame Heitz-Boyer, Madame Hélène, and Madame Esther. Each publication was published in five languages and sent to offices and agents around Europe, including the largest European cities and even as far afield as Brazil and

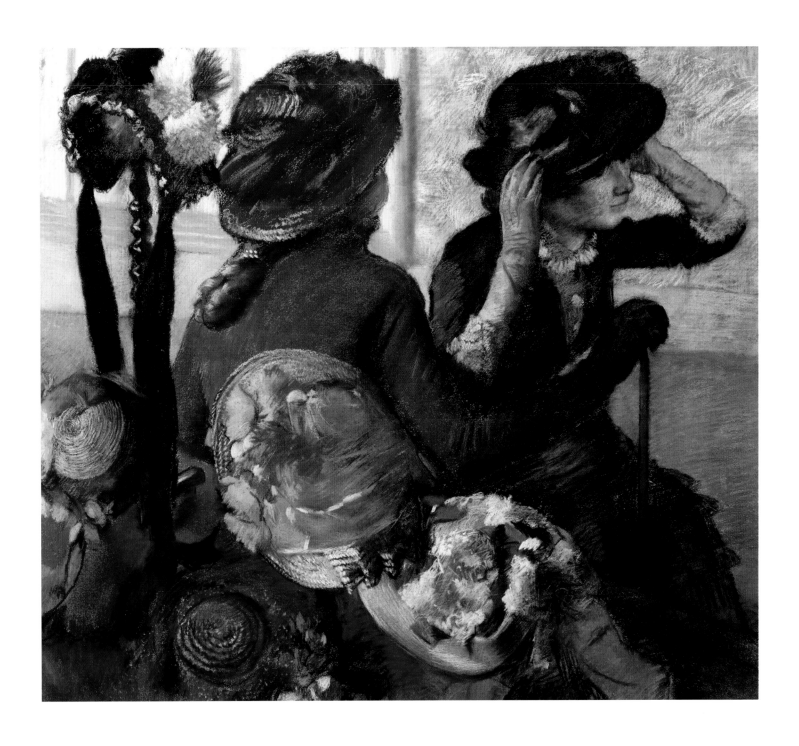

Egypt. As such, it highlighted the leading role of Paris in international hat fashion.

In the spring of 1882, straw bonnets with floral decorations were especially popular in the pages of *La Modiste universelle*. The bonnets of Madame Heitz-Boyer (see cat. no. 81) monopolized the March issue, her *bonnet campagnard* (or "rustic bonnet," fig. 17) reflecting the vogue for hats with a rural inspiration. It was described in the magazine as "in straw of dead-leaf color. . . . A fringe of steel is placed around the bonnet, and a bunch of mixed flowers, poppies, corn flowers, and daisies."[105] Similar flowered bonnets also appeared in department-store catalogues, such as a round straw hat decorated with a garland of forget-me-nots listed as "no. 301" in the summer 1882 catalogue of Au Bon Marché (fig. 18).[106] The hats in these catalogues generally followed designs originating in the haute couture stores around the rue de la Paix, but at cheaper prices.[107] The fashion critic Gabrielle d'Èze (see pp. 87–88 in Esther Bell's essay) noted on April 1, 1882: "Hats are covered with them. Flowers of all kinds and varieties, foliage of all sorts."[108] Demand was so high that by the early 1880s there were 984 *fleuristes* in Paris who prepared such flowers.[109]

This vogue for flowered hats in the early 1880s provides the essential context for understanding Degas's *At the Milliner's* (fig. 16). A range of differently colored spring straw hats here sits on a table: one hat in particular, on a low pole, stands out on account of its colorful trimming with several poppies and leaves, covered by light blue netting. Degas carefully mimicked the texture and physicality of the straw and flowers.[110] The artist famously never wanted to have cut flowers at his table; although this was probably due to allergies, it has been used as another sign of his antipathy to nature. Yet his rendering of flowers in this pastel suggests his sensitivity to natural forms. Degas's images of bonnets relate closely to contemporary prints such as that of Heitz-Boyer's "rustic bonnet" while being set apart by the artist's ability to use the qualities of pastel—its powdery dryness or its density when made wet—to mimic the very materiality of hats themselves. When *At the Milliner's* was shown in a small exhibition in London in the summer of 1882—a show organized by Durand-Ruel—Degas's ability to understand natural textures was noted by a perceptive critic, who wrote that "silk and feather, satin and straw, are indicated swiftly, decisively, with the most brilliant touch."[111]

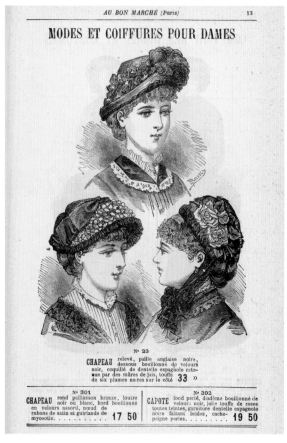

Janvier 1882.

17 *"Rustic Bonnet" by Madame Heitz-Boyer*, from *La Modiste universelle*, March 1882, M263. Lithograph. Bibliothèque nationale de France, Paris, FOL-V-832

18 *Millinery and Hairstyles for Women*, in *Au Bon Marché: Catalogue de la saison d'été* (1882), 13. Lithograph. Bibliothèque nationale de France, Paris, FOL-WZ-211

19 G. Gonin, *"Bourrelet Hat" by Madame Hélène*, from *La Modiste universelle*, January 1882, M255. Lithograph. Bibliothèque nationale de France, Paris, FOL-V-832

Perhaps the most spectacular aspect of late nineteenth-century hat fashion was the enormous vogue for bird plumage. Again Degas here showed himself as very up to date in his pastel renderings. This is most evident in the 1882 pastel *At the Milliner's* (cat. no. 16), in which he depicted a range of straw and fur felt hats with richly colored ostrich plumage in pink, yellow, and blue. Plumage was worn year-round but with especial prevalence in the fall and winter months due to the resistance of natural feathers to inclement weather. The hats depicted here were probably spring hats.

Ostrich plumage was at the center of an international trade and actually a more expensive commodity than cotton.[112] By weight, only diamonds were worth more. The vast majority of plumes came from Africa, particularly the British colony of Cape Province, where ostrich farms had developed from the 1860s and 1870s.[113] Some plumage also came from North Africa, especially the prestigious Barbary plume, via baggage trains of plumage crossing the Sahara and the Mediterranean from Tripoli to Marseille.[114] London was the international center for the import and export of

unprocessed plumage. Paris, in contrast, was the world center for the preparation and processing of these plumes.[115] An extraordinary 354 *plumassiers* were listed in the capital's *Annuaire-almanach du commerce* in 1882.[116] Plumes were bleached and then colored with natural and synthetic dyes using chemicals that were also employed in new paint colors. The exceptionally rich and various colors of dyed plumage probably encouraged Degas's interest in them as a subject.

At the Milliner's reflected the wide range of colored plumage in the most current hat fashion. Plumes enjoyed a vogue by the early 1880s, driven by their increasing availability from Africa. In 1882 Gabrielle d'Èze noted the "hats for formal dress that are nothing more than a jumble of ostrich plumes with wide, undulating feathers, set in a spiral on a tulle body."[117] In the early months of the same year, the pages of *La Modiste universelle* were dominated by hats trimmed with ostrich plumes in a panoply of colors including yellow, brown, blue, and pink. Pink plumage was especially popular, appearing in a hat by Madame Hélène in January 1882 (fig. 19). The hat was described as follows in

20 *Feathers and Flowers*, in *Au Bon Marché: Catalogue de la saison d'été* (1882), 48. Lithograph. Bibliothèque nationale de France, Paris, FOL-WZ-211

21 G. Gonin, *"Yvonette Hat" by Madame Hélène*, from *La Modiste universelle*, June 1883, M323. Lithograph. Bibliothèque nationale de France, Paris, FOL-V-832

the magazine: "The Bourrelet Hat. The velvet stretched on a frame. Strings of pink moiré ribbon and a plume of pink feathers with aigrette."[118]

Ostrich plumes were the most expensive and sought-after plumage. A single, high-quality, one-and-a-half-foot-long plume (known as an "Amazon") could sell for up to twenty-three francs—the equivalent of one week's wages for a Parisian manual worker, who was generally paid around five francs a day. Ostrich plumes were considerably more expensive than individual taxidermied birds; a tanager sold for two or three francs each.[119] The Au Bon Marché department store catalogue for summer 1882 reveals the complex range of plumes that were available at the *comptoir pour plumes et fleurs* (counter for plumage and flowers). The most attractive Amazon plumes were sold in a wide variety of lengths, ranging from six to eighteen inches.[120]

Two curling Amazon feathers—one dark and one light—were illustrated in the catalogue, framing a smaller spray (see fig. 20). Plumes were sold in black, white, natural, and a range of colored tints, allowing one to effectively customize a hat by choosing a feather to adorn it.

In addition to ostrich plumage, hats were decorated with a wide array of other feathers, such as those of the multicolored birds of paradise from New Guinea. These were especially popular, and they attracted even more interest when two birds were brought back to the Jardin des Plantes in 1877—the first time that the Parisian populace could see these birds alive.[121] Often whole taxidermied birds appeared on hats, with hummingbirds—generally from Central or South America—particularly favored; one elegant example from 1883 was trimmed with four black-and-red hummingbirds sitting atop the front brim (fig. 21). Birds native to France were also common (although less impressive) decorations, with doves, swallows, and even seagulls favored, as well as the iridescent plumage of blackbirds.

Despite the importance of taxidermied birds as an element of hat design, Degas never chose to represent them in his work, focusing instead on ostrich plumes. *At the Milliner's* (cat. no. 16) shows his careful, mimetic attention to the shape and texture of the individual barbules of the feather, as well as its shaft. Degas was fascinated by the materiality of hats. He once said that he chose to represent dancers because of his attraction to the pretty fabrics of their dresses.[122] In the same way, his images of hats demonstrate his interest in rendering the oily sheen of ostrich plumes but also the softness of velvet, the delicacy of silk flowers, the brittleness of straw, and the luminous color of ribbons.[123] In Marxist terms, his work could be seen as displaying a kind of commodity fetishism.[124] Degas's interest in the evocation of textures is further demonstrated by his advice to the publisher Georges Charpentier, that he ought to produce a New Year's edition of Zola's *Au bonheur des dames* (first published in serial form in the fall of 1882) with "samples of fabric and trimmings" opposite pages of text.[125]

Degas's embrace of commodity culture is also reflected in the fact that he represented upscale luxury goods that would have had significant commodity value, especially when compared with an average daily wage for a male Parisian worker of 5 to 7 francs a day, and around half that amount for women.[126] The most expensive hats were sold on the rue de la Paix and its environs. Berthe and Paul

Virot sold hats for 90 to 150 francs; the Maison Nouvelle from 50 to 100 francs; Camille Marchais from 80 to 200 francs; Esther Meyer from 100 to 150 francs; Caroline Reboux from 100 to 150 francs; and Michniewicz-Tuvée from 100 francs.[127] Alexandre affirmed that hats on that street could sell for up to 500 francs and noted that the top price paid was 7,000 francs.[128] Department stores generally sold hats for lesser, but still significant, sums (see fig. 18).[129] We may speculate that Degas's interest in hats also encouraged his collecting of them. Degas received good sums from Durand-Ruel for his work from the early 1870s and could easily have developed a collection of hats as study aids, even acquiring very expensive examples from the most upscale milliners.[130] His use of them as studio props is suggested by the presence of the same hats in different pastels. The same straw hat with yellow and blue flowers and long black ribbons appears, for example, in *Little Milliners* (fig. 6) and worn by the customer in *At the Milliner's* (fig. 61).[131] Their presence even suggests a sequential, time-based narrative in these pastels, whereby the hat passes from the production stage in the millinery workshop to display and sale in the fitting room.[132]

THE LATE MILLINER WORKS: "ORGIES OF COLORS"

In the late 1890s, Degas returned to the theme of millinery with a vengeance, producing a group of works that represents a late flowering of his dedication to the subject. While his earlier imagery had explored the theme with a quasi-scientific naturalism, informed by the writings of Duranty as well as contemporary science, these works highlight his increasing emphasis on color and abstraction. Scholars have generally recognized a conceptual break in Degas's production around the mid-1880s, with his output thereafter moving in a more non-naturalistic direction.[133] Renoir considered his good friend Degas's art "broaden[ing] out" after his fiftieth year, by which he probably meant that the artist moved away from scientific naturalism toward a greater sense of freedom and abstraction.[134] In his late turn to millinery, Degas concentrated his efforts on the single subject of the working milliner, aided by an assistant and absorbed in her study. His works on this theme signify a late shift of emphasis from his interest in the consumption to the production of hats.[135] In this series of images he

treated the same motif in several variants—in charcoal, pastel, and paint—exploring the effects of expressive color and abstraction. A picture, as he now noted to Jeanniot, was "an original combination of lines and tones which make themselves felt."[136] Degas told this same artist friend that a painting should have "a certain mystery, some vagueness, some fantasy."[137] In these late milliner works, faces are now blurred, forms are flattened, colors intensified.

The late shifts in Degas's art take place against a background of considerable commercial success. During the 1890s he sold his works to Durand-Ruel for very considerable prices.[138] In the early to mid-1890s, Degas's millinery images were exhibited in galleries across Europe and America. *At the Milliner's* (fig. 61), for example, appeared in Glasgow and London in 1892.[139] In 1896, moreover, Durand-Ruel negotiated the sale of the millinery work *The Conversation* (ca. 1884) to the Nationalgalerie of Berlin, the first work by Degas to enter a German public collection.

Degas's wealth freed him to explore color and abstraction in works that he probably did not intend for the marketplace. All of his late milliner pastels were in his studio at his death. So too were four of his five millinery paintings. It remains unclear whether the artist considered these works to have been finished. His resources also enabled him to build up a very substantial personal collection of work by those artists he admired. His collecting of the 1890s—and especially his enthusiasm for the work of great colorists such as Eugène Delacroix and Gauguin—is an important context for his later experiments. Degas acquired richly colorful oil sketches by Delacroix, an artist whom the critic Joris-Karl Huysmans had described as his "true master" as early as 1883.[140]

Perhaps most notably, Degas purchased ten paintings by Gauguin, including major works such as *Day of the God (Mahana No Atua)* (1894; Art Institute of Chicago), *The Brooding Woman (Te Faaturuma)* (1891; Worcester Art Museum), *La Belle angèle* (1889; Musée d'Orsay, Paris), *Vahine no te vi (Woman of the Mango)* (1892; Baltimore Museum of Art), and *The Moon and the Earth* (1893; fig. 22).[141] These were all on the second floor of Degas's townhouse in Montmartre, which must have been like a museum. He deeply admired Gauguin's painterly experiments, but the two also shared an interest in contemporary fashion.[142] This installation of Gauguin's works, with their dramatic coloristic effects and flattening patterns,

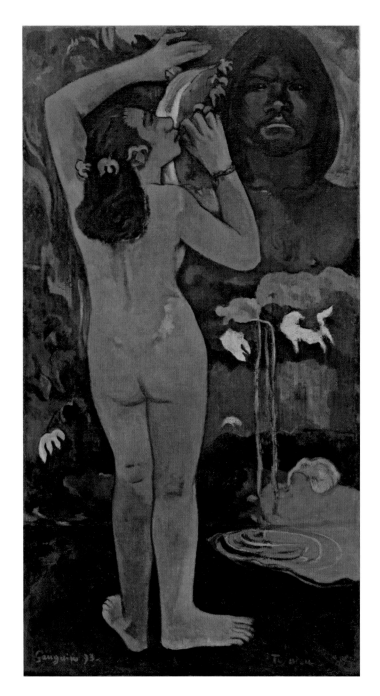

encouraged Degas's own experiment. The warm, red-dominated palette and solid, flat body masses of *The Moon and the Earth*, for example, relate to those of *The Milliners* (cat. no. 90), even if the subjects are different.

The Milliners is Degas's final painting on the millinery theme. Particularly notable is the mass of brick or Venetian red of the *première*'s dress.[143] To the left is a chair, rendered in a vibrant orange of a kind that he particularly favored in his late work. The importance that he gave to this hue as an animating force is evident in an observation that he made to Berthe Morisot that "orange lends color, green neutralizes."[144] Degas's interest in the vibrating play of complementary colors was particularly influenced by his attraction to Delacroix's color. In the 1890s, he regularly read Delacroix's *Journal*, which had been newly published in 1893.[145] In *The Milliners*, Degas offset the dominant warm tones of red by more subtle areas of green, as in the background wall and lines that silhouette his protagonists' heads. In *At the Milliner's* (cat. no. 89), a painting undoubtedly reworked in the 1890s, Degas rendered the background in an intense lemon yellow that vibrates against the turquoise of the customer's dress.

Degas's late coloristic experimentation coincided with his intoxication with photography in the mid-1890s.[146] Many of his photographs have been lost, but the three color negatives that do survive have an acidic palette of yellow and orange reds—notably *Dancer (Arm Outstretched)* (1895–1896; fig. 23)—that is very close to his late millinery paintings.[147] Degas always saw himself in competition with the masters of the past as well as the present, and his experience with the new technology of photography may have provided him with a way to ensure his coloristic difference from others' work.

Morisot's daughter, Julie Manet, remembered visiting Degas's studio in July 1899, when the artist told her of the "orgies of colors that I am making at the moment."[148] He then showed her a group of three pastels of Russian dancers "with flowers in their hair," a series of images that explored his late interest in Russian folk culture. Degas's late *At the Milliner's* (ca. 1905–1910; cat. no. 91) can be seen as comparably colorful and also includes flowers, this time as trimmings for a straw hat. Degas focused on richly colored plumage, rendered in tones of salmon pink, lavender, gray, indigo, red, and orange. These plumes had themselves been colored with a range of luminous dyes.[149] Degas's final

THE WOMAN BEHIND THE GUN.

treatment of the millinery theme and possibly one of his final works, the pastel is a development and variant on an earlier one (fig. 8), in which the features of a middle-aged woman are still clearly discernible. In *At the Milliner's* these features are no longer evident. Color and abstraction now seem to transcend individual personality. The face of the seated milliner is generalized and overlaid with an abstract grid of descending vertical red pastel marks. Degas's work here looks forward to twentieth-century abstraction.

LEGACY

Degas's millinery works record a trade that was both local and global and that was at its high point in the early twentieth century.[150] There was increasing international opposition to the plumage trade, although this was less evident in France, where powerful company and governmental interests ensured that the trade retained considerable power. In America prominent milliners were ridiculed: in 1911 a *Puck* magazine cartoon lampooned a society woman shooting several birds, which are then picked up by her faithful dogs identified as "French milliners" (see fig. 24).[151] In 1913 a law in America banned the importation of exotic plumage, and a similar statute followed in Britain in 1921. A comparable law did not, however, take hold in France until some time later. Following World War I, the millinery trade in France began to contract in size, although it maintained a prominent international presence. Sleeker, more streamlined and mini-malist designs, pioneered by Reboux, in a sense undermined the trade by reducing the need for the secondary industries of *fleuristes* and *plumassiers*.

Following an enforced move from his studio in 1912, Degas stopped producing work. A still image from Sacha Guitry's 1915 film *Ceux de chez nous* shows him on the streets of Paris as an old man, wearing a bowler hat and

24 Gordon Ross, *The Woman behind the Gun*, from *Puck* (New York), May 24, 1911. Photomechanical print. Library of Congress, Prints and Photographs Division, Washington, DC, 2011648990

25 Degas in Paris, film still from *Ceux de chez nous* (Those of our land, 1915; Sacha Guitry, dir.)

accompanied by a behatted woman (fig. 25). At his death in 1917, many of Degas's millinery paintings and pastels remained in his studio and were listed in his inventory. They appeared at his studio sale in 1918, where they sold for relatively low prices, particularly in comparison with the amounts paid for the artist's earlier, more linear work and better-known dancer subjects.[152] Taste at the time perhaps considered these later paintings unfinished and too abstract. Yet Degas's work arguably impacted younger artists. Pablo Picasso, for example, would paint *The Milliner's Workshop* (Musée national d'art moderne, Paris) in 1926, although in a very different visual language. Only in recent years have Degas's works begun to attract more attention, especially as they have moved from private collections into the public domain and become better known.

Over the course of his career, Degas produced a sustained examination of the complexity of the millinery trade. Although such images are relatively limited in number when compared with his prolific production of dancers, or his better-known nudes and horse-racing scenes, they nonetheless have a significant place within his wider project to represent modern life. I began this essay by arguing that the millinery works are crucial in understanding Degas's iconographical and formal experiment. We have seen that they were a crucible for the artist's compositional innovations and late experiments with color. We have also seen that they were a focus for Degas's avant-garde interest in producing imagery of modern women, whether foregrounding the artistry of the milliner or the complex role of the shopper at a transformational time in the retail industry.

The millinery images, indeed, provide insight into Degas's exploration of the status and identity of women in general. Degas never married and had few known intimate relationships with women. Yet, to a greater extent than "his unflattering depictions of dancers and prostitutes," these works show his ability to understand a woman's mentality with a rare empathetic sensibility.[153] The millinery series also highlights his enthusiasm for the ultimate female accessory, the hat itself. Degas was radical in treating the commodity of the hat—a central aspect of popular and commercial culture at the time—with such seriousness, anticipating later attitudes in Pop art. These images thus fused his interest in two pivotal iconographical areas of his output: the rendering of women and the world of commerce. The delicate balance of empathy and analysis in his imagery is suggested by a rare late view, by the Symbolist painter Maurice Denis, of the artist studying a model (fig. 26). Few comparable images exist of Degas at work. The young girl wears a plumed hat and veil and looks down. Degas holds a notebook, demonstrating that same meticulous and intense concentration that he brought to his study of milliners.

Thanks to Marilyn Brown for her comments on a draft of this essay. Thanks also to Theodore Reff for his early encouragement. All translations are by the author unless otherwise noted, with refinements by Alexandra Bonfante-Warren.

1 "Élevé dans un monde élégant, il [Degas] n'osa s'extasier devant ces magasins des modistes de la rue de la Paix, les jolies dentelles, ces fameux tours-de-main de nos Parisiennes, pour vous torcher un chapeau extravagant." Paul Gauguin, as quoted in Charles Morice, "Paul Gauguin," *Mercure de France*, vol. 48 (October–December 1903): 120–121.

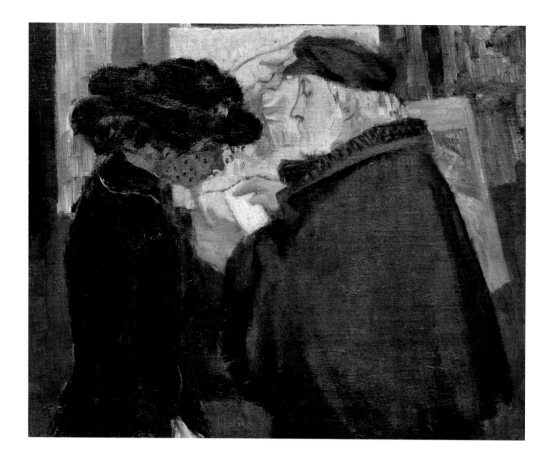

26 Maurice Denis, *Degas and His Model*, ca. 1906. Oil on canvas, 15 x 18 ⅛ in. (38 x 46 cm). Musée d'Orsay, Paris, RF 1992 414

2 "Degas gave up his omnibus rides towards the end of his life. He took long walks instead, which never seemed to tire him. . . . I met Degas one evening on the boulevard des Italiens. . . . As we went along, Degas would stop in front of shop-windows, look at the displays and the advertisements pasted on the plate glass, and then stare at me questioningly. I would then proceed to read them to him: *Chaussures de Limoges*; *Ribby habille mieux*; *Poule aux gibier*." Ambroise Vollard, *Degas: An Intimate Portrait* (New York: Crown Publishers, 1937), 87.

3 "Le complément et le couronnement de la robe, la touche suprême." Arsène Alexandre, *Les Reines de l'aiguille: Modistes et couturières* (Paris: Théophile Belin, 1902), 130.

4 See Ruth E. Iskin, *Modern Women and Parisian Consumer Culture in Impressionist Painting* (Cambridge: Cambridge University Press, 2007); and Gloria Groom, ed., *Impressionism, Fashion, and Modernity* (Chicago: Art Institute of Chicago; New York: Metropolitan Museum of Art; and Paris: Musée d'Orsay, 2012), 218–231. Groom identifies four paintings, seventeen pastels, and an unidentified work shown at the 1876 Impressionist exhibition (ibid., 318–319). The four paintings are L706, L832, L1023, and L1315, the seventeen pastels L681–683, L693, L694, L705, L729, L774, L827, L833–835, L1110, and L1316–1319. Degas's works are generally identified, as here, by their number in the catalogue raisonné of Paul-André Lemoisne, a curator at the Bibliothèque Nationale who first met Degas in 1895. See Lemoisne, *Degas et son oeuvre*, 4 vols. (Paris: Paul Brame and C. M. de Hauke, 1946–1949). Lemoisne argued that Degas was attracted to milliners by "their strangeness . . . by that appearance of a free animal."

5 The additional works are the circa 1884 painting *Woman Adjusting Her Hair* (cat. no. 16), the two circa 1884 pastels *Woman Adjusting Her Hair* (cat. no. 15) and *Young Woman in Blue* (cat. no. 14), and two charcoal drawings that appeared in Degas's third studio sale (see *Catalogue des tableaux, pastels et dessins par Edgar Degas*, April 7–9, 1919, lot 85, drawing 3 [*Seated Woman* (*Femme assise*)], and lot 400 [fig. 95]).

6 Degas's earliest known millinery pastel, *At the Milliner's* (1881; fig. 45), comprises five pieces of paper affixed together, while his last such work, *At the Milliner's* (ca. 1905–1910; cat. no. 91), also evolved to comprise three conjoined pieces of paper. There is considerable debate over the dating of Degas's millinery works. Lemoisne dated them from circa 1882 to 1898 but his dating is notoriously unreliable. Scholars, especially in the wake of the major 1988 Degas exhibition, have argued for a broader chronological range, beginning in 1881 with *At the Milliner's*, which was sold to Durand-Ruel in October 1881—the first recorded sale of a millinery work—and continuing as late as 1910 with *At the Milliner's*. If we also include the unidentified 1876 *Modiste*, this range can be extended from 1876 to 1910. Degas therefore was preoccupied, albeit intermittently, with millinery as a theme for close to thirty-five years. Perhaps surprisingly, Degas never produced any prints with millinery iconography.

7 "Effarement." In Paul Lafond, *Degas*, vol. 2 (Paris: H. Floury, 1919), 45–46.

8 In 1924 Gustave Coquiot noted that "the milliners form a very delightful group of Parisian coquettes." (Les modistes forment une très

réjouissante classe de la coquetterie parisienne.) See Coquiot, *Degas* (Paris: Librairie Ollendorff, 1924), 130.

9 Eunice Lipton, *Looking into Degas: Uneasy Images of Women and Modern Life* (Berkeley: University of California Press, 1986).

10 Hollis Clayson, *Painted Love: Prostitution in French Art of the Impressionist Era* (New Haven, CT: Yale University Press, 1991). The author notes that millinery was seen as a "suspicious profession" and cites the daily wages of milliners as being as low as between two and four francs, ensuring that many were driven to prostitution.

11 Iskin, *Modern Women and Parisian Consumer Culture*, 60.

12 Gloria Groom, "Edgar Degas: *The Millinery Shop*," in *Impressionism, Fashion, and Modernity*, 218–232.

13 See Norma Broude, "Degas's 'Misogyny,'" *Art Bulletin* 59 (March 1977): 95–107.

14 See George Moore, "Degas," in *Impressions and Opinions* (London: David Nutt, 1891), 316.

15 Françoise Tétart-Vittu, "Shops versus Department Stores," in Groom, *Impressionism, Fashion, and Modernity*, 209–217.

16 A very extensive discourse in cultural studies exists around the rise of the department store. Rosalind H. Williams's *Dream Worlds: Mass Consumption in Late Nineteenth-Century France* (Berkeley: University of California Press, 1982) is a seminal text. Michael B. Miller, *The Bon Marché: Bourgeois Culture and the Department Store, 1869–1920* (Princeton, NJ: Princeton University Press, 1981) is a useful case study.

17 Zola spent several weeks in the halls and aisles of Au Bon Marché to research for his book.

18 "Les fleurs montaient toujours, de grands lis mystiques, des branches de pommier printanières, des bottes de lilas embaumé, un épanouissement continu que surmontaient, à la hauteur du premier étage, des panaches de plumes d'autruche, des plumes blanches qui étaient comme le souffle envolé de ce peuple de fleurs blanches. . . . Dans les feuillages et dans les corolles au milieu de cette mousseline, de cette soie et de ce velours, où des gouttes de gomme faisaient des gouttes de rosée, volaient des oiseaux des Îles pour chapeaux, les Tangaras de pourpre à queue noire, et les Septicolores au ventre changeant, couleur de l'arc-en-ciel." Zola, *Au bonheur des dames* (1883).

19 "En juin, ce sont les Chapeaux de paille . . . tous les murs de l'etablissement sont tapissés de panamas, manilles et autres sombreros destinés aux bains de mer ou aux environs de Paris. On n'aperçoit du haut en bas des murs du grand bazar que des couvres-chefs éclatants de blancheur." Pierre Giffard, *Les Grands bazars: Paris sous la Troisième République* (Paris: Victor Havard, 1882), 280–281, 298.

20 *Annuaire-almanach du commerce, de l'industrie, de la magistrature et de l'administration, ou, Almanach des 1,500,000 adresses de Paris, des départements et des pays étrangers* (Paris: Firmin-Didot frères, 1882), 1,460–1,463. The *Annuaire* listed the following milliners on or near the rue de la Paix: "Maison Berthon, modes, haute nouveauté, rue de la Paix, 2; Mlle Marguerite, avenue de l'Opéra, 35; Camille et Valentine, 19; Chemin-Lafleur (Mme), Paix; Gelot (Mme), rue de la Paix, 13; Mme Henriette, rue de la Paix, 3; Mme Isabelle, Paix, 5; Mme Petit-Roger, Paix, 5; Louver et Carlier, Paix, 16; Caroline Reboux, Paix, 23; Mme Virot, Paix, 12; Mme Melanie Percheron, Vivienne, 30, et Paix, 24."

21 *Exhibition Paris 1900: A Practical Guide* (London: Heinemann, 1900), 108.

22 "The great milliner of the rue de la Paix is the leading creator of the form [of the hat]. As a result of the very high price that she charges, the number of her clients is limited. She knows the tastes of each of them; she knows the best hat for them, depending on the shape of their face." (Le grand modiste de la rue de la Paix est la première créatrice de la forme. Par suite du prix très élevé qu'elle prend, le nombre de ses clientes est limité. Elle connait les goûts de chacune d'elles; elle sait ce qui est de nature à les bien coiffer, suivant la conformation de leur visage.) A. Coffignon, *Les Coulisses de la mode* (Paris: Librairie illustrée, 1888), 54–55.

23 "Dans tout Paris . . . personne ne sait aussi bien . . . donner de la valeur à un ruban et poser avec art une fleur ou une plume." Paul Eudel, *L'Hôtel Drouot et la curiosité en 1883–1884* (Paris: G. Charpentier et Cie, 1885), 371. He added that she had established an international aristocratic clientele in the Second Empire before moving to her 12, rue de la Paix store, where she became a millionaire.

24 In 1904 *Les Modes*—the first fashion magazine to include photographs in its pages—published an article by Maurice Praslières on Alphonsine that argued her hat designs were underpinned by extensive European travel and viewing of work by the English eighteenth-century painters Joshua Reynolds, Thomas Gainsborough, and George Romney. Praslières, "Une grande modiste au XXe siècle," *Les Modes* 46 (1904): 18–22. The author also noted that she owned work by Jean-Marc Nattier, which hung in her salon, directly affirming her connection to French art of the eighteenth century.

25 Degas's letters show his familiarity with the street. In December 1885 he wrote to Paul Durand-Ruel: "Happy New Year. Yesterday I should have gone to the rue de la Paix if I had been able to leave the vicinity of a small place to which nature kept sending me." In another undated letter to the dealer, he noted, "If I do not come to the rue de la Paix before dinner I wish you would be good enough to put 1,500 francs aside for me for my rent of the 15." Cited in Marcel Guérin, ed., *Degas Letters* (Oxford: Bruno Cassirer, 1947), 124.

26 Célestine died in 1847 when Degas was only thirteen. His father died in 1874. Degas was the eldest of five children, with two younger brothers (René and Achille) and two younger sisters (Thérèse and Marguerite).

27 See Linda Nochlin, "Degas and the Dreyfus Affair," in *The Politics of Vision: Essays on Nineteenth-Century Art and Society* (New York: Harper and Row, 1989), 159–161.

28 Daniel Halévy recounted a meeting with Degas at the Henri Rouart sale on December 10, 1912: "Then he sat down again and said to me in an annoyed tone: 'Why are you wearing gloves? Gloves and no hat!' He said that twenty years ago. I replied: 'Have you forgotten that observation by a dancer's mother, which you enjoyed so much: a man is always better with gloves?' 'That's true,' he said, smiling." (Puis il se rassit et me dit d'une voix mécontente: "Pourquoi as-tu des gants? Pas de chapeau et des gants!" Il me disait cela voici vingt ans. Je lui répondis: "Vous avez donc oublié ce mot d'une mère de danseuse, qui vous plaisait tant: un homme est toujours mieux avec des gants?" "C'est vrai," fit-il en souriant.) Halévy, ed., *Degas parle . . .* (Paris: La Palatine, 1960), 143.

29 "Degas was very amused by my wife's paintings. Looking at an old peasant woman wearing a white bonnet, seated full face in her vegetable garden and mending her stockings, he said: 'Decidedly, naiveté is what is best in art: *look at the slit in the bonnet*, it's delightful. Here is a person who knows nothing, who did that instinctively, and, mind you, that's very difficult.'" (Degas s'amusait beaucoup des peintures de ma femme. Devant une vieille paysanne coiffée d'un bonnet blanc, assis de face dans son potager et raccommodant ses bas, il dit: "Decidement, la naïveté est-ce qu'il y a de meilleur en art: *voyez la fente du bonnet*, c'est délicieux. Voilà une personne qui ne sait rien, qui fait cela d'instinct, et notez que c'est très difficile.") Georges Jeanniot, "Souvenirs sur Degas," *La Revue universelle*, 1933, 299.

30 "He had a passion for canes, the different kinds of wood, their varieties." (Il a eu une passion pour les *cannes*, les bois, leurs variétés.) Halévy, diary entry, November 4, 1895, published in Halévy, *Degas parle . . .*, 78.

31 Degas's attendance as an *abonné* (subscriber) from 1885 to 1892 is recorded. He attended one single opera, *Sigurd*, on thirty-seven occasions. See Henri Loyrette, "Degas à l'Opéra," in *Degas inédit*. Actes du Colloque Degas, Musée d'Orsay, April 18–21, 1988 (Paris: La Documentation Française, 1989), 47–64.

32 See Aruna D'Souza, "Why the Impressionists Never Painted the Department Store," in D'Souza and Tom McDonough, eds., *The Invisible Flaneuse? Gender, Public Space, and Visual Culture in Nineteenth-Century Paris* (Manchester: Manchester University Press, 2006), 129–147.

33 Degas did not generally choose to specify the settings for his scenes. *At the Milliner's* (1881; fig. 45) is unusual in including a little more interior decoration, including a blue china pot with large plant. Colin B. Bailey argues persuasively that this scene represents the interior of a rue de la Paix store. The two protagonists could be in the front waiting area of a millinery shop before visiting the fitting salon. See Bailey in *The Annenberg Collection: Masterpieces of Impressionism and Post-Impressionism*, ed. Susan Alyson Stein and Asher Ethan Miller (New York: Metropolitan Museum of Art; and New Haven, CT: Yale University Press, 2009), 39.

34 Richard Thomson, "Les poses chez Degas de 1875 à 1886: Lecture et signification," in *Degas inédit*, 211–224.

35 Charles Baudelaire, "Salon de 1845," in *Art in Paris, 1845–1862*, ed. and trans. Jonathan Mayne (London: Phaidon, 1965), 32.

36 *Scene from the Steeplechase: The Fallen Jockey* (1866, reworked 1880–1881 and ca. 1897), National Gallery of Art, Washington, DC, 1999.79.10.

37 Degas, letter to James Tissot, November 19, 1872, published in Guérin, *Degas Letters*, 18.

38 "He showed me washerwomen and still more washerwomen . . . speaking their language and explaining the technicalities of the different movements in pressing and ironing." Edmond de Goncourt, quoted in *Pages from the Goncourt Journal*, ed. Robert Baldick (1962; reprint, New York: New York Review of Books, 2007), 206.

39 "We will say nothing about the *Atelier des modistes*, who are obviously too ugly not to be virtuous." (Nous ne dirons rien de l'*Atelier des modistes*, qui sont évidemment trop laides pour ne pas être vertueuses.) Émile Porcheron, "Promenades d'un flâneur: Les Impressionnistes," *Le Soleil*, April 4, 1876; reprinted in Ruth Berson, ed., *The New Painting: Impressionism, 1874–1886. Documentation*, vol. 1 (San Francisco: Fine Arts Museums of San Francisco, 1996), 103. Octave Maus may have been remembering this work when he later wrote in 1886 that Degas's "millinery ateliers, where he has drawn with an impeccable pencil their sickly, depraved population, worn out at twenty years of age from the double effect of work and pleasure, are already far from us. His implacable scalpel cuts deeper." (Les ateliers de modes, dont il a dessiné d'un crayon impeccable la population malingre, perverse, usée à vingt ans sous le double coup de lime du travail et du plaisir, sont déjà loin de nous. Son implacable scalpel s'enfonce davantage.) Maus, "Les Vingtistes parisiens," *L'Art moderne* (Brussels), June 27, 1886; reprinted in Berson, *The New Painting*, 462.

40 The meticulously rendered face of the central figure of *The Milliners*—an area that the artist never revised, in contrast to the majority of the painting—is characteristic of Degas's work from the early to mid-1870s and is rendered with considerable poignancy.

41 This milliner was a Madame Gileu, "modiste à façon." See Roberta Crisci-Richardson, *Mapping Degas: Real Spaces, Symbolic Spaces and Invented Spaces in the Life and Work of Edgar Degas (1834–1917)* (Newcastle upon Tyne: Cambridge Scholars Publishing, 2015), 85.

42 See *Inventaire après le décès de M. Degas*, November 29, 1917. See also Ann Dumas, ed., *The Private Collection of Edgar Degas*, exh. cat. (New York: Metropolitan Museum of Art, 1997).

43 See numbers 353 (*Ma santé est autant bonne . . .*, 1838), 1921 (*Marchande de modes*), and 1966 (*Un Chapeau neuf*, 1837) in J. Armelhaut and E. Bocher, *L'Oeuvre de Gavarni: Catalogue raisonné* (Paris: Librairie des Bibliophiles, 1873). These prints do not appear in the print catalogue of Degas's studio sale, so we cannot be certain that he was aware of them. Alfred-André Geniole's 1841 lithograph *La Modiste* (Musée Carnavalet, Paris, G6657), showing a milliner fitting a customer with a hat, is another notable example from the extensive early to mid-nineteenth-century print culture around millinery. This print, from the series *Les Femmes de Paris*, is inscribed: "Ah, Madame, it is intoxicating, it was in one like this that Melle N*** of the Opéra seduced Prince Fréderico de Bouffissman" (Ah madame, il est délirant, c'est avec le pareil que Melle N*** de l'Opéra a séduit le Prince Fréderico de Bouffissman).

44 See Judith G. Coffin, *The Politics of Women's Work: The Paris Garment Trades, 1750–1915* (Princeton, NJ: Princeton University Press, 1996), 253–254.

45 Uzanne also noted that there were approximately 125,000 women workers total in Paris, with the largest employers being the dressmaking and laundry industries. See Uzanne, *La Femme à Paris: Nos contemporaines* (Paris: Ancienne Maison Quantin, 1894), 76, 102.

46 "Donner la vie en jetant là-dessus tout ce qu'il y a d'original, de caractéristique et de précieux dans l'ornementation." See Alexandre, *Les Reines de l'aiguille*, 143–144.

47 This hierarchy was articulated as early as 1846 by Maria d'Anspach in her essay "La Modiste." See Iskin, *Modern Women and Parisian Consumer Culture*, 70–71.

48 Charles Benoist, *Les Ouvrières de l'aiguille à Paris: Notes pour l'étude de la question sociale* (Paris: L. Chailley, 1895), 87.

49 "L'aristocratie des ouvrières parisiennes, les plus élégantes et les plus distinguées." Uzanne, *La Femme à Paris*, 102.

50 "Les modistes sont de toutes les industries de l'aiguille la plus favorisée sous le rapport des salaires." See Lipton, *Looking into Degas*. Leroy-Beaulieu cited a government survey of 1860, which found that among the 2,475 milliners in Paris at the time, 200 earned three francs a day and 295 exceeded that (of which 20 earned five, 33 earned six, 5 earned seven, 4 earned eight, and 3 earned nine francs a day). In contrast, of 3,970 women working for dressmakers, 288 earned three francs a day and 168 exceeded that. Of 5,106 women working in the lingerie industry, 138 earned three francs a day and 144 exceeded that. See Leroy-Beaulieu, *Le Travail des femmes au XIXe siècle* (Paris: Charpentier, 1873).

51 Benoist, *Les Ouvrières de l'aiguille à Paris*. Male construction workers did not, however, earn much more: around five francs a day, on average.

52 Ibid., 87.

53 Iskin argues that the young girl on the left is a trimmer who is overseen by an older *première* on the right. See Iskin, *Modern Women and Parisian Consumer Culture*, 72.

54 "Il professe pour le caractère si *humain* de la jeune demoiselle de magasin la plus vive admiration." Paul Valéry, *Degas, danse, dessin* (Paris: Gallimard, 1938), 147. Halévy also remembered another comment by Degas, "It's in the ordinary that grace resides" (C'est dans le commun qu'est la grace). Halévy, diary entry, January 9, 1891, in *Degas parle . . .* , 54.

55 Cited in Lipton, *Looking into Degas*, 160. "Une des grandes gaîetés de Paris," Alexandre, *Les Reines de l'aiguille*, 7.

56 The work was once titled *Apprêteuse et garnisseuse (Modes), rue du Caire*. The rue du Caire lay approximately a mile to the east of the rue de la Paix and was a less desirable location.

57 See Robyn Roslak, "Artisans, Consumers and Corporeality in Signac's Parisian Interiors," *Art History* 29, no. 5 (2008): 860–886.

58 Gustave Geffroy noted "their monkey-like movements" (leurs mouvements simiesques) in "Salon de 1886: VIII. Hors du Salon: Les Impressionnistes," *La Justice*, May 26, 1886. Maurice Hermel described Degas's "trimmers, with their tiny gestures, their squirrel-like postures, their sly and vice-ridden faces like little *trottins*," although he also noted that the subjects were a "marvel of humor and observation." (Les appareilleuses, avec leurs menus gestes, leurs poses d'écureuils, leurs mines futées et vicieuses de petits trottins, quelles merveilles d'humour et d'observation.) Hermel, "L'Exposition de peinture de la rue Laffitte," *La France libre*, May 27, 1886. Both reviews reprinted in Berson, *The New Painting*, 451 and 456. As Groom said, these two comments reinforced existing stereotypes regarding the "morality and economic plight of this type of woman." See Groom, *Impressionism, Fashion, and Modernity*.

59 The young critic Jean Ajalbert described "the chlorotic milliners, tightly encased in their corsets, thin and withdrawn faces and curly hair with fringes, are those who earn two francs a day, creating twenty *louis* hats until they can wear them." (Les chlorotiques modistes, enserrées dans leurs corsets, minces et la figure chiffonnée, et les cheveux frisés à la chien, sont bien de celles qui gagnent deux francs par jour, et édifient des chapeaux à vingt louis, en attendant de les porter.) Ajalbert, "Le Salon des impressionnistes," *La Revue moderne* (Marseille), June 20, 1886; reprinted in Ruth Berson, ed., *The New Painting: Impressionism, 1874–1886. Documentation* (San Francisco: Fine Arts Museums of San Francisco, 1996), 1:430.

60 See Marilyn Brown, *Degas and the Business of Art: "A Cotton Office in New Orleans"* (University Park: Pennsylvania State University Press, 1994), 134–136; and Iskin, *Modern Women and Parisian Consumer Culture*, 107.

61 Cited in Brown, *Degas and the Business of Art*, 135–136.

62 "Ce sont des reines, en effet, qui ne font plus du métier, mais de l'art. . . . ce n'est plus leur travail que l'on paye, ce sont, le terme est courant, leurs 'créations,' leurs 'idées,' leur goût, leur adresse, ce qui constitue le talent." Benoist, *Les Ouvrières de l'aiguille à Paris*, 88.

63 "Artistes véritables." The same author noted that the milliner could be "a poet by means of her imagination, and a sorceress because of her wonders" (poète par l'imagination, et de sorcière par les prestiges). See Alexandre, *Les Reines de l'aiguille*.

64 See especially the 1895 social study of the garment trade by the Republican Benoist, *Les Ouvrières de l'aiguille à Paris*, 77–80. The first minimum wage was ultimately approved in 1915.

65 See Lisa Tiersten, *Marianne in the Market: Envisioning Consumer Society in Fin-de-Siècle France* (Berkeley: University of California Press, 2001), 33–46.

66 Ibid.

67 "And that's when the real work of the day begins, sometimes a real torment. It often consists of the same woman trying on ten hats ten times. Well, for a few sensible women who care about their appearance within the limits of a reasonable stylishness, how many absurd characters do we fit with hats, for whom the chosen hat is never the right one. And we start over! And we go through all the boxes! And this one is too small! And that one is too big! And this one is too old-fashioned! And that one is too dark! And so on and so on!" (Et alors, commence le vrai travail de la journée, quelquefois un vrai supplice. Il consiste souvent à essayer dix fois dix chapeaux à la même femme. Or, pour quelques femmes sensées et soigneuses de leur figure dans les limites de la coquetterie raisonnable, que de types extravagants nous coiffons, sans que jamais le chapeau choisi les satisfasse, Et c'est à recommencer! Et il faut chercher dans tous les cartons! Et celui-ci est trop petit! Et celui-là est trop grand! Et celui-ci est trop vieux! Et celui-là est trop sombre! Et ceci, et cela.) Giffard, "Confidences d'une vendeuse," in *Les Grands bazars*, 189.

68 See Tiersten, *Marianne in the Market*, 33–54.

69 Ibid., 37–38.

70 Madame Marty "avait passé une heure aux modes, installées dans un salon neuf du premier étage, faisant vider les armoires, prenant les chapeaux sur les champignons de palissandre qui garnissaient deux tables, les essayant tous, à elle et à sa fille, les chapeaux blancs, les capotes blanches, les toques blanches." Zola, *The Ladies' Paradise*, 416; *Au bonheur des dames*, 347–348.

71 See Tiersten, *Marianne in the Market*.

72 Articles in such magazines served to highlight a growing sense of independence among women. See Justine De Young, "Representing

the Modern Woman: The Fashion Plate Reconsidered (1865–75)," in Temma Balducci and Heather Belnap Jensen, eds., *Women, Femininity and Public Space in European Visual Culture, 1789–1914* (Farnham, UK: Ashgate, 2014), 97–114.

73 Ibid.

74 "La source de l'ornement. Penser à un traité d'ornement pour les femmes ou par les femmes, d'après leur manière d'observer, de combiner, de sentir leur toilette et toutes choses." Degas, notebook 23 (dated 1868–1872), 46–47. See Theodore Reff, ed., *The Notebooks of Edgar Degas* (Oxford: Clarendon Press, 1976), 1:117–118.

75 Edmond Duranty, *La Nouvelle peinture* (Paris, 1876).

76 Louisine W. Havemeyer, *Sixteen to Sixty: Memoirs of a Collector* (New York: Printed for the family of Mrs. H. O. Havemeyer and the Metropolitan Museum of Art, 1961), 257–258.

77 See Gary Tinterow, entry for *At the Milliner's*, in Jean Sutherland Boggs, ed., *Degas*, exh. cat. (New York: Metropolitan Museum of Art; and Ottawa: National Gallery of Canada, 1988), 396. As has been noted, the hat is close to that featured in her self-portrait (*Portrait of the Artist* [1878], Metropolitan Museum of Art, New York, 1975.319.1) from this time.

78 "This hat, she has kept an eye on it for a long time in the shop window, or coveted it on another woman: she loses herself in studying her new look closely; she imagines changes, a ribbon, a hat pin." (Ce chapeau, elle l'a guetté longtemps à la devanture, ou l'a jalousé à une autre femme: elle s'oublie à scruter sa nouvelle tête; elle imagine des changements, un ruban, une épingle.) Cited in Berson, *The New Painting*, 430.

79 See George T. M. Shackelford, "Pas de deux: Mary Cassatt and Edgar Degas," in Judith Barter, ed., *Mary Cassatt: Modern Woman*, exh. cat. (Chicago: Art Institute of Chicago; and New York: H. N. Abrams, 1998), 125–127.

80 Walter Sickert, "Degas," *Burlington Magazine for Connoisseurs* 31, no. 176 (November 1917): 185.

81 "À la ganterie et aux lainages, une masse épaisse de chapeaux et de chignons barrait les lointains du magasin. On ne voyait même plus les toilettes, les coiffures seules surnageaient, bariolées de plumes et de rubans." Zola, *Au Bonheur des dames*, 109.

82 "Degas aimait . . . beaucoup la société des femmes." Jeanne Fevre, *Mon oncle Degas* (Geneva: Piere Caillier, 1949), 67. See also Broude, "Degas's 'Misogyny.'"

83 See Chantal Bischoff, *Geneviève Straus: Trilogie d'une égerie* (Paris: Éditions Balland, 1992). For their relations, see also Roy McMullen, *Degas: His Life, Times, and Work* (Boston: Houghton Mifflin, 1984), 385, 427, 441.

84 Daniel Halévy later described her salon at 134, boulevard Haussmann in the late 1880s: "It was very enjoyable. There were living connections to the Second Empire, my father, Meilhac, Degas, Cavé, and the Ganderaxes. There were new talents, not Anatole France . . . but, very often, Jules Lemaître. There were Bourget and Hervieu, and Forain; the actors Lucien Guitry, Réjane, Emma Calvé; I saw Princess Mathilde there, a lofty relic; and the foreigners, Lady de Grey, Lord Lytton, George Moore, brought by Jacques Blanche, and Marcel Proust, a memorably handsome young man." (C'était très agréable.

Il y avait là les vivantes attachés avec le Second Empire, mon père, Meilhac, Degas, et Cavé, et les Ganderax. Il y avait les nouveaux talents: non pas Anatole France . . . mais, très souvent, Jules Lemaître. Il y avait Bourget et Hervieu, et Forain; les comédiens, Lucien Guitry, Réjane, Emma Calvé; j'ai vu là la princesse Mathilde, hautaine relique; et les étrangers, Lady de Grey, Lord Lytton, George Moore, amené par Jacques Blanche, et Marcel Proust, éphèbe inoubliable.) Halévy, *Notes sur les salons de ma tante Geneviève* (appendix 10). See Françoise Balard, ed., *Geneviève Straus, Biographie et correspondance avec Ludovic Halévy, 1855–1908* (Paris: CNRS éditions, 2002), 161.

85 See Malcolm Daniel, ed., *Edgar Degas, Photographer* (New York: Metropolitan Museum of Art, 1998), 62.

86 Geneviève wrote to Ludovic Halévy on September 12, 1885, regretting that she had not seen Degas before her departure for Italy: "To begin, I'm very sorry not to have seen Degas, who is delightful . . . the greatest painter of the century." (Je regrette bien, d'abord de ne pas voir Degas qui est délicieux . . . le plus grand peintre du siècle.) See Balard, *Geneviève Straus*, 156.

87 The other two men in the photograph are the drama critic Louis Ganderax and Albert Boulanger-Cavé.

88 Eugenia Parry, "Edgar Degas's Photographic Theater," in Daniel, *Edgar Degas, Photographer*, 72.

89 "I was dragged to a fashionable dressmaker's where, like a Béraud, I attended the fitting of a most impressive dress." (On m'a entraîné chez une grande couturière où j'ai assisté, comme un Béraud, à l'essayage d'une toilette à grand effet.) Degas, letter to Michel Manzi, n.d., published in Marcel Guérin, ed., *Lettres de Degas* (Paris: Grasset, 1945), 142. Degas refers to "Mme Strauss" [sic] in this letter. Straus didn't marry until November 1886, so Degas's use of this title indicates that the letter dates after this. Degas also noted that Straus was a "person, in demand everywhere" and that he had "neglected her so much."

90 Milliners and dressmakers were often compared in the press as the principal workers of the garment trade. There were, however, far more *couturières*, while milliners were seen as the elite workers in the trade, earning the higher salaries.

91 Guérin, *Degas Letters*, 267.

92 According to Daniel Halévy, in a diary entry of June 6, 1890, Degas noted of the portrait of Geneviève Halévy by Jules-Elie Delaunay (1878; Musée d'Orsay, RF 2642): "It's workshop grief. She mourns hanging on the picture rail." (C'est un deuil d'atelier. Elle pleure sur la cimaise.) Halévy, *Degas parle . . .*, 40. Halévy also wrote on December 14, 1890: "Yesterday evening, for the first time, resumption of our Thursday dinners. There were Duhesme, the Strauses, Meilhac, Reyer, and Degas, who was charming." (Hier soir, pour la première fois, reprise de nos dîners de jeudi. Il y avait Duhesme, les Straus, Meilhac, Reyer, et Degas qui fut charmant) (p. 42).

93 The Dreyfus Affair polarized French society around the fortunes of a Jewish military officer, Alfred Dreyfus, who was wrongly accused of selling secrets to the Germans and imprisoned. The fate of Dreyfus divided France between liberal Dreyfusard forces—most notably Zola—in favor of the officer and anti-Dreyfusards—which included Degas—who were more nationalistic and anti-Semitic in their stance.

94 Alexandre, *Les Reines de l'aiguille*.

95 Gary Tinterow, entry for *The Millinery Shop*, in Boggs, *Degas*, 400.

96 Around 1869, Degas compared himself to a shopkeeper, referring to his studio on the rue Laval, somewhat ironically, as an "établissement de bouillon" which had an *enseigne*, or shop sign. As Theodore Reff notes, a merchant of "bouillon" was a keeper of a small shop of remaindered or returned items. Letter to Emma Dobigny, ca. 1869, in Reff, "Some Unpublished Letters of Degas," *Art Bulletin* 50, no. 1 (March 1968): 91.

97 Degas's first use of the term "articles" appears in a circa 1879 letter to Félix Bracquemond, in which he notes: "I have finished two articles." Degas also used the term for art made by his friends, as in an 1880 letter to Jules Cazin referring to "your 'articles.'" Guérin, *Degas Letters*, 24 and 62.

98 *Au Bon Marché: Saison d'été* (Paris, 1882), 46.

99 Degas wrote circa 1879: "No time to do some really serious experiments. Always articles to fabricate. The last is a monochrome fan for M. Beugniet [a prominent art dealer]." See Guérin, *Degas Letters*.

100 See two works, both titled *Portraits at the Stock Exchange* (*Portraits à la Bourse*, ca. 1878–1879), in the collections of the Musée d'Orsay, Paris (RF 2444), and the Metropolitan Museum of Art, New York (1991.277.1).

101 See Marnin Young, "Capital in the Nineteenth Century: Edgar Degas's Portraits at the Stock Exchange in 1879," *Nonsite.org*, no. 14 (December 2014).

102 Although Degas is often seen as the quintessential Parisian—and indeed he lived in Paris throughout his life—his early travels in America provided him with a global outlook that was rare among the Impressionists. He was the only French Impressionist to visit North America, and he traveled extensively around Europe. He visited Italy from 1856 to 1859. He was in London in 1870, thereafter showing a considerable interest in English culture and fashion. He visited Spain in 1889. During his trip to America he expressed an interest in visiting Cuba, although ultimately he did not.

103 Musée des Beaux-Arts, Pau, France, inv. no. 215; acquired in 1878. Brown, *Degas and the Business of Art*.

104 Smaller, more schematic illustrations articulated the armature of the hats—generally made of straw, fur felt, or silk satin—before the addition of trimmings.

105 "Chapeau Campagnard, en paille de feuilles mortes . . . Frange d'acier autour de chapeau et bouquet de fleurs mélangées: coquelicots, myosotis, marguerites." *La Modiste universelle*, March 1882, no. 263.

106 Straw hats themselves were the subject of a considerable secondary industry, with approximately 250 suppliers in Paris, many of whom imported their hats from England or Italy. English hats came especially from the hat-manufacturing centers of Luton, Saint Albans, and Dunstable. The vogue for dyed straw hats was also notable at the time. *La Modiste universelle* described the wide range of straw used to make hats, from Dunstable straw (for example, in a hat in telegram blue, fig. 21 in the present volume) to Manila, Italian, and fine Belgian straw.

107 See figure 18, in which the prices listed of the three hats range from 17.5 to 33 francs.

108 Gabrielle d'Èze, "Modes," *Le Caprice*, April 1, 1882. Previously, d'Èze had remarked on the "wonders" of our florists, noting that "there are no flowers that they cannot copy with astonishing accuracy." (Nos fleuristes font chaque jour des merveilles. Il n'est point de fleurs qu'elles ne copient avec une exactitude surprenante.) *Le Caprice*, March 16, 1879.

109 *Annuaire-almanach du commerce* (Paris: Didot-Bottin, 1882), 1189–1194.

110 As such they can be considered a continuation of Degas's earlier interest in still life, as in *A Woman Seated beside a Vase of Flowers* (1865; Metropolitan Museum of Art, New York, 29.100.128).

111 "The 'Impressionists,'" *The Standard* (London), July 13, 1882, 3.

112 For a recent, ambitious examination of the cotton trade, see Sven Beckert, *Empire of Cotton: A Global History* (New York: Alfred A. Knopf, 2014).

113 Sarah Abrevaya Stein, *Plumes: Ostrich Feathers, Jews, and a Lost World of Global Commerce* (New Haven, CT: Yale University Press, 2008).

114 Plumes came to France from Syria, Tripoli (part of the Ottoman Empire), Algeria, Morocco, Egypt and the Upper Nile, the colonies of the Cape and Natal, Arabia, and Senegal. See "Fleurs et Plumes," in Coffignon, *Les Coulisses de la mode*, 68.

115 Edmond Lefèvre, in his account of the use of feathers in the millinery trade, noted that "few industries have gained ground as rapidly as that of feathers for headwear" (peu d'industries ont progressé aussi rapidement que celle de la plume pour parures) and affirmed that the annual turnover of the trade had increased from 5.5 million francs in 1865 to 39 million francs by 1888. Lefèvre, *Le Commerce et l'industrie de la plume pour parure* (Paris: Chez l'auteur, 1914).

116 *Annuaire-almanach du commerce*, 1882, 1605–1606.

117 "Des chapeaux de grande toilette qui ne sont qu'un fouillis de plumes d'autruche, aux brins larges et ondulés, posés en spirale sur une forme de tulle." D'Èze, "Modes."

118 "Chapeau Bourrelet, en velours houblon, complètement tendu. Brides en ruban de moiré rose et bouquet de plumes roses avec aigrette." *La Modiste universelle*, January 1882, no. 255.

119 *Au Bon Marché: Hiver 1895–1896* (Paris, 1895).

120 Prices ranged from three to twenty-three francs. *Au Bon Marché: Catalogue de la saison d'été* (Paris, 1882).

121 *Le Moniteur de la mode* carried the story of the naturalist Léon Laglaize bringing these birds back from New Guinea. The reviewer noted: "Everyone knows their beautiful plumes that adorn the hats of our elegant women but no one has yet seen them alive in France" (Tout le monde connaît leurs belles plumes qui parent les chapeaux de nos élégantes, mais personne encore ne les a vus vivants en France). *Le Moniteur de la mode*, November 1, 1877.

122 "They call me the painter of dancers; they don't understand that for me the dancer has been a pretext for painting pretty fabrics and rendering movement." (On m'appelle le peintre des danseuses, on ne comprend pas que la danseuse a été pour moi un prétexte à peindre de jolies étoffes et à rendre des mouvements.) Ambroise Vollard, *Degas (1834–1917)* (Paris: Crès, 1924), 109–110.

123 In his sonnet "Danseuse," Degas compared the act of embroidering with a needle—the intricate dance made by the fingers of a

milliner—to the dance made by the legs of a ballerina. He wrote, "Her satin feet embroider, like a needle, drawings of pleasure" (Ses pieds de satin brodent, comme l'aiguille, des dessins de plaisir). See Degas, *Huit sonnets* (Paris: La Jeune parque, 1946), 32. Gauguin also saw a comparison between Degas's dancers and his treatment of hats: "The dancers of Degas are not women, they are machines in motion with graceful lines that are extraordinary in their balance. Arranged like a hat from rue de la Paix with all that artifice, so pretty" (Les danseuses de Degas ne sont pas des femmes, ce sont des machines en mouvement avec de gracieuses lignes prodigieuses d'équilibre. Arrangées comme un chapeau de la rue de la Paix, avec tout ce factice, si joli). See Gauguin, "Paul Gauguin," 121.

124 See Iskin, *Modern Women and Parisian Consumer Culture*, 100.

125 "Des échantillons d'étoffes et de passementeries." See "Souvenirs de Berthe Morisot sur Degas," in Valéry, *Degas, danse, dessin*, 147.

126 See "La Vie en France: Les Prix en 1891," Bibliothèque nationale de France, Paris (Rec-80-Boite Pet Fol). Degas's imagery was certainly viewed at the time as showing objects on display for sale. When *At the Milliner's* was exhibited in London in 1883, it was described as "hats and feathers in a shop window." See *Western Daily Press*, July 16, 1883.

127 *Exhibition Paris 1900*, 108. See also Alexandre, *Les Reines de l'aiguille*, 158.

128 "A hat, at a distinguished house, is never less than one hundred francs or so, and, sometimes when it is made of expensive furs, precious lace, and embroidery, it can rise easily to six or seven hundred francs. . . . The highest price that has been reached in one of these houses is seven thousand, which is a pretty sum. . . . But, in fact, the average, normal price is between one hundred and one hundred and fifty francs." (Un chapeau, dans une maison de marque, ne vaut jamais moins d'une centaine de francs, et parfois lorsqu'il est constitué de fourrures de prix, de dentelles précieuses, de broderies, il peut monter sans peine jusqu'à six ou sept cents francs. . . . Le prix le plus élevé qui ait été atteint dans une de ces maisons est sept mille, qui est aimable. . . . Mais, enfin, le prix moyen, normal, est entre cent et cinq cents francs.) Alexandre, *Les Reines de l'aiguille*, 158. One unnamed society woman was said to have trimmed her hat with a diamond necklace worth 200,000 francs (ibid.).

129 The department store Au Petit Saint Thomas, for example, showed hats ranging from 10 to 29 francs in 1890. See *La Vie parisienne*, November 1, 1890. Iskin included an advertisement with the prices of hats at another department store, Au Tapis Rouge, ranging from 3.95 to 17 francs. Iskin, *Modern Women and Parisian Consumer Culture*, 103.

130 Degas sold 16,450 francs of work to Durand-Ruel in 1882. For a valuable overview of Degas's sales to Durand-Ruel as well as to Vollard from 1881 to 1913, see Gary Tinterow, with research by Asher E. Miller, "Vollard and Degas," in Rebecca E. Rabinow, ed., *Cézanne to Picasso: Ambroise Vollard, Patron of the Avant-Garde*, exh. cat. (New Haven, CT: Yale University Press; and New York: Metropolitan Museum of Art, 2006), 161.

131 The yellow-plumed hat held in the girl's right hand in *At the Milliner's* (cat. no. 16) also appears, held by the salesgirl, in *At the Milliner's* (fig. 61).

132 Within the context of this reading, it is perhaps not coincidental that Degas showed these two millinery pastels together at the 1886 Impressionist exhibition. We do not know if they were hung together.

133 See Richard Kendall, *Degas: Beyond Impressionism* (London: National Gallery; and Chicago: Art Institute of Chicago, 1996), 126; and Carol Armstrong, "Against the Grain: J. K. Huysmans and the 1886 Series of Nudes," in *Odd Man Out: Readings of the Work and Reputation of Edgar Degas* (Chicago: University of Chicago Press, 1991), 157–209. See also the analysis of Degas's treatment of smoke, a form that at times has the schematic appearance of an ostrich plume. Samantha Friedman, "On Smoke," in Jodi Hauptman, ed., *Degas: A Strange New Beauty*, exh. cat. (New York: Museum of Modern Art, 2016), 101–103.

134 See Vollard, *Degas* (1937), 320.

135 Iskin, *Modern Women and Parisian Consumer Culture*, 105–113.

136 "Un tableau est une combinaison originale de lignes et de tous qui font valoir." Jeanniot, "Souvenirs sur Degas," 281.

137 "Un certain mystère, du vague, de la fantaisie." Ibid.

138 Degas's recorded sales to Durand-Ruel increased greatly in the 1890s. His sales by year ran as follows: 1892, 22,200; 1893, 29,200; 1894, 11,200; 1895, 14,380; 1896, 43,000; 1897, 19,000; 1898, 34,000; and 1899, 28,000 francs. These were substantial sums. See Tinterow, "Vollard and Degas," 161.

139 In Glasgow, an anonymous reviewer noted that "the lady trying on a hat in front of a cheval mirror is not a grande dame incapable of raising her hands to her head but an energetic woman who relies on her own 'fixing' and her own judgment." *Glasgow Herald*, February 20, 1892, 4.

140 Joris-Karl Huysmans, "L'Exposition des indépendants en 1880," *L'Art moderne* (1883), reproduced in Berson, *The New Painting*, 292.

141 See Françoise Cachin, "Degas and Gauguin," in Dumas, *The Private Collection of Edgar Degas*, 221–234.

142 See the anonymous 1893 photographic portrait (private collection) of Gauguin in profile wearing a wide-brimmed hat before his painting *The Brooding Woman (Te Faaturuma)* (1891; Worcester Art Museum), a work that was acquired by Degas.

143 Sickert remembered Degas's aim of intensifying the effect of this relatively muted tone: Degas "said that the art of painting was so to surround a patch of, say, Venetian red, that it appeared to be a patch of vermilion." Sickert, "Degas," 185. See also Kendall, *Degas: Beyond Impressionism*, 117.

144 "Degas dit, 'l'orange colore, le vert neutralise.'" Valéry, *Degas, danse, dessin*, 147.

145 See *Eugène Delacroix: Journal*, 4 vols., ed. Paul Flat and René Piot (Paris: Plon, 1893–1895). Degas also made oil copies of eleven works by Delacroix, including one of *Convulsionists of Tangier* (1837–1838) around 1896–1897. See Theodore Reff, "'Three Great Draftsmen': Ingres, Delacroix, Daumier," in Dumas, *The Private Collection of Edgar Degas*, 137–176.

146 Boggs suggests the importance of photography for Degas's late paintings (Boggs, *Degas*, 483). See also Elizabeth C. Childs, "Habits of the Eye: Degas, Photography, and Modes of Vision," in Dorothy Kosinski,

ed., *The Artist and the Camera: Degas to Picasso*, exh. cat. (Dallas: Dallas Museum of Art, 1999), 70–87.

147 As Malcolm Daniel notes, these three glass plates were "commercially available gelatin dry plates; their startling color probably resulted from chemical intensification to compensate for underexposure or weak development or from chemical reduction to compensate for overexposure." See Daniel, *Edgar Degas, Photographer*, 137 and 44–46. The other two negatives are *Dancer (Adjusting Her Shoulder Straps)* and *Dancer (Adjusting Both Shoulder Straps)*. All are studies for *Behind the Scenes (Dancers in Blue)* (ca. 1899; Pushkin Museum of Art, Moscow) and *The Dancers* (ca. 1899; Toledo Museum of Art).

148 "Des orgies de couleurs que je fais en ce moment." See entry for July 1, 1899, in Julie Manet, *Journal (1893–1899): Sa jeunesse parmi les peintres impressionnistes et les hommes de letters* (Paris: Librairie C. Klincksieck, 1979), 238.

149 Feathers were dyed with a range of synthetic dyes, often newly discovered or invented, whether aniline, alizarin, or azo. Indigo, for example, was synthesized in 1887.

150 Degas arguably found in millinery a subject that mirrored the simultaneously parochial and cosmopolitan nature of his personality, a personality that frequented the same haunts in Paris over decades but was also fascinated by global culture, whether America of the 1870s or Russia of the 1890s.

151 It has been suggested that the woman depicted here is Coco Chanel, but it is doubtful that Chanel was sufficiently known in America at this time. Thanks to Nancy Mowll Mathews for pointing out this image to me.

152 *The Milliners* (cat. no. 90) sold for only 8,100 francs, and *At the Milliner's* and *The Milliners* (cat. nos. 89 and 88) fetched similar amounts. In comparison, the dancer works, especially the earlier paintings, sold for more than 150,000 francs. The millinery paintings were bought at the sale by a consortium of four dealers: Durand-Ruel, Vollard, Seligmann, and the Bernheim-Jeune brothers.

153 Carol Armstrong, "Degas in the Studio: Embodying Medium, Materializing the Body," in Martin Schwander, ed., *Edgar Degas: The Late Work*, exh. cat. (Basel: Fondation Beyeler; and Ostfildern: Hatje Cantz Verlag, 2012), 31. For more of her nuanced discussion of Degas's attitude toward women, see pages 31–32n5.

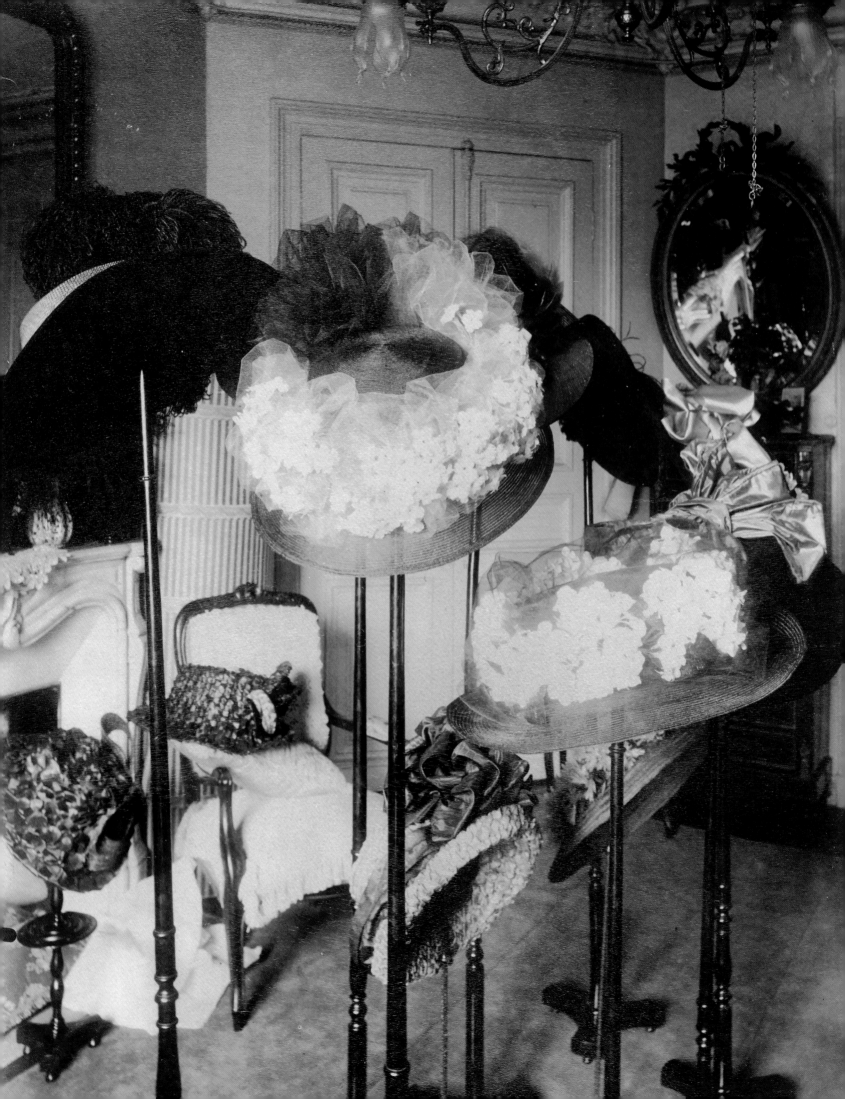

THE
MILLINERS
OF
PARIS,
1870–1910

FRANÇOISE TÉTART-VITTU

ILLINERY WAS THE quintessentially female profession in nineteenth-century France. The trade emerged from the eighteenth-century guilds of Parisian *marchandes de modes*—women retail merchants of fashionable accessories for upper-class women—the most celebrated of whom was Queen Marie Antoinette's *modiste*, Marie-Jeanne Bertin (better known as Rose Bertin[1]), whose clientele extended from London to Saint Petersburg. Already in her day the trade could encompass establishments selling not only headdresses of lace, feathers, ribbons, and artificial flowers but also, after 1770, hats in the new English style and numerous accessories such as mantelets, bags, and even dresses, which dressmakers who had agreements with the *marchandes de modes* would bring in to be embellished according to the latter's recognized taste. After the National Assembly abolished trade guilds in March 1791, the fashion trades diversified, and by the beginning of the nineteenth century any shop could expand its offerings. Fabric and women's apparel could be sold by all.

In a few cases *modistes* were men, as seen in the rise of Louis-Hippolyte Leroy. Starting out as a hairdresser, he went on to sell women's hats and subsequently opened a major fashion house at 82, rue de Richelieu,[2] furnishing the imperial court from 1804 to 1815 with court attire, embroidery, lace, dresses, and accessories. Nonetheless, the

fashion trades were still largely the prerogative of women, who excelled at crafting dresses, lingerie, embroidery, and of course, hats and headdresses. Men were more likely to pursue trades that required a knowledge of fabric quality or accounting in order to manage *magasins de nouveautés* (dry goods stores), or even to apprentice as cloth cutters if they wished to become tailors.

After 1840, with the global evolution of commercial practices spread by newspapers and the development of advertising and manufacturing, the situation changed: women were still dressmakers and milliners, but men competed in every aspect of the fashion trade. Some dealt in women's hats while others purveyed fashions at commercial establishments that gathered all the elements of women's apparel in stores of various sizes, from the small "specialty houses" that sold ready-to-wear clothing to the first fashion houses (such as Pingat, Hudson et Cie, on rue Louis-le-Grand; Worth et Bobergh, founded by fashion designer Charles Frederick Worth in 1858 with his associate Otto Gustaf Bobergh, at 7, rue de la Paix; and Kerteux Soeurs, on rue Taitbout) and, by the 1860s, the even larger department stores (such as Au Bon Marché and Les Grands Magasins du Louvre). Finally, after 1880, the term "haute couture" came into use, and along with it *messieurs les couturiers*—since the directors of these high-fashion houses were often men, even though women fashion designers existed as well (such

as Madame Roger, on rue Louis-le-Grand, and Madame Maugas, on rue Neuve-des-Petits-Champs at the corner of rue de la Paix).

More a complement than a competitor to the fashion house, the milliner retained a separate niche in this division of male and female professions. Indeed, statistics on the two professional spheres—dry goods stores on the one hand, and millineries on the other—show that the division was inversely proportional. In 1860 women represented 89 percent of the milliners and 95 percent of the dressmakers in Paris but only 31 percent of those dealing in ready-to-wear fashions. Millinery was the most coveted trade among mid-nineteenth-century Parisian women workers, since it enabled those with sufficient creative taste to break free of the workshop and attract their own clientele.

Milliners could be found everywhere in France, from the smallest towns and villages to big cities. However, the undisputed millinery capital was Paris, which in 1870 counted 946 milliners (125 men and 821 women). Parisian women milliners enjoyed the same renown as women designers. Both professions were present at the city's center: on the boulevard des Capucines; boulevard des Italiens; the neighborhood of the new Opéra, inaugurated in 1875; place Vendôme; rue de la Paix; rue de Castiglione; rue Saint-Honoré; and rue du Faubourg-Saint-Honoré.[3] In these areas an elegant clientele and visiting foreigners could come view their creations. Some milliners paid exorbitantly for ground-floor boutiques with display windows, thus directly competing with the women's fashion stores, but more often their shops were upstairs, like those of designers. They chose the mezzanine or the second floor, even though trade licenses were more expensive for boutiques at street level or on the second or third stories; however, making clients climb too many stairs would have been bad for business. Their shop names might be painted on signs affixed to the walls or the balconies of the building (see fig. 27), but publicity came from numerous sources: the press, both general and specialized publications; travel guides, such as Baedeker and Guides Joanne; and world's fairs (Paris in 1878, 1889, and 1900; Vienna in 1873; Chicago in 1893; and so on).

Their renown spread abroad with no need for them to travel, as they had done in the early nineteenth century, setting up showrooms for temporary displays in London or Calais. In an effort to authenticate their exceptional hats, milliners were the first, before designers, to put labels

Gorce phot.-édit., Talence (Gironde)
LEONY-TAFARÉ, Robes, 15, Rue de la Paix, PARIS

27 Postcard of design house Leony-Tafaré, showing the millinery Alphonsine Modes below, 15, rue de la Paix, Paris, ca. 1909. Postcard ed. Garce & Allard, Paris. Collection Diktats.com

28 Label inside a Madame Bonni hat, ca. 1890. Fine Arts Museums of San Francisco, Museum Collection, X1989.150

inside their pieces; *chapeliers* (makers of men's hats) would glue a circular printed sheet inside, while milliners would have their signature stamped in gold, as did Lucy Hocquet[4] beginning in the 1840s or the houses of Alexandre et Beaudrant and Madame Bonni around 1858 (see fig. 28).[5]

By the second half of the nineteenth century, the increasingly diversified fashion magazines had already long included mention of milliners' names alongside those of dressmakers or designers and fabric stores in their editorial pieces, often through illustrations showing the front and back of a hat or in explanations on color plates (see fig. 29). The plates apparently appeared as a form of advertising, since the store review column of each publication would mention only certain milliners and dressmakers—those that had accounts with the journal, which could send its illustrators to their shops: *La Mode illustrée* showcased Madame Aubert and *Le Bon ton* La Maison Laure, for example. Some magazines specialized in hat news or the creation of hats, such as *Le Journal des marchandes de modes: Revue spéciale des chapeaux, bonnets, coiffures et lingerie élégante* (1866–1884); *La Fantaisie* (1880–1889); *La Modiste universelle* (1876–1897), which published hat models with descriptions in French, English, Italian, Spanish, and German; *La Modiste française* (1885–1914); and *La Modiste parisienne* (1888–1913).[6]

These magazines were the work of industry illustrators such as Léon Sault (director of *La Fantaisie* and *La Figurine*), who created ideas for fashions that they sold to design houses and milliners as inspirations to propose to their clients.[7] At the same time all the luxury department stores in Paris—Les Grands Magasins du Louvre, Printemps, Au Bon Marché—offered hats at attractive prices that they announced in their illustrated catalogues, published in thousands of copies and distributed in hotels, passenger ships, and other places where they might reach potential clients. Finally, in the twentieth century the magazine *Les Modes* (1901–1937) featured photographs by Léopold-Émile Reutlinger, Paul Nadar (see fig. 30), and Henri Manuel of the great milliners' creations worn by models or actresses.[8]

A Parisian milliner's fame was hard won. As with any commercial enterprise, it was the result of great tenacity and industry, along with sure artistic talent as well as favorable circumstances and fortuitous meetings. Indeed, the female fashion worker was most often a very young, impoverished woman who had come to Paris to find employment in the workshop of a dressmaker or milliner. She would start out as a simple errand girl (*trottin*), carrying in her arms the often-large round box that held her employer's creation, which she would deliver to the client in the city. Next she would become a "preparer" (*ouvrière apprêteuse*), learning to garnish the brass or straw frames to create forms that would be covered with a variety of fabrics, from heavy silks, velvet, faille, and satin to lighter materials such as muslin, gauze, and lace. Under the supervision of a *seconde*—a coworker who had completed her apprenticeship—she would then learn to sew the straw and work with the different fabrics on the frame. Finally, if she proved to have taste and had observed the creations of the *première d'atelier*—the most seasoned and skilled worker, often second to the shop owner—she would be admitted to the salon, where clients tried on hats, so that she could take note of the *première*'s or shop owner's nuanced approach in creating the headdress most suitable to each client's needs. In the most exclusive establishments there would be two *premières*, one for hats and one for headdresses to be worn at balls or to complement formal outfits. These *premières* were under the direct supervision of the shop owner, who had established the company in her name (or in that of her associates as well), with her own funds or

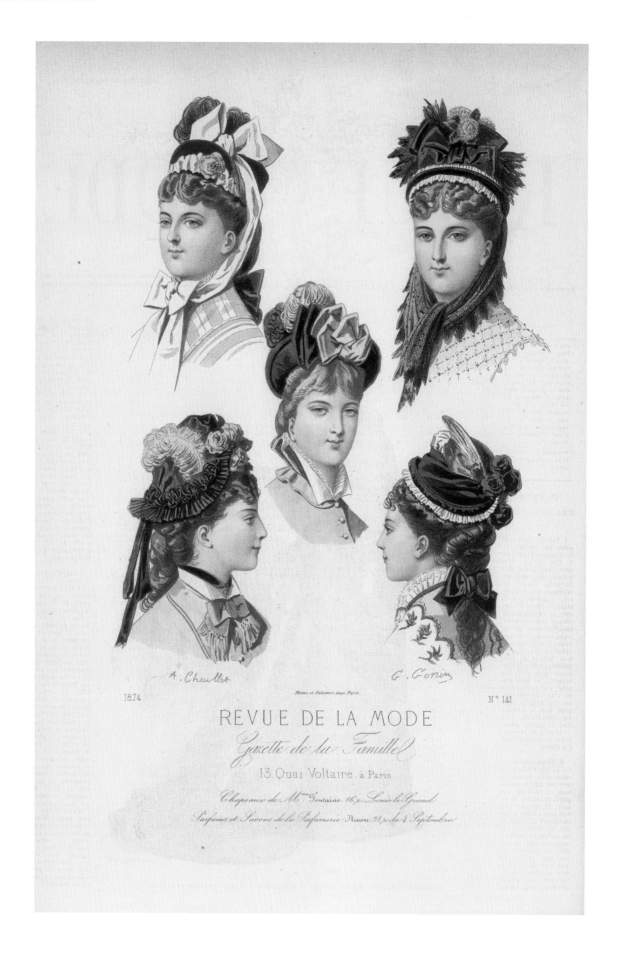

A. Chaillot

G. Gonin

1874

Moine et Falconer, imp. Paris

N° 141

REVUE DE LA MODE

Gazette de la Famille

13 Quai Voltaire, à Paris

Chapeaux de Mme Fontaine. 16 r. Louis-le-Grand

Parfums et Savons de la Parfumerie Ninon. 31 r. du 4 Septembre

29 A. Chaillot and G. Gonin, *The Hats of Madame Fontaine, 16, rue Louis-le-Grand*, from *Revue de la mode*, no. 141 (1874). Steel engraving. Bibliothèque nationale de France, Paris

30 Paul Nadar, Jane Henry in a hat by Maison Virot, 1900. Photograph. Médiathèque de l'architecture et du patrimoine, Charenton-le-Pont, France, fonds Nadar

with those of sponsors, known or anonymous (via private agreement).

The recognized taste of the milliner who owned the shop was key to its success, but she first had to establish a name and be able to pay a rent that was often quite high. For a boutique, including rooms at the mezzanine level, on a street such as boulevard des Capucines, the annual rent could be as much as 12,000 to 14,700 francs (the average milliner made about 400 francs a year); such was the case for Virginie Goldberg and Mesdemoiselles Camus et André in the late 1860s.[9] For a seven-room shop at mezzanine level, accessible from the courtyard but facing the street, the shop owners neighboring Worth (who occupied the second floor of 7, rue de la Paix)—Louise and Marie Hofele, official purveyors to Empress Eugénie—paid 9,000 francs in 1866.

Clearly, then, novice milliners, lacking substantial resources, were obliged to set up shop on the upper floors, along with simple workwomen. Nonetheless, some of these novices boldly forged ahead, encouraged by their first clients. Among these strong-minded entrepreneurs were Caroline Reboux on rue Louis-le-Grand, around 1860, whose designs were chosen by Princess Pauline von Metternich and Countess Mélanie de Pourtalès (trendsetters of the Second Empire); and Jeanne Lanvin on rue du Marché-Saint-Honoré, in 1885. Such monetary restrictions explain the frequent family partnerships, such as those among several sisters or a mother and her daughters who, even as minors, apprenticed in a trade that held great promise. Quite often women from the same workshop would likewise form partnerships, naming the source of their professional training to guarantee the quality of their creations: Madame Dusautoy, on rue de Caumartin, was advertised as a student of Madame Beaudrant, and Madame Abel-Homasmard, on rue Louis-le-Grand, an apprentice of the famous Mesdames Ode on rue de la Paix.[10]

Some milliners would move into the former boutique of a renowned milliner. Such was the case with Madame Bonni, who from 1860 to 1890 occupied 3, rue du Faubourg-Saint-Honoré, which had previously housed the millinery of Madame Drouart, purveyor to Queen Maria Amalia before 1848. Often milliners chose a first name (not necessarily their own) by which they were known; Alexandrine, Caroline, Hortense, Laure: these were merely trade names, since we also find names such as "Marguerite sisters" or "Clémence and sisters." Sometimes the last name implied connections that were fictional, but in other cases milliners were indeed married to fashion merchants or hairdressers, which often led to a diversified development of their businesses.

The fashion house A. Félix is a good example: the brothers Auguste and Émile Poussineau, assistants to Empress Eugénie's hairdresser Félix Escalier, founded the house at 15, rue du Faubourg-Saint-Honoré; Émile, who took the name Félix for the shop and himself, served as director until its sale in 1912. This great design house—known for creations such as the famous black velvet dress with diamond straps worn by Madame Pierre Gautreau in the portrait by John Singer Sargent that caused a scandal at the 1884 Salon—included a hat department directed by Madame Félix Poussineau, where in 1880 Lanvin started out

by trimming hats, after having apprenticed under Madame Bonni on the same street. The perfumer Guillaume-Louis Lenthéric also worked for Félix before opening his perfumery at 245, rue Saint-Honoré, where his wife Eugénie presented a successful line of hats that would be worn by actresses and models in posed photographs for newspapers of the 1900s. In October 1912 the firm was taken over by Velsch et Holtz, which brought together perfumes, hairdressing, and hats.

Out of concern for their success, and in the interest of establishing a good reputation among their bourgeois and aristocratic clients, milliners most often used last names with "Madame" as their business names to confer a certain authority, even if they were not married. Sometimes they had patrons who were not officially recognized. For example, Rosine Augustine Fourmentin, a milliner at 164, rue de Rivoli,[11] was the devoted girlfriend of Jean Julien Sacaley, second-in-command to Jean-François Mocquard, Napoléon III's private secretary. Jeanne Lanvin married Count Emilio di Pietro in 1896 but divorced him in 1903; her brothers and sisters were the ones who helped her launch her hat and children's clothing store in 1908–1909. In the case of Gabrielle "Coco" Chanel, boyfriend Arthur Capel funded her first boutique, Chanel Modes, on 21, rue Cambon in 1910.

Hats were the most visible sign of up-to-the-minute fashion. They could be made with imagination and originality, using little material but a wealth of ingredients: various fabrics, feathers, straw, lace, artificial flowers, ribbons, fur. The price for this theoretically unique and personalized work reflected the style and not necessarily the raw material, as Worth had determined in clothing design: he charged for his "personal touch" in addition to the luxurious fabrics. In her practice, the milliner proceeded in much the same way as the fashion designer. Even if she offered her clientele a line of finished hats that constituted the season's collection, presented twice a year (summer and winter), each one was made unique with original touches.

One of the qualities of a great shop owner or *première* was to anticipate what a hesitant client would choose in response to the milliner's suggestions. This activity required a suitable setting: millineries, like design houses, had salons furnished with chairs, banquettes, and, above all, numerous mirrors (see fig. 5). Arranged at eye level on chests and tables were the new hats, set at their best angles on stands

of varying heights called *champignons* (mushrooms), made of turned rosewood or lacquered wood (see fig. 16). In these calm and elegant salons a client could try on the hats and see how they looked. Arsène Alexandre, an art critic for *Le Figaro*, noted that the milliner's shop was quite different from the design house. Indeed, with fewer employees, a greater sense of harmony reigned because the roles were less rigidly defined: the saleswomen often also modeled for the clients, and the women in the workshop (called *le travail*), separated from the salon by a simple glazed door (see fig. 5), could potentially be admitted and circulate among the clientele.[12] Two Degas works held by the Metropolitan Museum of Art perfectly capture the ambience of the salons: *At the Milliner's* (1881; fig. 45), in which two women converse on a sofa facing away from the viewer; and *At the Milliner's* (1882; fig. 61), which portrays Mary Cassatt trying on a hat in front of a mirror.

This environment—at once familiar and artistic— during the years 1875–1890 attracted many painters, who portrayed these young and elegant Parisian *modistes* as an expression of the reality of modern life that so fascinated them. These young artists loved the fashion world, appreciating the harmony of dresses and the play of light on fabrics. Among their subjects were close family members or women friends, some of whom were supported by rich protectors such as Dr. Thomas W. Evans, the emperor's American dentist, whose mistress Méry Laurent frequented the shops of renowned creators for her dresses and hats.[13] Milliners and dressmakers often lived with painters and served as their models; Camille Doncieux, for example, was a dressmaker when she met Claude Monet.[14] The Belgian artist Félicien Rops lived with the sisters Aurélie and Léontine Duluc and drew for them dress as well as matching hat designs.[15]

The 1860 Didot-Bottin directory lists a milliner named Madame Norbert-Goeneutte at 10, rue Ménars—a name that curiously resembles that of the painter and engraver Norbert Goeneutte, born on rue Louis-le-Grand, a street in the same quarter. A friend of Edgar Degas, Pierre-Auguste Renoir, and the graphic artist Henri Guérard, Norbert Goeneutte frequently portrayed his three sisters or his wife sewing at home or wearing elegant hats (see fig. 31). One of his drypoints, titled *The Milliner* (ca. 1877; fig. 32), shows a milliner trimming a hat beside the usual base for such work, a cardboard *marotte* (head form). Goeneutte is an interesting figure because he was at the center of a

31 Norbert Goeneutte, *Portrait of Anna Goeneutte*, ca. 1880. Pastel, 21 x 17 ½ in. (53.5 x 44.5 cm). Private collection

32 Goeneutte, *The Milliner*, ca. 1877. Etching with drypoint and aquatint, 7 ⅛ x 5 ½ in. (18 x 13.9 cm). Musée Carnavalet, Paris, inv. G 14315

group of artists inspired by Édouard Manet and Renoir that met at Auvers-sur-Oise. His paintings featuring women wearing hats were made between 1880 and 1884, a period during which milliners were among the most popular subjects in that circle of friends, as this exhibition beautifully demonstrates.

Indeed Degas's impressive scenes of women trying on hats, a veritable anthology drawn in pastel, find their echo in Goeneutte's portraits and engravings as well as in *The Milliner* (ca. 1877; fig. 33) by Eva Gonzalès. Gonzalès once painted her sister at the theater in a blue silk evening gown trimmed with lace and portrayed herself before a mirror in a summer dress with red polka dots.[16] She even painted pairs of dance shoes in white or pink satin. In her painting *The Milliner*, the figure sits at her work table and chooses artificial flowers from a box. On the corner of the small table with drawers, we see a toque made of feathers and two hats on *champignons*, one of black fabric and the other of straw trimmed with red flowers.

The hats depicted in the pastel series by Degas and works of his disciples, friends, or competitors were in fashion during a brief period, between 1880 and 1883. There are three types shown: the capote (or hood bonnet), which fit closely around the face, with a ribbon knotted at the chin; the high-crowned hat, slightly masculine in style; and the soft hat in straw or cloth that was very fashionable in 1883. Comparison with historical hats conserved in museums confirms the veracity of the painted versions. The small bonnets arranged next to Cassatt as she tries one on in a circa 1882 pastel by Degas (fig. 11) are similar to two examples by Madame Mantel (37, rue des Capucines) in the Metropolitan Museum of Art's collection, a bonnet (ca. 1880) and a high-crowned black hat (ca. 1885).[17]

The best example showing the styles in fashion is Degas's *At the Milliner's* (1882; fig. 16), with its meticulously reproduced assortment of straw and cloth hats arranged on a table. Painters, like the first photographers, purchased furniture to stage dressing rooms as the settings for their compositions; if their milliner or dressmaker friends did not receive them in their boutiques, they had to buy hats and dresses as well. Jeanne Baudot, a student of Renoir's in 1893, later recalled accompanying him to the shop of the milliner Esther Meyer at 6, rue Royale, whom she knew from buying hats.[18] Degas even showed the supplies and the process of adorning these hats: in *At the Milliner's*

(ca. 1905–1910; cat. no. 91), a milliner holding a fashionably large, flat hat looks for the best spot for the blue ostrich feather that a workwoman hands to her; another milliner, in *The Milliner* (ca. 1882; Metropolitan Museum of Art, New York), rests her head on a table so that she can see from below the effect of a fold on a round hat set on a wooden stand, beside the cardboard *marotte* that served as a base to create it.

The artists evoked the stages of the milliner's work as well: Would the fabric about to be ruffled to decorate the body of a hat be the yellow, orange, or green pieces shown on the table (Degas, *The Milliners* [ca. 1882–before 1905; cat. no. 88])? And which ribbon would Paul Signac's milliners choose to trim the tall, tapered felt hats in *The Milliners* (1885–1886; fig. 7), a painting exhibited at the Salon of 1886? The shop owner picks up a pair of scissors that has fallen on the floor, beside rolls of paper on which the wide ribbons used by the milliners were wound and an oval hatbox with its label affixed to the lid. On the table, in front of the workwoman dressed in a black uniform, sit rolls of new ribbon still tightly wrapped around their spools.

The period from 1890 to 1900 witnessed the development of an incredible variety of types of hats. At first they were quite small but covered with flowers, pearls, feathers, birds, fur, and lace. They became increasingly larger, very much inspired by the immense hats from the days of Louis XVI (see Esther Bell's discussion, pp. 85–91); that era's interior design was adored at this time, and its fashions were also copied for formal dresses and evening wear. This historicist style, spurred by designers such as Charles Frederick Worth and his son Jean-Philippe, was spread at the theater and the many costume balls enjoyed by high society. Milliners' reference documents show the direct inspiration of late eighteenth-century engravings through copies made in libraries and pasted into albums. Some of these documents have been preserved; the Musée Galliera in Paris houses such albums from Esther Meyer's millinery.

33 Eva Gonzalès, *The Milliner*, ca. 1877. Pastel and watercolor on canvas, 17 ¾ x 14 ⅝ in. (45 x 37 cm). The Art Institute of Chicago, Olivia Shaler Swan Memorial Collection, 1972.362

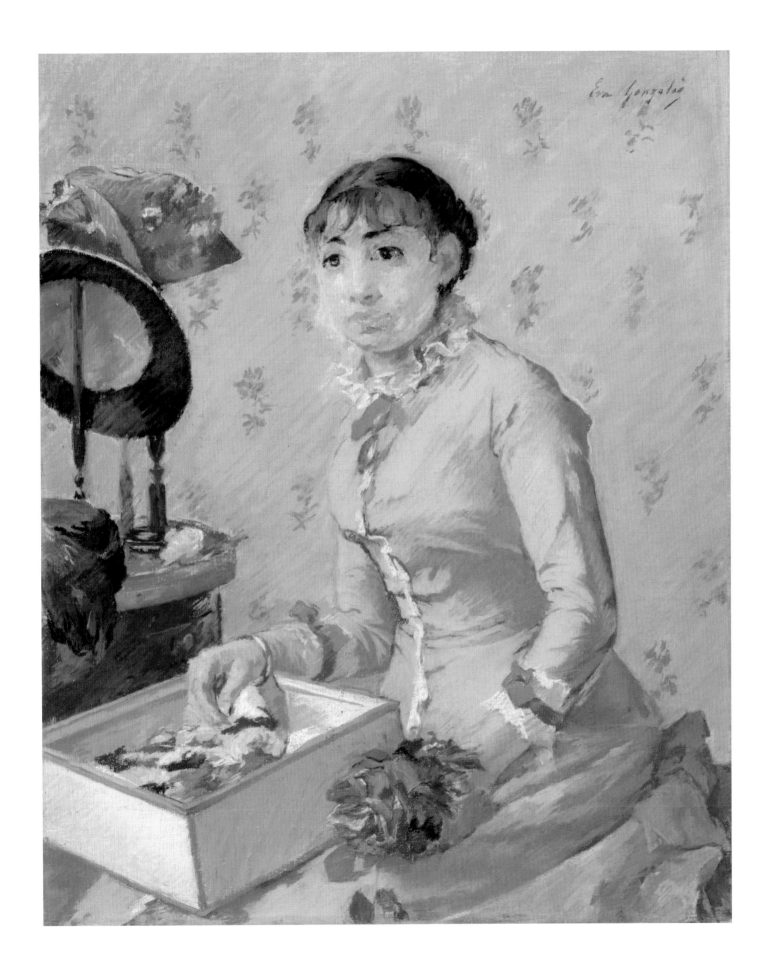

The taste for large hats with wide brims covered in artificial flowers (a specialty of the Parisian trade for more than a century; see fig. 34) lasted from 1900 to 1906, soon followed by that for *charlottes*—large bonnets of lace and fine fabric inspired by the eighteenth-century Queen Charlotte—and for all kinds of birds and feathers, which incited concern for avian conservation. Already in 1889 the English Society for the Protection of Birds and in 1896 the American Audubon Society opposed the practice of decorating hats with whole small birds—as in a feather toque adorned with three parakeets (1890; fig. 35)—as well as with the feathers of herons, egrets, and grebes, which were at risk of extinction. On the other hand, the great ostrich feathers that were highly prized on the large hats of 1910–1912, even by the understated Chanel (see fig. 36), posed no issue, because British ostrich farms had been established since 1865 in Cape Province, South Africa; intensive production of feathers had begun in 1880.

During this golden age of hats, Parisian milliners outdid themselves in terms of originality. The brims and crowns of these headdresses, the base for a wide array of decorative elements, reached such proportions that the elegant Countess Greffulhe launched the Ligue des petits chapeaux (League of small hats) in 1905 to promote headdresses that would not obscure the audience's view at the theater.[19] Between 1890 and 1910 Parisian milliners were still concentrated in the area of L'Opéra–La Madeleine–place Vendôme–rue de la Paix (after 1925 most of them would be found near rue du Faubourg-Saint-Honoré and avenue Matignon). Their shops neighbored those of great designers and fine jewelers. Take, for example, rue de la Paix, a street synonymous with Parisian fashion: Caroline Reboux's boutique (see fig. 37) was at number 23, between the *couturier* Doucet (at 21) and the jeweler Mellerio (at 25). Alphonsine was at number 15, on the mezzanine level above the perfumer Guerlain's boutique and below Leony-Tafaré's design house (see fig. 27). Madeleine Carlier had occupied number 16 since 1891; Camille Marchais, the favorite milliner of Anna Gould, Countess of Castellane, was at number 17; and the millinery Maison Lespiaut was at number 18 in 1895.[20] From 1887 to 1897 Maison Virot was at number 12, and later the millinery Madame Georgette opened at number 1.

34 Alphonsine hat, cover of *Les Modes*, October 1904. Bibliothèque nationale de France, Paris

35 Bonnet, 1890. Silk and feathers, 7 in. (17.8 cm) height. The Metropolitan Museum of Art, New York, Gift of Susan Dwight Bliss, 1937, 37.144.2

36 Actress Gabrielle Dorziat wearing one of Gabrielle Chanel's first hats, in *Les Modes*, May 1912. Bibliothèque nationale de France, Paris

Sometimes two businesses in the same building would form a sort of agreement: for example at number 7, mostly rented by Worth—who had his salons on the ground floor and his workshops on different stories facing the street or the courtyard—the empress's milliner Madame Hofele occupied the mezzanine. Her boutique was replaced around 1875 by that of Auguste Petit, the milliner who created Countess Greffulhe's remarkable hat of gold and silver lace mounted on a brass frame—a hat that matched the extraordinary dress of Byzantine inspiration created by Jean-Philippe Worth, all embroidered in silver, that she wore in 1904 for her daughter Elaine's wedding to the Duke of Gramont.[21]

Some of these millineries were long-standing institutions—such as that of Virot, purveyor to the courts of England and Russia. Milliners would sometimes mention in their advertisements the name of a previous owner; such was the case with Madame Petit-Roger at 5, rue de la Paix, who indicated in 1881 that her shop succeeded that of Claude Chevrillon, a famous milliner in the 1860s. Other times it was the name of the millinery that changed; for example, hats labeled "J. Suzanne" in 1875 give the address 14, rue Royale, which would be the shop of Suzanne Talbot by 1913.

At the end of the century the creations of Parisian milliners, much like those of fashion designers, were disseminated not only through drawings and photographs in French as well as foreign magazines, such as the American *Millinery Trade Review* (1876–1938), but also through versions produced by those who would purchase a style and make numerous replicas, legally or illegally, particularly for the US market. This procedure had existed for haute couture since the beginning of the nineteenth century; it spread to hats during the last years of that century. Catalogues for Montgomery Ward and Company and Sears, Roebuck and Company in Chicago, pioneers in mail-order sales, offered "genuine Paris-style" hats; the various styles were represented by engraved figures accompanied by reference numbers. For instance, in 1897 Sears, Roebuck released product number 23463, the "Bon Ton hat," which, the catalogue claimed, "will be seen much on the fashionable boulevards of our chief cities."[22]

For more than a century Parisian fashion houses had maintained agreements with certain importers—mostly those representing department stores in New York, Philadelphia, Chicago, and Washington, DC. But, as with haute couture clothing, there were on the one hand styles

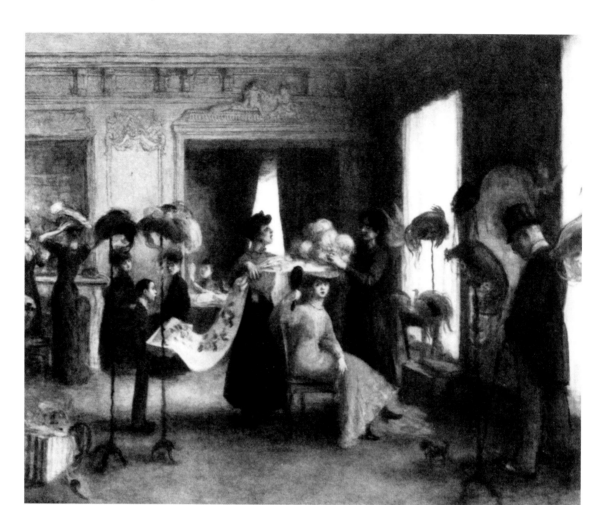

for reproduction, purchased with the intent of making copies, and on the other hats and dresses of French or English origin presented for sale in US department stores, their arrival announced in newspapers. The styles for reproduction enabled the spread of certain Parisian fashions, but retailers had to substitute their own labels for those of the French designers, sometimes being allowed to acknowledge that the item was a reproduction. Such was the case for several hats conserved at the Metropolitan Museum of Art: the labels of Mrs. M. J. Hunt of Washington and Madame J. M. Cary Pardee of New York bear the designation "importer."[23]

The more snobbish customers wanted to acquire only foreign-made hats and dresses, but since these were more expensive and less numerous, the temptation for sellers to create imitations to satisfy the demand was great. Some suppliers played with the wording on labels, with misleading mentions of Paris or rue de la Paix to lend their purely American creations a Parisian air. Thus, a hat conserved at the Metropolitan Museum of Art (and like an example in the present exhibition, cat. no. 49) bears the strange inscription "Louise / Regent Street / Rue de la Paix," associating the two prestigious streets of London and Paris on a spurious millinery label from about 1887 that is "authenticated" by the inclusion of the English royal motto "Honi soit qui mal y pense" as its central emblem (fig. 38). Though the practice was well established, it ended up inciting legal complaints and trials, as reflected in an article written by S. H. Adams for the *Ladies' Home Journal* of March 1913, which was illustrated with reproductions of the labels of Paris's most famous houses that were used to mislead buyers.[24] Thanks to the simple and ingenious method of having rolls of ribbon woven in local offices that reproduced, based on photographs, the most prestigious Parisian labels, and then selling these rolls of hundreds or even a thousand imitation labels to department stores and boutiques, retailers could cut individual labels to sew inside their hats. Without

37 Jean Veber, *Chez Caroline Reboux*, 1900. Oil on panel, 25 ½ x 32 in. (64.8 x 81.3 cm). Courtesy Christie's, New York

38 Label inside a Madame Louise bonnet, 1887. The Metropolitan Museum of Art, New York, Gift of Mrs. James G. Flockhart, 1968, C.I.68.53.17

undertaking a detailed analysis of the item, customers wishing to buy imported creations would be fooled by such merchandise.

This prosperous period saw millineries compete with fashion houses, which, like department stores, opened sections for hats, furs, accessories, and sometimes shoes as well. The haute couture houses of Redfern and Paquin both offered hats, and the newcomer Paul Poiret created turbans and novel types of headdresses, which were designed by Madeleine Panizon, in his interior design house Martine. Milliners likewise diversified; Reboux put her label on *collets* (capes made from 1890 to 1899 and worn over formal bodices).[25] By 1890 Lanvin headed a renowned millinery at 16, rue Boissy d'Anglas, which was managed by her brother Gabriel and her sister Madame Gaumont. After creating delightful dresses for her daughter Marie-Blanche, born in 1897, she opened a design house for children's fashion in 1908, expanding to include designs for girls and women

in 1909, at 22, rue du Faubourg-Saint-Honoré. Her models, wearing dresses and hats in a new, soft, and refined style similar to that of Poiret, were often photographed by Nadar for the magazine *Les Modes* in 1911–1913. As for Coco Chanel, her hats at 21, rue Cambon were in the feathered style of her model Lucienne Rabaté, an associate of Reboux, whose millinery she would assume in 1920. Chanel, interested in the new taste for sports and beachwear, opened a second boutique under her own name at Deauville and then a third, which offered clothing as well, at Biarritz in 1915. By 1918 her design house was primed for the success that it would know during the 1920s.

Having achieved international fame, the Parisian milliners of the beginning of the twentieth century represented the highest ranks of the fashion trade and embodied a true Parisian taste, disseminated by the most prominent women of the time. The finely crafted luxury publications of the 1910s—such as *Gazette du bon ton* and *Journal des dames et des modes*, with their *pochoirs* (fine stenciled illustrations) by André Marty, Charles Martin, or Robert Dammicourt (called "Dammy")—reflect this sumptuous standing. The great milliner Marcelle Demay, at 11, rue Royale, sought similar refinement in her 1912 catalogue titled *Nos étoiles* (Our stars), printed in 1911 by Draeger, with twenty-four stenciled plates by Charles Martin and photos of famous actresses in Demay hats accompanied by a sentence of praise for the milliner (see fig. 39).

By the end of the nineteenth century, all Parisian fashion houses had opened a hat department, complementing the departments for dresses and coats, accessories, furs, and, by the 1920s, sport and leisure clothes. At the beginning of the twentieth century milliners succeeded in raising their profession to the same stature as that of the great couturiers. High-fashion hats became inseparable from high-fashion dresses. Houses such as Félix and Lanvin came to be celebrated as much for their hats as for their dresses. The hat was even featured in advertising, as demonstrated by the fashion house Morin-Blossier on rue Daunou (purveyor to Queen Alexandra of England and her sister Maria Feodorovna, the czarina), which launched a new piece called "Triumph of the Exposition"—a black straw hat covered in artificial roses—for the 1889 Exposition Universelle in Paris. The years 1908 to 1914—the era of a new fashion by Paul Poiret, modern in line and silhouette (though inspired by a retro taste for the period

39 Marcelle Demay hat worn
by dancer Cléo de Mérode, 1912.
Photograph. Bibliothèque nationale de
France, Paris

1800–1810)—were also significant for the widening range of choices offered to clients from all countries and all classes. All the fashion magazines and department store catalogues placed great importance on the presentation of new hats and the creations of renowned milliners such as Camille Roger, Georgette, Alphonsine, and above all Caroline Reboux, celebrated for half a century, whose millinery (directed after her death by her assistant Lucienne Rabaté) would remain active until the early 1950s. The taste for hats persisted after World War I; Parisian millinery continued to thrive through the 1920s and 1930s, only to wane as new concepts of elegance emerged and the occasions for wearing hats dwindled.

Translated from the French by Rose Vekony

1 Michelle Sapori, *Rose Bertin: Ministre des modes de Marie-Antoinette* (Paris: Institut français de la mode and Éditions du Regard, 2003).

2 Fiona Ffoulkes, "L. H. Leroy (1763–1829), Grandfather of Haute-Couture" (master's thesis, Winchester School of Art, University of Southampton, 1995).

3 Sandrine Barnier, "La Place de la femme commerçante sous le Second Empire: Les marchandes de modes" (master's thesis, Université Paris-IV-Sorbonne, 1996), 44.

4 Françoise Tétart-Vittu, *"Au paradis des dames": Nouveautés, modes et confections, 1810–1870*, exh. cat. (Paris: Musée Galliera, 1992), 52.

5 See capotes of satin and lace, Musée du costume de Château-Chinon, France, C 207 and C 209.

6 Raymond Gaudriault, *La Gravure de mode féminine en France* (Paris: Éditions de l'Amateur, 1983).

7 Tétart-Vittu, *"Au paradis des dames,"* 37–39.

8 *L'Atelier Nadar et la mode, 1865–1913*, exh. cat. (Paris: Direction des Musées de France, 1977).

9 Barnier, "La Place de la femme commerçante," 87.

10 Ibid., 64.

11 Madame Fourmentin's dresses are conserved at the Musée Galliera (GAL2008-3 and GAL2008-4), and a silk and straw hat from about 1860 was sold at auction by Christie's in London on May 17, 1988.

12 Arsène Alexandre, *Les Reines de l'aiguille: Modistes et couturières* (Paris: Théophile Belin, 1902), 129–137.

13 *Méry Laurent, Manet, Mallarmé et les autres*, exh. cat. (Nancy, France: Musée des Beaux-Arts, 2005).

14 *Monet und Camille: Frauenportraits im Impressionismus*, exh. cat. (Bremen: Kunsthalle, 2005).

15 Drawings of the sisters' registered designs from the 1880s—when the Duluc house was at 76, rue Richelieu—are conserved at the Musée Provincial Félicien Rops, Namur, Belgium.

16 *Une loge aux Italiens* (ca. 1874), Musée d'Orsay, Paris, RF 2643; and *Self-Portrait before the Mirror* (ca. 1869–1870).

17 The two hats by Madame Mantel are in the collection of the Metropolitan Museum of Art, New York (respectively 2009.300.4198 and 2009.300.1415).

18 Jeanne Baudot, *Renoir: Ses amis, ses modèles* (Paris: Éditions Littéraires de France, 1949), 15. See also catalogue numbers 84–85 in this volume.

19 Countess Greffulhe led this initiative not so much through a formal group but as an informal aristocratic cause. Such actresses as Sarah Bernhardt and Réjane, who were also theater owners, campaigned in favor of having the large hats then in fashion be left at the cloakroom or of popularizing smaller headdresses. The countess seems to have succeeded because smaller, elegant headdresses—beaded or embroidered—were created for the theater.

20 Anna Gould married Boniface de Castellane in 1896 and subsequently the Duke de Talleyrand. Her hats and wardrobe were given to the Musée Galliera in 1968.

21 The dress and hat were given by the Gramont family to the Musée Galliera in 1984.

22 The catalogue page is illustrated in Madeleine Ginsburg, *The Hat: Trends and Traditions* (London: Studio Editions, 1988), 96.

23 See objects 1978.295.13 and C.I.40.13.9.

24 Samuel Hopkins Adams, "The Dishonest Paris Label: How American Women Are Being Fooled by a Country-Wide Swindle," *Ladies' Home Journal*, March 1913, 7–8, 81.

25 Examples are conserved at the Metropolitan Museum of Art (ca. 1899; C.I.56.16.4) and the Fine Arts Museums of San Francisco (ca. 1898; 59.21.7).

THE
MODISTE'S
PALETTE
AND THE
ARTIST'S
HAT

SUSAN HINER

"*Modiste*: What you must have to succeed in this trade are, above all, good taste and artfulness,
you must be able to rumple something prettily, place a bow, feathers, or flowers just so."

—*Que faire? Aimer!* (1890)

IN AN 1890 GUIDE intended to help bourgeois and upper-class women best direct charitable deeds for the Parisian working classes, the anonymous author of *Que faire? Aimer!* offers a series of encyclopedic entries describing such workers. The entry for *modiste* (milliner) cited in the epigram above echoes a century-old image of this fashion worker, a maker of hats for women. Although her daily salary at this time was a meager two to four francs, at least in the early stages of her career, she nonetheless is assumed to possess and display the ineffable *je ne sais quoi* of good taste (*goût*). Taste was indeed required of these workers, as was *élégance*, a characteristic prominently visible in so many early nineteenth-century representations of *modistes*. But so too were deft, nimble fingers for attaching the ribbons, laces, fabrics, flowers, vines, feathers, and veils to a blank slate of cap and brim, most often formed from felt or straw.

In the popular imagery representing the *modiste, les petites mains* (the little hands) of this premier artisanal worker complemented a performative flirtation. "Real" skills and handiwork with raw materials combined fruitfully with a reputation imagined and developed over time as a coquettish seductress in order to market fashionability to an expanding consumer class in nineteenth-century France.[1] And as the epigram illustrates, even in a manual that acknowledges the desperate situation of fashion workers, the actual labor and status of the *modiste* vanishes behind a popular conception that took hold in the era of high fashion.

Parisian *modistes* have a long and storied history. It should properly be called a mythology, since the history of the *modiste* has yet to be written, and most of what we know can be gleaned primarily from popular representations—both visual and literary—of this figure who was central to the identity of Paris as the capital of luxury fashion

production in the nineteenth century. From the beginning, the *modiste* inhabited a liminal space and, within that, occupied a unique and ill-defined position like her ancestress, the *marchande de modes*.[2] As Jennifer Jones explains (and as Françoise Tétart-Vittu discusses on page 51), the *marchande de modes* had emerged from the mercers' guild and eventually surpassed dressmakers in status, giving rise to a long-standing rivalry between *couturières* and *modistes*, as they were eventually known: "These women, who became the principal fashion merchants of their day, had risen, so to speak, from within the cracks of the corporate system."[3] Linked in part to bygone practices of Old Regime extravagance (Marie-Jeanne Rose Bertin, *marchande de modes* to Marie Antoinette, was famously accused of nudging the nation toward bankruptcy), *modistes* were also progressive, their work combining old and new, thus literally allowing them to incarnate the paradoxical mechanism of fashion, which at once refers to the past and introduces novelty. The space of the *atelier* was both workroom and showroom, and the *modiste* was thus both fashion creator and stylist-saleswoman.

This essay will explore the genealogy of the *modiste* in the French imaginary, with a primary focus on popular visual and literary representations in the nineteenth century as a frame for considering Edgar Degas's millinery images. While originating in the late eighteenth century, the *modiste* was a particularly nineteenth-century invention, hats having become crucial signifiers of social status in post-revolutionary France.[4] I shall also, therefore, consider here the cultural importance of one of the *modiste*'s most highly valued and frequently represented products—the *chapeau de paille* (straw hat), which was first popularized in the eighteenth century and maintained a ubiquitous position in ladies' wardrobes throughout the nineteenth. Just as the flowered straw hat in Pierre de La Mésangère's satirical print (1802–1812; fig. 40) sits squarely at the center of the worktable, likewise the *chapeau de paille* sat squarely at the center of every wardrobe of the nineteenth-century bourgeois lady.[5] "Every lady of leisure had to have an Italian straw hat in her wardrobe," writes costume historian Éliane Bolomier.[6] Not only was it materially omnipresent, but the *chapeau de paille* also had far-reaching symbolic and cultural value in nineteenth-century France. For it served as vital connective tissue between a nostalgic and idealized femininity, the creative work of the *modiste* to "naturalize" a cultural object, and the vast consumer network promulgated by the nineteenth-century fashion press and probed in works such as those of Degas. Before turning to this celebrated object of production and consumption, however, I will first consider its producer, the *modiste*, and revisit the myths swirling around her.

THE *MODISTE* IN THE POPULAR IMAGINARY

The fantasized world of the Parisian *modiste* is on full display in La Mésangère's early satirical print depicting *modistes* "at work" in their atelier. Printed during the Napoleonic era between 1802 and 1812 and published for *Le Bon genre*, a series of fashion-related plates dealing with social customs in post-revolutionary Paris published within *Le Journal des dames et des modes*, we find here important clues to both the popular perception of and details surrounding these fashion workers, the spaces they inhabited, and the hats they produced. In this image, the *modistes* are coded as both elegant ladies and erotic objects, both creative artisans and disorderly tarts.[7] Their tiny shoes and feet resemble those of popular fashion plates and thus indicate their fashionability as well as their eroticization, but surely the dainty dancing shoes pictured here are not what one would suppose workers, in particular those who would have to walk distances in the streets, like the *trottin* (or errand girl), would practically wear.[8] Similarly their long gloves—although some are fingerless, calling attention to the primary instruments of their work: their hands—nonetheless raise questions about the productivity in which the *modistes* are supposedly engaged, for they are smart accessories, not sewing gloves. How indeed could the *petites mains* of these fashion workers manipulate ribbon and glue, flowers and thread? The image disavows work even as it claims to represent it.

Elegantly dressed in simultaneously unstructured and form-hugging Empire fashions, each of these four *modistes* models a different look and engages in a different activity. The décolletage of the standing woman's pink gown is noteworthy, especially as she carries a hatbox and wears a capote (a hoodlike bonnet, also known as a poke bonnet), two details that signal she is about to go outside

Le Bon Genre, N.º 28.

40 Pierre de La Mésangère, *Atelier de modistes*, 1802–1812, number 28 of *Le Bon genre*. Hand-colored etching, 8 ⅛ x 10 ⅜ in. (20.6 x 26.3 cm). The British Museum, London, 1866,0407.889

of the atelier, into the street, most likely on a delivery. The so-called *trottin* was charged with transporting goods publicly, and, as the artist has made clear by depicting her with visible, full breasts, the virtue of young women circulating in the streets is represented here as questionable at best. Indeed, she belongs to the genre of the *grisette*, understood as a fashion worker of loose morals and a stock character of nineteenth-century literature and visual culture.[9] She seems to assist the seated woman on the left who wears a blue shawl and adjusts a headpiece atop her stylish Titus haircut, as if trying on one of her own creations. This gesture blurs the line between producer and consumer of luxury goods and thus reinforces the uncertain social status of the *modiste*, which I will explore further below.

Directly across from this seated worker we find another woman, the only worker to be *en cheveux* (that is, hatless), attaching feathers to a fashionable turban she is creating on the *marotte* (head form) she holds provocatively between her knees. The visibly erotic (lesbian) overtones of this kind of community of women workers would be exploited in many popular prints representing the *lever* (morning rise) and *coucher* (bedtime) of fashion workers, and the atelier in such illustrations was quite often figured as a space of licentious behavior—as though offering to the (male) bourgeois viewer a window into the private world of eroticized women.[10]

The fourth of these workers, perhaps the shop owner herself, is stylishly dressed in blue with a matching *coiffe*; she holds a book but appears to be more engaged in the sociability of the atelier than anything she is reading. On hatstands (called *pieds* or *champignons*) completed straw and fabric hats are displayed, while at the feet of one worker wide-brimmed straw hat forms await shaping and decoration; a hatbox barely escapes the frame of the image on the other side. Strewn across the table are the tools and elements of embellishment: ribbons, braids, flowers, scissors, tape measure, pins, and pincushion. Everything here is in disarray, from the scattered work materials to the appearance of the workers themselves, apparently unsupervised and absent the regulating presence of clients with their male companions.[11]

The image presents multiple and competing vignettes and layers of signification, all of which weave a rich texture for the cultural meaning of the *modiste*. The hierarchy of workers is expressed in the variety of activities on view.[12] The variability of fashions in hat wear is visible in the wide range of hats on display, the tools of production bear silent witness to the creative process, and the embodiment of sexy elegance together with the network of gazes that this print stages works to broadcast an identity—or a fantasy—that would remain potent for more than a century.

Satire notwithstanding, this spectacular print is a master image of both the actual tools and activities of the millinery craft in nineteenth-century France. It also contains the elements of a mythology surrounding the complex figure of the *modiste* that obscures her work and that would haunt the public conception of her throughout the nineteenth century. I do not use the word "spectacular" lightly,

for this image, like so many others, at once celebrates and critiques, mythologizes and effaces the spectacle of the working woman, who is as much on display as her products. The murkiness concerning the origins, status, and activities of the nineteenth-century *modiste* contributes to a more generalized instability, to use Hollis Clayson's word, regarding this worker, which in turn created an imaginative space ripe for mythologizing.[13] La Mésangère's print offers up the myth of the promiscuous *modiste*, free to circulate publicly in the streets and resembling a fashionable and proper lady consumer, a myth with longevity that hid her actual labor.

If these Napoleonic-era *modistes* bear little resemblance to Degas's more shadowy fashion workers, they nonetheless participate in a visual genealogy that winds its way from the early decades of the nineteenth century to the curious portrayals of the *petites mains*, so tenderly if often ambiguously rendered by Degas in the century's last decades. Obscured by both dim light and the fashion products looming in the foreground, Degas's workers pictured in *The Milliners* (1882–before 1905; cat. no. 88) seem the very antithesis of those of the La Mésangère print. Brightly colored ribbons are the only flash of contrast with the somber hues of the workers, one of whom sews with concentration in the half light an embellishment onto a hat, while the other stares abjectly through the spindly stands that rest on the worktable. Her hands seem frozen in the pink ribbon she works, the colorful sheen of which is reflected up into her greenish face: hers is not a healthful blush but rather merely the reflection from the dazzling fabric, or perhaps the unhealthy flush of illness or the fatigue of a worker exhausted by painstaking and poorly compensated work.[14]

The joyful bustle of the La Mésangère print, suggesting the pleasures of workplace community, is replaced here by a solitary oppression: the two workers do not look at each other and seem indeed to work in isolation, although they are seated adjacently. Their apposition suggests alienation rather than the social companionship depicted in the earlier illustration. Similarly, the foregrounding of La Mésangère's *modistes*, with products in secondary position, gives way nearly a century later to Degas's fragmented figures, blocked from view by their own product, reversing the significance of object and subject, as if to acknowledge the increased importance of the consumable product at the expense of its producer. Although Degas's hats are not

the focus of this painting, their hovering presence in the foreground presents them as obstacles to our view of the workers. Both images depict in different ways the efface-ment of workers—one through erotic mythologizing and the other through the overwhelming power of consumption. Degas, however, seems rather to want us to acknowledge the *modistes*' obfuscation.

Everyday myth is powerful in that it permeates every aspect of daily life: visible everywhere, it thus appears to be naturally occurring. The common perception of the *modiste* was that she was a woman of loose morals, eager to snag a husband and sneak into the middle class or better still. This myth proliferated in the popular genres of nineteenth-century France—namely, prints and vaudeville plays. The notion that especially *modistes* were actually prostitutes was a commonplace grounded in truth—the truth of wom-en's work—which was predicated on low wages, making it necessary to supplement a meager income, as many studies have argued from Alexandre Parent-Duchâtelet on.[15] But that stereotype also concealed the other work they did—fashion work, which was real, if poorly remunerated. How was a nineteenth-century viewing public to make sense of the image of a venal working woman creating a fashion object—*le chapeau féminin*—that was recognized as the single most important indicator not only of status but, more ironic still, of female propriety?

The *modiste*'s reputation developed throughout the nineteenth century, helped on its way by a vibrant print cul-ture that frequently represented these workers as flirty girls surrounded by luxury items, as well as by a popular theatri-cal culture that regularly staged scenes of workaday life and romantic entanglements in the ateliers of *modistes*.[16] Indeed, *modistes* were often portrayed at work—either creating goods in their ateliers or delivering them, concealed inside trademark hatboxes, as they strode the streets of Paris. Hiding the product, either literally within the hatbox or figu-ratively through the shift in focus from product to producer, deflects emphasis away from labor and product and indeed makes the *modiste*'s activity look nothing at all like labor.

A mid-century print by Claude Regnier (fig. 41) is one of the series of lithographs *Les Parisiennes* that shows Parisian women workers in various *métiers* (trades) of the capital. Such depictions belonged to a tradition popu-larized at the end of the eighteenth century: genre prints

41 Claude Regnier, *Modiste*, n.d. From *Les Parisiennes* (Paris: Aubert et Cie, n.d.). Cabinet des Arts Graphiques, Musée Carnavalet, Paris

representing what was known as *les petits métiers* that sought to classify working types and present a new urban landscape.[17] Linked to the older tradition of *les cris de Paris*, made famous in particular by Louis-Sébastien Mercier's 1781 *Le Tableau de Paris*, this visual genre remained vital well into the nineteenth century. As Anne Higonnet has observed in her study of nineteenth-century realism and photography, focusing in particular on the history of the *petits métiers* illustration genre, these

> images represented workers not as individuals with work experiences but as vehicles for signs of work. They classified labor into "types," which although seeming to individualize labor, in fact objectified it as costumes and accessories. . . . Workers in these images become a function of organizational schemata . . . so that labor can be recognized yet not acknowledged.[18]

Higonnet argues that by the July Monarchy, the period during which Regnier's lithograph was produced, women fashion workers were frequently eroticized, such that the focus of the image was less on the work and product and more on the seductions of the worker herself.[19] Production and consumption become blurred in such a schema; the elegance of the *modiste*, viewed here almost in profile to highlight her elaborate coiffure, delicate features, and graceful figure, emphasizes as much the requisite "good taste" of the fashion worker as the beauty of her product. Like the elegant product she makes, she too incarnates consumable elegance.

The recognizable signs of the *modiste*'s work are visible here. She stands at her worktable wearing a traditional black apron with a *marotte*, pincushion, and yards of ribbon before her. Her dainty hands are busy forming a knot or bow, which the viewer understands she will attach to the hat she is ornamenting. And yet she does not look at her handiwork; rather, she is disengaged from her work and gazes out, with a slight smile on her lips, beyond the frame at an unknown spectator—a consumer perhaps, or a male admirer? The unmistakable resemblance of this *modiste* to her *marotte* calls to mind the reification inherent in many representations of women in visual culture. As John Berger famously explored in his 1972 *Ways of Seeing*, the ideal spectator is male, and thus "women watch themselves being looked at. This determines not only most relations

between men and women but also the relation of women to themselves. The surveyor of woman in herself is male: the surveyed female. Thus she turns herself into an object— and most particularly an object of vision: a sight."[20] The gaze of this *modiste* is mirrored here by that of her lifeless *marotte*, "made up of a wood base and a head covered in fabric, which allows pins to hold," suggesting at once that the inanimate head form and the "live" fashion worker are mirrors of each other.[21] The "real" woman is also doubled in her tiny pincushion, itself shaped like a little lady wearing a dress with fashionably puffy sleeves. Her gaze beyond the frame of the image indicates the world of spectatorship and disrupts the purported intent of the illustration: to depict a *modiste* at work.

This representation insists instead upon the performative aspect of fashion work—the *modiste* is a spectacle to be observed, admired, and perhaps even herself consumed; her uncanny resemblance to the anthropomorphized tools of her trade hints at her own object status. Furthermore, the image is staged in a way similar to that of mid-century fashion plates—rather than depicting a workroom, the artist places this *modiste* in what appears to be an elegant salon, with moldings traced out on the surrounding walls and a velvet-covered sofa or chair behind her. Again, while this image participates in a visual tradition of illustrating Parisian women at work, the work in which she is ostensibly engaged is presented as secondary to her identity as an elegant, tasteful, even bourgeois lady. While this *modiste* is not represented as morally suspect, she demonstrates a different danger—that of passing into a higher class. This potential upward mobility of the high-end fashion worker was perceived by some as a class slippage that could produce anxiety in a period when social boundaries were being repeatedly breached and redefined, often through the vehicle of fashion itself.[22]

We have now seen in several examples how the visual culture depicting the *modiste* worked hard to instill a myth that emphasized fashionability verging on flirtation and elegance beyond a working girl's station. Whether overtly licentious, as La Mésangère's print proclaims, or subtly passing, as Regnier's stages, the nineteenth-century *modiste* in the first half of the century was disengaged from work by the illustrations that pictured her. Rather, other identities were central, most likely as a reaction to a new visibly public

role these fashion workers enjoyed. Their ateliers were also shops, thus opening the private feminized space of sewing, hat embellishment, and other artisanal labor to a buying public, who could see the goods produced as well as the young women producing them. Because of their semipublic role, these women needed to exude elegance to encourage a clientele to purchase. Furthermore, the *trottin* would take that seductive elegance to the street, unmistakably marked by her trademark hatbox. The *modiste* was the agent of anxieties surrounding class slippage—since *modistes* could often pass for their social betters and indeed established fashion trends that bourgeois and upper-class clients slavishly followed. But they also produced and reflected anxieties related to shifts in gender norms, for women were now working publicly. To quiet the fears that such shifts might elicit, popular visual culture subsumed them into the broad (and vilifying) category of "working girl."

The product itself, the ladies' hat, perhaps best exemplifies fashion's most extreme commodity fetish; the *chapeau féminin* conveyed status and taste and transformed its wearer as if through a magical process. As a hyper-feminine social symbol, the woman's hat offered a miniature, yet exaggerated, version of a dress. And like a dress, this luxury commodity, concealing its seams, pins, glue, and thread, was also removed from its conditions of production—this is why the term "commodity fetish," taken from Karl Marx, is particularly apt in characterizing this fashion object.[23] Its excesses defy its use value and hide the labor expended to create it; it also assumes a circulating social dimension. Considered as such, it is endowed with powers (social, economic) that ought to accrue to the workers who made it but attach to an inanimate object—a hat.

THE SEAMLESS *CHAPEAU DE PAILLE*

The mythology surrounding the Parisian *modiste* took root at the end of the eighteenth century, when these fashion workers began to claim autonomy from seamstresses and tailors at the same time that increasingly flamboyant hats replaced the ubiquitous and restrained bonnet as outdoor headgear for women. Nicole Le Maux explains that "the hat's social significance was established as of 1789: the aristocrats and bourgeoises gradually abandoned caps, at least

out-of-doors, and donned hats instead. Only the women of the lower classes still wore caps."[24] Other historians place the date earlier, in 1778, when the delicate *bonnets de lingerie* (lingerie caps) are modified "with the addition of a rigid brim"; it is at this point when "the cap . . . becomes a hat."[25]

Decorum required that women, and in particular sexualized married women, cover their hair—that most erotic of feminine attributes (along with minuscule feet). As the nineteenth-century fashion press corroborates, hats were essential accessories to the properly attired lady—for if she were outside *en cheveux*, she could easily be taken for a prostitute. In her exploration of the social, cultural, and aesthetic meanings of the veil in Second Empire Paris, Marni Kessler indicates, "Government officials took measures to facilitate the readability of a venal woman's class. . . . They were required to wear understated clothes and regulation-sized hats or none."[26] For centuries propriety had dictated that women cover their hair, and this moral imperative distinguished ladies' hats from those of their male counterparts, who primarily wore hats for protection against the elements. Claire d'Harcourt, in her whimsical encyclopedia of clothing, explains: "For women, beyond any wish to protect oneself from cold, sun, or rain, and even before any notion of stylish head wear, it is absolutely necessary to cover one's head from the age of about twelve, the age at which one takes Communion, and even more so after marriage. A morality that came from the Orient by way of the Church requires hair, the object of enticement, to remain covered."[27]

Adèle Romany's 1804 family portrait (fig. 42) illustrates the new importance of feminine headgear in the early nineteenth century by showcasing the painter's aunt's family in a set piece dramatizing three generations of women. This painting stages an initiation, with marriage as its central theme. It offers a visual tale of generational garments portraying the stages in the life of a bourgeois or upper-class woman in nineteenth-century France: eligible, married, dowager—each designated by a particular kind of headgear.[28] The grandmother's most readable garment is her cap. This kind of lacy *coiffe* garnished with a simple ribbon, commonly worn by older ladies, was a holdover from the previous century and was popular indoor wear for married ladies in the nineteenth century. While the dowager's cap indicates her retirement from both the social scene

42 Adèle Romany, *A Young Person Hesitating to Play the Piano in front of Her Family*, 1804. Oil on canvas, 44 ½ x 57 ½ in. (113 x 146.1 cm). Frances Lehman Loeb Art Center, Vassar College, Poughkeepsie, New York, Gift of Mary Bridges Boynton, class of 1936, 2009.5

43 Elisabeth Louise Vigée-LeBrun, *Self-Portrait in a Straw Hat*, ca. 1783. Oil on canvas, 38 ½ x 27 ¾ in. (97.8 x 70.5 cm). The National Gallery, London, Bought, 1897, NG1653

and the sphere of female sexuality, her daughter, Charlotte-Marie, wears a brimmed outdoor capote lined in satin and trimmed with flowers and a ribbon tie. With its very light striation, this capote seems to be fabricated from bleached fine straw, the suppleness of which made it one of the most desirable materials throughout the nineteenth century.[29] Finally, young Amélie-Justine, *en cheveux*, wears her hair up, her little curls coquettishly escaping their pins, suggesting for her viewer/appraiser the pleasures that await the lucky groom.

This painting demarcates female life stages through the fashion details, in particular headgear, attributed to each woman. In the nineteenth century, hats would truly take hold and become an essential fashion item in a woman's wardrobe. Le Maux writes, "A hat is not an accessory, but a distinguished element of a wardrobe; its shape, size, and trimming convey taste, sophistication, artistry, those of the male or female *modiste*, as well as, simultaneously, the personalities of the two protagonists, the creator and the

client."[30] Le Maux thus suggests not only the preeminence of the hat in the lady's wardrobe but also the symbiotic relationship between *modiste* and client, thus reinforcing the (class) slippage discussed above.[31]

The fashion correspondent for *Le Journal des demoiselles*—*l'évangile de la bourgeoisie* (the gospel of the bourgeoisie), according to Le Maux, and a widely circulated periodical containing literary excerpts, descriptions of society events, and home-economic and fashion advice—states with authority in an 1867 column that a particular type of hat, the *chapeau de paille*, was truly indispensable: "If your purse allows you two hats, you will have one of straw, *which can go with everything*, as I was just saying to you, and the other will go with your best outfit."[32] In 1858 *chapeaux de paille* are deemed *toujours convenables* (always suitable) and, in 1861, "the rice-straw hat, trimmed with a bunch of cornflowers at the top of the brim, or with a ring [of flowers] on the lower edge, is always youthful and distinguished."[33] The ubiquity and centrality in nineteenth-

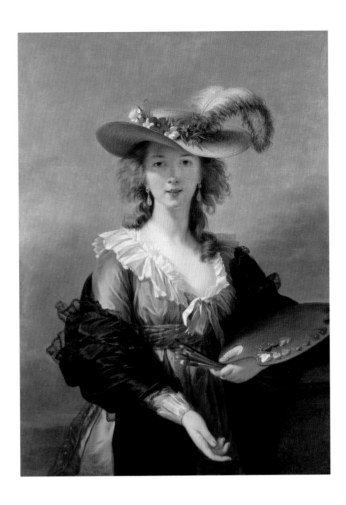

century France of the *chapeau de paille*—made of fine straw, sometimes bleached or dyed, and typically embellished with ribbons and flowers—are borne out by repeated references and descriptions throughout this journal's long run (1833–1896).[34] Indeed, a keyword search yields 294 articles that mention the "chapeau de paille" multiple times. Bolomier confirms what the plethora of references to the *chapeau de paille* in the fashion press suggests. A specialist in hats, she describes the persistence of *paille* as a predominant raw material from 1785 on, especially in summer collections:

> During the Napoleonic era, this was the raw material most often employed for the so-called Pamela bonnet; the crown is high, the brim is wide; two ribbons are attached there, compress the brim, and tie under the chin.
>
> In the nineteenth century, the crown, of percale, satin, or straw, would reign supreme. Under the Restoration, the brims would be very open, the underside trimmed with flowers, bows, and feathers; under

Louis Philippe, they would be narrow and closed, but under the Second Empire they would be very enclosing, small, and close-fitting.

> In the late nineteenth century and during the course of the twentieth, fashion sometimes favored the cloche, toque, and capeline, at other times the beret, hunt hat, and peaked cap. All of this headwear would have versions in straw.[35]

This synopsis attests to the great variety of shapes, sizes, and styles of hats made of different materials and ornamentation over the course of the century; in spite of this range, however, the constant was the *chapeau de paille*. Why did this particular hat become so essential to a lady's wardrobe, and how did it enter cultural discourse so powerfully?

We must return again to the last quarter of the eighteenth century to find the origins of this hat's popularity, when Rose Bertin, Marie Antoinette's "minister of fashion," indulged her famous client's taste for less formal attire, especially in her social gatherings at the Petit Trianon of Versailles.[36] Caroline Weber offers an analysis of the look that brought this fashion in hats to prominence in her study of the queen's relation to fashion.[37] Weber writes, "At Trianon, the hat of choice was usually made of straw. Garlands of real and artificial flowers, worn on the crown of a hat or directly on the hair, became another popular choice, which likewise emphasized the wearer's natural charms and eschewed the intensely artificial stylings of Versailles."[38] The straw hat, emblematic of the beautiful simplicity of nature, much like the queen's white gown or *gaulle*, which Weber analyzes in detail, became popularized on the streets of Paris and would stay in fashion throughout the nineteenth century.

Elisabeth Louise Vigée-LeBrun, who painted in 1783 what became a notorious portrait of the queen *en gaulle* sporting her Trianon-inspired pastoral look, including a wide straw hat with a giant feather, adopted this style of hat herself, as we see in a circa 1783 self-portrait (fig. 43).[39] And as Michelle Sapori explains in her biography of Bertin, Vigée-LeBrun was likely one of the famous *modiste*'s clients as well, since "among the *marchande de modes*'s clients were many who were featured in the 662 portraits by Madame Vigée-LeBrun. The two women shared the same clientele, and it is very likely that a good number of the ensembles reproduced in the latter's paintings came from

the former's shop."[40] Vigée-LeBrun's shallow wide-brimmed hat asserts her subscription to contemporary ideals of femininity and reinforces a studied "naturalness"; it is also the same style of hat, with its jaunty tilted brim, worn in her scandalous painting of the queen. The white and gray ostrich feather likewise recalls both the gray feather of that portrait and the white feathers of the "corrective" portrait, *Marie-Antoinette, à la rose*, painted in the same year.[41]

What distinguishes the painter's hat from that of the queen, however, is its garland of blue, white, and red flowers, whose colors repeat those of the artist's palette. This mirroring between the artist's hat and palette is striking: the golden tones of straw repeat those of wood, and the blues, greens, whites, and reds of flowers and leaves are echoed as paint daubs on the palette. This self-portrait suggests a fascinating circulation—not only between the identity of the queen and that of her favored painter through the shared elements of fashion created by a single *modiste*, Bertin—but also between the natural and the artificial, the "real" and the represented. The painter herself is both subject and object, and the painted hat quite explicitly refers to the palette as the origin of its beauty. If I dwell on this painting, it is because it showcases what would become the most popular type of hat in the nineteenth century, and it plays with the very undecidability between natural and artificial that was precisely the domain of the *modiste*. This hat is inscribed as a work of art.

Taken from nature and treated, dyed, formed, and molded, straw was most prized when it originated in Italy, valued for its fine quality and suppleness, as Bolomier emphasizes: "The thread where the sewn selvages met was invisible, which gave the illusion of a hat made in a single piece."[42] It was the very seamlessness of the product that elevated its status and made it the requisite spring–summer hat throughout the century. This erasure of the traces of fabrication recalls the mythologizing of the *modiste* herself. The straw used for making ladies' hats was so fine as to give the impression of seamlessness when worked—labor all but disappeared. This notion of seamlessness was tied not only to quality but also to morality when applied to nineteenth-century ladies' fashions.[43] The value attached to this particular type of hat was further reinforced by its inclusion in the *corbeille de mariage* (wedding basket) offered to bourgeois and upper-class brides by grooms both to acknowledge the expense of the dowry and to suggest future matronly propriety.[44] Like the cashmere shawl, that other indispensable accessory of a proper married woman, the straw hat signaled bourgeois respectability as well as the idealized notion of femininity linking women to the natural world popularized by Jean-Jacques Rousseau in his best-selling epistolary novel of 1761, *Julie, ou la nouvelle Héloïse*.[45]

The hat's popularity both reflected and emphasized a long-standing ideological equation between the natural environment and femininity. With its many references to the natural world it signified, among other things, freshness, beauty, and the ephemeral. Not only was the raw material of these hats visibly associated with nature, but *chapeaux de paille* were also typically decorated with flowers and vines, along with ribbons, lace, and sometimes feathers. Flowers were a staple motif for women's fashions, and never more frequently than in the nineteenth century, the golden age of hats, when *fleuristes* perfected the craft of artificial-flower production. An object that referenced nature and built upon an idealization of feminine innocence and "naturalness," the *chapeau de paille* was in fact constructed of artificial, trompe l'oeil elements: the "natural" is highly artificial. Le Maux tells us that in Paris, in the 1840s, there were "143 flowermakers and 16 dealers in the component parts: the latter made calyxes, pistils, buds, and stamens, which they sold to the artificial-flower makers, who assembled them and attached the various leaves and grasses sold to them by the 'greengrocers.'"[46] These artisans would then sell their goods to the *modiste*, who could attach them artistically to a hat.[47] Imitative of nature and embellished with nature's bounty, the *chapeau de paille* functioned as a sartorial shorthand for the ideological tradition of the *femme-fleur* (woman-flower), so prevalent in fashion iconography in the nineteenth century and beyond: fragile, delicate, and exquisitely beautiful.[48]

The constellation of propriety, marriage, and idealized (natural) femininity is on full display in Franz Xaver Winterhalter's 1857 portrait of the Empress Eugénie (fig. 44), which refers to Vigée-LeBrun's *Marie-Antoinette, à la rose* even as it emphasizes, indeed propagandizes, the natural beauty and delicate femininity of the emperor's wife. The painting features a broad *chapeau de paille* dressed with a diaphanous floating veil, once again attesting to the popularity and social standing of this kind of headdress.

Perhaps because of this hat's popularity and instant recognition value, nowhere however, was its importance more pointedly (if parodically) illustrated than in Eugène Labiche's 1851 blockbuster vaudeville play *Un Chapeau de paille d'Italie*, which places an embellished straw hat at the center of a slapstick marriage comedy. Here, the literal consumption of a hat, whose artificial flowers were so realistic as to be eaten by a horse, sets up a series of absurd plots around a wedding involving consumption of different kinds: the adulterous affair of the lady whose hat the horse consumed; the bridegroom Fadinard's feeble attempts to purchase a replacement for the destroyed hat in the atelier of his former girlfriend, Clara, a *modiste*; the inebriation of the ambulatory wedding party; and the bartering of the bride by her father as the wedding party follows along intact, yet unaware, on a madcap search for a replacement hat. The main character Fadinard refers to this hat as a "poppy-trimmed handful of straw," obviously a tempting treat for a horse.[49]

But the hat is only a simulacrum of nature, so it represents not only the several forms of consumption listed above, but also refers to the falseness of appearances that governs this play and, by extension, nineteenth-century social mores, according to Labiche. The hat, whose disappearance signals adultery (recall also the association of women *en cheveux* with prostitution), is also the key to Fadinard's happy marriage since, in the end, the wedding is complete, and the bride receives a *chapeau de paille* as a wedding gift, a gesture reinforcing literarily Le Maux's assertion that this item was commonly included in a *corbeille de mariage*. But the public is aware that Fadinard is a scoundrel, and that his "happy" marriage is founded on deceit.

But the veneer of happiness in marriage that the play seems to end on and thus promote is constantly undercut throughout, and the character of the *modiste* plays a key role in revealing the actual target of the play's satire—bourgeois marriage itself. Prior to the action of the play, Clara, the *modiste*, was the victim of the caddish Fadinard and left to fend for herself in Paris after being duped by him. When he turns up in her shop, we learn that Clara has landed on her feet, worked her way up to opening her own establishment, and struggled to distinguish herself from other Parisian *modistes*; unlike them, *she* is virtuous. Industrious, artistic, and entrepreneurial—and yet ever hopeful to

44 Franz Xaver Winterhalter, *Portrait of Empress Eugénie de Montijo, Wife of Napoléon III*, 1857. Oil on canvas, 54 ⅜ x 42 ⅞ in. (138 x 109 cm). Hillwood Estate, Museum & Gardens, Washington, DC, Bequest of Marjorie Merriweather Post, 1973, 51.11

marry—Clara both defines and defies the common myth of the promiscuous *modiste* explored above and produces the object that anoints some women with the status of propriety.[50]

THE *MODISTE*'S PALETTE

In this essay, I have explored both the paradox of the *modiste*'s identity and the layered cultural significance of the object of her labor through an analysis of various examples of nineteenth-century popular visual culture. These representations of *modistes* repeatedly cast her as flirtatious and elegant, with little concern for the actual labor of her trade, focusing instead on a mythology that compensated both for anxieties produced by women's visible presence in the labor force and the perception that lower-class women were gaining access to higher status. The objects they produced, in particular the *chapeau de paille*, gained their own prestige through a capacity to hide their production process. Laden with artificial "natural" embellishments, the *chapeau de paille* signified an idealized femininity that linked women to nature, modesty, and fragile beauty. But the hard work required to produce such an object was rendered invisible, as the seams, pins, and glue were either concealed beneath bouquets of artfully arranged flowers and ribbons or worked flawlessly into the delicate weave of fine straw. Popular conceptions of both the producer and the product thus obscured the actual labor that rightfully ought to identify both.

Degas's *The Milliners* of circa 1898 (cat. no. 90) acknowledges this tradition of popular-print culture even as it reclaims and valorizes labor by making it central to the representation. Work is captured here and represented with a measure of compassion rather than erotic mythologizing. This painting shows two *modistes* in the process of making *chapeaux de paille*. Their faces concealed, bent in concentration and unaware they are being watched, these workers offer a distinct contrast to the *modiste* in the Regnier print I discussed above. Their *petites mains* are blurred—in the case of the *modiste* on the left, because she appears to wear sewing gloves, which further signify her engagement in work, and in the case of the one on the right, because her agile fingers, active and visible, seem to be moving as they work with embellishments. Two straw hats occupy the center space of the canvas, and artificial flowers present a burst of color that harmonizes with the *modistes*' dresses. One *modiste* selects flowers, in a gesture of artistic consideration; the other attaches flowers or ribbons to a hat.

Degas's representation seems to create a parallel between the craft of the *modiste* and that of the artist for, in the hand of the *modiste* on the left, the hat resembles a palette both in its shape and placement of daubs of color, which are representations of artificial flowers and other embellishments. Likewise, the *modiste* on the right, reflecting on her creative decision, seems poised to place her colors—that is, her flowers—onto the blank canvas of the straw hat. The anonymity and humble status of these workers notwithstanding, their artistic choices, positioned at the heart of the picture, are acknowledged as important creative work. And with this acknowledgment comes its corollary: that the "work" of art is indeed labor. Although the hat is, in the end, the final product of the *modiste*'s artisanship, it bears a strong visual resemblance to an artist's palette, in this painting and elsewhere, and this resemblance produces a visual evocation linking labor to creativity, product to labor. Ultimately, Degas's identification of work recognizes a century's worth of anonymous *petites mains* and asks us to see the significance of the "*modiste*'s palette" as well as the power of the mythology that obscured it.

This essay draws on material to be included in my book in progress, *Behind the Seams: Women, Fashion, and Work in Nineteenth-Century France*. I would like to thank Masha Belenky, Mita Choudhury, Kaudie McLean, and Lise Schreier for reading drafts of this essay at various stages of completion. I offer my sincere gratitude to Alexandra Bonfante-Warren for her outstanding work translating the often-specialized French in this piece. Finally, I especially want to thank Marni Kessler for reading drafts and for helping me flesh out some ideas, especially as pertains to Edgar Degas.

EPIGRAPH: "C'est du goût, de l'adresse qu'il faut avoir avant tout pour réussir dans ce métier, il faut savoir chiffonner gracieusement, placer coquettement un nœud, des plumes, des fleurs." *Que faire? Aimer! Manuel de la charité pratique destiné aux femmes*, preface by Eugène Bersier (Paris: Librairie Fischbacher, 1890), 293.

1 *Petites mains* was the metonymic nickname given to female fashion workers who did the difficult and intricate handiwork required of dress- and hatmaking; reduced to pure skill, and thus signified as only labor, they were ironically represented in popular imagery throughout

the nineteenth century as dissociated from labor and tied primarily to coquettish flirtation and social climbing.

2 See Susan Hiner, "Production and Distribution," in Denise Baxter, ed., *The Age of Empire*, vol. 5 of *A Cultural History of Dress and Fashion* (London: Bloomsbury, forthcoming January 2017).

3 Jennifer M. Jones, *Sexing* La Mode: *Gender, Fashion, and Commercial Culture in Old Regime France* (New York: Berg, 2004), 95.

4 See Nicole Le Maux, *Histoire du chapeau féminin: Modes de Paris* (Paris: Massin, 2000), 56.

5 Although primarily a seasonal item (spring and summer), examples of dyed straw hats appeared in fashion journals year-round.

6 "Toute femme aisée se devait d'avoir dans sa garde-robe un chapeau de paille d'Italie." Éliane Bolomier, *Le Chapeau: Grand art et savoir-faire* (Chazelles-sur-Lyon, France: Musée du chapeau; and Paris: Editions Somogy, 1996), 70.

7 Eunice Lipton's *Looking into Degas* offers a groundbreaking study of the representation of the milliner as well as other women workers in nineteenth-century France. Speaking of frequent subjects for nineteenth-century illustration, she asserts: "Unbeknownst to later twentieth-century eyes, the milliner was considered a 'tart' and the naked woman with the basin, a prostitute." Lipton, *Looking into Degas: Uneasy Images of Women and Modern Life* (Berkeley: University of California Press, 1986), 152.

8 See Nathalie Preiss and Claire Scamaroni, *Elle coud, elle court, la grisette!*, exh. cat. (Paris: Paris-Musées, 2011), 74; "But it is by her foot that the volatile, fickle *grisette* is caught. . . . To shoe their nimble feet, the *grisettes* have a fertile imagination: they wear, depending upon the circumstances, delicate shoes . . . laced boots, hinged clogs, all the rage at the time, fanciful buskins, kerseymere ankle boots." (Mais c'est par le pied que l'on attrape la grisette volatile et volage. . . . Pour chausser leur pied agile, les grisettes ont l'imagination fertile: elles portent, selon les circonstances, de fin souliers . . . des brodequeins, des socques articulés, qui font fureur à l'époque, des cothurnes fantaisie, des bottines de casimir noir.)

9 See Jules Janin, "La Grisette," in *Les Français peints par eux-mêmes: Encyclopédie morale du dix-neuvième siècle*, vol. 1, ed. Pierre Bouttier (1840–1842; reprint, Paris: Omnibus, 2003), 35–44; see also Jones, *Sexing* La Mode, and Preiss and Scamaroni, *Elle coud, elle court*.

10 Illustrations of the *lever* and *coucher* of female fashion workers were plentiful in nineteenth-century popular visual culture. Milliners, *lingères* (linen maids), and dressmakers, and more generically *les ouvrières en mode* (female fashion workers) had been portrayed in such voyeuristic scenes since the eighteenth century. The Maciet collection of the Bibliothèque des arts décoratifs, Paris, contains numerous examples of prints in this genre. For a partial list of prints of the eighteenth century, see Gustave Bourcard, *Les Estampes du XVIIIe siècle*, preface by Paul Eudel (Paris: E. Dentu, 1885).

11 "It was not at all uncommon to find visibly upper-class men visiting and lounging in ateliers in which specifically feminine activities like dress- and hatmaking were taking place, as both nineteenth-century prints and early twentieth-century plays (such as Alfred Desfossez's *Les Midinettes* of 1904 or Artus's *Les Midinettes*) show. We also know, for example, that Manet and Mallarmé passed many an afternoon in couturier salons with Méry Laurent." Lipton, *Looking into Degas*, 213n7.

12 "There were three categories of milliners: apprentices, finishers, and trimmers. All three, according to Benoist, were privileged workers, and the most fortunate could ultimately go into partnership with the owner of a shop." Lipton, *Looking into Degas*, 160.

13 See Hollis Clayson, *Painted Love: Prostitution in French Art of the Impressionist Era* (New Haven, CT: Yale University Press, 1991); and Ruth E. Iskin, *Modern Women and Parisian Consumer Culture in Impressionist Painting* (Cambridge: Cambridge University Press, 2007).

14 Marni Kessler makes a similar argument in her reading of Degas's *blanchisseuses* (laundresses). See Kessler, *Sheer Presence: The Veil in Manet's Paris* (Minneapolis: University of Minnesota Press, 2006), 20–23.

15 Alexandre Parent-Duchâtelet was a nineteenth-century doctor who became famous for his work on public hygiene, in particular through his treatise on the sewers of Paris. But he is also well remembered for having written a lengthy work on prostitution in Paris, *De la prostitution dans la ville de Paris, considérée sous le rapport de l'hygiène publique, de la morale et de l'administration* (1836)—"the first extensively documented and statistically sophisticated study of prostitution," as Charles Bernheimer documents in his *Figures of Ill Repute: Representing Prostitution in Nineteenth-Century France* (Cambridge, MA: Harvard University Press, 1989), 270.

In the mid-nineteenth century *modistes* were, Carol Rifelj confirms, "thought to have loose morals or even to engage in clandestine prostitution to supplement their miserable wages," even more so than the *grisettes*, the larger group of female garment workers with whom they were associated. Rifelj, *Coiffures: Hair in Nineteenth-Century French Literature and Culture* (Newark: University of Delaware Press, 2010), 71. Rifelj also clarifies that, by 1827, the term *modiste* referred exclusively to hatmaker, or milliner (256n65). See also on this subject Alain Corbin, *Les Filles de noce: Misère sexuelle et prostitution au XIX siècle*, 2nd ed. (Paris: Flammarion Champs, 1982); Judith G. Coffin, *The Politics of Women's Work: The Paris Garment Trades, 1750–1915* (Princeton, NJ: Princeton University Press, 1996); and Rachel Fuchs, *Poor and Pregnant in Paris: Strategies for Survival in the Nineteenth Century* (New Brunswick, NJ: Rutgers University Press, 1992).

16 I argue in greater detail elsewhere that the popular vaudeville theater served as a counterpoint in many ways to the mythologizing of the popular-print culture of the period. For a classic literary depiction of the figure of the *modiste*, see Maria d'Anspach, "La Modiste" (1841), in *Les Français peints par eux-mêmes*, vol. 2, 193–202.

17 Anne Higonnet, "Real Fashion: Clothes Unmake the Working Woman," in *Spectacles of Realism: Gender, Body, Genre*, ed. Margaret Cohen and Christopher Prendergast (Minneapolis: University of Minnesota Press, 1995), 137–162.

18 Ibid., 144–145.

19 This type of series is common in nineteenth-century lithography; both Charles Philipon and Louis-Marie Lanté produced widely circulated illustrated series of female fashion workers.

20 John Berger, *Ways of Seeing* (London: BBC and Penguin Books, 1972), 47.

21 "Composée d'un pied en bois et d'une tête recouverte de toile ce qui permet de fixer des épingles." Le Maux, *Histoire du chapeau féminin*, 94.

22 See my "*La Femme comme il (en) faut* and the Pursuit of Distinction," in Hiner, *Accessories to Modernity: Fashion and the Feminine in Nineteenth-Century France* (Philadelphia: University of Pennsylvania Press, 2010), 9–44.

23 Karl Marx, "Commodities" (1867), reprinted in *The Marx-Engels Reader*, ed. Robert C. Tucker, 2nd ed. (New York: W. W. Norton, 1978), 302–329.

24 "L'importance du chapeau sur le plan social s'est imposé dès 1789: les aristocrates, les bourgeoises ont peu à peu délaissé le bonnet, du moins à l'extérieur pour se parer du chapeau. Seules les femmes du peuple conservaient le bonnet." Le Maux, *Histoire du chapeau féminin*, 56. See also Clare Haru Crowston, *Fabricating Women: The Seamstresses of Old Regime France, 1675–1791* (Durham, NC: Duke University Press, 2001).

25 "Par l'adjonction d'une passe rigide"; "le bonnet . . . devient un chapeau." Madeleine Delpierre, *Indispensables accessoires, XVIe–XXe siècles* (Paris: Musée de la mode et du costume, 1983), 17.

26 Kessler, *Sheer Presence*, 7.

27 "Pour les femmes, au-delà de toute volonté de se garder du froid, du soleil ou de la pluie, et avant même toute idée de coquetterie dans la coiffure, il est indispensable de se couvrir la tête à partir d'une douzaine d'années, âge de la communion, et, plus encore après le mariage. Venue d'Orient par le canal de l'Eglise, la morale veut que la chevelure, objet de séduction, reste cachée." Claire d'Harcourt, *Les Habits: Histoire des choses* (Paris: Seuil, 2001), 62.

28 This painting offers many interpretable vestimental signs that are not associated with hat wear, such as the white Empire gown and the cashmere shawl, but here I will focus on head wear.

29 My thanks to Elizabeth Nogrady for confirming this detail.

30 "Le chapeau n'est pas un accessoire mais une pièce éminente de la toilette; sa forme, sa dimension, son ornementation traduisent du goût, un savoir faire, un art, celui du ou de la modiste, en même temps que la personnalité des deux protagonistes, le créateur et la cliente." Le Maux, *Histoire du chapeau féminin*, 59.

31 It was indeed precisely this slippage, and the proximity and influence of Rose Bertin, that was at the root of much of the political criticism of Marie Antoinette. See Chantal Thomas, *La Reine scélérate: Marie-Antoinette dans les pamphlets* (Paris: Seuil, 1989).

32 "Si ta bourse te permet deux chapeaux, tu en auras un en paille, *pouvant aller avec tout*, comme je te disais tout à l'heure, et l'autre sera assorti à ta toilette principale." J[eanne]-J[acqueline] Fouqueau de Pussy, "Modes," *Le Journal des demoiselles* 35, no. 6 (1867): 186.

33 "Le chapeau de paille de riz, orné d'une touffe de bleuets posée sur le sommet de la passe, ou d'une couronne placé sur le bord du fond, est toujours jeune et distingué." Fouqueau de Pussy, "Correspondance," *Le Journal des demoiselles* 26, no. 6 (1858): 188; and "Modes," *Le Journal des demoiselles* 29, no. 7 (1861): 223. See also Le Maux, *Histoire du chapeau féminin*, 26.

34 Most such journals featured a fashion correspondence column, in which the writer would describe once or twice a month, depending on the journal's publication timetable, changing fashions and trends. Typically the correspondent would combine ruminations on fashions, instructions for re-creating them economically (sometimes with a pattern), as well as descriptions of social events and what fashions were observed at various types of gatherings. In higher-quality fashion periodicals, one or more color plates would be included, and the fashion writer (or *chroniqueuse*) would also offer a detailed description of the image on the plate as well as information on where to purchase each item. *Chapeaux de paille* were frequently described and illustrated throughout the century.

35 Bolomier, *Le Chapeau*, 60: "A l'époque du premier Empire, c'est la matière première qui compose le plus souvent le chapeau dit 'à la Paméla'; sa calotte est haute, ses bords sont grands, deux rubans partent du lieu, écrasent la passe et se nouent sous le menton.

Durant le XIXe siècle, la capote, en percale, satin, ou paille, va régner. Sous la Restauration, les bords en seront très ouverts, au dessous garni de fleurs, de noeuds, de plumes; sous Louis-Philippe, ils seront étroits et fermés, tandis que, sous le second Empire ils seront très enveloppants, petits et emboîtants.

À la fin du XIXe siècle et durant le XXe siècle, la mode favorise tantôt la forme cloche, toque ou capeline, tantôt le béret, le tricorne ou la casquette. Ces coiffures auront toutes une déclinaison en paille."

36 "Ministre des modes de Marie-Antoinette" is the subtitle of Michelle Sapori's 2003 biography of Rose Bertin. The phrase originates in anonymous revolutionary pamphlets that accused the queen of bankrupting the country through her lavish spending; Bertin, who dressed her, was viewed as dangerous because she had such political influence, and was thus satirically referred to as a "ministre," a political term.

37 For an analysis of the look that brought the straw hat to fashionable prominence, see especially "The Simple Life" in Caroline Weber, *Queen of Fashion: What Marie Antoinette Wore to the Revolution* (New York: Henry Holt, 2006), 131–163.

38 Ibid., 146.

39 *Marie-Antoinette en gaulle* (1783)—now in the collection of the Hessische Hausstiftung, Kronberg, Germany—was deemed far too informal a portrait of the queen. For a thorough discussion of the "scandal" around this painting, see ibid., 156–163. Although most critics acknowledge the *chapeau de paille* in her self-portrait as mainly a reference to Vigée-LeBrun's admiration for Peter Paul Rubens's *Le Chapeau de paille* of the 1620s (National Gallery, London), I also see in it, like Mary D. Sheriff, a clear link to her portrait of Marie Antoinette: "The plumed straw hat she wears was a favorite accessory, and one also sported by Marie Antoinette in Vigée-LeBrun's 1783 portrait *en chemise*. Vigée-LeBrun later repeated the composition and costume of her self-portrait for a portrait of Polignac, confusing the identity of the Duchess with her own." Sheriff, *The Exceptional Woman: Elisabeth Vigée-LeBrun and the Cultural Politics of Art* (Chicago: University of Chicago Press, 1996), 213. See also Joseph Baillio and Xavier Salmon, *Elisabeth Louise Vigée-LeBrun* (Paris: Editions de la Réunion des musées nationaux–Grand Palais, 2015).

40 "Parmi les clients de la marchande de modes, nombreux sont ceux qui comptent des 662 portraits réalisés par madame Vigée-LeBrun. Les deux femmes partageaient la même clientèle et il est fort probable que bien des costumes reproduits dans les tableaux de l'une provenait

du magasin de l'autre." Illustration caption in Michelle Sapori, *Rose Bertin: Ministre des modes de Marie-Antoinette* (Paris: Institut français de la mode and Éditions du Regard, 2003), n.p.

41 See *Marie-Antoinette, à la rose* (1783), Palace of Versailles, France. For more on the scandal of Vigée-LeBrun's painting, see Weber, *Queen of Fashion*, 160–164.

42 "Le fil à la jonction des lisières remaillées était invisible, ce qui donnait l'illusion d'un chapeau fait d'une seule pièce." Bolomier, *Le Chapeau*, 70.

43 Hiner, *Accessories to Modernity*.

44 "An Italian straw hat was long an indispensable wedding gift, and no woman could lay claim to elegance who did not have one in her summer wardrobe." (Pendant fort longtemps, le chapeau de paille d'Italie était indispensable dans une corbeille de noces, et une femme ne pouvait prétendre être élégante sans en posséder un dans sa garde-robe d'été.) Florence Müller and Lydia Kamitsis, *Les Chapeaux: Une histoire de tête* (Paris: Syros-Alternatives, 1993), 36.

45 The linkage of idealized femininity to nature had gained currency following the wild success of Jean-Jacques Rousseau's novel, whose heroine, Julie, is frequently portrayed in her garden and as authentically passionate and moral. See especially letter 11 in Rousseau, *Julie, or The New Eloise*, trans. Judith H. McDowell (University Park: Pennsylvania State University Press, 1987).

46 "143 fabricants de fleurs et 16 marchands d'apprêts: ceux-ci faisaient les calices, les pistiles, les bourgeons, les étamines qu'ils vendaient aux fleuristes qui les assemblaient et qui soudaient les divers feuillages et herbes que leur vendaient les 'verduriers.'" Le Maux, *Histoire du chapeau féminin*, 126.

47 For a fascinating look at the dangers of flower-making, along with many other artisanal jobs connected to fashion, see Alison Matthews David, *Fashion Victims: The Dangers of Dress, Past and Present* (London: Bloomsbury, 2015).

48 The *femme-fleur* has a long tradition in the representation of women and as a feminized fashion ideal, from J-J Grandville's satirical *Les Fleurs animées* (1847), which depicted fashionable ladies hybridized as flowers, to Christian Dior's "New Look," designed for "flower-like women," according to the designer himself. Dior, *Dior by Dior* (London: V&A, 1957), 21. Thanks to Colin Edwards for calling this to my attention.

49 "Bouchon de paille, orné de coquelicots." Eugène Labiche, *Un Chapeau de paille d'Italie* (1851; reprint, Paris: Larousse, 2000), 53.

50 There is a large body of less-familiar vaudeville plays from the 1810s through the early twentieth century staging the *modiste* in such a way; Labiche's is but the most familiar. In my current book project I argue that vaudeville pushes back against the mythic venality of women workers promoted in the popular visual culture of the nineteenth century.

DEGAS, MILLINERY, AND THE GRAND TRADITION

ESTHER BELL

"[Degas] bound the past to the most immediate present."

—Jacques-Émile Blanche

EDGAR DEGAS WAS CAPTIVATED by the visual spectacle of millinery for roughly three decades—creating, as argued in this volume, nineteen pastels, five oil paintings, two drawings, and one unidentified work (simply called *Modiste* when it was shown at the second Impressionist exhibition of 1876). *At the Milliner's* of 1881 (fig. 45), an early example, is arguably the artist's most ambitious and highly worked treatment of the subject. In an interior resembling the many showrooms that occupied rue de la Paix, two women—perhaps sisters, a mother and daughter, or a milliner and customer—contemplate a purchase. Their interlocking bodies recall the composition of Leonardo da Vinci's *Virgin and Child with Saint Anne* (ca. 1503–1519; fig. 46), which Degas had copied in the Musée du Louvre in 1853, while their concentration and intimate engagement suggest the figures in Domenico Ghirlandaio's *Visitation* (1491; fig. 47), which he had also copied at the Louvre as a young man.[1] While Degas rooted his scene in the history of art through his act of emulation, the straw bonnet of one of the women, with its blue ribbon and artificial cream rose, reminds the viewer that this picture is at the same time a product of modernity.

The millinery trade was the sort of subject touted by Charles Baudelaire in his "Peintre de la vie moderne" ("The Painter of Modern Life," written between 1859 and 1860 and published in 1863).[2] Baudelaire, a writer whose volumes of criticism Degas borrowed from Édouard Manet, argued that society should profit from the study of both the past and present, though artists should be most preoccupied with capturing the essence of modernity by, among other means, depicting contemporary fashion.[3] Baudelaire wrote:

> The past is interesting, not only because of the beauty that the artists for whom it was present were able to extract from it, but also as past, for its historical value. The same applies to the present. The pleasure we derive from the representation of the present is due, not only to the beauty it can be clothed in, but also to its essential quality of being the present.[4]

This essay will examine Degas's millinery pictures as emblematic of the balance he created between "the present" and the grand tradition, or the grand art-historical narrative. The millinery industry itself—including the circulation, promotion, and fetishization of its finest products,

45 Edgar Degas, *At the Milliner's*,
1881. Pastel on paper, 27 ¼ x 27 ¼ in.
(69.2 x 69.2 cm). The Metropolitan
Museum of Art, New York, The
Walter H. and Leonore Annenberg
Collection, Gift of Walter H. and
Leonore Annenberg, 1997, Bequest of
Walter H. Annenberg, 2002, 1997.391.1

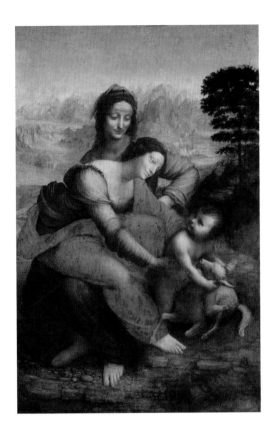

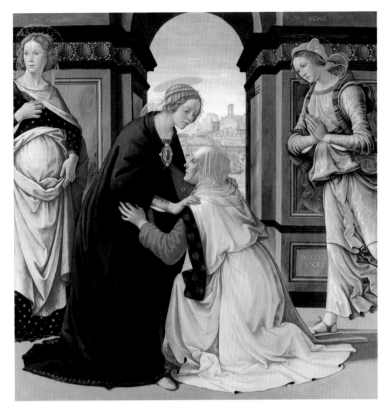

including their artistic depictions—was both modernizing and historicizing.[5] This paradox finds a counterpart in the artist's choice of materials, namely pastel, a medium that was reinvigorated as part of the Rococo Revival. Similar to many of Degas's finest pictures, nineteenth-century millinery relied upon its rich history for source material.

46 Leonardo da Vinci, *The Virgin and Child with Saint Anne*, ca. 1503–1519. Oil on panel, 66 ⅛ x 51 ⅛ in. (168 x 130 cm). Musée du Louvre, Paris, inv. 776

47 Domenico Ghirlandaio, *The Visitation*, 1491. Oil on panel, 67 ⅜ x 65 in. (171 x 165 cm). Musée du Louvre, Paris, inv. 297

THE HISTORICIZATION OF HATS

In the nineteenth century, there was a proliferation of publications devoted to the history of costume and, even more specifically, the history of the hat.[6] Such publications found precedent in the previous century, with examples such as Nicolas Dupin's *Galerie des modes et costumes français* (Gallery of French fashion and costumes, 1777–1778), which was printed during the reign of Marie Antoinette and reported that "French headwear . . . appeared to be the only object capable of capturing the interest of people of both sexes."[7] The book included short descriptions of the materials used to construct elaborate headwear and instructions for appropriate usage, but it was the whimsical engravings that brought these descriptions to life. The designs were

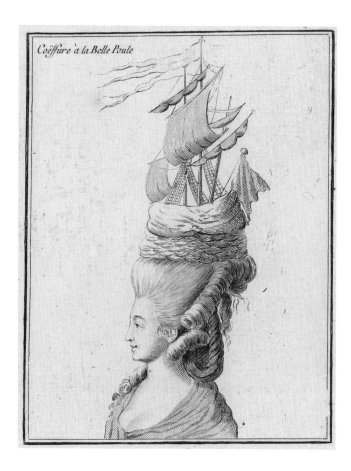

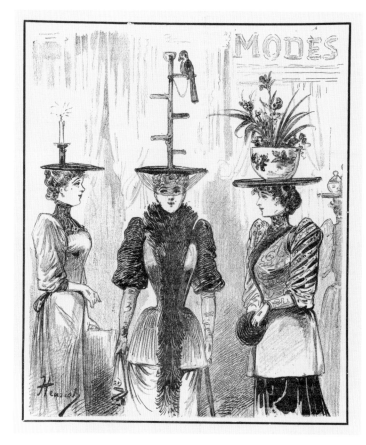

meant to delight and surprise; one such example featured a model of the famous French frigate the *Belle Poule*, balanced upon a straw base that was carefully pinned to a mound of teased hair (fig. 48).[8] The popularity of these fantastical images, based on actual models, persisted into the next century, with Baudelaire even reporting that he owned "a series of fashion plates, the earliest dating from the Revolution . . . [that] have a double kind of charm, artistic and historical."[9] Illustrations such as those found in Dupin's *Galerie des modes* served not only as a reminder of the past but also as fodder for reinvention. A caricature printed in *Le Charivari* in 1891 (fig. 49)—featuring three women in extravagant hats topped with a candle, a parrot, and a house plant, respectively—is not far removed from its equally playful eighteenth-century counterpart. Though a parody, it references the ever-outlandish products available up and down rue de la Paix—such as one, featured in September 1883, replete with a domestic cat's head.[10]

There was a demand for illustrated histories of fashion—likely generated by a boom in consumer culture (see

Simon Kelly's discussion, pp. 18–20)—and new volumes continued to appear throughout the nineteenth century, such as Paul Lacroix's ten-volume *Les Costumes historiques de la France d'après les mouvements les plus authentiques, statues, bas-reliefs* . . . (Historic costumes of France after the most authentic movements, statues, bas-reliefs . . . , 1852), Augustin Challamel's four-volume *La France et les français à travers les siècles* (France and the French through the centuries, 1884), and Auguste Racinet's six-volume *Le Costume historique* (Historic costume, 1888).[11] Gabrielle d'Èze (a pseudonym) and A. Marcel's *L'Histoire de la coiffure des femmes en France* (History of womens' hats in France, 1886) was devoted exclusively to hair and hat fashion, and, unlike many other contemporary publications, the narrative was primary over the illustrations. The authors approached their history in a scientific manner redolent with a post-Enlightenment sensibility:

When they finish this reading . . . in which the history of the hat is pleasantly likened to that of the most serious

Modèles de Hennins.

ÉTUDE SUR LES DIFFÉRENTES TRANSFORMATIONS APPORTÉES AUX CHAPEAUX DE FEMMES, PHOTOGRAVURE DE L'ŒUVRE.

bodies of knowledge, will our lady-readers please return to the foreword of our study, where, in attempting to identify the principal features of the history of hats, we have dared to also show their philosophical and serious side?[12]

Here the readers were reminded that one can appreciate current fashion only by understanding past models. Embracing the popularity of this instructive text, one of the premier periodicals devoted to hats, *La Modiste parisienne*, reprinted it in monthly installments. Thus, the history of the hat was even more widely circulated. The accompanying illustrations, documenting styles from the Middle Ages through the present day, typically featured a cluster of bust-length depictions of women in various profiles in order to best model the headwear (fig. 50). Periodicals devoted to millinery also included visual histories that allowed the reader to chart the stylistic development of the hat—one example from 1887 even did so in several-year increments beginning in 1801 (fig. 51)—further legitimizing

48 Unidentified artist, *Hat à la Belle Poule*, from Nicolas Dupin's *Galerie des modes et costumes français*, 1777–1778. Engraving. Bibliothèque nationale de France, Paris

49 Henriot, *Tomorrow's Styles*, from *Le Charivari*, ca. 1892. Lithograph, 11 ½ x 10 ½ in. (29.2 x 26.7 cm). Private collection

50 Unidentified artist, *Models of Hennins*, from *La Modiste parisienne*, 1893. Bibliothèque nationale de France, Paris, FOL-LC14-215

51 René Bressler, *Study of the Transformations in Women's Hats*, 1887. Photogravure, 13 ⅛ x 9 ¾ in. (33.2 x 24.9 cm). Private collection

52 Degas, page 143 in notebook 18, ca. 1859–1864. Pen and black ink, 10 x 7 ½ in. (25.4 x 19.2 cm). Bibliotheque nationale de France, Paris

53 Peter Paul Rubens, *Hélène Fourment with a Carriage*, 1639. Oil on canvas, 76 ¾ x 52 in. (195 x 132 cm). Musée du Louvre, Paris, RF 1977-13

the consumer's interest (and financial investment) in this time-honored accessory. Whether Degas consulted millinery literature is uncertain, though his annotation in a notebook about "a treatise on ornament for women or by women, based on their manner of observing," suggests his awareness of such texts.[13] His sketch of a disembodied head with a high conical hat ornamented with shells (fig. 52), while likely copied from an Italian red-figured vase painting, resembles, if inadvertently, the manifold illustrations in millinery journals.[14]

Prior to the publication of *L'Histoire de la coiffure*, d'Èze contributed serial installments to a publication largely devoted to millinery, *Le Caprice*. In an article of June 1881, she argued that women should embrace current fashion, which was better suited to a hectic urban lifestyle, while also acknowledging the ever-persistent demand for historicizing costume:

> We must resign ourselves, in our democratic century, in which all the classes are mixed together . . . we must resign ourselves to adopting the fashions that are best suited to our turbulent life, to the constant comings and goings in the streets, in the shops, on trains, to this American-style life that no longer comprises the particularly delicately elegant manners of the eighteenth century . . . we try to adapt them as much as possible to our current customs. This is why, we see many women of taste copy . . . the characteristic features of the clothing

that Versailles and Trianon wore to such marvelous advantage.[15]

Despite living in an age of urbanization, where women traversed town freely by foot or train, they nevertheless desired models that alluded to a largely imagined past. Journalist, critic, and politician (and briefly French Minister of Culture) Antonin Proust revealed that Manet encountered such a historicizing example when he visited the studio of Madame Virot, where he found her "leaning with her elbow on the mantel wearing a *fichu* à la Marie Antoinette and an arrangement of lace that set off the whiteness of her hair: 'Good heavens, Madame, . . . you have a fine head to take up to the executioner's scaffold!'"[16]

The models that inspired particular hat fashions were also deeply rooted in the history of art. In *L'Art dans la parure et dans le vêtement (Art in Ornament and Dress,* 1875), Charles Blanc suggested that "a woman who wishes to do all she can in order to please must . . . look to painters

enterprise, reinforcing the connection between the act of making a hat and that of painting a canvas.

Baroque painters such as Rubens, van Dyck, and Vélazquez inspired hat fashion, but artists of the eighteenth century were also avidly evoked. The positive reception of eighteenth-century–inspired hats should be seen as part of the greater Rococo Revival, largely initiated by Edmond and Jules de Goncourt's *L'Art du dix-huitième siècle* (*French Eighteenth-Century Painters*, 1880–1882).[20] The Goncourts' survey of the art of the previous century celebrated the ideal world of the *fête galante*—the genre of painting featuring elegant men and women in fancy dress outdoors—and such constructed fantasies were easily transferable to fashion.[21] The "chapeau Watteau," one of many such examples, was a prominently featured style in the spring of 1896 at the shop of Madame Avy on 14, avenue de l'Opéra. The written language used to describe this hat is seemingly meant to evoke the colors, textures, and frisson of Jean-Antoine Watteau's most celebrated painting at the Musée du Louvre, *Pilgrimage to the Isle of Cythera* of 1717 (fig. 54).[22] To heighten the Rococo overtones, the milliner draped white lace and black feathers under two large seashells—the literal source for the term "Rococo" (*rocaille*).[23] Milliners understood the commercial viability of products with links to fine art; for instance in July 1881, a featured hat in *Le Caprice* was described as a "Gainsborough hat covered in white plumes."[24]

The proliferation of styles—named not only after paintings but also after elite historic figures and structures of the eighteenth century such as Madame du Barry, Marie Antoinette, Louis XVI, the Princess of Lamballe, and the Trianon—signals a romanticization of the defunct aristocracy of the Third Republic. As reported in *La Modiste universelle* in the spring of 1895:

> The Louis XVI style has entered the fray, and our pretty society ladies examine one another secretly with the grand airs of the Duchess of Polignac and the Princess of Lamballe . . . which suit them enchantingly under their elegant hat in the *collier de la reine* style, which they all now own! . . . Oh! If they could risk the powder and the little red heels, without appearing to be in costume, how happily they would don them.[25]

The language used to describe millinery, as well as many of the hats on view in the millinery shops, was thus firmly

and especially to the portraits painted by the most famous artists . . . [Peter Paul] Rubens, [Anthony] van Dyck, [Diego] Velázquez, [Joshua] Reynolds, [Thomas] Lawrence, [François] Gérard, and [Jean-Auguste-Dominique] Ingres."[17] Specific paintings, in turn, directly inspired some of the most sought-after hats—imbuing the wearer with an added sophistication through association. The "chapeau Rubens" (see fig. 107)—sold at the shop of Madame Dubosc on 16, rue Daunou (near the corner of rue de la Paix)—was apparently inspired by Rubens's *Hélène Fourment with a Carriage* (1639; fig. 53) in the Musée du Louvre.[18] The painting features the artist's wife, dressed with a small black hat, about to alight with her children from a carriage. The "chapeau Rubens" was accordingly described as a "very elegant hat for visits to the chateau . . . [with] a ball of black velour."[19] By associating a hat with a celebrated old master painter and a work on public view, the milliner aligned herself with the grand tradition and asserted her craft as a cerebral

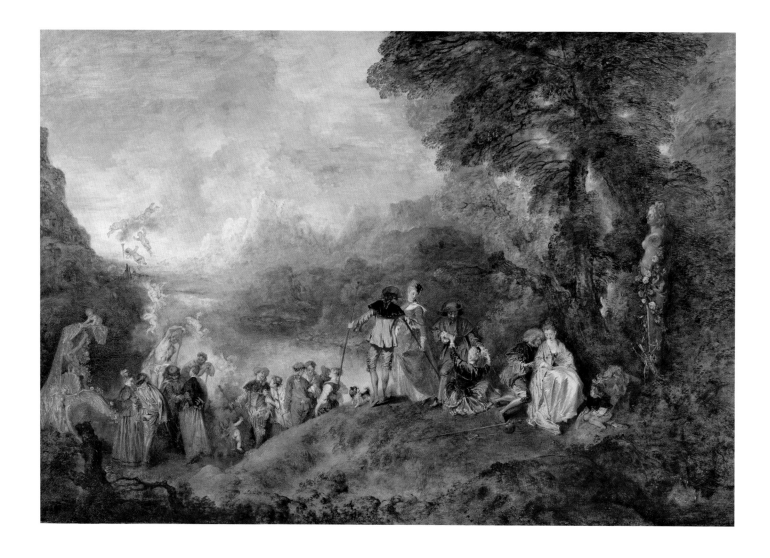

54 Jean-Antoine Watteau,
Pilgrimage to the Isle of Cythera, 1717.
Oil on canvas, 50 ¾ x 76 ⅜ in. (129 x
194 cm). Musée du Louvre, Paris, inv.
8525

55 Mariano Alonso Pérez y
Villagrosa, *Ladies at the Milliners*,
ca. 1890s. Oil on panel, 28 ¼ x
36 ⅛ in. (91.7 x 71.7 cm). Private
collection

rooted in history. The hat of the nineteenth century was
understood to have developed from the past, sometimes
quite literally from the art of the past. In a painting by
Mariano Alonso Pérez y Villagrosa, who was active in Paris
in the 1890s, we encounter a bizarrely disjointed scene
exemplifying this "historicizing paradox" (fig. 55). Two men
in pseudo-eighteenth-century court costumes—replete
with tricorns—accompany their modishly dressed ladies
for a hat fitting. The woman's dress in purple at far right is
typical of an 1890s silhouette, as is the floral-patterned tea
frock at center. Underscoring the disjointed time refer-
ence, an eighteenth-century gilded carriage passes by the
open window. This juxtaposition of contemporary fashion
with details drawn from the Rococo pictorial tradition is
emblematic of the greater discourse surrounding millinery
in the age of Degas.

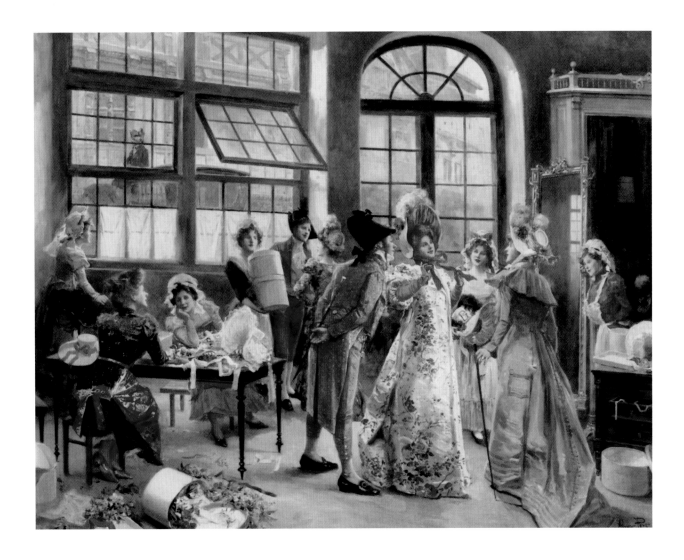

DEGAS, PASTEL, ROCOCO REVIVAL

Pastel, a dry and malleable material, allowed Degas to evoke an array of textures that corresponded to the milliner's fineries—be they beads, feathers, ribbons, or lace. He preferred pastel to oil paint when he treated the subject of millinery, and he employed it in nineteen of these scenes. Furthermore, he would have understood that pastel only heightened the intrinsic association between these pictures and the grand tradition as it was a preferred medium in eighteenth-century France, especially for portraits of the elite wearing their most stylish fashions. This connection was not lost upon contemporary critics. In his review of the Salon of 1877, Louis Gonse noted that Degas had tried "to revive the medium by rejuvenating it" and created works "not unworthy of the grand traditions of . . . [Georges de] La Tour and [Jean-Siméon] Chardin." Evidenced by Degas's

innovation, "pastel, an excellent medium for its lightness and freshness, will resume the role it had abdicated."[26]

Though pastel was used widely in the early eighteenth century, by the 1760s and 1770s enthusiasm for it had begun to wane as it was criticized for being frivolous and weak in comparison to the more "masculine" technique of oil painting.[27] Critic and philosopher Denis Diderot famously lambasted pastel for its ephemerality, writing that the "precious powder will fly from its support, half of it scattered in the air and half clinging to Saturn's long feathers."[28] Following the Revolution, its associations with Ancien Régime portraiture and an overall anti-Rococo sentiment further diminished the medium's desirability. Pastel largely became a secondary medium used for preparatory studies, until it was once again championed by Degas and his contemporaries.[29]

The first revival of interest in the medium was in the 1830s, when a growing number of pastels was exhibited at the Salon in a distinct category ("Les Aquarelles, pastels, dessins, etc.").[30] By the 1880s the revitalization had reached a crescendo due in part to gallery owner and entrepreneur Georges Petit.[31] Petit had inherited his father's business and inventory, which consisted largely of eighteenth-century pictures, and he opened his gallery on the rue de Sèze for private exhibitions, including those of La Société des Pastellistes Français. This society, including such artists as Rosa Bonheur, Léon-Augustin Lhermitte, Odilon Redon, and James Tissot, was founded in 1885 in order to "develop and encourage the art of pastel, principally by organizing exhibitions."[32] Petit's patronage was not altogether altruistic, as he likely hoped to stimulate the sale of his existing stock. The society met at Petit's gallery, and its first exhibition featured works by the founding members alongside those of such artists as Maurice-Quentin de La Tour, Charles-Antoine Coypel, and Rosalba Carriera.[33] Though Degas was not a member of the group, his avid use of pastel coincided with its widely publicized exhibitions, and he had even potentially encouraged their activity. According to *La Vie artistique*, "a week after the first exhibition opened, there wasn't a box of pastels to be found in Paris at the art-supply shops! Rest assured, they are now in stock."[34]

Auguste De Gas, Edgar Degas's father, was a friend of prominent collectors of eighteenth-century art such as Louis La Caze and Eudoxe Marcille, associations that likely encouraged his own acquisition of the eighteenth-century pastel portraits that his son would later inherit.[35] Though Edgar was forced to sell at least two works by Maurice-Quentin de La Tour in 1875 after the family business collapsed, he kept at least one eighteenth-century oil painting from his father's collection—Jean-Baptiste Perronneau's *Bust of a Woman (Madame Miron de Porthioux)* (1771; fig. 56), a work that appears on the wall in Degas's 1869 portrait of his sister Thérèse as she stands demurely with a feathered hat prominently featured in her left hand (fig. 57).[36] This highly worked pastel evokes the eighteenth century not only in its harmonious palette of reds, golds, and yellows but also quite literally in the display of the Louis XV frames and gilded-bronze candelabra surrounding her in the family's apartment.[37] The polished and thick application of pastel resembles La Tour's many portraits

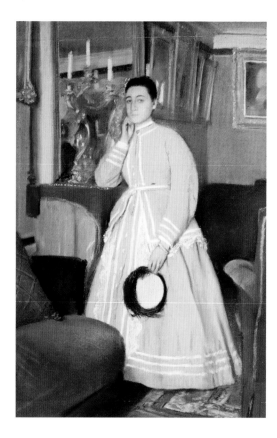

of his distinguished patrons, a stylistic allusion perhaps brought on, in part, by Degas's respectful acknowledgment of his father's taste.[38]

According to Louisine W. Havemeyer, a renowned collector of Impressionist pictures and a close friend of Mary Cassatt, Degas "loved to visit Saint-Quentin [La Tour's hometown] and see those wonderful pastel portraits there."[39] His early copy dated around 1868–1870 (fig. 58), after La Tour's *Portrait of a Man* (ca. 1760; Musée Jacquemart-André, Paris), attests to this artistic admiration.[40] So convincing was his copy that when the picture sold in his first posthumous sale in 1918, it was listed as "École française, XVIIIe siècle" (French school, eighteenth century).[41]

La Tour also possibly inspired one of Degas's most introspective compositions, *Self-Portrait in a Soft Hat* of 1857 (cat. no. 55), created when he was still a student of Louis Lamothe.[42] Though this painting has been described in relation to Lamothe's somber manner and to a self-portrait by Ingres, it seems equally convincingly inspired by an earlier model. By 1856, La Tour's *Self-Portrait in a Studio Toque* (ca. 1742; fig. 59) was on view in the chapel of the former abbey of Fervaques in Saint-Quentin—the city's first municipal museum—where Degas possibly encountered the work on one of his many visits.[43] La Tour's pastel is generally thought to have been a study, while Degas's painting follows the same example—using thin paint upon the paper's surface to render the bust with flourishes of white, black, and orange that even seem to suggest the pastel medium.

Chardin's *Self-Portrait with Spectacles* of 1771 (fig. 60), which was acquired by the Louvre in 1839 from the Bruzard collection, also bears comparison.[44] With his head covering and pink scarf tied around his neck, the aging Chardin looks to the viewer in a confident manner perhaps emulated by the young Degas. Marcel Proust was among the many champions of Chardin's pastels, imploring his readers to "go to the Pastel Gallery and see the self-portraits of Chardin. . . . Just like the fabric, [his skin] has retained and almost revived its shades of pink."[45]

The irony of Degas's millinery pastels is that they on the one hand inherently reference art of the past in the choice of their medium, but on the other hand are anti-traditional in the incredibly inventive manner of his practice. (For instance, he would occasionally wet the pastel stick to achieve heightened saturation, or create a pastel paste to apply with a brush.[46]) In Degas's final treatment of the subject, *At the Milliner's* of circa 1905–1910 (cat. no. 91), the woman at center is a solid and abstract mass of darkness. Degas blended the pastel on her face so that her identity is obscured and indistinct, and he placed a dense mound of colors in the foreground. A second milliner, truncated at right, holds the blue plume at the center of the composition, where Degas sharpened the tip of the pastel so he could apply fine, curled lines suggesting the feather's barb. It appears he even used a knife, or perhaps a fingernail, to create surface texture to the back wall. This quiet depiction, which references the age-old practice of millinery, is simultaneously traditional and radical.

MUSEUMS, MILLINERY, AND THE HISTORY OF ART

As noted by Gloria Groom, Degas's series of women viewing paintings in museums was made during the same period as his most intense preoccupation with millinery, and both represent "untouchable objects of desire and aesthetic consumption."[47] His museum series includes approximately half a dozen pastels, two paintings, two prints, and at least five drawings.[48] These quiet scenes of anonymous women gazing at fine art should be seen as closely related to the millinery pictures in their inherent meaning. Both series focus on a woman's absorption in objects that reference a historic continuum. Each work presents a quiet, distilled moment constructed around the feminine gaze, where the museum-goer or the milliner is consumed by the activity of looking and intellectualizing one's place in time and space.

In the loosely rendered *Woman Viewed from Behind (Visit to a Museum)* of circa 1879–1885 (cat. no. 31), Degas

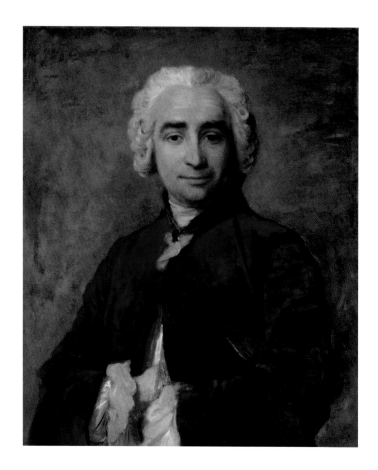

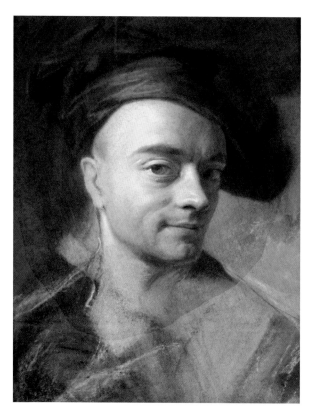

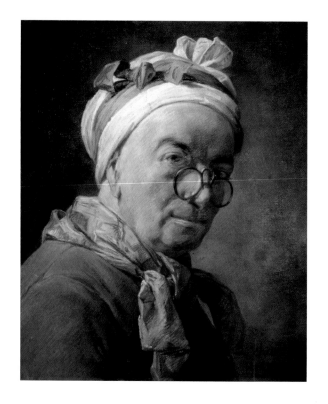

58 Degas, *Portrait of a Man* (copy after Maurice-Quentin de La Tour), ca. 1868–1870. Oil on canvas, 29 ⅝ x 24 ⅝ in. (75 x 62.5 cm). Musée cantonal des Beaux-Arts de Lausanne

59 Maurice-Quentin de La Tour, *Self-Portrait in a Studio Toque*, ca. 1742. Pastel on blue paper, 15 ⅜ x 12 ¼ in. (39 x 31 cm). Musée Antoine Lecuyer Saint-Quentin, France, inv. LT 3

60 Jean-Siméon Chardin, *Self-Portrait with Spectacles*, 1771. Pastel on gray-blue paper, 18 ⅛ x 15 in. (46 x 38 cm). Musée du Louvre, Paris, inv. 25206

was uninterested in portraying a formal likeness, instead featuring the woman (traditionally identified as Mary Cassatt) from behind, her profile cast in shadow and a plumed black hat cradling her head. The focus is her engagement with the pictures directly before her; judging from the paired pink scagliola columns visible at right, she stands in the Grande Galerie of the Musée du Louvre. The English painter Walter Sickert recalled that Degas had told him about the picture that "he wanted to give the idea of that bored and respectfully crushed and impressed absence of all sensation that women experience in front of paintings."[49] This statement, a secondhand remark and thus not entirely reliable, should be regarded with skepticism. Degas's supposed misogyny, an oft-remarked aspect of his practice that dates back to the nineteenth century, was anything but straightforward.[50] His pictures of women in museums hardly present vapid and inattentive figures; on the contrary, the women mirror their maker's activity in their act of seeing.[51] Sickert also reported that as Degas painted the background with bold, thick brushstrokes suggesting frames on the wall, the artist claimed: "With this I must give a bit of the idea of (Veronese's) *The Marriage at Cana*."[52] Degas's choice of setting in the Louvre's Grande Galerie is a direct indication of his respect and appreciation for the history of art, a fact made clear by the many copies he made in the museum when he was younger, predominantly between 1853 and 1861.

An association between the milliner and the painter was pervasive in popular culture in the time of Degas. In her essay of 1841, "La Modiste," Maria d'Anspach wrote of the *modiste*'s status, likening her workshop to that of an artist's studio:

> If you ask me again how and why she became what she is, I will reply that she became a *modiste* in the same way that perhaps you yourself became an artist . . . because it's sometimes a way to get somewhere, if one doesn't die in the meantime of despair and destitution . . . it is a fairly advantageous position for waiting, for being on the lookout for good luck and grabbing it on the fly. One is visible, or at least believes oneself to be, and who knows? Bankers, rich foreigners, and Russian princes sometimes visit millinery workshops as well as painters' studios, and if they buy a painting in the latter, they often select a pretty woman in the former.[53]

Like an artist, the milliner can use her craft to ensnare good fortune or, as d'Anspach pessimistically insinuated, the patronage of a man. Furthermore, the implication is that the milliner's display of her finest creations, as well as herself, finds a parallel in the display of an artist's paintings, which are meant to be venerated and contemplated. The milliner was superior to the shopgirl because of the requisite talent needed to perform her duties, much as a painter was elevated above a mere craftsman because of his erudition (a tenet of the founding of the Académie royale de peinture et de sculpture in 1648). A hat is not simply an object of everyday adornment; it is precious, and it has the ability to transform the life of its wearer, as well as the life of its maker.

At the Milliner's of 1882 (fig. 61) is one of Degas's most introspective pastels. It was acquired by Durand-Ruel directly from the artist and later sold to a Madame Angello, who lent it to the eighth Impressionist exhibition in 1886.[54] The work features a woman with a generalized visage in a nondescript interior, examining herself in the mirror. Upon her head rests a straw bonnet adorned with artificial flowers, while a milliner or shopgirl holds two alternative creations—one seemingly of brightly colored plumes and the other possibly of lace, flowers, and ribbons. The manner in which the woman contemplates her own reflection in the mirror, her face tightly framed by the hat—an artistic fabrication—finds parallel in the idea of a person gazing upon the two-dimensional product of a painter's act of creativity. The hat, like a painting does a viewer, transports the wearer into heightened reality. Critic Jean Ajalbert wrote in his review of the 1886 exhibition, "She has admired this hat for a long time in the shop window, or envied it on another woman. She forgets herself in scrutinizing her new head."[55] In "scrutinizing" her own reflection, she loses herself in aesthetic consumption.

In another pastel of 1882, Degas presents the milliner's wares as precious artistic objects (fig. 16). Here extravagant hats crowd the foreground, and with their variety of textures and bold colors they resemble a museum display of decorative art worthy of introspection. In his "The Painter of Modern Life," Baudelaire wondered if there would one day be a play in which there was a "revival of the fashions in which our fathers thought themselves just as captivating as we ourselves think we are, in our modest garments . . . the past, whilst retaining its ghostly piquancy, will recapture the light and movement of life, and become present."[56]

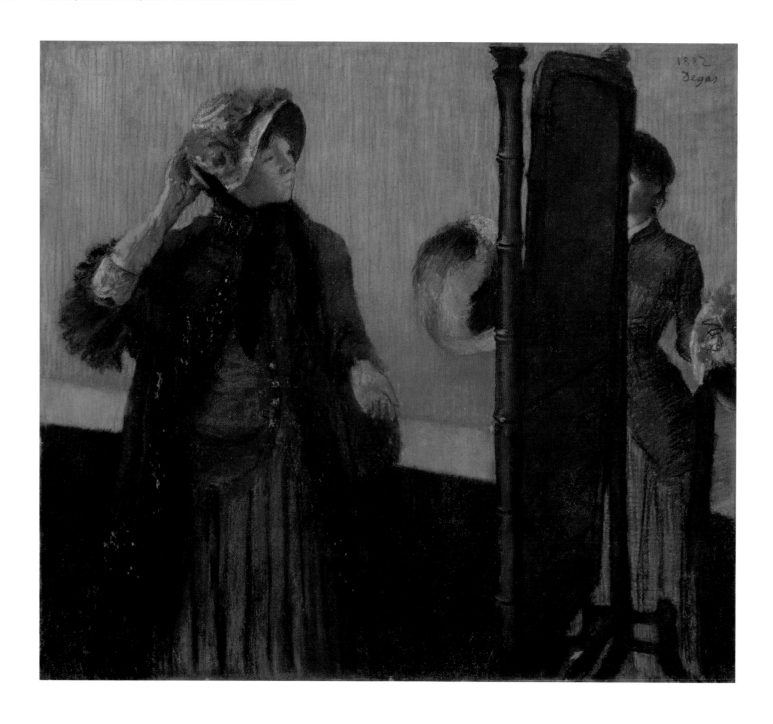

61　Degas, *At the Milliner's*, 1882.
Pastel on paper, 30 x 34 in. (76.2 x
86.4 cm). The Metropolitan Museum
of Art, New York, H. O. Havemeyer
Collection, Bequest of Mrs. H. O.
Havemeyer, 1929, 29.100.38

This play was, in fact, being enacted in the streets of Paris. The nineteenth-century millinery industry, with its pointed references to historic models and methods of practice, as well as to the history of art, did just this. In the first example cited, *At the Milliner's* (fig. 45), Degas subtly referenced the old masters—whereby the canon of art history served as the foundation from which he would establish his own unique contribution to an ever-unfolding grand tradition. For both the painter and the milliner, the study of, and respect for, the past gave gravitas to the creations of the present.

———•———

All translations are by the author unless otherwise noted, with refinements made by Alexandra Bonfante-Warren.

EPIGRAPH: "Il a jeté un pont entre deux époques, il relie le passé au plus immédiat présent." (He threw a bridge between two eras, he bound the past to the most immediate present.) Jacques-Émile Blanche, *De David à Degas*, vol. 1 of *Propos de peintre* (Paris: Émile-Paul Frères, 1919), 287; cited in Gary Tinterow, "The 1880s: Synthesis and Change," in Jean Sutherland Boggs, ed., *Degas*, exh. cat. (New York: Metropolitan Museum of Art; and Ottawa: National Gallery of Canada, 1988), 374.

1 These art-historical references were first observed by Colin B. Bailey. See Bailey, Joseph J. Rishel, and Mark Rosenthal, eds., *Masterpieces of Impressionism and Post-Impressionism: The Annenberg Collection*, exh. cat. (Philadelphia: Philadelphia Museum of Art, 1989), 20. On Degas using copying as a way of "creating works whose foundation is in the tropes of the canon," see Claire Louise Kovacs, "Edgar Degas and the Ottocento" (PhD dissertation, University of Iowa, 2010), 75–77.

2 On Baudelaire's influence on the Impressionists' depictions of fashion, see Ruth E. Iskin, *Modern Women and Parisian Consumer Culture in Impressionist Painting* (Cambridge: Cambridge University Press, 2007), 62–68.

3 Iskin, ibid., 62, 64, 236n8; and Ann Dumas, ed., *The Private Collection of Edgar Degas*, exh. cat. (New York: Metropolitan Museum of Art, 1997), 175n143.

4 Charles Baudelaire, *The Painter of Modern Life*, translated by P. E. Charvet (London: Penguin Books, 2010), n.p.

5 See Marie Simon's discussion of this phenomenon in greater nineteenth-century fashion. Simon, *Fashion in Art: The Second Empire and Impressionism* (London: Zwemmer, 1995), 82–125.

6 Ibid., 89.

7 "Le Costume des Têtes Françaises . . . paraissaient être le seul objet qui dût fixer la curiosité des Personnes de l'un & de l'autre sexe." Nicolas Dupin, *Galerie des modes et costumes français* (Paris: Srs Esnauts et Rapilly, 1777–1778), i. On millinery in the eighteenth century, see Kimberly Chrisman Campbell, "The Face of Fashion: Milliners in Eighteenth-Century Visual Culture," *British Journal for Eighteenth-Century Studies* 25 (2002): 157–172.

8 The *Belle Poule* dueled the British frigate HMS Arethusa in 1778—thus beginning France's involvement in the American War of Independence.

9 Baudelaire, *The Painter of Modern Life*, n.p.

10 *La Modiste universelle*, September 1883, M336. There was a market for the furs and skins of domestic cats; see Nicholas Daly, *The Demographic Imagination and the Nineteenth-Century City: Paris, London, New York* (Cambridge: Cambridge University Press, 2015), 180–181.

11 See Simon, *Fashion in Art*, 89.

12 "En terminant la lecture . . . où l'histoire du chapeau est plaisamment assimilée à celle de la plus grave des sciences, nos lectrices voudroint-elles se reporter à l'avant-propos de notre étude où, essayant de dégager les grandes lignes de l'histoire de la coiffure, nous n'avons pas craint d'en montrer en même le côté philosophiques et sérieux?" Gabrielle d'Èze and A. Marcel, *Histoire de la coiffure des femmes en France* (Paris: Paul Ollendorff, 1886), 152–153.

13 "La source de l'ornement. Pense à un traité d'ornement pour les femmes ou par les femmes, d'après leur manière d'observer, de combiner, de sentir leur toilette et toutes choses. Elles comparent journellement plus que les hommes mille choses visibles les unes aux autres." (The origin of ornament. Consider a treatise on ornament for women or by women, based on their manner of observing, putting together, experiencing their dress and all things. They compare daily, more than men, a thousand visible things among themselves.) Theodore Reff, ed., *The Notebooks of Edgar Degas* (Oxford: Clarendon Press, 1976), 1:117–118; Iskin, *Modern Women and Parisian Consumer Culture*, 60, 235n2; Gloria Groom, ed., *Impressionism, Fashion, and Modernity*, exh. cat. (Chicago: Art Institute of Chicago; New York: Metropolitan Museum of Art; and Paris: Musée d'Orsay, 2012), 218, 318n1.

14 Reff, *The Notebooks of Edgar Degas*, 1:97, 2:n.p.

15 Gabrielle d'Èze, "Modes," *Le Caprice*, June 16, 1881, 2: "Il faut nous résigner, dans notre siècle de démocratie, où toutes les classes sont confondues . . . il faut nous résigner à adopter les modes qui conviennent le mieux à notre vie turbulente, à ce va-et-vient perpetual dans les rues, dans les magasins, en chemin de fer, à cette existence à l'américaine qui ne comporte plus les élégances tout particulièrement delicates du XVIIIe siècle. Mais comme, avant tout, ells nous tentent, nous nous efforçons de les adapter autant que possible à nos moeurs actuelles. Aussi voit-on nombre de femmes de goût copier . . . les principaux caractères de ces costumes que Versailles et Trianon faisaient si merveilleusement valoir."

16 "En entrant chez Mme Virot, qui était accoudée à la cheminée avec un fichu à la Marie-Antoinette et un arrangement de dentelles qui faisant valoir la blancheur de ses cheveux. 'Sapristi, Madame, s'écria-t-il, vous avez une belle tête pour monter à l'échafaud.'" Antonin Proust, "Souvenirs sur Édouard Manet," *La Revue blanche* 11, no. 86 (January 1, 1897): 310–311.

17 "Une femme qui ne veut rien négliger pour plaire doit, sur ce point comme sur beaucoup d'autres, consulter les peintres et surtout les portraits peints par les plus fameux artistes en ce genre, Rubens, Van Dyck, Velázquez, Reynolds, Lawrence, Gérard, Ingres." Charles Blanc, *L'Art dans la parure et dans le vêtement* (Paris: Librairie Renouard, 1875), 270; cited in Simon, *Fashion in Art*, 130.

18 Marie Simon analyzes the relationship between this painting and the popular "Rubens dress" in the nineteenth century; see Simon, *Fashion in Art*, 93–94.

19 "Très elegant chapeau pour visites de château . . . [avec] un chou de velours noir." *La Modiste parisienne & Le Caprice réunis*, September 1, 1897, 196.

20 Edmond and Jules de Goncourt, *L'Art du dix-huitième siècle*, 2 vols. (Paris: A. Quantin, 1880–1882).

21 On the Rococo Revival and the Goncourts, see Ken Ireland, *Cythera Regained? The Rococo Revival in European Literature and the Arts, 1830–1910* (Madison, NJ: Fairleigh Dickinson University Press, 2006), 32.

22 "Grande capeline de paille de riz blanche, abaisée sur le front et coupée court derrière, où la garniture présente la partie la plus intéressante du chapeau. La calotte s'entoure d'un ruban rayé maïs et coquelicot qui vient en arrière, de chaque côté, former deux larges coques drapées resserrées au milieu par une aigrette de dentelle blanche accompagnée de 2 plumes noires posées droites. A droite, chou de même dentelle avec pan drapé retomant sur les cheveux relevés très haut à la Watteau (c'est-à-dire sans chignon apprent sous le chapeau, tel que l'exige la mode actuellement)." (A large, white-rice-straw capeline, low in the front and cut off short in back, where the decoration displays the most interesting part of the hat. The crown is wrapped in striped poppy- and corn-colored ribbon that comes around on either side to the back, where it forms two large stiffened loops cinched in the middle with a white-lace aigrette with 2 black feathers set upright. On the right, a cabbage knot of the same lace with a stiffened panel that falls onto hair piled very high à la Watteau [that is, with no chignon visible under the hat, as required by today's fashion].) *La Modiste parisienne*, May 16, 1896, 112.

23 According to Colin B. Bailey, "'Rocaille' were rocky substances used since the Renaissance with shells and other incrustations in the construction of grottoes." See Bailey, "Was There Such a Thing as Rococo Painting in Eighteenth-Century France?," in *Rococo Echo: Art, History and Historiography from Cochin to Coppola*, ed. Melissa Lee Hyde and Katie Scott, Oxford University Studies in the Enlightenment, no. 12 (Oxford: Voltaire Foundation, 2014), 172.

24 "Le Grand Prix nous a prouvé que la simplicité n'était pas encore descendue du ciel à la voix de la République . . . un chapeau *Gainsborough* couvert de plumes blanches." (The Grand Prix showed that simplicity has not yet come down from heaven in the Republic's opinion . . . a *Gainsborough* hat covered in white plumes.) *Le Caprice*, July 1, 1881, 7.

25 "Mesdames, le genre Louis XVI entre en lice, et nos jolies mondaines s'examinent toutes à la dérobée avec de grands airs de Duchesse de Polignac, de Princesse de Lamballe. . . qui leur siéent à ravir sous leur élégant chapeau genre Collier de la Reine, qu'elles possèdent toutes maintenant! Les coiffures si ondulées et si bouffantes s'y prêtent si bien du reste! Ah! Si elles pouvaient risquer la poudre et les petits talons rouges, sans avoir l'air travesties, comme elles s'en pareraient à plaisir." *La Modiste universelle*, May 1, 1895, 2.

26 "Un artiste de beau-coup d'esprit et d'infiniment plus de talent qu'il ne veut le paraître, M. Degas . . . essaye de faire revivre le procédé en le rajeunissant . . . Ses études . . . exécutées au pastel, sont très-remarquables comme vérité d'accent, comme justesse de ton, comme geste, comme mimique, et en outre ne sont point indignes des grandes traditions dès La Tour et dès Chardin. D'autres le suivant dans cette voie, il est à penser que le pastel, instrument excellent par sa légèrté et sa fraîcheur, pourra reprendre le rôle qu'il avait abdiqué." (An artist with a great deal of wit and infinitely more talent than he wishes to let on, M. Degas . . . tries to revive the medium by rejuvenating it. . . . His studies . . . executed in pastel are very remarkable in their ring of truth, precision of tone, gesture, and mimicry, and what is more they are not unworthy of the grand traditions of the works of La Tour and Chardin. If others will follow him in this course, we may believe that pastel, an excellent medium for its lightness and freshness, will resume the role that it had abdicated.) Louis Gonse, "Les aquarelles, dessins et gravures au Salon de 1877," *Gazette des Beaux-Arts*, August 1, 1877, 162; and Douglas W. Druick and Peter Zegers, "Scientific Realism: 1873–1881," in Boggs, *Degas*, 202.

27 Thea Burns, *The Invention of Pastel Painting* (London: Archetype Publications, 2007), 153.

28 Cited in Katharine Baetjer and Marjorie Shelley, *Pastel Portraits: Images of 18th-Century Europe*, exh. cat. (New York: Metropolitan Museum of Art, 2011), 27.

29 Ibid., 54.

30 Anne F. Maheux, *Degas Pastels* (Ottawa: National Gallery of Canada, 1988), 18, 78n8.

31 Esther Bell, "Degas, Renoir, and Poetic Pastels," *Pastel Journal* (October 2013), 24.

32 According to the society's constitution: "Article Premier. La Société de Pastellistes Français, fondée en 1885, est reconstituée pour manifester, développer et encourager l'art du pastel, principalement par l'organisation d'expositions." (First Article. The Société de Pastellistes Français, founded in 1885, is reconstitued in order to display, develop, and encourage the art of pastel, principally by organizing exhibitions.) *La Vie artistique*, February 17, 1888, 51.

33 Doreen Bolger, ed., *American Pastels in the Metropolitan Museum of Art* (New York: Metropolitan Museum of Art, 1989), 12.

34 "Une semaine après l'ouverture de la première exposition, on ne trouvait plus de boîtes de pastels, à Paris, chez les marchands de couleur! Rassurez-vous, ils en sont pourvus maintenant." *La Vie artistique*, April 22, 1888, 122.

35 Theodore Reff, *Degas: The Artist's Mind* (New York: Metropolitan Museum of Art, 1976), 114; Carol Armstrong, *Odd Man Out: Readings of the Work and Reputation of Edgar Degas* (Chicago: University of Chicago Press, 1991), 259n53; and Dumas, *The Private Collection of Edgar Degas*, 128–130.

36 The painting appeared in the artist's posthumous sale, Galerie Georges Petit, Paris, March 26–27, 1918, lot 4. See also Paul-André Lemoisne, *Degas et son oeuvre*, 4 vols. (Paris: Paul Brame and C. M. de Hauke), 1946–1948, 1:31; Theodore Reff, "Further Thoughts on Degas's Copies," *Burlington Magazine* 113, no. 822 (September 1971): 539n27; and Dumas, *The Private Collection of Edgar Degas*, 10–11, 67n40.

37 Henri Loyrette, entry for *Mme Edmondo Morbilli, née Thérèse De Gas*, in Boggs, *Degas*, 155–156, no. 94.

38 See Maheux, *Degas Pastels*, 28.

39 Louisine W. Havemeyer, *Sixteen to Sixty: Memoirs of a Collector* (New York: privately printed for the family of Mrs. H. O. Havemeyer and the Metropolitan Museum of Art, 1961), 256.

40 Reff, "Further Thoughts on Degas's Copies," 539, 541; and Alexander Eiling, *Degas: Klassik und Experiment*, exh. cat. (Karlsruhe, Germany: Staatliche Kunsthalle; and Munich: Hirmer, 2014), 102–103, no. 19.

41 Sale, Galerie Georges Petit, Paris, March 26–27, 1918, lot 37; see Dumas, *The Private Collection of Edgar Degas*, 67n43.

42 Sarah Lees, ed., *Nineteenth-Century European Paintings at the Sterling and Francine Clark Art Institute* (Williamstown, MA: Sterling and Francine Clark Art Institute, 2012), 255–258, no. 110.

43 Xavier Salmon, *Le Voleur d'âmes: Maurice Quentin de La Tour*, exh. cat. (Versailles: Musée national des châteaux de Versailles et de Trianon and Editions Artlys, 2004), 52–53, no. 1.

44 The author wishes to thank George Shackelford for suggesting Degas's possible interest in Chardin. Chardin's *Self-Portrait* (inv. 25206) was acquired along with *Self-Portrait* or *Portrait of Chardin Wearing an Eyeshade* (inv. 25207) and *Portrait of Madame Chardin* (inv. 25208) from the Bruzard sale in Paris on April 24, 1839;

45 Cited in Pierre Rosenberg, ed., *Chardin*, exh. cat. (London: Royal Academy of Arts; and New York: Metropolitan Museum of Art, 2000), 324, no. 96.

46 Maheux, *Degas Pastels*, 28.

47 Groom, *Impressionism, Fashion, and Modernity*, 225.

48 The subject of people looking at paintings interested him as early as 1860, as seen in a notebook drawing in which a couple studies a carefully rendered sketch of Giorgione's *fête champêtre* in the Louvre. Reff, *The Notebooks of Edgar Degas*, 1:94.

49 Walter Sickert, "Degas," *Burlington Magazine for Connoisseurs* 31, no. 176 (November 1917): 186; and Gary Tinterow, entry for *Mary Cassatt at the Louvre: The Paintings Gallery*, in Boggs, *Degas*, 440, no. 266.

50 On Degas and misogyny, see Norma Broude, "Degas's 'Misogyny,'" *Art Bulletin* 59, no. 1 (March 1977): 95–107; and Carol Armstrong, "Degas in the Studio: Embodying Medium, Materializing the Body," in Martin Schwander, ed., *Edgar Degas: The Late Work*, exh. cat. (Riehen/Basel: Fondation Beyeler; and Ostfildern, Germany: Hatje Cantz Verlag, 2012), 24, 30–31n5.

51 See Armstrong, "Degas in the Studio," 29.

52 Sickert, "Degas," 186; and Tinterow, entry for *Mary Cassatt at the Louvre*, in Boggs, *Degas*, 440.

53 Maria d'Anspach, "La Modiste," in *Les Français peints par eux-mêmes: Encyclopédie morale du dix-neuvième siècle*, ed. Pierre Bouttier (1840–1842; reprint, Paris: Omnibus, 2003), 3:410. "Que si vous me demandez encore comment et pourquoi elle est devenue ce qu'elle est, je vous réprondrai qu'elle est devenue modiste, comme vous êtes peut-être vous-même devenu artiste . . . parce que cela est commode, n'engage pas l'avenir, et que c'est parfois un moyen d'arriver à quelque chose, quand on ne meurt pas en chemin de désespoir et de misère. . . . c'est une position assez avantageuse pour attendre, pour épier la fortune et la saisir au passage. On est en évidence ou du moins on croit l'être, et qui sait? Les banquiers, les milords et les princes russes visitant quelquefois les ateliers de modes aussi bien que les ateliers de peinture, et s'ils achetent un tableaux dans ceux-ci, ils font souvent choix d'une jolie femme dans ceux-là."

54 Tinterow, entry for *At the Milliner's*, in Boggs, *Degas*, 395–396, no. 232.

55 Cited in ibid., 395; Jean Ajalbert, "Le Salon des impressionnistes," *La Revue moderne* (Marseille), June 20, 1886, 386.

56 Baudelaire, *The Painter of Modern Life*, n.p.

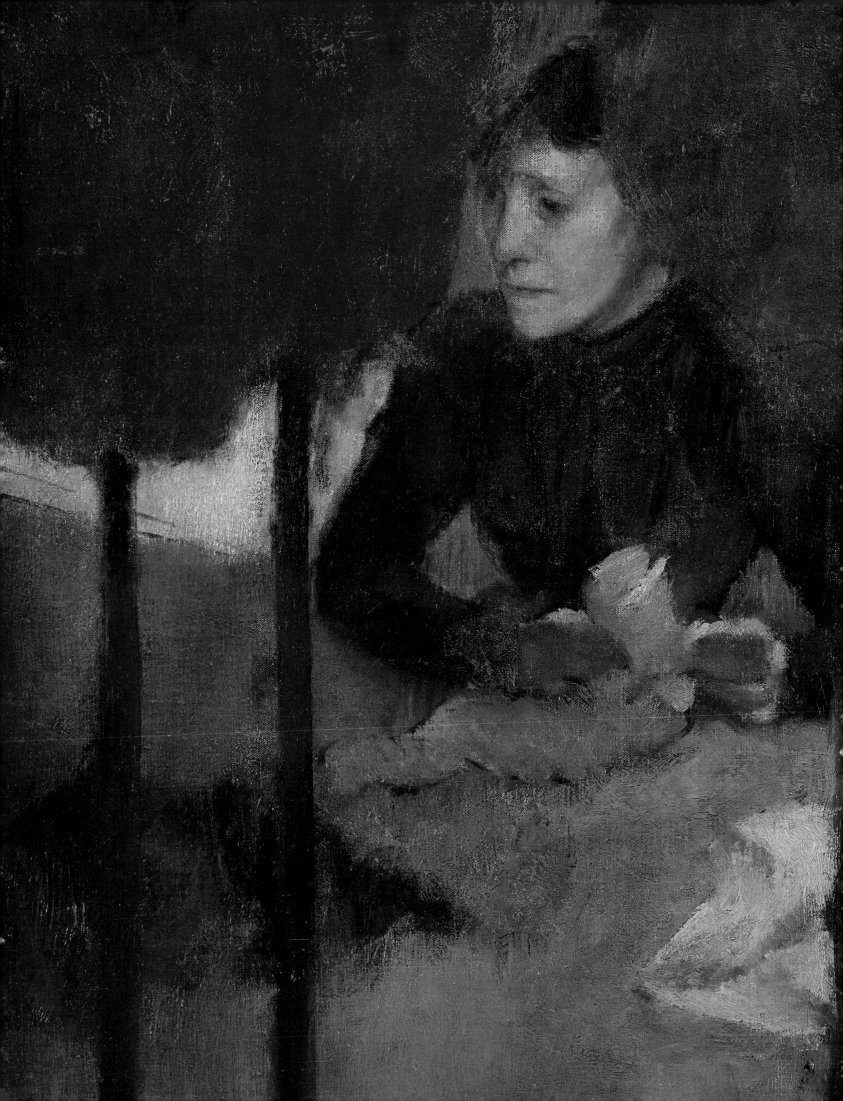

CATALOGUE

A NOTE TO THE READER

Catalogue entries were contributed by the following authors: Esther Bell (EB), Melissa E. Buron (MB), Kimberly Chrisman-Campbell (KCC), Simon Kelly (SK), Laura L. Camerlengo (LLC), and Abigail Yoder (AY). All hats are French-made unless otherwise noted; dimensions are listed height by width (then by depth, if provided).

Catalogue raisonné numbers are provided to identify certain works by Edgar Degas and are indicated by an "L." These numbers correspond to Paul-André Lemoisne, *Degas et son oeuvre*, 4 vols. (Paris: Paul Brame and C. M. de Hauke, 1946–1948).

DEGAS

AND THE

MILLINERY SHOP

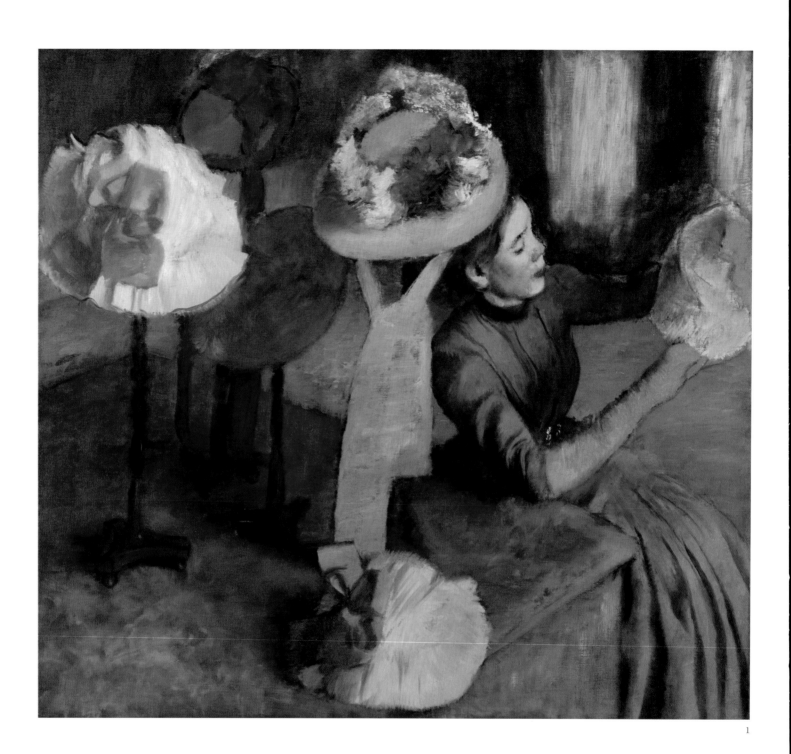

ribbons. There are two similarly designed hats in pale peach and in ice blue, the former in frilled silk taffeta with yellow grosgrain ribbons and the latter in pleated silk taffeta, again with grosgrain ribbons. In the center of the table on the lowest hatstand is a dark hat with a barely discernible red ostrich plume; behind it is a rust straw hat with red ribbon bow and streamers. The woman

holds apricot felt cone and tests a shell pink ribbon as a trim.[2] Degas here seems to have summed up the range of materials and colors of hats in style. (A straw hat with real moss, for example, appeared in the pages of *La Modiste universelle* in 1879 [fig. 62].) Degas placed his hats within a spartan background setting of bare floor and muslin-covered windows, even though many millinery shops had ornate Rococo decoration by the late nineteenth century. In so doing, he further emphasized the centrality of the hats in the composition.

The hats may dominate the work compositionally and coloristically, but the artist's process indicates that he paid special attention to the rendering of the woman.[3] Degas produced three preparatory pastels, two of which clearly represent the sitter as a fashionable customer.[4] The finely worked *Woman Holding a Hat* (1885; fig. 63) shows a customer in an elegant day dress, tight-fitting in form and tapering at the waist, examining a broad-brimmed hat. In *Woman Holding a Hat in Her Hand* (cat. no. 2), the customer appears in a similarly styled ensemble of dress, *fichu* (neck scarf), and hat, although now all in blue: she examines a red chapeau, perhaps of fur felt, with the suggestion of

1

EDGAR DEGAS

The Millinery Shop,
1879–1886

Oil on canvas
39 ⅜ x 43 ⅝ in. (100 x 110.7 cm)
The Art Institute of Chicago, Mr. and Mrs. Lewis Larned Coburn Memorial Collection, 1933.428
L832

2

EDGAR DEGAS

Woman Holding a Hat in Her Hand, ca. 1885

Pastel on paper
19 ¼ x 25 ⅛ in. (48.8 x 63.6 cm)
Private collection
L833

62 *"Lydia Hat" by Madame Dufourmantelle*, in *La Modiste universelle*, June 1879. Lithograph. Bibliothèque nationale de France, Paris, FOL-V-832

The Millinery Shop is Degas's largest painting on a millinery theme. Much writing has been devoted to the identity of the woman—did the artist intend her to be a customer or a milliner?—but less attention has been given to the remarkable range of hats in the work's foreground that dominate the composition.[1] The six hats reflect the very latest fashions for spring and summer in the early 1880s. Notable is a wide-brimmed straw hat trimmed with silk chrysanthemums and white lilacs and with lime green jacquard silk

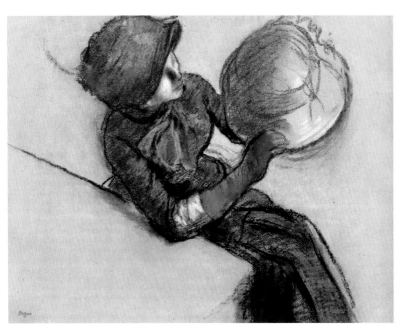

63 Degas, *Woman Holding a Hat*, 1885. Pastel on paper, 18 x 33 ⅝ in. (46 x 60 cm). Private collection (L834)

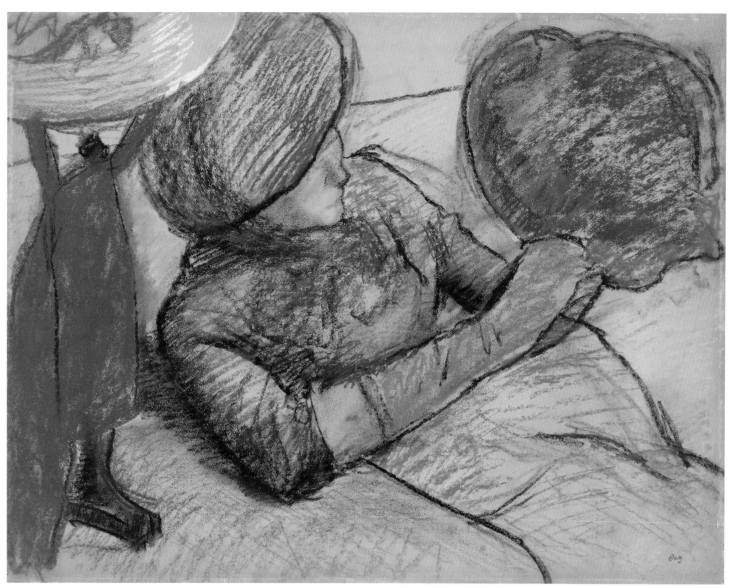

2

an ostrich plume on the back crown. Degas included a diagonal line to suggest a back wall; to the woman's right is the straw hat with green streamers that remains in the final work.

The artist also produced a third pastel (fig. 64), in which he chose to represent the sitter as a milliner, wearing a more functional and less decorative dress: no longer does the woman wear an elaborate *fichu* or broad-brimmed hat to cover her eyes demurely. This latter pastel was probably the latest study for the painting; it seems to under-pin an earlier configuration of the sitter, as seen in three-quarter profile in an infrared

reflectogram of the painting (fig. 65).[5] This infrared image also indicates that the table was once higher in the composition as well as further back and with visible front legs: the lit window behind extended lower.

As X-ray imaging has also shown (fig. 66), Degas revised his painting surface exten-sively, most notably raising the position of his seated woman, who was originally lower in the composition. Degas perhaps felt that his sitter was too tightly constrained and adapted his composition to provide a greater sense of space around her. Notably, he reduced the size of the orange hat that she holds: the pentimenti of its original

shape are clearly visible. As was often his wont, Degas chose to be elliptical and leave the identity of his sitter in the painting open ended. The sitter's stylish but understated dress—tailored in olive-green wool with fur trim around the neck and a silver buckle at her waist—as well as her tan gloves resemble those worn by the customer in *At the Milliner's* (ca. 1882–1898; cat. no. 89). Yet the overall evidence supports a reading of her as a milliner.[6] Milliners, especially *premières*—and most likely a *première* is pic-tured here—wore similar dresses that were both practical and elegant. Perhaps Degas's choice of his sitter's dress is itself suggestive

64 Degas, *At the Milliner's* (*Milliner Trimming a Hat*), ca. 1885. Pastel and charcoal, 18 ⅛ x 23 ¼ in. (46 x 59 cm). Private collection (L835)

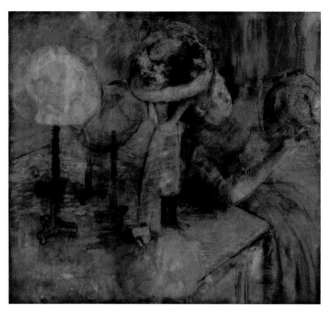

65 Infrared reflectogram of *The Millinery Shop*

of the growing social prestige of the milliner by the end of the nineteenth century and the blurring of hierarchical lines between milliner and customer.

Degas's painting has an impressive provenance, having been sold by the artist to his dealer Paul Durand-Ruel in 1913 for the large sum of 50,000 francs, an amount that far exceeded any sum that Degas received for any other millinery work.[7] —SK

66 X-radiograph image of *The Millinery Shop* showing Degas's original composition, overlaid with outline of final composition

1 Richard R. Brettell identified the sitter as a milliner, making the argument, for the first time, that she has a hatpin between her lips. See Brettell and Suzanne Folds McCullagh, eds., *Degas in the Art Institute of Chicago* (Chicago: Art Institute of Chicago; and New York: Harry N. Abrams, 1984), 131–135. Ruth E. Iskin agrees with this identification (Iskin, *Modern Women and Parisian Consumer Culture in Impressionist Painting* [Cambridge: Cambridge University Press, 2007], 73–76). Gloria Groom's conclusion is more open ended; see Groom, "Edgar Degas: *The Millinery Shop*," in Groom, ed., *Impressionism, Fashion, and Modernity*, exh. cat. (Chicago: Art Institute of Chicago; New York: Metropolitan Museum of Art; and Paris: Musée d'Orsay, 2012), 218–231.

2 Thanks to the milliner Stephen Jones for his assistance in identifying various hat materials in the painting. See Jones, email to the author, November 20, 2016.

3 Brettell and McCullagh, *Degas in the Art Institute*, 131–135; and Groom, *Impressionism, Fashion, and Modernity*, 221.

4 See Groom, "Edgar Degas," 218.

5 Thanks are due to Frank Zuccari, chief conservator at the Art Institute of Chicago, for providing this image and the X-radiograph, and for his thoughtful assistance. See also Gary Tinterow's entry for *The Millinery Shop*, in Jean Sutherland Boggs, ed., *Degas*, exh. cat. (New York: Metropolitan Museum of Art; and Ottawa: National Gallery of Canada, 1988), 400, which argues that "the last preparatory drawing" was *Woman Holding a Hat in Her Hand* (cat. no. 2).

6 In the example of *The Milliners* (ca. 1882–before 1905; cat. no. 88), Degas also transformed his sitters from customers to milliners. The pose of the seated woman in *The Millinery Shop* is closely related to that of the right figure in this painting.

7 The painting was given the title *L'Atelier de la modiste* (The studio of the milliner) in the Durand-Ruel stock book for 1913.

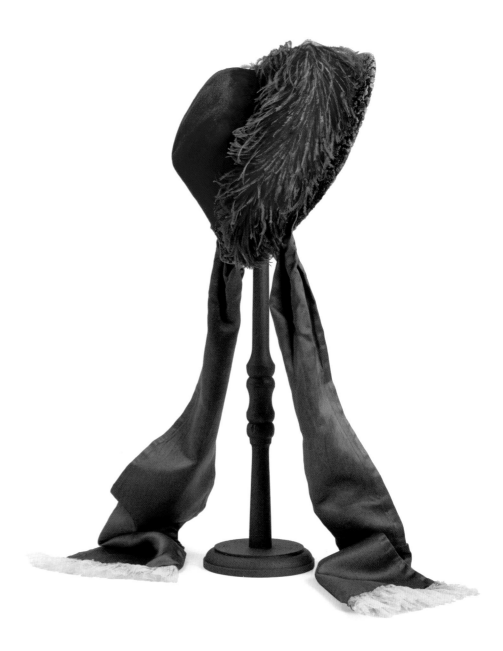

3

MADAME HARTLEY
(American, ca. 1865–1901), retailer

Woman's bonnet, ca. 1860s–1870s

Label: "Manufactured in Paris/
Expressly for Mme. Hartley/
947 Broadway &/177 Fifth Ave/NY"
Silk velvet, silk and cotton voided
velvet, metal seed beads, dyed ostrich
feathers, and silk satin ribbon
with white cotton lace
5 x 11 in. (12.7 x 27.9 cm)
Philadelphia Museum of Art, Gift of the
heirs of Charlotte Hope Binney Tyler
Montgomery, 1996-19-31

French hats were highly coveted by shoppers on both sides of the Atlantic; in the United States, Parisian models were retailed by both large department stores as well as small specialty shops.[1] This Paris-made maroon silk velvet bonnet with ostrich feathers and metal seed beads was sold by Madame Hartley, a milliner and importer based in New York. Hartley established her shop on Broadway around 1865, where she employed "several first-class milliners and trimmers" to create unique designs as well as reproduce bonnet and hat models imported from Paris and London.[2] Hartley's advertisements, particularly those published in the *New York Herald* and the *National Republican* in the 1860s and 1870s, boasted that her stock included designs by leading French and English milliners such as Madame Virot and Brown's, London.[3] Her "elegant assortment" was suitable for individual purchase as well as for the wholesale trade, as the designs were available at "very low" or "greatly reduced" prices that were "less than cost of importation."[4]

As Dilys E. Blum noted, duty, freight, and packing costs could easily double the cost of a Paris-made hat; re-creating licensed copies of imported models allowed wholesalers like Madame Hartley to sell hats below cost, "as the profit was made not on the hat but on the materials milliners purchased to reproduce the models."[5] —LLC

1 Dilys E. Blum, *Ahead of Fashion: Hats of the 20th Century.* Exh. cat. *Bulletin* (Philadelphia Museum of Art) 89, nos. 377/378 (Summer–Autumn 1993): 8.

2 "Help Wanted—Females," *New York Herald,* August 27, 1865, 6.

3 "Millinery and Dressmaking," *New York Herald,* April 15, 1870, 1.

4 "Millinery," *New York Herald,* May 17, 1867, 11; "Millinery," *New York Herald,* June 6, 1867, 1; "Millinery and Dressmaking," *New York Herald,* February 21, 1875, 1; "For the Ladies," *National Republican,* January 17, 1876, n.p.; and "Millinery and Dressmaking," *New York Herald,* December 2, 1877, 15.

5 Blum, *Ahead of Fashion,* 10.

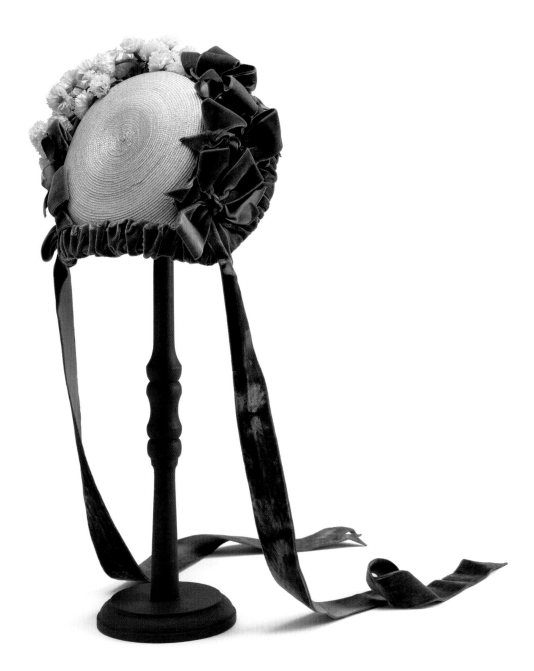

4

ANONYMOUS
(French, late nineteenth century)

Woman's bonnet, last quarter of the nineteenth century

Straw, silk velvet ribbon, cotton
plain weave, twisted paper and wire
flowers, and silk lining
9 ½ x 9 x 4 in. (24.1 x 22.9 x 10.2 cm)
overall (without ties)
Museum of Fine Arts, Boston,
Gift of Miss Amelia Peabody and
Mr. William S. Eaton, 46.324

Variations of the capote (named after the
French word for "hood," whose shape it
resembles) emerged in Paris and London
during in the 1880s and remained fashion-
able through the end of the nineteenth cen-
tury. This bonnet is an example of the style's
resurgence. In capotes "the crown is soft
and the hat . . . sets well back on the head,"
and their "style and shape entitle[d] them
to be placed [on the head] in the plural."[1] By
the 1890s the bonnets were no longer worn
in multiples; they were intended instead to
be worn on the head singularly, as fashion
plates found in contemporary women's peri-
odicals reveal.[2] This elegant example, which
features a firm, rather than soft, crown of
plaited straw, appears to be a version of the
capote *toute en fleurs* ("all in bloom"), a style
common in the 1890s.[3] True to form, this

bonnet is lavishly embellished with pale blue
velvet ribbon and bows and cream-colored
silk flowers.—LLC

1 "Gossip from London," *Millinery Trade
 Review* 1, no. 2 (February 1876): 15; and "Notes
 from Paris," *Millinery Trade Review* 1, no. 2
 (February 1876): 14.

2 Based on a survey of women's plates from *La
 Mode illustrée*, 1890–1895.

3 "Chapeaux de printemps et d'été," *La Mode
 illustrée*, no. 14 (April 6, 1890): 105.

5

BROWN, CHICAGO
(American, active late nineteenth
century), importer

Woman's bonnet, ca. 1894

Label: "MODES DE PARIS/Brown/
IMPORTER/171 WABASH AVE./
PALMER HOUSE/CHICAGO"
Straw, velvet, lace, and ribbon
10 x 8 in. (25.4 x 20.3 cm) overall;
ribbon ties 27 x 1 in. (68.6 x 2.5 cm)
Chicago History Museum, Gift of
Mrs. J. J. Glessner via Art Institute
of Chicago, 1960.612

This winter bonnet trimmed with black
lace, artificial violets, and brown velvet
ribbon recalls Marcel Proust's wistful
description in *À la recherche du temps perdu*
(*Remembrance of Things Past*, 1913–1927)
of the "little hats" of the 1890s, "so low-
crowned as to seem no more than garlands
about the brows of women."[1]

Brown was a well-known importer of
"modes de Paris" to the American Midwest.
Two surviving hats with the Brown label
belonged to the wife of Chicago industri-
alist Charles Hosmer Morse; another can
be found in the Oshkosh Public Museum
in Wisconsin.[2] Much like Madame Hartley
did (see cat. no. 3), Brown likely imported
selected Parisian "models" and made
licensed copies of them.[3]

Brown's showroom was located in the
Palmer House, the iconic Chicago hotel that
opened in 1871. The hotel was retail and
real-estate magnate Potter Palmer's wed-
ding gift to his bride, Bertha. A Francophile
and friend of Claude Monet, Bertha accu-
mulated one of the largest collections of
Impressionist art outside of France (much
of it now in the Art Institute of Chicago's
collection). The hotel had a long association

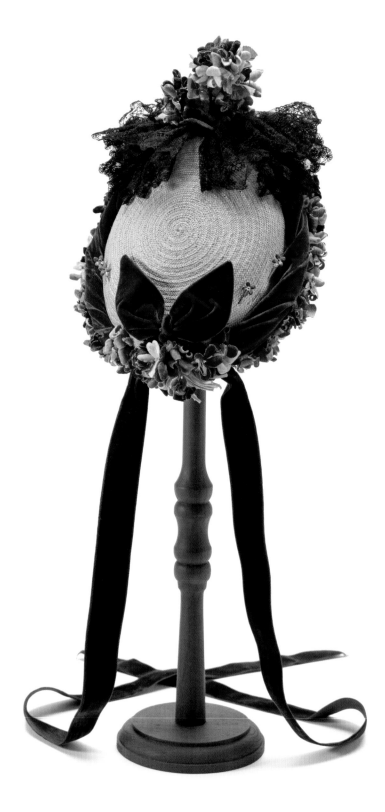

with the millinery business, hosting sea-
sonal trade shows as well as permanent
showrooms.[4] —KCC

1 Marcel Proust, *Remembrance of Things Past*,
 vol. 1, trans. C. K. Scott Moncrieff (London:
 Wordsworth Editions, 2006), 400.
2 See Charles Hosmer Morse Museum
 of American Art, Winter Park, Florida,
 NY 012-014 and NY 012-016; and Oshkosh
 Public Museum, 2770-113.
3 Christina Bates, "The Ontario Millinery Trade
 in Transition," in Alexandra Palmer, ed.,
 Fashion: A Canadian Perspective (Toronto:
 University of Toronto Press, 2004), 123.
4 See *Millinery Trade Review* 46, no. 9
 (September 1921): 99.

6

MADAME JOSSE
(French, active late nineteenth century),
designer

Woman's hat, ca. 1885

Label: "Mme. Josse/3 BOUL. DES
ITALIENS/Paris"
Plush, moiré ribbon, feather, and beads
27 x 12 ½ x 5 ¼ in. (68.6 x 31.8 x 13.3 cm)
Chicago History Museum, Gift of
Mrs. Thurlow G. Essington, 1964.934

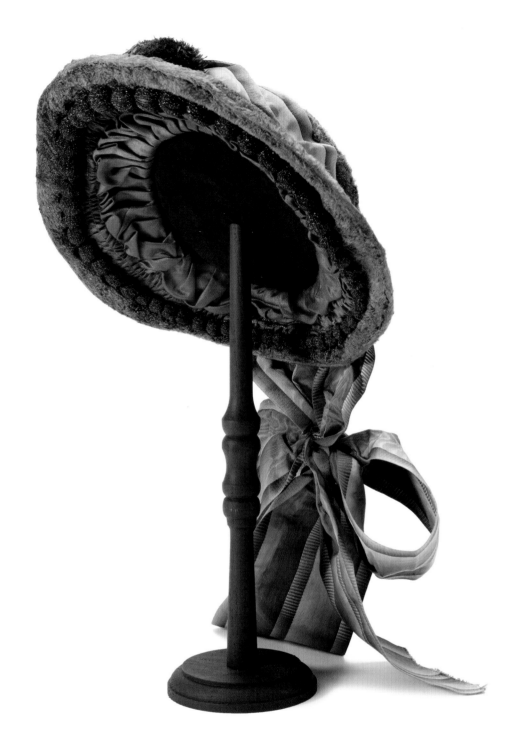

Madame Josse had an international following for her innovative millinery. According to the Paris *Herald*, a woman was meant to wear her *fanchon* (handkerchief) bonnet of 1878—trimmed with "crocuses and wallflowers softened down by an airy chenille fringe in moss tints spangled to imitate early dew"—with a small bouquet of violets in her breast pocket; "the perfume therefrom is supposed to proceed from her *fanchon*."[1] One such violet- and jet-trimmed bonnet of Chantilly lace by Madame Josse is in the collection of the Fine Arts Museums of San Francisco.[2] In 1889 she anticipated the fashion for brimless hats by introducing "a unique crownless toque" of grass-green velvet trimmed with cut jet and "a dragonfly made of the breast-feathers of humming-birds."[3] The same year, Madame Josse paid tribute to the newly completed Eiffel Tower with a large velvet hat of "Eiffel" brown, a terra-cotta hue.[4]

This unusual hat of the mid-1880s is constructed like a bonnet; however, the striped green moiré streamers are meant to be tied in back rather than under the chin. A large pom-pom magnifies the effect of the moiré-patterned plush, while a halo of graduated beaded balls frames the wearer's face.

Like many Parisian milliners, Madame Josse sold garments and accessories as well as hats; her label can be found on a lace-trimmed velvet capelet of the 1890s in the Texas Fashion Collection.[5] Such wearable luxuries were known as "articles de Paris," a phrase Degas playfully borrowed to describe his paintings of urban life.[6] —KCC

1 Quoted in the *Christian Union* 17, no. 13 (March 27, 1878): 270.

2 Accession number 51.29.8.

3 *Millinery Trade Review* 14, no. 9 (September 1889): 16.

4 Ibid., 18; and *Millinery Trade Review* 14, no. 8 (August 1889): 19.

5 Accession number 1998.014.001.

6 Ruth E. Iskin, *Modern Women and Parisian Consumer Culture in Impressionist Painting* (Cambridge: Cambridge University Press, 2007), 95.

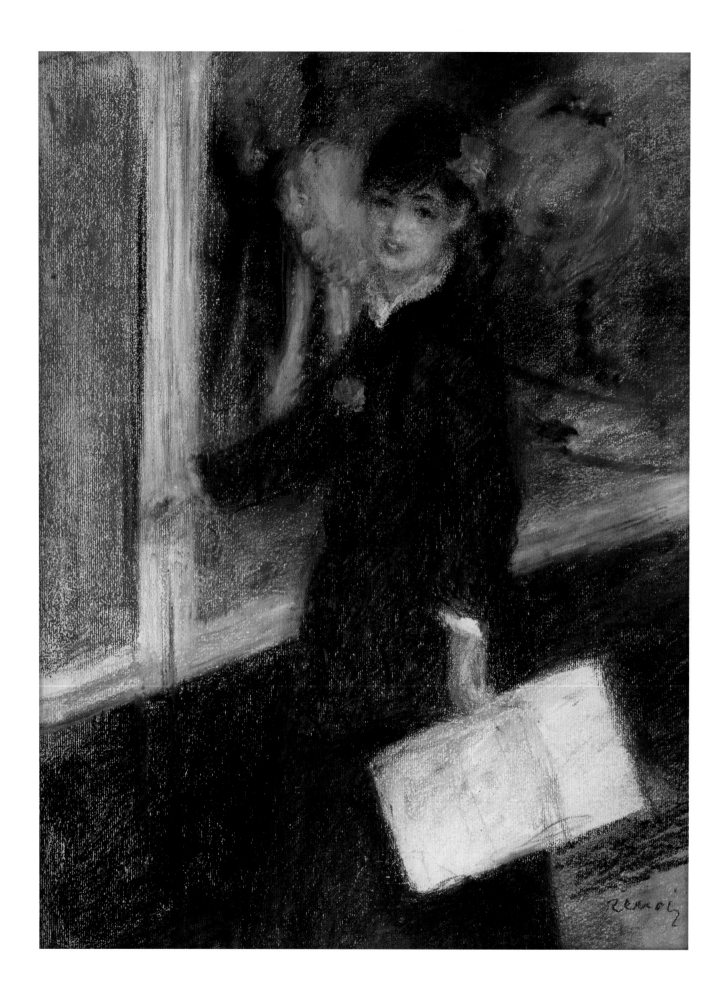

7

PIERRE-AUGUSTE RENOIR
(French, 1841–1919)

The Milliner, ca. 1879

Pastel on paper
21 x 16 ¼ in. (53.3 x 41.3 cm)
The Metropolitan Museum of Art,
New York, The Lesley and Emma Sheafer
Collection, Bequest of Emma A. Sheafer,
1973, 1974.356.34

67 Renoir, *The Milliner* (or *Young Woman in an Overcoat Carrying a Box*), ca. 1879. Lithographic crayon on Gillot paper, 12 ½ x 6 ½ in. (31 x 16.5 cm). Museum of Fine Arts, Boston, Gift of Mr. and Mrs. Stephen A. Fine, 2010.5

68 Benjamin Rabier, *Fashion: A Trottin Delivering a Hat*, cover image of *Le Pêle-Mêle* 17, no. 3 (January 15, 1911). Private collection

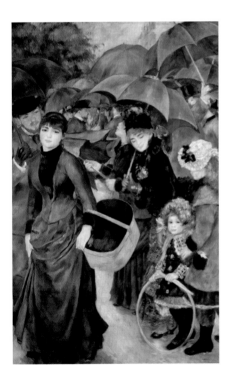

69 Renoir, *The Umbrellas*, ca. 1881–1886. Oil on canvas, 71 x 45 ¼ in. (180.3 x 114.9 cm). The National Gallery, London, Sir Hugh Lane Bequest, 1917, NG3268

After the launch of Georges Charpentier's magazine *La Vie moderne* in 1879, Renoir offered to work for his friend as an illustrator.[1] He wrote to Charpentier's wife, Marguérite: "We could make an arrangement with milliners and seamstresses—hats one week, dresses the next, etc. I would go there and draw from life from different angles."[2] *The Milliner* appears to be a reworking of a black lithographic crayon drawing (fig. 67) likely intended for, though never included in, *La Vie moderne*.[3]

Renoir presented a *trottin* or *trotteuse*, or a junior-level apprentice who delivered hats to customers (see fig. 68). In this pastel, she stands holding a hatbox, her employer's latest creations visible through the window behind her. She smiles, although according to Maria d'Anspach's 1841 essay about millinery, a *trottin* enjoyed scant pleasures. They were "poor little girls who, laden with enormous boxes, do the house's errands, thereby paying for their apprenticeship by acting as a sort of servant."[4]

Colin B. Bailey has adroitly placed this pastel within a series of early ideas for the figure at left in *The Umbrellas* (ca. 1881–1886; fig. 69). A cross section of pigment taken from what is presumably the lid of the woman's cane bandbox reveals mauve with cobalt blue and red lake, which suggests instead an open container with merchandise inside and the woman's identity as a milliner.[5] —EB

1 This entry is indebted to Colin B. Bailey's thoughtful analysis of Renoir's millinery series; see Bailey, *Renoir, Impressionism, and Full-Length Painting*, exh. cat. (New York: Frick Collection; and New Haven, CT: Yale University Press, 2012), 143–153.
2 "On peut faire un arrangement avec modistes et couturières. Une semaine de chapeaux, l'autre de robes, etc. . . . J'irai chez elles faire le dessin d'après nature de différentes côtés." Michel Florisoone, "Lettres inédites: Renoir et la famille Charpentier," *L'Amour de l'art* 19, no. 1 (February 1938): 35; cited in Bailey, *Renoir*, 145.
3 For information on related works in this series, see Bailey, *Renoir*, 145–150.
4 "Au dernier échelon de la hiérarchie des modistes se trouvent les *trotteuses*. Ce sont de pauvres petites filles qui font, chargées d'un énorme carton, les commissions de la maison, et payent ainsi leur apprentissage par une sorte de domesticité." Maria d'Anspach, "La Modiste," published in *Les Français peints par eux-mêmes: Encyclopédie morale du dix-neuvième siècle*, vol. 2 (1841; reprint, Paris: Omnibus, 2003), 107.
5 Bailey, *Renoir*, 145.

8

PIERRE-AUGUSTE RENOIR
(French, 1841–1919)

At the Milliner's, 1878

Oil on canvas
13 x 9 ¾ in. (32.9 x 24.8 cm)
Harvard Art Museums/Fogg Museum,
Bequest of Annie Swan Coburn, 1934.31

The son of a tailor and a dressmaker, Renoir was equally intrigued by working-class laundresses, seamstresses, and milliners as he was by the most fashionable set of Parisian society.[1] According to his early biographer, Gustave Coquiot, "Suzanne Valadon [a painter and one of Renoir's models] told us how many hats she had worn that Renoir had bought from all the milliners! He never came home empty-handed; he was a maniac, a sort of erotomaniac of women's hats: toques, bonnets, felts, straws, various kinds of lace, flowers. He also delighted in multi-colored fabrics."[2] Though Coquiot might be exaggerating for the sake of a compelling narrative, the anecdote is corroborated by other sources (see pp. 237–239).

Here Renoir seemingly presented the interior of a millinery shop; the format recalls Degas's method of cropping into a composition to intensify the interaction of the figures. However, any exact meaning is obscured by the deliberate lack of overall finish and the blurred, apparitional forms.[3] He evoked the textures of the milliner's materials, as with the plumage at lower center, with thinly painted strokes of bold color. The action of the figure at upper right is indeterminate, while the one at left reaches for her own head, perhaps admiring a hat that is suggested in diagonal patches of purple. The hatless woman at center, possibly the milliner, looks vacantly into the distance— not unlike the figure in Edgar Degas's *The Milliners* (ca. 1882–before 1905; cat. no. 88).

Like Degas, Renoir explored the subject of millinery in the late 1870s and 1880s, raising the question whether the two artists directly exchanged ideas. For the central figure, Renoir used one of his preferred models, Marguerite ("Margot") Legrand. Legrand sat for him frequently between 1875 and 1879, including for his *Bal du moulin de la Galette* (1876; Musée d'Orsay, Paris).[4] —EB

1 On Renoir and fashion, see Colin B. Bailey, *Renoir, Impressionism, and Full-Length Painting*, exh. cat. (New York: Frick Collection; and New Haven, CT: Yale University Press, 2012).

2 "Suzanne Valadon nous a dit combien elle en avait mis de ces chapeaux achetés par Renoir chez toutes les modistes! Il ne rentrait jamais les mains vides; il était un maniaque, une sorte d'érotomane du chapeau féminin: toque, bonnet, feutre, paille, dentelles, fleurs. Les étoffes multicolores aussi le ravissaient." Gustave Coquiot, *Renoir* (Paris: Albin Michel, 1925), 199–200.

3 For alternative readings of the painting, see Hollis Clayson, *Painted Love: Prostitution in French Art of the Impressionist Era* (New Haven, CT: Yale University Press, 1991), 121–124; and John House, *Renoir: Master Impressionist*, exh. cat. (Sydney: Art Exhibitions Australia, 1994), 74, no. 12.

4 François Daulte, *Auguste Renoir: Catalogue raisonné de l'oeuvre peint* (Lausanne: Éditions Durand-Ruel, 1971), 415.

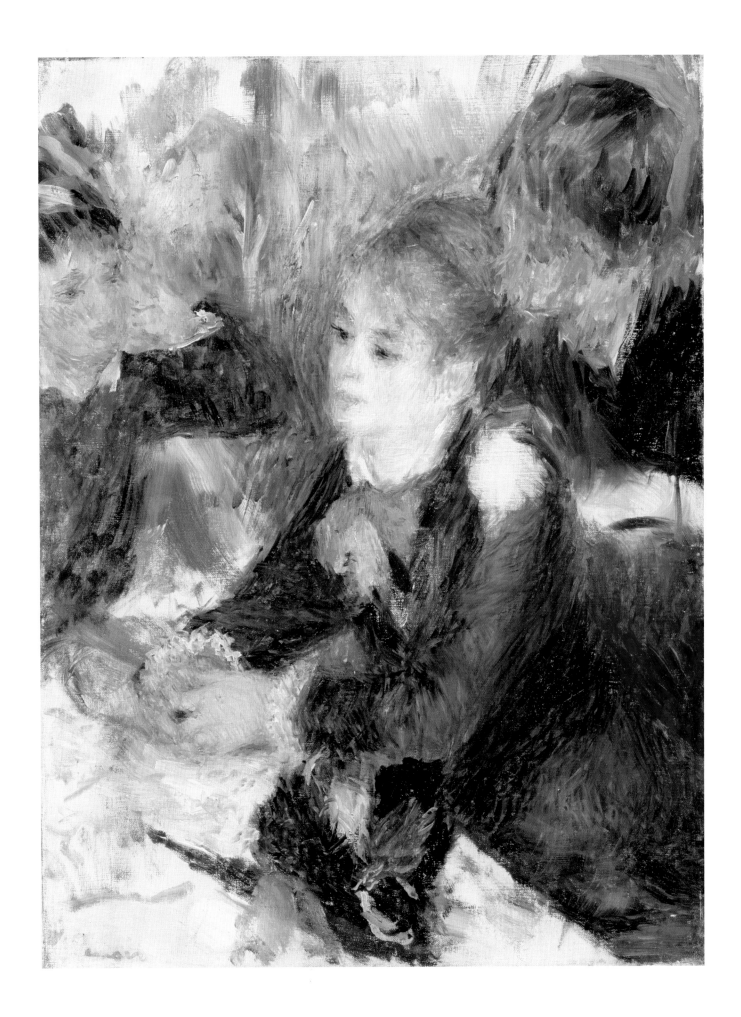

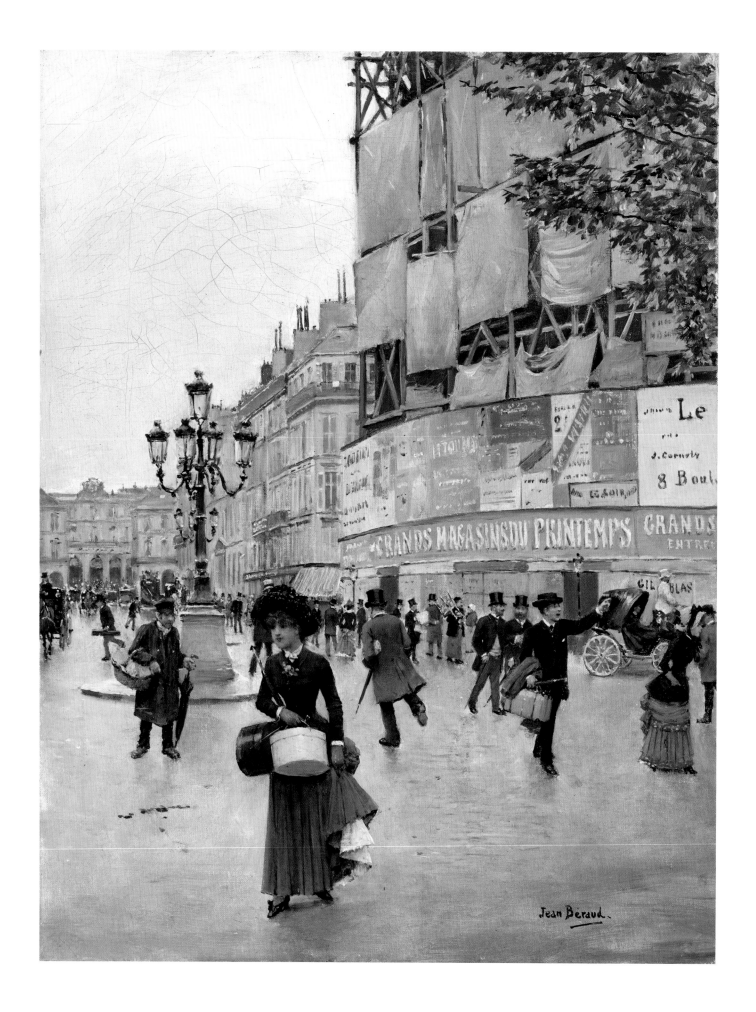

Jean Béraud.

9

JEAN BÉRAUD
(French, 1849–1935)

Paris, rue du Havre, 1882

Oil on canvas
13 ⅞ x 10 ¾ in. (35.2 x 27.3 cm)
National Gallery of Art, Washington,
Ailsa Mellon Bruce Collection, 1970.17.2

Frequently associated with the Belle Époque and known for his many depictions of Parisian boulevards, Béraud highlighted two significant sites of modern Paris in this lively street scene set in the eighth arrondissement: the Saint-Lazare train station in the left background and the Printemps department store on the right. The latter, founded in 1865 on the corner of rue du Havre and boulevard Haussmann, drew large crowds of fashionable consumers before it suffered a disastrous fire in March 1881.[1] In Béraud's depiction, a colorful row of posters—a ubiquitous feature of the nineteenth-century Parisian visual landscape—appears in vibrant contrast to the exposed scaffolding of the damaged building.[2]

The new Printemps, with its soon-to-be iconic cathedral-like facade, reopened in 1883.[3] Although a portion of the store may have remained accessible to shoppers like the young woman in the foreground carrying two hatboxes, she could have procured her purchases from another merchandise purveyor in this dense shopping district. She is part of the crowd in motion, and the textured material of her black hat demonstrates a degree of fashionable elegance in contrast to the comparably plain straw hat with a dark ribbon worn by the woman in a maroon skirt at the right edge of the composition. The woman in the foreground lifts her skirt with a gloved hand, giving viewers a glimpse of her white petticoat, which seems more like a practical motion than a movement leading to questions about her respectability. Ostensibly supporting the veracity of Béraud's observations about consumer culture, Degas once likened his contemporary's paintings to the act of accompanying his fashionable friend, the *salonnière* Geneviève Straus, on a shopping trip: "Like a Béraud, I attended the fitting of a most impressive dress."[4] —MB

For facilitating access to collections records and documentation regarding this painting , the author thanks Michelle Bird, curatorial assistant, Department of French Paintings, National Gallery of Art, Washington, DC.

1 Patrick Offenstadt, ed., *Jean Béraud, 1849–1935: The Belle Époque, a Dream of Times Gone By. Catalogue Raisonné* (Cologne: Taschen, 1999), 96, no. 18. See also Jacques Hillairet, *Dictionnaire historique des rues de Paris* (Paris: Les Éditions de Minuit, 1963), 626–623.

2 For more on the urban display of nineteenth-century posters, see "Art and Advertising in the Street," in Ruth E. Iskin, *The Poster: Art, Advertising, Design, and Collecting, 1860s–1900s* (Hanover, NH: Dartmouth College Press, 2014), 173–208.

3 Reconstruction began in 1881. The building is the plausible inspiration for Émile Zola's *Au bonheur des dames* (*The Ladies' Paradise*), published in 1883. See Meredith L. Clausen, "Department Stores and Zola's *Cathédrale du Commerce Moderne*," *Notes in the History of Art* 3, no. 3 (Spring 1984): 18–23.

4 "On m'a entraîné chez une grande couturière où j'ai assisté, comme un Béraud, à l'essayage d'une toilette à grand effet." Degas, letter to Michel Manzi, n.d., published in Marcel Guérin, ed., *Lettres de Degas* (Paris: Éditions Bernard Grasset, 1931), 147.

10

JEAN BÉRAUD
(French, 1849–1935)

*Fashionable Woman on the
Champs-Élysées*, n.d.
[ca. 1902?]

Oil on canvas
21 ⅝ x 16 ⅜ in. (55 x 41.5 cm)
Private collection

Béraud's depiction of the bustling Champs-Élysées—the famous Parisian shopping boulevard—resonates with Émile Zola's description of the same setting in his tragic novel *L'Oeuvre* (*The Masterpiece*, 1886):

> The Champs-Élysées climbed up and up, as far as the eye could see, up to the gigantic gateway of the Arc de Triomphe, which opened on to infinity. The Avenue itself was filled with a double stream of traffic, rolling on like twin rivers, with eddies and waves of moving carriages tipped like foam with the sparkle of a lamp-glass . . . crossed in every direction by the flash of wheels, peopled by black specks which were really human beings.[1]

The *modiste*, with hatboxes slung across her arm, was a pervasive feature of the urban spectacle as described by Zola. Like the figure in Paul Balluriau's illustration for the song "La Modiste et le capitaine" (ca. 1895; fig. 70), Béraud's model walks unaccompanied through Paris. She appears in three known versions of this composition wearing a sculptured hat that echoes the vertical architecture of the Arc de Triomphe in the distance.[2] Possibly made of black velvet with a transparent veil, the hat perched atop her head also punctuates a row of streetlamps receding behind her, and there is the suggestion of bird wings or feathers in its construction. She forms the peak of a compositional triangle between an upper-class gentleman and a laboring street sweeper behind her.

The *modiste* is representative of Ruth E. Iskin's suggestion that "female spectators/consumers are paradigmatic of a modern type of looking—a browsing performed in crowds and characteristic of the age of mass consumption."[3] The only woman visible in the painting's foreground, she may be an object of potential consumption, like the hats available for purchase from a millinery shop. The urbane top-hatted man standing on the sidewalk's edge has paused, ostensibly to admire her silhouette; she lifts her skirt high,

70 Paul Balluriau, illustration for "La Modiste et le capitaine," *Gil Blas*, ca. 1895. Color gillotage with pochoir, 14 ⅛ x 9 ⅝ in. (35.9 x 24.3 cm). Fine Arts Museums of San Francisco, Achenbach Foundation for Graphic Arts, 1963.30.32229

revealing cascading ruffles of white petticoat, and smiles in a manner insinuating plausible complicity in the act of being watched.[4] —MB

1 Émile Zola, *The Masterpiece*, trans. Thomas Watson, revised and introduced by Roger Pearson (1886; Oxford: Oxford University Press, 1999), 76.

2 The titles for the other versions of this painting all identify the female figure as a *modiste*. Patrick Offenstadt, ed., *Jean Béraud, 1849–1935: The Belle Époque, a Dream of Times Gone By. Catalogue Raisonné* (Cologne: Taschen, 1999), 138–139, no. 121.

3 Ruth E. Iskin, *Modern Women and Parisian Consumer Culture in Impressionist Painting* (Cambridge: Cambridge University Press, 2007), 46.

4 For more, see "The Invasion of the Boulevard," in Hollis Clayson, *Painted Love: Prostitution in French Art of the Impressionist Era* (New Haven, CT: Yale University Press, 1991), 93–112.

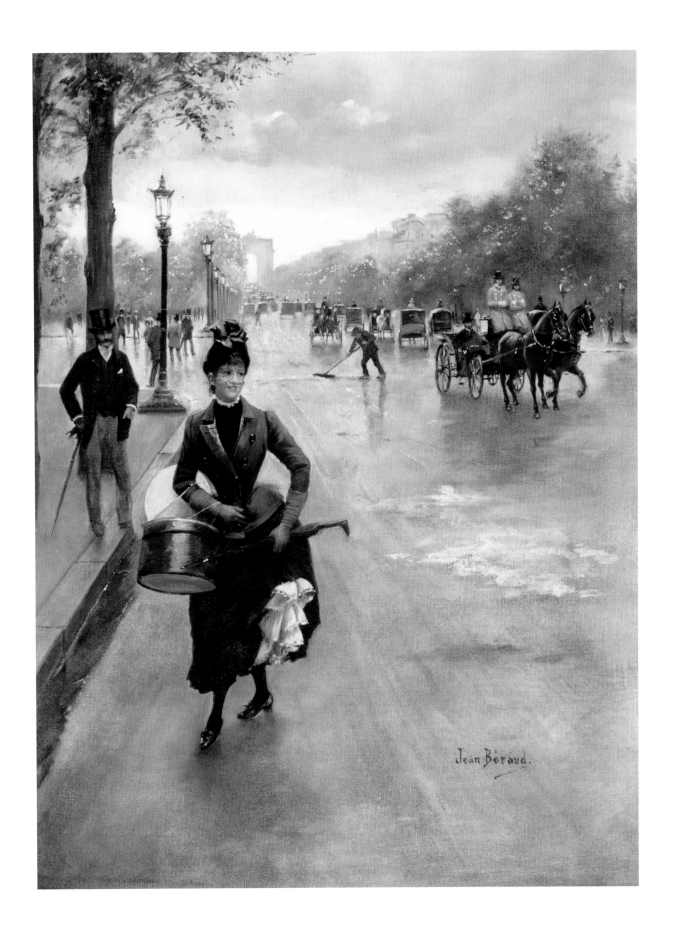

II

JAMES TISSOT
(French, 1836–1902)

The Shop Girl, 1883–1885

Oil on canvas
57 ½ x 40 in. (146.1 x 101.6 cm)
Art Gallery of Ontario, Toronto, Gift from
Corporations' Subscription Fund, 1968

Tissot's parents were self-made textile and fashion-industry merchants in Nantes—Marie was a milliner and Marcel-Théodore was a linen draper—which may account for his sophisticated renderings of sartorial nuances. After training in Paris, where he met and befriended Degas, Tissot spent a prolific decade in London, only returning to Paris following the untimely death of his companion and muse, Kathleen Newton.[1] He then embarked on an ambitious project to paint a series of large canvases featuring the contemporary *femme à Paris*, which he exhibited in 1885 at the Galerie Sedelmeyer, Paris, and in 1886 at the Arthur Tooth and Sons Gallery, London.[2]

Tissot originally planned to reproduce the paintings from this series as prints, each to be supplemented with a short story by a prominent author. Although the full scope of this campaign did not come to fruition, Émile Zola was designated to write about *The Shop Girl*, through which viewers assume the perspective of a customer exiting through the door of a haberdashery held open by

a shopgirl.[3] This unseen client could have purchased ribbons to adorn a hat, like the pink and red tendrils coiled on the table at left, which are echoed in the red decoration on the hat of the woman walking outside the shop.[4] On the street near her is a prospective customer with perhaps more amorous intentions: he leans forward to peer at a second shop assistant at the composition's upper left edge.[5] Her expression in response is obscured from view, but based on the catalogue description that originally accompanied the painting at the Arthur Tooth and Sons Gallery, "she will not notice him; her aim is to obtain a better and more serious suitor."[6] An encouraging response would assign her to the *demimonde*: a class of prostitution associated with working women during the nineteenth century, who were on display in a similar fashion to the merchandise they sold.[7] —MB

1 Degas encouraged Tissot to participate in the first Impressionist exhibition in 1874. Tissot, based in London at that time, did not contribute.

2 *Quinze tableaux sur la femme à Paris*, exh. cat. (Paris: Galerie Sedelmeyer, 1885), no. 14; *Pictures of Parisian Life*, exh. cat. (London: Arthur Tooth Gallery, 1886), no. 5.

3 According to a *New York Times* article advertising the project: "Tissot's Novel Art Work," May 10, 1885, 10; cited in Michael Wentworth, *James Tissot* (Oxford: Clarendon Press, 1984), 168n39 and 171. According to Wentworth, Zola may not have written the accompaniment to Tissot's painting, but his *Au bonheur des dames* (*The Ladies' Paradise*), published in 1883, is the closest approximation to the short story. Tissot also started a second series depicting foreign women called *L'Étrangère*. For Wentworth's excellent commentary on the campaign, see "La Femme à Paris," in *James Tissot* (1984), 154–173. See also Nancy Rose Marshall and Malcolm Warner, *James Tissot: Victorian Life/Modern Love*, exh. cat. (New Haven, CT: Yale University Press, 1999), 154, no. 67.

4 The painting was sold at Christie's, London, on January 22, 1965, lot 55, with an alternate title: *At the Milliner's Shop*. Cited in Krystyna Matyjaszkiewicz, ed., *James Tissot* (New York: Abbeville Press, 1984), 138, no. 172.

5 Tamar Garb likens the outstretched tongue of the creature carved from the counter leg to the French idiom for "window-shopping": *lèche-vitrines* (licking the window). See page 108 in "James Tissot's 'Parisienne' and the Making of the Modern Woman," in Garb, *Bodies of Modernity: Figure and Flesh in Fin-de-Siècle France* (New York: Thames & Hudson, 1998), 80–113.

6 The catalogue entry describes: "It is on the boulevard; a scene full of life and movement is passing out of doors, and our young lady with her engaging smile is holding open the door till her customer takes the pile of purchases from her hand and passes to her carriage. She knows her business, and has learned the first lesson of all, that her duty is to be polite, winning, and pleasant. Whether she means what she says, or much of what her looks express, is not the question; enough if she has a smile and an appropriate answer for everybody. The second-rate 'man about town' is staring at her companion through the window, attempting to attract her attention, but she will not notice him; her aim is to obtain a better and more serious suitor." *Pictures of Parisian Life*, no. 5. See also David S. Brooke and Henri Zerner, *James Jacques Joseph Tissot, 1836–1902: A Retrospective Exhibition*, exh. cat. (Providence: Rhode Island School of Design Museum of Art, 1968), no. 39; and Hollis Clayson, *Painted Love: Prostitution in French Art of the Impressionist Era* (New Haven, CT: Yale University Press, 1991), 124 and 183n30.

7 See Richard Thomson, "Ambiguity, Allure and Uncertainty," in Nienke Bakker, Isolde Pludermacher, Marie Robert, and Thomson, eds., *Splendours & Miseries: Images of Prostitution in France, 1850–1910*, exh. cat. (Paris: Musée d'Orsay and Flammarion, 2015), 80–117. See also Ruth E. Iskin, *Modern Women and Parisian Consumer Culture in Impressionist Painting* (Cambridge: Cambridge University Press, 2007); and Clayson, *Painted Love*.

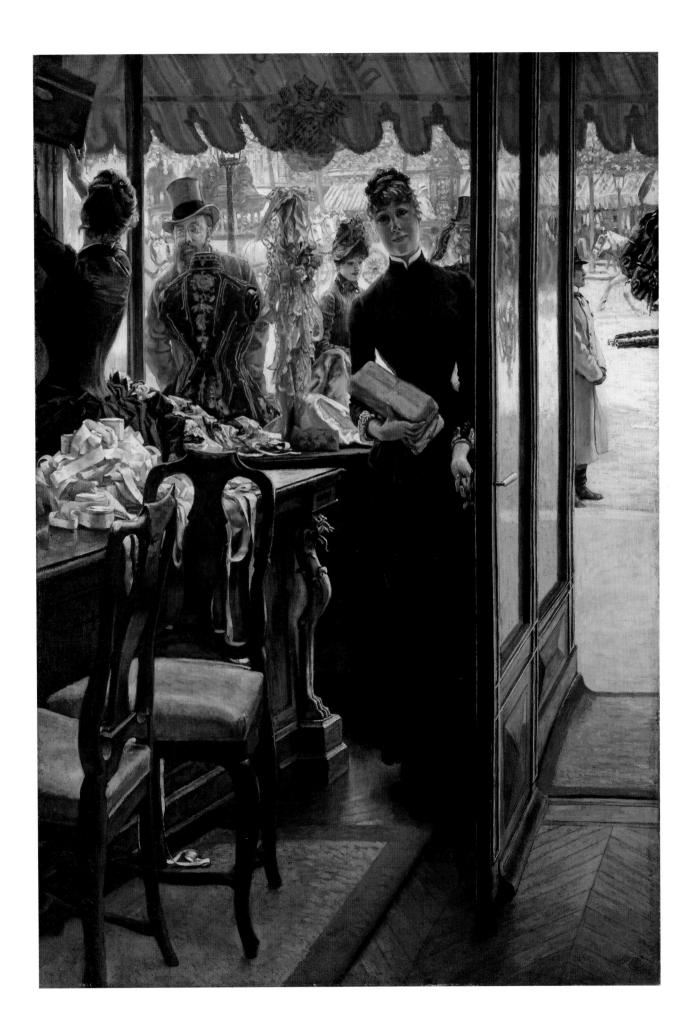

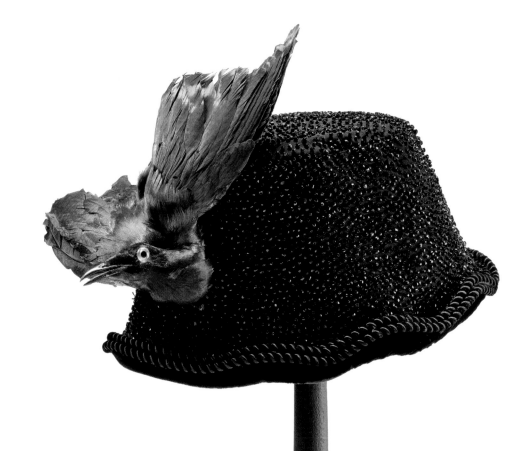

12

ANONYMOUS
(French, late nineteenth century)

Woman's hat, ca. 1890

Silk faille, velvet, cord, jet beads,
and an African starling
4 in. (10.2 cm) crown height; 8 ¼ x 9 in.
(21 x 22.9 cm) overall
Fine Arts Museums of San Francisco,
Gift of Mrs. Caroline Schuman, 53020.6

Although feathers were used to embellish women's hats throughout the nineteenth century, they reached their greatest variety and grandest ornament at the turn of the twentieth century.[1] This toque—or small woman's hat with a narrow, closely turned-up brim—is decorated with diminutive black beads and a sizable, shimmering bird with outstretched wings perched above the undulating silk-cord–trimmed and tapered brim.

This hat style—in particular the exotic bird as central embellishment—is typical of the last decade of the nineteenth century. The bird is an African starling, as distinguished by its strong pointed bill and luminous iridescent feathers that reveal a spectrum of blue, green, and violet hues. The exportation of starlings is frequently mentioned in late nineteenth-century texts about France's African colonies—particularly Senegal and the French Congo (today the Republic of the Congo, Gabon, and the Central African Republic)—along with other

beaux oiseaux de parure (beautiful birds for trimming).[2] Contemporary writers often remarked on the species' luxurious plumage and frequent use in women's millinery, citing it as one of the most beautiful birds found in these areas of the African continent.[3] —LLC

1 Florence Müller and Lydia Kamitsis, *Les Chapeaux: Une histoire de tête* (Paris: Syros-Alternatives, 1993), 63–64.

2 *Bulletin* (Société de géographie commerciale de Bordeaux), 1894, 462.

3 Among others, Marcel Decressac-Villagrand wrote about the exportation of feathers from various types of starling in *Souvenirs du Sénégal: Lettres sur la Gambie et la Casamance* (Guéret, France: P. Amiault, 1890): "Ces trois espèces de merles sont très recherchées pour la parure des chapeaux. Il faut compter par dizaines de mille l'exportation que l'on en fait du Sénégal" (pages 183–184). See also *Bulletin* (Société de géographie commerciale de Bordeaux), 1891, 303; and Édouard Foà, *Le Dahomey: Histoire, géographie, moeurs, coutumes, commerce, industrie, expéditions françaises 1891–1894* (Paris: A. Hennuyer, 1895), 88.

CONSUMER CULTURE: SHOPPING FOR HATS

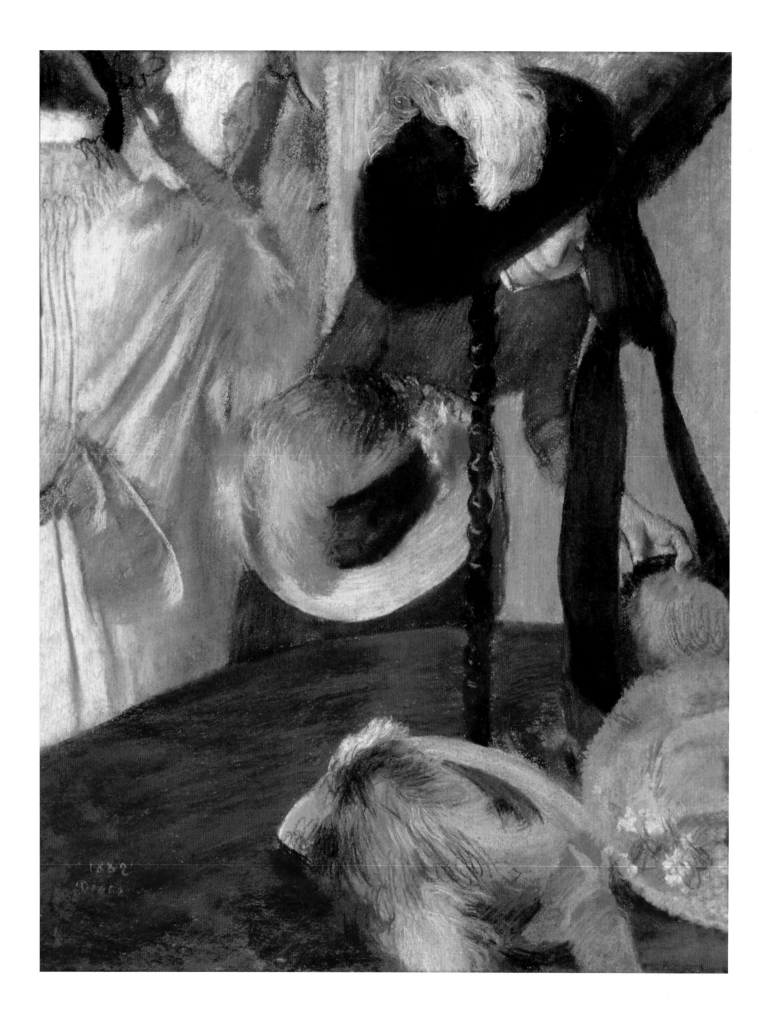

13

EDGAR DEGAS

At the Milliner's, 1882

Pastel on paper
26⅜ x 20 in. (67 x 52 cm)
Musée d'Orsay, Paris, RF 52075
L683

At the Milliner's is a key example of Degas's focus on rendering the materiality of hats. The artist shows a fitting session in a millinery shop: the customer at left tries on a hat before a mirror while the shopgirl leans forward to pick up hats off a table. Yet, rather than focusing on these figures, Degas chose to offer a radical, close-up view of six carefully rendered straw and felt hats in the foreground. These hats, and their ostrich plume and flower trimmings, are represented with the mimetic naturalism that is characteristic of the artist's early millinery works. Carefully applied and repetitive pastel marks articulate the curve of pink and yellow plumes, while delicate touches render tiny yellow silk flowers. His selection of broad-brimmed spring hats represents the latest fashions of the early 1880s (see page 35).

The Irish writer George Moore, a friend of the artist's, recognized the radicalism of Degas's composition in showing a view through a shop window, and read the picture as a comment on the harsh working conditions of women in the millinery trade:

Perhaps the most astonishing revolution of all was the introduction of the shop-window into art. Think of a large plate-glass window, full of bonnets, a girl leaning forward to gather one! Think of the monstrous and wholly unbearable thing any other painter would have contrived from such a subject; and then imagine a dim, strange picture, the subject of which is hardly at first clear; a strangely contrived composition, full of the dim, sweet, sad poetry of female work. For are not these bonnets the signs and symbols of long hours of weariness and dejection? And the woman that gathers them, iron-handed fashion has set her seal upon.[1]

Other artists certainly explored the spectacle of hats, but Degas was exceptional in placing his hats in the very foreground of the composition.[2] As Ruth E. Iskin has shown, Degas's unusual compositions would resonate in the photography of Eugène Atget (see cat. no. 103), in which hats are also presented close up as alluring spectacles for the consumer.[3]

At the Milliner's is notable for its radical cropping, suggesting the compositions of the Japanese prints that Degas is known to have collected extensively. Perhaps even more notable is the artist's treatment of the women's faces. The customer's head at top left is cropped as is her reflection, suggested in the tiny quarter-oval fragment of the

mirror. The shopgirl's downturned head is also obscured and only partly visible. The picture was sold to Durand-Ruel in July 1882 and appears in the dealer's stock book with the title *Chapeaux (Nature morte)* (Hats [Still life]). It was exhibited in London a year later as simply *Chapeaux* at the Dowdeswell and Dowdeswell Gallery at 133 New Bond Street.[4] These titles, which probably originated with Degas, indicate that the artist thought of his composition as a still life rather than a modern genre scene.

Critics responded to Degas's innovation in very different ways. One sympathetic reviewer affirmed that "Degas determines to find new subjects—new effects" and "has done so" with this work.[5] Others were more hostile. One attacked the subject of Degas's pastel as unworthy of artistic treatment, describing it as "so totally wanting in all dignity of motive that one wonders what could have induced the artist . . . to employ the degree of talent that he has on such subjects."[6] Another was even more blunt, noting that *Chapeaux* was one of Degas's "horrors" that was "enough to make one shudder."[7] A crude caricature with the title *Depression* satirized the studied atmosphere of the work, showing a darkened interior with Degas's hats transformed into ungainly shapes, one even changed into a twisted stovepipe hat (fig. 71). A *Punch* reviewer joked that the hats looked "to have been sat upon."[8]

71 "Mistaken Impressions: No. 56.—Depression," in *Punch*, May 5, 1883

The connection of *At the Milliner's* with the tradition of French millinery is heightened by the fact that the pastel was once owned by renowned milliner Jeanne Lanvin, also a former owner of *Woman in a Blue Hat* (ca. 1889; cat. no. 18), who perhaps responded to Degas's understanding of the complexity of hat materials. The work was donated to the French state by the physicist and collector Philippe Meyer in 2000.[9] —SK

1 George Moore, "Degas," in *Impressions and Opinions* (London: David Nutt, 1891), 316.

2 See also *At the Milliner's* (1882; fig. 16) and *The Millinery Shop* (1879–1886; cat. no. 1).

3 Ruth E. Iskin, *Modern Women and Parisian Consumer Culture in Impressionist Painting* (Cambridge: Cambridge University Press, 2007), 67.

4 See *Catalogue of Paintings, Drawings and Pastels by Members of "La Société des Impressionistes"* (London, 1883), no. 56. The work had been sold to Durand-Ruel for 800 francs on July 15, 1882 (Durand-Ruel stock book, no. 2509) and appeared in the 1883 exhibition with a sale price of £60.

5 "The Impressionists at Messrs. Dowdeswells," *The Standard* (London), April 25, 1883.

6 "The 'Impressionists,'" *Western Daily Press* (Bristol), July 16, 1883, 6.

7 "The 'Impressionistes,'" *Morning Post* (London), April 26, 1883.

8 See "Mistaken Impressions" in *Punch, or The London Charivari*, May 5, 1883, 208. For a reproduction of the full page of *Punch* caricatures of the show, see Anna Gruetzner Robins and Richard Thomson, *Degas, Sickert and Toulouse-Lautrec: London and Paris, 1870–1910*, exh. cat. (London: Tate Publishing, 2005), 53–55.

9 It entered the Musée d'Orsay collection in 2007 after the death of Philippe Meyer.

14

EDGAR DEGAS

Young Woman in Blue, ca. 1884

Pastel over charcoal on buff paper
18 x 12 in. (45.7 x 30.5 cm)
Indianapolis Museum of Art,
Delavan Smith Fund, 38.12
L782

Degas was fascinated by the young shopgirls who served customers in hatshops. Berthe Morisot noted that "he professed the deepest admiration" for their "very *human* quality."[1] Commentators often discussed the role of the shopgirl. As art critic and fashion historian Arsène Alexandre noted, she had to be a "psychologist" in order to understand the varied mentalities of her clients.[2] Some customers needed to be encouraged, others challenged. The journalist Pierre Giffard wrote that the shopgirl needed to have "the patience of an angel" as clients could be excessively demanding, requesting endless hat changes.[3]

Degas generally represented the shopgirl as highly attentive, and implicitly subservient, to her customers: at times she is even literally effaced, as in *At the Milliner's* (1882; fig. 61), where her face is obscured by a mirror. In *Young Woman in Blue*, Degas gives a rather different, and more distant, persona to his sitter. The shopgirl is now the center of the composition, sitting with arms

tightly entwined behind her back, her head raised and looking up, perhaps with a certain disdain. Behind her, shadowy charcoal marks suggest the presence of customers. Degas's pastel has been read as caricaturing the shop assistant.[4] Yet it can equally be seen as a naturalistic exploration of one particular dynamic between shopgirl and clients within an increasingly complex retail culture.

Degas's pastel highlights his interest in the unconventional viewpoint, representing his sitter from above and behind. It also showcases his abilities as a colorist, particularly in the play of primary colors: the intense blue of the girl's bodice, the yellow of her skirt, and the red of the armchair. The pastel was probably a study for a painting that was never begun.[5] —SK

1 "Il professe pour le caractère si *humain* de la jeune demoiselle de magasin la plus vive admiration." See "Souvenirs de Berthe Morisot sur Degas," in Paul Valéry, *Degas, danse, dessin* (Paris: Gallimard, 1934), 147.

2 Arsène Alexandre, *Les Reines de l'aiguille: Modistes et couturières* (Paris: Théophile Belin, 1902), 113.

3 "Une patience d'ange." See Pierre Giffard, "Confidences d'une vendeuse," in *Les Grands bazars: Paris sous la Troisième République* (Paris: Victor Havard, 1882), 194.

4 Noting her "expressly caricatured profile," Jean Sutherland Boggs once described her as "a stalwart and comic figure—the saleswoman determined to snub her customers." See *Drawings by Degas*, exh. cat. (St. Louis: City Art Museum of Saint Louis, 1966), 172.

5 It was likely produced around the same time as the Courtauld pastel (ca. 1884; cat. no. 15), which shows a similar pose, of a woman leaning forward in her chair.

15

15

EDGAR DEGAS

Woman Adjusting Her Hair,
ca. 1884

Charcoal, chalk, and pastel
on buff wove paper
24 ¾ x 23 ⅝ in. (63 x 59.9 cm)
The Samuel Courtauld Trust, The
Courtauld Gallery, London,
D. 1948. SC. 115
L781

16

EDGAR DEGAS

Woman Adjusting Her Hair,
ca. 1884

Oil on canvas
24 x 29 in. (61 x 74 cm)
Private collection, UK
L780

This pastel and painting, both of which stayed with Degas until his death, represent central examples of the artist's examination of the female consumer in late nineteenth-century Paris. The title of the painting *Woman Adjusting Her Hair* (cat. no. 16) was first ascribed by Paul-André Lemoisne. However, it is a misleading one, as the subject is a woman who is clearly trying on a hat in front of a mirror at a fitting session. Although

this picture has been little discussed in the literature on Degas, it is one of five known paintings by the artist in his millinery series. In portraying the enigmatic, unidentified woman, Degas chose the unconventional perspective of seeing her from behind—an approach advocated by his friend, the critic Edmond Duranty.[1] The sitter's elegant silhouette features arms raised to form a tri-angle—a pose favored in other works in the millinery series, notably *At the Milliner's* (ca. 1882–1898; cat. no. 89).[2] Here she adjusts a blue toque, a brimless hat that sits on the top of the head. The light blue of the hat seems to reflect the light, perhaps by way of pail-lettes (decorative pieces of metal or colored foil) covered by a darker blue tulle netting;

a few feathers may be affixed to the back of the hat. The hat crowns a stylish ensemble of a tightly fitting dark blue bodice, buttoned down the back, and a complementary yellow-orange skirt that splays out beneath the sitter's waist. Perhaps most notable coloris-tically is a luminous red carpet that plays off the green tone of the mirror.

These elements all suggest Degas's grow-ing interest in color in the 1880s, particularly in combinations of complementary colors. It is possible that Degas also reworked the picture at a later date, heightening its color and adding to its sense of abstraction. Behind the woman are what appear to be bright windows, covered by muslin curtains, but the precise nature of the setting—whether

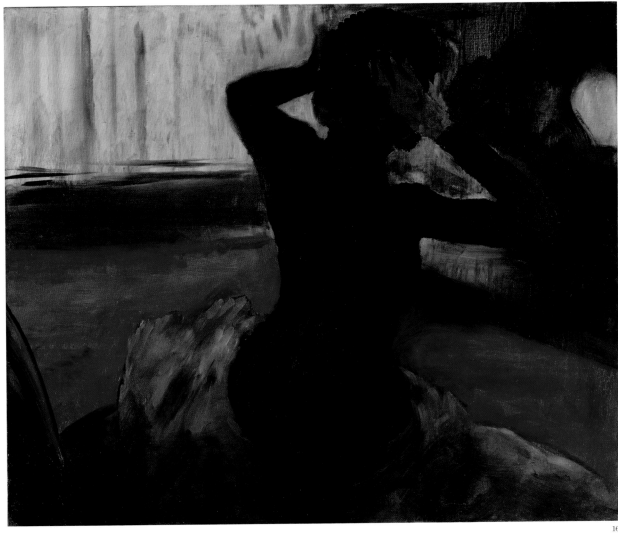

16

independent millinery shop or area of a department store—is left unclear. The reflections in the mirror to the right are also not clearly differentiated but perhaps suggest those of the orb of a gas or electric lamp.[3]

Degas's painting relates closely to the pastel *Woman Adjusting Her Hair* (cat. no. 15), a work that again should be thought of as depicting a woman arranging a hat or toque. There has been considerable debate regarding the status of this pastel relative to the painting.[4] For the present writer, it is probable that it was a study for the picture and a means of resolving the pose of the customer. Degas originally placed the woman lower in the composition of the pastel; there are clearly pentimenti of the original

configuration of the arms.[5] He then added a strip of paper, enabling him to raise her arms, head, and hat. As he worked on the painting, Degas made her posture slightly more vertical. The artist's interest in this gesture of a woman raising her arms in a triangular pattern was also explored in several drawings of dancers, indicating the crossover between his different subjects.[6] The folds of the dress in the pastel are carefully delineated and suggest the influence of the early Northern Renaissance drawing of Albrecht Dürer and Hans Holbein, which Degas had copied as a student.[7] The artist also employed rich color, particularly in the olive-green dress and the marks of bright vermilion pastel that hint at the later painting's carpet. —SK

1 Duranty had argued that "a back should reveal temperament, age and social position." See Janet McLean, ed., *Impressionist Interiors*, exh. cat. (Dublin: National Gallery of Ireland, 2008), 114–115. McLean suggests that the elegant form and red hair are reminiscent of Mary Cassatt.

2 These two paintings are exactly the same size; both highlight Degas's interest in intense areas of color, whether in their backgrounds of vermilion red or citrus yellow. See also the pose of the woman to the right in *At the Milliner's* (1882; fig. 16).

3 These orbs appeared in department stores; see the anonymous circa 1876 photograph of the interior balconies of the Louis-Charles Boileau and Gustave Eiffel–designed Au Bon Marché store, Art, Architecture and Engineering Library, University of Michigan, 01-03137. For Degas's fascination with mirrors, see catalogue number 89.

4 Paul-André Lemoisne considered the pastel to be a study for the painting. Later commentators have, however, suggested that the pastel followed the painting; see Lemoisne, *Degas et son oeuvre* (Paris: Paul Brame and C. M. de Hauke, 1946–1948), 3:444, L781. Susan Grace Galassi argues that "in the pastel, Degas's composition evolves in the direction of greater sleekness of form and dynamism" as compared to the more "static" composition of the painting. See entry in Colin B. Bailey and Stephanie Buck, eds., *Master Drawings from the Courtauld Gallery*, exh. cat. (London: Courtauld Gallery and Paul Holberton Publishing, 2012), 236–238. See also William Bradford and Helen Braham, *Mantegna to Cézanne: Master Drawings from the Courtauld, A Fiftieth Anniversary Exhibition*, exh. cat. (London: Courtauld Institute Galleries, 1983), 97–98; and John House, ed., *Impressionism for England: Samuel Courtauld as Patron and Collector* (London: Courtauld Institute Galleries; and New Haven, CT: Yale University Press, 1994), 194–195.

5 House argues that the initial state of the pastel "may have been a preparatory study" for the painting but that Degas's revisions on the pastel "probably began . . . after completing the painting." House, *Impressionism for England*, 194.

6 *Catalogue des tableaux, pastels et dessins par Edgar Degas et provenant de son atelier* (Paris: Galerie Georges Petit, 1918–1919), lots 140 a–c, 141 a and c, 142 a and b. See House, who notes the connection with lot 140, *Impressionism for England*, 194.

7 House, *Impressionism for England*, 194.

17

GEORGES WILLIAM THORNLEY
(French, 1857–1935)

Women in a Hat Shop,
ca. 1888–1890

Lithograph on wove paper
9 ⅜ x 10 ¾ in. (23.4 x 27.1 cm)
The Art Institute of Chicago, The Charles
Deering Collection, 1927.5517.1

———————

The young artist Georges William Thornley produced this reproductive lithograph after Degas's large-scale pastel *At the Milliner's* (1882; fig. 16). Thornley had previously established his reputation with lithographs after the work of François Boucher and Pierre Puvis de Chavannes, the latter being shown at the Paris Salons of 1884, 1885, 1888, and 1889. He would later reproduce the landscapes of Claude Monet. In an age before widespread photography, reproductive prints—notably lithographs and etchings—played an important role in disseminating the compositions of artists and were also seen as artworks in their own right. This delicately toned print highlights Thornley's ability to delineate the complex and often abstract patterns—and especially the textures of the hats—in Degas's pastel.

Women in a Hat Shop was one of a series of fifteen lithographs that Thornley produced after Degas's works. The series highlighted the range of subjects in Degas's output, including nudes, dancers, café scenes, and racecourse views, and was printed in a variety of colored inks; it was published as a portfolio by the dealer Boussod, Valadon et Cie.[1] Degas was very involved with the project and set elevated standards, as he himself was a highly accomplished lithographer. He showed a particular interest in *Women in a Hat Shop*, an unusually complex lithograph in the series. On August 28, 1888, he noted that the printmaker, the atelier Becquet, had brought him two proofs for this work but that he had not been happy with their quality and had sought to stop the printing.[2] He wanted to compare Thornley's reproductive drawing on transfer paper with the original pastel then belonging to Henri Rouart (see cat. no. 57), but had not had the time to do so. Degas affirmed his intention to make "a few alterations" to the drawing, noting that he had only restrained himself because Thornley was not present, and that they would finish the changes after Thornley returned to Paris. He subtly chided his young colleague for being "in too much of a hurry" in making his drawing, noting that "things of art must be done at leisure." Degas's letter indicates that he himself was ultimately responsible for some of the draftsmanship in this lithograph.[3]

Several of Thornley's prints after Degas appeared in an exhibition in the galleries of Boussod, Valadon et Cie in September 1888. *Women in a Hat Shop* was probably among these, although we cannot be certain. The prominent critic Félix Fénéon offered high praise for these works, singling out in particular the interpretative, rather than exactly reproductive, nature of the drawing style: "Here he [Thornley] provides evidence of a truly disconcerting wisdom: it is Mr. Degas's very spirit, at its most intimate, that he has imprinted on these plates. In order to arrive at this secondary reality, he has freely treated his text, and found daring, expressive equivalences when a literal translation

of such painterly idioms would have been a betrayal."[4] —SK

1 *Quinze lithographies d'après Degas* (1889), printed by Becquet Frères in a limited edition of one hundred.

2 "A few days after your flight they brought me two proofs from Béquet [*sic*] (women trying on hats). I told them to stop the printing and warned them that I would go to the printing office. It was impossible for me to go there, also to return to Rouart with your drawing on transfer paper. I wanted to make a few alterations on this latter one; and I scarcely regret not having done so as you were not there. I shall be in Paris about the 15 September and we shall get it finished." Degas, letter to Thornley, published in Marcel Guérin, ed., *Degas Letters* (Oxford: Bruno Cassirer, 1947), 146–147. The letter is mistakenly dated as April 28, 1888, in the English and French editions but should be August 28. See Gary Tinterow, entry for *At the Milliner's*, in Jean Sutherland Boggs, ed., *Degas*, exh. cat. (New York: Metropolitan Museum of Art; and Ottawa: National Gallery of Canada, 1988), 399.

3 This is further indicated by the fact that Boussod, Valadon, in addition to the edition of one hundred, sold an edition of twenty-five proofs that were signed by both Degas and Thornley. For one example, a proof of *Young Dancer with a Fan*, signed by both artists, see Richard Kendall, *Degas: Beyond Impressionism*, exh. cat. (London: National Gallery; and Chicago: Art Institute of Chicago, 1996), 50. A proof (*The Jockeys*, ca. 1888–1889; Queensland Art Gallery) after *Before the Race* (ca. 1887–1889; Cleveland Museum of Art) is also signed by both Degas and Thornley.

4 "Ici fait-il preuve d'une sagacité vraiment déconcertante: c'est l'esprit même, et le plus intime, de M. Degas qu'il empreint sur ces planches. Il a, pour atteindre à cette réalité seconde, traité librement son texte et quand traduire stricts tel idiotismes de peinture eut été trahir, il a trouvé de hardies équivalences d'expression." Félix Fénéon, "Calendrier de Septembre. Chez M. Van Gogh," *La Revue indépendante* 9, no. 24 (October 1888): 139.

18

EDGAR DEGAS

Woman in a Blue Hat,
ca. 1889

Pastel on blue paper
18 ¼ x 23 ⅝ in. (46.4 x 60.2 cm)
Private collection, Asia
L984

This intimate scene raises the question of whether the sitter is preparing to leave the house or is just returning. The composition is reduced to the form of the woman's body—pushed against the picture frame—and her unadorned headwear. Degas deftly used pastel to render various textures, such as the more thickly applied chartreuse pigment to the background and wispy staccato strokes upon her back to suggest light hitting her milky flesh. This pastel is an earlier version of the more highly finished *In Front of the Mirror* (1889; fig. 72), which features a figure before her scattered toiletries as she contemplates, her russet hair beneath the brim of an electric blue hat. Between the first and second compositions Degas designed the hat as a milliner might—starting with an unadorned form and then applying ribbons and flowers, as well as a colored lining.

As has been discussed elsewhere in this volume, Degas was likely attracted to the pastel medium for his millinery subjects because of the versatility it allowed in the conveying of materials—be it lace, silk ribbons, or coarse straw. During the 1870s and 1880s, pastel was experiencing a resurgence in Paris (see also pp. 91–95), and no artist pushed the medium to such daring effect as Degas. *Woman in a Blue Hat*, along with *At the Milliner's* (1882; cat. no. 13), was once owned by the milliner Jeanne Lanvin, who established her first shop in 1885 on rue du Marché-Saint-Honoré—not long before the execution of this work.—EB

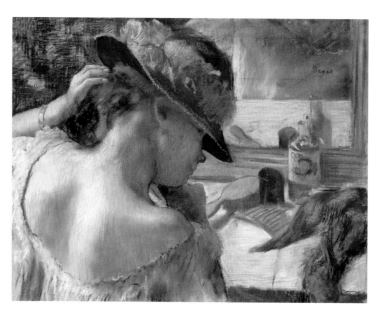

72 Degas, *In Front of the Mirror*, 1889. Pastel on paper, 19 ⅜ x 25 ⅛ in. (49.3 x 63.8 cm). Hamburger Kunsthalle, HK 1078

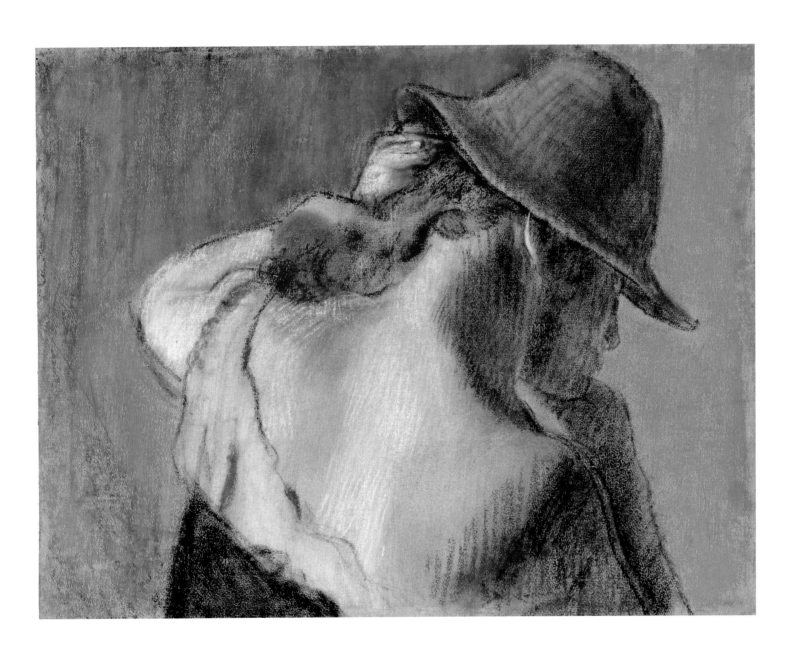

19

MICHNIEWICZ-TUVÉE
(French, active ca. 1868–ca. 1905),
designer

Woman's hat, ca. 1892

Label: "25, Place Vendôme/
Michniewicz-Tuvée/Paris"
Rabbit felt, ostrich feathers, silk satin rib-
bon, and faceted jet buckles
1¾ in. (4.4 cm) crown height;
12¾ x 12⅝ in. (32.4 x 32.1 cm) overall
Fine Arts Museums of San Francisco,
Gift of Mrs. Walter Haas, 56.18.6

This hat was part of the wedding trousseau
for San Franciscan Rosalie Meyer upon her
marriage to Levi Strauss and Company heir
Sigmund Stern in 1892.[1] It is a variant of the
low-crowned, wide-brimmed hats charac-
teristic of the last quarter of the nineteenth
century, which were especially popular in
the late 1880s and early 1890s.[2] The hat
has a wide, elliptical brim and a low crown
trimmed with brown satin ribbon that has
been pleated into five bows with jet buck-
les. Its back is accentuated by a flourish of
large ostrich feathers. The hat's rich color
and thoughtful application of embellish-
ment, which serves to emphasize the hat's
form, are characteristic of the work of
Michniewicz-Tuvée, whose stamp appears
on the hat's lining.

Contemporary news and fashion outlets
cited Michniewicz-Tuvée as one of the

leading French millinery houses during the
end of the nineteenth century.[3] Genealogical
and marriage records show that the firm's
founder, Augustine-Marie Michniewicz,
was a *marchande de modes* who married
merchant Alexis Tuvée in 1868.[4] Tuvée, the
son of Jacques-Louis Tuvée, a merchant of
silks and ribbons, founded his firm Tuvée
et Cie on the rue de Choiseul in 1827.[5] It is
unclear when Michniewicz began working
as Michniewicz-Tuvée, but records suggest
that she started designing under this name
shortly after her marriage.[6] By the mid-1870s
Michniewicz-Tuvée was operating on the
place Vendôme, where she and her house
remained through the first decades of the
twentieth century.[7] The house's closure may
have coincided with the death of its founder
in 1905.[8] —LLC

1 This attribution was made by the hat's
donor, Mrs. Walter Haas, daughter of Rosalie
Meyer Stern. See object file for 56.18.6, Fine
Arts Museums of San Francisco. A promi-
nent member of San Francisco society, Mrs.
Stern donated to the city the Sigmund Stern
Recreation Grove, among other civic contri-
butions. For more information about her, see
Michael Moses Zarchin, *Glimpses of Jewish Life
in San Francisco* (Berkeley: Judah L. Magnes
Memorial Museum, 1964), 48; Leonora Wood
Armsby, "Mrs. Sigmund Stern," *California
Historical Society Quarterly* 35, no. 2 (June
1956): 184; *The Collected Letters of Robinson
Jeffers, with Selected Letters of Una Jeffers:
Volume Three, 1940–1962*, ed. James Karman
(Stanford, CA: Stanford University Press,
2015), 111; and Jeanne E. Abrams, *Jewish
Women Pioneering the Frontier Trail: A History
in the American West* (New York: New York
University Press, 2006), 74.

2 Georgine de Courtais, *Women's Hats,
Headdresses, and Hairstyles*, 2nd ed. (New
York: Dover Publications, 1986), 138; R. Turner
Wilcox, *The Mode in Hats and Headdress*
(New York: Charles Scribner's Sons, 1945),
270; and Colin McDowell, *Hats: Status, Style,
and Glamour* (London: Thames and Hudson,
1992), 220.

3 See, for example, "Spring Hats in Paris; Capotes
Do Not Change Their Shape but the Round Hat
Is Varied," *New York Times*, February 3, 1889, 4.

4 Although historically *marchande de modes*
referred to retail merchants of fashionable
accessories for upper-class women, by the
nineteenth century the term was often used
synonymously with *modiste*. For examples, see
*Dictionnaire des dictionnaires, ou, vocabulaire
universel et complet de la langue française*
(Brussels: Société Belge de Librairie; Hauman
et Comp., 1839), 459; Charles Fleming and J.
Tibbins, *Royal Dictionary, English and French,
French and English*, vol. 1 (Paris: Firmin Didot
frères, 1857), 746; Émile Littré, *Dictionnaire
de la langue française*, vol. 3 (Paris: Librairie
Hachette et Cie, 1878), 586; J. N. Charles and
L. Schmitt, *Dictionnaire classique français-
allemand et allemand–français*, vol. 2 (Paris:
Librairie Ch. Delagrave, 1899), 590. For mar-
riage records, see "Mariages du 21 au 28 juin
1868: 2e arrondissement (Mairie de la Bourse),
rue de la Banque," *L'Indicateur des mariages de
Paris* (Bureaux à Paris) 28, no. 1271 (June 21,
1868).

5 "Marchande de rubans, soieries pour modes et
nouveautés." *Annuaire des notables commer-
çants de la ville de Paris* (Paris: J. Techener,
1861), 171. Tuvée et Cie is known to have sold
millinery materials; it won a medal for its
"nouvelle fabrication des tissus pour articles de
modes" at the Dublin International Exhibition
in 1865. "Section XV. – Tissus mélangés et
châles," *La Propagation industrielle: Revue des
arts et des manufactures*, no. 1 (April 1865):
273.

6 "Dissolutions," *Journal officiel de l'empire
français* 1, no. 249 (September 10, 1869): 1,210.
Several articles from 1879 mention Monsieur
Tuvée helping his wife with an issue of forg-
ery—another Parisian milliner, Durst-Wild
Frères, produced hats bearing the Michniewicz-
Tuvée label—but it is unclear to what extent he
was involved in his wife's day-to-day business
activities. *Le Temps*, "Judgment," January 1,
1879, n.p.; *Journal des débats politiques et lit-
téraires*, January 25, 1879, n.p.; and *Le Figaro:
Journal non politique*, January 26, 1879, 4.

7 Advertisements and articles found in both
French and American newspapers and French
trade journals mention Michniewicz-Tuvée and
its hats through the first years of the 1900s. See
*Paris-Hachette: Annuaire complet, commercial,
administratif et mondain* (Paris: Hachette &
Cie., 1904), 674; and "Hamburger's Safest Place
to Trade," *Los Angeles Herald*, September 23,
1906, image 4.

8 *Journal des débats politiques et littéraires* 117,
no. 45 (February 15, 1905): 3.

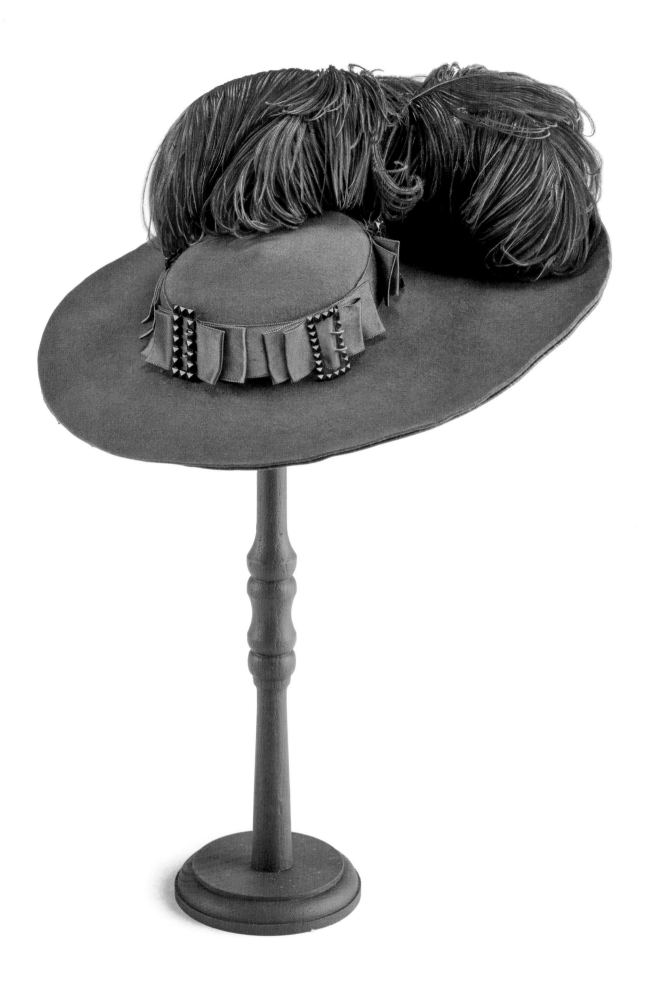

20

CORDEAU ET LAUGAUDIN
(French, active 1888–1897), designer

Woman's bonnet, ca. 1885

Label: "Cordeau & Laugaudin, modes,
32 rue des Mathurins, Paris"
Silk chiffon, Chantilly lace,
horsehair, artificial flowers, egret
feather, and silk faille ribbon
9 ⅞ in. (25 cm) height
Musée des arts décoratifs, Paris, Gift
of André d'Eichthal, 1932, 28185.A

———————

The hatmaking firm of Cordeau et Laugaudin
is best remembered as an early employer of
couturière Jeanne Lanvin.[1] But it narrowly
avoided a much grimmer legacy. On October
15, 1890, Cordeau et Laugaudin's recently
constructed atelier at 32, rue des Mathurins
was the site of a dramatic industrial acci-
dent, as nine *modistes* almost succumbed
to asphyxiation.

The atelier was heated by two portable
wood-burning stoves, which were placed at
opposite ends of the three-room premises;
such stoves were notoriously badly venti-
lated, often filling rooms with smoke and
carbon monoxide. At 11 am, without any
warning, one *modiste*, a Madame Cousteau,
suddenly collapsed unconscious. "In less
than an instant, eight other people fell
successively," a newspaper reported the
following day in a breathless account of the
near-tragedy. Luckily, a doctor lived in the
same building and administered oxygen, sav-
ing the milliners.[2]

Asphyxiation was only one of many dan-
gers that workers in the hatmaking trades
faced, including mercury poisoning, lung
disease, and exposure to lethal arsenic-based
dyes.[3] This chic bonnet of ruched red silk
chiffon trimmed with black lace, artificial
flowers, and a perky egret feather was more
dangerous than it looked.—KCC

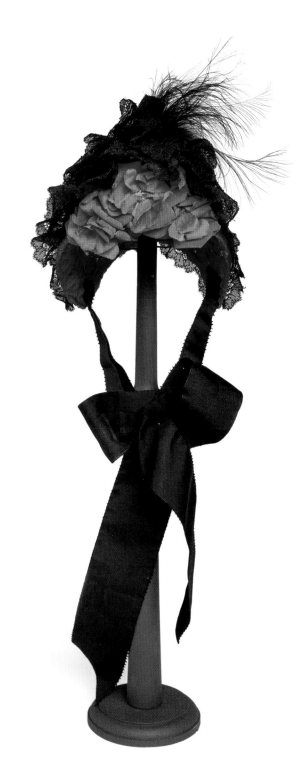

1 Jérôme Picon, *Jeanne Lanvin* (Paris:
Flammarion, 2002), 37.

2 "En moins d'un instant, huit autres personnes
tombèrent successivement." *Le Rappel*,
no. 7524 (October 16, 1890). See also *Le
Voleur illustré: Cabinet de lecture universel* 42,
no. 1739 (October 30, 1890): 702; and *Le Temps*,
no. 10743 (October 15, 1890).

3 The felting process involved mercury as
well as steamy conditions that often caused
tuberculosis and pulmonary diseases. This
was more common among men's hatmakers
than milliners, however. Arsenic dyes were a
problem across the fashion trades. For more on
this topic, see Alison Matthews David, *Fashion
Victims: The Dangers of Dress Past and Present*
(London: Bloomsbury Visual Arts, 2015), 42–71
and passim.

21

CAROLINE REBOUX
(French, 1837–1927), designer

Woman's bonnet, ca. 1883

Label: "Caroline Reboux/
23. Rue de la Paix/PARIS"
Velvet, gold braid, and feathers
14 x 11¾ in. (35.6 x 29.9 cm) overall;
ribbon ties 27½ x 2⅝ in. (69.9 x 6.7 cm)
Chicago History Museum, Gift of
Mrs. Gilbert A. Harrison, 1954.332
Worn by Mrs. Cyrus Hall
(Nettie Fowler) McCormick

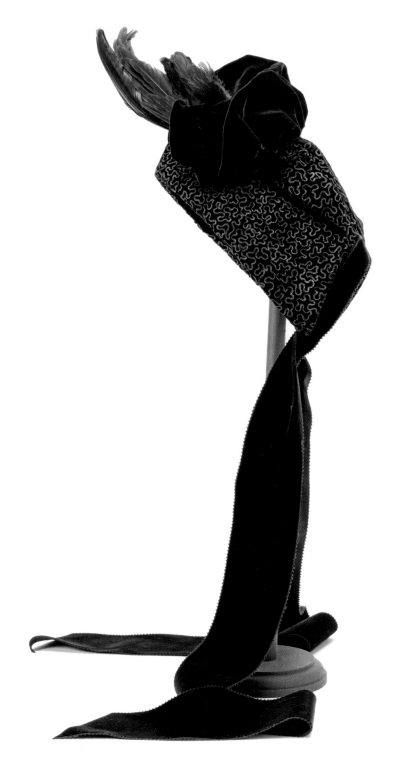

Milliner Caroline Reboux dressed the
grandes dames of Second Empire Paris.
After being discovered by the stylish
Princess Pauline von Metternich in the
1860s, she counted among her clients
Napoléon III's wife, Empress Eugénie, and
his mistress, the Countess of Castiglione, as
well as the comic actress Gabrielle Réjane.
An 1896 guidebook described Reboux as "the
modiste of both the true Parisienne, elegant
and distinguished, and the *demi-mondaine*
who has 'arrived.'"[1] By 1900 her rue de la
Paix establishment employed more than one
hundred people.[2]

Even in her later years, Reboux remained
an influential innovator; she is credited with
popularizing the close-fitting cloche hat,
the minimalist antithesis of the exuberantly
braided and beplumed bonnet from the
1880s shown here. Feathers were a favor-
ite ornament; with its soaring black wings,
this bonnet recalls the hat perched on the
back of a woman's (possibly Mary Cassatt's)
head in Edgar Degas's *Woman Viewed from
Behind (Visit to a Museum)* (ca. 1879–1885;
cat. no. 31).

After her death in 1927, Reboux's label
continued to flourish under the direction
of her assistant Lucienne Rabaté. The shop

expanded its wares to include modernist
scarves, capes, muffs, and other accessories,
finally closing its doors three decades after
the designer's death.[3] —KCC

1 "La modiste de la vraie Parisienne élégante et
 distinguée, autant que de la demi-mondaine
 'arrivée.'" *Paris-Parisien* (Paris: Paul Ollendorff,
 1896), 432.
2 *L'Album du Musée de la mode & du textile*
 (Paris: Éditions Réunion des musées nationaux,
 1997), 95.
3 See, for example, several scarves, capes, and
 muffs in the collection of the Metropolitan
 Museum of Art, New York, and a *collet*
 (ca. 1898) in the collection of the Fine Arts
 Museums of San Francisco, 59.21.7.

22

ÉDOUARD MANET
(French, 1832–1883)

At the Milliner's, 1881

Oil on canvas
33 ½ x 29 in. (85.1 x 73.6 cm)
Fine Arts Museums of San Francisco,
Museum Purchase, Mildred Anna
Williams Collection, 1957.3

———

Like Degas and Pierre-Auguste Renoir, Manet was enraptured by the art of millinery. Journalist, critic, and politician (and, briefly, French Minister of Culture) Antonin Proust revealed that Manet "spent the day in ecstasies over the fabrics that Madame Decot unrolled before him. The next day, it was the hats of a famous milliner, Madame Virot, that enthralled him. . . . On his return to the rue d'Amsterdam, he could not stop talking about the splendor of the things he had seen at Madame Virot's."[1] He had treated the subject of millinery in two drawings from 1880 (figs. 73 and 74), the first featuring three summer hats seemingly sketched from life, and the second resembling the detailed illustrations that appeared in fashion magazines such as *La Modiste universelle*.

When the present painting appeared in Manet's posthumous sale, it was called *La Modiste*.[2] Who exactly the woman was intended to be, and where she is depicted, has long been debated. Her casual dress, baring shoulder and back to reveal her porcelain flesh, suggests she is in an intimate space and not merely a consumer in a rue de la Paix showroom. Ruth E. Iskin alternatively argues that her "dress mode indicates she may be a madam of a hat shop functioning as an establishment for clandestine prostitution."[3] While this might be the case, it was not uncommon for respected milliners

to turn their residences into salesrooms, as evidenced by Eugène Atget's 1910 photographs of the domestic interior of a Madame C. on place Saint-André-des-Arts (cat. nos. 103 and 104). Furthermore, instructive texts were published in order to give women the skills they needed to become milliners in the privacy of their own homes. Louise d'Alq's *La Lingère et la modiste en famille* (1883) advocated:

> The milliner's art is even much more suitable for families. . . . Indeed, is there anything more graceful than a girl trimming her hats with her dainty fingers? One might add: Is there anything more economical? . . . We will begin with information and principles, advice and guidance that can be applied to almost all hats, both those for winter and those for summer.[4]

Regardless of the woman's identity, what is certain is that with its dazzling palette, technical mastery, and bravura brushwork—particularly evident in the black of her shawl—this painting is one of Manet's late masterpieces. It bears direct comparison to *Jeanne (Spring)* (fig. 84), painted the same year, featuring the actress Jeanne Demarsy also in three-quarter length with a carefully delineated silhouette against a decorative background. Proust recalled that Manet had accompanied Demarsy to Madame

Virot's—further linking these two paintings through their connections to millinery.[5] —EB

1 "Il passa une journée en extase devant des étoffes que déroulait devant lui Mme Decot. Le lendemain, c'étaient les chapeaux d'une modiste célèbre, Mme Virot, qui l'enthousiasmaient. Il voulait composer une toilette pour Jeanne, qui est devenue depuis au théâtre Mlle Demarsy et d'après laquelle il a peint cette toile exquise du *Printemps*. . . . En revenant à la rue d'Amsterdam, il ne tarissait pas sur la splendeur des choses qu'il avait vues chez Mme Virot." Antonin Proust, "Souvenirs sur Édouard Manet," *La Revue blanche* 11, no. 86 (January 1, 1897): 310–311.

2 Sale, Hôtel Drouot, Paris, February 4–5, 1884, lot 51, "La Modiste."

3 Ruth E. Iskin, *Modern Women and Parisian Consumer Culture in Impressionist Painting* (Cambridge: Cambridge University Press, 2007), 96; see also Hollis Clayson, *Painted Love: Prostitution in French Art of the Impressionist Era* (New Haven, CT: Yale University Press, 1991), 126–128.

4 "L'art de la modiste est encore beaucoup plus pratique dans les familles . . . en effet, est-il rien de plus gracieux qu'une jeune fille chiffonnant ses chapeaux de ses doigts mignons? On pourrait ajouter: est-il rien de plus economique? . . . Nous allons commencer par les renseignements et les principes, les conseils et avis pouvant s'appliquer a peu près à tous les chapeaux, à ceux d'hiver comme à ceux d'été." Louise d'Alq, *La Lingère et la modiste en famille* (Paris: Bureaux des Causeries Familières, 1883), 81–82.

5 Antonin Proust, *Édouard Manet: Souvenirs* (Paris: Librairie Renouard, 1913), 113.

73 Manet, *Three Heads of Women*, 1880. Watercolor, 7 ½ x 4 ⅜ in. (19 x 11 cm). Musée des Beaux-Arts, Dijon, Inv. 2959 A

74 Manet, *Two Hats*, 1880. Watercolor, 7 ½ x 4 ¾ in. (19 x 12 cm). Musée des Beaux-Arts, Dijon, Inv. 2959 C

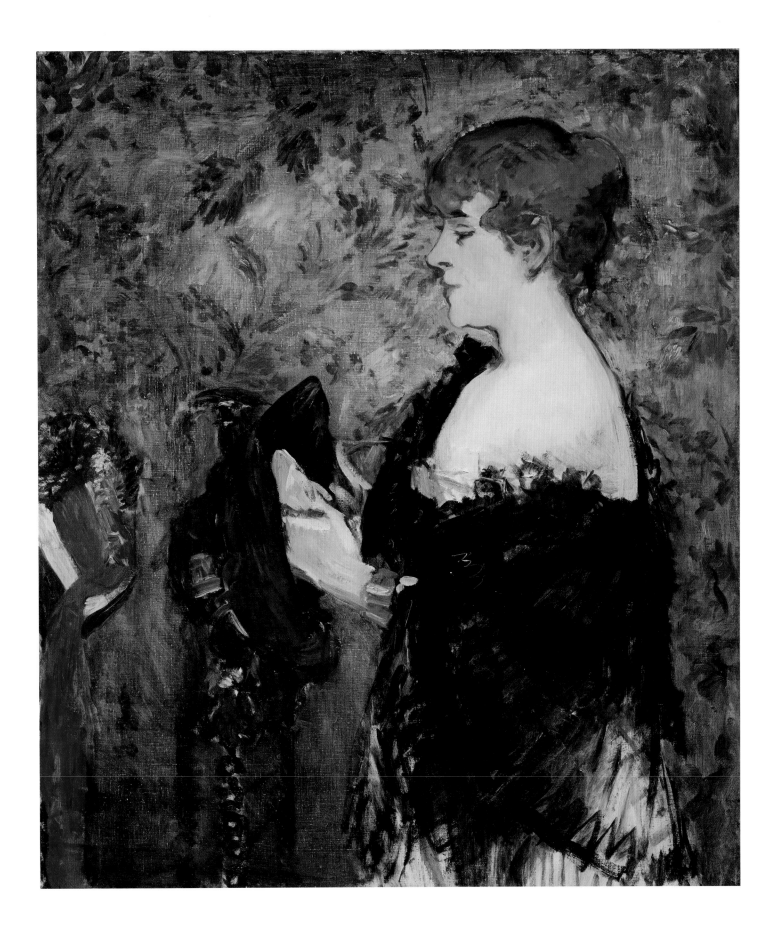

23

MANGIN MAURICE
(French, active 1880s–ca. 1920), designer

Woman's bonnet, ca. 1880

Label: "Mangin Maurice/27. Rue du
4 Septembre/PARIS."
Cotton lace and plain weave with ostrich
feathers, silk velvet ribbon, metal
sequins, metal, and faceted glass stones
8⅜ x 10½ x 3¾ in. (21.3 x 26.7 x 9.5 cm)
overall (hat only); 39 and 41½ in.
(99 x 105.4 cm) long streamers
Los Angeles County Museum of Art,
Purchased with funds provided by
Suzanne A. Saperstein and Michael
and Ellen Michelson, with additional
funding from the Costume Council, the
Edgerton Foundation, Gail and Gerald
Oppenheimer, Maureen H. Shapiro,
Grace Tsao, and Lenore and Richard
Wayne, M.2007.211.660

This beautiful but utterly impractical style represents the last gasp of the bonnet, which had dominated female headgear for most of the nineteenth century. Standing straight up, the wired brim offers no protection from the elements, but instead serves as a frame for a halo of botanically accurate pink roses of stiffened muslin, complete with stamens. Black velvet streamers tie under the chin, and several pins are required to keep the hat in place.

The crown is transparent, its wire frame covered in machine-made lace whose three-dimensional floral pattern replicates the artificial flowers. An inexpensive alternative to handmade lace, machine-made lace was a relatively recent addition to the elite milliner's arsenal of trimmings. "Imitation laces are now so well made, and in such handsome patterns, that they are used in the same way," *Myra's Home Journal* informed its readers in February 1885.[1]

Little is known about Madame Mangin Maurice, though hats based on her models were sold by Best and Company and other United States retailers as well as in France. One petite evening bonnet of 1885 is crafted of materials similar to those found in this example, with black sequins and white ostrich plumes.[2] In 1902 the *Illustrated Milliner* reported that "Mme. Mangin Maurice is noted for her beautiful children's bonnets."[3] She soon found a new audience, however, making "smart little toques and bonnets expressly designed for" elderly ladies—a demographic "that fashion, and particularly millinery fashion, neglects . . . shamefully, inventing styles only for the young," according to *Vogue*.[4] By 1917 Mangin Maurice specialized in "hats for elderly women."[5] —KCC

1 *Myra's Home Journal*, February 1885; quoted in Lucy Johnston, *Nineteenth-Century Fashion in Detail* (London: V&A Publications, 2005), 92.

2 See the evening bonnet in the Brooklyn Museum Costume Collection at the Metropolitan Museum of Art, New York, 2009.300.2473.

3 "How to Make the Paris Hats," *Illustrated Milliner* 3, no. 9 (September 1902): 59.

4 *Vogue* 32, no. 18 (October 28, 1908): 664.

5 "Les Chapeaux de Paris," *Millinery Trade Review* 42 (September 1917): 31.

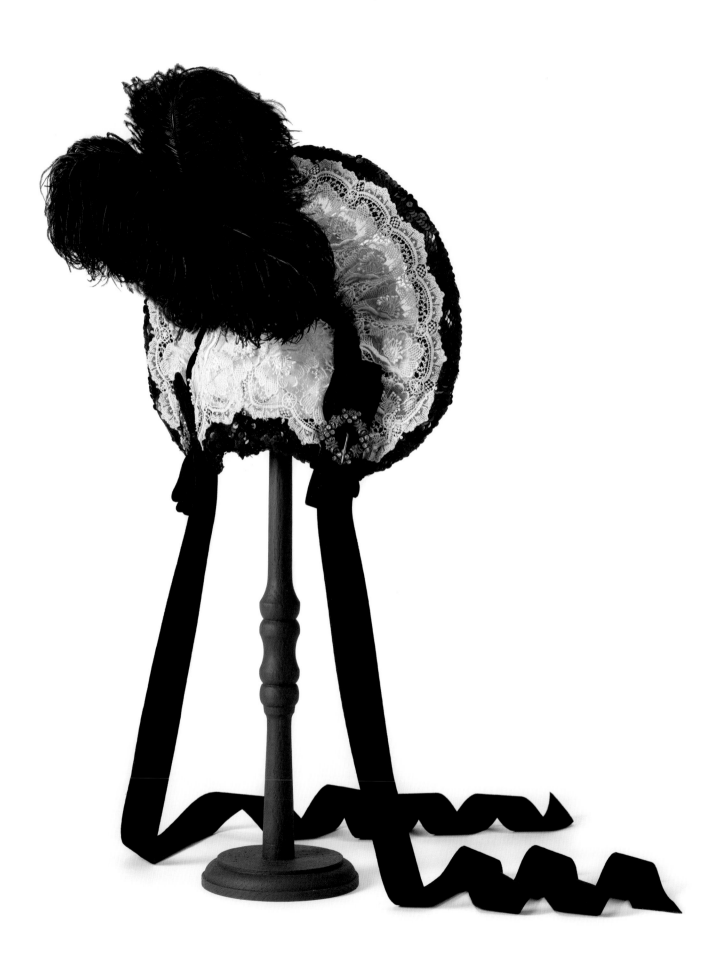

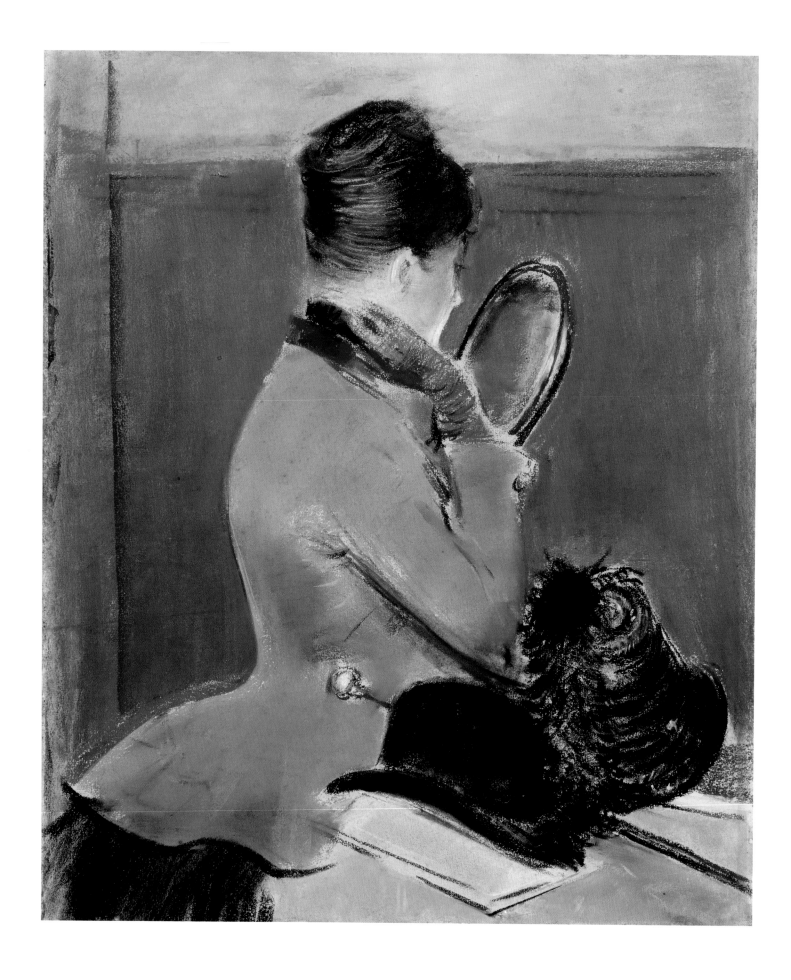

24

PAUL CÉSAR HELLEU
(French, 1859–1927)

The Final Touch, ca. 1885

Pastel on paper
20 ¾ x 17 ½ in. (54.6 x 46 cm)
Collection of the Dixon Gallery and
Gardens, Memphis, Museum
purchase with funds provided by
Brenda and Lester Crain, Hyde Family
Foundations, Irene and Joe Orgill, and
the Rose Family Foundation, 1993.7.34

Helleu was known during his lifetime for his portraits of upper-class women. Early on in his career, he became interested in the world of leisure, privilege, and fashion, constructing his own dandyish persona to match.[1] In 1886, through aesthete and poet Robert de Montesquiou, he became part of the fashionable set of the Faubourg Saint-Germain, the Parisian neighborhood much of the aristocracy called home. By the 1890s his young wife frequented the haute couture shops of Worth and Chéruit, as well as the most famous milliners.[2]

The Final Touch depicts a Parisienne examining herself in a handheld mirror. She wears a tan walking jacket over a black bustled skirt, her hair perfectly swept up in a chignon. The "final touch" of her ensemble is the tall-crowned straw hat beside her, an appropriate complement to her dress, as seen in many fashion plates from this period.[3]

The scene seems to take place in the woman's home; the presence of a man is suggested here by the bowler hat and walking stick next to her.[4] But this image also resembles those of clients trying on hats at the milliner's, like Degas's images from the same period illustrating women viewed from behind, adjusting their hair as they try on hats (see cat. nos. 15 and 16). The pastel was in fact previously identified as *Chez la modiste* and attributed to Jean-Louis Forain—another follower of Degas and the Impressionists. It was not until a recent revival of interest in Helleu's oeuvre that this pastel was "returned" to its rightful creator, when it was recognized and reattributed by Helleu's daughter Paulette.[5] —AY

1 Frédérique de Watrigant, ed., *Paul-César Helleu* (Paris: Somogy, 2014), 10, 17–19. Xavier Narbaïts remarks that, while he came from wealth, Helleu faced financial difficulties early in his artistic career. Despite this he presented himself as a man of fashion, wearing false shirt-fronts to cover the holes in his shirts.

2 *Paul Helleu: Drypoints*, exh. cat. (London: Lumley Cazelet, 1970), n.p.; and Watrigant, *Paul-César Helleu*, 47.

3 Illustrations from fashion magazines, such as the first page of *La Mode illustrée*, no. 12 (1885), show women in walking dresses wearing such tall-crowned hats as the one featured in Helleu's pastel.

4 Bowler hats and other menswear-inspired styles were also popular for women during the 1870s and 1880s, as seen in Édouard Manet's *Young Woman in a Round Hat* (ca. 1877–1878; Henry and Rose Pearlman Foundation, on long-term loan to the Princeton University Art Museum, L.1988.62.14). See Helen Burnham, "Changing Silhouettes," in Gloria Groom, ed., *Impressionism, Fashion, and Modernity*, exh. cat. (Chicago: Art Institute of Chicago; New York: Metropolitan Museum of Art; and Paris: Musée d'Orsay, 2012), 256.

5 The 2014 monograph edited by Watrigant serves as a biography of the artist as well as his catalogue raisonné. For Paulette's attribution of the pastel, see page 97.

25

ANONYMOUS
(French, late nineteenth century),
designer

Woman's hat, ca. 1885

Plaited straw, silk taffeta ribbon,
and pheasant wing
12 x 11⅛ in. (30.5 x 28.3 cm) overall
Fine Arts Museums of San Francisco,
The Laura Dunlap Leach Collection,
1985.40.40

This plaited straw hat evokes the style of
the *chapeau amazone*, or woman's riding
hat. Derived from men's top hats, the style
first emerged for women's riding dress in the
early 1800s, but became popular for fashion-
able headwear in the 1880s and 1890s.[1] This
example is accented by a silk taffeta ribbon
band and large pheasant wing. Although
pheasant wings and feathers were used to
embellish an array of women's hats in the

late nineteenth century, they were often
recommended for hats of this style.

A comparable hat, illustrated in the 1884
edition of *Journal des demoiselles et Petit
courrier des dames*, is described there as
a "bronze straw riding hat with a pheasant
wing."[2] Indeed, the wings provided vibrant
color to women's headwear through their
brilliantly marbled and speckled feathers,
which were rarely dyed. While some pheas-
ant species are common to Europe, many
others and their feathers were imported to
the continent from China beginning in the
mid-eighteenth century.[3] The wing on this
particular hat bears a strong resemblance to
those of the ring-necked pheasant.[4] Although
this breed and its feathers were imported,
the species was also reared in Europe and
the United States, where it proliferated
during the 1880s.[5] —LLC

1 *Amazone* was generally used at the time to
describe strong or athletic women; proper
women rode sidesaddle (or *en amazone* in
French) during this period. See also Nicole Le
Maux, *Histoire du chapeau féminin: Modes de
Paris* (Paris: Massin, 2000), 152.
2 "Chapeau amazone en paille bronze avec aile de
faisan." *Journal des demoiselles et Petit courrier
des dames* (1884), plate no. 4462.
3 John Tracy, "Pheasant Farming in America,"
Technical World Magazine 18 (February 1913):
713; and Andrew Lawler, *Why Did the Chicken
Cross the World? The Epic Saga of the Bird
That Powers Civilization* (New York: Atria
Paperback, 2014), 15.
4 Based on a comparison of specimens in the col-
lection of the California Academy of Sciences,
San Francisco, in consultation with Anne Getts,
Mellon Assistant Textiles Conservator, Fine
Arts Museums of San Francisco, April 2016.
5 *Birds of Paradise: Plumes and Feathers in
Fashion*, exh. cat. (Antwerp: Modemuseum; and
Tielt, Belgium: Lannoo, 2014), 71.

26

ANNIE & GEORGETTE
(French, ca. 1883–ca. 1888), designers

Woman's bonnet, ca. 1885

Label: "Mon Annie & Georgette–
3 Rue de la Paix/Paris/Fournisseur
Breveté/de la Court Royale d'Espagne"
and "M. T. Bringhurst/Wilmington, Del."
Silk velvet and metallic braid
9 x 7 in. (22.9 x 17.8 cm)
Philadelphia Museum of Art, Gift of
Mrs. Henry W. Farnum, 1948-18-44

The millinery house of Annie & Georgette
was founded at 24, rue Louis-le-Grand
around 1883. By 1884 the firm had relocated
to the rue de la Paix, where it remained
until at least 1888.[1] This bonnet's grace-
fully gathered front, typical of styles from
the mid-1880s, suggests that it was made
around 1885, after the firm had relocated to
its new location. Unlike similar styles of this
period—which were often embellished with
delicate applications of flowers or feathers—
this hat is accented by a lustrous metallic
braid.[2] The bonnet would have been worn at
the back of the head, atop a low chignon, and
with curled bangs.[3] The style was recom-
mended especially for young women in con-
temporary French fashion periodicals.[4]

This bonnet once belonged to Mary
Thomas Bringhurst of Wilmington,
Delaware, who would have been about
twenty years old when she wore it.
Bringhurst was a descendant of the trans-
atlantic merchant banker Joseph Shipley,
whose prominent Quaker family helped
found the city of Wilmington.[5] —LLC

1 Based on a survey of *Le Figaro*, 1880–1890.
2 For comparable bonnets, see *Le Journal des
modistes*, August 1, 1884, plate 1021; and
Journal des demoiselles, November 1, 1882,
plate 4388.
3 R. Turner Wilcox, *The Mode in Hats and
Headdress* (New York: Charles Scribner's Sons,
1945), 255.
4 *Journal des demoiselles*, November 1, 1882, 47.
5 "Shipley–Bringhurst–Hargraves family papers,
1660–1978," MSS 684, Special Collections,
University of Delaware Library, Newark, http://
www.lib.udel.edu/ud/spec/findaids/html/
mss0684.html.

27

ANONYMOUS
(active late nineteenth century), designer

Woman's bonnet, ca. 1890

Cotton cord and straw, plaited, with
papier-mâché, silk velvet ribbon, metal,
and faceted glass stones
Probably France
6 ¾ x 7 ½ x 3 ¼ in. (17.1 x 19.1 x 8.3 cm)
overall (without "ears"); 12 ⅝ and 13 in.
(32.1 and 33 cm) long streamers
Los Angeles County Museum of Art, Gift
of Mrs. Samuel S. Perry, CR.286.64-29

While the capacious bonnets of the early
nineteenth century protected the wearer's
face from the elements and her modesty
from prying eyes, by the 1870s such acces-
sories were purely ornamental. "A hat is
nothing but a pretext for a feather, an excuse
for a spray of flowers, the support for an
aigrette, the fastening for a plume of Russian
rooster's feathers," wrote Charles Blanc in
his 1875 treatise *L'Art dans la parure et dans
le vêtement* (*Art in Ornament and Dress*). "It
is placed on the head, not to protect it, but so
that one can see it better. Its great usefulness
is to be charming." The once-functional bon-
net had been reduced to "an elegant irony."[1]

Composed almost entirely of intricately
coiled and entwined black and natural straw,
this petite, playful bonnet is notable for its
trimmings of imitation berries and wired
"ears," which would have complemented

the vertical thrust of fashionable women's
hairstyles of the time. Velvet streamers are
anchored with bow-shaped brooches of
bejeweled gold, similar to the lozenge-shaped
buckles seen on a Mangin Maurice bonnet
(ca. 1880; cat. no. 23). As the *Millinery Trade
Review* noted in 1889, "Millinery jewelry
is still regarded as essential to the finish of
elegant millinery. . . . It appears in pins with
small, fancy heads, buckles, brooches, and
slides."[2] — KCC

1 "Le chapeau n'est plus que le prétexte d'une
plume, l'occasion d'un piquet de fleurs, le
soutien d'une aigrette, l'attache d'un plumet
de coq russe. Il est placé sur la tête, non pour
la protéger, mais pour qu'on la voie mieux.
Sa grande utilité est d'être charmant. . . . Une
élégante ironie." Charles Blanc, *L'Art dans la
parure et dans le vêtement* (Paris: Librairie
Renouard, 1875), 151.

2 *Millinery Trade Review* 14, no. 3 (March
1889): 18.

PLUMED
HATS

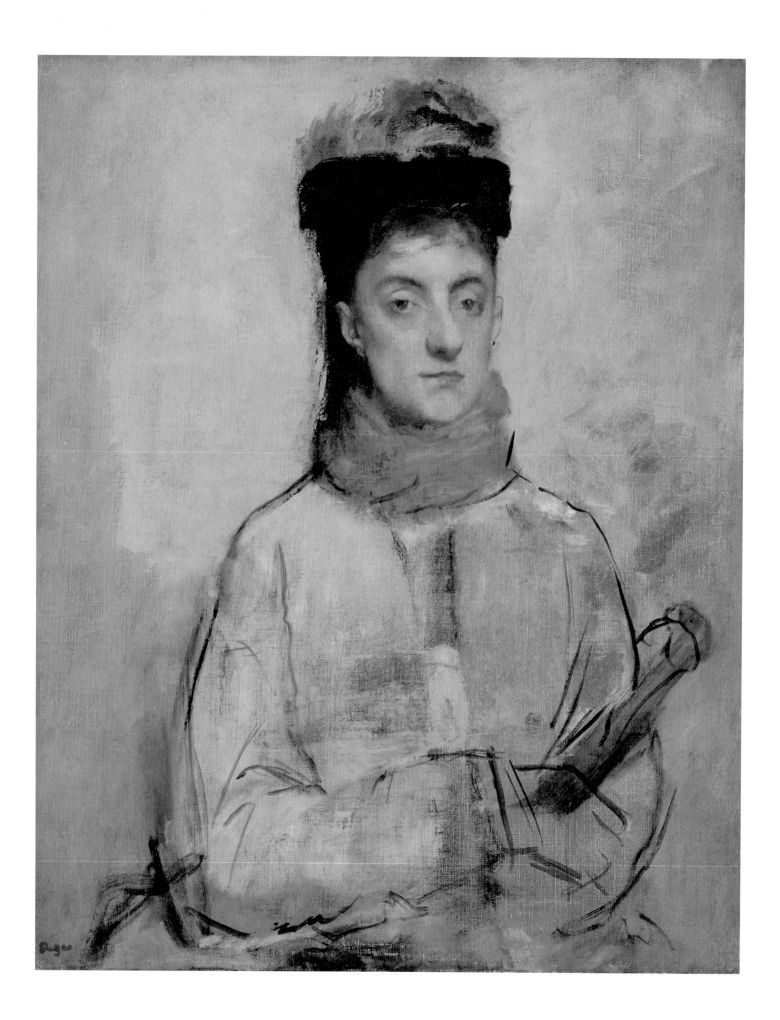

28

EDGAR DEGAS

*Woman with an Umbrella
(Berthe Jeantaud)*, ca. 1876

Oil on canvas
24 x 19 in. (61 x 50.2 cm)
National Gallery of Canada, Ottawa,
Purchased 1969, no. 15838
L463

Here Degas portrays Berthe Jeantaud, née Berthe Marie Bachoux, in a plumed hat that is comedically exuberant given her nonplussed expression and her arms folded against her chest.[1] She was the cousin of engraver Viscount Ludovic Lepic and the wife of Degas's good friend Jean-Baptiste Jeantaud (known as Charles), an engineer who invented the first electric automobile. Charles had served alongside Degas in the National Guard during the Franco-Prussian War in 1870.[2] The Jeantauds were part of Degas's social circle in the 1870s, when they lived near Henri Rouart (see cat. no. 57) at 24, rue de Téhéran.[3] This unfinished work features the sitter wearing a popular winter hat fashion, presumably of black velvet, accented with white and blue feathers and with cascading ties down the back (comparable styles were advertised in January 1875 in *La Mode illustrée*).[4]

For this portrait Degas reused a canvas, as evidenced by a sleeve appearing in the middle of Madame Jeantaud's coat. He had painted her in a slightly earlier work, also featuring her in a lavish hat, this one covered with pink artificial flowers and ribbons, gazing at own her reflection in a mirror.[5] Degas would later return to the idea of a woman examining her own likeness, particularly her headwear, in *At the Milliner's* of 1882 (fig. 61). When Clement Greenberg encountered the painting after a Degas exhibition at Wildenstein and Company in 1949, he exclaimed: "The apparently unfinished *Lady with Umbrella* of 1877 . . . gives us the other pole of Degas's talent: the head is Ingresque but more intensely naturalistic, brushed in with a swift yet precise delicacy that reminds one of Goya—to whom Degas must have gone as directly as did Manet."[6] —EB

1 Paul-André Lemoisne, *Degas et son oeuvre*, vol. 2 (Paris: Paul Brame and C. M. de Hauke, 1946), no. 463; on the identification of the sitter, see Alexander B. Eiling, ed., *Degas: Klassik und Experiment*, exh. cat. (Karlsruhe, Germany: Staatliche Kunsthalle; and Munich: Hirmer, 2014), 120–122.

2 Henri Loyrette, entry for *Jeantaud, Linet, and Lainé* (1871), in Jean Sutherland Boggs, ed., *Degas*, exh. cat. (New York: Metropolitan Museum of Art; and Ottawa: National Gallery of Canada, 1988), 166–167, no. 100.

3 Michael Pantazzi, entry for *Madame Jeantaud before a Mirror* (ca. 1875), in Boggs, *Degas*, 247, no. 142.

4 See *La Mode illustrée*, January 3, 1875.

5 *Madame Jeantaud before a Mirror* (ca. 1875), Musée d'Orsay, Paris, RF 1970-38.

6 Clement Greenberg, "Review of an Exhibition of Edgar Degas [at Wildenstein and Company, New York]," *The Nation* (April 30, 1949); reprinted in Greenberg, *Arrogant Purpose: 1945–1949*, vol. 2 of *The Collected Essays and Criticism*, ed. John O'Brian (Chicago: University of Chicago Press, 1986), 302.

29

ÉDOUARD MANET
(French, 1832–1883)

Berthe Morisot, ca. 1869–1873

Oil on fabric
29 ⅛ x 23 ⅝ in. (74 x 60 cm)
The Cleveland Museum of Art, Bequest of
Leonard C. Hanna Jr., 1958.34

Manet painted eleven portraits of the artist Berthe Morisot, all of them in the period between 1868 and the end of 1874, when Morisot married his older brother, Eugène.[1] Édouard was introduced to Morisot at the Louvre in either June or July 1868 and subsequently invited her to frequent his Thursday soirées with her sister Edma and her mother. Manet seems to have been fascinated by Morisot's dress and paid particular attention to her fashion choices, especially her hats. His portraits show her wearing mourning hats, elegant summer hats, as well as winter hats.

Berthe Morisot shows the sitter in winter dress, wearing a violet hat with gray ostrich plumes. Plumage, as a natural material that was resistant to the elements, was particularly associated with winter hats. The violet of Morisot's hat is also echoed in the color of her sleeve. There was often a connection made between plumes and fur in women's dress, since both were natural materials, and Manet shows his sitter holding a fur muff.[2] The artist's rapid brushwork and gestural impasto serve to evoke the materiality and texture of both feathers and fur.

This portrait is unsigned, and there has been debate over its dating.[3] It was never exhibited in Manet's lifetime, nor did it appear in the 1884 memorial exhibition of the artist's painting. Manet may have considered the work unfinished. The painting, nonetheless, embodies his interest in the rendering of the fashionably dressed Parisian woman. —SK

1 MaryAnne Stevens and Lawrence W. Nichols, eds., *Manet: Portraying Life*, exh. cat. (London: Royal Academy of Arts; and Toledo: Toledo Museum of Art, 2012), 182. Degas also produced two watercolors and three prints of Morisot.

2 See Louise Rousseau, *Fourrures et plumes: L'Art de les connaître, de les porter et de les conserver* (Paris: Ch. Mendel, n.d. [1890]). Rousseau's book explains the complicated process of preparing plumes. First, excess grease was removed, then the plumes were worked to render them flexible and flat: this often caused weakening and necessitated reinforcement by the sewn-on addition of a second plume. Such "doubled" plumes were "much less expensive than a simple [plume]" (beaucoup moins cher qu'une simple). Plumes were then bleached (in order to clean them completely) before being dyed in either traditional colors or newly invented aniline hues. Ibid., 91–95.

3 Manet's early biographers, Théodore Duret and Adolphe Tabarant, both dated the work to 1869. It could have been painted in 1868–1869, when Morisot sat for *The Balcony* (1868–1869; Musée d'Orsay, Paris). It is possible, however, that it was painted at a later date, such as the winter of 1870–1871, since Manet and Morisot remained in Paris during the siege of the capital at this time (see Stevens and Nichols, *Manet* [2012], 183). The fugitive quality of the work is also emblematic of Manet's portraits of Morisot in the early 1870s. See Duret, *Histoire de Édouard Manet et de son oeuvre* (Paris: Bernheim-Jeune, 1926), 250, no. 111; and Tabarant, *Manet et ses oeuvres* (Paris: Gallimard, 1947), 157–158. For a discussion of the possibility of a later dating, see Tabarant, *Manet et ses oeuvres*, 158; and the Cleveland Museum of Art's web page on the work, http://www.clevelandart.org/art/1958.34.

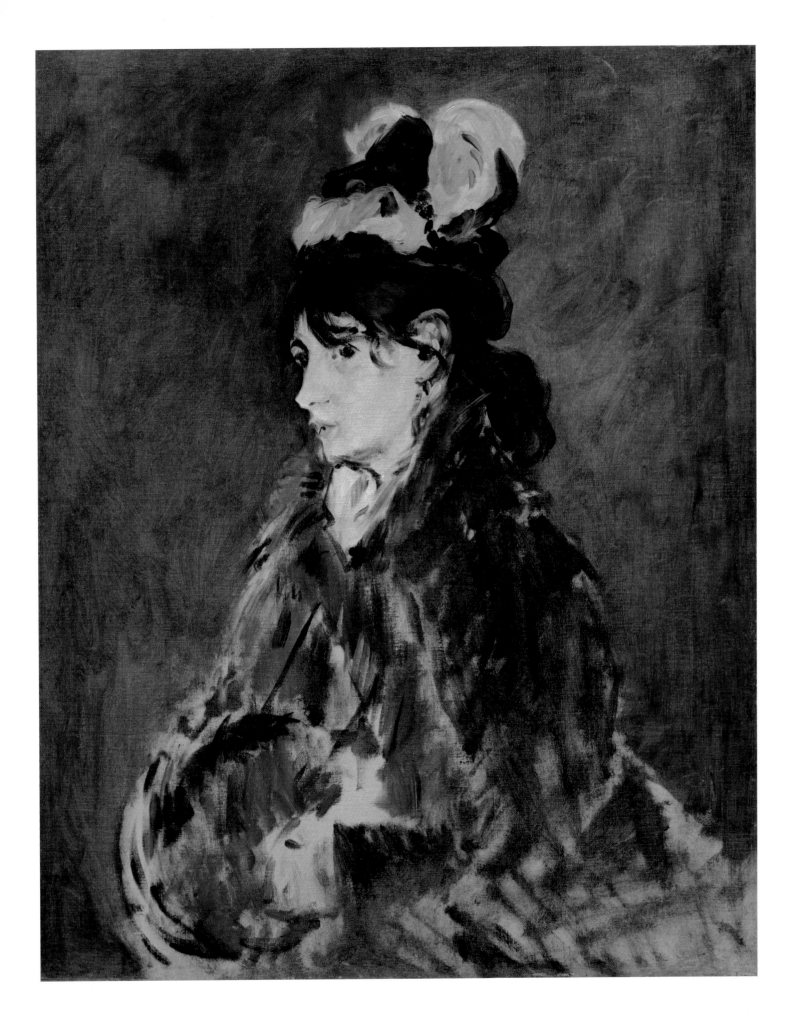

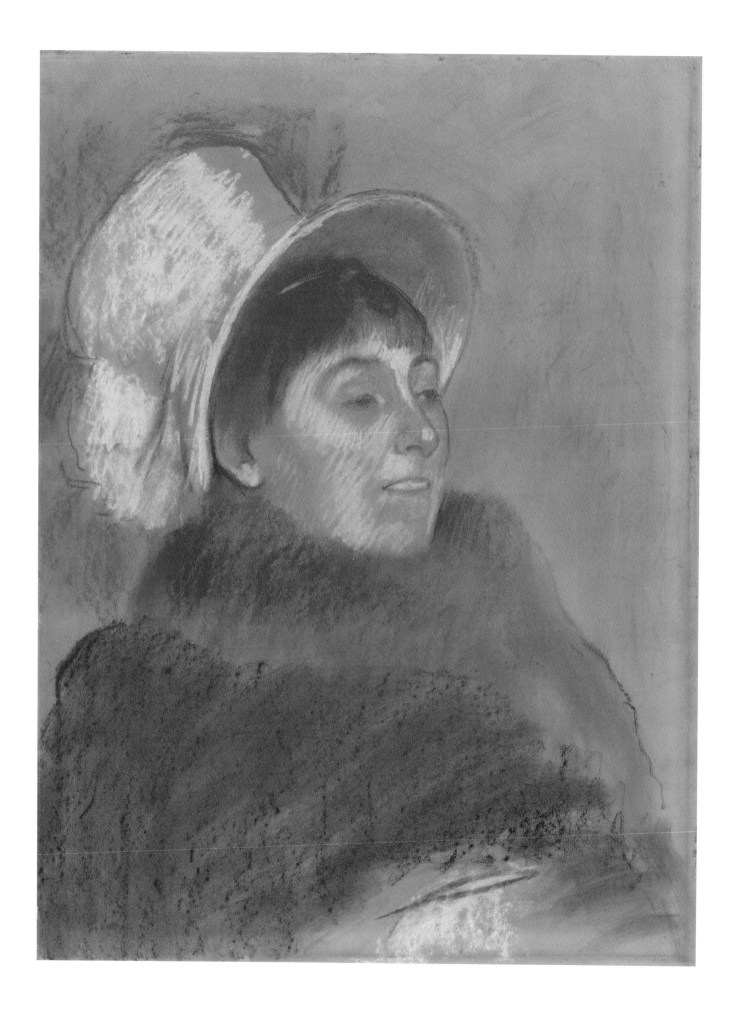

30

EDGAR DEGAS

Madame Dietz-Monnin, 1879

Pastel on paper
23 ⅝ x 17 ¾ in. (60 x 45.1 cm)
National Gallery of Art, Washington,
Gift of Mrs. Albert J. Beveridge
in memory of her aunt, Delia
Spencer Field, 1951.2.1
L535

Adèle Dietz-Monnin (née Adèle Monnin) was Swiss by birth; she took on her hyphenated surname when she married the Alsatian senator Charles Dietz. Little is known about her; according to her granddaughter, she was an "excellent amateur pianist" and from a family that took a considerable interest in the arts, especially music.[1] This pastel is one of three studies that Degas made for her painted portrait *Portrait after a Costume Ball* (fig. 75), exhibited at the 1879 Impressionist exhibition.[2] In the pastel Degas shows his sitter, who was then in her late forties, in costume regalia, with a tall hat that has the appearance of an early nineteenth-century bonnet. A pink rosette ribbon embellishes the front of the hat, and behind it is a very sketchily rendered white ostrich plume. The artist also paid careful attention to the textures of her brown fur boa. In the final painting, Dietz-Monnin was placed in a complex setting, her pink hat now rendered with larger white plumes.

Portrait after a Costume Ball seems to be a rare example of a portrait commissioned from Degas, in contrast to his general practice of representing his friends and family. Two surviving letters from Degas to Dietz-Monnin indicate that he sought to control carefully the arrangement of accessories in the painting. In one note, he affirmed that an umbrella no longer needed to be included, while the boa in contrast was "very good, as well as the long suede gloves with big folds."[3] Another drafted letter, which Degas never sent, indicates that there was tension between the artist and his sitter.[4] Degas affirmed his frustration at the suggestions of Dietz-Monnin and particularly the idea "that I reduce it [the painting] to a boa and a hat."[5] His note indicates that although the accessories were important, they were nonetheless supporting elements in framing the sitter's portrait. Their presence here suggests Dietz-Monnin's eccentric personality. It is possible too that the period hat could have belonged to Degas himself, thus reflecting his own historicizing interests. —SK

1 See the July 31, 1961, letter from Juliette Clarens, granddaughter of Madame Dietz-Monnin, to Robert K. Haycraft in the National Gallery of Art, Washington, DC, archives. Dietz-Monnin's daughter would become a noted singer.

2 The other two studies are a graphite portrait of Dietz-Monnin (1877/1879; Art Institute of Chicago, 1947.810) and a three-quarter length pastel (1879; Norton Simon Museum, M.1976.07.P).

3 See Theodore Reff, "Some Unpublished Letters of Degas," *Art Bulletin* 50, no. 1 (March 1968): 90.

4 Tensions were probably exacerbated by the fact that the commission may have been arranged by Dietz-Monnin's son-in-law, Auguste de Clermont, to whom Degas owed money.

5 "Let us leave the portrait alone, I beg of you. I was so surprised by your letter suggesting that I reduce it to a boa and a hat that I shall not answer you. . . . Must I tell you that I regret having started something in my own manner only to find myself transforming it completely into yours?" Degas, letter to Dietz-Monnin, n.d.; in Marcel Guérin, ed., *Degas Letters* (Oxford: Bruno Cassirer, 1947), 60–61.

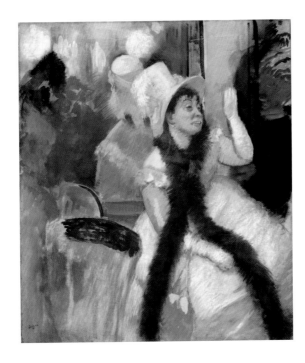

75 Degas, *Portrait after a Costume Ball (Portrait of Madame Dietz-Monnin)*, 1879. Distemper, with metallic paint and pastel, on fine-weave canvas, 33 ¾ x 29 ⅝ in. (85.7 x 75.3 cm). The Art Institute of Chicago, Joseph Winterbotham Collection, 1954.325

31

EDGAR DEGAS

Woman Viewed from Behind (Visit to a Museum), ca. 1879–1885

Oil on canvas
32 x 29 ¾ in. (81.3 x 75.6 cm)
National Gallery of Art, Washington,
Collection of Mr. and Mrs. Paul Mellon,
1985.64.11

Degas explored the subject of women viewing art in a museum in a variety of media, including two prints, at least five drawings, about twelve pastels, and two paintings.[1] This series bears comparison to his millinery one in that both focus on a woman's suspended absorption in an aesthetic object (see pp. 95–97). His first investigation of the subject of the museum visit dates to a sketch that he adhered to a page of one of his notebooks in 1860, featuring a man and a woman looking at a painting then attributed to Giorgione.[2] He would return to the theme for approximately two decades, including among his many variations the painting *Visit to a Museum* (ca. 1879–1890; fig. 76) and the etching *Mary Cassatt at the Louvre: The Etruscan Gallery* (1879–1880; fig. 77). In the latter he presented his friend Cassatt (although the identity of this figure has been debated) in the midst of appreciating ancient sculptures before her.[3] The seated figure engrossed in her guidebook has been traditionally identified as Cassatt's sister Lydia.

As in the present painting, the primary figure's face is deflected, and her hat anchors her slight body. The etching was intended for a journal, *Le Jour et la nuit*, Degas had hoped to establish (it never came to fruition).

Degas would have been familiar with the genre of museum gallery depictions, as views of the Louvre's interior were exhibited with regular frequency at the Paris Salons in the nineteenth century.[4] The Louvre was also hallowed ground for Degas and his contemporaries; it was the site of their artistic training as they studied, and made copies after, the old masters. The woman in the present painting stands in the Grande Galerie, distinguished by its paired pink columns, where one could view large-format masterpieces. The artist Walter Sickert recalled that in this picture Degas was trying to "give the idea of that bored and respectfully crushed and impressed absence of all sensation that women experience in front of paintings," adding that the brushstrokes upon the wall were meant to suggest Veronese's *The Wedding Feast at Cana* (1563).[5] Despite this misogynistic statement, Degas's respect for skilled women such as Cassatt is well known. Like the fashionable consumers he depicted thoughtfully inspecting hats on rue de la

76 Degas, *Visit to a Museum*, ca. 1879–1890. Oil on canvas, 36 ⅛ x 26 ¾ in. (91.8 x 68 cm). Museum of Fine Arts, Boston, Gift of Mr. and Mrs. John McAndrew, 64.49

77 Degas, *Mary Cassatt at the Louvre: The Etruscan Gallery*, 1879–1880. Aquatint, drypoint, soft-ground etching, and etching with burnishing, 10 ½ x 9 ¼ in. (26.8 x 23.6 cm). Fine Arts Museums of San Francisco, Museum purchase, Achenbach Foundation for Graphic Arts Endowment Fund, 1971.29.3

Paix, women such as this one contemplate artistic production. The woman pictured in profile—with light shining upon her ear and upon the top of her head—is crowned by the brilliant plumage of her black hat.—EB

1 See Gloria Groom, ed., *Impressionism, Fashion, and Modernity*, exh. cat. (Chicago: Art Institute of Chicago; New York: Metropolitan Museum of Art; and Paris: Musée d'Orsay, 2012), 225.

2 Theodore Reff, ed., *The Notebooks of Edgar Degas* (Oxford: Clarendon Press, 1976), 1:94, no. 35; and Kimberly A. Jones, "'A Much Finer Curve': Identity and Representation in Degas's Depictions of Cassatt," in Jones, ed., *Degas/Cassatt*, exh. cat. (Washington, DC: National Gallery of Art; and Munich: Prestel/DelMonico Books, 2014), 89.

3 Jones, "'A Much Finer Curve,'" 88.

4 Lucretia H. Giese, "A Visit to the Museum," *MFA Bulletin* 76 (1978): 51; J. J. Marquet de Vasselot, "Répertoire des vues des salles du Musée du Louvre," *Archives de l'art français*, 20 (1937–1945), nos. 268, 273, 648–655, 703.

5 Walter Sickert, "Degas," *Burlington Magazine for Connoisseurs* 31, no. 176 (November 1917): 186; and Gary Tinterow, entry for *Mary Cassatt at the Louvre: The Paintings Gallery*, in Jean Sutherland Boggs, ed., *Degas*, exh. cat. (New York: Metropolitan Museum of Art; and Ottawa: National Gallery of Canada, 1988), 440, no. 266.

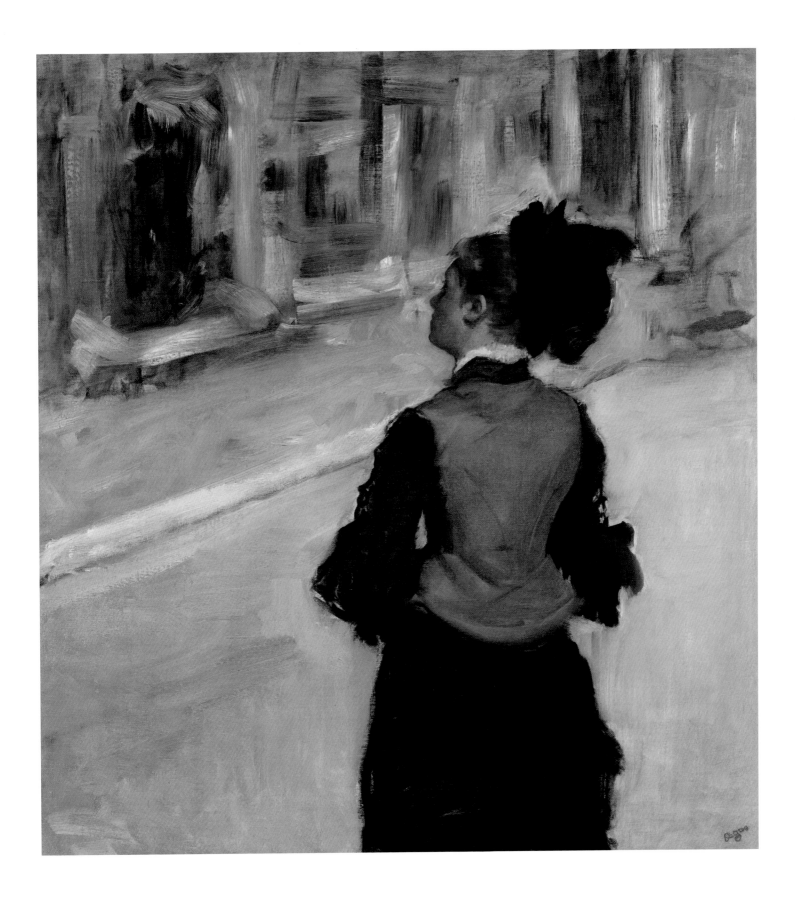

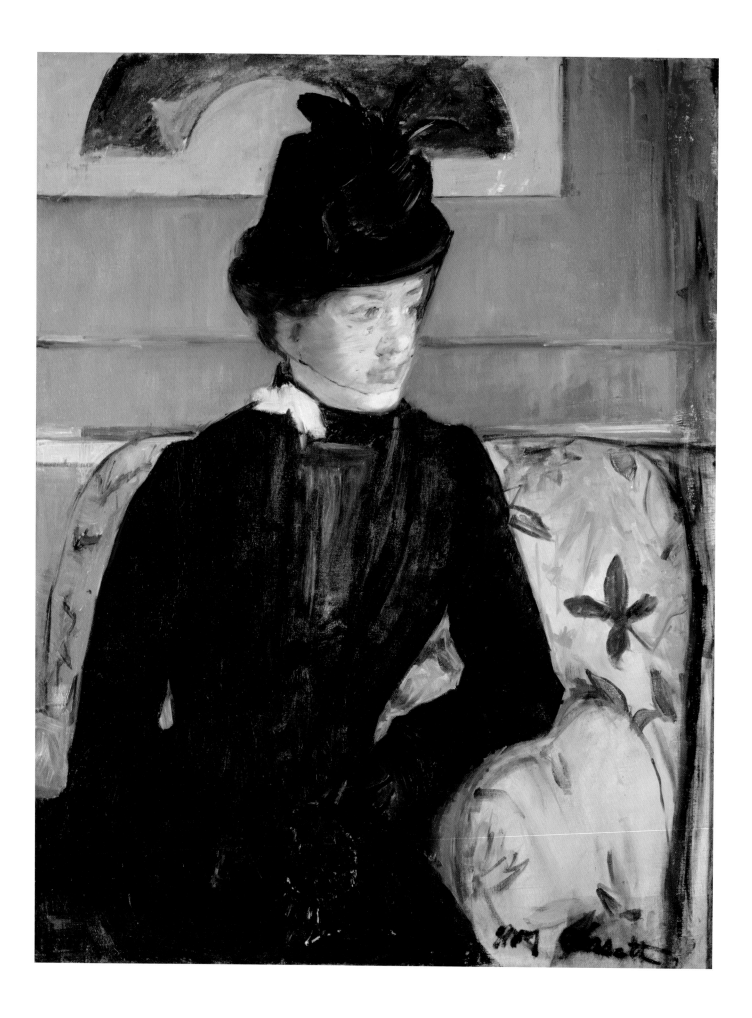

32

MARY CASSATT

(American, 1844–1926)

Portrait of Madame J (Young Woman in Black), 1883

Oil on canvas
31 ½ x 25 in. (80 x 63.5 cm)
Collection of the Maryland State
Archives: The Peabody Art Collection,
MSA SC 4680-10-0010

Cassatt's portrait possibly depicts her energetic sister-in-law Eugenia ("Jennie") Cassatt.[1] Jennie married the artist's brother, Joseph Gardner ("Gard") Cassatt, in 1882 and encouraged her to paint family members whenever possible.[2] The painting's subject is seated on a floral-patterned armchair wearing a plumed black hat trimmed with bird wings and a thin veil.[3] This decoration had a practical function when worn outdoors: it protected a woman's face from dust while simultaneously mediating her vision of urban spaces as well as access to her features.[4]

The American expatriate artist's close personal and professional relationships with members of Impressionist circles were mainly through Edgar Degas. Acknowledging that she was transformed by the work of Degas, Cassatt traded her own *In the Loge* (ca. 1879) and *Girl Arranging Her Hair* (1886) for two works by Degas: *Fan Mount: Ballet Girls* (1879) and the pastel *Woman Bathing in a Shallow Tub* (1885).[5] Evocative of a shared interest with Degas in Japanese aesthetics, *Fan Mount* was a particular favorite of Cassatt's, and she considered it "the most beautiful one that Degas painted."[6] It is visible in a circa 1903–1905 photograph (fig. 78), taken in Cassatt's Paris living room by Theodate Pope (née Effie Brooks Pope, later Theodate Pope Riddle). An architect, philanthropist, and friend of Cassatt, she featured Degas's *Fan Mount* above the artist's head in a similar way to its framing of the hat in this painting.—MB

1 Sona Johnston, *Faces of Impressionism: Portraits from American Collections*, exh. cat. (Baltimore: Baltimore Museum of Art; and New York: Rizzoli, 1999), 58–59, cat. no. 10. See also Charles S. Moffett, ed., *The New Painting: Impressionism, 1874–1886*, exh. cat. (San Francisco: Fine Arts Museums of San Francisco, 1986), 311 and 321, where this painting is cited as the work exhibited by Cassatt in 1880 as *Portrait de Mme J.* (no. 17) in the fifth Impressionist exhibition. This complicates the identification of the subject as Jennie, since the portrait would predate her marriage and subsequent visit to see Mary Cassatt in Paris in 1883.

2 Nancy Mowll Mathews, *Mary Cassatt: A Life* (New York: Villard Books, 1994), 242.

3 Adelyn Dohme Breeskin, *Mary Cassatt: A Catalogue Raisonné of the Oils, Pastels, Watercolors, and Drawings* (Washington, DC: Smithsonian Institution Press, 1970), 76, no. 129.

4 Marni Reva Kessler, *Sheer Presence: The Veil in Manet's Paris* (Minneapolis: University of Minnesota Press, 2006).

5 Cassatt: *In the Loge* (ca. 1879), Philadelphia Museum of Art, 1950-52-1, and *Girl Arranging Her Hair* (1886), National Gallery of Art, Washington, DC, 1963.10.97; and Degas: *Fan Mount: Ballet Girls* (1879) and *Woman Bathing in a Shallow Tub* (1885), Metropolitan Museum of Art, New York, 29.100.555 and 29.100.41, respectively. See ibid., 128–129. See also Ann Dumas, ed., *The Private Collection of Edgar Degas*, exh. cat. (New York: Metropolitan Museum of Art, 1997); and Colta Ives, Susan Alyson Stein, and Julie A. Steiner, eds., *The Private Collection of Edgar Degas: A Summary Catalogue* (New York: Metropolitan Museum of Art, 1997), 6, no. 46, and 7, no. 47.

6 Cassatt, letter to Durand-Ruel, end of 1912; published in Lionello Venturi, ed., *Les Archives de l'impressionnisme* (Paris: Durand-Ruel, 1939), 2:129.

78 Theodate Pope Riddle, *Mary Cassatt Seated beneath Her Degas Fan*, ca. 1903–1905. Photograph, 3 x 2 ¾ in. (7.6 x 6.9 cm). Archives, Hill-Stead Museum, Farmington, CT, 288

33

ALFRED STEVENS
(Belgian, 1823–1906)

*Portrait of Mademoiselle
Dubois,* 1884

Oil on canvas
27 ½ x 21 ½ in. (69.9 x 54.5 cm)
Minneapolis Institute of Art, Gift of
funds from the Paintings Curatorial
Council 2007 Germany trip members, the
Paintings Curatorial Council's George S.
Keyes Discretionary Fund, and the Ethel
Morrison Van Derlip Fund, 2007.45

This portrait depicts Anne Dubois, one of Stevens's students, and is therefore different from the representations of unidentified Parisienne beauties for which he is best known.[1] A friend of the Impressionists, Stevens did not formally adopt their painting techniques; he did, however, favor similar subject matter such as scenes of modern Paris, where the Belgian artist spent a majority of his career.[2] The contemporary translator of his treatise *Impressions sur la peinture* (*Impressions on Painting*, 1886) proposed, "As a painter of women, this artist might well be called the Balzac of the brush, for his tender and gracious rendering of the subtle beauties of the modern woman—and especially the Frenchwoman of fashion. One breathes in his compositions the atmosphere of the *grand monde* on its most exquisite, feminine side."[3]

The subject's direct gaze and casually reclining posture suggest that the artist was well acquainted with his pupil. She likely modeled for him in accordance with his suggestion that "the student should be forbidden to draw from memory. . . . He ought always to work *de visu.*"[4] Stevens was one of the first artists in Paris to collect Japanese decorative art and prints, which may have inspired the compressed compositional space of the figure against the railing and the awning above. Framed in front of a tan sunshade, she holds a sprig of purple irises that provides a hint of vibrant color. Dubois's ensemble is accented with the articulation of specific accessories, including the luscious, tall plumage on her fashionable black hat, which is striking against the sunlight-drenched canopy.—MB

The author would like to thank Patrick Noon, Elizabeth MacMillan Chair of Paintings, and Heather Everhart, Paintings Department assistant, at the Minneapolis Institute of Art, as well as Sue Canterbury, Associate Curator of American Art, at the Dallas Museum of Art.

1 Sue Canterbury, "New on View," *Arts* (Minneapolis Institute of Art) 30, no. 6 (November/December 2007).

2 For more on Stevens, see *Alfred Stevens: Brussels 1823–Paris 1906*, exh. cat. (Brussels: Mercatorfonds and Royal Museums of Fine Arts of Belgium; and Amsterdam: Van Gogh Museum, 2009); and Danielle Derrey-Capon and Alain Dierkens, *Alfred Stevens (1823–1906) et le panorama de l'histoire du siècle* (Gand, Belgium: Snoeck, 2009).

3 Charlotte Adams, introduction to Alfred Stevens, *Impressions on Painting* (New York: George J. Coombes, 1886), xii.

4 Stevens, in ibid., 43.

34

MAISON VIROT
(French, ca. 1845–ca. 1915), design house

Woman's hat, ca. 1895

Label: "Mon Virot/
12 Rue de la Paix/Paris"
Silk velvet ribbon, ostrich and
bird of paradise feathers, paillettes,
and metal buckle
8 x 9 x 7 in. (20.3 x 22.9 x 17.8 cm)
Chicago History Museum, Gift of Mrs.
Albert J. Beveridge, 1949.297
Made for Mrs. Augustus Newland Eddy

Madame Virot began her career as an assistant to the milliner Laure; after marrying a sculptor, she established her own house around 1860.[1] Her designs—distinguished by their "charm of coloring" and unique "twist and turn [of] ribbon"—quickly captured the attention of Empress Eugénie, who became her client.[2] Édouard Manet also held her in high esteem (see cat. no. 22).

As Virot's fame grew—"owing to her extraordinary native taste and skill"—she moved her shop to the rue de la Paix, where this hat was made.[3] Intended as eveningwear, the delicate design is made from sumptuous black and navy silk velvet ribbon, which gathers at the hat's front by a metal buckle; black, blue, and green paillettes as well as black ostrich and bird of paradise feathers accent the creation.[4]

The hat was made for and worn by the wife of the prominent Chicago manufacturer and merchant Augustus Newland Eddy.[5] Born Abbie Louise Spencer, she traveled often to Paris, where she frequented the shops of the leading milliners, most notably Maison Virot, as well as the houses of such preeminent *couturiers* as Charles Frederick Worth and Émile Pingat.[6] Indeed, as Phyllis Magidson has documented, elite Americans would rarely visit the House of Worth without shopping at the nearby Maison Virot for hats to complement their new garments,[7] and Mrs. Eddy was no exception.—LLC

1 "The Contributors' Club," *Atlantic Monthly: A Magazine of Literature, Science, Art, and Politics*, October 1884, 570; and "Maison Virot, Limited," *The Statist*, July 17, 1897, 98.

2 "Paris Fashions," *Woman's World*, edited by Oscar Wilde, vol. 3 (London: Cassell & Company, 1890), 31 and 418.

3 "The Contributors' Club," 570.

4 The hat is similar in style and shape to other eveningwear hats of this period. For a comparable example, see *La Mode illustrée*, no. 7 (February 17, 1895): 52.

5 I am thankful to Petra Slinkard, curator of costumes at the Chicago History Museum, for sharing information about the hat and its donor.

6 Website for the 2007 exhibition *Chic Chicago: Couture Treasures from the Chicago History Museum*, Museum at the Fashion Institute of Technology, New York, http://sites.fitnyc.edu/depts/museum/ChicChicago/NewlandEddy.htm.

7 Phyllis Magidson, "A Fashionable Equation: Maison Worth and the Clothes of the Gilded Age," in *Gilded New York: Design, Fashion, and Society*, ed. Donald Albrecht and Jeannine Falino (New York: Museum of the City of New York and Monacelli Press, 2013), 119.

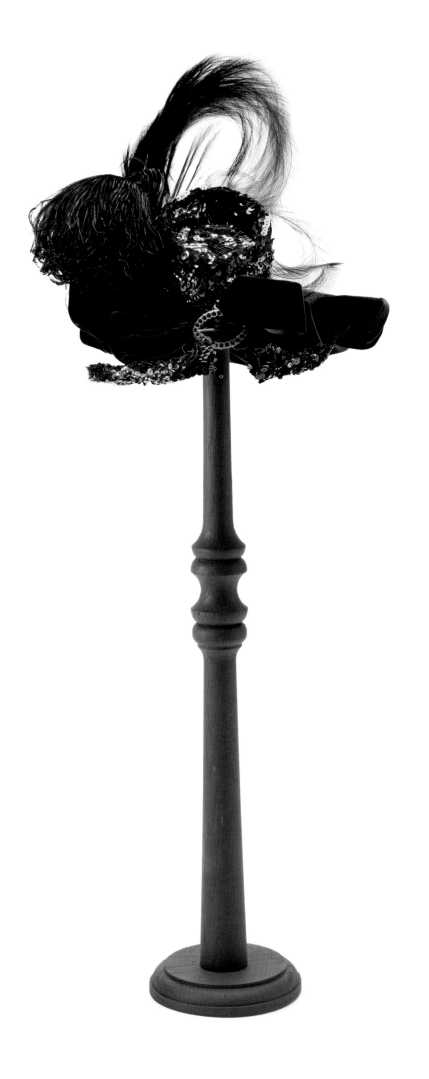

35

ANCIENNE MAISON PAUL
VIROT & BERTHE
(French, active late nineteenth–
early twentieth century), design house

Woman's hat, ca. 1905–1910

Label: "26 Place Vendôme/
Ancienne Maison/Paul Virot &
Berthe/Léontine Succr./Paris"
Plush and ostrich feathers
15 ⅜ x 16 ⅞ x 11 ¾ in.
(39 x 43 x 30 cm) overall
Fine Arts Museums of San Francisco, Gift
of Mrs. Philip van Horne Lansdale, 55.6.4

Madame Virot retired from her house in 1885, but the firm remained in operation on the rue de la Paix through the turn of the twentieth century.[1] Although the original house endured, various entities attempted to adopt Virot's prestigious name so as to capitalize on her legacy, including Madame Virot's former *première* Berthe Raymond. After Madame Virot's retirement, Raymond founded "Paul Virot & Berthe" with Madame Virot's son Paul in 1886.[2] Located near Madame Virot's house, the new business was contested by Paul's brother Léon on the grounds that the new millinery establishment, its brand, and its resulting designs were not distinctive from the original and would confuse clients and the larger public.[3] This "Paul Virot & Berthe" design appears to substantiate Léon's claims, as the hat, with its oversize crown and luxurious sweep of ostrich feathers, evokes known Virot designs from the period.[4] Ultimately, the French courts ruled in favor of Léon and ordered Raymond to replace signs, invoices, letters, brochures, and other materials bearing "Paul Virot & Berthe" with "Ancienne Maison Paul Virot & Berthe," the name found on this hat's label.[5] —LLC

1 See "Maison Virot, Limited," *The Statist*, July 17, 1897, 98; and "For Women's Fancies," *Lewiston Daily Sun*, August 19, 1897, 3.

2 *Journal des tribunaux de commerce* (Paris: Chevalier-Marescq et Cie, 1896), 429.

3 "Tribunal civil de la Seine," *La Gazette du palais* (Paris: Rédaction et Administration, 1894): 405–406; and "Jurisprudence: France," *Bulletin officiel de la propriété industrielle & commerciale*, no. 586 (April 18, 1895): 261.

4 For comparable Virot hats, see "Spring Millinery from Paris," *Vogue*, January 24, 1907, 132–133; "French Hats and How to Wear Them," *Vogue*, April 25, 1907, 691; and "Millinery Supplement," *Vogue*, January 14, 1909, 39.

5 *Journal des tribunaux de commerce*, 431.

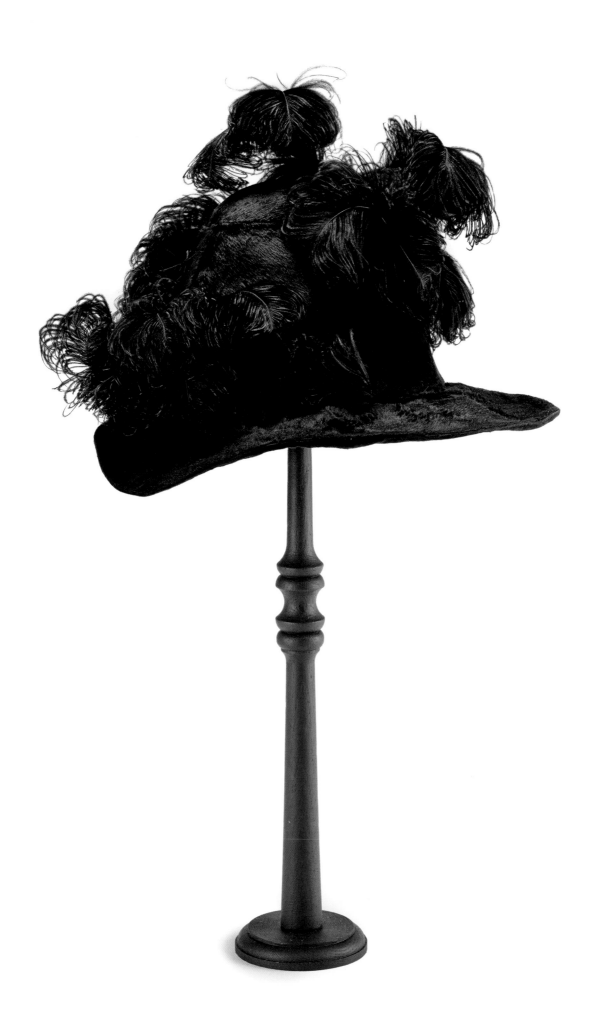

36

CAROLINE REBOUX
(French, 1837–1927), designer

Woman's toque, ca. 1900

Label: "Caroline Reboux /
9 avenue Matignon, Paris"
Lady Amherst pheasant feathers
and silk tulle
9 ⅞ in. (25 cm) length;
13 in. (33 cm) width
Musée des arts décoratifs, Paris, UFAC
collection, Museum purchase, UF 89-48-3

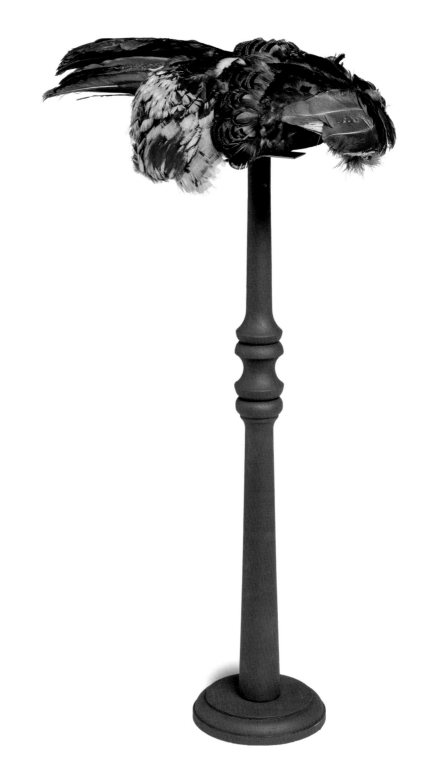

Birds and birds' wings were popular trimmings for toques, lending dimension and visual interest to the low, brimless style. "It's the toque that dominates," the weekly magazine *La Semaine littéraire* declared in 1901. "Birds, alas, entire seagulls rest on these toques, or else a bird's head forms the middle in front, the two wings spread out to cover the whole hat."[1] This example designed by Caroline Reboux—a milliner as well known for her innovative use of feathers as she was for her toques—is entirely covered with plumes of green, red, brown, and yellow, topped by two shapely pheasant wings. It gives the impression of a fully fledged exotic bird without resorting to the increasingly frowned-upon practice of employing avian carcasses, or, as the magazine called them, "these sad fantasies."[2]

Such winged hats were admired for their natural beauty and artful craftsmanship. In February 1900, *Vogue* described a chic Parisienne wearing a "little toque . . . adorned with a few upright wings of some sort of South American bird, the sleek feathers of which gleamed like jewels."[3] However, moralists and naturalists criticized naive European women who believed that wearing wings and aigrettes was a compassionate alternative to slaughtering entire birds: "It

has never occurred to them that the pretty wings in their hats did not fall of themselves from the bright birds that once flew with them."[4] —KCC

1 "C'est la toque qui domine. . . . Des oiseaux, hélas! des mouettes tout entières se couchent sur ces toques, ou bien une tête d'oiseau forme le milieu par devant, les deux ailes déployées recouvrant tout le chapeau." *La Semaine littéraire* 9, no. 411 (November 16, 1901): 552.

2 "Ces tristes fantaisies." Ibid.

3 *Vogue* 15, no. 6 (February 8, 1900): 91.

4 *The Selborne Society's Magazine* 7, no. 78 (June 1896): 115.

37

JEANNE LANVIN
(French, 1867–1946), designer

Woman's hat, ca. 1915

Label: "Jeanne Lanvin PARIS/
22, Faubourg St. Honoré"
Artificial silk and silk plain weave,
artificial silk and cotton plain-weave
(grosgrain) ribbon, ostrich feathers,
and linen buckram lining
10 ⅝ x 11 ¾ x 13 in. (27 x 30 x 33 cm)
overall, with plumes
Museum of Fine Arts, Boston, Gift of
Miss Agnes Mongan, 1979.198

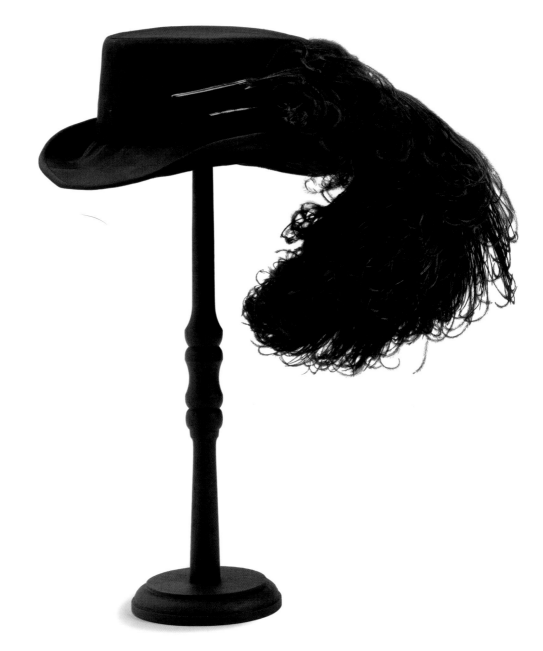

The couture house of Jeanne Lanvin began as a small millinery workshop on the rue du Marché-Saint-Honoré in 1885.[1] In 1889 Lanvin moved to a boutique at 16, rue Boissy-d'Anglas, and by 1893 she had established her house at 22, rue du Faubourg-Saint-Honoré. Much like her later clothing designs, she designed her hats from a wide range of materials, including *soie artificielle* (artificial silk), as seen in this example.[2] The production of an artificial silk was first suggested by Swiss chemist Georges Audemars in 1855 but not produced in France until the late nineteenth century.[3] By the early 1910s artificial silk was being employed frequently in millinery, first for trimmings and then for hat foundations, particularly as the cost of true silk increased in the years prior to the outbreak of World War I.[4] French hats made from artificial silk were subject to lower duties in America than those made from true silk, which may have contributed to the fabric's use and appeal.[5] Additionally, as Thomas Woodhouse noted in his treatise on the material, "The sight of almost any article made from artificial silk . . . is sufficient to arouse admiration, and in many cases to create a desire to possess the article."[6] This hat also evidences the return of ostrich feathers to French-made women's headwear during the early 1910s, after conservation efforts led to a ban on aigrettes and their importation in America.[7] —LLC

1 Dean Merceron, *Lanvin* (New York: Rizzoli, 2007), 40.
2 Lanvin's use of rayon is documented in contemporary writings; the house even lent its name to a series of promotional advertisements by the Rayon Institute, a cooperative of rayon manufacturers formed in 1928. "Rayon Institute," *Harvard Business Reports*, vol. 2 (New York: McGraw-Hill Book Company, 1932), 127–132.
3 Thomas Woodhouse, *Artificial Silk: Its Manufacture and Uses* (London: Sir Isaac Pitman & Sons, 1927), 4.
4 "Progress of Artificial Silk Industry in France," *Women's Wear* 6, no. 48 (February 23, 1913): 8.
5 For discussions of duties on artificial silk hats, see "Millinery," *Women's Wear* 6, no. 15 (January 18, 1913): 4; and "Millinery," *Women's Wear* 6, no. 107 (May 8, 1913): 5.
6 Woodhouse, *Artificial Silk*, 1.
7 "Banishment of Aigrettes," *Women's Wear* 7, no. 114 (November 14, 1913): 2.

With his feathery and summarily painted forms, Renoir expertly captures the bustle and energy of the Parisian street in *La Place Clichy*. The place Clichy is located in the Montmartre quarter in the eighteenth arrondissement. Here, the commerce and sociability of the neighborhood is suggested by the mass of transient figures on the sidewalk and in the street, forming a dreamlike background for the woman at right. She wears a bonnet trimmed with ostrich plumes and black velvet ribbons and bows, a style typical of the 1880s and one appropriate for the daytime; it is reminiscent of the slightly later model created by Madame Pouyanne (see cat. no. 40). This painting is likely an earlier idea for a circa 1880 work of the same title (now in the Fitzwilliam Museum, Cambridge), in which the woman's hat is even more finely articulated.[1]

38

PIERRE-AUGUSTE RENOIR
(French, 1841–1919)

La Place Clichy, ca. 1880

Oil on canvas
12 ⅝ x 10 in. (32.1 x 25.5 cm)
Collection of Ann and Gordon Getty

39

PIERRE-AUGUSTE RENOIR

Girl Seated with a White Hat,
1884

Pastel on paper
18 ½ x 12 ½ in. (47 x 31.75 cm)
Musée Marmottan Monet, Paris
inv. 5330

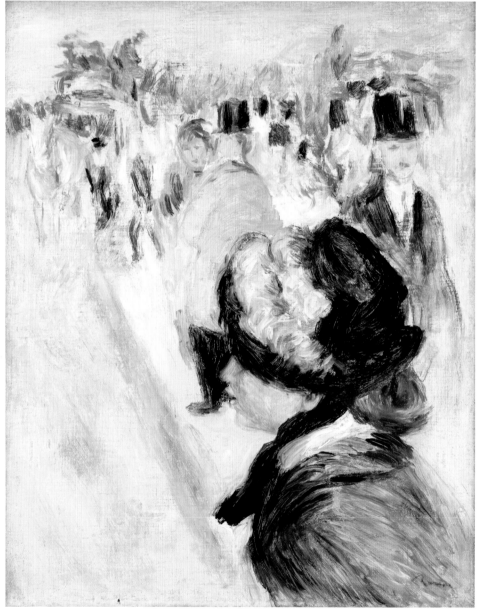

38

Girl Seated with a White Hat is one among many Renoir pastels to feature a young woman or girl seated in profile in order to best model her plumed hat. This billowing style with prominent white ostrich plumes resting upon a straw base was particularly favored for young women and girls. As mentioned elsewhere in this volume (see cat. nos. 8 and 84–85), the artist was transfixed by women's hats, and he carefully selected specific styles depending on each project. For instance, he wrote in a letter dated September 17, 1880, to a woman named Lucie: "So come to Chatou tomorrow with a pretty summer hat. . . . Do you still have that big hat that makes you look so pretty, if so, that's the one I want, the gray one. The one you wore in Argenteuil." Underneath this plea, the artist sketched a head adorned with an oversize hat.[2] —EB

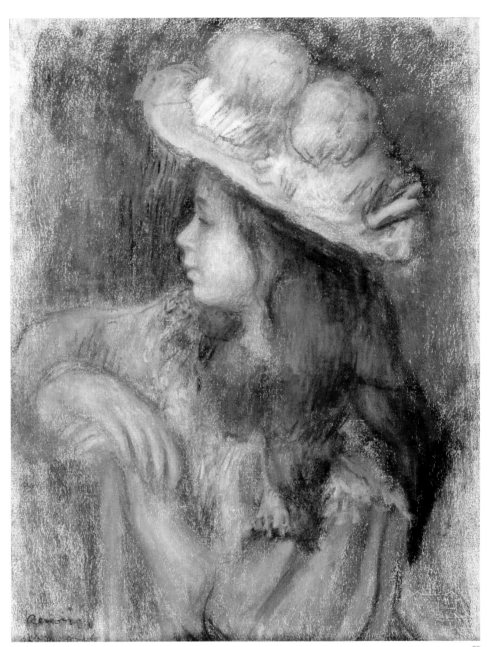

39

1 *La Place Clichy* (ca. 1880), Fitzwilliam Museum, Cambridge, PD. 44-1986. For this painting, and related works in the series, see François Daulte, *Auguste Renoir: Catalogue raisonné de l'oeuvre peint* (Lausanne: Éditions Durand-Ruel, 1971), 1: nos. 323–326; see also Denys Sutton, "An Unpublished Sketch by Renoir," *Apollo* (May 1963), 392–394.

2 An excerpt from a letter dated September 17, 1880, appeared in an auction of autographs. See sale, Hôtel Drouot, Paris, December 18, 1959, lot 150. "Venez donc à Chatou demain avec un joli chapeau d'été. . . . Avez-vous toujours ce grand chapeau qui vous rend si jolie, si oui, c'est celui-là que je veux, le gris. Celui avec lequel vous avez été à Argenteuil." The lot description adds: "Below, a sketch executed by the artist, represents his correspondent's face, wearing a big hat." (Au-dessous, un croquis exécuté par l'artiste, représente le visage de sa correspondante, coiffée d'un grand chapeau.)

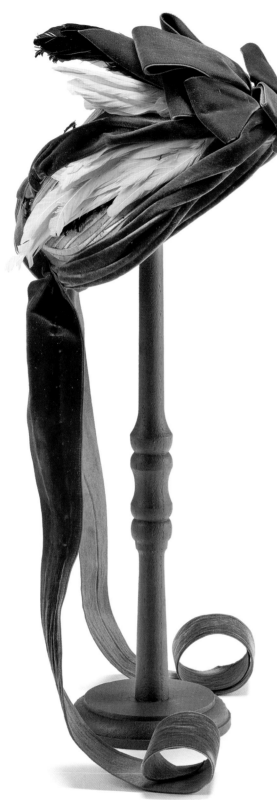

40

MADAME POUYANNE
(French, active late nineteenth–
early twentieth century), designer

Woman's bonnet, ca. 1885

Label: "Mme. Pouyanne/
4 Rue de la Paix/Paris"
Wool felt, silk velvet, silk
embroidery in satin stitches, and bird
of paradise, cock, and other feathers
8 ⅝ x 6 ¼ x 6 ¼ in.
(22 x 16 x 16 cm) overall
Fine Arts Museums of San Francisco,
Gift of Osgood Hooker, 51.29.6
Worn by donor's mother,
Ella Goad Hooker

Neatly arranged strips of plain wool felt and silk embroidered wool felt form the foundation of this woman's bonnet by Madame Pouyanne. Secured by diminutive running stitches, the strips spiral outward from the center of the bonnet's crown and are trimmed by twists of brown and red-brown silk velvet ribbon as well as two coiling black bird of paradise feathers and sprays of light and dark brown feathers. By its harmonious mix of myriad textures and colors, the bonnet is a remarkable example of the work of Pouyanne, who was well known for her "very artistic combination of colorings."[1] The placement of the bonnet's velvet trim—which starts as a bow at the bonnet's top, cascades down both sides in two rows, and then gathers into a knot to form ties just above the nape of the wearer's neck—is remarkably similar to that found on a bonnet worn by Mary Cassatt in Edgar Degas's *Young Woman Tying Her Hat Ribbons* (ca. 1882; Musée d'Orsay, Paris), which dates to the same period.

This bonnet once belonged to the former Ella Wall Goad. She was a daughter of millionaire lawyer William Frank Goad, famed for his magnificent mansion on the northwest corner of Washington and Gough Streets in San Francisco. She later became the wife of lumberman Charles Osgood Hooker.[2] Described as "decidedly blonde, of medium height," and considered a "rare beauty of person and mind," Ella was frequently lauded by the local press in the 1880s and 1890s for her feminine charms.[3] In 1886 she embarked on an eight-month grand tour of Europe with her mother, Sarah Cook Goad, during which she may have purchased this bonnet.[4] The hat, in particular its deeply colored trim, would have served to contrast Ella's flaxen features.—LLC

1 "Report of the Importers' First Openings," *Millinery Trade Review* 29 (January 1904): 76. Madame Pouyanne's skills as a colorist are also noted in "Parisian Hats," *San Francisco Call* 87, no. 134 (October 12, 1902): 7.

2 "'Frisco Heiresses: Pretty Girls on the Pacific Coast with Dazzling Fortunes," *Coronado Mercury* 3, no. 39 (February 15, 1890): 1.

3 The *Coronado Mercury* was quite effusive in its description of Ella Goad's beauty and charm: "One of the most bewitching, kissable mouths to be found anywhere is that belonging to Miss Ella Goad's pretty face. She is decidedly blonde, of medium height, exceedingly good figure, and has a fair, clear complexion and very white, regular teeth. She made her social debut year before last, and it is therefore presumed that she is about twenty years old. She has a sweet voice, is up in music and can ride a horse well. In society she is quite a belle." Ibid. See also "Hooker-Goad Nuptials," *San Francisco Call* 79, no. 68 (February 6, 1896): 8.

4 "Personals," *Daily Alta California* 40, no. 13412 (May 17, 1886): 7; and "Personals," *Daily Alta California* 41, no. 13618 (December 12, 1886): 7.

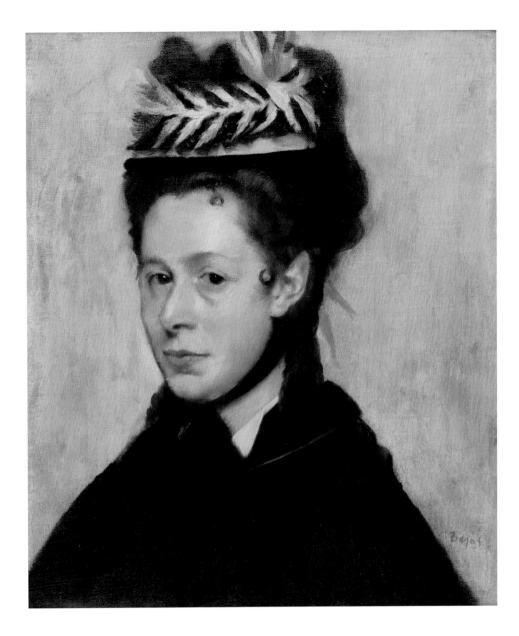

41

EDGAR DEGAS

Head of a Woman,
ca. 1887–1890

Oil on canvas
14 ¾ x 12 ¾ in. (37.5 x 32.4 cm)
Collection of Ann and Gordon Getty

This portrait's unidentified sitter wearing a plumed hat was likely an acquaintance or a friend; judging from her headwear, she was a woman of means.[1] Her serious expression and intense gaze stand in stark contrast to the exuberance of her hat. It appears to have a straw base, topped with white and black feathers and a black velvet trim. Her hair is swept up into a chignon at the back, which Degas captures in a few deft strokes. The hairstyle allows the hat to rest on top of the head—secured by a thick black ribbon tied beneath her chin. The bust-length portrait, with the acute attention paid to the hat, resembles the manifold illustrations adopting the same format in publications such as *La Modiste universelle* (see cat. nos. 47 and 48), *La Modiste parisienne*, and *Le Caprice*. A variant composition of slightly larger dimensions was recorded by Paul-André Lemoisne as being in the Monteux collection in Paris.[2] —EB

1 See Philippe Brame and Theodore Reff, *Degas et son oeuvre: A Supplement* (New York: Garland Publishing, 1984), no. 128.

2 See L922.

42

MARY CASSATT
(American, 1844–1926)

Head of Simone in a Green Bonnet with Wavy Brim (No. 2), ca. 1904

Pastel on paper
16 x 17⅞ in. (40.6 x 45.4 cm)
Saint Louis Art Museum, Funds given by
Mr. and Mrs. John E. Simon, 23:1957

While she was already known in the 1890s for maternal scenes, by the early twentieth century Cassatt almost exclusively created images of women with children or single portraits of little girls, often portrayed in frilly dresses, bows, and massive hats.[1] In this pastel, Cassatt depicted one of her frequent models, Simone—whose exact identity is unknown, but who was likely a child in the village near the artist's home—in a large blue-green bonnet with wavy brim. It is one of three portraits of Simone in this costume, all dating from about 1903 to 1904.[2] The portraits are in various states of finish; the present example shows her face in considerable detail, with delicately rendered features, a common trait in Cassatt's late pastels.[3] Also apparent in such late works is the artist's fascination with representing the different textures of clothing. Simone's dress and hat are less finished than her face, but the swooping lines and softness of the hat suggest a velvety

material, while sketchy strokes on the crown indicate the presence of a plume.

Costume and hats had always been key elements of Cassatt's works, as signifiers of identity and social standing.[4] Moreover, she was clearly aware of current fashion trends for both women and girls. Her late pastels tend to depict young girls virtually overwhelmed by immense hats, the millinery style that had come into fashion by the turn of the century, as seen in fashion plates from journals like *Les Modes* (see fig. 79). Her pastel portraits may also have had a deeper psychological meaning. Nancy Mowll Mathews proposes that Cassatt posed the girls and selected their costumes, possibly playing up the size of the hats, to suggest that they were playacting as adults and to reflect their understanding of adult responsibility and social roles. This interpretation complements Cassatt's interest in child psychology and adds another dimension to what might otherwise be viewed as a relatively straightforward portrait.[5] —AY

79 Child's costume in "English Warehouse," from *Les Modes*, no. 5 (May 1901): 22. Bibliothèque nationale de France, Paris, FOL-V-4312

1 Critic André Mellerio praised Cassatt's images of mothers and children at her solo exhibition in 1895, while fellow critics Camille Mauclair and Gustave Geffroy both referred to her as "un peintre de l'enfance" (a painter of childhood), praising her understanding of the movements and expressions of children in her paintings. See Nancy Mowll Mathews, "Mary Cassatt and the 'Modern Madonna' in the Nineteenth Century" (PhD dissertation, New York University, 1980), 177–196. Mathews also suggests that Cassatt's renewal of this theme was due in large part to the fact that these works sold well. See Mathews, *Mary Cassatt* (New York: Harry N. Abrams; and Washington, DC: National Museum of American Art, Smithsonian Institution, 1987), 121.

2 See *Head of Simone in a Green Bonnet with Wavy Brim (No. 1)*, last in a collection in New York, which shows Simone in the same hat and costume, but turned more fully to the right. *Head of Simone in a Green Bonnet with Wavy Brim (No. 3)*, location unknown, presents a view closer to that in the Saint Louis pastel, with a higher degree of finish to the hat, but

only depicting Simone's head and the outline of her shoulders. There is also a counterproof of the Saint Louis pastel in a private collection in London. See Adelyn Dohme Breeskin, *Mary Cassatt: A Catalogue Raisonné of the Oils, Pastels, Watercolors, and Drawings* (Washington, DC: Smithsonian Institution Press, 1970), 177, for these and other images of Simone.

3 Mathews, *Mary Cassatt* (1987), 128.

4 See George T. M. Shackelford, "*Pas de deux*: Mary Cassatt and Edgar Degas," in Judith A. Barter, ed., *Mary Cassatt: Modern Woman*, exh. cat. (Chicago: Art Institute of Chicago; and New York: H. N. Abrams, 1998), 127. See also Simon Kelly's essay in this volume, p. 27.

5 Mathews, *Mary Cassatt* (1987), 125, 129.

43

JULES CHÉRET
(French, 1836–1932)

Halle aux chapeaux, 1892

Lithograph
48 x 33 in. (121.9 x 83.8 cm)
Musée des arts décoratifs, département
publicité, Paris, 10914

Widely considered the father of modern poster art for his innovative use of color lithography, Chéret unified commercial printing techniques with artistic expression in his lively posters.[1] Among the many hundreds he designed between 1866 and 1895, nearly 150 were advertisements for clothing shops, accessories, and *grands magasins* (department stores) like Au Bon Marché and Printemps.[2] Beginning in the 1880s he created a series of advertisements for Halle aux chapeaux—the largest warehouse of headwear in Paris, according to its posters—located on the rue de Belleville, far removed from the exclusive shopping districts near the rue de la Paix. These posters, including this example from 1892, touted their wares as being "the most elegant for men, women, and children"; the ready-to-wear hats were surprisingly affordable, with listed prices starting at 3.60 francs. In contrast, those crafted and sold around the rue de la Paix went for as much as 150 to 200 francs by the end of the century.[3]

This poster exemplifies Chéret's mature style, with its vivid colors, convivial mood, and depiction of beautiful and graceful women.[4] Visible in the foreground are several hatstands: a tan bowler and a top hat are seen in front, while a white plumed hat is raised slightly above them, set off by the dark blue background. However, the poster's main focus is on the woman, dressed in vibrant red, and two young girls trying on extravagant plumed hats, which were popular during the 1890s, due to the international obsession with ostrich plumes in fashion.[5] Chéret's innovations in poster design influenced a later generation of poster artists, including Pierre Bonnard and Henri de Toulouse-Lautrec, as can been seen in the latter's *Confetti* (1894), which borrows the figure of the little girl in white from Chéret's design here.[6] —AY

1 Jane Kinsman and Stéphane Guégan, *Toulouse-Lautrec: Paris and the Moulin Rouge,* exh. cat. (Canberra: National Gallery of Australia, 2012), 188. See also Bradford R. Collins, "Jules Chéret and the Nineteenth-Century French Poster" (PhD dissertation, Yale University, 1980); and Ruth E. Iskin, *The Poster: Art, Advertising, Design, and Collecting, 1860s/1900s* (Hanover, NH: Dartmouth College Press, 2014).

2 Despite his long career, which lasted well into the twentieth century, nearly all of Chéret's posters were designed in a thirty-year span, starting from the 1860s. See Phillip Dennis Cate, review of *La Belle époque de Jules Chéret: De l'affiche au décor* (2010), in *West 86th: A Journal of Decorative Arts, Design History, and Material Culture* 18, no. 2 (Fall–Winter 2011): 276. For a complete listing of Chéret's poster designs, see Lucy Broido, *The Posters of Jules Chéret,* 2nd ed. (New York: Dover Publications, 1992).

3 The most prestigious shops rarely listed their prices in public advertisements, but shops and prices could be found in an English guidebook to the 1900 Exposition Universelle. See *Exhibition Paris 1900* (New York: F. A. Stokes Coy; London: William Heinemann; and Paris: Hachette & Cie., 1900), 108. Among the most expensive hats were those from Caroline Reboux (100–150 francs), Esther Meyer (100–150 francs), and the *fleuriste-modiste* Camille Marchais (80–200 francs).

4 Women of this type were so common in Chéret's posters that they came to be known as "Chérettes." See Collins, "Jules Chéret and the Nineteenth-Century French Poster," 112–113.

5 See Sarah Abrevaya Stein, *Plumes: Ostrich Feathers, Jews, and a Lost World of Global Commerce* (New Haven, CT: Yale University Press, 2008).

6 Kinsman and Guégan, *Toulouse-Lautrec,* 188. For *Confetti,* see the example in the collection of the Museum of Modern Art, New York, 74.1999.

44

HENRI DE
TOULOUSE-LAUTREC
(French, 1864–1901)

Divan Japonais, 1892–1893

Color lithograph
Image: 31 ¼ x 23 ⅝ in. (79.4 x 60 cm);
sheet: 31 ¾ x 24 ⅜ in. (80.5 x 61.9 cm)
Saint Louis Art Museum, Bequest of
Horace M. Swope, 630:1940

During the 1890s Toulouse-Lautrec turned
his attention to the cafés and nightclubs
of Montmartre, focusing especially on the
lively performers at the Moulin Rouge and
other locales. One of his most famous and
frequent models was the cancan dancer Jane
Avril. The pair formed a lasting friendship
that was documented through Toulouse-
Lautrec's numerous prints, drawings, and
paintings of Avril, both as a performer and in
everyday life.

Costume was an important component of
Avril's dancing, as noted by the critic Arsène
Alexandre in 1893, who commented on the
way she integrated her stage dress with her
choreography, selecting colors and fabrics
that would complement her movement.[1]
She was often pictured wearing a range of
extravagantly plumed hats on- and offstage;
these hats became widely recognizable fea-
tures of her style.[2] Indeed, one was playfully
highlighted in a photograph from 1892 of
Toulouse-Lautrec dressed in the clothes of

Avril, including one of her signature feath-
ered hats (see fig. 80).

This poster for the café Divan Japonais
in Montmartre illustrates Avril not as a
performer but as a member of the audience,
watching Yvette Guilbert—recognizable by
her trademark long black gloves—onstage.[3]
Despite her role as spectator, Avril is the
most prominent figure in the poster, domi-
nating the composition and drawing in the
viewer. Her solid black dress and hat form
a silhouette against the brightly lit stage.
This formal device as well as the diagonal
composition show the influence of Japanese
printmaking; they perhaps referenced the
new renovations of the Divan Japonais
featuring Japanese motifs.[4] Avril's hat is
especially significant; this striking plumed
example resembles the designs of the famed
milliner Madame Virot.[5] Indeed, the hat is
believed to have come from Virot herself,
as she frequently designed hats for famous
actresses and dancers during the late nine-
teenth century (see cat. no. 69).[6] —AY

1 See Arsène Alexandre, "Celle qui danse,"
 L'Art français, July 29, 1893. Cited in Ruth
 E. Iskin, *The Poster: Art, Advertising, Design,
 and Collecting, 1860s/1900s* (Hanover, NH:
 Dartmouth College Press, 2014), 85. See
 also Nancy Ireson, ed., *Toulouse-Lautrec
 and Jane Avril: Beyond the Moulin Rouge*,
 exh. cat. (London: Courtauld Gallery and Paul
 Holberton, 2011), 130–133.

2 Several images by Toulouse-Lautrec such as
 The Moorish Dance (1895; Musée d'Orsay, Paris)
 illustrate Avril, recognizable primarily by her
 hats, from behind. Contemporary photographs
 of Avril also depict her in various hats, both
 in costume and in street clothes. See Ireson,
 Toulouse-Lautrec and Jane Avril, 75–76,
 108–111.

3 Iskin, *The Poster*, 88. See also Jane Kinsman
 and Stéphane Guégan, *Toulouse-Lautrec: Paris
 and the Moulin Rouge*, exh. cat. (Canberra:
 National Gallery of Australia, 2012), 196.

4 *MoMA Highlights*, rev. ed. (New York: Museum
 of Modern Art, 2004), 41.

5 Virot hats were featured in many fashion maga-
 zines of the day, including *La Vie parisienne*, *La
 Grande dame*, *Les Modes* (after 1901), and even
 international magazines like *Harper's Bazaar*.
 See related hats by Virot in *La Grande dame* 1,
 no. 1 (1893), color plate between pages 32
 and 33.

6 Katherine Joslin, *Edith Wharton and the
 Making of Fashion* (Durham: University of New
 Hampshire Press, 2009), 73.

80 Toulouse-Lautrec dressed in Jane Avril's clothes to
attend the *Bal des femmes* held by the *Courrier français*
at the Elysée-Montmartre, Paris, 1892. Photograph.
Musée Toulouse-Lautrec, Albi, France

45

HENRI DE
TOULOUSE-LAUTREC
(French, 1864–1901)

La Revue blanche, from the
series *Les Maîtres de l'affiche,*
1895

Lithograph
15 ½ x 10 ⅞ in. (39.4 x 27.6 cm)
Mildred Lane Kemper Art Museum,
Washington University, St. Louis,
Gift of Melissa Henyan Redler, 1981,
WU 1981.18.2

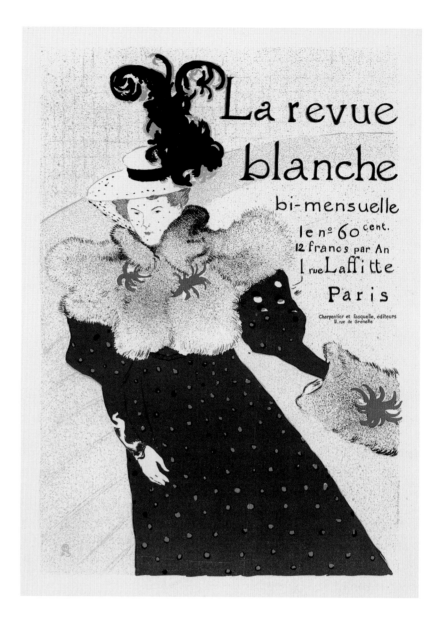

In this poster for *La Revue blanche*—the Symbolist art and literary magazine funded and published by the wealthy and progressive tastemakers Thadée and Alexandre Natanson—Toulouse-Lautrec depicted Thadée's wife and muse of the journal, Misia Natanson. Misia—who posed for numerous other works by Toulouse-Lautrec—was well known for her charm and wit and was celebrated for her salons, which were well attended by some of the most important avant-garde writers and artists of the 1890s.[1] Born Maria Godebska in Russia of Polish descent, she came from an artistic background—her father was a sculptor and her grandfather a cellist—and was herself a skilled pianist. She developed a discerning eye for fine art and decoration, largely fostered by her relationships with the emerging artists she met through Thadée. Though not officially involved in running the magazine, her opinions on art indirectly played a significant role in the works that were promoted, and often artists appealed to her to have their work published. She was especially supportive of less-known but promising young artists such as Pierre Bonnard, Félix Vallotton, and Édouard Vuillard, as well as Toulouse-Lautrec.[2]

Toulouse-Lautrec captured both her style and her imposing personality in this poster commissioned by the Natansons in 1895.[3] Dressed in a straw hat embellished with a black band, veil, and immense, flourishing ostrich plumes, Misia is presented as a woman of high fashion. She dominates the space of the poster, perhaps insinuating that it was truly through her that artists and writers could find their way into the pages of *La Revue blanche.*[4] —AY

1 See for example *Madame Thadée Natanson at the Theater* (ca. 1895), Metropolitan Museum of Art, New York, 64.153.
2 For Misia's involvement with the magazine, see Isabelle Cahn, "Misia, au temps de *La Revue blanche,* 1893–1903," in *Misia, reine de Paris,* exh. cat. (Paris: Editions Gallimard,

2012), 41–53. See also Arthur Gold and Robert Fizdale, *Misia: The Life of Misia Sert* (New York: Knopf, 1980). There is some difficulty in determining the facts of Misia's biography, as much of the available information comes from her own accounts or unsubstantiated rumors; see Debra J. DeWitte, review of exhibition *Misia, reine de Paris* (Misia, Queen of Paris) at the Musée d'Orsay, Paris, *Nineteenth-Century Art Worldwide* 12, no. 1 (Spring 2013).
3 This poster also appeared as part of 1895's *Les Maîtres de l'affiche,* a serial publication that featured colored posters by artists such as Jules Chéret and Toulouse-Lautrec.
4 Toulouse-Lautrec originally depicted her ice skating but removed the background imagery in the final image. See Jane Kinsman and Stéphane Guégan, *Toulouse-Lautrec: Paris and the Moulin Rouge,* exh. cat. (Canberra: National Gallery of Australia, 2012), 232.

46

EUGÉNIE PARISET
(French, active 1874–1903), designer

Woman's bonnet, ca. 1875

Label: "Eugénie Pariset/
10, rue du 4 Septembre/Paris"
Silk velvet, dyed ostrich feathers,
and gilded glass beads
8 x 7 in. (20.3 x 17.8 cm)
Philadelphia Museum of Art, Gift of
Mrs. W. Logan MacCoy, 1956-38-2

This sumptuous silk velvet bonnet is an exceptional example from the mid-1870s. Its soft folds are accented by a flourish of ostrich feathers, dyed to match the dark red velvet, and a face-framing trim of acorn-shaped gold beads. The bonnet was made by the milliner Eugénie Pariset, who worked at 10, rue du Quatre-Septembre from the mid-1870s through the first years of the twentieth century.[1] While Pariset's outstanding millinery skills are seen in this creation, in her time she was not celebrated for her output but rather maligned as embodying the stereotype of the ill-mannered milliner, as popularized in contemporary cartoons, artworks, and works of literature.[2] Published news accounts allude to Pariset working clandestinely as a prostitute and displaying erratic, often violent, behavior.[3] In 1903 Pariset was involved in an altercation with fellow milliner Rosalie Deguyter over a supply of ostrich feathers, during which the two reputedly attempted to attack each other with hatpins.[4] —LLC

1 These dates are based on a survey of extant documentation as well as surviving hats and bonnets by Pariset. For documentation, see "Eugénie Pariset receipt, 1874," in "Edwin Howland Family Papers, 1860–1944," Rhode Island Historical Society Manuscripts Division, http://www.rihs.org/mssinv/Mss1076.htm,

accessed May 16, 2016; "Nouvelles diverses," *L'Aurore: Littéraire, artistique, sociale* 6, no. 1714 (June 29, 1902): 3; and "À travers Paris," *Le Matin: Derniers télégrammes de la nuit* 20, no. 6992 (April 18, 1903): 4. For hats and bonnets, see the woman's bonnet, ca. 1875, in the Costume Institute of the Metropolitan Museum of Art, New York, C.I.45.79.15; and woman's hat, ca. 1900, Fine Arts Museums of San Francisco, X1983.17.

2 For a detailed account of these representations, see Hollis Clayson, *Painted Love: Prostitution in French Art of the Impressionist Era* (1991; reprint, Los Angeles: Getty Research Institute, 2003), 116–131.

3 "Nouvelles diverses," 3; and "À travers Paris," 4.

4 "Leurs épingles à chapeau." "À travers Paris," 4.

47

Fabia Hat, from
La Modiste universelle,
March 1885

Color lithograph
14 x 10 ¼ in. (35.6 x 26 cm)
Fine Arts Museums of San Francisco,
Bequest of John Gutmann,
2000.119.3.89.2

48

G. GONIN

Canadian Hat, from
La Modiste universelle,
August 1885

Color lithograph
14 x 10 ¼ in. (35.6 x 26 cm)
Fine Arts Museums of San Francisco,
Bequest of John Gutmann,
2000.119.3.89.1

MARS 1885

405

Hte Lefèvre imp.Paris. Reproduction Interdite Abel Goubaud,Editeur

LA MODISTE UNIVERSELLE.
Publiée par Abel Goubaud

PARIS : RUE DU 4 SEPTEMBRE 3.
LONDON : 39 Bedford Street Covent Garden.

47

These color lithographs, featuring plumed hats from spring and summer of 1885, appeared in the monthly publication *La Modiste universelle*. The magazine was founded in 1876 by Abel Goubaud at 3, rue du Quatre-Septembre—a street that housed Eugénie Pariset (see cat. no. 46) and many other prestigious milliners. It was internationally distributed with the goal of establishing Paris as a center of the global fashion world.[1] Goubaud published other fashion journals, including *Le Caprice* and *La Modiste parisienne*, which were also devoted largely to millinery.[2] These journals catered to women interested in the latest shapes, colors, trimmings, and descriptions of hats.

Specialist trade publications such as *La Modiste universelle* as well as fashion magazines like *La Mode illustrée* and *Le Petit courrier des dames* also helped spread information and images of new fashions from Paris to the provinces. Between 1840 and 1875, more than sixty such magazines appeared in France alone, some in several editions at different price points depending on the quality of the illustrations. Unlike today's fashion magazines, which typically appear on a monthly basis, they were often published weekly.[3]

The illustration from the March 1885 issue of *La Modiste universelle* is a prime example of the influence of the equestrian

hat were printed in serial, as were instruction manuals and patterns for making one's own hats.[5] Purveyors of artificial flowers, plumes, ornament, and fabric ran advertisements, and milliners' creations were widely disseminated. The illustrations, which were often unsigned and middling in execution, were intended to relay precise details of the most recent styles.—EB

1 For more on this topic, see Simon Kelly's discussion in this volume, p. 32. There was a demand for *La Modiste universelle* in the United States: "These journals [such as *La Revue de la mode*, *Le Bon ton et Le Moniteur de la mode*, *Le Monde élégant*, and *La Modiste universelle*] . . . are mainly devoted to the interests of dressmakers, and the latter to milliners. These journals are carefully anglicised by S. T. Taylor, and being published in Paris, contain the designs of the famous leaders of fashion in that great center. They are beautiful printed magazines, containing large colored plates of various styles, and have deservedly attained a very wide circulation in America." *New York's Great Industries: Exchange and Commercial Review* (New York: Historical Publishing Company, 1884), 281.

2 Henri Avenel, *Annuaire de la presse française et du monde politique* (Paris: Ernest Flammarion, 1899), 61; Goubaud also published *Le Moniteur de la mode*, *La Revue de la mode*, *La Mode artistique*, *Le Moniteur des dames et des demoiselles*, *Le Guide des couturières*, *Les Nouveautés parisiennes*, *La Nouveauté*, and *Le Messager des modes*.

3 JoAnne Olian, *Victorian and Edwardian Fashions from "La Mode Illustrée"* (Mineola, NY: Dover Publications, 1998), iv.

4 See Justine De Young, "Representing the Modern Woman: The Fashion Plate Reconsidered (1865–75)," in *Women, Femininity and Public Space in European Visual Culture, 1789–1914*, ed. Temma Balducci and Heather Belnap Jensen (Farnham, UK: Ashgate, 2014), 105.

5 See pp. 85–91 for more about such histories.

style on everyday fashion during this period (see cat. no. 25). The model, called the "chapeau Fabia," is made from plaited straw with bands of velvet and gold braid folded around the crown, with added ostrich and egret feathers. The hat from the August 1885 issue, the "chapeau Canadien," is constructed of plaited straw meant to resemble thatch, with a velvet and straw brim adorned with a patterned ribbon and a plume of egret feathers. The styles are

typical of hats from the 1880s, with high crowns and upswept brims.

As noted by Justine De Young, during this period "fashion, like France itself, had been transformed from an absolutist state into a democratic republic."[4] Women could begin to craft their own individual styles from the comfort of home, before arriving at the store, which only further drove consumption. These magazines were also intended to be instructive: histories of the

49

MADAME LOUISE
(English, active ca. 1870–1898), designer

Woman's bonnet,
ca. 1888–1890

England, London
Label: "Louise/Regent Street/
Rue de la Paix, Paris"
Velvet and feather trim
11 x 10 in. (27.9 x 25.4 cm); ribbon ties
23 x 2 in. (58.4 x 5.1 cm)
Chicago History Museum, Gift of
Mrs. Gilbert A. Harrison, 1954.324
Worn by Mrs. Cyrus Hall
(Nettie Fowler) McCormick

"We're Madame Louise young girls," declare a group of fashion-conscious ladies in Gilbert and Sullivan's 1881 operetta *Patience*.[1] As "the noted leader of fashion in millinery," Madame Louise was a household name and a byword for fashionability.[2] By 1895 her business had grown into Louise and Co., with five "conveniently adapted and luxuriously appointed shops in exceptionally favorable positions in the West-End," including Oxford Street, Regent Street, and Brompton Road, three of the busiest shopping districts in London.[3]

This crimson bonnet and other surviving hats reveal Madame Louise's way with color, shape, and three-dimensional trimmings.[4] In keeping with the contemporary taste for historicism, she copied many of her designs from old portraits.[5] She also pioneered innovative marketing practices, enlisting the actress Sarah Bernhardt to wear her hats onstage.[6]

But the true secret of Madame Louise's success was her knack for putting the right hat on the right head. *Sylvia's Home Journal* called her "an artist in bonnets" who was

"also an artist in faces, in proportions, in suitability of colours and forms." As Madame Louise herself once insisted: "It is not sufficient to study the face. You must consider the width of the shoulders and the general outline."[7]

Madame Louise had another secret: her real name was Mrs. E. A. Thompson. Like many English milliners, she adopted a French moniker to lend cachet to her creations. The Paris address on her label may have been an affectation as well, for there is no evidence that she ever had a shop there (see also Françoise Tétart-Vittu's discussion, p. 63).[8] —KCC

1 "We're Swears & Wells young girls, / We're Madame Louise young girls, / We're prettily pattering, cheerily chattering, / Every-day young girls." Act II, lines 557–560.

2 *Cassell's Family Magazine* (London: Cassell and Company, 1895), 473.

3 *The Sketch* 10, no. 118 (May 1, 1895): 7.

4 See, for example, an 1887 woman's bonnet at the Metropolitan Museum of Art, New York, C.I.68.53.17; and an 1879–1885 bonnet at Historic New England, Boston, 1942.218.

5 *Sylvia's Home Journal* (London: Ward, Lock, and Co., 1879), 222.

6 Hermione Hobhouse, *A History of Regent Street: A Mile of Style* (London: Phillimore, 2008), 74.

7 *Sylvia's Home Journal*, 222.

8 *The Sketch*, 7.

50

E. GAUTHIER
(French, late nineteenth century),
designer

Woman's capote, ca. 1890

Label: "E. Gauthier, 49 bis avenue
d'Antin, Champs Elysées"
Silk tulle, velvet, ostrich feather,
pongee, paper, and metallic thread
9 ⅞ in. (25 cm) length;
8 ¼ in. (21 cm) width
Musée des arts décoratifs, Paris, UFAC
collection, Gift of Mlle. de Lestrange,
1954, UF 54-69-63

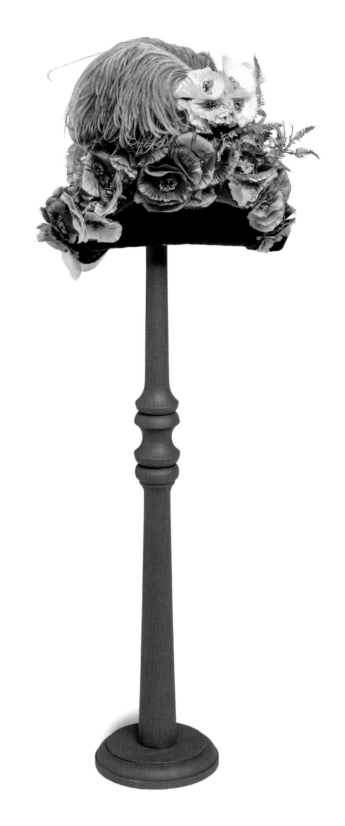

The capote, popular in the 1850s and 1860s, made a resurgence in the late 1880s for evening and reception wear (see cat. no. 83 for another example). It was considered flattering to most faces and, though small in size, could be rich in ornamentation, like this ostrich-trimmed example of silk tulle, velvet, and pongee, a lightweight raw silk.[1]

"The tendency now is to make [capotes] very decorative," *Vogue* reported in 1893. "All sorts of jeweled passementerie, embroidered crêpes and tulles enter into their composition, and notwithstanding their diminutive size they are sometimes very costly."[2] For example, in 1893 the Duchess of Maillé attended an exhibition opening wearing a capote "covered with mistletoe, the berries being represented by gigantic pearls and the leaves by emeralds, which attracted much notice, so close to nature was this costly imitation of Christmas 'blossoms.'"[3]

The capote's comeback was short-lived. By 1895 the Paris edition of the *New York Herald* would declare: "The capote is dead and the toque has taken its place." Only elderly women still wore capotes, though the writer admitted that the new, brimless

toques "are entirely made of flowers as the capotes were and there is really little difference between the styles. The show-rooms . . . of all the leading milliners are regular flower gardens."[4] —KCC

1 "Fashion: Bonnets and Hats," *Vogue* 1, no. 5 (January 14, 1893): 68.

2 Ibid.

3 "Paris," *Vogue* 1, no. 19 (April 22, 1893): S4.

4 Hebe Dorsey, *Age of Opulence: The Belle Epoque in the Paris* Herald, *1890–1914* (New York: Harry N. Abrams, 1987), 147.

51

MESDEMOISELLES COTEL
(French, active ca. 1870s–1910s),
designers

Woman's bonnet, ca. 1885

Label: "Melles Cotel/Modes/Paris"
Silk velvet, silk flowers, dyed ostrich
feathers, and silk satin ribbon
8 ½ x 8 x 8 in.
(21.6 x 20.3 x 20.3 cm) overall
Philadelphia Museum of Art, Gift of Mr.
and Mrs. George K. Rogers, 1970-263-11

52

MADAME MARIE COLLIN
(French, active early twentieth
century), designer

Woman's hat, ca. 1900

Label: "Mme Marie Collin/Paris/
8 Rue de Port-Mahon/near the OPÉRA"
Silk velvet, dyed feathers, and cut
steel and brass buckles
13 x 9 x 6 in. (33 x 22.9 x 15.2 cm) overall
Museum of Fine Arts, Boston, Gift of
Mrs. H. de Forest Lockwood, 54.809

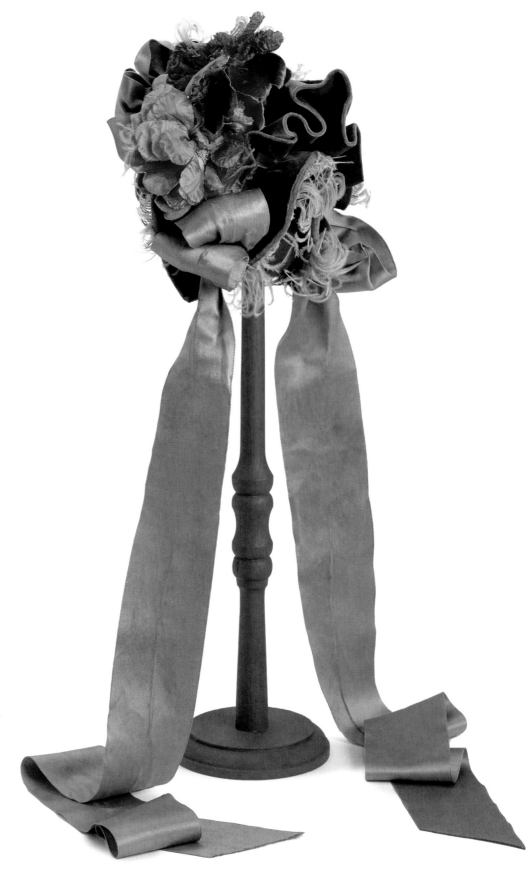

Since the discovery in antiquity of a natural purple dye, the color has been associated with power and wealth. Originally derived from mollusks, the dye's intensive production, as well as the appeal of the finished color, contributed to its desirability and helped establish it as the color of royalty.[1] That is until 1856, when chemist William Henry Perkin, while trying to find a cure for malaria, accidentally discovered how to produce the color from synthetic dye.[2] The resulting color—called *mauve* in French after the mallow flower—rapidly became popular for women's dress and accessories. *Punch* magazine described the fervor for mauve fashions as "the Mauve Measles" in 1859: "One of the first symptoms by which the malady declares itself consists in the eruption of a measly rash of ribbons"—presumably in the form of bonnets and hats—"about the head and neck of the person who has caught it."[3] The circa 1885 bonnet by Mesdemoiselles Cotel features a *Punch*-esque "rash" of mauve tones in its sumptuous silk flowers and dyed ostrich feathers. The bonnet's materials are similar to those found on another extant Mesdemoiselles Cotel design from this period, a woman's hat now in the collection of the Norsk Folkemuseum.[4] Mauve and similar hues remained stylish for several decades, as seen in the other example here, a circa 1900 flat-crowned woman's hat by Madame Marie Collin.—LLC

1 Susan Kay-Williams, *The Story of Colour in Textiles: Imperial Purple to Denim Blue* (London: Bloomsbury, 2013), 21.

2 Ibid., 139–140; and Allison Matthews David and Elizabeth Semmelhack, *Fashion Victims: The Pleasures and Perils of Dress in the 19th Century*, exh. cat. (Toronto: Bata Shoe Museum, 2014), 18–19.

3 "The Mauve Measles," *Punch* 37 (August 20, 1859): 81.

4 Accession number NF.1976-0198.

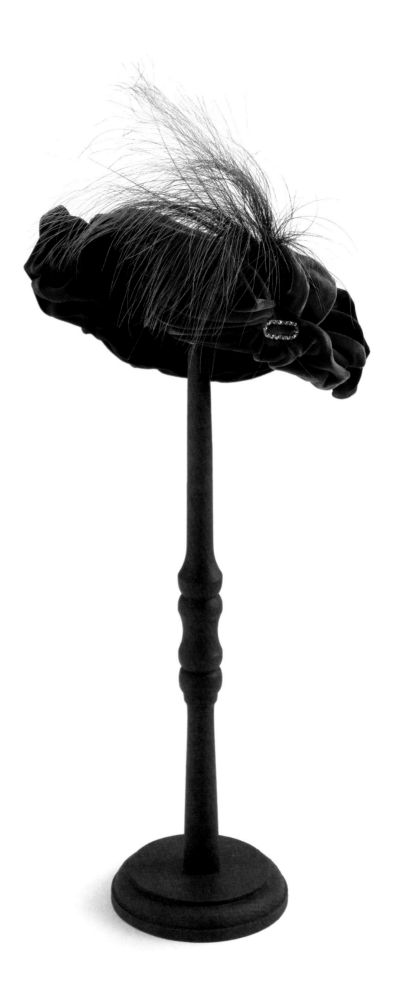

53

ANONYMOUS
(French, early twentieth century),
designer

Hat, ca. 1912

Label (partially erased): " . . . , 9 rue
St Honoré . . . la rue Castiglione, Paris"
Tawny owl, glass, silk velvet, silk
satin ribbon, and matting
5 ⅛ x 12 ⅝ x 11 ⅜ in. (13 x 32 x 29 cm)
overall; 5 ¾ in. (14.5 cm) crown diameter
Musée des arts décoratifs, Paris,
UFAC collection, UF 2009-01-1

The fashion for hats incorporating not just feathers but the wings, heads, and even entire bodies of birds paralleled the commercial development of the sportsman's art of taxidermy in the 1880s and 1890s.[1] The small, feathered toque hats popular around the turn of the century quickly ballooned into wide, mushroom-shaped nests for pheasants, birds of paradise, hummingbirds, peacocks, and even owls, such as this one mounted with glass eyes.[2]

So popular were these avian accessories that, in 1911, it was estimated that the Paris fashion industry was responsible for the deaths of 300 million birds per year.[3] Growing concern over the rampant pillaging of exotic bird populations for their plumage led to the formation of England's Royal Society for the Protection of Birds in 1889 and the United States' National Audubon Society in 1905. The use of game and poultry feathers remained morally neutral, as did ostrich feathers, which could be plucked from the tail without harming the bird.[4] As the tide of public opinion turned against so-called murderous millinery, French *modistes* increasingly employed their talents to lend exoticism to materials from non-endangered, domestic fowl like ducks and chickens, or to create artificial "birds" out of feathers and glue.

In France caricaturists made much of the birdlike appearance of some fashionable hats, as well as their increasing size. In general, however, criticism was directed at the *modistes* and *plumassiers* (feather dealers) who made the hats rather than their wearers, who were simply trying to follow fashion.[5] Perhaps surprisingly, French naturalists and ornithologists rallied to the defense of the *plumassiers*, pointing out that their destructive tendencies had been exaggerated by ignorant if well-meaning activists; after all, it was not in their financial interests to hunt birds to the point of extinction.[6]

Hats adorned with owls and other large birds of prey enjoyed a long vogue, though they became something of a cliché as the tide of public opinion turned against taxidermied headwear. In her 1918 essay on screenwriting, the French writer Colette remarked of the *femme fatale*: "When the spectator sees the evil woman coiffing herself with a spread-winged owl, the head of a stuffed jaguar, a bird aigrette, or a hairy spider, he no longer has any doubts; he knows just what she is capable of."[7] —KCC

1 Fiona Clark, *Hats* (London: B. T. Batsford, 1982), 48.

2 A similar owl hat of the same date can be found in the Royal Albert Memorial Museum in Exeter, England.

3 Hebe Dorsey, *Age of Opulence: The Belle Epoque in the Paris* Herald, *1890–1914* (New York: Harry N. Abrams, 1987), 124.

4 Clark, *Hats*, 48.

5 Anne Monjaret, "Plume et mode à la Belle Époque: Les Plumassiers parisiens face à la question animale," *Techniques & Culture* 50 (2008): 233–235.

6 Ibid., 236–238.

7 Colette, "A Short Manual for the Aspiring Scenario Writer," quoted in Karyn Kay and Gerald Peary, eds., *Women and the Cinema: A Critical Anthology* (New York: Dutton, 1977), 5.

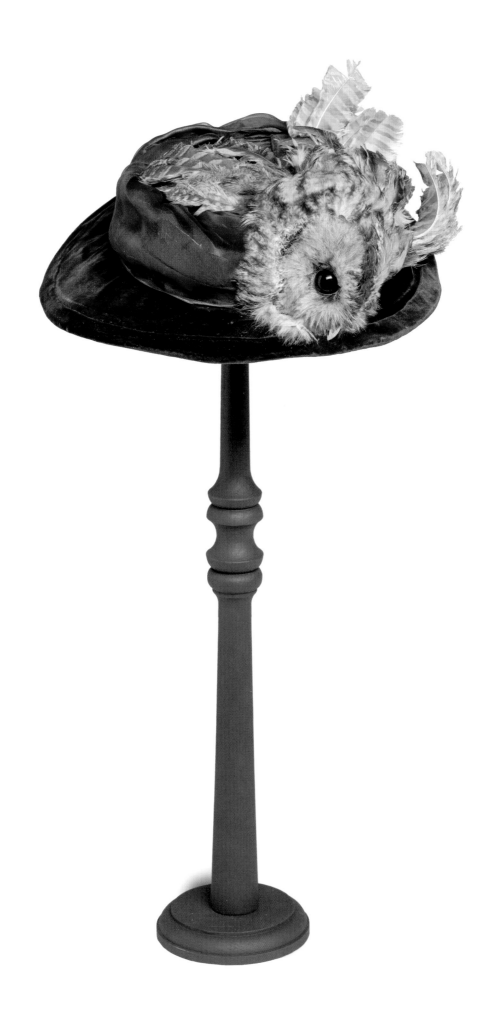

54

ANONYMOUS
(French, active late nineteenth
century), designer

Hat, ca. 1890

Hummingbird heads, golden
pheasant feathers, and felt
10 ⅜ x 8 ¼ x 13 ⅜ in. (26.5 x 21 x 34 cm)
overall; 3 ¾ in. (9.5 cm) crown diameter
Musée des arts décoratifs, Paris, UFAC
collection, Gift of Michel Therouanne,
UF 68-28-36

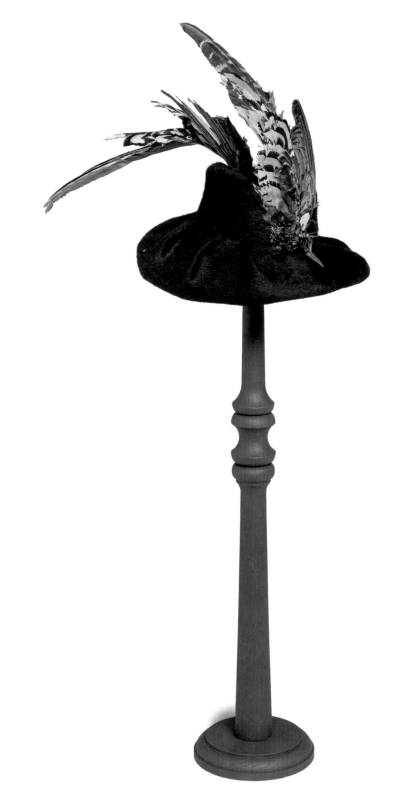

The conical shape and peaked crown of this
black felt hat was inspired by a traditional
Burmese cane hat, although the diminutive
size—consistent with the vertical emphasis
of 1890s millinery—offers little of the cane
hat's protection from the elements. On each
side of the crown, a spray of golden pheas-
ant feathers is anchored by a decapitated
hummingbird's head. These macabre orna-
ments were a common element of female
adornment at the time. In the mid-nineteenth
century, European and North American
incursions into Central and South America
made hummingbirds found there readily
available to fashion dealers as well as speci-
men collectors. The tiny birds' iridescent
feathers, heads, skins, and even entire bodies
were incorporated into hats and jewelry,
such as an ornate pair of hummingbird-head
earrings (late nineteenth century) and a
gold-mounted hummingbird-head brooch
(ca. 1870) in the Cooper Hewitt Museum.[1]

In nineteenth-century France, *colibri*
(French for "hummingbird") was used as
slang for a frivolous person, making the
frolicsome creature an especially fitting
fashion emblem.[2] Here, the combination of
hummingbird heads and colorful, dramatic
plumage gives the impression that a pair of

particularly exotic birds have alighted on the
wearer's head.—KCC

1 Cooper Hewitt, Smithsonian Design Museum,
New York, accession numbers 1946-50-87-a/c
and 1988-14-1.

2 See, for example, Noël François de Wailly and
Étienne Augustin de Wailly, *Nouveau vocabu-
laire françois* (Paris: Chez Rémont, 1803), 192.

MEN'S HATS

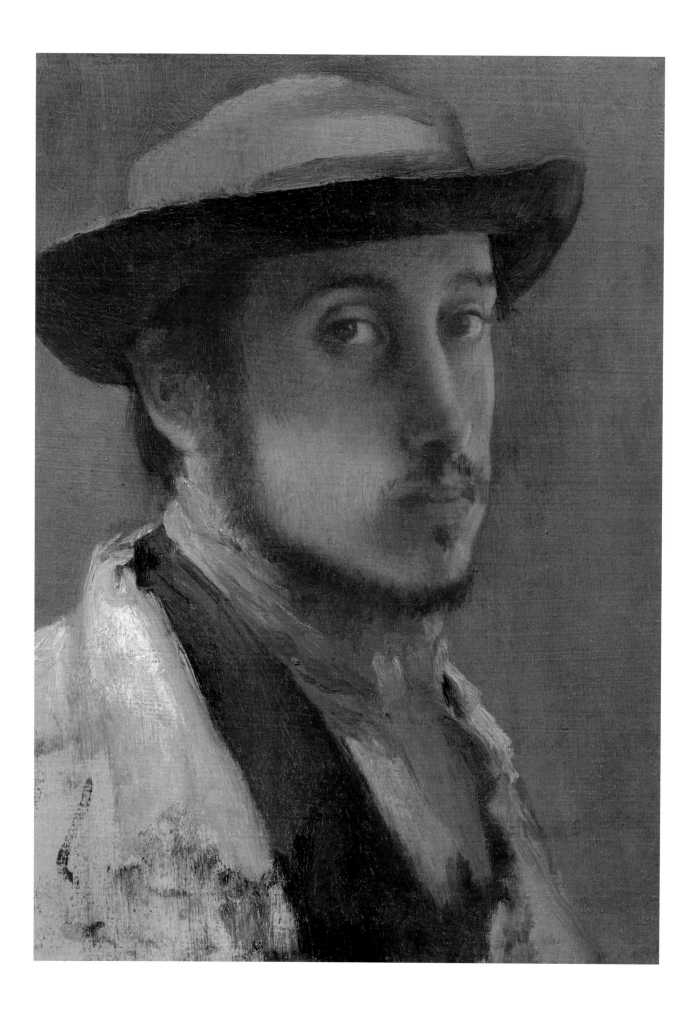

55

EDGAR DEGAS

Self-Portrait in a Soft Hat,
1857

Oil on paper, mounted on canvas
10 ¼ x 7 ½ in. (26 x 19.1 cm)
Sterling and Francine Clark Art Institute,
Williamstown, Massachusetts, Acquired
by Sterling and Francine Clark, 1948,
1955.544
L37

Over the course of his long career, Degas showed an acute awareness of the role of hats in fashioning identity. This understanding is reflected in the approximately forty self-portraits that he produced in paintings, pastels, and prints between 1854 and 1864. Degas wears a hat in a significant proportion of these works. On one occasion (ca. 1863), he was a fashionable Parisian *flâneur*, raising his top hat to greet an imaginary viewer. He produced fewer self-portraits later in his career but, in his final such image (ca. 1900), he wears a working cap.[1]

Degas's early self-portraits date from the period when the artist was working in Paris and in Italy.[2] *Self-Portrait in a Soft Hat* shows the artist as a twenty-three-year-old student in Rome. His soft, malleable hat, circled by a hatband, has been described as "strikingly bohemian."[3] Complementing his hat is an orange cravat, which adds a striking accent of color. The brim of the hat casts Degas's eyes and nose into shadow, ensuring a subtle chiaroscuro contrast with the illuminated lower part of his face, notably its slightly pouting lips and sparse beard, and lending an air of mystery to the sitter. This portrait stands in marked contrast to the more formal self-portraiture that Degas had produced before his trip to Italy.

The importance of the soft hat to the artist's self-fashioning is suggested by the fact that it also appears in a half-length portrait etching of the same year, as well as a second painted self-portrait.[4] As Richard Kendall has suggested, this choice may have reflected his admiration for Rembrandt, who had produced portrait prints of himself (in 1631 and 1633–1634) wearing a similar accessory.[5] —SK

1 See *Self-Portrait*, or *Degas saluant* (ca. 1863), Calouste Gulbenkian Museum, Lisbon, inv. no. 2307; and *Self-Portrait* (ca. 1900), Arp Museum, Sammlung Rau für UNICEF, Remagen, Germany.

2 See L2–5, L11–14, L31–32, L37, L51, L103–105, and L116 in Paul-André Lemoisne, *Degas et son oeuvre*, 4 vols. (Paris: Paul Brame and C. M. de Hauke, 1946–1948); and Philippe Brame and Theodore Reff, eds., *Degas et son oeuvre: A Supplement* (New York: Garland, 1984), 28–30.

3 See Richard Kendall, entry in Sarah Lees, ed., *Nineteenth-Century European Paintings at the Sterling and Francine Clark Art Institute* (Williamstown, MA: Sterling and Francine Clark Art Institute, 2012), 1:255–259.

4 See *Self-Portrait* (1857), Metropolitan Museum of Art, New York, 29.107.53; and *Self-Portrait* (1857–1858), J. Paul Getty Museum, Los Angeles, 95.GG.43. The latter is not listed in Lemoisne's catalogue raisonné or the supplement of Brame and Reff.

5 Kendall, entry.

56

EDGAR DEGAS

Standing Man in a Bowler Hat, ca. 1870

Essence (thinned oil paint) on
oiled brown paper
12 ¾ x 7 ⅞ in. (32.3 x 20.1 cm)
The Morgan Library & Museum,
New York, Bequest of John S. Thacher,
1985.39
L344

Degas here represented an urbane and well-dressed *flâneur* accessorized with a bowler hat, umbrella, and cigar in his left hand.[1] The bowler was invented in 1849 by London hatmakers Thomas and William Bowler, as a sturdy riding hat for gamekeepers. Known as a *chapeau melon* in French for its melon-shaped crown of hard felt, the hat was more practical than a top hat for navigating low-hanging branches while on horseback. As a less formal—and less expensive—alternative to the top hat, the bowler was quickly incorporated into the uniform of the middle and lower classes, as well worn as casual headgear by elite men (and the occasional *equestrienne*). The style's American name, the derby, comes from its popularity among English horse racing fans; a derby is a race for three-year-old horses, named after the twelfth Earl of Derby, who popularized it.

Degas himself wore a bowler hat, increasingly so in his later years. This work relates to two other drawings of standing men wearing top hats and may represent Degas's younger brother Achille.[2] All three works suggest Degas's interest in men's hat fashion.

Degas's drawing is in essence, an innovative technique that he developed in the late 1860s and early 1870s whereby oil paint was drained of its oil and thinned instead with turpentine. Essence enabled Degas to "draw" more easily than with thicker, more viscous oil paint and also to create a matte appearance similar to gouache or pastel.[3] The artist prepared the paper with an application of clear oil to create a rich, dark tone; he also used white paint to silhouette the form of the standing man. Pentimenti reveal that Degas slightly raised the outline of the bowler hat as well as lowering the man's left shoulder. The rapidly sketched lines to the left of his body also suggest the presence of another figure.

Degas's intention in making this drawing is unclear. As Theodore Reff has argued, such a study would have been made for a larger painting, although the identification of such a work is unclear.[4] An inscription on the back of the drawing indicates that it was a study for *Interior* (or *The Rape* [1868 or 1869]).[5] However, it has also been suggested that the study was intended for other compositions including a view of spectators at the racetrack or *The Cotton Office at New Orleans* (1873; Musée des Beaux-Arts de Pau).[6] —SK

1 For earlier discussions of this drawing, see Jennifer Tonkovich's entry in Rhoda Eitel-Porter, ed., *From Leonardo to Pollock: Master Drawings from the Morgan Library* (New York: Pierpont Morgan Library, 2006), 186–187. See also *In August Company: The Collections of the Pierpont Morgan Library* (New York: Pierpont Morgan Library, 1993), no. 30; and Cara D. Denison, *French Master Drawings from the Pierpont Morgan Library* (New York: Pierpont Morgan Library, 1993), no. 118.

2 See *Achille De Gas* (1868–1872; Minneapolis Institute of Art, 61.36.8 [L307]) and *Achille De Gas, Standing, in a Top Hat*, 1872–1873, private collection [L308].

3 Degas is often said to have pioneered this technique, but it was also used earlier by the Barbizon painter Narcisse Virgile Díaz de la Peña.

4 Cited in Eitel-Porter, *From Leonardo to Pollock*, 186.

5 Philadelphia Museum of Art, 1986-26-10. The early owner of *Standing Man in a Bowler Hat*, Marcel Guérin, the editor of Degas's letters, wrote on the back of the drawing "première idée pour le Viol, homme adossé à la porte, vers 1874 par Edgar Degas" (preliminary sketch for the Rape, man leaning against the door, about 1874 by Edgar Degas).

6 Jean Sutherland Boggs, ed., *Degas at the Races*, exh. cat. (Washington, DC: National Gallery of Art, 1998), 97.

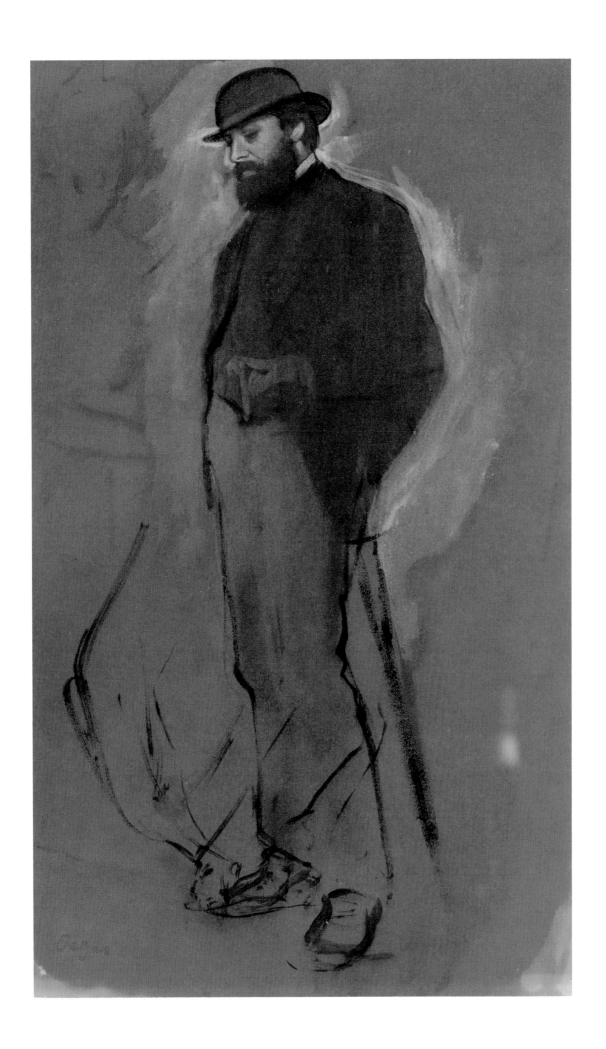

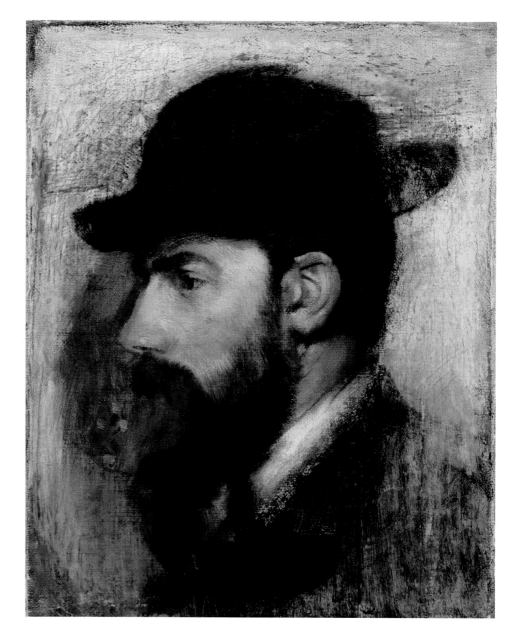

57

EDGAR DEGAS

Portrait of Henri Rouart, 1871

Oil on canvas
10 ½ x 8 ½ in. (27 x 22 cm)
Musée Marmottan Monet, Paris
L293

This portrait in profile features Degas's close friend Henri Stanislaus Rouart in a bowler hat. Rouart and Degas met in 1849 as third-year students at the Lycée Louis-le-Grand in Paris. Their paths would diverge when Degas pursued the study of law and Rouart entered the École Polytechnique in 1853. (Graduating as an engineer, Rouart would keep diverse interests: he invented a refrigerator and a machine that sent telegrams.[1]) Their friendship intensified during the Franco-Prussian War, when in October of 1870 Degas served under Rouart's command. Rouart was also a distinguished painter, having exhibited works in Paris Salons between 1867 and 1872 and in all of the Impressionist exhibitions between 1876 and 1886 (except in 1882, when Degas withdrew). However, he is best known as a collector, having acquired works by such artists as Jean-Baptiste-Camille Corot, Gustave Courbet, Eugène Delacroix, Jean-François Millet, and the Impressionists—including Mary Cassatt, Édouard Manet, Claude Monet, and his friend Degas.[2]

In his five known paintings of Rouart, Degas consistently represented him in profile from the left—a compositional decision that still allowed for penetrating expression.[3] The present work is most closely related to *Henri Rouart in front of His Factory* (ca. 1875), though the headwear differs.[4] Here Rouart wears a bowler hat (see cat. no. 56), a style that developed in 1849 and became increasingly popular into the late nineteenth and early twentieth century. It eventually usurped the top hat for everyday dress.—EB

1 See Michael Pantazzi, entry for *Henri Rouart and His Daughter Hélène*, in Jean Sutherland Boggs, ed., *Degas*, exh. cat. (New York: Metropolitan Museum of Art; and Ottawa: National Gallery of Canada, 1988), 249, no. 143.

2 Arsène Alexandre, *La Collection Henri Rouart* (Paris: Goupil & Cie, 1912); see also Jean-Dominique Rey, *Henri Rouart: L'Oeuvre peinte (1833–1912)*, exh. cat. (Paris: Musée Marmottan Monet, 2012).

3 See L293, L373, L424, L1176, and L1177 in Paul-André Lemoisne, *Degas et son oeuvre*, 4 vols. (Paris: Paul Brame and C. M. de Hauke, 1946–1948).

4 Now in the collection of the Carnegie Museum of Art, Pittsburgh, 69.44.

58

EDGAR DEGAS

Portrait of Zacharian,
ca. 1885

Pastel on paper laid down on board
15 ⅝ x 15 ⅝ in. (39.7 x 39.7 cm)
Private collection
L831

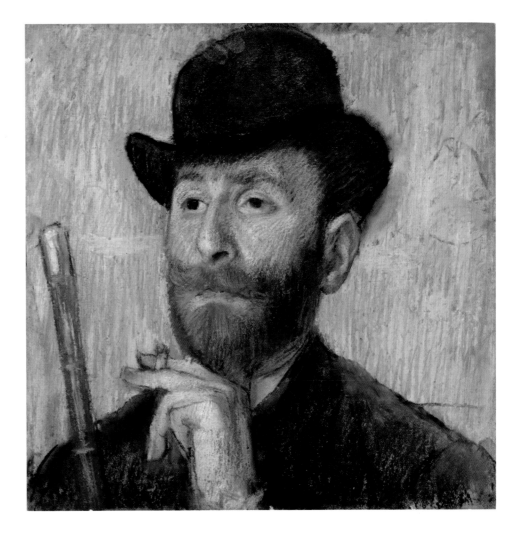

Here Degas represented a friend, the Turkish-Armenian painter Zacharie Zacharian. Born in Istanbul, Zacharian had moved to Paris as a young man and first begun to exhibit at the Paris Salons in the 1870s, enjoying some official success for his Chardinesque still lifes.[1] Degas shows his friend as a dandyish bohemian. He carefully rendered the fine features of Zacharian: the chiseled nose, the pursed lips, the intensely gazing eyes, and the carefully manicured copper-colored beard. Zacharian wears a bowler hat with upturned brim—a hat that by the 1880s not only carried working-class associations but also conveyed bohemian status for artists and intellectuals. This bohemian quality is further emphasized by the silver-topped malacca cane—an accessory that Degas himself collected extensively.[2] Degas used a wide range of colors to represent Zacharian's face—hatchings of pinks and yellow, and bright red for his left ear. A circle in the air just to the right of his head suggests the passage of smoke from his cigarette.

Degas admired the paintings of Zacharian and noted his endless facility with a limited range of subjects: "Now take old Zakarian [*sic*], for example. With a nut or two, a grape, and a knife, he had enough material to work with for twenty years, just so long as he changed them around from time to time."[3] Degas showed this work at the 1886 Impressionist exhibition. It attracted some interest, with the Belgian critic Octave Maus noting that the rendering of the sitter with "proud eye, upturned moustache, strong face, virile hand, asserts the master painter's insight and evocative power."[4] —SK

1 Zacharian won gold medals at the Exposition Universelle in 1889 and 1900 and was named Chevalier of the Légion d'honneur in 1889. His

work was bought by the state, for example *Glass of Water and Figs*, ca. 1888 (Musée d'Orsay, Paris, RF 527), which was acquired for the Luxembourg Museum in 1888.

2 See Jean Sutherland Boggs, *Portraits by Degas* (Berkeley: University of California Press, 1962).

3 See Ambroise Vollard, *Degas (1834–1917)* (Paris: G. Crès, 1924), 56.

4 "Enfin, *le portrait du peintre Zakarian* [*sic*], oeil fier, moustache relevée, visage énergique, main nerveuse, affirme la pénétration et la puissance d'évocation du maître-peintre." Octave Maus, "Les Vingtistes parisiens," *L'Art moderne* (Brussels), June 27, 1886; reprinted in Ruth Berson, ed., *The New Painting: Impressionism, 1874–1886. Documentation* (San Francisco: Fine Arts Museums of San Francisco, 1996), 1:463.

59

HENRI DE
TOULOUSE-LAUTREC
(French, 1864–1901)

Gaston Bonnefoy, 1891

Oil on cardboard
28 x 14 ⅝ in. (71 x 37 cm)
Museo Thyssen-Bornemisza, Madrid
inv. nr. 773, 1977.27

The ways in which hats served as markers of social status and identity interested Toulouse-Lautrec. Surviving photographic portraits of the artist show him in a range of hats, including top hats, bowler hats, and even, in drag, plumed hats (see fig. 80). In this full-length portrait, the artist shows his friend Gaston Bonnefoy in a bowler hat, which stands as a complement to his long overcoat.[1] Bonnefoy was known for his dandyish, fun-loving personality, and the jauntily angled hat here may signify this as much as his suggestively angled, quasi-phallic cane.[2] By the 1890s the bowler hat, especially for wealthier wearers, could signify an artistic, antiestablishment identity.[3]

Bonnefoy, the son of a doctor and a family friend of Toulouse-Lautrec, came from Bordeaux.[4] The artist's correspondence reveals that he knew Bonnefoy as early as 1886.[5] By February 1891 the two men were enjoying expeditions together around Paris. The artist wrote then: "We are enjoying splendid weather here. So good I had the buggy hitched up and with Gaston we've been out to breathe in the Bois de Boulogne air two or three times."[6]

Gaston Bonnefoy is one of three portraits of male friends that the artist exhibited at the seventh Société des artistes indépendants, which opened on March 20, 1891.[7] The two other portraits show Henri Bourges and Louis Pascal, both of whom wear top hats in contrast to Bonnefoy's bowler hat. Toulouse-Lautrec depicted Bonnefoy in the bare setting of the artist's sparsely furnished rooms on rue Caulaincourt. The artist's composition is also notable for the mysterious abstract line of red, green, white, and blue visible through the doorway.—SK

1 Toulouse-Lautrec often represented bowler hats. See, for example, *After the Meal* (1891; Museum of Fine Arts, Boston), representing Maurice Guilbert.

2 See Jane Kinsman and Stéphane Guégan, *Toulouse-Lautrec: Paris and the Moulin Rouge*, exh. cat. (Canberra: National Gallery of Australia, 2012), 98–99.

3 The bowler was invented in England, and Bonnefoy's wearing one may suggest his Anglophilic interest in the fashion of the English dandy. One reviewer noted the "snobbery of Parisian pseudo-boulevardiers, who get their laundry done in London." See Anne Roquebert's entry on the related portrait *Louis Pascal* (see note 7) in *Toulouse-Lautrec*, exh. cat. (New Haven, CT: Yale University Press, 1991), 152.

4 Toulouse-Lautrec later used Bonnefoy as the model for the bowler hat–wearing pimp standing at a bar in *Alfred la Guigne* (1894; National Gallery of Art, Washington, DC, 1963.10.220).

5 "I had lunch with Gaston Bonnefoy and his very pleasant wife": letter to his mother, [Tuesday, 1886]; published in Herbert D. Schimmel, ed., *The Letters of Henri de Toulouse-Lautrec* (Oxford: Oxford University Press, 1991), 105–106, letter no. 133.

6 See Toulouse-Lautrec, letter to his mother, [February 1891], in ibid., 140, letter no. 186.

7 Toulouse-Lautrec, letter to his mother, ibid.: "I'm busy with my exhibition, with three portraits in the works: Gaston, Louis and Bourges." Louis Pascal was Toulouse-Lautrec's second cousin, Henri Bourges a good friend. See *Louis Pascal* (1891; Musée Toulouse-Lautrec, Albi, France); and *Portrait of Dr. Henri Bourges* (1891; Carnegie Museum of Art, Pittsburgh, 66.5).

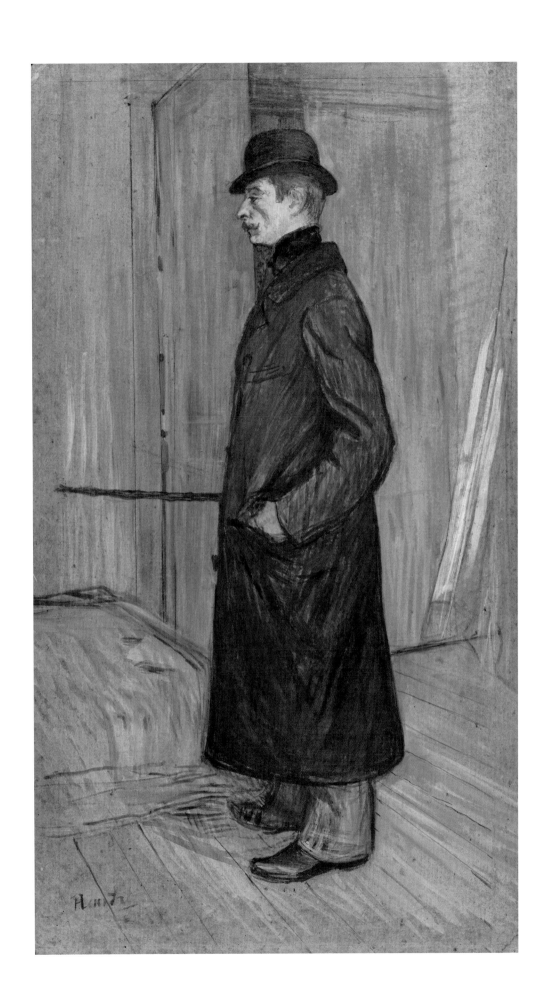

60

EDGAR DEGAS

In the Wings, ca. 1881

Pastel on paper
26 x 15 in. (66 x 38 cm)
Private collection, UK
L715

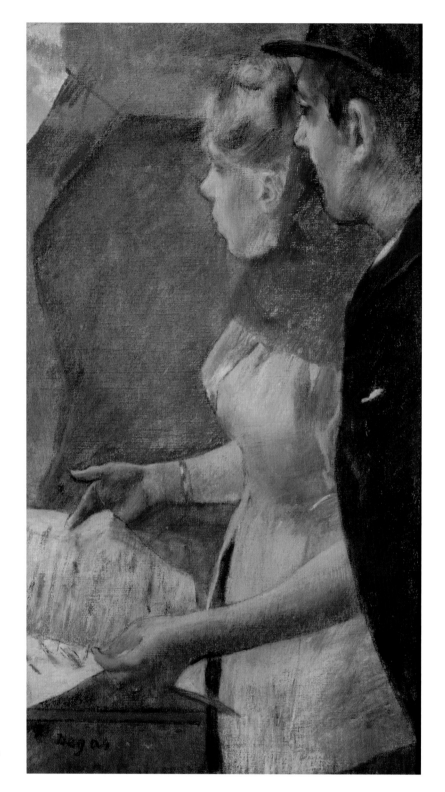

This pastel presents a backstage scene, its left and right margins truncated to heighten the focus on a singer's concentration in a quiet moment before she steps onstage. This perspective also emphatically crowds the two bodies depicted, those of the singer and a hovering man, which suggests an intimate, perhaps even clandestine moment. The man wears a *chapeau haut-de-forme,* or top hat, whose cylindrical crown would have been about six inches tall (see cat. nos. 61 and 63). By the 1870s such hats were worn only by men of the middle and upper classes. The hat marks him as an affluent opera-goer, like Degas himself, who was allowed elite access to the *coulisses,* or wings, as well as the foyer and the rehearsal rooms to interact with female performers. Such a highly charged interaction would have been understood by viewers to be laced with titillation. The *coulisses* were fodder for a literary and visual genre that detailed salacious anecdotes about the private lives of dancers, singers, and actresses in the back rooms of the theater.[1] Here, the hat symbolizes the man's bourgeois wealth and his masculine privilege.

In early 1881 Paul Durand-Ruel purchased *In the Wings,* along with *Dancer in Her Dressing Room* (ca. 1879) and an unidentified pastel of jockeys; these were the first works he had purchased from the artist in more than six years.[2] It later appeared in the posthumous sale of Degas's friend Henri Rouart (who is represented in cat. no. 57).[3] —EB

1 On clandestine encounters in the *coulisses* (and the mythology surrounding them), see Carol Armstrong, *Odd Man Out: Readings of the Work and Reputation of Edgar Degas* (1991; reprint, Los Angeles: Getty Publications, 2003), 58–72.

2 *Dancer in Her Dressing Room* is in the collection of the Cincinnati Art Museum, 1956.114. Journal, Durand-Ruel archives, Paris; cited in Jean Sutherland Boggs, ed., *Degas,* exh. cat. (New York: Metropolitan Museum of Art; and Ottawa: National Gallery of Canada, 1988), 219, 375.

3 Second sale, Collection Henri Rouart, Galerie Manzi-Joyant, Paris, 1912, no. 74.

61

E. MOTSCH
(active France, late nineteenth–
early twentieth century), designer

Man's top hat, 1915–1930

Labels: "Special E. M"; "E. Motsch/
42. Avenue George V/
68. R. François 1er./Paris"; "D. P."
Silk pile with cotton foundation, wool
hatband, silk grosgrain ribbon binding,
leather headband, and silk lining
22 ⅝ in. (57.5 cm) circumference
Museum of Fine Arts, Boston,
Bequest of Dana Pond, 1979.393

First worn in London in 1797, top hats quickly proliferated throughout Europe through young British gentlemen on their Grand Tour, the traditional trip to the continent that served as an educational rite of passage. Top-hat styles varied throughout the following century, their crowns generally appearing slim and cylindrical in the first decades of the 1800s; extremely tall (as high as eight inches) and wide by the middle of the century; and moderately tall (not exceeding six inches) and symmetrical by the century's end.

While initially worn in various forms by men of all social classes, by the 1870s the hats were generally only worn by men of the middle or upper classes.[1] By the 1890s top hats had been relegated to formal wear, and remained so through the first years of the twentieth century. Indeed, contemporary writers lamented the decline of the top hat— once so deeply ingrained in men's fashion— to the popularization of more casual styles, such as "the felt hat, so velvety and soft, or the straw, so light and pliable," by the turn of the twentieth century.[2] This top hat, with its high flat crown and brim rolled at each side,

was designed by E. Motsch, a well-known *chapelier* (hatmaker) who created elegant men's and women's hats in Paris from the late nineteenth through early twentieth centuries.[3] Much like the styles of the second half of the nineteenth century, this hat is made from a black silk plush that imitates beaver fur. —LLC

1 Florence Müller and Lydia Kamitsis, *Les Chapeaux: Une histoire de tête* (Paris: Syros-Alternatives, 1993), 33–34; and Mike Paterson, *A Brief History of Life in Victorian Britain: A Social History of Queen Victoria's Reign* (London: Robinson, 2008).

2 "Le chapeau de soie à haute forme est tellement ancré chez nous, qu'il faut désespérer de la voir détrôner pas le feutre si moelleux et si doux ou par la paille si légère et si flexible." "Vêtements," *Revue encyclopédique: Recueil documentaire universel et illustré*, ed. M. Georges Moreau (Paris: Librairie Larousse, 1892), 1885.

3 Among others, Motsch is listed in the following sources, which date from the 1890s to the 1930s: *Annuaire Didot-Bottin: Commerce industrie* (Paris: Didot-Bottin, 1892), 1070; *Annuaire Didot-Bottin: Commerce industrie* (Paris: Didot-Bottin, 1900), 1213; and "La longeur des jaquettes," *Figaro: Journal non politique* 113, no. 55 (February 24, 1938): 7. I am thankful to Simon Kelly for referring me to the *Annuaire Didot-Bottin*. See also *Les Amis des Champs-Élysées* (Syndicat d'initiative et de défense du quartier des Champs-Élysées, Paris), April/May 1934, 34.

62

HENRI DE
TOULOUSE-LAUTREC
(French, 1864–1901)

*Monsieur Delaporte at the
Jardin de Paris,* 1893

Gouache on cardboard, glued on wood
29 ⅞ x 27 ½ in. (76 x 70 cm)
Ny Carlsberg Glyptotek, Copenhagen,
inv. nr. MIN 1911

Toulouse-Lautrec produced a series of portraits of top-hatted Parisian men.[1] *Monsieur Delaporte at the Jardin de Paris* is a key work in this group and shows Léon Delaporte, the director of an advertising firm that specialized in posters.[2] Toulouse-Lautrec undoubtedly knew Delaporte through his own extensive poster output, and their friendship is suggested by the artist's inscription at bottom right.[3]

The urbane Monsieur Delaporte appears in a top hat of the latest fashion, made of silk plush with a moderately high crown of around six inches and a narrow brim turned down at front and back. He also carries a silver-tipped malacca cane. Toulouse-Lautrec, like his artistic hero Degas, recognized the importance of accessories in illuminating a sitter's personality.[4] Here, as in his portrait of Gaston Bonnefoy (cat. no. 59), the placement of the cane, encircled by the sitter's hands, may suggest sexual potency.[5] The top hat can also be read as a phallic symbol.

The setting is the café-concert Jardin de Paris on the Champs-Élysées, which employed two hundred people and offered a wide range of entertainment from singers and acrobats to tightrope walkers.[6] In the background is a woman in mauve, with red hair and ostrich-plumed hat; she is probably Jane Avril (see cat. no. 44), a regular dancer at the Jardin de Paris. The presence of two other top-hatted men suggests the extent to which the hat was part of the male uniform at this establishment.

Toulouse-Lautrec focused his composition on Delaporte, producing a study of his behatted head.[7] The painting's format was even more vertical before the artist added a strip of cardboard to the left, enabling the inclusion of two more fashionable women in the background.—SK

1 See, for example, *Maxime Dethomas* (1986; National Gallery of Art, Washington, DC, 1963.10.219), which is a compositional variant on this painting.

2 See Anne Roquebert entry in *Toulouse-Lautrec*, exh. cat. (New Haven, CT: Yale University Press, 1991), 162–163. Richard Thomson agrees with this identification: see Thomson, Phillip Dennis Cate, and Mary Weaver Chapin, eds., *Toulouse-Lautrec and Montmartre*, exh. cat. (Washington, DC: National Gallery of Art; and Princeton, NJ: Princeton University Press, 2005), 113.

3 "Pour M Delaporte–HTLautrec."

4 According to Toulouse-Lautrec's friend François Gauzi, the artist affirmed: "You must understand that the accessories are an integral part of the picture." Cited in Jane Kinsman and Stéphane Guégan, *Toulouse-Lautrec: Paris and the Moulin Rouge*, exh. cat. (Canberra: National Gallery of Australia, 2012), 96.

5 See Thomson, who makes this connection in *Toulouse-Lautrec and Montmartre*, 114.

6 Ibid., 110.

7 See *Study for the Portrait of Monsieur Delaporte* (1892), Musée Toulouse-Lautrec, Albi, France, P432.

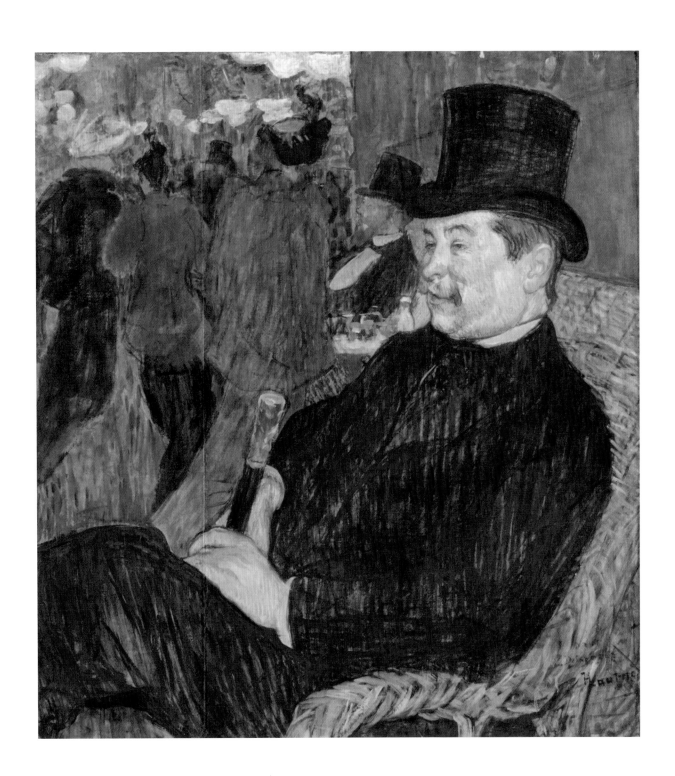

63

ALFRED BERTEIL
(French, active 1870–present),
design house

Top hat, ca. 1910

Label: "2 grands prix, Paris 1900–
Bruxelles 1910, manufacture de
Chapeaux, A. Berteil, 1878–1889,
rue de Richelieu, 79 et rue
du 4 septembre, 10, Paris"
Silk plush, wool, and grosgrain
lined with moiré
7 ¼ x 9 ⅞ x 12 ¼ in.
(18.5 x 25 x 31 cm) overall
Musée des arts décoratifs, Paris, UFAC
collection, Gift of Mrs. Lacau, UF 52-3-15

While women's hats were one-of-a-kind
works of art created by *modistes*, men's hats
were made by *chapeliers* in a much more
standardized form—a quality emphasized by
Édouard Manet's *Masked Ball at the Opera*
(1873; fig. 81). Despite their uniformity,
however, hats were one of many essential
accessories that enlivened and complicated
the comparatively limited palette, range of
garments, and choice of textiles available to
men in the late nineteenth century.

The *chapeau haut-de-forme* (top hat) was
a formal hat worn day and night throughout
the nineteenth century. Originally made of
expensive felted beaver fur, by the 1850s it
was covered in gleaming silk "hatter's plush."
This shift has been attributed to the overall
ease in manufacturing silk, as compared

to processing beaver fur, as well as to the influence on contemporary men's fashion of British Prince Consort Albert, who preferred silk top hats to beaver.[1] Although the top hat underwent minor changes in shape over time as the size and curvature of the crown and brim evolved, its phallic silhouette remained a distinctive aspect of menswear.

The top hat's ubiquity belies its unfavorable reception. Art critic Charles Blanc deplored its "frightful cylindrical shape . . . altogether at variance with the spherical form of the head," while author and critic Gabriel Prévost complained that the "absurd and hideous" style was useless in wind and rain.[2] In *À la recherche du temps perdu* (*Remembrance of Things Past*, 1913–1927), Marcel Proust took his literary revenge on the offending garment: his narrator tramples and destroys a rival's new top hat,

in an outburst drawn from the author's own experience.[3] Offering neither practical nor aesthetic benefits, the top hat confounded both good taste and good judgment. "In a sense this was the point of the top hat," fashion historian Aileen Ribeiro has observed. "It was an art to wear it with a certain style and self-confident authority."[4]

Despite its defects, the top hat enjoyed a long vogue, which extended well into the twentieth century. As Philippe Perrot has argued, it remained in fashion for so many years precisely because it offered "both bourgeois propriety, through its stiffness and funereal sobriety, and aristocratic bearing, because it made any physical activity completely impossible" while "simultaneously integrating democratic equality, by abandoning feathers or embroidery."[5] It could be worn with equal aplomb by the aristocrat,

the businessman, and the *flâneur*, as seen in *Achille De Gas* (1868–1872) or Henri de Toulouse-Lautrec's portrait *Monsieur Delaporte at the Jardin de Paris* (1893; cat. no. 62).[6]

Like the top hat itself, Berteil's hatmaking business enjoyed an unusually long life. By 1900 he had two locations, at 79, rue de Richelieu and 91, boulevard Haussmann at place Saint-Augustin. After President John F. Kennedy's refusal to wear a hat at his 1961 inauguration portended the collapse of the men's hat industry, the firm reinvented itself as Berteil, a ready-to-wear clothing shop, in 1970. It currently sells men's and women's fashions from its place Saint-Augustin boutique and online.—KCC

1 Florence Müller and Lydia Kamitsis, *Les Chapeaux: Une histoire de tête* (Paris: Syros-Alternatives, 1993), 33–34; and Mike Paterson, *A Brief History of Life in Victorian Britain: A Social History of Queen Victoria's Reign* (London: Robinson, 2008), n.p.

2 Quoted in Aileen Ribeiro, "Gustave Caillebotte: *Paris Street; Rainy Day*," in Gloria Groom, ed., *Impressionism, Fashion, and Modernity*, exh. cat. (Chicago: Art Institute of Chicago; New York: Metropolitan Museum of Art; and Paris: Musée d'Orsay, 2012), 191.

3 Adam Watt, *Marcel Proust* (London: Reaktion Books, 2013), 90.

4 Ribeiro, "Gustave Caillebotte: *Paris Street*," 191.

5 Philippe Perrot, *Fashioning the Bourgeoisie: A History of Clothing in the Nineteenth Century*, trans. Richard Bienvenu (Princeton, NJ: Princeton University Press, 1994), 122.

6 *Achille De Gas* is in the collection of the Minneapolis Institute of Art, 61.36.8; the work served as a preparatory sketch for Degas's *At the Races* (1868–1872; private collection (L307)].

81 Édouard Manet, *Masked Ball at the Opera*, 1873. Oil on canvas, 23 ¼ x 28 ½ in. (59.1 x 72.5 cm). National Gallery of Art, Washington, Gift of Mrs. Horace Havemeyer in memory of her mother-in-law, Louisine W. Havemeyer, 1982.75.1

64

BERTHE MORISOT
(French, 1841–1895)

*Eugène Manet on the
Isle of Wight*, 1875

Oil on canvas
15 x 18 ⅛ in. (38 x 46 cm)
Musée Marmottan Monet, Paris

———————————

In the summer of 1875 Morisot and her new
husband, Eugène Manet, visited the Isle of
Wight off the coast of England. They rented
Globe Cottage, which had a desirable view
upon Queen's Parade, the town's main port.[1]
Morisot created a series of paintings of the
boats and vacationing boaters, exclaiming
in her letters that the Yacht Club was full
of "fashionable society."[2] In a letter to her
sister Edma, she wrote of the town of Cowes
that it was "the prettiest place for paint-
ing. . . . People come and go on the jetty, and
it is impossible to catch them. . . . I began
something in the sitting room, of Eugène . . .
he is a less obliging model; at once it
becomes too much for him."[3]

 Here Manet, who rarely appears in
Morisot's paintings, sits in profile before
a window, his torso twisted so that he can
watch the anchored boats in the pale blue
water, or perhaps the woman and child who

pass before him on the quay. The diapha-
nous curtains, painted with rapid strokes of
white paint, frame the sitter and reinforce
his attention to the exterior activity. Manet
wears a *canotier*, or straw boater hat, with
a dark ribbon around the crown. These hats
with their flat, stiff crowns and brims were
part of popular nineteenth-century fashion
around water or water sports.[4] —EB

1 Alain Clairet, Delphine Montalant, and Yves
 Rouart, *Berthe Morisot, 1841–1895: Catalogue
 raisonné de l'oeuvre peint* (Paris: CÉRA-nrs
 éditions, 1997), 138, no. 51; and Michèle Moyne
 in *Berthe Morisot, 1841–1895*, exh. cat. (Paris:
 Éditions de la Réunion des musées nationaux,
 2002), 162–163, no. 28.

2 Denis Rouart, ed., *The Correspondence of
 Berthe Morisot with Her Family and Friends:
 Manet, Puvis de Chavannes, Degas, Monet,
 Renoir, and Mallarmé*, trans. Betty W. Hubbard
 (New York: George Wittenborn, 1957), 90; see
 also Anne Higonnet, *Berthe Morisot* (New York:
 Harper & Row, 1990), 129–130.

3 Rouart, *The Correspondence of Berthe
 Morisot*, 89.

4 See, for instance, the boy in nautical dress and
 a similar hat in *La Revue de la mode: Gazette de
 la famille*, no. 30 (1891).

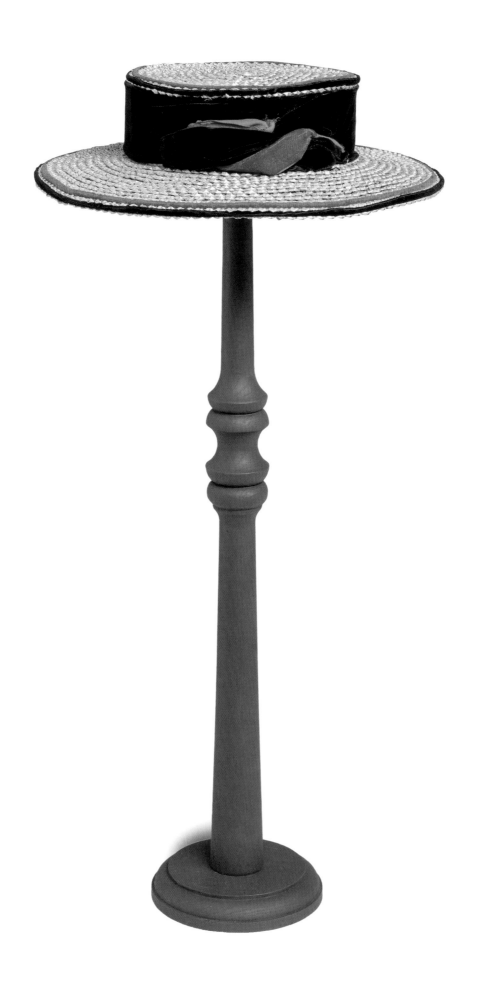

65

CAROLINE REBOUX
(French, 1837–1927), designer

Woman's boater, 1900

Label: "Caroline Reboux/
23. Rue de la Paix/Paris"
Straw and red and black piping
10 ¼ in. (26 cm) diameter
Musée des arts décoratifs, Paris, UFAC
collection, Gift of Lucienne Rabaté,
UF 56-62-70

The boater was known as a *canotier* in French, from the word *canot*, meaning a small boat. Usually made of stiffened straw, it had a shallow, flat crown, often trimmed with a hatband of ribbon. Popularized in the early 1870s, after new technologies facilitated the mechanical sewing of plaited straw, the boater was reserved for yachting and other summer sports until the 1890s, when it began to appear on city streets.

During the 1880s the boater was adopted by women, who often paired it with tailored ensembles inspired by menswear. It was a rare example of a unisex hat style in the Impressionist era and quickly became associated with the active, independent "New Woman" of the 1890s. Although this is a woman's hat, designed by high-society milliner Caroline Reboux, it is similar to the one Eugène Manet wears in Berthe Morisot's 1875 portrait painted on the Isle of Wight (cat. no. 64), a popular sailing destination off the southern coast of England.

Lightweight and breathable, the hat allowed its wearer to preserve decorum while engaging in a wide range of outdoor activities beyond boating. In 1884 Maud Watson won the first women's singles championship at Wimbledon wearing a boater, which lent a masculine touch to her corseted and bustled tennis ensemble.[1] Boaters were part of the uniform of England's first female cricket club, founded in 1887.[2] In 1894, when a bicycling craze swept France, "the fashionable sportswoman's dress consisted of voluminous pleated knickers and a tiny boater perched on the very top of the head."[3]

The boater remained in fashion through the 1920s, although *modistes* increasingly used the term *canotier* to denote any straw or boater-shaped hat. In 1916, for example, Reboux created "a *canotier* of midnight-blue velvet, shirred on the crown and turned back in two sharp points with ornaments of tortoise-shell."[4] After Reboux's death

in 1927, her shop remained open under the direction of Lucienne Rabaté, who donated this hat—and many others—to the Musée des arts décoratifs in Paris when she retired in 1956.—KCC

1 Kate Brasher, "Traditional Versus Commercial Values in Sport," in Lincoln Allison, ed., *The Politics of Sport* (Manchester: Manchester University Press, 1986), 189.

2 Kathleen E. McCrone, *Playing the Game: Sport and the Physical Emancipation of English Women, 1870–1914* (Lexington: University Press of Kentucky, 1988), 144.

3 "Une grosse culotte plissée et un tout petit canotier perché sur le haut de la tête constituait le costume de la sportswoman à la mode." "30 ans de mode," *Vogue* 4, no. 18 (January 1, 1923): 7.

4 "The Latest Pattern Hats," *Millinery Trade Review* 41 (November 1916): 49.

66

LAVILLE PETIT & CRESPIN
(French, founded 1823), designer

Woman's riding hat, ca. 1890

Label: "Deux Médailles de 1ère Classe./
Exposition Universelle 1855/Chapeau
Breveté/Laville Petit & Crespin/Paris."
Silk pile on cotton foundation,
silk grosgrain ribbon, leather headband,
and silk lining (interior)
5 x 6 x 10 in. (12.7 x 15.2 x 25.4 cm)
Museum of Fine Arts, Boston, Gift of
Mrs. Jason Westerfield, 60.910

The shape of this woman's riding hat demonstrates the transition from the high silk or top-hat styles of the 1880s to the dome-shaped or bowler-inspired styles of the early 1890s.[1] The hat was designed by the Parisian firm of Laville Petit & Crespin. Founded in 1823, it was known for its advances in the processing and manufacturing of beaver hair and fur, which included developing tools for trimming and dyeing as well as new machines and hydraulic presses for shaping hats.[2] Its innovative designs were displayed at numerous world's fairs, including the Exposition Universelle in 1855, where they received two first-class medals.

In addition to riding hats, the firm made men's top hats and military hats.[3] While this hat could have been purchased in Paris, it may have been acquired in the New England area; among other merchants, Laville Petit & Crespin designs were retailed by Jackson & Co. Hatters and Furriers in Boston; Bennett & Marr, wholesale and retail dealers in ready-made clothing in Gloucester, Massachusetts; and Aaron Nourse, a purveyor of hats, caps, and furs in Salem, Massachusetts.[4] —LLC

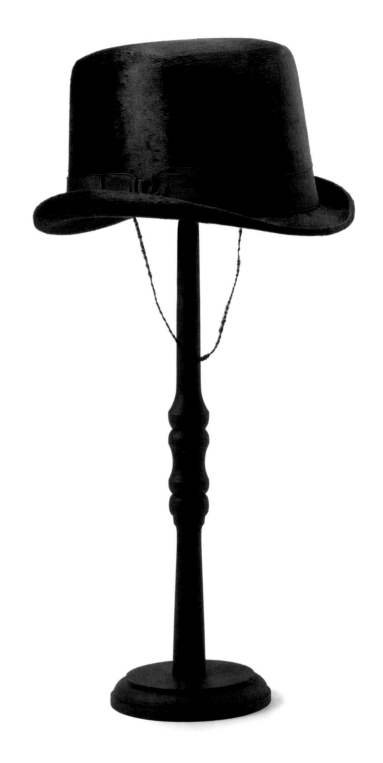

1 For more information, see Janet Arnold, "Dashing Amazons: The Development of Women's Riding Dress, c. 1500–1900," in *Defining Dress: Dress as Object, Meaning and Identity*, ed. Amy de la Haye and Elizabeth Wilson (Manchester: Manchester University Press, 1999), 10–29; Juliana Albrecht, Jane Farrell-Beck, and Geitel Winakor, "Function, Fashion, and Convention in American Women's Riding Costume, 1880–1930," *Dress* 14 (1988): 56–67; and Alison Matthews David, "Elegant Amazons: Victorian Riding Habits and the Fashionable Horsewoman," *Victorian Literature and Culture* 30, no. 1 (2002): 179–210.

2 *Bulletin de la Société d'encouragement pour l'industrie nationale*, second series, vol. 17 (Paris: Madame Veuve Bouchard-Huzard, 1870), 89.

3 For extant examples of these styles, see two top hats (1855–1875 and 1860–1879) and a captain's hat (n.d.) in the collection of Historic New England, Boston (accession numbers 1939.564A, 1988.210, and 1942.5198, respectively).

4 Per labels found in Laville Petit & Crespin hats from the collection of Historic New England.

FLOWERED

AND

RIBBONED

HATS

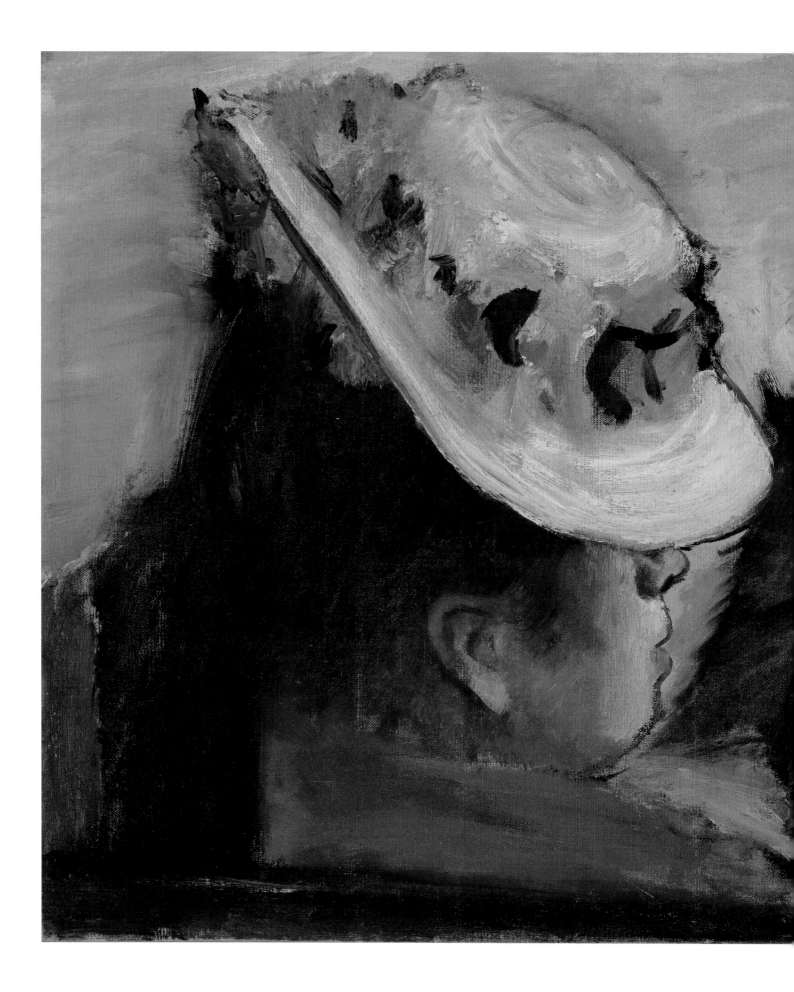

67

EDGAR DEGAS

Woman with a Dog,
ca. 1875–1880

Oil on canvas
15 ½ x 18 ¾ in. (39 x 48 cm)
Nasjonalmuseet for kunst, arkitektur og
design, Oslo, NG.M.01170
L390

Even before delving into the subject of millinery in earnest in the early 1880s, Degas had shown a significant interest in women's hat fashions, as exemplified here in *Woman with a Dog*. The painting offers an unconventional perspective: the viewer looks down at a woman from above and slightly behind so that her hat is the focal point and her face is almost entirely obscured.[1] The hat largely dominates the composition, its pale straw body contrasting with the woman's dark hair as well as her small brown griffon dog. The crown is encircled with blue and violet blossoms in a style that was popular during the late 1870s and 1880s.[2] Illustrations from prominent fashion magazines like *Le Moniteur de la mode* and *La Modiste universelle* show similar styles of low-crowned straw hats embellished with flowers. Floral straw hats like these and the one in Degas's painting were often worn in the garden, on seaside holidays, or for leisurely activities, and were especially prevalent during the summer months, when artificial flowers were the trimming of choice for the fashionable Parisienne.[3]

Despite the lack of a distinctly identifiable setting, the woman's hat and her dog suggest a scene of leisure, and the work can be seen as part of a larger trend by the Impressionists of depicting bourgeois ladies with their dogs.[4] Images of women and their dogs in gardens, at the beach, and on boats appear frequently in the works of Mary Cassatt, Berthe Morisot, and Pierre-Auguste Renoir from this same period.[5] Yet Degas places his figure in a more ambiguous space, relying on the hat and the dog to convey the relaxed atmosphere and suggesting his awareness not only of fashion but its social function as well. —AY

1 This compositional arrangement also appeared in some of Degas's later pastels, like *In Front of the Mirror* (1889; fig. 72) and *Woman in a Blue Hat* (ca. 1889; cat. no. 18), in which a woman is viewed from behind with a hat that essentially obstructs the view of her face. See Sigurd Willoch, "Edgar Degas i Nasjonalgalleriet," *Kunst og kultur* 63, no. 1 (1980): 22. My thanks to Leah Chizek for her assistance with this translation.

2 Ibid. Willoch raises questions about the date of the painting, suggesting the earliest possible date of the early 1870s. Others have dated it as late as the 1890s. Variations of this hat style were popular for several decades, but seem to have been especially stylish in the late 1870s and early 1880s, based on fashion plates from these years in *La Modiste universelle*, *La Mode illustrée*, and *Le Moniteur de la mode*.

3 See *Artisans de l'élégance*, exh. cat. (Paris: Réunion des musées nationaux, 1993), 64; and Mary van Kleeck, *Artificial Flower Makers* (New York: Survey Associates, 1913), 161.

4 During the mid- to late nineteenth century, petkeeping—that is, keeping animals for companionship rather than for working purposes—developed as an almost exclusively bourgeois social practice. See Kathleen Kete, *The Beast in the Boudoir: Petkeeping in Nineteenth-Century Paris* (Berkeley: University of California Press, 1994).

5 For more on the subject, see James Rubin, *Impressionist Cats and Dogs* (New Haven, CT: Yale University Press, 2003), 94, 103.

68

EDGAR DEGAS

At the Theater: Woman Seated in the Balcony, ca. 1877–1880

Oil on canvas
9 ⅞ x 13 in. (25 x 33 cm)
The Montreal Museum of Fine Arts,
Gift of Mr. and Mrs. Michal Hornstein,
1999.18
L466

For Degas and his Impressionist contemporaries, the subject of the theater occupied a significant place in their artistic output, not only for the performances but also for the overall spectacle. Indeed, the theater in nineteenth-century Paris was considered a place where the "principal attraction is the splendor of costume."[1] This referred to the attire of both the performers—actresses were often dressed by the best *couturiers* and wore the finest hats—as well as the women in attendance. Images of fashionable theater attendees often illustrated them looking out from the balconies not at the stage but at other people in the audience.[2] Thus, the right costume, including hat or headwear, was an essential part of a woman's theatergoing experience.[3]

Degas's painting *At the Theater: Woman Seated in the Balcony* presents a young woman leaning over the edge of a balcony and looking below. In comparison to the often smartly dressed ladies depicted in other works,[4] Degas's woman is dressed more demurely, wearing a dark, high-necked jacket with lace trim and a bright blue

82 Cover of *La Mode illustrée* featuring models by Madame Deloffre, February 11, 1877; top center shows an appropriate hat for attending the theater. Bunka Gakuen University Library

flowered hat. This sort of ensemble, of a day dress with a less formal hat, was more frequently seen at matinee showings or in less expensive theaters or seats, thus suggesting that Degas's subject may be a working-class woman.[5]

Flowered hats were considered appropriate for certain activities, including visiting the theater, and artificial flowers were common accessories for all kinds of theater dress (see fig. 82). Even elegant costumes for the loge or soirees typically included sprays of flowers in a woman's coiffure, along with jewels and ribbons. In fact, flowers were so prominent that designer Paul Poiret recalled in his memoirs that during the Belle Époque, women's hats at the theater transformed the space into a sort of flower garden.[6] —AY

1 H. Despaigne, *Le Code de la mode* (Paris: Chez l'auteur, 1866), 8–9; quoted in Valerie Steele, *Paris Fashion: A Cultural History*, 2nd ed. (Oxford: Berg, 1998), 161.

2 See, for example, Mary Cassatt's *In the Loge* (ca. 1877–1878; Museum of Fine Arts, Boston, 10.35), which not only shows the main subject gazing out across the audience, but also a man behind her studying someone else through opera glasses.

3 Ruth E. Iskin, "Was There a New Woman in Impressionist Painting?," in Sidsel Maria Søndergaard, ed., *Women in Impressionism: From Mythical Feminine to Modern Woman*, exh. cat. (Copenhagen: Ny Carlsberg Glyptotek; and Milan: Skira, 2006), 191–195.

4 See Pierre-Auguste Renoir's *La Loge (Theatre box)* (1874; Courtauld Gallery, London, P.1948. SC.338) and Mary Cassatt's *Woman in a Theater Box (Woman with a Pearl Necklace in a Loge)* (1879; Philadelphia Museum of Art, 1978-1-5). The women featured are likely attending opening-night performances, thus their formal gowns and headdresses. See Aileen Ribeiro, "The Art of Dress: Fashion in Renoir's *La Loge*," in Ernst Vegelin van Claerbergen and Barnaby Wright, eds., *Renoir at the Theatre: Looking at La Loge*, exh. cat. (London: Courtauld Gallery and Paul Holberton, 2008), 54. See also Iskin, "Was There a New Woman," 195.

5 Ribeiro, "The Art of Dress," 54.

6 See quote in Marilyn Boxer, "Women in Industrial Homework: The Flowermakers of Paris in the Belle Epoque," *French Historical Studies* 12, no. 3 (Spring 1982): 401.

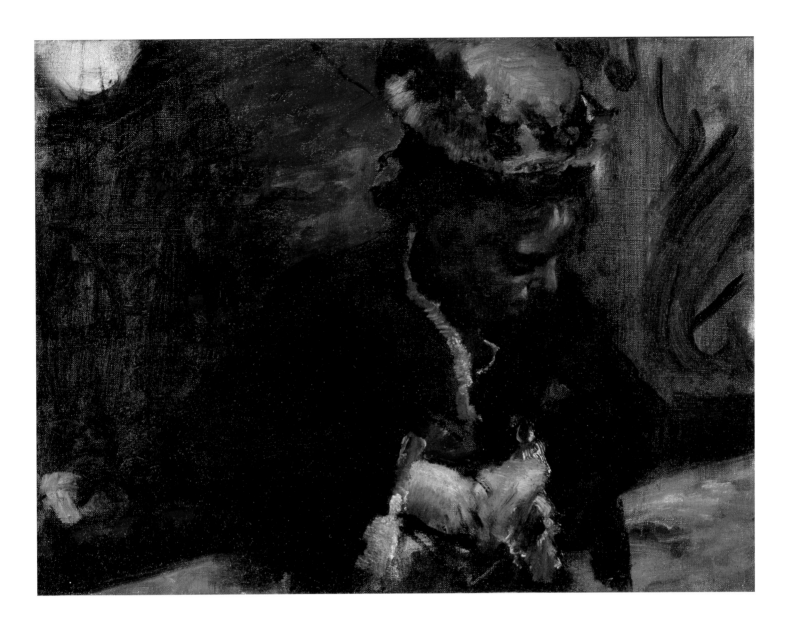

69

ÉDOUARD MANET
(French, 1832–1883)

Girl in a Summer Bonnet (Jeanne Demarsy), ca. 1879

Pastel on canvas
22 x 13¾ in. (56 x 35 cm)
Collection of Diane B. Wilsey

———————————

Manet gravitated toward pastel during the latter part of his career, predominantly using the medium for his bust- or half-length portraits of women set against neutral backgrounds.[1] The present sitter's identity has been the subject of debate, but it seems likely that she is Jeanne Demarsy, the Parisian actress. Born Anne Darlaud in Limoges in 1865, Demarsy was the daughter of a bookbinder and a brocade maker, and the sister of the more successful actress Eugénie-Marie Darlaud. She made her debut in 1887 at the Théâtre de la Gaîté in the role of Venus in *Orphée aux enfers* (*Orpheus in the Underworld*), and she later performed frequently at the Châtelet, Gymnase, Nouveautés, and Variétés theaters.[2]

Demarsy was introduced to Manet before the peak of her career, and she appears in three or four other works of his from this period.[3] *On the Bench* (1879; fig. 83), also a pastel on canvas, depicts Demarsy in profile

wearing a similar hat and brown coat and seated in the conservatory-studio of the painter Otto Rosen, where Manet worked between July 1878 and April 1879.[4] She also sat for the allegorical painting *Jeanne (Spring)* (fig. 84), painted in 1881 and exhibited in the Paris Salon the following year as part of a larger commission of four paintings for the journalist and politician Antonin Proust. In the present composition Demarsy wears a straw hat with pleated gray fabric around the crown, adorned with a white artificial flower. Proust writes in his letters that Manet visited Madame Virot expressly to study her fabric and lace because "he wanted to put together an outfit for Jeanne, who subsequently took the stage name Mlle. Demarsy."[5] In "designing" the headwear of his sitter, Manet's practice was aligned with that of the milliner.—EB

1 See Françoise Cachin and Charles Moffett in collaboration with Michel Melot, *Manet, 1832–1883*, exh. cat. (New York: Metropolitan Museum of Art, 1983), 439, 182.

2 See Leah Rosenblatt Lehmbeck, "Edouard Manet's Portraits of Women" (PhD dissertation, Institute of Fine Arts, New York University, 2007), 55–63, 239–240.

3 The number of paintings of Demarsy has been debated; Ronald Pickvance argues there are four images—including the present composition. Lehmbeck argues for only three. See Robert Pickvance, *Manet* (Martigny, Switzerland: Fondation Pierre Giannada, 1996), 238; and Lehmbeck, "Edouard Manet's Portraits of Women," 56.

4 *Manet* (1983), 439, 182.

5 "Il voulait composer une toilette pour Jeanne, qui est devenue depuis au théâtre Mlle Demarsy." Antonin Proust, *Édouard Manet: Souvenirs* (Paris: Librairie Renouard, 1913), 113.

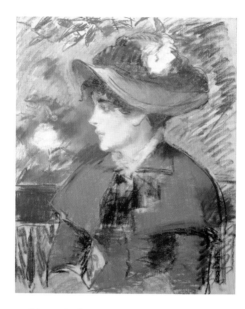

83 Manet, *On the Bench*, 1879. Pastel on canvas, 24 x 19 ⅝ in. (61 x 50 cm). Private collection

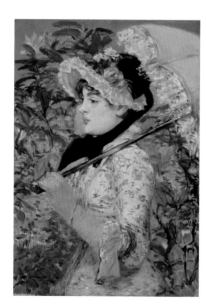

84 Manet, *Jeanne (Spring)*, 1881. Oil on canvas, 29 ⅛ x 20 ¼ in. (74 x 51.5 cm). The J. Paul Getty Museum, Los Angeles, 2014.62

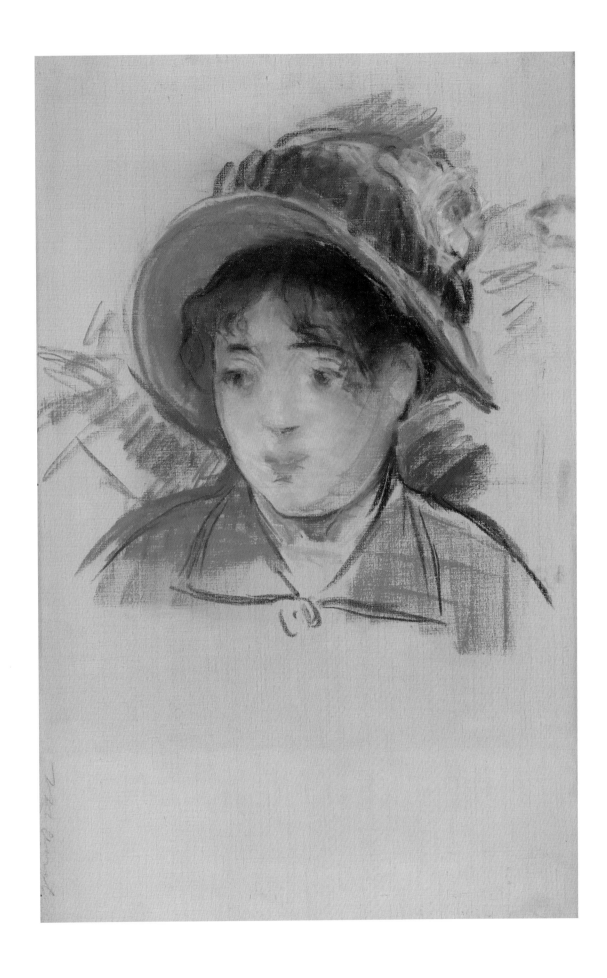

70

BERTHE MORISOT
(French, 1841–1895)

Young Girl on the Grass,
Mademoiselle Isabelle
Lambert, 1885

Oil on canvas
29 ⅛ x 23 ⅝ in. (74 x 60 cm)
Ordrupgaard Museum, Charlottenlund,
Denmark, Inv. nr. 251 WH

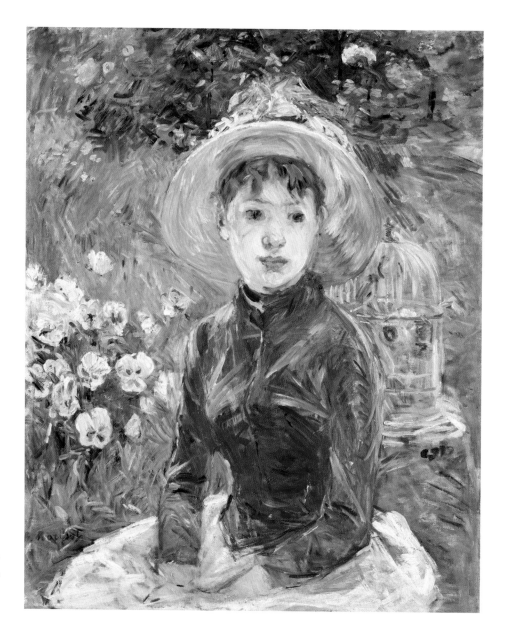

Morisot's early training alongside her sister Edma included working *en plein air* supervised by their teacher, Camille Corot. In this painting her subject, Isabelle Lambert, is situated in a verdant garden animated by expressive brushwork. The birdcage in the background recalls the voracious nineteenth-century taste for plumed hat decorations, although Lambert's beribboned straw hat—very typical of the period, and especially suitable for a young woman—seemingly does not include these trimmings. The hat's coarse texture is suggested by swirling strokes of paint in yellow and golden hues. Morisot was both praised and criticized for this sketchy, abbreviated brushwork, which was sometimes described by critics including Georges Rivière and Paul de Charry as a particularly feminine style, although it was also a hallmark of male Impressionists.[1]

Lambert became Morisot's favorite model, and she posed for the artist on multiple occasions, beginning in the summer of 1885 when she was sixteen.[2] This painting was exhibited at the eighth and final Impressionist exhibition in 1886, along with many pastel portraits of the same sitter.[3] The rosy glow in Lambert's fair complexion and cheeks emphasize her youth, which is echoed by the pansies behind her in full bloom. Morisot may have been familiar with the popular nineteenth-century "language of flowers," a broad genre ascribing symbolic, iconographic meaning to floral types, in which the pansy was associated with "thoughts."[4] This connotation might relate to Lambert's pensive expression and the distant focus of her gaze. A contemplative atmosphere permeates this peaceful garden setting; the poignancy of Isabelle Lambert's delicate beauty is underscored by the fact that she would be deceased by age seventeen.[5] —MB

1 See Kathleen Adler and Tamar Garb, *Berthe Morisot* (Oxford: Phaidon Press, 1987), 57 and 6–65.

2 Margaret Shennan, *Berthe Morisot: The First Lady of Impressionism* (Thrupp, England: Sutton Publishing, 1996), 229. Richard Kendall refers to Lambert as Morisot's "personal friend" in Sarah Lees, ed., *Nineteenth-Century European Paintings at the Sterling and Francine Clark Art Institute* (Williamstown, MA: Sterling and Francine Clark Art Institute, 2012), 2:560.

3 Charles S. Moffett, ed., *The New Painting: Impressionism, 1874–1886*, exh. cat. (San Francisco: Fine Arts Museums of San Francisco, 1986), 445.

4 See, for example, *Language of Flowers*, illustrated by Kate Greenaway (London: F. Warne, 1899), 32.

5 Alain Clairet, Delphine Montalant, and Yves Rouart, eds., *Berthe Morisot, 1841–1895: Catalogue raisonné de l'oeuvre peint* (London: Percy Lund, Humphries & Co., 1997), 201, no. 177.

71

MAISON VIROT
(French, ca. 1845–ca. 1915), design house

Woman's hat, ca. 1900, with alterations

Label: "Maison Virot/
12 Rue de la Paix/Paris."
Plaited straw over wire frame, silk velvet
and maline, silk roses, leaves, and ferns
15 ½ x 15 in. (39.4 x 38.1 cm) overall
Fine Arts Museums of San Francisco,
Gift of Jane Scribner, 49.10.25

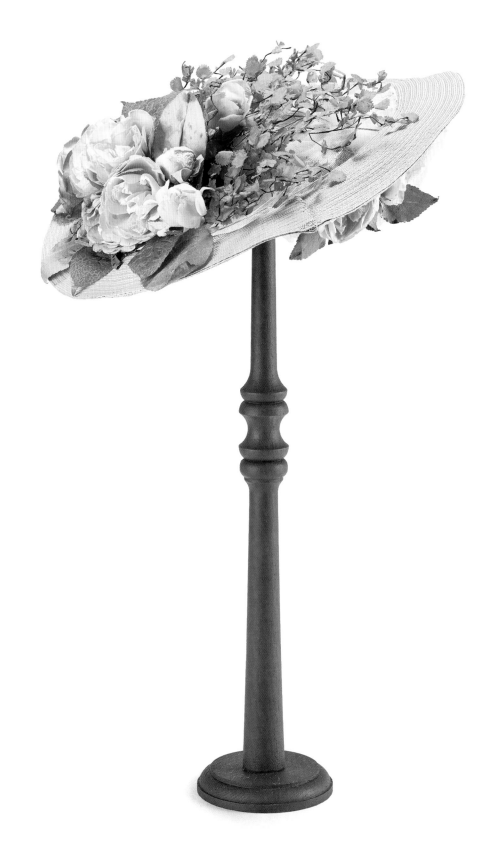

As Jessica Ortner wrote in *Practical Millinery* (1897), at the turn of the twentieth century it was "customary . . . to make foundations of wire for hats . . . which were to be covered with tulle, lace, jet, or other transparent material."[1] This wire-frame hat by Maison Virot is delicately covered with translucent layers of silk maline, a fine stiff net with a hexagonal mesh, and features a finely plaited straw brim. The hat's front is embellished with sumptuous silk roses, leaves, and ferns, while the underside of its back brim is enriched by lush silk roses and tufts of tulle.[2] Worn asymmetrically at the top of the head, the beautiful foliate forms would have delicately framed the wearer's face and hair.[3]

This hat's brim shows evidence of alteration; at each side as well as at the back, the brim was either tucked or cut and then layered upon itself and restitched. These alterations decreased the brim's original circumference. Indeed, hats were often altered to conform to the latest fashion, and Virot designs were no exception, as contemporary writings reveal.[4] —LLC

1 Jessica Ortner, *Practical Millinery* (London: Whittaker & Co., 1897), 48.

2 A comparable hat of this style, also by Virot and dated to circa 1902, is found in the Brooklyn Museum Costume Collection at the Metropolitan Museum of Art, New York, 2009.300.2229.

3 As an example of this wear, see *La Mode illustrée: Journal de la famille*, no. 14 (March 20, 1904): 163.

4 As an example, see a passage in Edith Wharton's *The House of Mirth*: "Madam sent for me to alter the flower in that Virot hat—the blue tulle." Wharton, *The House of Mirth* (New York: Charles Scribner's Sons, 1922), 461.

72

CAROLINE REBOUX
(French, 1837–1927), designer

Woman's hat, ca. 1904–1905

Label: "Caroline Reboux/
23. Rue de la Paix/ PARIS"
Woven straw and dyed cotton
10 ⅝ in. (27 cm) diameter
Musée des arts décoratifs, Paris, UFAC
collection, Gift of Lucienne Rabaté,
UF 56-62-76

Women's hats grew in size along with fashionable hairstyles. The large, full coiffures of the early 1900s—often augmented by false hair—brought a corresponding inflation in hat size. This straw hat would have been worn perched atop a full coiffure, anchored by hatpins (*épingles à chapeaux*). The large bouquet of artificial flowers would mask the gap between the smartly tilted black straw hat and the hair, a visual trick also employed in a hat of the same period by Madame Georgette (cat. no. 97).

In order to be anchored firmly atop clouds of hair, the increasingly huge hats of the early 1900s required multiple hatpins up to twelve inches long. These sharp skewers ending in decorative finials sometimes doubled as weapons of defense in crowded streets and conveyances but also posed public-safety hazards. "With the advent of the big hat it has become fashionable for a woman to go about the streets with her head bristling on all sides with hatpin weapons of many designs. Sometimes the pins are nearly a foot-and-a-half long and are like thin bladed swords."[1] In Paris, hatpins even became an instrument of civil disobedience, as striking dressmakers used hatpins and umbrellas to defend themselves against the police in 1910.[2] New regulations penalizing wearers of long, sharp hatpins went into effect in Paris in January 1914, the municipal government having decided that it could wait no longer for the fashion to pass.[3]

Hatpins and elaborate hairstyles finally went out of style with the onset of World War I, to be replaced by boyish bobbed haircuts and bell-shaped cloche hats that hugged the head without the aid of hatpins: a more practical and less labor-intensive style appropriate for the new social and economic conditions of wartime.—KCC

1 *Arkansas City Daily Traveler*, August 17, 1909.
2 Kerry Segrave, *The Hatpin Menace: American Women Armed and Fashionable, 1837–1920* (Jefferson, NC: McFarland and Company, 2016), 112.
3 Ibid.

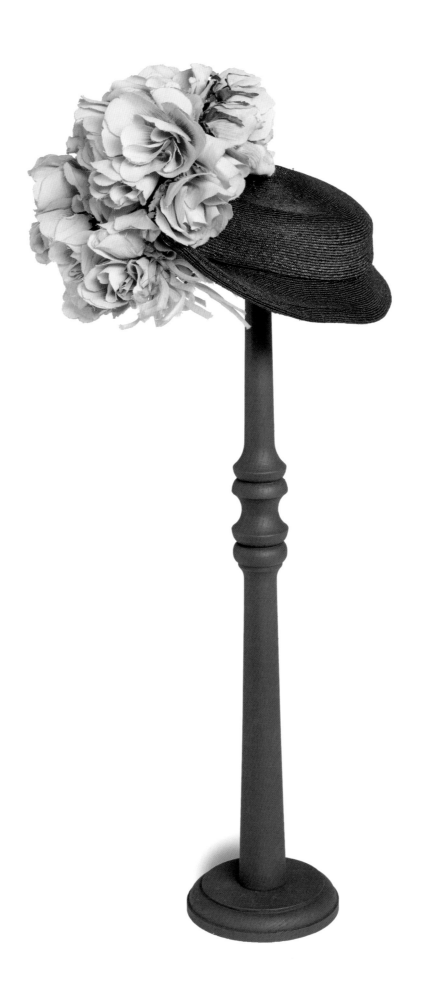

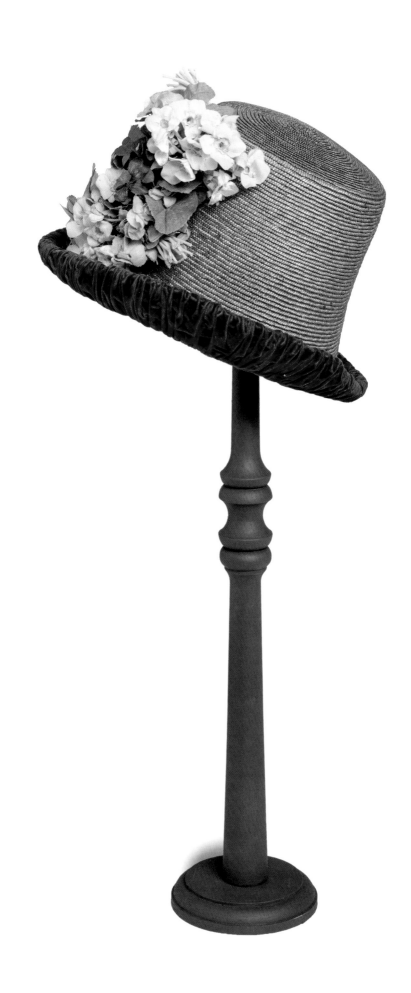

73

AU BON MARCHÉ
(French, active 1838–present), retailer

Woman's hat, ca. 1884

Label: "Au bon marché Paris, Modes"
Plaited straw, silk velvet, cotton, metallic
thread, and artificial flowers
8 x 8⅝ in. (20 x 22 cm)
Musée des arts décoratifs, Paris, UFAC
collection, purchase, UF 49-32-100

Au Bon Marché began as a small haberdashery in the 1830s, gradually expanding into a flourishing dry goods store by the 1840s. In 1852 entrepreneur Aristide Boucicaut—the son of a *chapelier*—became a partner and introduced innovative retailing practices. He divided the shop into semi-independent departments, transforming it into the first modern department store.[1] These shops within shops were formalized in the design of Au Bon Marché's new vast, light-filled, iron-and-glass building (executed by Gustave Eiffel, among others).[2] The structure, completed in 1876, took up an entire city block on the rue du Bac (where it remains today) and featured reading rooms for bored husbands, an art gallery, and on-site dormitories for unmarried female employees.[3]

Au Bon Marché was the first of the great Parisian department stores (or *grands magasins*), followed by Les Grands Magasins du Louvre in 1855, Printemps in 1865, La Samaritaine in 1869, and Galeries Lafayette in 1889. (Printemps, Galeries Lafayette, and Au Bon Marché—renamed Le Bon Marché in 1989—are still in business.) These lavish urban retail palaces inspired Émile Zola's 1883 novel *Au bonheur des dames* (*The Ladies' Paradise*), but they are conspicuously absent from Impressionist art. However, Ruth E. Iskin has suggested that some of Degas's paintings of milliners may actually depict small boutiques within the *grands magasins*.[4]

This straw hat trimmed with artificial violets, its brim lined in velvet, was sold by Au Bon Marché; it is a typical *Directoire*-revival style popular between 1884 and 1886. While some *Directoire* fashions of the late nineteenth century had little to do with the neoclassical dress of the period immediately following the French Revolution, this closely resembles the tall-crowned hats worn at that time, albeit usually by men.[5] —KCC

1 Michael B. Miller, *The Bon Marché: Bourgeois Culture and the Department Store, 1869–1920* (Princeton, NJ: Princeton University Press, 1981), 20.

2 Meredith L. Clausen, "Department Stores and Zola's *Cathédrale du commerce moderne*," *Notes in the History of Art* 3, no. 3 (Spring 1984): 19.

3 Miller, *The Bon Marché*, 168; and Jan Whitaker, *The World of Department Stores* (New York: Vendome Press, 2011), 22.

4 See Aruna D'Souza, "Why the Impressionists Never Painted the Department Store," in *The Invisible Flâneuse? Gender, Public Space, and Visual Culture in Nineteenth Century Paris*, ed. D'Souza and Tom McDonough (Manchester: Manchester University Press, 2006), 129–147; and Ruth E. Iskin, *Modern Women and Parisian Consumer Culture in Impressionist Painting* (Cambridge: Cambridge University Press, 2007), 89.

5 Fiona Clark, *Hats* (London: B. T. Batsford, 1982), 35.

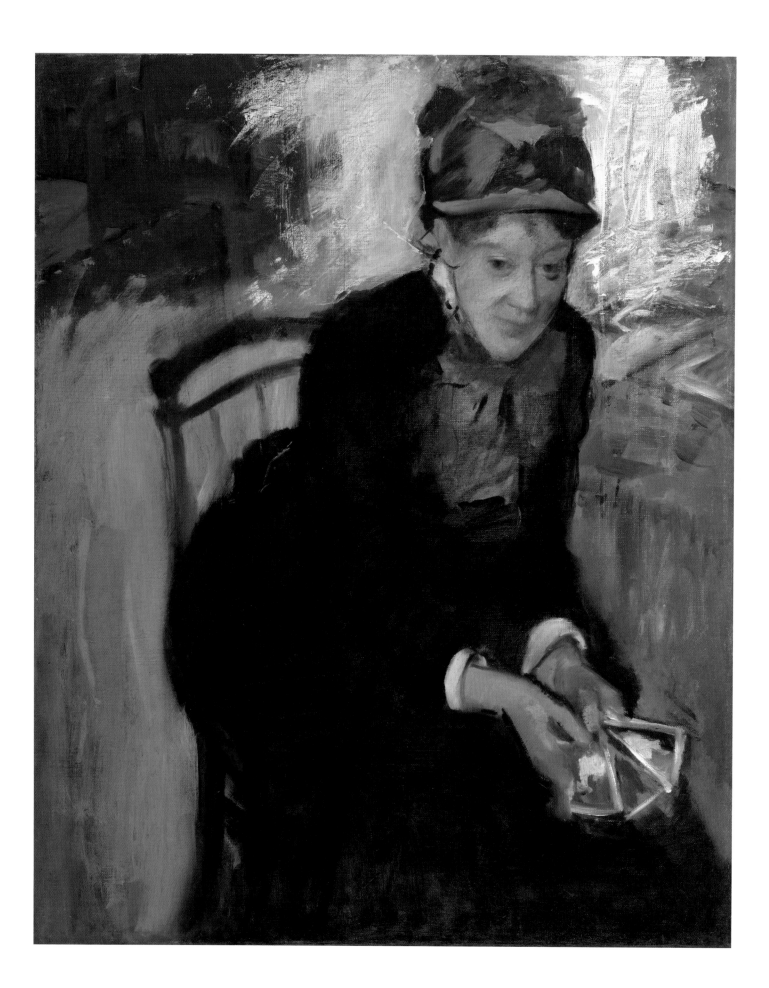

74

EDGAR DEGAS

Mary Cassatt, ca. 1880–1884

Oil on canvas
28 ⅞ x 23 ⅝ in. (73.3 x 60 cm)
National Portrait Gallery, Smithsonian
Institution, Gift of the Morris and
Gwendolyn Cafritz Foundation and
the Regents' Major Acquisitions Fund,
NPG.84.34
L796

The well-documented friendship between Degas and Mary Cassatt was tempestuous (or in the words of Louisine W. Havemeyer, it was filled with "spicy estrangements"), but the relationship was based largely on mutual respect.[1] In reminiscing about seeing Degas's pastels in a dealer's window on boulevard Haussmann, Cassatt wrote: "How well I remember, nearly forty years ago. . . . I used to go and flatten my nose against the window and absorb all I could of his art. It changed my life. I saw art then as I wanted to see it."[2] Though Cassatt modeled for Degas on occasion, including for his *At the Milliner's* (1882; fig. 61) and a second pastel with the same title (ca. 1882; fig. 11), this is the only true portrait he ever painted of her.[3] Executed sometime between 1880 and 1884, it was reworked at a later date—not an uncommon practice for Degas. Cassatt's head shifted in position, and her hands and the objects that she holds were retouched in black, white, and gray.[4]

Scholars have long debated the setting and whether or not she holds tarot cards, playing cards, photographs, *cartes des visites*, or even *pochades* (small oil studies) that she may have been thinking of working into larger compositions.[5] What is certain, however, is that toward the end of her life, this

blunt image of decades before now brought embarrassment. She wrote to her dealer Paul Durand-Ruel in late 1912: "This portrait by Degas, I certainly don't want to leave it with my family as being of me. It has artistic qualities but it is painful and depicts me as such a repugnant person, that I don't want anyone to know that I posed for it. . . . I would prefer that it be sold abroad and certainly without my name attached to it."[6] Ambroise Vollard would acquire it the following year.[7]

What was so "painful" and "repugnant" about this picture?[8] Perhaps it was her masculine and ungraceful posture—back hunched, elbows on knees, leaning forward. This pose was used in several other portraits by Degas, including an earlier painting of 1871–1872 featuring his aging father (fig. 85), which, as noted by Norma Broude, indicates "a formal echo that may in part be interpreted as an indication of the artist's affection and high regard for his sitter."[9] Her hat serves a vital compositional function: the felt bonnet adorned with satin ribbons and feathers at back counterbalances this markedly unfeminine pose; the large russet ribbons tied beneath her chin intensify the verticality of her face with its vacant expression. —EB

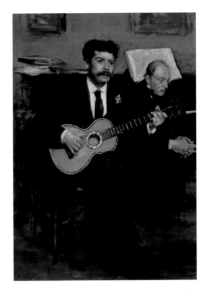

85 Degas, *Lorenzo Pagans and Auguste De Gas*, ca. 1871–1872. Oil on canvas, 21 ¾ x 15 ¾ in. (54.5 x 40 cm). Musée d'Orsay, Paris, RF 3736

1 Louisine W. Havemeyer remarked: "After they met, some time later, long years of friendship ensued, of mutual criticism and, I must frankly add, of spicy estrangements, for Degas was addicted to the habit of throwing verbal vitriol, as the French call it, upon his friends, and Miss Cassatt would not have been the daughter of the Cassatts if she had not been equal to parrying his thrusts." Havemeyer, "Mary Cassatt," *Bulletin of the Pennsylvania Museum* 22, no. 113 (May 1927): 377.

2 Ibid.

3 For an insightful discussion of the present painting, see Kimberly A. Jones, "'A Much Finer Curve': Identity and Representation in Degas's Depictions of Cassatt," in *Degas/Cassatt*, exh. cat. (Washington, DC: National Gallery of Art, 2014), 94–97.

4 Ibid., 95; Richard Thomson postures that the hands "have been reworked in a rather hasty way, and not in a fashion that suggests Degas himself did it. . . . Did she herself repaint the area?" Thomson, "Notes on Degas's Sense of Humour," in *Degas, 1834–1984*, ed. Richard

Kendall (Manchester: Department of History of Art and Design, Manchester Polytechnic, 1985), 11.

5 For instance, see Nancy Hale, *Mary Cassatt* (New York: Doubleday, 1975), 94; Adelyn Dohme Breeskin, *Mary Cassatt: A Catalogue Raisonné of the Graphic Work* (Washington, DC: Smithsonian Institution Press, 1979), 15; Thomson, "Notes on Degas's Sense of Humour," 12; and Jones, "'A Much Finer Curve,'" 97.

6 Lionello Venturi, ed., *Les Archives de l'impressionnisme* (Paris: Durand-Ruel, 1939), 2:129; cited in Jones, "'A Much Finer Curve,'" 96.

7 "Je ne peux qu'espérer que Vollard s'en déferait à l'étranger avec un bénéfice. Je partage l'horreur de M. Durand-Ruel pour ce tableau." Cassatt, letter, April 9, 1913, published in Venturi, *Les Archives*, 2:130–131.

8 Thomson suggests that Degas intended her as a fortune-teller, which would have been an indecorous guise; see Thomson, "Notes on Degas's Sense of Humour," 12. Jones suggests that her distaste for the painting "may well have more to do with the encroaching conservatism of old age than any sustained and enduring empathy." See Jones, "'A Much Finer Curve,'" 97.

9 Degas uses a similar pose in, for instance, *Victoria Dubourg (Mme Fantin-Latour)* (1866; Toledo Museum of Art [L137]) and *The Collector of Prints* (1866; Metropolitan Museum of Art, New York [L138]). See Norma Broude, "Degas's 'Misogyny,'" *Art Bulletin* 59, no. 1 (March 1977): 102.

75

ÉDOUARD MANET
(French, 1832–1883)

Madame Guillemet, 1880

Pastel on canvas mounted on Masonite
21 ⅝ x 13 ⅞ in. (54.8 x 35.2 cm)
Saint Louis Art Museum, Funds given
by John Merrill Olin, 133:1951

Manet depicted here the fashionable Madame Jules Guillemet wearing a practical day bonnet, probably for travel around Paris. The artist carefully represented the black bonnet's decoration of ribbon folds, in tones of dark blue and green, held in place by a gold buckle. The bonnet design complements Guillemet's delicate features, particularly her *retroussée* nose. Similar bonnets regularly appeared in the fashion press in 1880. Buckles themselves were also a regular source of commentary.[1] This bonnet may have been provided by Madame Virot, whose shop Manet frequented, or by Guillemet herself, who ran an upscale fashion store with her husband on the rue du Faubourg-Saint-Honoré.

Madame Guillemet was born Jeanne Julie Charlotte Besnier de la Pontonerie in 1850; she married her husband in 1871. Manet enjoyed the company of the couple and represented them in a major Salon painting, *In the Conservatory* (1878/1879; Nationalgalerie, Berlin). In addition to the Saint Louis pastel, he also produced two other pastels of Madame Guillemet, one showing her in a winter dress, wearing fur muffs, and another showing her reclining on a sofa.[2] The Saint Louis work is based on a rapidly sketched black chalk drawing of the same year.[3]

In the final years of his life, Manet often corresponded with Madame Guillemet. In 1880, while convalescing in Bellevue outside Paris, he sent her a letter decorated with watercolors of shoes, stockinged legs, and a woman wearing a straw hat, noting that such sketches were "sweet nonsense which enables me to spend my time very pleasantly."[4] —SK

1 The Girondin hat, for example, which enjoyed great popularity in the early 1880s and harked back to the hat styles of the French Revolution, was often decorated with an encircling ribbon secured by a buckle. See the illustration of this hat in Gabrielle d'Èze, "Modes," *Le Caprice,* August 16, 1882, 2.

2 *The Parisienne* (1880; Ordrupgaard Museum, Charlottenlund, Denmark) and *Repos* (1881; private collection).

3 *Portrait of Mme Jules Guillemet* (ca. 1880), Hermitage Museum, Saint Petersburg, OP-43094.

4 Manet, letter to Madame Guillemet, Thursday, n.d. [1880], in Musée du Louvre, Département des Arts Graphiques, RF 11 186.

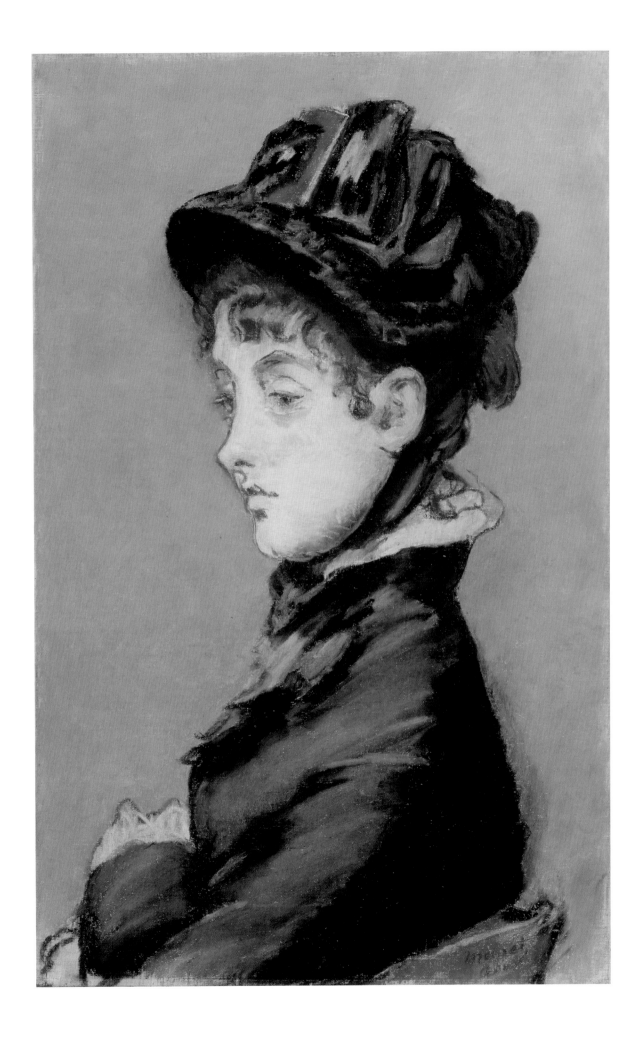

76

EDGAR DEGAS

Three Women at the Races, ca. 1885

Pastel on paper
27 x 27 in. (68.6 x 68.6 cm)
Denver Art Museum, Anonymous gift,
1973.234
L825

───────────

Degas's earliest treatments of modern life, dating to the early 1860s, dealt with the theme of the racetrack. Most of these scenes focused on horses and jockeys, although the spectators who visited the races also fascinated him. In the mid-1880s he began a series of pastels of women in conversation at the racetrack.[1] *Three Women at the Races* shows a group of women in front of a railing: the figure on the left is speaking and gesturing with her left hand while the other two women listen, the woman on the right with an almost inquisitive expression.[2]

Women wore a wide range of dresses and hats to attend the races, considering the locale—notably the Paris racecourse of Longchamp in the Bois de Boulogne—as an important site for the display of fashion.[3] The women here wear fitted brown wool suits, brown hats with moderately wide brims and simple trim, and veils. Fashion magazines reported the exuberant dress—and hat plumage—sometimes worn at the racetrack; an 1884 illustration in the magazine *Le Salon de la mode* provides an example of one such report (fig. 86).[4] Degas's women, in contrast, are dressed in a muted and understated, although nonetheless refined, fashion. Degas may have used the same model, and even the same costume, for each of his figures.[5] Although he suggests a moment of animated spontaneity, this work was, in all likelihood, a staged composition. The red hair of each of the women suggests that Mary Cassatt could have been the model.

Degas was a regular visitor to Longchamp.[6] There is, however, little indication of the setting here. The artist renders his background in abstract, generalized terms, only suggesting the green of grass, the brown of the racetrack, and the yellow-green of tree foliage.—SK

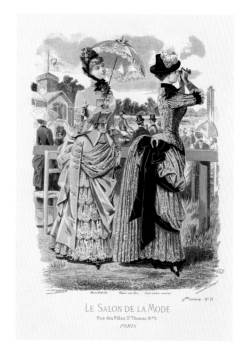

86 Plate from *Le Salon de la mode* 9, no. 21 (1884). Thomas J. Watson Library, The Metropolitan Museum of Art, New York, Gift of Woodman Thompson, b17520939

1 Another notable pastel in the group is *Conversation at the Racetrack* (1882/1885; Milwaukee Art Museum, M1957.20 [L712]). For other examples, see L710, L711, and L1007.

2 The pastel remained with Degas until his death and appeared in his atelier sale with the title *At the Races (three women chatting)*.

3 See, for example, "Bonnet for the Races," model from Madame A. Séguin in *La Modiste universelle*, March 1878, no. 69. This straw hat perched on top of the head was decorated with a cluster of white feathers and daisy leaves. By the 1880s racecourse hats often had far broader brims.

4 See a reviewer who noted the vogue for elaborate plumes and flowered hats at the Longchamp racetrack: "I don't know if they've already hit upon a name for this grand prix, but I propose the Grand Prix of Plumes. There were so many! So many! Plumes must be very inexpensive. . . . plumes, more plumes, plumes everywhere. . . Every time the sun comes out, everything changes; light-colored dresses emerge from gray coats; you would think that flowers grow from hats." (Je ne sais si on a trouvé déjà un nom pour ce grand prix; mais je propose le Grand Prix des plumes. Y en avait-il! Y en avait-il! La plume doit être très bon marché. . . . Et des plumes, encore des plumes, toujours des plumes . . . chaque fois que le soleil paraît tout change d'aspect; des robes claires sortent des manteaux gris, on dirait qu'il pousse des fleurs des chapeaux.) See "Notes sur le Grand Prix," *La Vie parisienne*, June 13, 1891.

5 See Jean Sutherland Boggs, ed., *Degas at the Races*, exh. cat. (Washington, DC: National Gallery of Art; and New Haven, CT: Yale University Press), 134.

6 He also represented the racetrack at Argentan near Ménil-Hubert, the family estate of his friend Paul Valpinçon in Normandy.

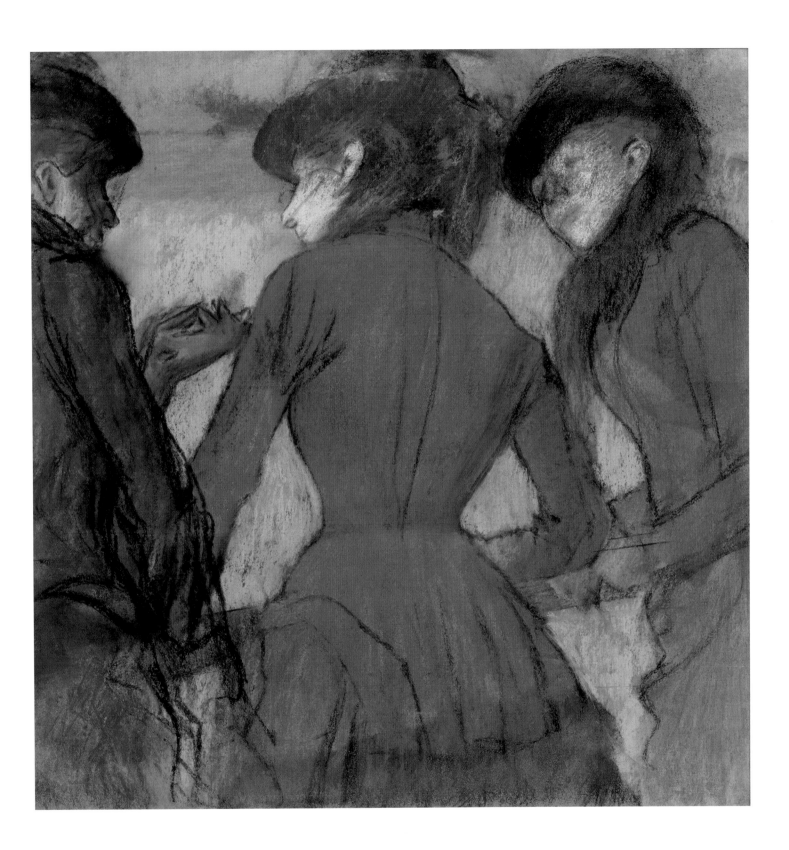

77

77

EDGAR DEGAS

Two Women Talking,
ca. 1882–1885

Pastel on paper laid down on board
22 x 31½ in. (55.9 x 80 cm)
Collection of Ann and Gordon Getty
L711

78

EDGAR DEGAS

Women Seated on the Grass,
ca. 1882

Pastel on paper
30 x 34 in. (76.2 x 86.4 cm)
Collection of Ann and Gordon Getty
L696

As in Degas's *Three Women at the Races* (ca. 1885; cat. no. 76), *Two Women Talking* likely takes place at the racetrack.[1] In the mid-1880s Degas frequently focused on the diverse spectators at sites such as the Longchamp track on the edge of Paris, much in the same way he examined privileged leisure in his café and theater scenes of the same period.[2] Here a woman—dressed in a brown wool coat, fitted tightly at the waist, and leather gloves—leans casually against a railing. Her fine hat made of natural straw and adorned with feathers or flowers completely obscures her face, and its russet-colored ribbons, accented with a touch of violet pastel, fall loosely against her body, although they were meant to be tied under the chin. A second figure, dressed in blue, leans in closely to engage in conversation; her headwear is more finely articulated than her companion's, with its artificial white flowers and silk ribbon ties. Their conversation is seemingly more interesting than whatever equestrian event unfolds outside the picture plane. The figures' bodies are pushed forward by a series of geometric patterns, such as the emphatically horizontal blue bar and diagonal beds of grass and dirt.

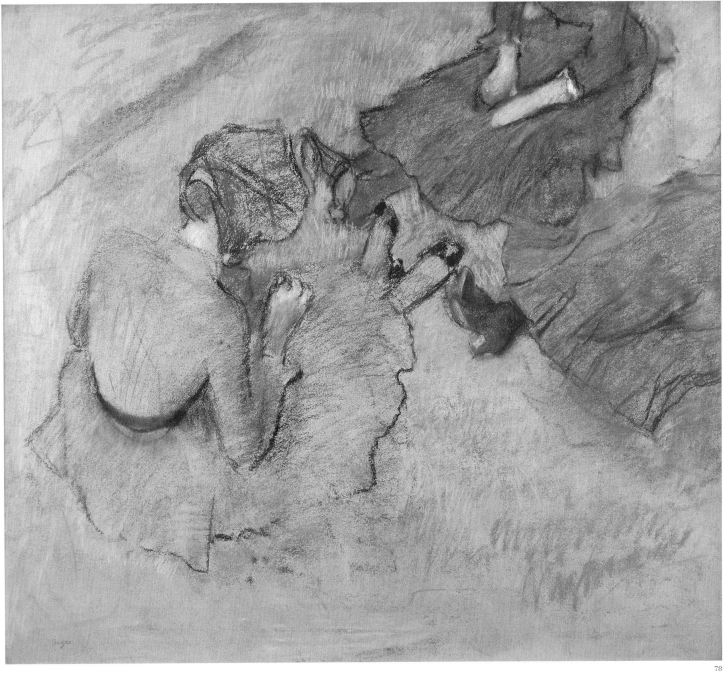

78

In *Women Seated on the Grass* of around 1882, Degas was equally interested in exploring radical perspective and abstracted space. As if standing upon a ladder to gain this bird's-eye view, he featured three women seated with their legs casually stretched out before them. He cropped the paper along the upper and right margins so that the woman in brown's head, and presumably headwear, has been eliminated. The figure in a lilac gown leans gently forward, her bonnet—likely with chin ties—covering the back of her head. From his perspective behind her, Degas playfully portrayed the heels of her companions' shoes. Regardless of the precise location of this scene, whether a racetrack, a garden, or a park, the women are nonetheless attired for outdoor activity.—EB

1 On Degas and the racetrack, see Jean Sutherland Boggs, ed., *Degas at the Races*, exh. cat. (Washington, DC: National Gallery of Art, 1998).

2 The subject of women leaning against a railing either at a racetrack or on a boat was explored in several pastels by Degas during the 1880s. See L710, L712, L825, L879, and L1007.

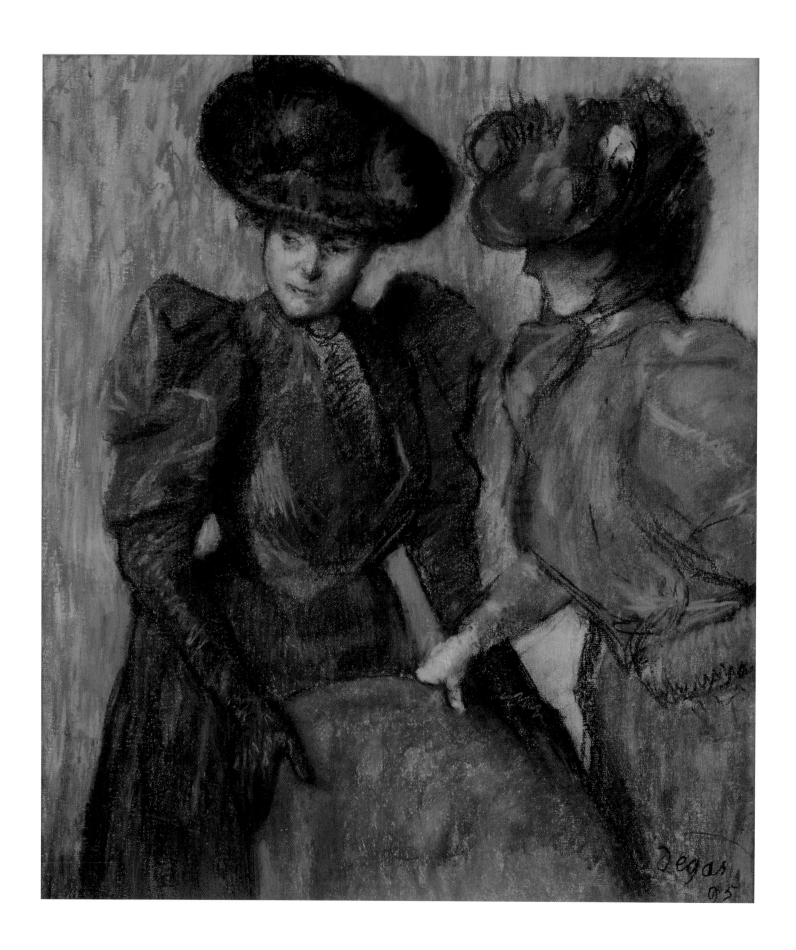

79

EDGAR DEGAS

The Conversation, 1895

Pastel on paper
25 ⅝ x 19 ¾ in. (65 x 50 cm)
Courtesy Acquavella Galleries
L1175

In Degas's *The Conversation* two women are shown in the midst of a lively dialogue, both elegantly dressed in tailored two-piece dresses with fitted waists and gloves. Both also wear the broad-brimmed hats with ornate plumage and floral trimming that were in fashion during the mid-1890s. The pastel reflects the artist's growing interest in color late in his career. He plays with complementary colors, contrasting the warm tones of the background with the cooler blues of the left woman's dress and the bright green of the foreground armchair. This work is the last in an extensive series of pastels starting from the mid-1880s that show women chatting among themselves.

The Conversation is unusual in Degas's work of the 1890s in being dated by the artist.[1] It should be seen within the context of the photographs that he began to produce in the same year. Many of these showed women in the artist's circle. The sitters in this pastel have not been firmly identified but bear a particular resemblance to Yvonne and Christine Lerolle, daughters of the painter Henry Lerolle.[2] These two young women—who would have been sixteen and eighteen in 1895—also appear at this time in the company of Degas in a contemporaneous photograph (fig. 87). Their dress—in particular their *gigot* (or leg-of-mutton) sleeves—is very similar to that in this pastel. The Lerolle sisters also served as models for Pierre-Auguste Renoir and Maurice Denis in the 1890s.[3] —SK

1 Degas sold this work to Durand-Ruel on July 15, 1896 (Durand-Ruel stock number 3904). See Caroline Durand-Ruel Godfroy, "Lettres de Degas provenant des archives Durand-Ruel," in *Degas inédit* (Paris: La Documentation Française, 1989), 462.

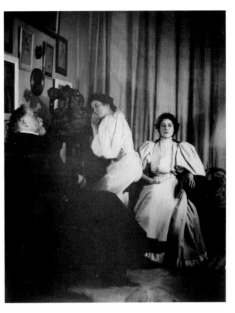

87 Degas, *Self-Portrait with Yvonne and Christine Lerolle*, ca. 1895–1896. Gelatin silver print, 13 ⅜ x 11 ½ in. (34.1 x 29.3 cm). The Metropolitan Museum of Art, New York, Purchase, The Horace W. Goldsmith Foundation Gift, through Joyce and Robert Menschel and Rogers Fund, 2004, 2004.335

2 It has also been suggested that these sitters may have been Geneviève and Marie Mallarmé (Stéphane Mallarmé's daughter and wife), although Marie would seem to have been too old. Marie Fontaine has also been suggested as a possible model for one of the women. All of these women were photographed by Degas during this time. See *Impressionist and Modern Art Evening Sale*, Sotheby's, New York, May 7, 2014, no. 49.

3 See Pierre-Auguste Renoir's *Yvonne and Christine Lerolle at the Piano* (1897; Musée de l'Orangerie, Paris, RF 1960-19) and Maurice Denis's *Triple Portrait of Yvonne Lerolle* (1897; Musée d'Orsay, Paris, RF 2010 9).

80

MARY CASSATT
(American, 1844–1926)

Bust of a Young Woman,
ca. 1890

Pastel on paper
16 ⅞ x 15 ¼ in. (42.9 x 38.6 cm)
Fine Arts Museums of San Francisco,
Memorial gift from Dr. T. Edward and
Tullah Hanley, Bradford, Pennsylvania,
69.30.22

Cassatt's unfinished pastel of a young woman wearing a tight-fitting toque is one of only three pastels of hers that appeared in Degas's posthumous estate.[1] An avid art collector, he was seemingly more interested in Cassatt's practice as an experimental printmaker, judging from the more than ninety prints found in his studio following his death.[2] This pastel was once erroneously assigned to Degas because of an inscription bearing his name in red chalk on the verso. What attracted him to this particular work is unknown, though it certainly embodies a similar interest in direct expression as one finds in, for instance, his *Head of a Woman* (ca. 1887–1890; cat. no. 41).

Here the young model, with her drooping almond-shaped eyes and emphatically arched eyebrows, is seated on a richly hued red chair reminiscent of the velvet-clad theater loge that Cassatt would so frequently render. The backdrop created with freely crosshatched yellow pastel underscores the sitter's seemingly acidic temperament. Her identity is uncertain, though she appears in a second, signed version of comparable dimensions.[3] The narrow-fitting hat with upturned brim is possibly adorned with a large feather or even a bird carcass, as suggested by the touch of blue pastel that might indicate a beak and the strokes of black at the upper right part of the formation that could be tail feathers.—EB

1 Ann Dumas, ed., *The Private Collection of Edgar Degas*, exh. cat. (New York: Metropolitan Museum of Art, 1997), 311, fig. 398; and Colta Ives, Susan Alyson Stein, and Julie A. Steiner, eds., *The Private Collection of Edgar Degas: A Summary Catalogue* (New York: Metropolitan Museum of Art, 1997), 7, no. 49.

2 Dumas, *The Private Collection of Edgar Degas*, 63, 240.

3 Mary Cassatt, *Head of a Woman with Bangs, Wearing a Toque* (ca. 1890; private collection). For both versions, see Adelyn Dohme Breeskin, *Mary Cassatt: A Catalogue Raisonné of the Oils, Pastels, Watercolors, and Drawings* (Washington, DC: Smithsonian Institution Press, 1970), 92, nos. 168 and 169.

81

MONSIEUR HEITZ-BOYER
(active France, late nineteenth–
early twentieth century), designer

Woman's hat, 1898

Label: "Mon. Heitz-Boyer/
28, Place Vendôme/Paris"
Felted wool, silk velvet,
silk velvet ribbon, and silk lining
5 ⅞ x 9 ⅞ x 9 ⅞ in.
(15 x 25 x 25 cm) overall
Museum of Fine Arts, Boston,
Gift of Mrs. Henry Bliss, 62.624

Brown and pink silk velvet intricately intertwine around a crown of pale brown fur felt to form this hat. The hat is evocative of the diminutive styles popular for women's headwear in the late 1890s, designed to sit at the top of the head above upswept hair, but is unusual due to its lack of feather embellishment. Rather than a plume or an aigrette, the two large folds of silk velvet rise from the front of the hat as "wings" to form the main decorative interest. The use of velvet and fur suggest that the hat was intended for daytime winter wear; as noted in the illustrated encyclopedia *Le Costume, la mode* (1899), plush, silk, velvet, felt, or cloth were considered most appropriate for winter headwear at this time.[1]

Designs by the house of Heitz-Boyer are distinguished generally by their incorporation of varied materials in an array of often contrasting colors, particularly during the late 1880s and 1890s.[2] The firm was founded at 28, place Vendôme by Madame Heitz-Boyer, but transitioned to being owned and operated by Monsieur Heitz-Boyer sometime in the 1890s, as seen in contemporary business records as well as on extant hat and bonnet labels.[3] In addition to this example, other extant Heitz-Boyer hats from the

period feature dynamic combinations of silk velvet, silk plain weave, silk satin, fur felt, and other sumptuous materials in lively color pairings, like chartreuse silk satin, black velvet and feathers, and pale pink artificial flowers; and rose-pink silk taffeta with black silk velvet, lace, and passementerie with gold spangles.[4] —LLC

1 "Aujourd'hui les chapeaux . . . d'hiver en peluche, soie, velours, feutre ou drap." *Encyclopédie populaire illustrée . . . Le Costume, la mode* (Paris: Société française d'éditions d'art, 1899), 37.
2 Heitz-Boyer's design aesthetic is discussed in articles dating throughout the house's active period, from about 1890 until 1920; for examples, see *Milliner Trade Review* 14, no. 1 (January 1889): 19, 56, 76–78; "Advertisement," *Indianapolis Journal* 51, no. 265 (September 22, 1901): 15; and "July Openings," *Millinery Trade Review* 29, no. 7 (July 1904): 84. The firm remained in operation until about 1920, under head designer Auguste Petit. *Fairchild's National Directory and Digest* 17 (1920): 395.
3 See the *Annuaire Didot-Bottin: Commerce industrie* 1892 (page 1791) and 1902 (page 2253) directories.
4 See a bonnet (ca. 1885–1890) and a hat (ca. 1890) bearing the labels, "Mme. Heitz-Boyer, 28 Place Vendôme, Paris" in the collection of the Costume Institute at the Metropolitan Museum of Art, 1978.295.15 and C.I.58.1.4, respectively. See also a woman's bonnet (ca. 1890) with the "Mon. Heitz Boyer" label in the Litchfield Historical Society, Connecticut, 1928-11-0.

82

CAMILLE MARCHAIS
(French, active 1854–1922), designer

Woman's hat, ca. 1895

Label: "Fleurs Artistiques/
Camille Marchais/Rue de la Paix, 17/
NE M'OUBLIEZ PAS"
Silk geranium flowers, leaves, and velvet
8 ½ in. (21.6 cm) height;
8 in. (20.3 cm) diameter
Chicago History Museum, Gift of
Mrs. Albert J. Beveridge, 1949.306
Made for Ms. Augustus (Abbie
Louise Spencer) Eddy

—————

"The artificial flower industry has become, under the small hands consecrated to it, an art that defies nature," a visitor to the Paris Exhibition of 1900 marveled.[1] Those "small hands" invariably belonged to women, whether working in ateliers (like Nana, the flowermaker-turned-courtesan of Émile Zola's eponymous novel of 1880) or toiling at home (like Mimi, the doomed heroine of Giacomo Puccini's 1896 opera *La Bohème*). Of the estimated 24,000 flowermakers working in Paris between 1896 and 1906, 80 to 85 percent were women.[2] French *fleuristes* used a vast array of stamps, irons, and goffers to transform delicate silks and muslins into botanically accurate flowers that rivaled those produced by the traditional masters of the genre, China and Italy.

Maison Camille Marchais was known for creating remarkably lifelike imitation flowers. The roses on the hats the firm exhibited at the Exposition Universelle of 1889 were so realistic "that a bee tried one the other day," one visitor observed.[3] Customers visited the boutique at the corner of rue de la Paix and rue Daunou for artificial bouquets as well as flower-trimmed hats. "It is *extrachic . . .* to offer a mass of flowers from Camille Marchais," the magazine *La Grande revue* reported in 1888.

> The mass is stuffed with huge bunches of violets, gillyflowers, roses, daffodils . . . and at the base a clump of natural lily of the valley with one or two roses to complete the illusion; impossible to imagine anything more successful . . . because this bouquet is durable, whereas the bouquet from Nice is withered before it arrives.[4]

So convincing was the illusion that the butler to a Russian princess once ruined a bouquet Marchais had sent from Paris by plunging it into a vase of water.[5]

The owner of this geranium bush of a hat in the brimless toque style, Chicago socialite Abbie Louise Eddy, once enlisted Camille Marchais to improve upon an haute couture gown she had commissioned for her daughter, Catherine Eddy Beveridge, from Charles Frederick Worth, whose couture house was located nearby at 7, rue de la Paix. The gown—inspired by an eighteenth-century portrait by Jean-Marc Nattier—"was pale blue taffeta, with superb sleeves," Beveridge remembered. "From the shoulder was suspended a wreath of unbelievably lovely flowers that she had had made especially for the dress by Camille Marchais."[6] The gown survives with the hat in the collection of the Chicago History Museum.[7] —KCC

1 T. Bentzon, "Woman at the Paris Exhibition," *Outlook* 66, no. 5 (September 29, 1900): 259.

2 Marilyn J. Boxer, "Women in Industrial Homework: The Flowermakers of Paris in the Belle Époque," *French Historical Studies* 12, no. 3 (Spring 1982): 407.

3 *Reports of the United States Commissioners to the Universal Exposition of 1889 at Paris*, 5 vols. (Washington, DC: Government Printing Office, 1891), 2:370.

4 "L'extrachic . . . c'est d'offrir une masse de fleurs de Camille Marchais, 17, rue de la Paix; la masse est bourrée de gros bouquets de violettes, de giroflées, de roses, de narcisses . . . et au fond une touffe de muguet naturel avec une ou deux roses pour faire illusion; impossible de rien imaginer de plus réussi . . . car ce bouquet est durable, tandis que le bouquet de Nice est fané avant d'être arrivé." Baronne de Spare, "Carnet parisienne," *La Grande revue, Paris et Saint-Pétersbourg* 1, no. 4 (December 25, 1888): 598.

5 "Les Fleurs dans la mode," *Le Figaro: Supplément littéraire du dimanche*, May 16, 1891, 80.

6 Albert J. Beveridge and Susan Randomsky, *The Chronicle of Catherine Eddy Beveridge: An American Girl Travels into the Twentieth Century* (Lanham, MD: Hamilton Books, 2005), 85.

7 The gown's accession number is 1976.270.10.

83

A. FÉLIX
(French, active ca. 1860s–1901), designer

Woman's capote,
ca. 1880–1885

Label: "A. Félix Breveté/
15 Faubourg St. Honoré, Paris"
Tulle, jet, and faille
9 ½ x 8 ⅝ x 5 ½ in.
(24 x 22 x 14 cm) overall
Musée des arts décoratifs, Paris,
UFAC collection, gift of Martin
Desnoyers, UF 80-23-2

Félix was a fashion house jointly operated by brothers Auguste and Emile Poussineau, who labeled their wares "A. Félix" or "E. Félix," often with the addendum *breveté* (patented). The house's original owner, Félix Poussineau, was hairdresser to Empress Eugénie. It was he who persuaded the empress to allow him to change the street number of his *salon de coiffure* from 13 to the luckier 15; at his death, he left the business to a younger brother, who converted it into a fashion house.[1]

Though forgotten today, Félix was a serious rival to the *couturiers* Charles Frederick Worth, Jacques Doucet, and Jeanne Paquin.[2] The house's illustrious clients included Princess Margherita, Queen Consort of Italy; Princess Maria Pia, Queen Consort of Portugal; the Princess of Wales; the Duchess of Orléans; Countess Greffulhe; the Duchess of Uzès; and the Marchioness of Londonderry, as well as the actresses Sarah Bernhardt and Lillie Langtry.[3]

In around 1893 Félix inaugurated "new and beautifully decorated and furnished salons" with electric lighting and panels painted by the artist Louise Abbéma representing the salon's actress clients in their famous roles, wearing fancy dress costumes by Félix.[4] There, visitors could view finished dresses on mannequins as well as living models—"tall, graceful young ladies with perfect figures, who not only know how to wear a dress well, but how to move about with ease and elegance."[5]

But Félix retained its "chocolate-coloured exterior. . . which stamps it at once as belonging to the ancient rue du Faubourg St. Honoré," the *Lady's Realm* reported in 1900, adding: "Whereas other houses nearby have changed their physiognomy, becoming modernised, this house has to some extent retained the characteristics of a member of that old aristocracy of houses of which we frequently read in the pages of Balzac."[6]

According to a business card of the 1870s, Félix sold "Modes & Robes, Lingerie, Trousseaux, Layettes."[7] But hats and drawings of hats by Auguste Félix survive from as early as the 1860s; in 1894 *Vogue* described Félix as a "*maison de robes et chapeaux*, which is now one of the most chic, in Paris."[8] Fashion plates depict Félix gowns paired with coordinating hats, so closely were the arts of couture and millinery entwined. This capote of tulle, jet, and faille was undoubtedly created to complement an evening or reception gown (see also cat. no. 50).—KCC

1 *Vogue* 3, no. 3 (January 18, 1894): S3.
2 See Heidi Brevik-Zender, *Fashioning Spaces:* Mode *and Modernity in Late Nineteenth-Century Paris* (Toronto: University of Toronto Press, 2015), 325n102.
3 Intime, "A Parisian Prince of Dress," *Lady's Realm* 9 (November 1900): 22.
4 *Vogue* 3, no. 3 (January 18, 1894): S3; *Pall Mall Magazine* 7, no. 31 (November 1895): 380; and M. Griffith, "Paris Dressmakers," *Strand Magazine* 8 (December 1894): 748.
5 Intime, "A Parisian Prince of Dress," 25.
6 Ibid., 21.
7 Librairie Diktats, Paris.
8 Metropolitan Museum of Art, New York, 49.3.2, 1980.1010.1–5; and *Vogue* 3, no. 3 (January 18, 1894): S3.

84

PIERRE-AUGUSTE RENOIR
(French, 1841–1919)

Young Girl with a Hat, 1890

Oil on canvas
16 ⅜ x 12 ¾ in. (41.5 x 32.5 cm)
The Montreal Museum of Fine Arts,
Purchase, grant from the Government of
Canada under the terms of the Cultural
Property Export and Import Act, and gifts
of Mrs. A. T. Henderson, the families of
the late M. Dorothea Millar and the late
J. Lesley Ross, the Bank of Montreal,
Redpath Industries Ltd. and the Royal
Trust Company, in memory of Huntly
Redpath Drummond, inv. 1984.17

85

PIERRE-AUGUSTE RENOIR

*Young Girls Looking at an
Album,* ca. 1892

Oil on canvas
32 x 25 ½ in. (81.3 x 64.3 cm)
Virginia Museum of Fine Arts, Richmond,
Adolph D. and Wilkins C. Williams Fund,
53.7

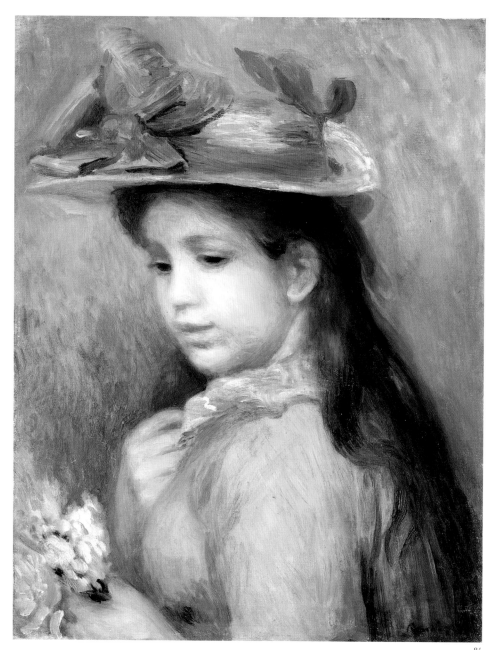

84

Jeanne Baudot, Renoir's informal student and biographer, revealed that Paul Durand-Ruel tried to persuade the artist to depict his sitters bareheaded, as he believed such paintings would be even more commercially successful. But as shown here, Renoir's interest in portraying women, particularly young girls, with elaborate hats could hardly be bridled. According to Baudot, at Durand-Ruel's recommendation:

> Renoir leaped. He refused to curtail his freedom, his imagination, to subject his art to a commercial matter. He came over, asked me to accompany him to the milliner's to buy some hats. He added: "If I show up alone, they'll treat me like an old fool." I knew Esther Meyer, on rue Royale; we went to her shop, and she unloaded several of her designs on us. Renoir asked if she would make a hat for me after a pastel he would do. The proposal was accepted. The next day I went to pose [for him] at rue Tourlaque for the sketch for the illustrious hat. As soon as it was finished, Renoir had me convey it to the milliner.[1]

Renoir seemingly viewed Esther Meyer as a like-minded artist; by designing his own hat that she would then execute, he underscored the affinity between painting and millinery. Furthermore, Julie Manet, Berthe Morisot's daughter, revealed that he had even constructed hats on occasion; she wrote in her diary in November 1895 that he had shown her "the portrait of a model in a delightful hat of white muslin with a rose on it, which he had made."[2]

Renoir was particularly interested in portraying young girls in wide-brimmed hats, especially, as in the case of *Young Girl with a Hat*, styles that physically overwhelm their bodies and dominate the picture plane.[3] In *Two Girls Reading* (ca. 1890–1891; fig. 88) and *Young Girls Looking at an Album*, the same white hat with peach-colored ribbon appears, suggesting it was a studio prop. This model with "frilly lace" and "silk ribbons" was illustrated and described in

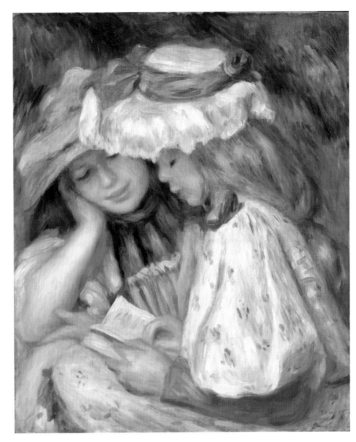

88 Renoir, *Two Girls Reading*, ca. 1890–1891. Oil on canvas, 22 ¼ x 19 in. (56.5 x 48.3 cm). Los Angeles County Museum of Art, Frances and Armand Hammer Purchase Fund, M.68.46.1

La Mode illustrée in March 1892 as being suitable for young girls ages four to six.[4] Renoir's paintings of girls from the 1890s are similar to each other in palette and composition, as well as the decorative leitmotifs of detailed hats and the sitters' absorption in their respective activities.[5] *Girls' Heads* (ca. 1889; fig. 89), a canvas of bust-length oil sketches seemingly made from life, recalls Gustave Coquiot's accusation that Renoir was "obsessive, a sort of erotomaniac" about hats.[6] —EB

1 "Renoir bondit. Il n'admettait pas de brider sa liberté, sa fantaisie, de soumettre son art à une question commerciale. Il vient me trouver, me demande de l'accompagner chez des modistes, afin d'acheter des chapeaux. Il ajoute: 'Si je me presente seul, on me traitera de vieux serin.' Je connaissais Esther Meyer, rue Royale; nous allons chez elle, et elle nous solde plusieurs de ses modèles. Renoir la prie de faire executer un chapeau pour moi d'après un pastel qu'il va faire. La proposition est accepté. Le lendemain, j'allai poser rue Tourlaque pour l'esquisse du fameux chapeaux. Des qu'elle fut terminée, Renoir me chargea de la transmetter à la modiste." Jeanne Baudot, *Renoir: Ses amis, ses modèles* (Paris: Éditions Littéraires de France, 1949).

2 "We lunched at M. Renoir's, we passed a very pleasant day at his home, he showed us the portrait of a model in a delightful hat of white muslin with a rose on it, which he had made, and a white dress with a green belt. It was extremely pretty, the clothes are so delicate and so light, as is the very beautiful brown hair. We saw the portrait of Jean with Gabrielle, it's charming." (Déjeuné chez M. Renoir, nous avons passé une très agréable journée chez lui, il nous a montré le portrait d'un modèle avec un ravissant chapeau de mousseline blanche avec une rose dessus, confectionné par lui, puis

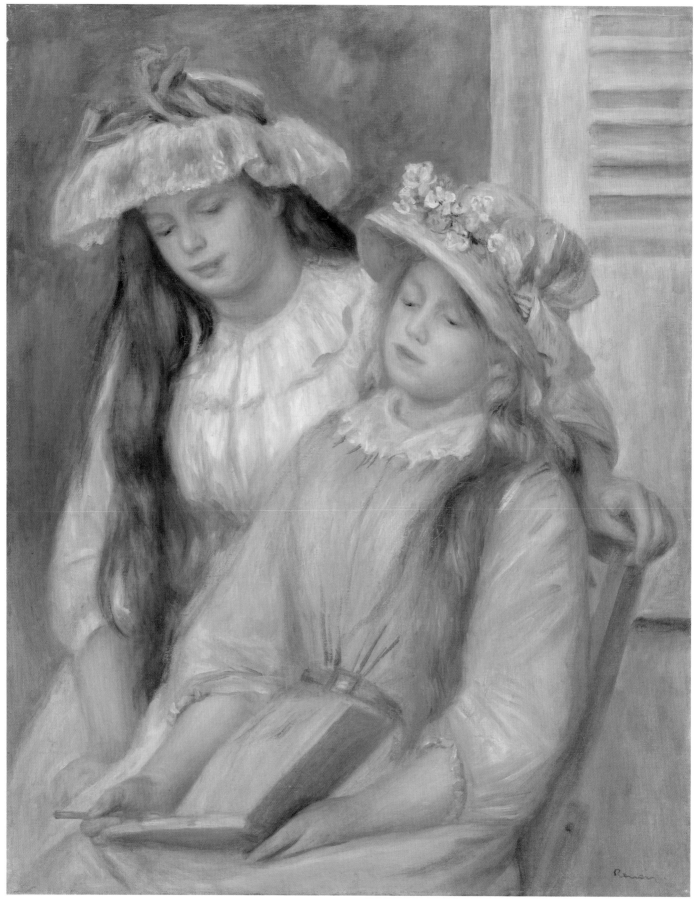

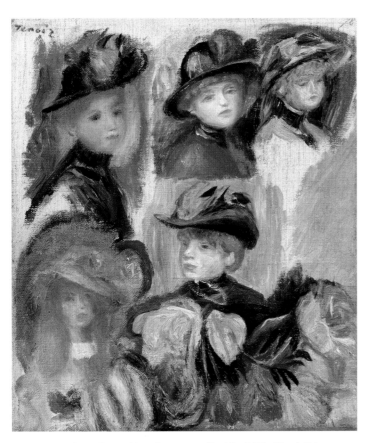

89 Renoir, *Girls' Heads*, ca. 1889. Oil on canvas, 10 x 9 in. (26.5 x 23 cm). Private collection

une robe blanche avec une ceinture verte. Cela est extrêmement joli, les vêtements sont d'une délicatesse, d'une légèreté ainsi que les cheveux bruns qui sont très beaux. Nous avons vu le portrait de Jean avec Gabrielle, il est charmant.) Julie Manet, entry for November 17, 1895, published in *Journal (1893–1899): Sa jeunesse parmi les peintres impressionnistes et les hommes de lettres* (Paris: Librairie C. Klincksieck, 1979), 72; cited in Martha Lucy and John House, *Renoir in the Barnes Foundation* (New Haven, CT: Yale University Press; and Merion, PA: Barnes Foundation, 2012), 245.

3 There has been much debate about the sitters' identities. Claudia Einecke proposes that they were the daughters of the novelist and journalist Paul Alexis, the Renoir family's neighbor in Paris in the early 1890s; see Einecke and Sylvie Patry, eds., *Renoir in the 20th Century*, exh. cat. (Ostfildern, Germany: Hatje Cantz, 2010), 174–175, nos. 4 and 5. On Renoir and children, see Ann Dumas and John Collins, *Renoir's Women*, exh. cat. (London: Merrell; and Columbus: Columbus Museum of Art, 2005), 40–52.

4 "Hat for a little girl, 4 to 6 years old. The body of this hat, whose brim comes out in front, is lined on the underside of the brim with strips of white figured lace laid flat; the outside of the brim is covered with lace laid flat at the edge, the crown with lace joined with 1-centimeter-wide silk ribbons; the outside edge of the crown is trimmed with a similar ribbon; to this ribbon slightly ruched lace has been attached, which falls onto the brim." (Chapeau pour petite fille de 4 à 6 ans. La forme de ce chapeau à bord avançant devant, est recouverte à l'intérieur de la passe avec de la lèze de dentelle blanche à dessins posée à plat; on recouvre l'extérieur de la passe avec de la dentelle posée à plat au bord, la calotte avec de la dentelle réunie par des rubans de soie ayant 1 centimètre de largeur; le bord extérieur de la calotte est garni d'un ruban semblable; on attache à ce ruban une dentelle légèrement froncée, retombant sur la passe.) *La Mode illustrée*, no. 13 (March 27, 1892): 109.

5 Nathaniel J. Donahue, "Decorative Modernity and Avant-Garde Classicism in Renoir's Late Work, 1892–1919" (PhD dissertation, New York University, 2013), 78–79.

6 Gustave Coquiot, *Renoir* (Paris: Albin Michel, 1925), 199–200.

86

PIERRE-AUGUSTE RENOIR
(French, 1841–1919)

Pinning the Hat, ca. 1898

Color lithograph
24 ¼ x 19 ½ in. (61.5 x 49.5 cm)
The Cleveland Museum of Art, Mr.
and Mrs. Charles G. Prasse Collection,
1976.143

Renoir's well-documented enthusiasm for women's hats and trimmings is evident in a series of images from the 1890s illustrating young girls pinning flowers onto hats (see also cat. nos. 84–85 for related subject matter). These works reflect the various materials of hatmaking, including artificial flowers and hatpins. Silk flowers could be purchased separately, allowing women to customize their headwear by trimming and re-trimming them according to changing styles.[1] This became particularly common during the economic downturn following the Franco-Prussian War. Buying an unadorned hat and trimming it oneself was more affordable to the average Parisian woman than purchasing a new hat each season, and trimming materials were widely available at reasonable prices. Hatpins were used both to secure trimmings to the hat, as seen here, and, as hats grew ever larger around the turn of the century, to secure the hat to the wearer's head. By the 1880s they became accessories in their own right, often embellished with jewels and metalwork designs.

Renoir depicted this image multiple times during the 1890s, working in a wide variety of media, including a painting and a pastel (1890–1895; fig. 90), as well as numerous graphic works.[2] The present example, *Pinning the Hat*, is one of six prints he made—three etchings and three lithographs—and represents one of his most important color prints. This particular impression comes from an edition of two hundred that was printed in eleven colors by the highly regarded printer Auguste Clot.[3] It depicts Julie Manet and her cousin Paulette Gobillard, who wears a large white lace bonnet while pinning brightly colored flowers on Julie's floppy straw hat. The print, the pastel, and the other related works illustrate the affinities between painting and millinery. Like the artist using a lithographic crayon, pastel, and paint on a blank surface, the *modiste* places a variety of materials—lace, flowers, and ribbons—on an unadorned hat to create a work of art.[4] Furthermore, by showing the act of trimming, Renoir called to mind other images of milliners at work,

such as the *première* in Degas's *The Millinery Shop* (1879–1886; cat. no. 1), who examines a hat while holding a hatpin between her lips.—AY

90 Renoir, *The Flowered Hat*, 1890–1895. Pastel on paper, 25 ⅝ x 20 ⅛ in. (65.1 x 51.1 cm). The Nelson-Atkins Museum of Art, Kansas City, Missouri, Gift of Henry W. and Marion H. Bloch, 2015.13.20

1 See Augustin Challamel, *Histoire de la mode en France* (Paris, 1875), 257; cited in Justine De Young, "Women in Black: Fashion, Modernity, and Modernism in Paris" (PhD dissertation, Northwestern University, 2009), 68.

2 See Joseph G. Stella, *The Graphic Work of Renoir* (London: Lund Humphries, 1975), nos. 6–8, 29–30; and Richard Brettell and Joachim Pissarro, eds., *Manet to Matisse: Impressionist Masters from the Marion and Henry Bloch Collection*, exh. cat. (Kansas City, MO: Nelson-Atkins Museum of Art, 2007), 94–96.

3 The composition was also printed in an edition of two hundred in eight colors; it lacks the second signature added by Clot at the bottom of the first edition. Clot worked closely with numerous artists to print color lithographic albums for the dealer Ambroise Vollard during the late nineteenth century. See Deborah Wye, *Artists and Prints: Masterworks from the Museum of Modern Art*, exh. cat. (New York: Museum of Modern Art, 2004); and A. Hyatt Mayor, *Prints and People: A Social History of Printed Pictures* (New York: Metropolitan Museum of Art, 1971), no. 718.

4 See Nathaniel J. Donahue, "Decorative Modernity and Avant-Garde Classicism in Renoir's Late Work, 1892–1919" (PhD dissertation, New York University, 2013), 125–126; and *Manet to Matisse*, 97.

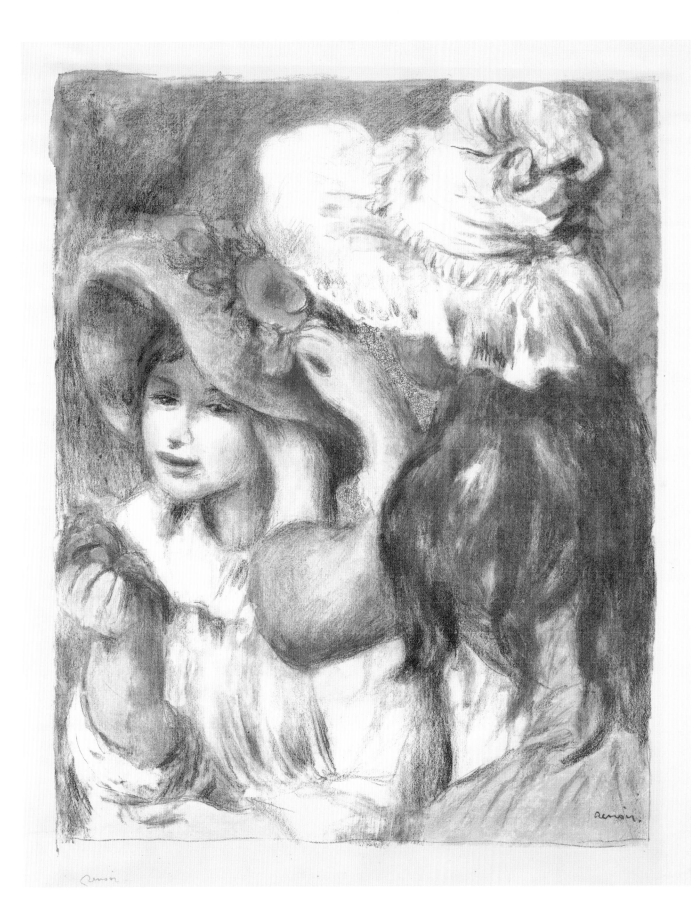

87

BRU JEUNE ET CIE
(French, 1867–1899), designer

Doll with costumes and accessories, ca. 1875

Doll: leather with bisque and wood components, sawdust filling; stockings: cotton; dress: silk taffeta with cotton lace trim; hat and bonnet: straw, cotton, and silk; shoes: leather and silk ribbons; and necklace and crucifix: metal and glass Doll: 14 in. (35.6 cm) height; stockings: 3 ½ in. (8.9 cm) length; dress: 12 ¼ in. (31.1 cm) center back length of bodice, 8 in. (20.3 cm) center front length of skirt; hat: 3 ⅝ in. (9.1 cm) length; bonnet: 2 in. (5.1 cm) length; shoes: 1 ⅛ x ⅝ in. (2.9 x 1.6 cm) each; and necklace and crucifix: 3 ½ in. (9 cm) length of necklace, 1 ¼ in. (3.2 cm) length of crucifix Museum of Fine Arts, Boston, Gift of Anne Bennett Vernon, 2000.971.1 (doll), 2a–b (stockings), 9a–b (dress), 15 (hat), 16 (bonnet), 17a–b (shoes), 18c–d (necklace and crucifix)

Fashion dolls emerged in fifteenth-century France as a form of advertisement. Dressed in the latest costumes and accessories, the extravagantly outfitted dolls were sent to the royal courts of Europe to disseminate the preferred fashions of the French court at Versailles.[1] By the second half of the nineteenth century, fashion dolls had become the chosen toys of well-heeled girls on both sides of the Atlantic. Equipped with stylish dresses, underclothes, shoes, hats, jewelry, toiletries, and various accoutrements like sewing kits and calling cards, the dolls served not only as a form of entertainment but as educational devices to teach elite girls how to comport themselves as well-to-do women.

Bru Jeune et Cie was one of the finest makers of fashion dolls in late nineteenth-century France, known for producing dolls of superb quality and exquisite beauty as well as of ingenious design.[2] Founded by Leon Casimir Bru in 1868 on the rue Saint-Denis, the firm produced a variety of fashion dolls (*poupées*) and, later, baby dolls (*bébés*).[3] Typical of Bru fashion dolls from the mid-1870s, this doll has a bisque (unglazed porcelain) torso and articulated bisque forearms with a kid leather body.[4] Bru dolls were either outfitted with a wardrobe made by the firm or simply wearing a chemise. In the latter instance, the doll's clothes and other accessories would have been purchased from other doll specialists in Paris.[5]

It is unclear if this doll's wardrobe was made by Bru.[6] Among many necessities, it contains several fashionable dresses typical of the mid-1870s, with cuirass (close-fitting, hip-length) bodices and skirts gathered full in the back to accommodate bustles, as well as a hat and a bonnet that resemble fashionable examples of this period.[7] The hat, made from cream cotton tape and straw, is accented by bands of black silk velvet with delicate red and green silk flowers, while the bonnet is made from cream silk plain weave and trimmed with turquoise silk velvet, beige

straw, and silk grosgrain ribbon that gathers into a large bow at the top of the crown. In addition to complementing the ensembles, the headwear would have accentuated the doll's flaxen hair and complexion.—LLC

1 Andrew McClary, *Good Toys, Bad Toys: How Safety, Society, Politics and Fashion Have Reshaped Children's Playthings* (Jefferson, NC: McFarland and Company, 2004), 29–30; and Alice K. Early, *English Dolls, Effigies, and Puppets* (London: B. T. Batsford, 1955), 156–157.

2 Among others, the firm filed patents for dolls with articulated crying, laughing, and sleeping faces and, later, for walking and talking dolls. François Theimer, *The Bru Book: A History and Study of the Dolls of Leon Casimir Bru and His Successors* (Annapolis, MD: Theriault's Gold Horse Publishing, 1991), 25, 27, 29, 119.

3 More information about the range of Bru's dolls can be found in contemporary business listings. See *Annuaire-almanach du commerce, de l'industrie, de la magistrature et de l'administration* (Paris), 1870, 678, and 1880, 2147.

4 The doll's face also bears a slight smile, a facial signature first developed by Bru in 1873. Theimer, *The Bru Book*, 18, 22.

5 Ibid., 162.

6 The doll's shoes are stamped "J.J." on one sole, suggesting that at least parts of the ensemble were not made by Bru. Bru-made shoes often bear the stamp "Bru Jne / Paris." Ibid., 166.

7 For comparable examples, see *Revue de la mode* 6 (May 6, 1877): no. 279; and *Revue de la mode* 8 (1879): no. 409.

DEGAS:

THE

LATE MILLINER WORKS

91 | X-radiograph of Degas's *The Milliners*

88

EDGAR DEGAS

The Milliners,
ca. 1882–before 1905

Oil on canvas
23 ¼ x 28 ½ in. (59.1 x 72.4 cm)
The J. Paul Getty Museum,
Los Angeles, 2005.14
L1023

In his most somber portrayal of the millinery industry, Degas presented two workers sitting at an emphatically angled table—their activity underscored by the three hatstands that hold amorphous forms in the immediate foreground. The woman at right is cast completely in shadow, while her companion at left looks forlornly into the distance. Their dark bodies, painted in thick ocher, are starkly juxtaposed against the vibrantly colored ribbons that occupy the middle ground. Degas's first documented exploration of the subject, simply called *Modiste*, had been presented as part of the second Impressionist exhibition in 1876, and critic Émile Porcheron described its workers as being "too ugly not to be virtuous."[1] *Modiste* has not been firmly identified, but it is possible that it was an early iteration of the present composition (see Simon Kelly's discussion, p. 18).

X-rays reveal that Degas radically changed the painting's composition at a later date (fig. 91), just as he had done in *The Millinery Shop* (1879–1886; cat. no. 1). In the latter work he had transformed an elegantly dressed customer into a more modest milliner.[2] Here, though, the changes are more extreme: the table was originally oriented horizontally, and the hats, now rendered as abstract geometrical masses, were once meticulously painted still-life objects in the foreground, much as they appear in *At the Milliner's* (1882; fig. 16). The milliner at right was not originally part of the composition, and there was another female figure at the right margin. The most striking change was to the milliner on the left, who originally wore a hat and had ruffles at her wrists and a scarf around her neck; Degas transformed her from a privileged patron to a laborer—completely altering the meaning of the picture.[3]

The milliner's apparent exhaustion, evidenced by her face's grayish pallor and her trancelike stare, finds comparison in Degas's hunchbacked, belabored laundresses (see fig. 3).[4] In 1895 conservative journalist Charles Benoist published in *Le Temps* an article about milliners' grueling working conditions.[5] Women could work up to twelve hours a day, fifteen to twenty during peak season. The night shift, or *veillée*, was particularly arduous, often ending at one o'clock in the morning; those who lived far away would be forced to spend the night in the cold, uncomfortable shop.[6] This beautifully haunting painting presents the unglamorous work behind the scenes, far removed from the sophisticated showroom occupied by carefree consumers. —EB

1 "We will say nothing of *The Workshop of the Milliners*, who are obviously too ugly not to be virtuous." (Nous ne dirons rien de l'*Atelier des modistes*, qui sont évidemment trop laides pour ne pas être vertueuses.) Émile Porcheron, "Promenades d'un flâneur: Les Impressionnistes," *Le Soleil*, April 4, 1876; reprinted in Ruth Berson, ed., *The New Painting: Impressionism, 1874–1886. Documentation* (San Francisco: Fine Arts Museums of San Francisco, 1996), 1:103.

2 See Gloria Groom, ed., *Impressionism, Fashion, and Modernity*, exh. cat. (Chicago: Art Institute of Chicago; New York: Metropolitan Museum of Art; and Paris: Musée d'Orsay, 2012), 218–222; and Richard Kendall, "Colour: The Late Pastels and Oil Paintings," in *Degas: Beyond Impressionism*, exh. cat. (London: National Gallery; and Chicago: Art Institute of Chicago, 1996), 109.

3 The author wishes to thank Scott Allan at the Getty Museum for sharing the painting's condition report, which details the X-ray and its findings. See also Ruth E. Iskin, *Modern Women and Parisian Consumer Culture in Impressionist Painting* (Cambridge: Cambridge University Press, 2007), 108–110.

4 See also, for example, *The Laundress* (ca. 1873), Norton Simon Art Foundation, M. 1979.05.P.

5 Charles Benoist, *Les Ouvrières de l'aiguille à Paris: Notes pour l'étude de la question sociale* (Paris: L. Chailley, 1895); cited in Eunice Lipton, *Looking into Degas: Uneasy Images of Women and Modern Life* (Berkeley: University of California Press, 1986), 160–161.

6 Lipton, *Looking into Degas*, 160–161.

89

EDGAR DEGAS

At the Milliner's,
ca. 1882–1898

Oil on canvas
23 ⅝ x 29 in. (60 x 74 cm)
Virginia Museum of Fine Arts,
Richmond, Collection of Mr. and
Mrs. Paul Mellon, 2001.27
L709

At the Milliner's can be seen as the central work in Degas's interest in the fitting session, and particularly the sitter's experience of observing herself in a mirror. Degas shows a copper-haired woman in an elegant green-turquoise day dress—tight-fitting and tapering at the waist—and tan-colored gloves. She stands in front of a mirror, trying on a cream silk taffeta hat, trimmed with black aigrette or ribbon.[1] Degas's painting has been little discussed in the literature on the artist and seldom exhibited, largely because it has been in a private collection until recently, but it represents a key image in his small corpus of millinery paintings. In particular, it embodies the shift from naturalism to a growing degree of abstraction and neo-Symbolist mystery in his late work. Degas told his friend Georges Jeanniot of his ambition to find "mystery, vagueness, fantasy."[2]

Degas's early treatments of the fitting session are naturalistic and finely detailed, as in the 1882 pastel *At the Milliner's* (fig. 16). In contrast, this painting highlights the deepening experiment with color and abstraction of his late work.[3] Paul-André Lemoisne dated the work to 1882–1885, but there can be little doubt that this picture, although begun in the early 1880s, was later reworked, probably in the mid- to late 1890s, when Degas returned to the theme of millinery with a renewed interest.[4] The artist's strong silhouetting of the customer's form is characteristic at this date, as is his rendering of flat areas of luminous color, for example the background wall's intense citrus yellow and the floor's vibrant orange. Such a color palette and interest in flattening effects may have been indebted to his contemporary admiration for the work of Paul Gauguin.[5] It may also reflect his fascination with the acidic palette of color photography, with which he was concurrently experimenting (see fig. 23).

Degas's changing attitude toward color is also reflected in the woman's dress. Careful examination indicates that he initially painted it in a muted olive green, similar to that of the sitter's dress in *The Millinery Shop* (1879–1886; cat. no. 1), before later revising his figure by adding a layer of a far more vibrant turquoise green.[6] Also very notable is Degas's penchant for vigorous, non-naturalistic, vertical hatching in his paint application, a further characteristic of his late work: this is particularly evident in the reflections in the mirror.

Degas was fascinated by mirrors, often including them in his work from the 1870s, for example the brothel monotypes.[7] As he noted, these offered the opportunity to study a subject from various perspectives.[8] *At the Milliner's* is, however, particularly jarring since Degas self-consciously rejected naturalism and showed the face of his sitter reflected as an abstract white oval. Why did he do this? Ruth E. Iskin suggests that the sitter's blank face suggests her loss of identity "in the process of commodification."[9] Yet it is possible too that Degas may have been looking to Symbolist literature and painting, where the mirror and its reflection were seen as a source of enigma. The woman's mysterious aspect is heightened by the fact that her reflected hat looks different—a sharper upturned bonnet with dark trim under the brim—from the one seen from the back.[10]

One further detail emphasizes the artifice of Degas's painting: the cropped form of the shop assistant's hand, which offers a russet fur-felt hat. The artful pose of its fingers suggests that Degas may have employed a hand model. *At the Milliner's* remained in the artist's studio until his death, and it is unclear if he considered it finished. It appeared in the 1918 atelier sale, where it sold for the sum of 10,500 francs.—SK

1 As was Degas's wont, he represented his consumer, as in so many of his millinery works, with red hair. It is possible that the copper-haired Mary Cassatt could have posed for this work.

2 See Georges Jeanniot, "Souvenirs sur Degas," *La Revue universelle*, 1933, 281.

3 See also *Woman Adjusting Her Hair* (ca. 1884; cat. no. 16). The triangular configuration of the arms in that work is very similar to the one in the present painting.

4 Paul-André Lemoisne, *Degas et son oeuvre* (Paris: Paul Brame and C. M. de Hauke, 1946–1948), L709.

5 See Françoise Cachin, "Degas and Gauguin," in Ann Dumas, *The Private Collection of Edgar Degas*, exh. cat. (New York: Metropolitan Museum of Art, 1997), 221–234.

6 The similarity of the gloves and the sitter's orange hair in both works suggests that Degas may have used the same model.

7 See Carol Armstrong, "Degas in the Dark," in Jodi Hauptman, ed., *Degas: A Strange New Beauty*, exh. cat. (New York: Museum of Modern Art, 2016), 39–40. Degas's interest in mirrors may also be indebted to the prominence of that theme in the work of Japanese printmakers. The work of Kitagawa Utamaro in particular, which Degas collected, includes views of women seen from behind in a way that may have influenced the French artist. See, for example, Utamaro's well-known woodblock print *Beauty in front of a Mirror*. Thanks to Rhiannon Paget.

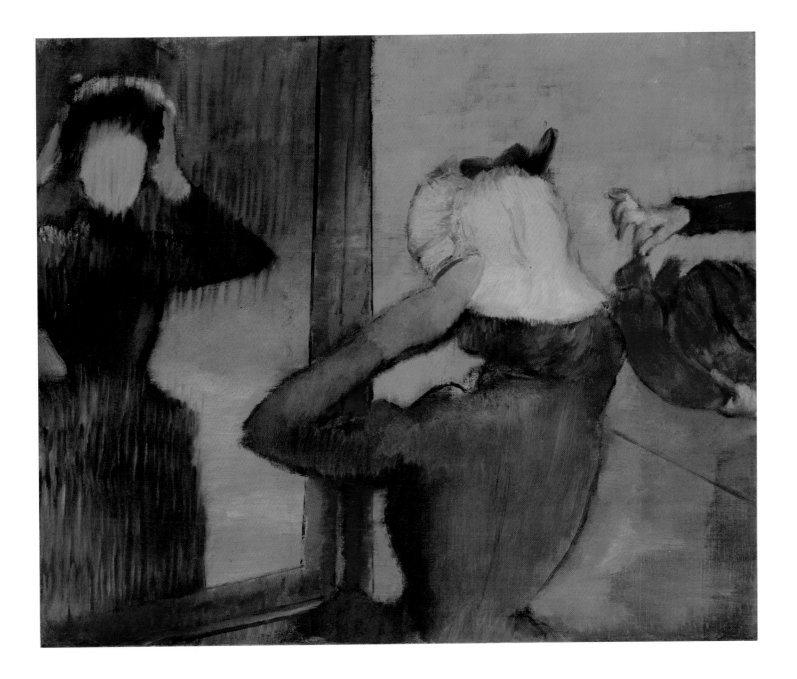

8 "Finally, to study a figure or an object, anything at all, from all perspectives. You can use a mirror for this—and just stay where you are." (Enfin étudier à toute perspective une figure ou un objet, n'importe quoi. On peut se server pour cela d'une glace—on ne bougerait [pas] de sa place.) Degas, notebook 30 [1877–1883], 65; published in Theodore Reff, ed., *The Notebooks of Edgar Degas* (Oxford: Clarendon Press, 1976), 1:134. Cited in Raisa Rexer, "Stockings and Mirrors," in Hauptman, *Degas* (2016), 141.

9 Ruth E. Iskin, *Modern Women and Parisian Consumer Culture in Impressionist Painting* (Cambridge: Cambridge University Press, 2007), 113.

10 Thanks to Michele Hopkins for this observation.

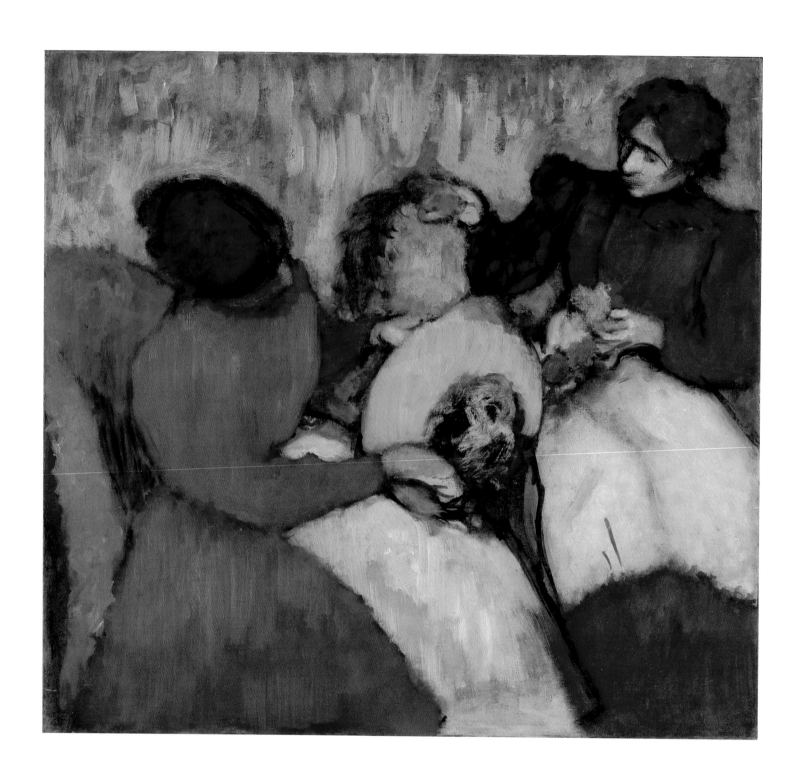

90

EDGAR DEGAS

The Milliners, ca. 1898

Oil on canvas
29 ⅝ x 32 ¼ in. (76 x 82 cm)
Saint Louis Art Museum, Director's
Discretionary Fund; and gift of
Mr. and Mrs. Wilbur D. May, Dr. Ernest
G. Stillman, Mr. and Mrs. Sydney
M. Shoenberg Sr. and Mr. and Mrs.
Sydney M. Shoenberg Jr., Mr. and
Mrs. Irving Edison, and Harry
Tenenbaum, bequest of Edward
Mallinckrodt Sr., and gift of Mr. and
Mrs. S. J. Levin, by exchange, 25:2007
L1315

92 Degas, *Milliner Trimming a Hat,* ca. 1898. Pastel and charcoal, 18 ⅞ x 11 ¾ in. (48 x 30 cm). Private collection (L1317)

an Amazon, and lemon yellow and scarlet flowers or, perhaps, feathers.

The Milliners was underpinned by at least two preparatory studies. Degas initially produced a charcoal study of the seated milliner, animated by passages of orange pastel, showing her face in three-quarter profile

(fig. 92). He then drew a large-scale and complex pastel study on three joined sheets (fig. 93), in which he essentially worked out the composition for this painting. Initially he concentrated on the central section, carefully representing the configuration of the dress of a milliner, her focused features, and her trimming of a mass of dark blue ostrich plumes on a straw hat. An assistant holds an ostrich plume and feathers but her face was initially cropped. The artist, however, changed his mind and added her head after he attached a sheet along the top. He also added a strip along the base of the composition, extending the milliners' dresses and aprons.

In his painting, in contrast to the studies, Degas hid the face of the seated milliner, emphasizing her interiority and intense absorption in her study. Such an approach may have reflected his respect for the role of the milliner as a creative artist in her own right.[3] The picture also highlights Degas's late abstraction, especially in the mass of the seated milliner's dress, now rendered as a flat form as opposed to the greater detailing of the pastel study. An X-radiograph (fig. 94) indicates that Degas initially did give more

The Milliners represents Degas's final painting on the theme of hatmaking. More than any other such picture, it embodies the artist's characteristic late, warm palette that is better known from his related nudes and coiffure scenes.[1] The work has, however, attracted little attention in the discourse around the painter, largely because it had been in a private collection for several decades before being acquired by the Saint Louis Art Museum in 2007.[2] *The Milliners* seems a paean to the meditated introspection of the milliner's art, showing a seated *modiste* who carefully trims a wide-brimmed straw hat. Her assistant sits alongside offering a curling ostrich plume, known as

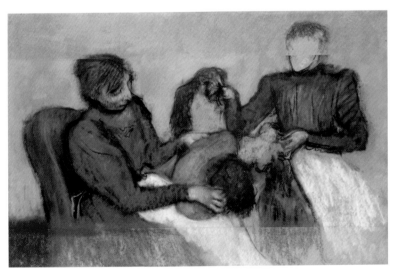

93 Degas, *Milliners Trimming a Hat,* ca. 1898. Pastel on paper, 23 ⅝ x 36 ¼ in. (60 x 92 cm). Private collection (L1316)

frilly detailing to the apron before choosing to employ a more abstract and radical effect.[4]

The Milliners was in Degas's studio at his death, and it is unclear if the artist considered it finished. Degas left the center of the straw hat undefined, probably intending to render cream feathers wrapped around the crown. Areas of the pale cream ground show through in places, such as the base of the seated milliner's apron and her right hand. The dark outlines of both milliners' aprons in the lower center of the composition (which could at first sight be confused with ribbons hanging from the hat) have also been left in a manner that could be considered either as an underpainting stage or as a sign of Degas's formal radicalism.

The Milliners is particularly notable for its warm colors, reflecting Degas's love of such Venetian painters as Titian and Tintoretto.[5] Degas employed rich red for the left milliner's dress and vibrant orange for the chair, while the red brown mass of the assistant's dress is echoed in the warm reds of the women's hair. Such warmth is offset by cooler colors, as in the curling, abstract lines of green that frame the heads of the women or the lively pink brush marks in the background that are echoed in the pinks of the milliners' aprons.[6] The rich color of this painting sums up the appeal of Degas's late work for younger artists of the modernist tradition, perhaps most notably Henri Matisse, who was fascinated by the artist's warm palette and acquired similar, intensely colored work for his own collection.[7] —SK

94 X-radiograph of Degas's *The Milliners*

1 See, in particular, *Combing the Hair* (ca. 1896), National Gallery, London, NG4865; and *After the Bath (Woman Drying Herself)* (ca. 1896), Philadelphia Museum of Art, 1980-6-1.

2 The picture appeared with the title *Les Modistes et le chapeau de paille d'Italie* (Milliners and the Italian straw hat) at the Jacques Seligmann sale, American Art Association, New York, January 21, 1921. For a rare previous discussion of the picture, emphasizing its abstract qualities, see Jean-Louis Prat, *L'Oeuvre ultime de Cézanne à Dubuffet* (Saint-Paul, France: Fondation Maeght, 1989), 52–53.

3 See Marilyn Brown, *Degas and the Business of Art: "A Cotton Office in New Orleans"* (University Park: Pennsylvania State University Press, 1994), 134–136; and Ruth E. Iskin, *Modern Women and Parisian Consumer Culture in Impressionist Painting* (Cambridge: Cambridge University Press, 2007), 107.

4 See Saint Louis Art Museum conservation archive.

5 See Richard Kendall, *Degas: Beyond Impressionism*, exh. cat. (London: National Gallery; and Chicago: Art Institute of Chicago, 1996). Degas's attraction to red hair was also inspired by that of the women in the Venetian painting tradition.

6 These marks in the background cover red circles that may have been intended to suggest wallpaper decoration.

7 Matisse acquired *Combing the Hair* (ca. 1896; National Gallery, London) for his collection in the early 1920s.

91

EDGAR DEGAS

At the Milliner's,
ca. 1905–1910

Pastel on three joined
sheets of tracing paper
35 ¾ x 29 ½ in. (91 x 75 cm)
Musée d'Orsay, Paris, RF 37073
L1318

92

EDGAR DEGAS

Milliner Trimming a Hat,
ca. 1905–1910

Charcoal on paper
17 ½ x 21 ⅞ in. (44.5 x 55.6 cm)
Private collection, Courtesy Justin Miller
Art, Sydney, Australia

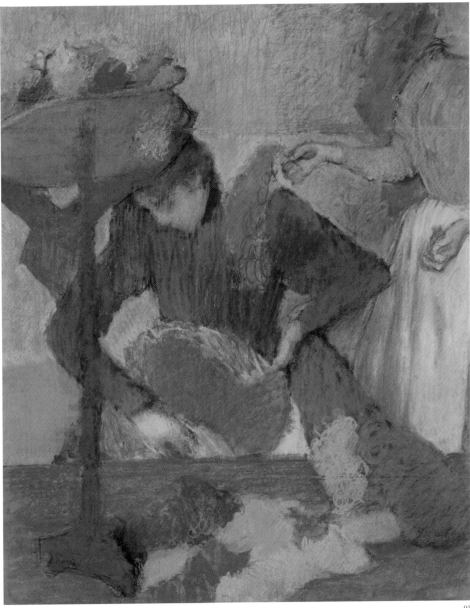

91

At the Milliner's is Degas's final pastel treatment of the millinery theme, and is generally recognized to be his last millinery image. It highlights the extent to which the millinery pastels, alongside his well-known dancer and nude works, served as a focus for his artistic experimentation in his final years, and especially his innovations with color and abstraction.[1] Here Degas represents a milliner absorbed in her work of trimming a brown hat with encircling blue ostrich

plumes. She wears a dress with *gigot* (or leg-of-mutton) sleeves, a fashion that emerged in the mid-1890s and continued until around 1905. Her assistant stands alongside proffering an additional blue plume.

At the Milliner's was the result of protracted thought, and there are at least three related studies that demonstrate Degas's evolving work on this composition as his process moved toward greater abstraction. The pastel itself is made of three pieces of paper affixed together, and Degas seems to have focused initially on the seated milliner in the central section. The pose of the

milliner probably originates in a charcoal drawing that establishes her essential posture (cat. no. 92). Degas also produced another drawing (fig. 95) in which the milliner's form was rendered in a strong, more angular charcoal outline, animated by areas of orange-red pastel.[2] Most significantly, he drew a closely related pastel (fig. 8), showing the milliner in greater detail and carefully representing her facial features as well as her dress, which seems to be trimmed with fur. The woman here is probably middle-aged and, in all likelihood, a *première* or figure of stature in the millinery shop. Millinery

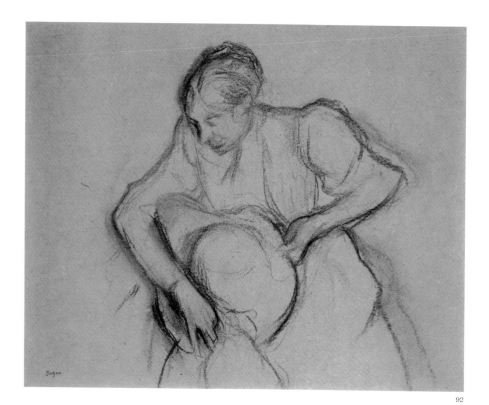

92

Sutherland Boggs and Gary Tinterow to circa
1905–1910, the latest in Boggs, ed., *Degas*, exh.
cat. (New York: Metropolitan Museum of Art;
and Ottawa: National Gallery of Canada, 1988),
a dating with which the Musée d'Orsay and,
in particular, its Degas specialist, Xavier Rey,
concurs.

2 Lemoisne identifies this work as a study for *At
the Milliner's* (see L1319). It is, however, possi-
ble that it could be a study for the Saint Louis
painting *The Milliners* (ca. 1898; cat. no. 90).
Seen in reverse, the figure of the woman, and
particularly her lower arm, is closer to that of
the seated milliner in *The Milliners*. The loca-
tion of the drawing is presently unknown, but it
appeared at auction in 1999 (*Impressionist and
Twentieth-Century Works on Paper*, Christie's,
London, December 9, 1999), when it was
identified as charcoal and pastel on paper laid
on board. If the support were to be identified as
tracing paper, as was often employed in Degas's
practice, this hypothesis of its relationship
to the Saint Louis picture would be all the
more likely. One further related study, also in
charcoal and heightened with pastel (location
unknown), appeared in the Degas atelier III
sale, 1918, no. 85.3.

3 Boggs, entry for *At the Milliner's*, in *Degas*, 606.

4 See Françoise Cachin, "Degas and Gauguin,"
in Ann Dumas, ed., *The Private Collection of
Edgar Degas*, exh. cat. (New York: Metropolitan
Museum of Art, 1997), 221–234.

was generally considered a young person's
profession, but the *premières* and heads of
the millinery shops were often middle-aged
or older.

The central figure in *At the Milliner's* was
therefore underpinned by several studies.
Degas subsequently chose to expand his
composition by adding pieces of paper along
the top and bottom, thus creating a far more
ambitious work. He added the full-length
profile of an assistant, now no longer a dis-
embodied hand as in the related pastel; she
wears a brightly colored red bodice, while a
wide-brimmed hat now sits atop a hatstand.
Perhaps most spectacularly, the addition of
the lower section ensured that Degas was
able to explore a remarkably rich range of
colors through a selection of curling ostrich
plumes, rendered as abstract masses, on the
tabletop.

In addition to its color, *At the Milliner's*
is notable for its flattened forms. Indeed,
Jean Sutherland Boggs compared the pastel
to an Art Nouveau poster, such as the one
Pierre Bonnard made for *La Revue blanche*
in 1894.[3] Degas would have been aware
of such developments among the younger

avant-garde. He was particularly aware
of flattening effects in the work of Paul
Gauguin, whose paintings he greatly admired
and collected extensively in the 1890s.[4] In *At
the Milliner's*, Degas effectively reduced the
brown table, gray floor, and yellow wall into
three abstract areas of color that, were the
figures removed, would take on the aspect of
an abstract painting. The dress of the seated
milliner is also greatly flattened in contrast
to forms in earlier works, as are her facial
features, which are no longer clearly defined.
Particularly notable are the non-naturalistic,
vertical red lines of the milliner's face, in
which the pigment seems to exist as an end
in itself with no representative function.
Such lines are in fact also evident in the
related pastel study but are here developed
to a greater extent. These abstracting effects
may, in part at least, have been the result of
Degas's greatly impaired eyesight by the turn
of the twentieth century. *At the Milliner's*
remained in Degas's studio until his death; it
sold in his studio sale for 13,000 francs.—SK

1 Paul-André Lemoisne dated the pastel to circa
1898 (see L1318). The pastel was dated by Jean

95 Degas, *Milliner Trimming a Hat*,
ca. 1905–1910. Pastel and charcoal, 17 ¼ x
10 ⅝ in. (43.8 x 27 cm). Private collection.
Courtesy Christie's, London (L1319)

93

LOUISE-CATHERINE BRESLAU
(Swiss, 1856–1927)

The Milliners, 1899

Pastel on paper mounted on board
22 ½ x 29 ⅛ in. (57.2 x 74 cm)
Private collection, Michigan

Breslau was a German-born Swiss artist who lived and worked in Paris during the late nineteenth century, training at the Académie Julian, a progressive art school that allowed and encouraged women students.[1] Known during her lifetime primarily for images of flowers and children,[2] Breslau also devoted considerable attention to images of women, particularly of women artists in the act of creating. This is reflected in *Friends* (1881; fig. 96), which was exhibited in the Salon of 1881 and was her first painting to receive significant critical attention. The work depicts Breslau with her roommates Sophie Schäppi, a fellow Swiss artist, and Maria Fuller, an Italian singer. Each woman is shown with professional or artistic accoutrements, with Breslau absorbed in painting at an easel while her friends are writing and sitting contemplatively at a table.[3]

Breslau was a younger follower of the Impressionists, particularly Degas. The two artists became close friends and admired each other's work.[4] Breslau especially found inspiration in Degas's use of pastel and his often-sympathetic views of women working.[5]

Her 1899 pastel *The Milliners* shows clear affinities to Degas's milliner series from the 1880s, as it illustrates two women—likely a *première* and a finisher—absorbed in trimming a range of hats, creating beautiful art objects from the raw materials on the table. Like Degas, Breslau gave considerable attention to rendering the assortment of silk flowers, which range from vivid blue and bright orange to pale yellow and pastel violet, and skillfully utilized the medium to show the

different textures of the materials, with the diaphanous lace of one hat contrasting with the stiff straw of another. A second pastel, *At the Milliner's* (1899; fig. 97), depicts the same interior but focuses on the *première* on the left, who adjusts the now nearly completed flowered hat in front of her.—AY

1 Despite allowing women to train, the Académie Julian still kept them separated from the male students. See Gabriel P. Weisberg and Jane

96 Breslau, *Friends*, 1881. Oil on canvas, 33 ½ x 63 in. (85 x 160 cm). Musée d'art et d'histoire, Geneva, inv. no. 1883-0002

97 Breslau, *At the Milliner's*, 1899. Pastel on paper, 18 ½ x 22 ⅞ in. (47 x 58 cm). Private collection. Courtesy Gallery Jean-François Heim

R. Becker, eds., *Overcoming All Obstacles: Women of the Académie Julian*, exh. cat. (New York: Dahesh Museum; and New Brunswick, NJ: Rutgers University Press, 1999), 13–67; and *Louise Breslau: De l'impressionnisme aux années folles*, exh. cat. (Milan: Skira/Seuil; and Lausanne: Musée cantonal des beaux-arts, 2001).

2 See Arsène Alexandre, "Les pastels de Louise Breslau," *L'Art et les artistes* 11 (1910): 208–213.

3 Janalee Emmer, "Autobiographical Projects: Women Artists and Identity in the Second Half of Nineteenth-Century France" (PhD dissertation, Pennsylvania State University, 2009), 178–187; and Tamar Garb, *The Body in Time: Figures of Femininity in Late Nineteenth-Century France* (Lawrence: Spencer Museum of Art, University of Kansas; and Seattle: University of Washington Press, 2008). See also William Hauptmann, review of *Louise Breslau: De l'impressionnisme aux années folles*, *Nineteenth-Century Art Worldwide* 1, no. 1 (Spring 2002).

4 See Karen Santschi-Campbell, "The Swiss Painter Louise Catherine Breslau (1856–1927): 'It is not allowed for a woman to paint as well as you'" (master's thesis, California State University, Dominguez Hills, 2000), 16.

5 Emmer, "Autobiographical Projects," 202.

94

GEORGES JEANNIOT
(Swiss-French, 1848–1934)

At the Milliner's, 1900

Oil on canvas
20 x 24 in. (50.8 x 61 cm)
Collection of John E. and
Lucy M. Buchanan

Jeanniot was one of Degas's closest friends during the latter's later years. The two men met in 1881 at the house of the painter-engraver Viscount Ludovic Lepic and remained in contact until Degas's death.[1] Jeanniot's "Souvenirs sur Degas" (1933) is an important firsthand account of his friend's life and beliefs. Jeanniot had been an officer in the French army, a background that probably appealed to Degas, a strong supporter of the military. He turned to painting on a full-time basis around 1880 and shared the interest of his mentor Degas in the representation of modern life, focusing on views of fashionably dressed men and women in Belle Époque Paris.

At the Milliner's, one of a group of paintings that he produced on that theme, shows the neo-Rococo interior of a milliner's shop.[2] On view is an array of hats, trimmed with pink flowers, tulle, and white ostrich plumes that rise up like puffs of smoke. A customer—in a fashionable, broad-sleeved dress and lace *fichu* (neck scarf)—sits in a contemplative pose while considering her hat choice. Jeanniot's work shows the lively brushwork and rich color that won Salon

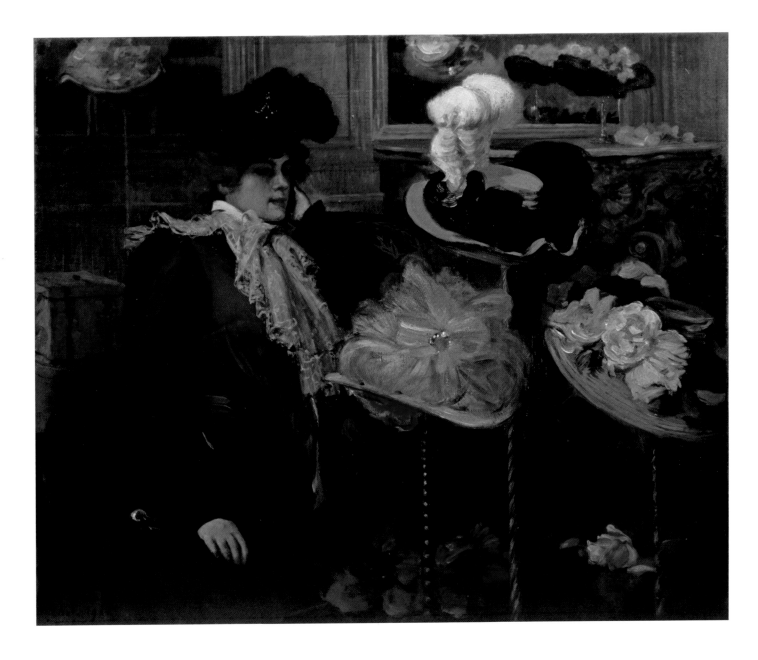

success for him as well as state patronage and the award of Chevalier of the Légion d'honneur in 1906.[3]

Jeanniot's interest in millinery was probably influenced by his firsthand experience of Degas's works. On one visit to his friend's studio, he recalled seeing the large-scale pastel *At the Milliner's* (1882; fig. 61) and its "exquisite color."[4] Degas noted that he had been influenced by the colors of an Oriental rug that he had seen on the place de Clichy in Paris.[5] Jeanniot remembered Degas's satisfaction with this pastel and the "triumphant expression I knew so well when he achieved one of those thrilling successes that sometimes light up the lives of artists with incomparable joy!"[6] —SK

1 Georges Jeanniot, "Souvenirs sur Degas," *La Revue universelle* 55, no. 14 (October 15, 1933): 152.

2 See also *Outing at the Milliner's* (1901), private collection (European Art Signature Sale, Heritage Auctions, Dallas, December 10, 2014, lot 69010).

3 Jeanniot's *Les Femmes* (1896; Musée d'Orsay, Paris, RF 1046), for example, entered the collection of the Musée du Luxembourg in 1897. The artist won a silver medal at the Paris Expositions Universelles in 1889 and 1900.

4 "Couleur exquise." See Jeanniot, "Souvenirs sur Degas," *La Revue universelle* 55, no. 15 (November 1, 1933): 280. Jeanniot described this work as "a woman in profile trying on a hat, reflected straight on in a mirror, with an indefinable tone, vaguely recalling in its matte finish the appearance of certain frescoes, whose remnants you can see at the Louvre" (une femme de profil essayant un chapeau, reflétée de face dans une glace, d'un ton indéfinissable, rappelant vaguement par sa matité l'aspect de certains fresques dont on voit des vestiges au Louvre). The visit can probably be dated to 1882, when *At the Milliner's* was still in Degas's studio before being sold soon after.

5 Degas also noted the importance of memory and that the blue (the color of the ground in the pastel) was based on a tone that was, in reality, "cool green": "You must draw on your memory; but, you know, that blue there is actually a cool green" (Il faut se server de sa mémoire; mais, vous savez, ce bleu-là, en réalité, c'est du vert froid). Ibid.

6 "Cette expression victorieuse que je lui connaissais quand il atteignait une de ces passionnantes réussites qui illuminent parfois la vie des artistes d'une joie incomparable!" Ibid.

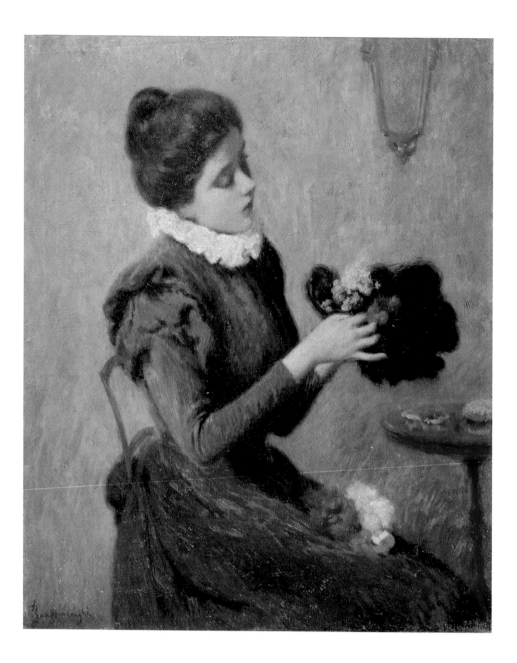

95

FEDERICO ZANDOMENEGHI
(Italian, 1841–1917)

The Milliner, 1895–1900

Oil on canvas
19 ⅛ x 14 ⅛ in. (48.5 x 36 cm)
Private collection, Milan

Zandomeneghi left his native Italy for Paris in 1874—the year of the first Impressionist exhibition—and his temporary visit ultimately turned into a permanent relocation. The critic and fellow Italian Diego Martelli may have encouraged Zandomeneghi's move. Both men were associated with the Florentine realist artists who called themselves the Macchiaioli, and they were each friendly with members of the Impressionist circle, including Edgar Degas.[1] "Zandò," as his French associates affectionately called him, or "the Venetian," as he was referred to by Degas, contributed to four of the Impressionist exhibitions, in 1879, 1880, 1881, and 1886.[2] His illustrations for fashion magazines supplemented an income from selling his art to clients, including Degas, who owned examples of his works on paper.[3] Degas also may have helped him secure crucial early patronage in Paris from the dealer Paul Durand-Ruel, who would feature Zandomeneghi in exhibitions at Galerie Durand-Ruel in 1893, 1898, and 1903.[4]

Zandomeneghi and Degas shared an interest in certain subjects, such as millinery, which sometimes manifested in the former's explicit imitation of specific compositions by the elder artist.[5] The two were especially close in the 1890s, when Zandomeneghi painted *The Milliner*. One example of their creative relationship during this period is the portrait bust sculpture of Zandomeneghi that Degas worked on in 1895.[6] Zandomeneghi also posed for photographs by Degas, and in two 1895 letters to Martelli, he describes "four little portraits that Degas made of me . . . last winter in his studio," adding in the second letter that when looking at one of the photographs, "You will think you are looking at a Velázquez."[7] These examples attest to the rapport between the artists and, moreover, to Zandomeneghi's respect for Degas during this period, which he expressed in a letter at the time of Degas's death: "He was the most noble and independent artist of our epoch; he was a very great artist, and I will never forget, as long as I live, the great friendship that bound us for many years."[8]

Similar to that of Degas, Zandomeneghi's late work is often characterized by interior settings featuring candidly posed feminine subjects. *The Milliner* is an intimate representation of a single milliner at work and recalls Degas's treatment of milliners

in profile, such as the woman featured in *The Millinery Shop* (1879–1886; cat. no. 1). The hat on which she delicately arranges artificial flowers is likely destined for a fashionable boutique akin to the showroom in *At the Milliner's* (ca. 1894–1905; fig. 98), which presents several female clients in the midst of merchandise placed on wooden hatstands. The voyeuristic atmosphere of *The Milliner*—also a hallmark of Degas's late style—is heightened by the compressed spaces in which the woman is presented.—MB

I For more on the Macchiaioli, see Norma Broude, *The Macchiaioli: Italian Painters of the Nineteenth Century* (New Haven, CT: Yale University Press, 1987). For a comprehensive source on the artist, see Camilla Testi, Maria Grazia Piceni, and Enrico Piceni, *Federico Zandomeneghi: Catalogo generale* (Milan: Fondazione Piceni and Libri Scheiwiller, 2006), 332, no. 619, and 255, no. 247. See also Dario Durbé and Enrico Piceni, *Three Italian Friends of the Impressionists: Boldini, De Nittis, Zandomeneghi*, exh. cat. (New York: Stair Sainty Matthiesen, 1984).

2 "Bonjour au Fleury et au Vénitien." Degas, letter to the artist Paul-Albert Bartholomé, September 9 [1888], published in Marcel Guérin, ed., *Lettres de Degas* (Paris: Éditions Bernard Grasset, 1931), 145n2.

3 Marialuisa Rizzini, "Zandomeneghi e la moda," in *Federico Zandomeneghi: Un veneziano tra gli impressionisti* (Rome: Chiostro del Bramante; and Milan: Mazzotta, 2005), 63–71. According to Rizzini, it is difficult to trace where the illustrations were reproduced, since such images were infrequently signed. For Degas's collection, see Ann Dumas, ed., *The Private Collection of Edgar Degas*, exh. cat. (New York: Metropolitan Museum of Art, 1997); and Colta Ives, Susan Alyson Stein, and Julie A. Steiner, eds., *The Private Collection of Edgar Degas: A Summary Catalogue* (New York: Metropolitan Museum of Art, 1997), 121, nos. 1051 and 1052.

4 Zandomeneghi's first monographic exhibition in Paris was at Paul Durand-Ruel's gallery; *Exposition de tableaux, pastels, dessins de F. Zandomeneghi*, exh. cat. (Paris: Galerie Durand-Ruel, 1893). See also Ann Dumas, *Degas and the Italians in Paris*, exh. cat. (Edinburgh: National Galleries of Scotland, 2003), 20–21 and 93.

5 For an example of Zandomeneghi's influence on Degas, see Norma Broude, "The Italian Expatriates: De Nittis and Zandomeneghi," in *Foreign Artists and Communities in Modern Paris, 1870–1914: Strangers in Paradise* (Burlington, VT: Ashgate, 2015), 34–36. For Zandomeneghi's copies after Degas, see 38–39 and 41n45; and Dumas, *Degas and the Italians in Paris*, 21, fig. 11, and 64, pl. 30.

6 The bust is currently untraced and possibly has not survived. See "Chronology IV" in Jean Sutherland Boggs, ed., *Degas*, exh. cat. (New York: Metropolitan Museum of Art; and Ottawa: National Gallery of Canada, 1988), 490. In her memoirs, Julie Manet recalled being very impressed by this likeness on a visit with Pierre-Auguste Renoir to Degas's studio. Manet, entry on November 29, 1895, published in Manet, *Journal (1893–1899): Sa jeunesse parmi les peintres impressionnistes et les hommes de lettres.* (Paris: Librairie C. Klincksieck, 1979), 73–74.

7 As with Degas's sculpture of Zandomeneghi, the survival and location of these photographs is currently unknown. Letter from Zandomeneghi to Diego Martelli, August 31, 1895: "Al mio ritorno a Parigi mi farò far la riproduzione di quattro ritrattini che Degas mi fece in una terribile giornata dello scorso inverno nel suo studio"; and "9bre" 1895, "Ti parrà di vedere un Velasquez [*sic*]," in Francesca Dini, *Federico Zandomeneghi, la vita e le opere* (Florence: Il Torchio, 1989), 511 and 513. Translated in Malcolm Daniel, ed., *Edgar Degas, Photographer*, exh. cat. (New York: Metropolitan Museum of Art, 1998), 20. See also 49n17, and 137, nos. 45–48.

8 "Fu l'artista il più nobile e il più indipendente dell'epoca nostra; fu un grandissimo artista e non dimenticherò finché vivo la grande amicizia che ci legò durante molti anni." Lamberto Vitale, *Lettere dei macchiaioli* (Turin: Einaudi, 1953), 299n2. Translated in Broude, "The Italian Expatriates," 39; and Dumas, *Degas and the Italians in Paris*, 21.

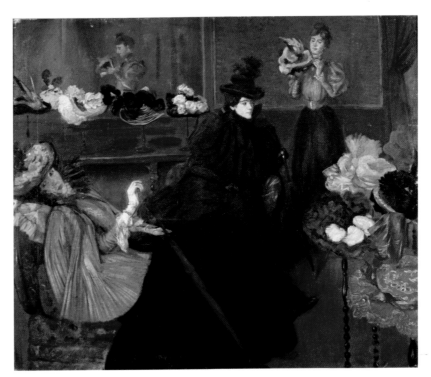

98 Zandomeneghi, *At the Milliner's*, ca. 1894–1905. Oil on canvas, 21 ¼ x 25 ⅝ in. (54 x 65 cm). Private collection

96

HENRI DE
TOULOUSE-LAUTREC
(French, 1864–1901)

The Milliner (Renée Vert),
1893

Lithograph
Composition: 17 ⅝ x 11 ½ in.
(44.9 x 29.1 cm); sheet: 21 ⅝ x 13 ¾ in.
(54.9 x 34.9 cm)
Private collection

Toulouse-Lautrec engaged with many of
the same themes as Degas—much to the
older artist's chagrin. Degas often treated
Toulouse-Lautrec with condescension,
regarding the younger artist as a rival; he
once accused him of stealing his ideas, but
he also offered advice on occasion.[1] By the
1890s Toulouse-Lautrec picked up on Degas's
interest in the theme of millinery and the
modiste, creating his own images based on
frequent visits with female friends to hat
shops, where he was known to spend hours
drawing both customers and workers.[2]

In contrast to Degas's often-anonymous
modistes, Toulouse-Lautrec here depicted
a working milliner by the name of Renée
Vert, whose shop on the rue du Faubourg-
Montmartre was registered in the *Annuaire-
almanach du commerce* as early as 1892.[3]
Madame Vert is shown examining an
extravagant plumed hat, similar in style to
those worn by Jane Avril and other cabaret

performers (see cat. no. 44). Toulouse-
Lautrec selected this image to illustrate the
menu for the annual dinner of the Société
des Indépendants in June 1893, possibly as a
tribute to Degas.[4]

Toulouse-Lautrec came to know many of
the models and employees at Renée Vert's
shop, including Louise Blouet—nicknamed
"Le Margouin"—whom he depicted in two
late works.[5] A painting from 1900, *The
Milliner (Louise Blouet d'Enguin)* (fig. 99),
shows her in the darkened interior of the
shop, highlighted with a warm light, with
silhouettes of plumed hats before her. With
her head turned down, she seems engrossed
in her task. A lithograph from the same
year illustrates Louise facing the opposite
direction (fig. 100). As in the painting, feath-
ered hats are on display in the background,
while in the center Louise gazes downward.
However, here she seems to have turned
away from the worktable, giving the print a
more ambiguous meaning.—AY

1 For more on Edgar Degas's relationship with
 Toulouse-Lautrec, see Riva Castleman and
 Wolfgang Wittrock, eds., *Henri de Toulouse-
 Lautrec: Images of the 1890s*, exh. cat. (New
 York: Museum of Modern Art, 1985), 45–51.
2 Thadée Natanson, *Un Henri de Toulouse-
 Lautrec* (Geneva: Pierre Cailler, 1951), 59. See
 also Nancy Ireson, ed., *Toulouse-Lautrec and
 Jane Avril: Beyond the Moulin Rouge*, exh. cat.
 (London: Courtauld Gallery and Paul Holberton
 2011), 64.
3 See *Annuaire-almanach du commerce* (Paris:
 Didot-Bottin, 1892), 1793.
4 George L. McKenna, *The Collections of the
 Nelson-Atkins Museum of Art: Prints 1460–1995*
 (Kansas City, MO: Nelson-Atkins Museum of
 Art, 1996), 183; Gilles Néret, *Henri de Toulouse-
 Lautrec, 1864–1901* (Cologne: Taschen, 1999),
 188; and Pierre Cabanne, *Henri de Toulouse-
 Lautrec: The Reporter of Modern Life* (Paris:
 Editions Pierre Terrail, 2003), 195.
5 Toulouse-Lautrec gave her the nickname
 "Croqsimargouin," slang for "the model who is
 nice to draw" or, alternatively, "nice to nibble."
 See Götz Adriani, *Toulouse-Lautrec: The
 Complete Graphic Works. A Catalogue Raisonné*
 (London: Thames and Hudson, 1988), 417.

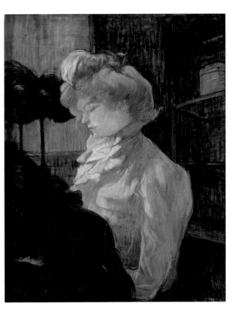

99 Toulouse-Lautrec, *The Milliner (Louise Blouet
d'Enguin)*, 1900. Oil on wood, 24 x 19 ½ in. (61 x
49 cm). Musée Toulouse-Lautrec, Albi, France,
MTL.212

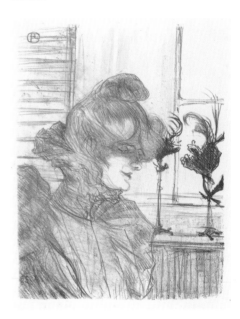

100 Toulouse-Lautrec, *Madame Le Margouin, Milliner*,
1900. Lithograph on velin paper, 12 ½ x 9 ⅝ in. (31.7
x 24.5 cm). National Gallery of Art, Washington,
Rosenwald Collection, 1952.8.454

97

MADAME GEORGETTE
(French, active ca. 1900–1925), designer

Woman's hat, ca. 1905

Label: "Mme Georgette/11. Rue Scribe/
PLACE DE L'OPÉRA/PARIS"
Straw, roses, velvet, and net
18 x 16 x 2 ¾ in. (45.7 x 40.6 x 7 cm)
Chicago History Museum, Gift of
Mrs. Albert J. Beveridge, 1949.309
Worn by the donor

Madame Georgette was celebrated for the beauty, originality, and exaggerated size of her hats, impressive even by the standards of the pre–World War I era. A generous bouquet of artificial pink roses protrudes from under the wide brim of this straw hat; more roses are tucked into the blue velvet band that circles the crown before disappearing under the brim to tie at the nape of the neck. Similarly broad, flowered examples of her early work can be found in the Philadelphia Museum of Art (see cat. no. 99) and seen in G. Agié's 1910 photo of her *salon de vente* (fig. 121).[1]

Like many Parisian milliners of her time, Madame Georgette established close ties with American retailers, permitting them to make authorized copies of her hats and communicating her fashion dictates to clients and journalists via telegram.

In 1912 Madame Georgette was invited to spend a month in the United States as the guest of the exclusive New York department store Henri Bendel. It was her first visit, and she confessed to a journalist: "I did not expect to find everywhere the evidences of good taste that I have found." If Madame Georgette was pleasantly surprised by America, she made it clear that it was France that deserved the credit. "They are all French modes in America—hats, costumes, gowns, everything is from Paris," she declared. "You are wearing precisely the same hats that we are in Paris. There is no original American style."[2] The journalist, in turn, was impressed by Madame Georgette's quiet elegance, so unexpected in a Parisian *modiste*: "She is one of the most famous milliners in the world, and yet she has the affect of never having given hats a thought.... Because she looks like an artist, she quite smashes our ideas of how a milliner ought to look."[3]

During the war years, Madame Georgette successfully adapted her exuberant style to the new mood of austerity, offering smaller models with minimalist trimmings. The firm continued to operate under her assistant, Madame Alphonsine, until at least 1940.[4] — KCC

1 See also a 1910 leghorn straw hat with lace, silk velvet, and artificial flowers, Philadelphia Museum of Art, 1935-13-86.
2 "Masses of American Women Best Dressed in the World," *Crerand's Cloak Journal*, October 1912, 138.
3 Ibid.
4 Dilys E. Blum, *Ahead of Fashion: Hats of the 20th Century*, exh. cat., *Bulletin* (Philadelphia Museum of Art) 89, nos. 377/378 (Summer–Autumn 1993): 11.

98

MADAME GEORGETTE
(French, active ca. 1900–1925), designer

Woman's hat, ca. 1910

Label: "Mme. Georgette/11, Rue Scribe/
PLACE DE L'OPÉRA/PARIS"
Plaited straw, wool felt, bird of
paradise and other feathers, and
silk satin trim and lining
20 ¾ x 19 in. (52.7 x 48.3 cm) overall
Fine Arts Museums of San Francisco,
Gift of I. Magnin & Company, 56.35.40

99

MADAME GEORGETTE

Woman's hat, ca. 1910

Label: "Mme. Georgette/
11 Rue Scribe/Paris"
Silk lace, painted sized cotton plain-
weave flowers and leaves, and
silk stems on wire frame
20 x 11 ¾ in. (50.8 x 29.8 cm) overall
Philadelphia Museum of Art, Gift of
Mrs. Pierre Fraley, 1994-108-1

Madame Georgette was best known for her picture hats, or highly decorated hats with wide brims. Worn at the back of the head to frame the face—thus adding "very much to the merit of the picture"—the hats evoked those elaborate styles found in the work of the English eighteenth-century portrait painter Thomas Gainsborough and coincided with a larger trend for historicism in contemporary women's fashion.[1]

No historical revival was more popular than that of the delicate, neoclassical Louis XVI style, which influenced interior decoration and textile design as well as dress.[2] Empress Eugénie, who married Napoléon III in 1853, was fascinated by her royal predecessor, the beautiful and tragic Marie Antoinette, and frequently dressed as the martyred queen for court masquerades. Following her lead, ladies of fashion took inspiration from the Louis XIV, XV, and XVI periods indiscriminately, donning Watteau tunics, Pompadour hairstyles, Lamballe hats, and gowns of Trianon gray and *cheveux de la Reine*, the color of Marie Antoinette's ash-blond hair. These historical fashion pastiches were facilitated by the publication of lavishly illustrated scholarly costume books such as Auguste Racinet's *Le Costume historique* (1876–1888), Augustin Challamel's *Histoire de la mode en France* (1875), and comte de Reiset's 1885 edition of the account book of *marchande de modes* Madame Eloffe, who dressed Marie Antoinette.

Although Madame Georgette was not the only *modiste* to offer such hats in the first years of the twentieth century, the house was unique for maintaining wide-brimmed styles despite changes in yearly and seasonal headwear trends.[3] As one *New York Times* reporter satirically remarked in 1914, "even last Winter, when the world was ruled by small hats . . . we would again burden our heads with [Madame Georgette's] cartwheels," the cartwheel hat being a variation

of the picture hat, with a very large straight brim and shallow crown.[4]

Madame Georgette's hats were known for their rich decoration, typically lustrous feathers, and verdant artificial flowers. The first example shown here features a striking combination of white bird of paradise, egret, and other feathers against black wool felt—a signature arrangement and coloring for which the house became well known. By comparison, the house's masterful manipulation of artificial flowers is most evident in the second example here.[5] In both, the embellishments dramatically cascade over the hats' crowns. Both were made at Madame Georgette's salon at 11, rue Scribe. Madame Georgette worked at this location, famously captured in G. Agié photographs for Léon Roger-Milès's *Les Créateurs de la mode* (1910; see figs. 121–122), from about 1904 until about 1913, before relocating her salon to the rue de la Paix, where it would remain through the 1920s.[6] —LLC & KCC

1 "Editorial: The Hat," *Photo-Era: The American Journal of Photography* 27, no. 5 (November 1911): 240.

2 See Esther Bell's discussion on pp. 89–91 for more on such revivals.

3 "Potpourri of Fashion: The Very Large Hat Having Its Day in Paris," *New York Times*, August 16, 1908.

4 "Georgette Brings Out Italian Plateau Hat," *New York Times*, March 15, 1914; and Mary Brooks Picken, *A Dictionary of Costume and Fashion: Historic and Modern* (New York: Dover Publications, 1985), 161.

5 M. D. C. Crawford, *The Ways of Fashion* (New York: G. P. Putnam's Sons, 1941), 80.

6 By a comparison of Madame Georgette hat labels found in the collections of the Musée des arts décoratifs, the Philadelphia Museum of Art, the Metropolitan Museum of Art, the Texas Fashion Collection, and the Norsk Folkemuseum. See also Elizabeth Otis Williams, *Sojourning, Shopping & Studying in Paris: A Handbook Particularly for Women* (Chicago: A. C. McClurg & Co., 1907), 150–151; "Georgette Brings Out Italian Plateau Hat"; *Paris* (New York: Fanners' Loan and Trust Company, 1914); and "The House of Georgette," *Ladies' Home Journal*, February 1916. Alice K. Perkins, *Paris Couturiers and Milliners* (New York: Fairchild Publications, 1949), 49. See also Steven Zdatny, ed., *Hairstyles and Fashion: A Hairdresser's History of Paris, 1910–1920* (Oxford: Berg, 1999), 39.

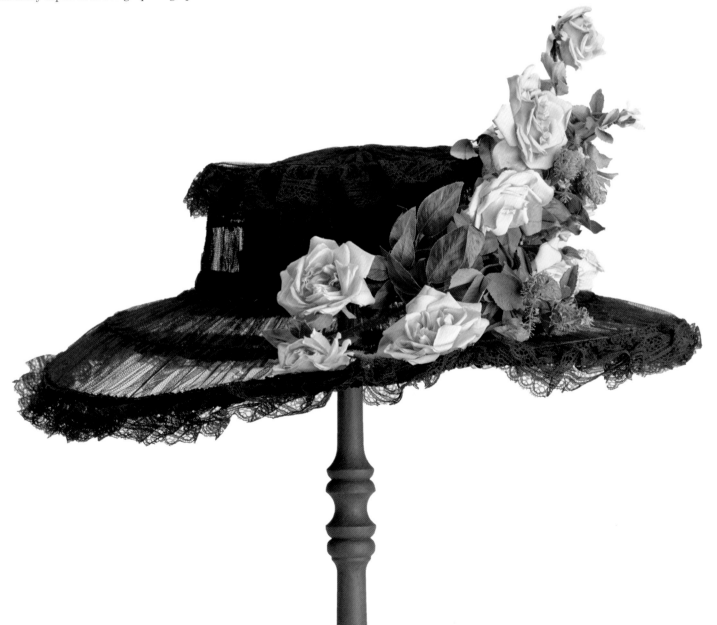

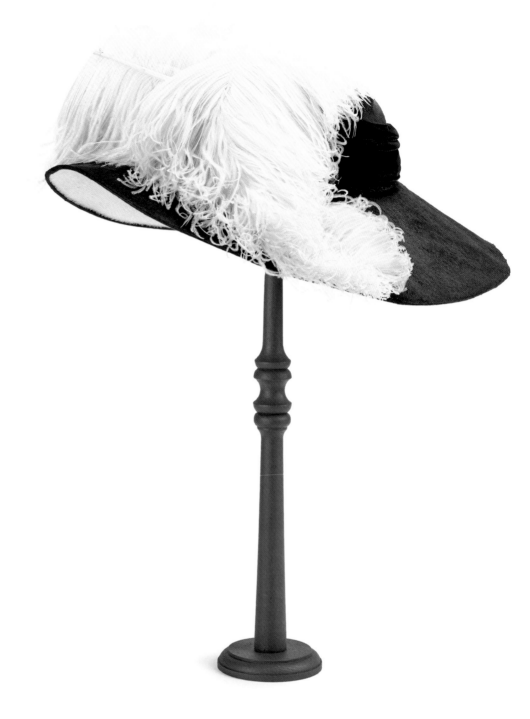

100

IDA MARGUERITTE
(French, active early twentieth
century), designer

Woman's hat, ca. 1910

Label: "Ida Margueritte/
8. Bould. Malesherbes/Paris"
Beaver plush, ostrich feathers,
and silk velvet
21 ⅝ x 19 ½ in. (54.9 x 49.5 cm) overall
Fine Arts Museums of San Francisco,
Gift of Jane Scribner, 49.10.29

———————————

While many of Paris's leading milliners were praised by contemporaries for their imaginative creations, perhaps none received as frequent and effusive commendations as Ida Margueritte.[1] As one writer reflected, "decidedly [Margueritte] brings to each of her creations a concern of art, an ingenuity worthy of the highest praise."[2] Situated on boulevard Malesherbes, just blocks away from rue de la Paix, Margueritte distinguished herself in the 1910s for eye-catching hat styles featuring almost comically oversize embellishments.[3] While many hats from the early twentieth century were judiciously decorated—a trend remarked upon in many contemporary articles—her hats boast bows, flowers, furs, and feathers that tower atop or cascade behind their crowns. Margueritte's designs were admired and worn by France's fashionable elite, who reputedly could be seen wearing her extraordinary creations while promenading along Paris's rue de la Paix, as well as

on resort in Nice and Monte Carlo.[4] Despite the large, luxurious sweep of white ostrich feathers across its black beaver crown and brim, this hat is a rather subdued example of the designer's work.—LLC

1 For example, see *Fairchild's National Directory and Digest*, vol. 17 (1920): 394.
2 *Gil Blas* 13, no. 195 (April 7, 1913): 5.
3 For examples, see "Fashion: Variations in Hat Brims," *Vogue* 41, no. 9 (May 1, 1913): 40; and "Fashion: The Small Black Velvet Hat and a Drecoll Suit," *Vogue* 42, no. 10 (November 15, 1913): 58.
4 "À Nice, à Monte-Carlo et rue de la Paix, de cinq à sept." "La Mode au Théâtre," *Le Gaulois: littéraire et politique* 47, no. 12,544 (February 17, 1912): 3.

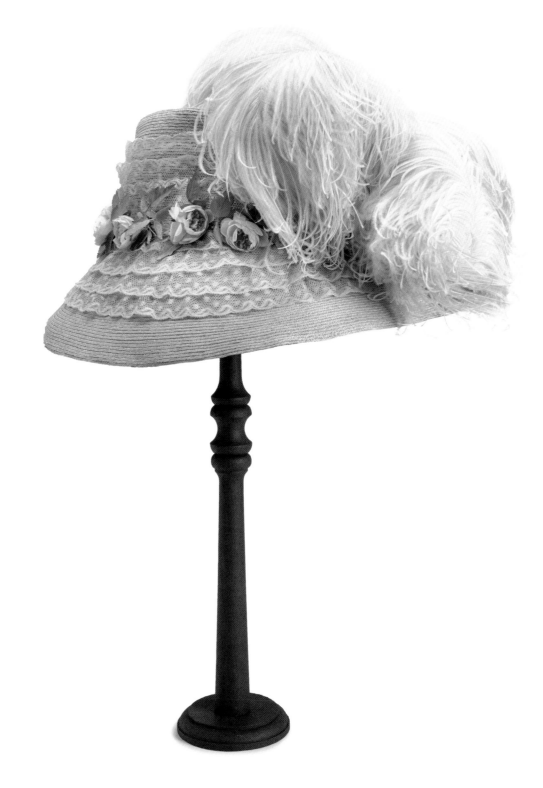

101

GUILLARD SOEURS
(French, active late nineteenth–
early twentieth century), designers

Woman's hat, ca. 1910

Label: "Guillard Soeurs/38 Avenue
de l'Opéra/Près la rue de la Paix/Paris"
Straw plain weave, straw basket
weave, ostrich feathers, silk lace,
and painted sized cotton plain-weave
flowers and leaves
9 ½ x 19 x 16 ¼ in.
(24.1 x 48.3 x 41.3 cm) overall
Philadelphia Museum of Art, Gift of
Mrs. Pierre Fraley, 1975-99-17

This hat by Guillard Soeurs (Guillard sisters)
is a quintessential example of the large
picture-hat styles that were popular for
women during the early 1910s. A fine plain-
weave straw was used for the hat's outer
shell, while a coarse basket weave lines its
large brim.[1] Typical of Guillard Soeurs's hats
from this period, it is embellished with a del-
icate application of lace and artificial flowers
and accented by a large ostrich plume along
its crown.[2]

The Guillard sisters were active in the
late nineteenth and early twentieth cen-
turies, during which time they were often
praised by their contemporaries for their
remarkable creations, especially after they
were awarded a silver medal at the 1900
Exposition Universelle in Paris.[3] Indeed,
contemporary press even considered

the milliners and their designs as among France's most precious national treasures: "Make no mistake," announced *Le Figaro* in March 1916. "The collection of hats that Mmes. the Guillard sisters display in their showrooms at 38, avenue de l'Opéra . . . is delightful, in exquisite taste. Expensive? Not at all. Mmes. Guillard work for others more than for themselves; for their staff, for their clientele, and for the reputation of Parisian fashion, which we must uphold."[4] —LLC

1 Dilys E. Blum, *Ahead of Fashion: Hats of the 20th Century*, exh. cat., *Bulletin* (Philadelphia Museum of Art) 89, nos. 377/378 (Summer–Autumn 1993): 10.

2 For comparison, see *Le Figaro* 62, no. 190 (July 8, 1916): 3.

3 Guillard Soeurs is frequently mentioned in French newspapers and journals from approximately 1897 until 1916. See "Guillard Soeurs," *La Revue illustrée*, July 1, 1897, n.p.; *Le Gaulois: Littéraire et politique* 33, no. 6033 (June 1, 1898): 2; and "Entre Nous," *Le Figaro* 62, no. 204 (July 22, 1916): 3. *Journal officiel de la république française* 32, no. 223 (August 19, 1900): 241.

4 "Ne nous y trompons pas. C'est une ravissante collection de chapeaux d'un goût exquis . . . que celle que Mmes Guillard soeurs exposent dans leurs salons, 38, avenue de l'Opéra. Chers? Pas du tout. Mmes Guillard travaillent pour les autres plus que pour elles; pour leur personnel, pour leur clientele et pour la reputation de la mode parisienne qu'on ne doit pas laisser tomber." "Entre Nous," *Le Figaro* 62, no. 64 (March 4, 1916): 3.

102

MADAME LOUISON
(French, active early twentieth century), designer

DINAN IMPORTER
San Francisco (American, active early twentieth century), retailer

Woman's hat, ca. 1910

Labels: "Madame Louison/
416 Rue St. Honoré/Pris la Rue Royale/
Paris" and "Dinan/Importer/
160 Geary St./San Francisco"
Plaited straw, metallic lace,
silk velvet ribbon, and dyed
ostrich and egret feathers
19 ¼ x 19 ¾ in. (48.9 x 50.2 cm) overall
Fine Arts Museums of San Francisco,
The Laura Dunlap Leach Collection,
1985.40.39

Meticulously plaited braids of straw form the foundation of this summer hat by Madame Louison. In the early twentieth century plaited straw strands were retailed by the yard for use in bonnets and hats; like many examples from this period, this hat's straw foundation was made by sewing together plaited strands at the center of the crown and working outward in a spiral.[1] Italy was known for growing the finest straw—the crop had been cultivated there since the fifteenth century. However, by the late nineteenth century, England also had a flourishing straw crop that was frequently employed for millinery.[2] While many hats from this period were made from English straw, contemporary press suggests that Madame Louison used Italian straw for her designs.[3]

Straw hats accented by extravagant plumes were a signature of Madame Louison. This example features a large spray of dyed ostrich and egret feathers, and the underside of its brim is distinguished by dyed rust-orange straw. This Louison design was retailed by Nellie Dinan of Dinan Importer in San Francisco, which sold imported headwear as well as trimmings for women's clothing and accessories in the early twentieth century.[4] —LLC

1 Jessica Ortner, *Practical Millinery* (London: Whittaker & Co., 1897), 111.

2 Florence Müller and Lydia Kamitsis, *Les Chapeaux: Une histoire de tête* (Paris: Syros-Alternatives, 1993), 36–38.

3 See "Fashion: Millinery Fashions," *Vogue*, May 2, 1907, 721; and "A Malines Hat and Two of its Feather-Brimmed Rivals," *Vogue*, August 15, 1913, 36.

4 *Crocker-Langley San Francisco Directory: Part 1* (San Francisco: H. S. Crocker Co., 1917), 626; and *Garment Manufacturer's Index* 1, no. 13 (August 1920): 68.

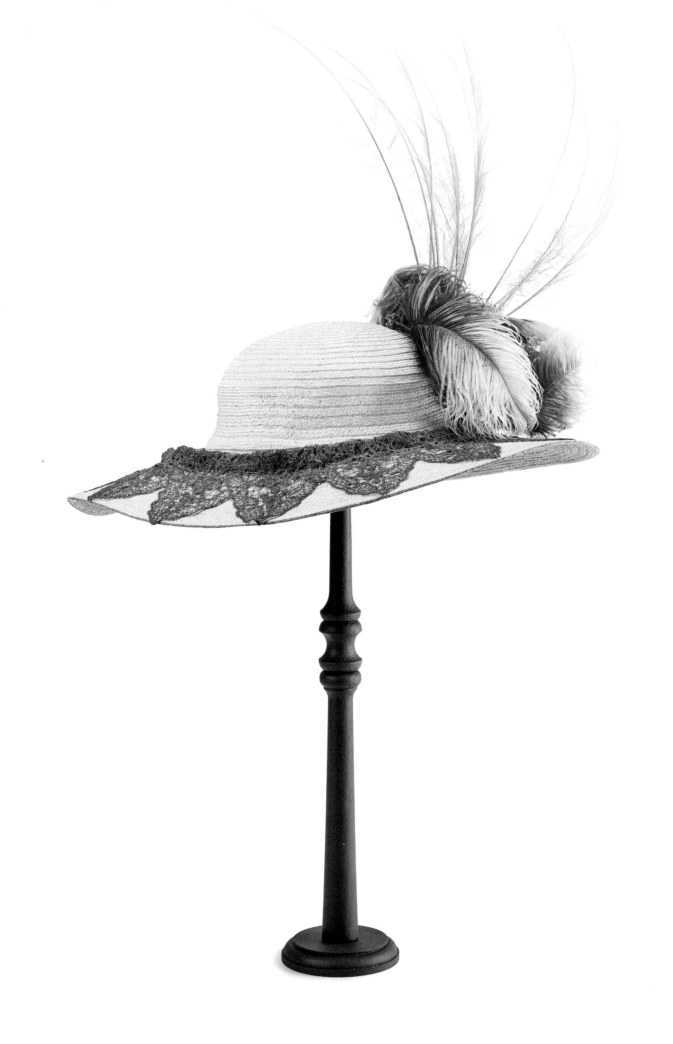

103–105

EUGÈNE ATGET
(French, 1857–1927)

Le Salon de Mme C., Modiste and *Intérieur de Mme C., Modiste,* from *Intérieurs parisiens, début du XXe siècle,* 1910

Three albumen silver prints
8¾ x 6⅞ in. (22.3 x 17.5 cm);
8⅞ x 6⅞ in. (22.5 x 17.6 cm); and
8⅞ x 7⅛ in. (22.6 x 18 cm)
Bibliothèque nationale de France, Paris,
Département Estampes et photographie

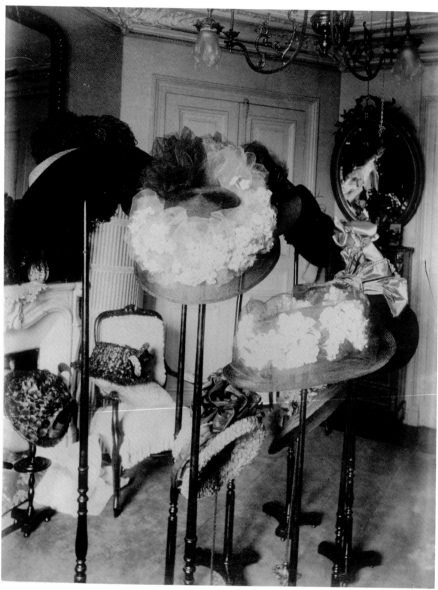

103

Nearly thirty years after Edgar Degas first depicted the interiors of millinery shops, Atget presented some of the first photographic views of a *modiste*'s atelier. Part of his large series of photographs of modern Parisian apartments of different social classes, published as *Intérieurs parisiens, début du XXe siècle, artistiques, pittoresques et bourgeois,*[1] Atget's photographs offer views of the salon and domestic space of a "Mme C., Modiste." The titular Madame C. is not present in the photographs, however, and is otherwise unknown; her shop in the place

Saint-André-des-Arts does not appear in commercial directories of the time.

While Atget's photographs serve as documentary evidence of Madame C.'s shop and wares, as well as offering an intimate view of her living conditions, they also suggest aesthetic similarities with the works of Degas. The two views of the salon (cat. nos. 103 and 104) feature an impressive array of hats; one immediately calls to mind Degas's 1882 pastel of hats on display in a millinery shop (see cat. no. 13), while the other playfully incorporates mirrors in the composition. The hats

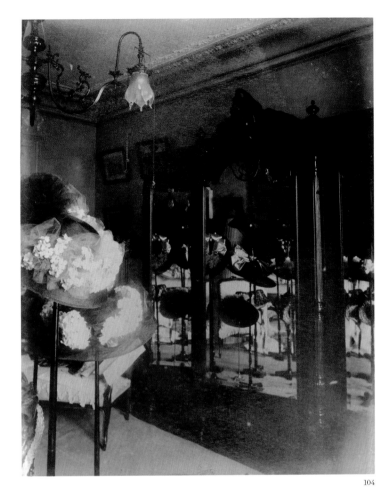

104

105

not only serve as a testament to Madame C.'s skills as a milliner but also stand in for the absent *modiste* herself, through traces of her existence in the apartment.[2]

Atget's inclusion of Madame C.'s living quarters (cat. no. 105 and fig. 101) in his study suggests that she partly used her domestic space as a millinery shop. Women's homeworking was prevalent during this period, particularly in the garment industry (see also cat. no. 22).[3] However, despite being highly skilled, homeworkers were notoriously underpaid, and, in the early years of the twentieth century, trade unions began to push for reform.[4] —AY

1 See Margaret Nesbit, "Atget's Seven Albums, in Practice" (PhD dissertation, Yale University, 1983).

2 Katie Hartsough Brion, "Eugène Atget and the Fin de Siècle Interior: Revelatory Excess," *Bulletin of the University of Michigan Museums*

of Art and Archaeology, no. 16 (2005–2006): 64.

3 See, for example, Marilyn J. Boxer, "Women in Industrial Homework: The Flowermakers of Paris in the Belle Époque," *French Historical Studies* 12, no. 3 (Spring 1982): 401–423; and "Protective Legislation and Home Industry: The Marginalization of Women Workers in Late Nineteenth–Early Twentieth-Century France," *Journal of Social History* 20, no. 1 (Autumn 1986): 45–65.

4 Miriam Cohen and Michael Hanagan Vassar, "The Political Economy of Social Reform: The Case of Homework in New York and Paris 1900–1940," *French Politics and Society* 6, no. 4 (October 1988): 34.

101 Atget, *Interieur de Mme C., Modiste*, 1910. Albumen print, 8 ⅞ x 6 ⅞ in. (22.5 x 17.6 cm). Bibliothèque nationale de France, Paris, BNF-Est. Oa 173. G045687 Atget 736

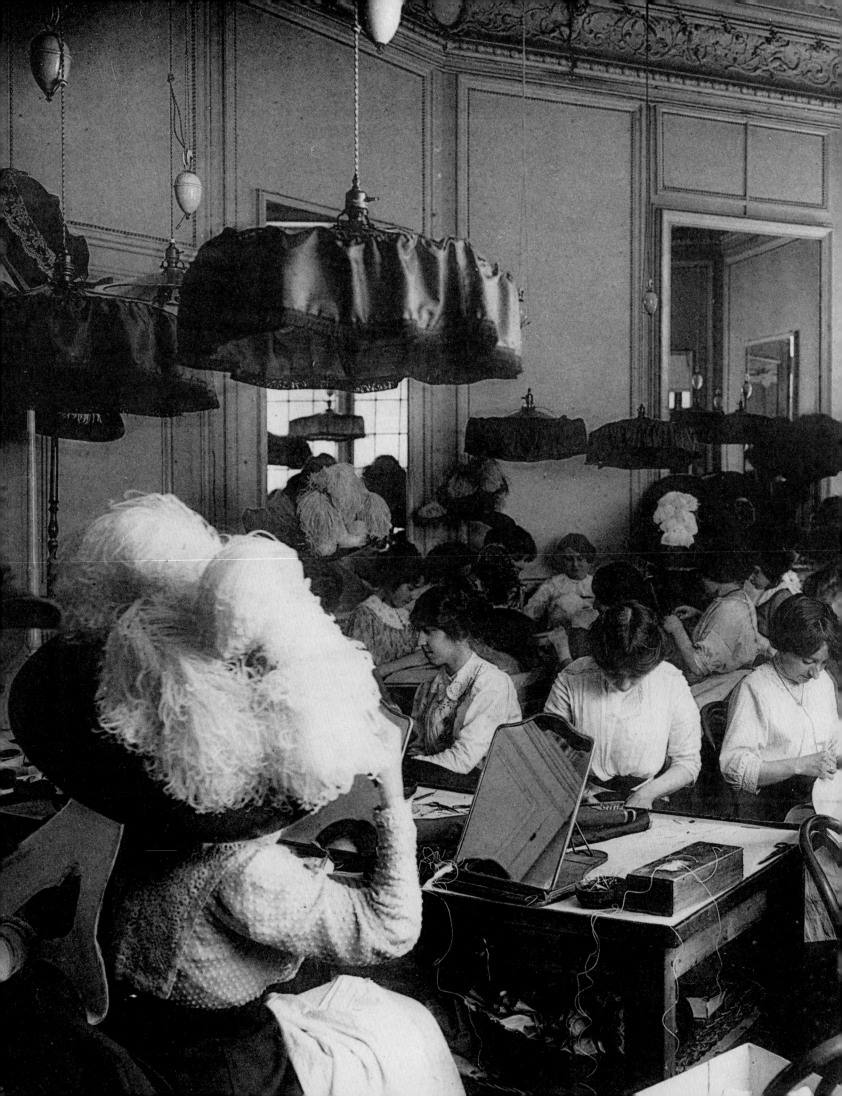

CHRONOLOGY

ABIGAIL YODER

1834

PAINTING

Hilaire-Germain-Edgar De Gas is born on July 19 in Paris.

1870

HISTORY & CULTURE

The Franco-Prussian War begins in July, over French fears of German unification efforts upsetting the balance of power in Europe. Degas and Édouard Manet volunteer to fight in the National Guard in September. Degas serves under the command of Henri Rouart. Pierre-Auguste Renoir also enlists in the National Guard but is later discharged for health reasons. James Tissot enlists as a sharpshooter.

Napoléon III is defeated at the Battle of Sedan by Prussia, bringing about the end of the Second Empire. The Third Republic is declared on September 4.

Beginning on September 19 the Prussian army lays siege to Paris; it lasts until January 1871.

HATS & FASHION

Hats come back into fashion after being supplanted by the bonnet in the 1860s; they are usually small, flat, and round, worn on top of the head or pushed to the front, while bonnets are hoodlike and typically worn on the back of the head.

Caroline Reboux opens a millinery shop at 23, rue de la Paix—a street already known for its fashion and luxury items—after being "discovered" by Princess Pauline von Metternich.

1871

HISTORY & CULTURE

France surrenders to Prussia in January. The Treaty of Frankfurt is signed in May, which cedes control of Alsace-Lorraine to the newly formed German empire and outlines the details of France's reparation payments to Germany.

Adolphe Thiers is elected as provisional leader of France by the National Assembly in February; he becomes the first president of the republic in August.

On March 18, tensions in Paris following the end of the war give way to a violent insurrection, leading to the establishment of a radical republican government known as the Commune of Paris. The socialist Commune reigns for two months before being bloodily suppressed by the government. During this time Tissot moves to England.

PAINTING

Degas visits London and views an exhibition of French art organized by Paul Durand-Ruel.

Around this time he begins to complain of problems with his eyes, a condition that will plague him for the rest of his life.

HATS & FASHION

Prominent French fashion journals continue to be published during the war and the Commune, moving out of Paris to do so. *Le Moniteur de la mode*, which began in the 1840s, is published in Belgium, while *La Mode illustrée* illustrations are printed in Berlin.

Following the war and the Commune, French fashion turns decidedly demure, opting for simplicity and economy. Mourning costumes, though worn throughout the nineteenth century until about 1910, reach their height from 1860 to 1890. Etiquette guides and fashion plates helped navigate the extremely nuanced rules. Color (black signifying the deepest level, followed by purple or white) and choice in fabrics conveyed the intensity of mourning.

1872

PAINTING

By 1872 Degas moves his studio from the rue Laval (later rue Victor-Massé) in Montmartre to 77, rue Blanche nearby. He is introduced to Durand-Ruel, who has been showing and selling works by Manet, Claude Monet, and Camille Pissarro. In October he leaves for New Orleans with his brother René.

HATS & FASHION

Halle aux Chapeaux is established at 17, rue de Belleville, featuring inexpensive hats for men, women, and children. As a special offer, the store gives away a free beret with the purchase of a hat (as advertised in numerous posters by Jules Chéret; see cat. no. 43).

Often inspired by popular stage performances, milliners name bonnets after plays such as 1872's *Rabagas* by Victorien Sardou. A Rabagas bonnet has a rounded crown, narrow upturned brim, and veil, usually of black lace (see fig. 102).

Traditional Alsatian costumes become popular to honor the province lost to Germany. Especially popular are Alsatian bows; traditionally small bows on top of bonnets, toward the last quarter of the nineteenth century they become much larger, folded into shape and tied with smaller ribbons.

Ernest Cognacq and Marie-Louise Jaÿ open the *grand magasin* La Samaritaine, which will become the largest department store in Paris by the end of the century. It is based on the model of Au Bon Marché, which originally opened as a novelty shop in 1838 and expanded to become the first department store in 1852.

1873

HISTORY & CULTURE

The opera house Salle Le Peletier burns down.

On the heels of massive reparations to Germany, a long economic depression sets in, affecting the art market.

PAINTING

A group of artists—including Degas, Monet, Berthe Morisot, and Pissarro—form the Société Anonyme des Artistes. These artists

102 *Rabagas Bonnet*, plate from *Haute nouveauté de Paris*, 1873

are unified by their tendency to paint scenes of modern life in an "unfinished manner" that is not acceptable to the official Salon and by their desire for alternative, non-juried venues for exhibitions.

Monet introduces Renoir to Durand-Ruel.

HATS & FASHION

Women's costume becomes luxurious again, with especially extravagant trimmings. Often, dresses and hats are personalized based on the wearer's preference.

Bonnets adorned with crowns of flowers are popular, as noted by historian Augustin Challamel (see 1875).

1874

PAINTING

The first exhibition of the Société Anonyme des Artistes opens on April 15 at 35, boulevard des Capucines, in the former studio of the photographer Nadar. It is organized by Degas, Monet, Pissarro, and Renoir. Of the 165 works in the exhibition, Degas shows ten, Morisot nine, and Renoir seven. Despite being encouraged by Degas and Monet to join, Manet chooses not to participate in this or any other such exhibitions, opting instead to fight for recognition in the official Salons. Degas encourages Tissot to join the group and exhibit with them, but he ultimately never does. A hostile critic refers to the artists in the show as "Impressionists," a name that is taken up by the painters and their supporters; the show is later referred to as the first Impressionist exhibition.

After leaving Paris during the Franco-Prussian War and the Commune to travel through Italy and Spain, Mary Cassatt returns to Paris and settles at 19, rue Laval, close to Degas's studio in Montmartre.

Federico Zandomeneghi moves to Paris from Italy.

HATS & FASHION

The poet and critic Stéphane Mallarmé begins publication of the short-lived *La Dernière*

mode, an illustrated journal that explores fashion as art. Mallarmé visits various shops and theaters and describes the styles he finds on display.

Bertall (pseudonym for Charles-Albert d'Arnoux) publishes *La Comédie de notre temps* (The comedy of our times), which features caricatures of Parisian life, with an emphasis on fashion. Bertall also contributes cartoons to *La Vie parisienne*, teasing French women about their obsession with fashion.

Bonnets with a low crown and wide brim, decorated with plumes, become fashionable. "Merveilleuse" bonnets—with upturned brims lavishly decorated with plumes and especially flowers—are recommended for the spring (see fig. 103).

1875

HISTORY & CULTURE

The Palais Garnier, the new opera house under construction since 1861, opens in January.

The foundation stone of the church of Sacré-Coeur is laid in Montmartre. Construction is completed in 1914, but its consecration is delayed until 1919 due to the First World War.

A series of constitutional laws are passed to officially define the organization of the Third Republic.

PAINTING

Hôtel Drouot holds an unsuccessful auction of Impressionist works by Monet, Morisot, Renoir, and Alfred Sisley. Prices remain very low for their works.

Renoir paints his first *Modiste*, which shows a young girl trimming a hat with flowers (Oskar Reinhart Collection, Winterthur), illustrating his early interest in millinery and hat fashions. He goes on to create several other images of milliners and hat shops (see cat. nos. 7 and 8) but ultimately tends to focus on hats and fashion rather than the working *modiste*. Renoir also meets the publisher Georges Charpentier.

103 "Merveilleuse bonnet," upper-right illustration of plate featuring new hat models, *Le Moniteur de la mode*, March 2, 1874, 127. Bibliothèque nationale de France, Paris, FOL-LC14-85

HISTORY & CULTURE

Edmond Duranty publishes *La Nouvelle peinture* (The new painting). In it he suggests a range of subjects that could be treated in modern painting, including fashion shops and department stores.

PAINTING

The second Impressionist exhibition opens in March at Durand-Ruel's gallery at 11, rue le Peletier. Degas exhibits twenty-four works, including one titled *Modiste*, which is singled out by the critic Émile Porcheron for its "ugly" figures. The work's exact identity is unknown today.

Degas moves to a new studio at 4, rue Frochot, between the rue Laval and the place Pigalle in Montmartre.

HATS & FASHION

Publication begins for *La Modiste universelle*, featuring designs and models of the latest hat fashions. Descriptions of the hats are

HATS & FASHION

Charles Blanc, a prominent art historian and former director of the Académie des Beaux-Arts, publishes *L'Art dans la parure et dans le vêtement* (*Art in Ornament and Dress*), which outlines the history of fashion as well as the rules for dress, headwear, and accessories. This is part of a larger study, the *Grammaire des arts décoratifs* (Grammar of the decorative arts), which explores ornamentation in all its forms: personal adornment, domestic spaces, and public architecture. Blanc's treatment of personal ornament elevates the level of discourse on fashion, considering it alongside other forms of art.

Challamel also publishes the first edition of *Histoire de la mode en France* (*The History of Fashion in France*), tracing the development of women's fashion from the Gallo-Roman period to the Third Republic. He describes the rapidly changing styles of the late nineteenth century in considerable detail, illustrating the way fashion shifts from season to season.

As observed in Challamel's text, white bonnets become popular again after the several-year reign of black hats following the Franco-Prussian War and the Commune.

Historicized fashion styles are seen, borrowing from the Middle Ages, Renaissance, and Louis XIV periods, among others.

104 Marcellin Desboutin, *Degas Wearing a Hat*, 1876. Drypoint, 8¾ x 5¾ in. (22.3 x 14.5 cm). Fine Arts Museums of San Francisco, Museum purchase, gift of Mr. and Mrs. George D. Hart, 1985.1.31

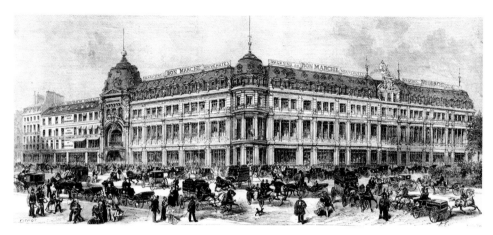

105 Michel-Charles Fichot, *The Bon Marché Department Stores*, ca. 1887. Engraving. Bibliothèque des arts décoratifs, Paris

provided in French, English, Italian, Spanish, and German.

The Au Bon Marché department store opens in its new building (see fig. 105).

1877

PAINTING

The third Impressionist exhibition opens on April 4 at 6, rue le Peletier, across from Durand-Ruel's gallery. Degas plays an extensive role in organizing the exhibition, and shows twenty-five works. Renoir shows twenty-one works. While Manet still does not participate, he lends three paintings from his own collection—two by Monet and one by Sisley—to the exhibition.

Degas rents an apartment at 50, rue Lepic in Montmartre. He visits Cassatt in her nearby studio and encourages her to show with the Impressionists.

Louise-Catherine Breslau moves to Paris from Switzerland and enrolls at the Académie Julian, one of the more inclusive academies. She trains alongside other women artists such as Mariya Bashkirtseff.

HATS & FASHION

Bonnets, often so covered in blossoms that they are said to resemble flower beds, are especially popular again in the mid- to late 1870s and into 1880. However, by the end of this year, flowers fall out of fashion, while plush, fur, and feathered hats are on the rise.

High-crowned hats with the brim upturned on one side, inspired by those in the paintings of Peter Paul Rubens, become especially popular (see fig. 106).

1878

HISTORY & CULTURE

The Exposition Universelle, Paris's third world's fair, is held May through November at the Palais de Trocadéro. Like the previous fairs, it features displays of fashion and accessories from France and around the world.

PAINTING

There is an exhibition of fine arts at the Exposition Universelle, but no Impressionist works are exhibited.

Degas is supportive of Zandomeneghi, who paints many of the same subjects as he does. He encourages the Italian artist to exhibit with the Impressionists.

The art critic Théodore Duret, a friend of Manet and a supporter of Impressionism,

publishes *Les Peintres impressionnistes* (The Impressionist painters), which focuses on several important members of the movement, including Monet, Morisot, and Renoir.

HATS & FASHION

Blanc publishes another study on women's fashion, "Considérations sur le vêtement des femmes" (Considerations on women's clothing), in the *Gazette des Beaux-Arts*.

1879

PAINTING

The fourth Impressionist exhibition is held at 28, avenue de l'Opéra, where Cassatt exhibits for the first time, along with Jean-Louis Forain and Zandomeneghi. Other artists who usually participate, including Renoir and Morisot, choose not to, in part because of a rule instituted by Degas that artists who exhibit in the Salon be excluded from the group show.

Charpentier founds *La Vie moderne*, a magazine and art gallery. Renoir has a one-man show here, and offers to create images of the

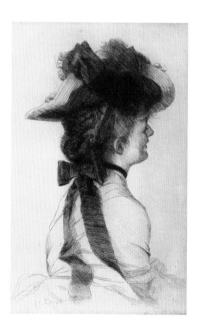

106 James Tissot, *The Rubens Hat*, 1875. Etching on laid paper, 10⅜ x 6¾ in. (26.5 x 17.2 cm). The Metropolitan Museum of Art, New York, Harris Bridbane Dick Fund, 1924, 24.73.4

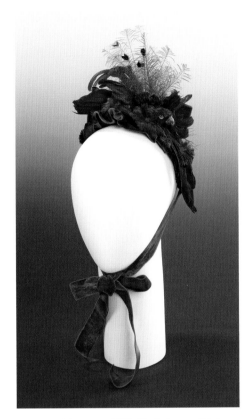

107 Woman's bonnet, ca. 1880. Silk, feathers, and bird. Brooklyn Museum Costume Collection at The Metropolitan Museum of Art, New York, Gift of the Brooklyn Museum, 2009; Gift of the Princess Viggo in accordance with the wishes of Misses Hewitt, 1931, 2009.300.1417

fashion industry for the magazine by visiting millinery shops and drawing hats from life, from different angles.

HATS & FASHION

A wide variety of hat styles are in fashion, ranging from small flowered bonnets to wide-brimmed plumed hats.

1880

HISTORY & CULTURE

In the 1880s Montmartre—which had been annexed by Paris in 1860—begins to attract working-class, bohemian, and liberal-leaning artists, writers, and students to the area. Rents are much lower here than in the city center.

PAINTING

The fifth Impressionist exhibition is held at 10, rue des Pyramides. There are eighteen participants, only six of whom showed in the 1874 group exhibition, including Degas and Morisot. The show is very poorly reviewed.

Renoir meets Aline Charigot, a *modiste* and daughter of a *couturière*. She becomes one of his frequent models and, later, his wife.

La Vie Moderne mounts a one-man exhibition of Manet's works in April.

HATS & FASHION

Jeanne Lanvin works as a *trottin* with Madame Bonni at 3, rue du Faubourg-Saint-Honoré.

Publication begins for *L'Art et la mode*, a newspaper founded by Ernest Hoschedé, a collector and supporter of Impressionism. Many of the Impressionists contribute illustrations of the fashions of the day.

Ostrich plumes come into prominent use in hats during the 1880s and will remain a major trimming material for nearly three decades. A new fad for using whole birds as hat embellishments starts (see fig. 107).

Cabriolet hoods, those that could be worn either over a bonnet or alone, are fashionable in the early months of 1880, due to an especially cold winter.

1881

HISTORY & CULTURE

Le Chat Noir nightclub and dance hall opens in Montmartre.

PAINTING

The sixth Impressionist exhibition is held in the same location as the first exhibition, on boulevard des Capucines, but in five small rooms in the back of the building. With just 170 works displayed, it is the smallest of the Impressionist exhibitions. Degas's invitations to his artist friends to show with the group causes conflict with other members, particularly Gustave Caillebotte. Caillebotte takes exception to the recruitment of Jean-François Raffaëlli—whom he believes to be less talented than the others—and ultimately refuses to participate in the show. However, works shown by Cassatt, Degas, and Morisot draw praise from critics.

Manet paints *At the Milliner's* (cat. no. 22), illustrating his interest in fashion and millinery. The painting relates to his numerous portraits of fashionable women, including famous actresses and high-society women such as Ellen Andrée, Jeanne Demarsy, and Méry Laurent.

Renoir meets Suzanne Valadon, a milliner's assistant and circus performer who later becomes an artist in her own right; she works as a model for him and other artists, including Morisot, Henri de Toulouse-Lautrec, and Pierre Puvis de Chavannes. She later meets Degas in the 1890s, and he encourages her art and purchases several of her drawings.

HATS & FASHION

Challamel publishes a revised and expanded edition of *Histoire de la mode en France*.

1882

HISTORY & CULTURE

The Union Générale bank crashes, causing one of the worst economic crises in France during the nineteenth century and nearly forcing the closure of the Paris Stock Exchange. Durand-Ruel is supported by this bank and plunges into severe financial trouble.

PAINTING

The seventh Impressionist exhibition is held at 251, rue Saint-Honoré. Some of the earlier participants rejoin the group, but Degas remains in conflict with Caillebotte and, in protest, chooses not to exhibit. His protégés, including Cassatt and Zandomeneghi, also do not participate.

Manet visits the salon of Madame Virot to select a hat for Demarsy to wear in his portrait *Jeanne (Spring)* (1881; fig. 84).

Degas produces his first dated milliner works. These include *Little Milliners* (fig. 6) and two works titled *At the Milliner's* (fig. 16 and cat. no. 13). By June he moves into a new apartment at 21, rue Pigalle.

In a letter to her friend Louise Havemeyer, Cassatt says she poses for Degas's millinery images.

Breslau meets Degas through Forain.

HATS & FASHION

The fedora, a soft felt hat with a wide brim, is introduced in Sardou's play *Fédora*, starring Sarah Bernhardt. The hat is originally worn by women but would become a popular style for men during the twentieth century.

1883

HISTORY & CULTURE

Émile Zola publishes *Au bonheur des dames* (*The Ladies' Paradise*), the eleventh novel in his Rougon-Macquart series. Based on his research at Parisian department stores, including Au Bon Marché and Les Grands Magasins du Louvre (founded in 1855), the novel explores their impact on smaller shops, as well as examining consumer culture and the psychology of shopping in the late nineteenth century.

PAINTING

An exhibition in London organized by Durand-Ruel shows several of Degas's works, including *At the Milliner's* (cat. no. 13), and receives positive reviews.

Manet dies in April.

HATS & FASHION

Lanvin works as an apprentice *modiste* for Madame Félix (15, rue du Faubourg-Saint-Honoré) and as *apprêteuse* and *garnisseuse* for Cordeau et Laugaudin (32, rue des Mathurins).

Jules Guillemet opens a high-end fashion boutique. He and his fashionable wife pose for several paintings by their friend Manet, including *In the Conservatory* (1879) and *Madame Guillemet* (1880; cat. no. 75).

Printemps department store re-opens after being destroyed by a fire in 1881. The store originally opened in 1865, following the model of other department stores like Au Bon Marché and Les Grands Magasins du Louvre (see fig. 108 and cat. no. 9).

108 Charles Lansiaux, *Printemps, boulevard Haussmann. Street façade. 9th arrondissement, Paris,* September 6, 1919. Gelatin silver print. Département Histoire de l'Architecture et Archéologie de Paris

1884

PAINTING

A memorial exhibition for Manet is held at the École des Beaux-Arts.

Toulouse-Lautrec resides at 19, bis rue Fontaine, in Montmartre. Degas lives and works in the same building.

1885

HATS & FASHION

Madame Virot retires, but her millinery shop at 12, rue de la Paix continues as Maison Virot.

Large bustles come back into fashion and, as silhouettes change, hats grow smaller to complement the style. Hats often feature narrow brims—or none at all—with flowers, feathers, and ribbons (see fig. 109).

PAINTING

The eighth and final Impressionist exhibition takes place at 1, rue Laffitte. Paul César Helleu declines an invitation from Degas to join the Impressionist exhibition; his refusal stems from his dislike of Paul Gauguin, who

began exhibiting with the Impressionists in 1879. Degas shows *Little Milliners* and *At the Milliner's* (ca. 1882; fig. 11) together and receives praise for their color and drawing. He also exhibits, among other pastels, *Portrait of Zacharian* (cat. no. 58). Also featured are Georges Seurat's *A Sunday on La Grande Jatte* (1884; Art Institute of Chicago)—which illustrates fashionable women in exaggerated bustles—and Paul Signac's *The Milliners* (1885–1886; fig. 7).

1886

HATS & FASHION

In the United States, the first Audubon Society chapter is founded in response to the slaughter of wild and exotic birds for fashion, part of the growing international protest against the use of feathers for hats and fashion. (Other chapters are established in 1896, and the national society is formed in 1905.) The society supports legislation in the US Congress to prevent the import and export of feathers, as France continues to promote feathers and birds as fashionable hat decorations.

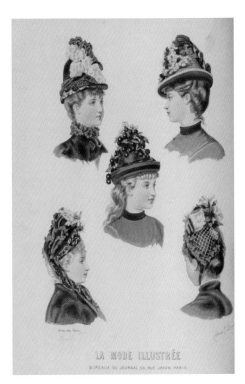

109 Anais Toudouze, *Hats by Mademoiselle Boitte, 4, rue d'Alger*, from *La Mode illustrée*, April 11, 1886. Bibliothèque nationale de France, Paris, FOL-LC14-130

110 *Fleuriste Workshop*, frontispiece from Ali Coffignon, *Les Coulisses de la mode* (Paris: Librairie illustrée, 1888). Bibliothèque nationale de France, Paris, 8-Z LE SENNE-3663

1887

HATS & FASHION

E. Motsch establishes his hat shop at 62, avenue de l'Alma (now avenue George V), where it still exists today (see cat. no. 61).

1888

PAINTING

Georges William Thornley produces a series of lithographs after works by Degas (see cat. no. 17), including images of *At the Milliner's* (fig. 16) as well as *In the Wings* (ca. 1881; cat. no. 60). Degas is involved in the reproduction of these images and their fidelity to his original works. Four of the lithographs are exhibited at Galerie Boussod, Valadon.

Sometime between 1888 and 1890, Degas moves to 18, rue de Boulogne (now rue Ballu).

HATS & FASHION

Ali Coffignon publishes *Les Coulisses de la mode* (Behind the scenes of fashion), a study detailing the history and work of the fashion industry, including *modistes/chapeliers*, *fleuristes* (see fig. 110), and *plumassiers*.

1889

HISTORY & CULTURE

The Eiffel Tower is inaugurated, and serves as the entrance to the Exposition Universelle (see fig. 111). The fair is held from May to October and commemorates the centennial anniversary of the storming of the Bastille.

The Moulin Rouge nightclub opens in Montmartre in October and becomes a popular venue for cancan and other dance performances. Toulouse-Lautrec is a frequent visitor and often depicts scenes of the dancers and patrons here.

PAINTING

The Exposition Universelle has a pavilion of fine art, with an exhibition organized by critic and politician Antonin Proust. Several

111 *The Eiffel Tower, View of the Exposition Gardens*, plate 47 from Octave Uzanne, *Les Modes de Paris* (Paris: Société française d'éditions d'art, 1898). Bibliothèque nationale de France, Paris

Impressionists agree to participate, including Monet and Jean Béraud, but Degas and Renoir decline.

Thornley's full set of lithographs after Degas's works is published.

HATS & FASHION

The Exposition Universelle features an exhibition of couture, hats, artificial flowers, plumes, and the products of many other trades within the fashion industry.

Lanvin opens her own millinery boutique on the rue Boissy-d'Anglas. She will open her fashion house, Maison Lanvin, at 22, rue du Faubourg-Saint-Honoré four years later.

Britain establishes the Royal Society for the Protection of Birds (see fig. 112). France is still resistant to calls for bird conservation and continues to use plumes and birds for fashion.

dress: some are wide brimmed and flat, often embellished with upright feathers, bird wings, and flowers, while others remain small and sit on the top of the head (see figs. 113–114).

112 *A Bird of Prey*, cartoon from *Punch*, May 14, 1892. Courtesy Punch Limited

1890

PAINTING

Degas travels in Burgundy with Georges Jeanniot, who is influenced by Degas in his own artwork (see cat. no. 94). During this trip Degas makes landscape monotypes. He also returns to the theme of millinery during the 1890s, with renewed focus on the working milliner. He moves to a studio at 37, rue Victor-Massé and remains there for more than twenty years.

Jane Avril becomes one of the stars of the Moulin Rouge and features prominently in works by Toulouse-Lautrec, often wearing elaborate hats.

HATS & FASHION

Maison Virot begins to collaborate with the House of Worth, creating full ensembles of dresses with matching headwear.

By the early 1890s, after approximately five years of dominating women's silhouettes, the bustle falls out of fashion and dresses become slimmer. As skirts become simpler, more emphasis is placed on the head and shoulders. Large *gigot* (leg-of-mutton) sleeves are fashionable. Hat styles vary with this new form of

1891

HATS & FASHION

Le Figaro publishes a feature on flowers in Paris, with a special section dedicated to flowers in fashion. Highlighted in the article is Maison Camille Marchais, considered one of the preeminent *fleuristes* in the city (see cat. no. 82). The article relays an anecdote about Marchais's silk flowers being disqualified from an international competition of artificial flowers because the judges believed them to be real. Also featured are some of the shop's most significant workers, including a Madame Patay and a Mademoiselle Suzanne—herself considered a "veritable artist in every sense of the word."

1892

PAINTING

Degas's *At the Milliner's* (fig. 11) is exhibited in London and Glasgow and generates a great deal of interest. It is praised by critics for its color and novelty, particularly the "snapshot" effect of the milliner being cut off by the mirror.

HATS & FASHION

Léon Virot, a son of the famous milliner Madame Virot and founder of the establishment Maison Nouvelle at 1, rue de la Paix, sues Berthe Raymond—Madame Virot's former *première* and business partner with another son, Paul Virot, in the shop Paul Virot & Berthe (see cat. no. 35)—for continuing to use the Virot name after Paul's death.

113 *Summer 1891*, plate from *Le Caprice*, no. 7 (April 1, 1891). Bibliothèque nationale de France, Paris, FOL-LC14-42

114 *Winter 1891*, plate from *Le Caprice*, no. 19 (October 1, 1891). Bibliothèque nationale de France, Paris, FOL-LC14-4

1894

HISTORY & CULTURE

The trial of Alfred Dreyfus, a French army captain of Jewish descent accused and convicted of selling military secrets to the Germans, begins. The trial causes divisions in France between Dreyfus supporters—called Dreyfusards—and anti-Semitic opponents, and tensions remain until 1906. Degas is staunchly opposed to Dreyfus.

PAINTING

Julie Manet reports seeing Degas's pastel *At the Milliner's* (1882; fig. 61) at the Martin et Camentron gallery in Paris. The pastel is reacquired by Durand-Ruel this year and eventually makes its way to his gallery in New York, where it is purchased by the Havemeyers. Cassatt had been instrumental in encouraging the Havemeyers to collect Degas's work.

Renoir meets Marie Dupuis (called Madame Dupuy or La Boulangère), an artificial flower worker who becomes his frequent model until around 1910.

1895

HISTORY & CULTURE

The Lumière brothers (Auguste and Louis) create the first motion-picture film camera, the *cinématographe*; the first projected movie is shown in France. The *cinématographe* will later be used to film events at the 1900 Exposition Universelle.

PAINTING

Morisot dies in March.

Publication begins of *Les Maîtres de l'affiche* (The masters of the poster), a series dedicated to the art of the illustrated poster. During its run, it features more than 240 posters and lithographs by prominent French and international poster artists and printmakers, especially Chéret and Toulouse-Lautrec (see cat. no. 45).

115 *The Day of the Grand Prix of Paris: The Racetrack, 1895*, plate from Uzanne, *Les Modes de Paris*. Bibliothèque nationale de France, Paris

HATS & FASHION

Hats in the mid-1890s come in a wide range of styles, including boaters, toques (small hats with narrow brims), and *bergères* (large, flat straw hats often covered with flowers and based on eighteenth-century hat styles).

The vogue for women's skirts is bell-shaped, and hats grow in size to balance the silhouette (see fig. 115).

Between 1895 and 1900, ground-level shops become highly desirable, as they allow greater access. Haute couture shops begin to move to the ground floor and take advantage of storefront windows to display their wares.

1896

PAINTING

Along with Manet's *In the Conservatory* and sixteen other Impressionist works, Degas's *The Conversation* (ca. 1884) is sold to the Nationalgalerie, Berlin. It is Degas's first work to enter a German public collection.

Durand-Ruel holds a memorial exhibition of Morisot featuring her work. Degas, along with Monet and Renoir, hangs many of the works for the show.

HATS & FASHION

The large *gigot* sleeves that had been popular since the beginning of the 1890s suddenly fall out of fashion for formal wear.

1898

HISTORY & CULTURE

Zola publishes the letter "J'accuse" in the newspaper *L'Aurore* in support of Dreyfus, accusing the French military of covering up the mistakes it made in convicting Dreyfus in 1894. This forces a reopening of the case.

PAINTING

Degas paints *The Milliners* (cat. no. 90), which betrays an increasing formal abstraction compared to earlier *modiste* works.

HATS & FASHION

Octave Uzanne publishes his study of women's fashion in the nineteenth century, *Les Modes de Paris, variations du goût et de l'esthétique de la femme, 1797–1897 (Fashion in Paris: The Various Phases of Feminine Taste and Aesthetics from 1797 to 1897,* see figs. 111 and 115), considered one of the most thorough examinations of fashion of its time. Uzanne had also published earlier studies of fashion accessories, including fans, parasols, and gloves.

1900

HISTORY & CULTURE

The Exposition Universelle is held for a fifth time in Paris, from April to November. It is greatly expanded from previous years, with pavilions located in two regions: the first in the Palais de Trocadéro, Champ de Mars, and Esplanade des Invalides on the west, and the second in the Bois de Vincennes park to the east of the city. The massive exhibition features new technologies such as the

diesel engine and introduces the world to Art Nouveau through the design of many structures and pavilions. In association with the fair, Paris's new subway system, Le Métropolitain, opens.

PAINTING

The Centenary Exhibition of French Art is held at the Exposition Universelle and includes two rooms of Impressionist works. The rooms are organized by Roger Marx, an important art critic and collector.

HATS & FASHION

The Exposition Universelle again features aspects of the fashion industry, including hats from numerous *modistes*, as well as trimmings such as artificial flowers and feathers. The costume pavilion includes a replica of a House of Worth fitting room.

Between 1900 and 1904, the Atelier Nadar produces the series *Modes* of photographs of fashionably dressed women; it includes numerous models of hats by famous milliners (Virot, Leontine, Pouyanne, and Marescot among them).

116 Cover of *La Mode illustrée* 45, no. 14 (April 3, 1904). FIDM Library Special Collections

117 Cover of the first issue of *Les Modes*, January 1901. Bibliothèque nationale de France, Paris, FOL-V-4312

The S-silhouette is introduced into women's fashion (see fig. 116). Flat plateau hats over high chignons are worn over ensembles of puffed bodices, narrow wasp waists, and full skirts that end with a slight train.

1901

PAINTING

Toulouse-Lautrec dies in September.

HATS & FASHION

Publication begins for *Les Modes*, a new monthly illustrated magazine that features some of the first fashion photographs, as well as features on important painters and designers of the day (see fig. 117).

Photography is used to create fashion postcards, which become popular in the early twentieth century.

1902

HATS & FASHION

Arsène Alexandre publishes *Les Reines de l'aiguille* (Queens of the needle trade), a study of Parisian *modistes* and *couturières* (see fig. 118).

Hats in vogue are divided into two main styles: one large and relatively flat, often covered with flowers, the other featuring wide brims turned up dramatically, usually decorated with plumes.

1904

PAINTING

Les Modes publishes drawings by various artists including Helleu and poster artist and fashion illustrator Félix Fournery, and also occasionally runs features on painters. Gustave Geffroy writes an article on Cassatt, published in February. An article on Breslau, written by Gabriel Mourey, appears in June.

HATS & FASHION

Les Modes publishes a highlight on Madame Alphonsine ("Une grande modiste au XXe siècle") in October (see fig. 2), who had recently established her shop at 15, rue de la Paix.

The tricorne hat—a felt hat with a broad brim that is folded or pinned up to form a triangle shape—becomes very popular and receives garnitures of all different sorts. Large hats based on seventeenth- and eighteenth-century styles are also frequently seen.

1905

PAINTING

Around 1905–1910, Degas produces his last milliner work, *At the Milliner's* (cat. no. 91).

HATS & FASHION

La Samaritaine department store reopens after a redesign and expansion. Its new design by Frantz Jourdain, a Belgian architect and designer, is heavily influenced by Art Nouveau.

After complaints about the massive hats women are wearing to performances, some theaters ban hats. In response to the controversy that ensues, Countess Greffulhe—herself a renowned beauty and salon

118 *Millinery Salon*, plate from Arsène Alexandre, *Les Reines de l'aiguille* (Paris: T. Belin, 1902). New York Public Library, Spencer Coll. French 1902

119 Paul Poiret, "La Rosière" dress, 1911. Linen. The Metropolitan Museum of Art, New York, Catharine Breyer Van Bomel Foundation Fund, 2005, 2005.188

hostess—founds the Ligue des petits chapeaux (League of small hats). As a result, theater hat fashions evolve into small poufs embellished with sequins or feathers.

1906

HISTORY & CULTURE

The Dreyfus Affair finally comes to an end with Dreyfus's exoneration and reinstatement into the army. Dreyfus had been found guilty by a second military court martial in 1899—even after evidence implicating other officers had come to light—but had been pardoned by the president.

HATS & FASHION

After opening his own fashion house in 1903, Paul Poiret introduces his *Directoire* revival collection, which dramatically changes women's silhouettes. His style features high waistlines, soft fabric, and narrow, flowing lines—most notably eliminating the corset from women's fashion (see fig. 119).

1907

HISTORY & CULTURE

France, Great Britain, and Russia form an alliance called the Triple Entente, stemming from existing pacts between France and Russia (from 1894) and France and Britain (1904). It is formed in response to the Triple Alliance of 1882 between Germany, Austria-Hungary, and Italy, which pledges mutual military support if other members are threatened.

The Lumière brothers develop the first successful method of color photography.

PAINTING

Degas is still working, creating pastels and sculptures, but his eyesight continues to fail.

HATS & FASHION

Hat styles reach immense proportions and essentially remain large until the beginning of the First World War. The ideal feminine silhouette shifts from an S-shape to an I-shape,

120 Promenade dress, from *La Mode illustrée* 52, no. 4 (January 22, 1911). FIDM Library Special Collections

as gowns become slimmer and hats grow ever larger (see fig. 120).

1908

HATS & FASHION

The small, fitted cloche hat is said to have been invented by milliners Caroline Reboux and Lucie Hamar. It goes on to become one of the most popular hat styles of the 1920s.

1910

HISTORY & CULTURE

Advances in aviation in France, including a successful flight across the English Channel by the aviator and inventor Louis Blériot in 1909, lead to the development of the first national air force.

HATS & FASHION

By 1910 Madame Georgette establishes her shop at 1, rue de la Paix.

The book *Les Créateurs de la mode* (The Creators of fashion) by Léon Roger-Milès is published, featuring Madame Georgette (see

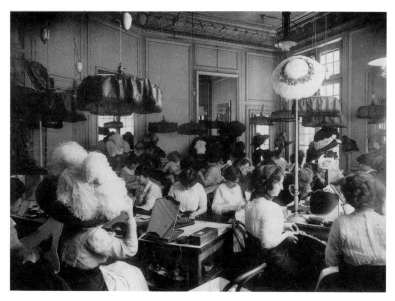

121 G. Agie, *Salon of Madame Georgette*, from Léon Roger-Milès, *Les Créateurs de la mode* (Paris: 1910), 68. Philadelphia Museum of Art library, Rare Books

122 G. Agie, *Workroom of Madame Georgette*, from Roger-Milès, *Les Créateurs de la mode*, 155. Philadelphia Museum of Art library, Rare Books

figs. 121–122). The popular picture hat—a massive broad-brimmed hat usually embellished with flowers or plumes—is one of Madame Georgette's signature styles.

After opening a small millinery shop in the apartment of her friend Etienne Balsan in 1909, Gabrielle "Coco" Chanel moves her shop to 21, rue Cambon and works exclusively as a milliner until 1913. She refers to current hat styles as "enormous pies" filled with feathers and fruit, and aims to create a new style of hats characterized by simplicity and elegance, often using a single plume as decoration (fig. 123).

1912

HISTORY & CULTURE

Auguste Ménégaux, an ornithologist at the Muséum national d'histoire naturelle, cofounds the Ligue pour la protection des oiseaux (League for the protection of birds), a society dedicated to the preservation of birds in France. This comes one year after Ménégaux published his study on the plumage trade, *La Protection des oiseaux et l'industrie plumassière* (*Bird Protection and the Feather Trade*).

PAINTING

Degas is forced to move from his studio on the rue Victor-Massé. Valadon helps him find a

new apartment at 6, boulevard de Clichy, but he effectively gives up painting and drawing at this time.

1913

HISTORY & CULTURE

Marcel Proust publishes the first of six volumes of *À la recherche du temps perdu* (*Remembrance of Things Past*); the character of Elstir, an Impressionist painter, is based on a conflation of Helleu, Monet, Gustave Moreau, Édouard Vuillard, and James McNeill

123 Coco Chanel wearing a hat of her own design, in *Comoedia Illustré*, October 1, 1910, 28. Bibliothèque nationale de France, Paris, Département littérature et art, FOL-YF-183

Whistler. Fashion and painting play important roles in this and other novels published by Proust.

HATS & FASHION

Ostrich plumes reach their peak in both price and popularity on the international market. In the previous year, France had imported nearly eight million francs worth of ostrich plumes to be used in millinery and fashion shops.

The continued use of plumage in headwear is mocked by caricaturists, particularly the artist Sem (pseudonym of Georges Goursat), himself a friend of Helleu, Marcel Proust, and Chanel (fig. 124).

1914

HISTORY & CULTURE

The First World War breaks out after Archduke Franz Ferdinand, heir to the throne of Austria-Hungary, is assassinated in Sarajevo in June. In July Austria-Hungary declares war on Russian-backed Serbia. More countries are pulled into the conflict: Germany, an ally to Austria-Hungary, declares war on Russia on August 1 and France on August 3. The German army invades neutral Belgium on August 4 as part of its plan to

swiftly attack France in the following days. In response to the invasion, Britain declares war on Germany.

HATS & FASHION

Many *couturières* and *modistes*, including Lanvin, Poiret, and Worth, assist in the war effort. Poiret, stationed in Bordeaux, oversees the production of uniforms for soldiers, while his shop employees make sheets, shirts, and bandages.

Hat fashions take on a military look, often using materials and colors closely associated with military uniforms and utilizing forms like the bicorne and tricorne in hat designs (see figs. 125–126).

Sem publishes the album *Le vrai et le faux chic* (The true and false chic), mocking contemporary fashions.

The international ostrich-feather market crashes due to changes in fashion trends as well as bird preservation laws. This same year, Edmond Lefèvre publishes *Le Commerce et l'industrie de la plume pour parure* (The commerce and industry of feathers for ornamentation), outlining the history of the plumage trade in Paris and the world.

1915

HISTORY & CULTURE

Sacha Guitry, a playwright, releases a documentary film *Ceux de chez nous* (Those of our land) featuring prominent artistic figures of the nineteenth and twentieth centuries. The film includes short clips of Degas (see fig. 25), Monet, and Renoir.

HATS & FASHION

Fashion houses in Paris reopen after the outbreak of the war. Shops owned by women are the first to open their doors again, as many male *couturiers* are still deployed. Among the first stores to reopen are Lanvin and Callot Soeurs.

1917

PAINTING

Degas dies in September. More than one hundred people attend his funeral, including Breslau, Cassatt, Forain, Monet, and Zandomeneghi.

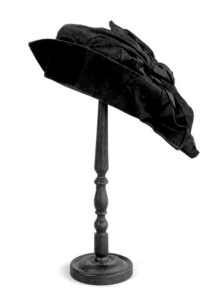

125 Madame Georgette, woman's bicorne hat, 1914. Felt *taupé* and satin. Palais Galliera, musée de la mode de la Ville de Paris, GAL1958.17.3

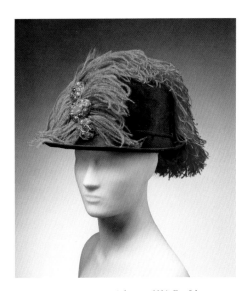

126 Jeanne Lanvin, woman's hat, ca. 1914. Fur felt, paste jewels, and ostrich feathers, 8¾ x 12½ x 6 in. (22.2 x 31.8 x 15.2 cm). Philadelphia Museum of Art, Gift of Margaretta S. Hinchman, 1951, 1951-21-13

124 Sem, *Marcelle Demay*, from the album *Sem à la mer bleue*, 1913. Lithograph, 12½ x 18 in. (31.7 x 45.8 cm). Musée Carnavalet, Paris, CARG020662-08verso

SELECTED BIBLIOGRAPHY

Adhémar, Jean, and Françoise Cachin. *Degas: The Complete Etchings, Lithographs and Monotypes*. New York: Viking Press, 1974.

Adriani, Götz. *Degas: Pastels, Oil Sketches, Drawings*. Exh. cat. Translation of *Edgar Degas* by Alexander Lieven. New York: Abbeville Press, 1985.

Alexandre, Arsène. *Les Reines de l'aiguille: Modistes et couturières*. Paris: Théophile Belin, 1902.

Allan, Scott. "Degas's *Milliners* and the Craft of Painting." Lecture presented at the Getty Center, Los Angeles, November 20, 2011.

Amphlett, Hilda. *Hats: A History of Fashion in Headwear*. Chalfont St. Giles, UK: Sadler, 1974. Reprint, Mineola, NY: Dover Publications, 2003.

Armstrong, Carol. *Odd Man Out: Readings of the Work and Reputation of Edgar Degas*. Chicago: University of Chicago Press, 1991.

———. "Reflections on the Mirror: Painting, Photography, and the Self-Portraits of Edgar Degas." *Representations* 22 (Spring 1988): 108–141.

Art in the Making: Degas. Exh. cat. London: National Gallery, 2004.

Artisans de l'élégance. Exh. cat. Paris: Réunion des musées nationaux, 1993.

Bailey, Colin B. *Renoir, Impressionism, and Full-Length Painting*. Exh. cat. New York: Frick Collection; and New Haven, CT: Yale University Press, 2012.

———, and Stephanie Buck, eds. *Master Drawings from the Courtauld Gallery*. Exh. cat. London: Courtauld Gallery and Paul Holberton Publishing, 2012.

Balducci, Temma, and Heather Belnap Jensen, eds. *Women, Femininity and Public Space in European Visual Culture, 1789–1914*. Farnham, UK: Ashgate, 2014.

Barter, Judith A., ed. *Mary Cassatt: Modern Woman*. Exh. cat. Chicago: Art Institute of Chicago; and New York: H. N. Abrams, 1998.

Baumann, Felix, and Marianne Karabelnik, eds. *Degas: Portraits*. Exh. cat. Zurich: Kunsthaus; and London: Merrell Holberton, 1994.

Benoist, Charles. *Les Ouvrières de l'aiguille à Paris: Notes pour l'étude de la question sociale*. Paris: L. Chailley, 1895.

Berson, Ruth, ed. *The New Painting: Impressionism, 1874–1886. Documentation*. 2 vols. San Francisco: Fine Arts Museums of San Francisco, 1996.

Birds of Paradise: Plumes and Feathers in Fashion. Exh. cat. Antwerp: Modemuseum; and Tielt: Lannoo, 2014.

Blanc, Charles. *Art in Ornament and Dress*. Translation of *L'Art dans la parure et dans le vêtement*. New York: Scribner, Welford, and Armstrong, 1877.

Blanchon, H.-L. Alphonse. *L'Industrie des fleurs artificielles et des fleurs conservées*. Paris: J.-B. Baillière et Fils, 1900.

Blum, Dilys E. *Ahead of Fashion: Hats of the 20th Century*. Exh. cat. *Bulletin* (Philadelphia Museum of Art) 89, nos. 377/378 (Summer–Autumn 1993): 1, 4–48.

———. *Illusion and Reality: Fashion in France 1700–1900*. Exh. cat. Houston: Museum of Fine Arts, 1986.

Boggs, Jean Sutherland. *Degas*. Artists in Focus. Chicago: Art Institute of Chicago, 1996.

———. *Drawings by Degas*. Exh. cat. St. Louis: City Art Museum of Saint Louis, 1966.

———. *Portraits by Degas*. California Studies in the History of Art, no. 2. Berkeley: University of California Press, 1962.

———, and Anne Maheux. *Degas Pastels*. New York: G. Braziller, 1992.

———, ed. *Degas*. Exh. cat. New York: Metropolitan Museum of Art; and Ottawa: National Gallery of Canada, 1988.

———, ed. *Degas at the Races*. Exh. cat. Washington, DC: National Gallery of Art, 1998.

Bolomier, Éliane. *Cent ans de chapeaux, 1870–1970*. Exh. cat. Chazelles-sur-Lyon, France: Musée du chapeau, 1993.

———. *Chapeaux, mode et savoir-faire*. Riom, France: De Borée, 2014.

———. *Le Chapeau: Grand art et savoir-faire*. Chazelles-sur-Lyon, France: Musée du chapeau; and Paris: Somogy, 1996.

Boxer, Marilyn J. "Women in Industrial Homework: The Flowermakers of Paris in the Belle Époque." *French Historical Studies* 12, no. 3 (Spring 1982): 401–423.

Brame, Philippe, and Theodore Reff, eds. *Degas et son oeuvre: A Supplement*. New York: Garland, 1984.

Breeskin, Adelyn Dohme. *Mary Cassatt: A Catalogue Raisonné of the Oils, Pastels, Watercolors, and Drawings*. Washington, DC: Smithsonian Institution Press, 1970.

Brettell, Richard R., and Suzanne Folds McCullagh, eds. *Degas in the Art Institute of Chicago*. Chicago: Art Institute of Chicago; and New York: Harry N. Abrams, 1984.

Brevik-Zender, Heidi. *Fashioning Spaces: Mode and Modernity in Late Nineteenth-Century Paris*. Toronto: University of Toronto Press, 2014.

Brion, Katie Hartsough. "Eugène Atget and the Fin de Siècle Interior: Revelatory Excess." *Bulletin of the University of Michigan Museums of Art and Archaeology*, no. 16 (2005–2006): 49–74.

Broude, Norma. "Degas's 'Misogyny.'" *Art Bulletin* 59, no. 1 (March 1977): 95–107.

Brown, Marilyn. *Degas and the Business of Art: "A Cotton Office in New Orleans"*. University Park: Pennsylvania State University Press, 1994.

Burnham, Helen. "Fashion and the Representation of Modernity: Studies in the Late Work of Édouard Manet (1832–1883)." Ph.D. diss., Institute of Fine Arts, New York University, 2007.

Burns, Thea, and Philippe Saunier. *The Art of the Pastel*. Translation of *Art du pastel* by Elizabeth Heard. New York: Abbeville Press, 2014.

Calahan, April. *Fashion Plates: 150 Years of Style*. Ed. Karen Trivette Cannell. New Haven, CT: Yale University Press, 2015.

Callen, Anthea. *The Spectacular Body: Science, Method, and Meaning in the Work of Degas*. New Haven, CT: Yale University Press, 1995.

Castleman, Riva, and Wolfgang Wittrock, eds. *Henri de Toulouse-Lautrec: Images of the 1890s*. Exh. cat. New York: Museum of Modern Art, 1985.

Catalogue des tableaux, pastels et dessins par Edgar Degas et provenant de son atelier. 4 vols. Paris: Galerie Georges Petit, 1918–1919.

Challamel, Augustin. *Histoire de la mode en France: La toilette des femmes depuis l'époque gallo-romaine jusqu'à nos jours*. Paris: Hennuyer, 1881.

Clark, Fiona. *Hats*. London: B. T. Batsford, 1982.

Clausen, Meredith L. "Department Stores and Zola's *Cathédrale du commerce moderne*." *Notes in the History of Art* 3, no. 3 (Spring 1984): 18–23.

Clayson, Hollis. *Painted Love: Prostitution in French Art of the Impressionist Era*. New Haven, CT: Yale University Press, 1991. Reprinted in 2003 by the Getty Research Institute, Los Angeles.

Coffignon, A. *Les Coulisses de la mode*. Paris: Librairie illustrée, 1888.

Coffin, Judith G. *The Politics of Women's Work: The Paris Garment Trades, 1750–1915*. Princeton, NJ: Princeton University Press, 1996.

Collins, Bradford R. "Jules Chéret and the Nineteenth-Century French Poster." Ph.D. diss., Yale University, 1980.

Coquiot, Gustave. *Degas*. Paris: Librairie Ollendorff, 1924.

———. *Renoir*. Paris: Albin Michel, 1925.

Crane, Diana. *Fashion and its Social Agendas: Class, Gender, and Identity in Clothing*. Chicago: University of Chicago Press, 2000.

Crisci-Richardson, Roberta. *Mapping Degas: Real Spaces, Symbolic Spaces and Invented Spaces in the Life and Work of Edgar Degas (1834–1917)*. Newcastle upon Tyne, UK: Cambridge Scholars Publishing, 2015.

Daniel, Malcolm, ed. *Edgar Degas, Photographer*. Exh. cat. New York: Metropolitan Museum of Art, 1998.

D'Anspach, Maria. "La Modiste" (1841). In *Les Français peints par eux-mêmes: Encyclopédie morale du dix-neuvième siècle*, ed. Pierre Bouttier, vol. 2 (1840–1842; reprint, Paris: Omnibus, 2003), 193–202.

Dauberville, Guy-Patrice and Michel. *Renoir: Catalogue raisonné des tableaux, pastels, dessins et aquarelles*. 4 vols. Paris: Editions Bernheim-Jeune, 2007–2012.

David, Alison Matthews. *Fashion Victims: The Dangers of Dress Past and Present*. London: Bloomsbury Visual Arts, 2015.

Degas, Edgar. *Degas Letters*. Ed. Marcel Guérin. Trans. Marguerite Kay. Oxford: Bruno Cassirer, 1947.

———. *Lettres de Degas*. Ed. Marcel Guérin. Paris: Éditions Bernard Grasset, 1931. New edition, Paris: Bernard Grasset, 1945.

Degas inédit. Actes du Colloque Degas, Musée d'Orsay, Paris, April 18–21, 1988. Paris: La Documentation Française, 1989.

Degas' Racing World: A Loan Exhibition of Paintings, Drawings and Bronzes. Exh. cat. New York: Wildenstein, 1968.

Degas: Un peintre impressionniste? Exh. cat. Giverny: Musée des impressionnismes Giverny; and Paris: Editions Gallimard, 2015.

DeGroat, Judith Ann. "The Working Lives of Women in the Parisian Manufacturing Trades, 1830–1848." Ph.D. diss., University of Rochester, 1991.

Delpierre, Madeleine. *Restauration, Louis-Philippe, Second Empire, Belle Époque*. Vol. 6 of *Le Costume*. Paris: Flammarion, 1990.

DeVonyar, Jill, and Richard Kendall. *Degas and the Dance*. Exh. cat. New York: American Federation of Arts and Harry N. Abrams, 2002.

Dini, Francesca. *Il mondo di Zandomeneghi: Dai Macchiaioli agli impressionisti*. Florence: Edizioni Polistampa, 2004.

Dorsey, Hebe. *Age of Opulence: The Belle Epoque in the Paris Herald, 1890–1914*. New York: Harry N. Abrams, 1987.

Doughty, Robin W. *Feather Fashions and Bird Preservation: A Study in Nature Protection*. Berkeley: University of California Press, 1975.

D'Souza, Aruna. "Why the Impressionists Never Painted the Department Store." In *The Invisible Flâneuse? Gender, Public Space, and Visual Culture in Nineteenth-Century Paris*. Ed. D'Souza and Tom McDonough. Manchester: Manchester University Press, 2006.

Düchting, Hajo. *Edouard Manet: Images of Parisian Life*. Munich: Prestel, 1995.

Dumas, Ann, ed. *The Private Collection of Edgar Degas*. Exh. cat. New York: Metropolitan Museum of Art, 1997.

Edgar Degas (1834–1917). Exh. cat. Tokyo: Tokyo Shimbun, 1988.

Edgar Degas: The Many Dimensions of a Master French Impressionist. Exh. cat. Dayton: Dayton Art Institute, 1994.

Eiling, Alexander B., ed. *Degas: Klassik und Experiment*. Exh. cat. Munich: Hirmer; and Karlsruhe, Germany: Staatliche Kunsthalle, 2014.

Einecke, Claudia, and Sylvie Patry, eds. *Renoir in the 20th Century*. Exh. cat. Ostfildern, Germany: Hatje Cantz, 2010.

Fernandez, Rafael, and Alexandra R. Murphy. *Degas in the Clark Collection*. Exh. cat. Williamstown, MA: Sterling and Francine Clark Art Institute, 1987.

Fevre, Jeanne. *Mon oncle Degas*. Geneva: Pierre Caillier, 1949.

Garb, Tamar. *Bodies of Modernity: Figure and Flesh in Fin-de-Siècle France*. New York: Thames & Hudson, 1998.

———. *The Body in Time: Figures of Femininity in Late Nineteenth-Century France*. Lawrence: Spencer Museum of Art, University of Kansas; and Seattle: University of Washington Press, 2008.

Giffard, Pierre. *Les Grands bazars: Paris sous la Troisième République*. Paris: Victor Havard, 1882.

Goody, Jack. *The Culture of Flowers*. Cambridge: Cambridge University Press, 1993.

Gordon, Robert, and Andrew Forge. *Degas*. New York: Harry N. Abrams, 1988.

Groom, Gloria, ed. *Impressionism, Fashion, and Modernity*. Exh. cat. Chicago: Art Institute of Chicago; New York: Metropolitan Museum of Art; and Paris: Musée d'Orsay, 2012.

Grossiord, Sophie, et al. *Roman d'une garde-robe: Le chic d'une Parisienne de la Belle Époque aux années 30*. Exh. cat. Paris: Paris Musées, les musées de la Ville de Paris, 2013.

Halévy, Daniel, ed. *Degas parle. . . .* Paris: La Palatine, 1960.

Hauptman, Jodi, ed. *Degas: A Strange New Beauty*. Exh. cat. New York: Museum of Modern Art, 2016.

Havemeyer, Louisine W. *Sixteen to Sixty: Memoirs of a Collector*. New York: Privately printed for the family of Mrs. H. O. Havemeyer and the Metropolitan Museum of Art, 1961.

Hiner, Susan. *Accessories to Modernity: Fashion and the Feminine in Nineteenth-Century France*. Philadelphia: University of Pennsylvania Press, 2010.

Hofmann, Werner. *Degas: A Dialogue of Difference*. Translation of *Degas und sein Jahrhundert* by David H. Wilson. London: Thames and Hudson, 2007.

Ireson, Nancy, ed. *Toulouse-Lautrec and Jane Avril: Beyond the Moulin Rouge*. Exh. cat. London: Courtauld Gallery and Paul Holberton, 2011.

Iskin, Ruth E. *Modern Women and Parisian Consumer Culture in Impressionist Painting*. Cambridge: Cambridge University Press, 2007.

———. *The Poster: Art, Advertising, Design, and Collecting, 1860s/1900s*. Hanover, NH: Dartmouth College Press, 2014.

Ives, Colta. "French Prints in the Era of Impressionism and Symbolism." *Metropolitan Museum of Art Bulletin*, n.s. 46, no. 1 (Summer 1988): 1, 8–56.

———. Susan Alyson Stein, and Julie A. Steiner, eds. *The Private Collection of Edgar Degas: A Summary Catalogue*. New York: Metropolitan Museum of Art, 1997.

Jeanniot, Georges. "Souvenirs sur Degas." *La Revue universelle* 55, no. 14 (October 15, 1933): 152–174; and 55, no. 15 (November 1, 1933): 280–304.

Johnston, Lucy. *Nineteenth-Century Fashion in Detail*. London: V&A Publications, 2005.

Jones, Kimberly A., ed. *Degas/Cassatt*. Exh. cat. Washington, DC: National Gallery of Art; and Munich: Prestel/DelMonico Books, 2014.

Jones, Stephen, and Oriole Cullen. *Hats: An Anthology by Stephen Jones*. Exh. cat. London: V&A Publications, 2009.

Joslin, Katherine. *Edith Wharton and the Making of Fashion*. Durham: University of New Hampshire Press; and Hanover: University Press of New England, 2009.

Julia, Isabelle, ed. *The Modern Woman: Drawings by Degas, Renoir, Toulouse-Lautrec and Other Masterpieces from the Musee d'Orsay, Paris*. Exh. cat. Vancouver: Vancouver Art Gallery; and Paris: Musée d'Orsay, 2010.

Kendall, Richard. *Degas: Beyond Impressionism*. Exh. cat. London: National Gallery; and Chicago: Art Institute of Chicago, 1996.

———, ed. *Degas: Images of Women*. Exh. cat. London: Tate Gallery, 1989.

———, and Jill DeVonyar. *Degas and the Ballet: Picturing Movement*. Exh. cat. London: Royal Academy of Arts, 2011.

Kessler, Marni Reva. *Sheer Presence: The Veil in Manet's Paris*. Minneapolis: University of Minnesota Press, 2006.

Kinsman, Jane, and Stéphane Guégan. *Toulouse-Lautrec: Paris and the Moulin Rouge*. Exh. cat. Canberra: National Gallery of Australia, 2012.

Kliot, Jules, ed. *Millinery and Fashion 1891: From* Le Caprice, Les Modes de l'enfance réunis *and* Société des journaux de modes réunis. Berkeley, CA: Lacis Publications, 2005.

Kliot, Jules and Kaethe, eds. *Millinery Feathers, Fruits and Flowers*. Berkeley, CA: Lacis Publications, 2000.

Lafond, Paul. *Degas*. 2 vols. Paris: H. Floury, 1918–1919.

Lees, Sarah, ed. *Nineteenth-Century European Paintings at the Sterling and Francine Clark Art Institute*. 2 vols. Williamstown, MA: Sterling and Francine Clark Art Institute, 2012.

Lefèvre, Edmond. *Le Commerce et l'industrie de la plume pour parure*. Paris: Chez l'auteur, 1914.

Le Maux, Nicole. *Histoire du chapeau féminin: Modes de Paris*. Paris: Massin, 2000.

Lemoisne, Paul-André. *Degas et son oeuvre*. 4 vols. Paris: Paul Brame and C. M. de Hauke, 1946–1948.

Leniston, Florence, ed. *Elegant French Fashions of the Late Nineteenth Century: 103 Costumes from* La Mode illustrée. Mineola, NY: Dover, 1997.

Lipton, Eunice. *Looking into Degas: Uneasy Images of Women and Modern Life*. Berkeley: University of California Press, 1986.

Lloyd, Christopher. *Edgar Degas: Drawings and Pastels*. London: Thames and Hudson; and Los Angeles: J. Paul Getty Museum, 2014.

Loyrette, Henri. *Degas*. Paris: Librairie Arthème Fayard, 1991.

Magidson, Phyllis. "A Fashionable Equation: Maison Worth and the Clothes of the Gilded Age." In *Gilded New York: Design, Fashion, and Society*. Exh. cat. Ed. Donald Albrecht and Jeannine Falino. New York: Museum of the City of New York and Monacelli Press, 2013.

Mancoff, Debra N. *Fashion in Impressionist Paris*. London: Merrell, 2012.

Manet, Julie. *Journal (1893–1899): Sa jeunesse parmi les peintres impressionnistes et les hommes de lettres*. Paris: Librairie C. Klincksieck, 1979.

Marshall, Nancy Rose, and Malcolm Warner. *James Tissot: Victorian Life, Modern Love*. Exh. cat. New York: American Federation of the Arts; and New Haven, CT: Yale University Press, 1999.

Mathews, Nancy Mowll. *Mary Cassatt*. New York: Harry N. Abrams; and Washington, DC: National Museum of American Art, Smithsonian Institution, 1987.

———. *Mary Cassatt: A Life*. New York: Villard Books, 1994.

Matyjaszkiewicz, Krystyna, ed. *James Tissot*. New York: Abbeville Press, 1984.

Mauclair, Camille. *Jules Chéret*. Paris: Maurice le Garrec, 1930.

Maumené, Albert. *Les fleurs dans la vie: L'art du fleuriste. Guide général de l'utilisation des plantes et des fleurs dans l'ornementation des appartements, du montage des fleurs et de la composition des bouquets, des corbeilles et des couronnes*. Paris: Librairie Horticole "Du Jardin," 1897.

McDowell, Colin. *Hats: Status, Style, and Glamour*. London: Thames and Hudson, 1992.

McLean, Janet, ed. *Impressionist Interiors*. Exh. cat. Dublin: National Gallery of Ireland, 2008.

McMullen, Roy. *Degas: His Life, Times, and Work*. Boston: Houghton Mifflin, 1984.

Mémoires d'une modiste, écrits par elle-même. Paris: F. Cournol, 1866.

Merceron, Dean L. *Lanvin*. New York: Rizzoli, 2007.

Mercié, Marie, and Sophie-Charlotte Capdevielle. *Voyages autour d'un chapeau*. Paris: Editions Ramsay/de Cortanze, 1990.

Miller, Michael B. *The Bon Marché: Bourgeois Culture and the Department Store, 1869–1920*. Princeton, NJ: Princeton University Press, 1981.

Miniatures from Paris, Showing the Leading Designs (From Life) by the Great Parisian Modistes: Spring and Summer, 1899. Hamilton, Canada: Hinman and Co., 1899.

Moffett, Charles S., ed. *The New Painting: Impressionism, 1874–1886*. Exh. cat. San Francisco: Fine Arts Museums of San Francisco, 1986.

Monjaret, Anne. "L'art de la plume: Quand la nature devient parure de mode (XIXe–XXe siècles)." In *Plumes: Motif, mode & spectacle*, 7–25. Exh. cat. Bourgoin-Jallieu, France: Musée de Bourgoin-Jallieu; and Lyon: Livres–Édition média conseil communication, 2011.

———. *La Sainte-Catherine: Culture festive dans l'entreprise*. Paris: Éditions du Comité des travaux historiques et scientifiques, 1997.

———. "Les modistes: De l'artisan à l'artiste. Les mutations d'un corps de métier à travers le contexte de production." *Ethnologie française* 28, no. 2 (April–June 1998): 235–246.

———. "Plume et mode à la Belle Époque: Les Plumassiers parisiens face à la question animale." *Techniques & Culture* 50 (2008): 228–255.

Moore, George. *Impressions and Opinions*. London: David Nutt, 1891.

Morin, E. *La Plume des oiseaux et l'industrie plumassière*. Paris: Librairie J.-B. Baillière et fils, 1914.

Müller, Florence, and Lydia Kamitsis. *Les Chapeaux: Une histoire de tête*. Paris: Syros-Alternatives, 1993.

Mystery and Glitter: Pastels in the Musée d'Orsay. Exh. cat. Paris: Réunion des musées nationaux, 2009.

Offenstadt, Patrick. *Jean Béraud, 1849–1935: The Belle Epoque, A Dream of Times Gone By. Catalogue Raisonné*. Cologne: Taschen, 1999.

Ortner, Jessica. *Practical Millinery*. London: Whittaker & Co., 1897.

The Paris Hat, 1885–1910: From the Costume Collections of the Fine Arts Museums of San Francisco and Los Angeles County Museum of Art. Exh. cat. San Francisco: Fine Arts Museums of San Francisco, 1983 [?].

Payen, Édouard. "Le Commerce des fleurs à Paris." *L'Économiste Français*, September 6, 1902, 319–321.

Pedersen, Line Clausen, ed. *Degas' Method*. Exh. cat. Copenhagen: Ny Carlsberg Glyptotek; and London: Black Dog, 2013.

Perkins, Alice K. *Paris Couturiers and Milliners*. New York: Fairchild Publications, 1949.

Perrot, Philippe. *Fashioning the Bourgeoisie: A History of Clothing in the Nineteenth Century*. Translation of *Dessus et les dessous de la bourgeoisie* by Richard Bienvenu. Princeton, NJ: Princeton University Press, 1994.

Pfeiffer, Ingrid, ed. *Women Impressionists: Berthe Morisot, Mary Cassatt, Eva Gonzalès, Marie Bracquemond*. Exh. cat. Frankfurt am Main: Schirn Kunsthalle; and Ostfildern, Germany: Hatje Cantz, 2008.

Picardie, Justine. *Coco Chanel: The Legend and the Life*. New York: Itbooks and Harper Collins, 2010.

Pickvance, Ronald. "Degas and the Painting of Modern Life." *Journal of the Royal Society of Arts* 128, no. 5285 (April 1980): 250–263.

Pierre-Auguste Renoir. Revoir Renoir. Exh. cat. Martigny, France: Fondation Pierre Gianadda, 2014.

Pissargevsky, Lydie de. "Les Salaires féminins dans l'industrie de la fleur artificielle en France et de la dentelle en Belgique." *Journal de la Société statistique de Paris* 54 (August–September 1913): 461–464.

Proust, Antonin. "Souvenirs sur Édouard Manet." *La Revue blanche* 11, no. 86 (January 1, 1897): 310–311.

Proust, Marcel. *Remembrance of Things Past*. Translation of *À la recherche du temps perdu* (1913–1927) by C. K. Scott Moncrieff. London: Wordsworth Editions, 2006.

Rabinow, Rebecca E., ed. *Cézanne to Picasso: Ambroise Vollard, Patron of the Avant-Garde*. Exh. cat. New York: Metropolitan Museum of Art; and New Haven, CT: Yale University Press, 2006.

Reff, Theodore. "Degas: A Master Among Masters." *Metropolitan Museum of Art Bulletin*, n.s. 34, no. 4 (Spring 1977): 2–48.

——. "Some Unpublished Letters of Degas." *Art Bulletin* 50, no. 1 (March 1968): 87–94.

——, ed. *The Notebooks of Edgar Degas: A Catalogue of the Thirty-Eight Notebooks in the Bibliothèque Nationale and Other Collections.* 2 vols. Oxford: Clarendon Press, 1976.

Reynaerts, Jenny, and Stella Versluis-Van Dongen. "A Portrait of the Artist as a Young Man: Edgar Degas Inspired by Rembrandt." *Rijksmuseum Bulletin* 59, no. 2 (2011): 102–133.

Robins, Anna Gruetzner, and Richard Thomson. *Degas, Sickert and Toulouse-Lautrec: London and Paris, 1870–1910.* Exh. cat. London: Tate Publishing, 2005.

Robinson, Fred Miller. *The Man in the Bowler Hat: His History and Iconography.* Chapel Hill: University of North Carolina Press, 1993.

Roger-Milès, L. *Les Créateurs de la mode.* Paris: Ch. Eggimann, 1910.

Roskill, Mark. "Early Impressionism and the Fashion Print." *Burlington Magazine* 112, no. 807 (June 1970): 390–393, 395.

Rouart, Denis. *The Unknown Degas and Renoir in the National Museum of Belgrade.* New York: McGraw-Hill, 1964.

Rousseau, Louise. *Fourrures et plumes: L'Art de les connaître, de les porter et de les conserver.* Paris: Ch. Mendel, n.d. [1890?].

Russoli, Franco. *L'opera completa di Degas.* Milan: Rizzoli, 1970.

Sainsaulieu, Marie-Caroline, and Jacques de Mons. *Eva Gonzalès, 1849–1883: Étude critique et catalogue raisonné.* Paris: La Bibliothèque des Arts, 1990.

Sapori, Michelle. *Rose Bertin: Ministre des modes de Marie-Antoinette.* Paris: Éditions du Regard and Institut français de la mode, 2003.

Schwander, Martin, ed. *Edgar Degas: The Late Work.* Exh. cat. Riehen/Basel: Fondation Beyeler; and Ostfildern, Germany: Hatje Cantz Verlag, 2012.

Sébillot, Paul. *Légendes et curiosités des métiers.* Paris: Ernest Flammarion, n.d. [1895?].

Shackelford, George T. M., and Xavier Rey. *Degas and the Nude.* Exh. cat. Boston: Museum of Fine Arts, 2011.

Sickert, Walter. "Degas." *Burlington Magazine for Connoisseurs* 31, no. 176 (November 1917): 183–191.

Simon, Marie. *Fashion in Art: The Second Empire and Impressionism.* London: Zwemmer, 1995.

——. *Les métiers de l'élégance.* Paris: Éditions du Chêne, 1996.

Søndergaard, Sidsel Maria, ed. *Women in Impressionism: From Mythical Feminine to Modern Woman.* Exh. cat. Copenhagen: Ny Carlsberg Glyptotek; and Milan: Skira, 2006.

Steele, Valerie. *Paris Fashion: A Cultural History.* 2nd. ed. Oxford: Berg, 1998.

Stein, Sarah Abrevaya. "'Falling into Feathers': Jews and the Trans-Atlantic Ostrich Feather Trade." *Journal of Modern History* 79, no. 4 (December 2007): 772–812.

——. *Plumes: Ostrich Feathers, Jews, and a Lost World of Global Commerce.* New Haven, CT: Yale University Press, 2008.

Stevens, MaryAnne, and Lawrence W. Nichols, eds. *Manet: Portraying Life.* Exh. cat. Toledo: Toledo Museum of Art; and London: Royal Academy of Arts, 2012.

Sutton, Denys. *Edgar Degas: Life and Work.* New York: Rizzoli, 1986.

Takeda, Sharon Sadako, and Kaye Durland Spilker, eds. *Fashioning Fashion: European Dress in Detail, 1700–1915.* Exh. cat. Los Angeles: Los Angeles County Museum of Art; and Munich: DelMonico Books/Prestel, 2010.

Terras, Lucien. *L'Histoire du chapeau: Réflexions, citations et anecdotes inspirées par le chapeau.* Paris: Jacques Demase, 1987.

Testi, Camilla, Maria Grazia Piceni, and Enrico Piceni. *Federico Zandomeneghi: Catalogo generale.* 3rd. ed. Milan: Fondazione Piceni and Libri Scheiwiller, 2006.

Tétart-Vittu, Françoise. "Shops versus Department Stores." In Gloria Groom, ed. *Impressionism, Fashion, and Modernity,* 209–217.

Thomson, Richard. *The Private Degas.* Exh. cat. London: Arts Council of Great Britain, 1987.

Tiersten, Lisa. *Marianne in the Market: Envisioning Consumer Society in Fin-de-Siècle France.* Berkeley: University of California Press, 2001.

Touches d'exotisme: XIVe–XXe siècles. Paris: Musée de la mode et du textile, Union centrale des arts décoratifs, 1998.

Troy, Nancy J. *Couture Culture: A Study in Modern Art and Fashion.* Cambridge, MA: MIT Press, 2003.

Uzanne, Octave. *Fashion in Paris: The Various Phases of Feminine Taste and Aesthetics from 1797 to 1897.* Translation of *Modes de Paris* by Lady Mary Loyd. London: William Heinemann; and New York: Charles Scribner's Sons, 1898.

——. *La Femme à Paris: Nos contemporaines. Notes successives sur les Parisiennes de ce temps dans leurs divers milieux, états et conditions.* Paris: Ancienne Maison Quantin, 1894.

Valéry, Paul. *Degas, danse, dessin.* Paris: Gallimard, 1934.

Van Kleeck, Mary. "The Artificial Flower Trade in Paris." Chapter 7 of Van Kleeck, *Artificial Flower Makers.* New York: Survey Associates, 1913.

Vegelin van Claerbergen, Ernst, and Barnaby Wright, eds. *Renoir at the Theatre: Looking at La Loge.* Exh. cat. London: Courtauld Gallery and Paul Holberton, 2008.

Vollard, Ambroise. *Degas (1834–1917).* Paris: Éditions G. Crès, 1924.

——. *Degas: An Intimate Portrait.* New York: Crown Publishers, 1937.

Watrigant, Frédérique de, ed. *Paul-César Helleu.* Paris: Somogy Art Publishers, 2014.

Werner, Alfred. *Degas Pastels.* New York: Watson-Guptill, 1968.

Wilcox, R. Turner. *The Mode in Hats and Headdress.* New York: Charles Scribner's Sons, 1945.

Zdatny, Steven, ed. *Hairstyles and Fashion: A Hairdresser's History of Paris, 1910–1920.* Oxford: Berg, 1999.

Zola, Émile. *The Ladies' Paradise.* Translation of *Au bonheur des dames* by Brian Nelson. Oxford: Oxford University Press, 1995.

INDEX

CREDITS

Images generally appear courtesy of the institutions acknowledged in the captions. Below is a list of those photographs for which separate or further credits are due.

Courtesy Acquavella Galleries, pl. 79. Art Gallery of Ontario, Toronto/Bridgeman Images, pl. 11. © The Art Institute of Chicago: figs. 65–66 and pl. 17; Bridgeman Images, front cover, figs. 33 and 75, pl. 1. Photo Les Arts Décoratifs, Paris/Jean Tholance, pls. 20, 36, 43, 50, 53–54, 63, 65, 72–73, 83. Courtesy of the Art Renewal Center®, www.artrenewal. org, fig. 55. Bibliothèque des arts décoratifs, Paris, France/Archives Charmet/Bridgeman Images, fig. 105. Courtesy of the Bibliothèque nationale de France, Paris, pp. 12, 50; figs. 1, 2, 4–5, 9–10, 17–21, 23, 29, 34, 36, 39, 48, 50, 52, 62, 79, 101, 103, 111, 113–115, 117; pls. 103–105. Bildarchiv Preußischer Kulturbesitz, Berlin/Neue Pinakothek, Bayerische Staatsgemäldesammlungen, Munich/Art Resource, NY, fig. 3. © The Trustees of the British Museum, fig. 40. Courtesy of Lucy M. Buchanan, pl. 94. Bührle Collection, Zurich, Switzerland/Bridgeman Images, fig. 7. Bunka Gakuen University Library, figs. 82, 109. Courtesy of the Chicago History Museum, pls. 5–6, 21, 34, 49, 82, 97. © Christie's Images Limited: © 1999, fig. 14; © 1984, fig. 37; Bridgeman Images, fig. 95 and pl. 2; © 2008, pl. 18. © Cleveland Museum of Art: pl. 86; Bridgeman Images, pl. 29. © Comoedia Illustré, 1910, Photo Félix, fig. 123. Courtesy of the Denver Art Museum, pl. 76. © Département Histoire de l'Architecture et Archeologie de Paris/Roger-Viollet/Charles Lansiaux, fig. 108. Collection Diktats bookstore, fig. 27. Archivio Dini, Montecatini Terme-Firenze, pl. 95. Courtesy of the Dixon Gallery and Gardens, Memphis, pl. 24. Archives Durand-Ruel © Durand-Ruel & Cie, fig. 8. Courtesy of the Fashion Institute of Design & Merchandising, figs. 116, 120. © Fine Arts Museums of San Francisco: Photography by Joseph McDonald, p. 9; Photography by Randy Dodson, figs. 28, 70, 77, 104 and pls. 12,

19, 22, 25, 35, 40, 47–48, 71, 80, 98, 100, 102, back cover. Fogg Art Museum, Harvard Art Museums/Bridgeman Images, fig. 15 and pl. 8. Frances Lehman Loeb Art Center, Vassar College, Poughkeepsie, New York, fig. 42. © Galliera/Roger-Viollet/Stéphane Piera, fig. 125. Courtesy Ann and Gordon Getty, photograph by Ben Rose, pls. 38, 41, 77–78. Digital image courtesy of the Getty's Open Content Program, fig. 84. Courtesy of the Getty Research Institute, fig. 118. Hamburger Kunsthalle, Hamburg, Germany/Bridgeman Images, fig. 72. Image courtesy of Archives, Hill-Stead Museum, Farmington, CT, fig. 78. HIP/Art Resource, NY, fig. 44. Courtesy of Hôtel Marcel Dassault, fig. 93. Indianapolis Museum of Art/Bridgeman Images, pl. 14. © The J. Paul Getty Museum, Los Angeles: fig. 91; Bridgeman Images, pp. 100–101 and pl. 88. Courtesy Gallery Jean-François Heim, Basel, Switzerland, fig. 97. Courtesy of Justin Miller Art, Sydney, Australia, pl. 92. Erich Lessing/Art Resource, NY, fig. 60. Library of Congress, Prints & Photographs Division, [LC-DIG-ppmsca-27739], fig. 24. Courtesy of the Los Angeles County Museum of Art: pls. 23, 27; Bridgeman Images, fig. 88. Louvre, Paris/Bridgeman Images, figs. 46, 53–54. Collection of the Maryland State Archives, pl. 32. Courtesy of The Metropolitan Museum of Art, p. 82; figs. 13, 35, 38, 45, 61, 86–87, 106–107, 119; pl. 7. Courtesy of the Mildred Lane Kemper Art Museum, pl. 45. © Ministère de la Culture/Médiathèque du Patrimoine, Dist. RMN-Grand Palais/Art Resource, NY, fig. 30. Minneapolis Institute of Art/Bridgeman Images, pl. 33. Montreal Museum of Fine Arts: Brian Merrett, pl. 68; Denis Farley, pl. 84. The Morgan Library and Museum, New York, pl. 56. Musée Antoine Lecuyer Saint-Quentin, France/Bridgeman Images, fig. 59. Musée cantonal des Beaux-Arts, Lausanne, J.-C. Ducret, fig. 58. © Musée Carnavalet/Roger-Viollet, p. 66; figs. 32, 41, 124. © Musée d'art et d'histoire, Ville de Genève, Photo: Bettina Jacot-Descombes, fig. 96. Musée Marmottan Monet,

Paris/Bridgeman Images, pls. 39, 57, 64. Musée d'Orsay, Paris/Bridgeman Images, figs. 26, 85 and pl. 91. © Musée Toulouse-Lautrec, Albi, France: fig. 80; Bridgeman Images, fig. 99. © Museo Thyssen-Bornemisza, Madrid: fig. 16; Scala/Art Resource, NY, pl. 59. Photograph © 2017 Museum of Fine Arts, Boston, figs. 67, 76, 110 and pls. 4, 37, 52, 61, 66, 81, 87. © The Museum of Modern Art/Licensed by Scala/Art Resource, NY, figs. 11 and 22. Nasjonalmuseet for kunst, arkitektur og design/The National Museum of Art, Architecture and Design/Anne Hansteen, pl. 67. © National Gallery, London: Art Resource, NY, fig. 43; Bridgeman Images, fig. 69. Courtesy National Gallery of Art, Washington, figs. 81, 100 and pls. 9, 30–31. © National Gallery of Canada, pl. 28. National Portrait Gallery, Smithsonian Institution, pl. 74. Courtesy The Nelson-Atkins Museum of Art: fig. 90; Jamison Miller, p. 16 and fig. 6. Ny Carlsberg Glyptotek, Copenhagen, photo by Ole Haupt, pl. 62. Ordrupgaard Museum, Charlottenlund, Denmark, photo by Pernille Klemp, pl. 70. Courtesy of the Philadelphia Museum of Art, p. 270; figs. 121, 122, 126; pls. 3, 26, 46, 51, 99, 101. Private Collection/Bridgeman Images, fig. 83. © Punch Limited, figs. 71, 112. Courtesy of Pyms Gallery, London, pls. 16, 60. © RMN-Grand Palais/Art Resource, NY, fig. 47 and pl. 13. Courtesy Saint Louis Art Museum: fig. 94; photography by Jean Paul Torno, p. 2 and pls. 42, 75, 90; photography by Brian van Camerik, figs. 49, 51, 68 and pl. 44. The Samuel Courtauld Trust, The Courtauld Gallery, London, pl. 15. Courtesy of Simon C. Dickinson Ltd., fig. 89. Courtesy of Galerie Sophie Scheidecker, Paris, fig. 63. Courtesy of Sotheby's, Inc.: pl. 58; © 2004, fig. 12. Sterling and Francine Clark Art Institute, Williamstown, Massachusetts/Bridgeman Images, pl. 55. © Virginia Museum of Fine Arts: Travis Fullerton, p. 6 and pl. 89; Katherine Wetzel, pl. 85. Courtesy Diane B. Wilsey, photo by Randy Dodson, pl. 69.

This catalogue is published in 2017 by the Fine Arts Museums of San Francisco and DelMonico Books • Prestel on the occasion of the exhibition *Degas, Impressionism, and the Paris Millinery Trade*:

Saint Louis Art Museum
February 12–May 7, 2017

Legion of Honor, San Francisco
June 24–September 24, 2017

This exhibition is organized by the Fine Arts Museums of San Francisco and the Saint Louis Art Museum.

The Saint Louis presentation is generously supported by the William T. Kemper Foundation, Commerce Bank, Trustee. Financial assistance has been given by the Missouri Arts Council, a state agency. The exhibition is supported by a grant from the National Endowment for the Arts.

The San Francisco exhibition is made possible by Presenting Sponsors John A. and Cynthia Fry Gunn and Diane B. Wilsey, as well as Patron's Circle donor Marion Moore Cope.

The catalogue is published with the assistance of the Andrew W. Mellon Foundation Endowment for Publications.

Fine Arts Museums of San Francisco
de Young, Golden Gate Park
50 Hagiwara Tea Garden Drive
San Francisco, CA 94118
www.famsf.org

Leslie Dutcher, Director of Publications
Danica Michels Hodge, Editor
Jane Hyun, Editor
Diana K. Murphy, Editorial Assistant

Edited by Jane Hyun
Picture research by Diana K. Murphy
Translations by Rose Vekony and Alexandra Bonfante-Warren
Proofread by Susan Richmond
Indexed by Jane Friedman
Designed and typeset by Joan Sommers, Glue + Paper Workshop LLC
Production management by Karen Farquhar, DelMonico Books • Prestel
Printed in China

DelMonico Books, an imprint of Prestel, a member of Verlagsgruppe Random House GmbH

Prestel Verlag
Neumarkter Strasse 28
81673 Munich

Prestel Publishing Ltd.
14–17 Wells Street
London W1T 3PD

Prestel Publishing
900 Broadway, Suite 603
New York, NY 10003

www.prestel.com

978-3-7913-5621-1 (hardcover)
978-3-7913-6747-7 (paperback)

Library of Congress Cataloging-in-Publication Data

Names: Kelly, Simon (Simon R.) | Bell, Esther (Esther Susan) | Hiner, Susan | Tétart-Vittu, Françoise | Buron, Melissa E. | Camerlengo, Laura L. | Chrisman-Campbell, Kimberly | Yoder, Abigail. | Legion of Honor (San Francisco, Calif.), organizer, host institution.
Title: Degas, impressionism, and the Paris millinery trade / Simon Kelly and Esther Bell ; with Susan Hiner and Françoise Tétart-Vittu, and Melissa Buron, Laura L. Camerlengo, Kimberly Chrisman-Campbell, and Abigail Yoder.
Description: San Francisco : Fine Arts Museums of San Francisco • Legion of Honor, 2017. | Includes bibliographical references and index.
Identifiers: LCCN 2016044559| ISBN 9783791356211 (hardcover) | ISBN 9783791367477 (pbk.)
Subjects: LCSH: Hats in art—Exhibitions. | Hats—France—Paris—Exhibitions. | Millinery—France—Paris—Exhibitions. | Degas, Edgar, 1834–1917—Themes, motives—Exhibitions. | Impressionism (Art)—France—Paris—Exhibitions.
Classification: LCC N8217.H34 D44 2017 | DDC 704.9/4939143074044361—dc23
LC record available at https://lccn.loc.gov/2016044559

A CIP catalogue record is available from the British Library.

DETAILS

Cover: Edgar Degas, *The Millinery Shop*, 1879–1886 (cat. no. 1)
Endsheets: *Summer 1891* and *Winter 1891*, both 1891, plates from *Le Caprice* (figs. 113 and 114)
Page 2: Degas, *The Milliners*, ca. 1898 (cat. no. 90)
Page 6: Degas, *At the Milliner's*, ca. 1882–1898 (cat. no. 89)
Page 9: Édouard Manet, *At the Milliner's*, 1881 (cat. no. 22)
Page 12: *Paris in 1889*, plate XIII from Eugène-René Poubelle and Adolphe Alphand, *Les Travaux de Paris, 1789–1889* (Paris: Imprimerie nationale, 1889). Bibliothèque nationale de France, Paris, GR FOL LE SENNE-129
Page 16: Degas, *Little Milliners*, 1882 (fig. 6)
Page 50: Eugène Atget, *Le Salon de Mme C., Modiste*, 1910, from *Intérieurs parisiens, début du XXe siècle* (cat. no. 105)
Page 66: Claude Regnier, *Modiste*, n.d., from *Les Parisiennes* (fig. 41)
Page 82: Degas, *At the Milliner's*, 1882 (fig. 61)
Pages 100–101: Degas, *The Milliners*, ca. 1882–before 1905 (cat. no. 88)
Page 270: G. Agie, *Workroom of Mme Georgette*, from Léon Roger-Milès, *Les Créateurs de la mode* (Paris: 1910) (fig. 122)

BACK COVER

Maison Virot, woman's hat, ca. 1900, with alterations (cat. no. 71)